The Official U.S. Casino Chip Price Guide

Second Edition

James Campiglia &
Steve Wells

4880 Lower Valley Road, Atglen, PA 19310 USA

Published by Schiffer Publishing Ltd., 4880 Lower Valley Road, Atglen, PA 19310, Phone: (610) 593-1777; Fax: (610) 593-2002, E-mail: Schifferbk@aol.com

Please visit our web site catalog at **www.schifferbooks.com.** This book may be purchased from the publisher. Include $3.95 for shipping. Please try your bookstore first.

We are interested in hearing from authors with book ideas on related subjects. You may write for a free catalog.

In Europe, Schiffer books are distributed by Bushwood Books 6 Marksbury Ave., Kew Gardens, Surrey TW9 4JF England, Phone: 44 (0) 208 392-8585; Fax: 44 (0) 208 392-9876, E-mail: Bushwd@aol.com.
Free postage in the U.K., Europe; air mail at cost.
Try your bookstore first

Designed by Douglas Congdon-Martin
Chip photography by Steve Wells
Type set in Swiss 721BT

ISBN: 0-7643-1157-3
Printed in China

This book is dedicated to all chip, token and gaming memorabilia collectors who share our interests in collecting and preserving gaming history.

Acknowledgments

This book was the end result of the efforts of the most knowledgeable chip collectors and dealers all across the United States. These generous individuals are noted down below and throughout the book itself. A special mention goes out to Jim Kruse, who did the lion's share of work on our new Riverboat section. Barry Weintraub and David Sarles, Secretary and President respectively, of the national Casino Chips & Gaming Tokens Collectors Club, have given generously of their knowledge, time, and personal collections from day one.

Also, we'd like to thank our parents for supporting this project: Sue Campiglia, Eddy Campiglia, Bill Wells, and Joyce & Ken Kephart.

In addition, we'd like to thank Peter Schiffer of Schiffer Publishing for his enthusiastic support of this project, which has allowed this book to reach a national audience and expand our great and growing hobby.

Last, but not least, a special thank-you to our editor Molly Higgins.

Contributors of non-Nevada information (in alphabetical order): **Atlantic City:** Dick Brach, Russ Diaz, Gene Grossblatt and Nate Pincus; **Deadwood:** Rick Bernhard, Steve Brock, Ford Jensen, Bob Matthews, and Janice O'Neal; **Colorado:** Gary Oryniak; **Riverboats:** Bob Gabel, Jim Kruse, and Greg Susong.

Generous contributors of Nevada information/chips, or anything else that had a positive effect on this project are:
Dick Allard, Bill Akeman, Roger Ashby, Ed Bellew, Bob Bosseler, Lynn Brooks, Todd Brunson, Rich Burgel, Carey

Burke, John Chamberlain, Tim and Sherry Claire, Norm Cordt, Tommy & Ruth Costanzo, Charles Crate, Steve Cutler, Lance Deal, Walter Dirzulaitis, Bob Feeney, Kurt Field, Daryl Fossier, Mark Freitag, Henry Garrett, David Gehl, Jim Gillette, Walt Gonski, Gene and Arlene Grossblatt, Doug Hancock, Dave and Debbie Harber, Scott and Estelle Hartman, Howard and Kregg Herz, Fred Holabird, Clint Hubbard, Doris Jackson, Scott Jaske, Phil Jensen, Rock Johnson, Bill Judge, Mel Jung, Michael Knapp, Tammy Kongsrud, Bruce Landau, Terry Lazarus, Dr. Eugene Lonstein, Don Lueders, Bo Maciech, Larry Markman, Steve McClendon, Bill Merrill, Bud Meyer, Jim Mooradian, Allan Myers, Rene Nezhoda, Joy Nichols, Dennis O'Neill, Dennis Owen, Steve Passalacqua, Robert Peccole, Mike Pertgen, Armin Pfaender, Steve Piccolo, Nate Pincus, Dean Porter, Shannon Porter, Richard Price, John Rauzy, John Rebottaro, Charles Rodgers, Dave Romagnoli, Bill St. Claire, Allen Sandquist, David Sarles, Bill and Yvonne Schmidt, Gary Shepard, Reggie Shoeman, Josh Shore, Mike Spinetti, Jim Steffner, Don Totoian, Carl Vidano, Jerry Wall, Barry Weintraub, Ralph Weiss, Ernie Wheelden, and John Yee.

Contents

Introduction

The book you hold in your hands is intended to be the finest work ever produced on the subject of collecting and evaluating U.S. casino chips. As a price guide, it is meant to be definitive. Our goal was and is to produce a work of superior quality which can compare favorably with any other book on American collectibles. Only you can decide whether we have succeeded. Virtually every serious major casino chip collector and dealer in the United States was consulted numerous times in order to cross-check the voluminous amount of factual data contained within.

This undertaking was massive indeed, and we are not naïve enough to believe that no errors were made. Nevertheless, we assure you that our very best efforts were given and we will work even harder in future editions to correct mistakes and uncover new information.

In putting together this book, certain key questions had to be addressed immediately. The biggest decision was to settle on the scope of the book. We decided that all major, legal, full-service American casino areas with legitimate gaming commissions would be included. This includes Nevada, Atlantic City, New Jersey; Colorado; Deadwood, South Dakota; and the various Riverboat casinos. Card Clubs and illegal/Indian casinos will not be covered in this or any future edition of the *Official U.S. Casino Chip Price Guide*.

The primary purpose of this book is to cover the real, regular issue chips actually used on the tables. However, due to popular demand, we have included a special section just for Nevada Limited Editions and Commemoratives in the back of this book. Riverboat Commemoratives and Limited Editions are simply listed with the regular issues, because there are not that

many to list.

As you have probably noticed, this book is printed in full color, and is the only price guide of its type that can make this claim.

We have also included old photos of selected casinos, along with capsule histories, in an attempt to bring a bit of the past to life. The history of the old casinos is part of the allure to own a piece of time that the chips represent.

You may have questions about the format, pricing, and grading. These topics are explained in great detail in the chapter entitled *How to use this Price Guide*. Make sure you read this carefully—we'd hate for you to miss something important!

Lastly, we appeal to all chip collectors reading this book to help out. If you have new information or wish to correct something you feel is in error, please contact us at the following address: American Chip Enterprises, 3540 W. Sahara Ave. #168, Las Vegas, NV 89102. Please do not go through the Chip Rack and write down chips we haven't listed. We intentionally omitted any chips we couldn't verify first-hand. We feel it is better to be a bit incomplete rather than inaccurate. Only correct us on chips or information that you have first-hand or on which you would bet your life!

Chip Collecting:
20 Questions & Answers

1. Q: Is there a national Chip Club I can join?

A: Yes—the Casino Chips & Gaming Tokens Collectors Club (CC>CC for short). You will find a membership form in the back of the book. Dues are only $20 a year and this will entitle you to the quarterly club magazine and access to thousands of collectors across the country. There are also branch clubs located in various cities.

2. Q: What is the best way to begin collecting chips?

A: There are several different ways to start. The easiest way to get good chips is to buy them from dealers or in auctions. In many cases you must do this to get the pieces you want for your collection. Several coin dealers are now selling chips and others are beginning to take notice. Also, you can just get them from your favorite casinos right now. If you have an eagle eye, you might get lucky and find an error or get a chip that's placed on the table for a short time and becomes valuable quickly. The internet auction, eBay, has thousands of chips for sale, every day! However, the way which is actually the most lucrative and satisfying, is to get off the beaten path and try to find people that have old chips but don't know they're valuable. This could be at a garage sale, flea market, antique shop, rummage sale, etc. Many people have placed ads in various publications offering to buy chips and this has turned up many incredible pieces. Use your imagination, because there's a lot of great stuff hidden all over the country.

3. **Q: When did chip collecting really start?**

A: The first serious chip collector was probably Howard Herz, whose uncle, Harvey Gross, (of Harvey's Casino) financed his travels around Nevada beginning in the summer of 1964. After acquiring enough chips, Howard Herz displayed them in Harvey's casino from 1967 to about 1983. Herz's intention was to preserve gaming history. In the late 1960s, Phil Jensen was so inspired by the display that he also went around Nevada collecting chips. His collection included many incredible rarities, but has since been stolen, recovered, then broken up in various ways among collectors across the country. The national club, CC>CC, was started in 1988 and has enrolled over 4,000 members since. There are many more thousands of chip collectors across the country who have not joined any clubs, but are content to collect privately.

4. **Q: Where can I attend chip shows?**

A: The best show every year is the annual Convention held by CC>CC in Las Vegas. The 2000 show will take place at the Tropicana on July 20-22, 2000. In addition, there is an annual auction that only club members can attend. This auction is expected to break price records and should be very exciting. There are also shows at Arizona Charlie's, Las Vegas; Arcadia, California; and even one in Mississippi. There are others too, from time to time, and the best place to find out about them is to join the club and read the ads!

5. **Q: What advantages do casino chips have over other collectibles?**

A: In general, they are easier to store and display. They are legitimately rare and undervalued compared to many other collectibles.

6. Q: Is Chip Collecting the real deal or just another fad?

A: This is a very important question and the short answer is that chip collecting is not a fad. Thousands of people collect chips because they want to—not because of some ridiculous hype. Fast food chains are not giving away souvenir chips with hamburgers and fries. Smooth-talking hucksters on those cable-shopping channels are not hawking chips. Chip collectors are generally very serious about their collections and are not in them just for the money. This strong collector base means that chips are a good investment. But to real collectors, the value is secondary to their enjoyment of filling holes in their collections, finding chips in out of the way places, learning about the history of chips and their casinos, and enjoying the overall camaraderie that takes place in this hobby.

7. Q: What is the potential for chip collecting?

A: Huge. This is still your chance to get in on the ground floor. Chip collecting is growing daily, but is still in its infancy. For example, twenty years ago the best comic book sold for about $5000. Now, there have been several issues that have exceeded $100,000 at auction—the highest being about $175,000. The really interesting fact is that the best chips are far, far rarer than the best comic books! Similar comparisons can be made to other hobbies if you care to look.

8. Q: What are the best casino chip websites?

A: Greg Susong's website is excellent and can be accessed at chipguide.com. From there you can link to the CC>CC web site. Ebay.com is a good place to buy chips, as well as everything else in the universe that isn't nailed down!

9. Q: What is the best way to store and display chips?

A: Your first, and most important consideration, is to keep your chips away from sunlight. If you frame your chips and hang them on a wall in your home, make sure it's an inside wall not exposed to sunlight. Another enemy of chips is fluorescent light because it emits UV rays and will destroy a chip's color in a relatively short time. Normal light bulbs are better, but your best bet is to store chips in binders just to be on the safe side.

The highest quality binders are Dansco albums. You can fit nine chips to a page. The binders themselves hold seven or nine pages, depending on which type you purchase. No cardboard flips are necessary, because spaces for the chips are already cut into the page. A thin plastic sheet slides over the chips to allow for their placement and removal. The only drawback to Dansco binders is that they are expensive. They cost about $30 each. Most collectors only use this kind of binder for their very best chips.

A more cost-effective way to store chips is to use three-ring binders you can purchase in any office supply store. The next thing you need are pages. The best-quality pages are made by Cowens. The plastic is more durable and the chips fit in snugly. We recommend the kind of pages that have room for exactly twelve chips. These pages use 2 1/2" X 2 1/2" cardboard flips, which put less stress on the chips and allow for easier removal. You can buy sheets that hold 30 chips and need no flips. However, we strongly advise against this, because the chips barely fit and are in there so tight that they can be damaged. Just spend a little extra money and do it right.

Temperature is rarely a factor with chips inside a home, but be very careful when transporting chips in

your car if you live in a hot state like Nevada. Summer temperatures inside a closed car can be so intense that chips can warp or literally melt in a shorter time than you think.

10. Q: Is counterfeiting a problem in chip collecting?

A: The short answer is no. Chips are generally very hard to duplicate. There is one notable example that must be mentioned. Chip collector Bill Borland obtained the rights to the Nevada and Diecar molds and he produced some hot stamped chips that were not issues ordered by the casinos. These are considered counterfeit chips and have been noted throughout the book. In general, these can be recognized by the brassy color of the gold hot stamp that looks quite different from the genuine article. Chips with inlays are much more difficult to fake and very few, if any, of these have ever been successfully counterfeited. One group of inlaid fakes must be mentioned. These are all Nevada mold chips with the opening and closing dates of the casino printed on the chip. For example, there is a Dunes set ranging in denominations from $5 to $5000, and other casinos have similar chips. These are all junk souvenir chips and virtually worthless.

11. Q: What is a chip's "mold" and why is it so important?

A: The mold identifies the actual maker or distributor of the chip as well as helps to date the issue. Also, some molds are more collectible than others and this can greatly affect the value.

12. Q: Should you clean chips?

A: In coin collecting, cleaning is a disaster and will destroy the value of your holdings. Coins have a mint luster that is ruined by cleaning them. Fortunately, chips do not suffer the same fate. Cleaning chips does not

inherently hurt their value. Done properly, a cleaned chip is far more attractive than an uncleaned chip. Of course, cleaning will rarely improve the grade of a chip, just the appearance. The key to cleaning chips is to use the proper substance. The first rule of chip cleaning is to NEVER, EVER use soap and water. This will permanently ruin your chips. Water causes inlay bubbles, among other things. A pink goo is sold at chip shows which should also be avoided. This pink stuff can discolor your chips and give them a washed-out look. The best substance on earth for cleaning chips, in our opinion, is Armor All Multi-Purpose Cleaner. Do not confuse this with Armor All Wheel Cleaner which is way too powerful to use on chips. Just spray a small amount directly on the chip and distribute the liquid across the surface lightly with a soft-bristle toothbrush—get the smallest brush head possible for greater control. For best results, let the liquid sit on the chip for at least twenty seconds, longer for really filthy chips. When ready, brush the surface of the chip with short, light strokes. The liquid has already done most of the work, so don't overly abrade the surface. Wipe the chip with a dry cloth and admire your results. By the way, the above advice applies to chips with inlays. Hot stamped chips are tricky to clean, because it's easy to remove the gold stamping. Certain C&J mold chips have a light imprint, so these must be treated with extreme caution. Other companies have stronger hot stamps that are easier to clean. Either way, you should brush lightly and carefully.

13. Q: What's the difference between regular issue, limited edition, and commemorative chips?

A: Regular issue chips are chips produced by the casino for play on the tables. Limited edition chips are produced by the casino primarily for collectors to take home and collect, although they could be used on the

tables. In addition, these are usually dated with a year or a specific date—which is basically unheard of for any regular issues. Also, limited edition chips are produced in limited numbers, 2,000 on average, and this quantity is imprinted on the chip. Commemoratives can be either, but if it's a limited edition, a quantity will usually be stamped on the chip.

14. Q: Is the grading system in this book universally accepted?

A: No. However, it is the only serious and detailed grading system that has ever been published. At this point, it is used mainly by high-end collectors. The average collector may not be as concerned with condition yet, but as is the case with every other hobby in America, this factor will increase in importance whether one likes it or not.

15. Q: How often are hoards discovered and does this make chip collecting dangerous?

A: This is an important, but touchy subject. A couple times every year, a once-rare chip will be found in quantities ranging from maybe twenty pieces to twenty boxes. This is fine if an honest dealer or collector then sells them. He or she will announce the exact quantity, set a price, and begin selling them. The occasional cheat will lie about the quantities and sell them for much more than they are worth, brutalizing the first group of people who bought into their story. Some collectors will wait months or years after a discovery is announced, out of fear. That's why it's important to establish a relationship with people in the hobby you can trust. Of course, there's an upside to hoards. New discoveries allow you to expand your collection. The key is to buy at the right price. Overall, this is not a major problem for the hobby.

16. Q: What is the best way to collect chips, by location or denomination?

A: Whatever makes you happy. Some collectors specialize in just $1 or $5 chips and try to get all of them. Some collectors specialize in a specific location, although trying to complete a set of all Las Vegas chips is impossible. Other collectors focus on a specific casino and try to complete a set that way. Another very popular way to collect is to make a type set. This means you get one chip from each casino in the location of your choice. Or, you might try assembling a city type set by getting a chip from every town in Nevada—a very challenging endeavor! In short, chip collecting is a bit different from other hobbies in that there is no standard way to collect, but the above ways are the most popular.

17. Q: Is there any museum where I can see rare chips on permanent display?

A: Yes, in the Casino Legends Hall of Fame at the Tropicana Casino in Las Vegas. The Museum Curator, Steve Cutler, has an extensive collection of rare Nevada chips and memorabilia on display. This is a must-see for beginning or advanced collectors. In addition, old and new chips and casino memorabilia are sold in the gift shop. Call (702) 737-2111 for details.

18. Q: How many unknown chips are out there?

A: Plenty! There are hundreds of early Nevada Casinos where no chips exist whatsoever!

Many early casinos used initialed chips with no location listed. Others used silver dollars instead of chips. Yet, it's amazing how many dice have been found from clubs where chips are not yet known. Also, there are certain denominations of chips from well-known casinos that still pop up to excite the hobby, as you will

see by reading this book. This treasure-hunting aspect of chip collecting is part of the allure. Great material is out there, you just have to find it!

19. Q: Where can I find out more about chip collecting?

A: At the risk of being repetitious, join CC>CC. Talk to fellow collectors and ask lots of questions. Unfortunately, there is not an abundance of books or literature on the subject—that's one of the reasons we wrote this book!

20. Q: What is the most valuable chip worth?

A: This is a fun question with which to close our Q&A session. As of late 1999, the highest confirmed price ever paid for a casino chip was $8,750 for a third-issue Flamingo $100. However, that price is expected to be shattered by the private sale of the previously unknown first-issue Sands $5 Arodie. This CS95 chip is expected to sell for over $10,000 after this book goes to press. In addition, there are several other chips that would probably exceed $10,000 if they were offered for sale. In our opinion, these would include the first-issue Sahara $5; second-issue Sahara $25 (Sm-key); and New Boulder Club $5 (Arodie). Having said this, there are rumors of a $100 Flamingo first-issue. If this appeared on the market and came up for auction, it might bring as much as $15,000! The same can be said of a $25 New Boulder Club Arodie that is rumored to exist overseas.

How To Use This Price Guide

The easiest way to explain everything is to take a sample section and go over each column individually. First, here's a sample section from Black Hawk, Colorado:

Issue	Den.	Color	Mold	Inserts	Inlay	Rarity	GD30	VF65	CS95
BLACK HAWK STATION			Black Hawk, CO		1991-				
1st	5.00	Red	Chipco	None	FG	R-2	*	5	7

The first column, Issue, is the chronological order in which we feel that the chips were issued. Significant research was done to try and unlock this mystery. In most cases, the accuracy is very high; but some issues of some clubs are very difficult, if not impossible to determine. Nevertheless, we feel this is a huge step forward in classifying chips. In the past, other authors used long, complicated codes which are impossible to remember—and frankly, unnecessary. Using "issue" is a much easier way for everyone to communicate. Yes, it is possible that new discoveries could cause an issue change, but this should be rare enough not to cause any serious confusion.

The second column refers to the dollar amount of the chip. "Den." is an abbreviation for "Denomination." Roulette chips do not have a denomination. We signify them by using "RLT" instead. Other chips exist without denominations, but are not proven to be roulette chips. In these cases, we use "n/d". Here is a complete rundown of all the abbreviations you will encounter in the category.

bac: Baccarat	n/d: No Denomination
error: Error	NN: Non-Negotiable
faro: Faro	pok: Poker
FP: Free Play	RLT: Roulette
NCV: No Cash Value	

Incidentally, there is no earth-shattering reason why some abbreviations are capitalized and some aren't. We simply tried to make these terms distinct and easy for the eye to recognize.

The third column refers to the basic color of the chip body. Most colors are not abbreviated in this column, so confusion here is unlikely. However, we must say that everyone sees colors a bit differently. Were you aware of the scientific fact that women see subtle shades of color more clearly than do men? This probably explains why many women like pastels, whereas men prefer solid colors like black, red, blue, etc. On more than one occasion, we had lengthy discussions with others over whether a chip was pink, lavender, fuchsia, etc!

Nevertheless, you should not have trouble identifying any chips. Just try not to get too excited thinking you have some unknown turquoise chip as opposed to the "ltgrn" or "ltblu" chip that is listed. Also, we are not impressed by many of these so-called color variations some people claim to have. Most likely, the chip has just faded from light—be it fluorescent, sun, or some other source. Greens turn grey, reds turn pink, and so on.

The fourth column, Mold, is one of the most important because it identifies the look/manufacturer/distributor of the chip. Many of the following terms have been created by author Howard Herz and the co-authors of the Chip Rack (Allan Myers, Ernie Wheelden, and Michael Knapp). Usage of these abbreviations has become widespread and is now common terminology. We have, for the most part, adopted these terms for this book, because it doesn't make sense to reinvent the wheel!

One departure in our book is how we list the Bud Jones chips. Technically, there are hundreds of different Bud Jones chips, but we decided it was not important to have hundreds of different abbreviations for chips that basically look very similar. After giving it some thought, we realized that all Bud Jones chips can be covered under five headings as you will see. Here is the complete list of different molds covered in this price guide:

MOLDS DESCRIPTIONS

2Hubdi	2 Hubs and a diamond (8 repetitions)
Arodie	12 Repetitions of Arrows and Dice.
BJ	Bud Jones chips which are hot stamped.
BJ-H	Bud Jones chips with house mold (casino logo).
BJ-P	Bud Jones' version of a modern crest and seal chip. Plain mold.
BJ-1	Incused Bud Jones chips. (Usually mid-1970s.)
BJ-2	Non-incused Bud Jones chips with a mold design.
C	Large "C"
C&J	Christy & Jones. Hat & Cane with shiny, reflective surfaces.
C&S	Crest & Seal
Chipco	Chipco
Clover	Clover leaf on mold.
Cord	Looks like a rope.
Diamnd	Diamond Pattern.
Diasqr	Alternating pattern of 13 Diamonds & 13 Hub squares.
Diecar	4 pairs of dice & 4 groups of 4 cards.
Diswrl	6 dice with a "comet's tail."
Dots	25 repetitions of dots.
Dragon	4 dragons.
Ewing	1 die, heart, & spade, 1 die, club, & diamond.
Flower	12 repetitions of flower and stem.
G-N	Mold for Golden Nugget
H&C	Hat & Cane with non-reflective surfaces
HCE	8 repetitions of H's with a rectangle between them.
HHL	16 horse heads pointing left.
HHR	16 horse heads pointing right.
Horshu	16 horse shoes, alternating up and down.
House	House mold. (Individual casino's logo.)
Hrglas	30 hourglasses.
Hub	25 rectangles.
Lcrown	4 Large Crowns and long dash line.
Lg-key	Large Greek key.
Lgsqur	Large alternating squares & rectangles.
Lzydia	Lazy Diamonds
Nevada	"Nevada", pair of dice, "Nevada", cluster of four aces.
Plain	Chip without any mold design.
PMSC	Plastic Molded Slug Core
Rascir	Raised Circle
Rcthrt	11 repetitions of alternating rectangles & hearts.
Rectl	19 repetitions of rectangles.

Roulet	"Roulette" on mold.
S's	24 slanted "S's"
Scrown	12 small crowns.
Sm-key	Small Greek key.
Sqincr	Repetition of 16 squares in 16 circles.
Sqsqrt	Repetition of 2 squares and 1 rectangle.
T's	26 repetitions of "T's"
TK	13 repetitions of "TK"
Triang	24 repetitions of triangles, alternating up & down.
Triclb	12 repetitions of clubs & triangles.
Unicrn	8 repetitions of unicorn.
Wave	24 repetitions of wave crests, looks like "C's"
Weave	24 crossing weaves.
X's	22 repetitions of X's.
Zigzag	25 repetitions of zigzag pattern.

The fifth column, Inserts, refers to the different color patterns used on a chip's edge. Because so many chips have several different colors, we found that saving space became a factor. As a result, we use three-letter abbreviations with no capital letters and no spaces. If a chip is light green, for example, we call it "ltgrn". "Dark" is abbreviated "dk". Here is a list of all the colors we use in the insert category:

COLOR	DESCRIPTIONS	COLOR	DESCRIPTIONS
aqa	aqua	nvy	navy
bei	beige	olv	olive
blk	black	org	orange
blu	blue	pch	peach
brn	brown	pnk	pink
crm	cream	pur	purple
fch	fuchsia	red	red
gld	gold	sam	salmon
grn	green	slv	silver
gry	grey	tan	tan
lav	lavender	trq	turquoise
lim	lime	wht	white
mar	maroon	yel	yellow
mst	mustard		

The sixth category, Inlay, refers to the size and shape of the inlay, as well as composition and color. Here are the

different abbreviations we use in this category. Once again, credit goes to Howard Herz and the Chip Rack authors for many of these terms:

INLAY	DESCRIPTIONS
BRASS	PMSC
COG	Cogwheel
COIN	Metal Coin inlay. (Usually Bud Jones)
DIECUT-metal	Diecut metal inlay
FG	Full graphic (Chipco).
HEX	Hexagon
HS	Hot stamped. (Assume a gold hot stamp. Other colors are noted.)
HUB	Hub
L	Large (example: LSCA means a large scallop inlay.)
MC	Metal Center (Paulson) Not to be confused with a Coin inlay.
NOT	Notched on four sides.
O	Oversized. (Example: OR means "Oversized Round".)
OCT	Octagonal
PENTA	Pentagon
R	Round
SAW	Saw tooth
SCA	Scallop
SS	Silk Screened
STAR	Star
TRI	Triangle
WHL	Wheel

The seventh column, rarity, is the best estimate of the number of surviving chips that actually still exist on the planet. In some cases, the numbers are known precisely, and in other cases, a consensus was reached based on experience, observation, and the opinions of knowledgeable collectors across the country. This is the first time that this critical information is reaching chip collectors. Without it, how can anybody know what anything is worth?

Once the approximate number of chips is determined, we categorize the chip based on the following rarity scale. This is

similar to a Richter scale of sorts. Each time the rating drops a point, the population roughly doubles. Another good way to remember the chart is to remember that an R-5 (75-150 chips) is roughly a box of chips. We did this intentionally, so that the chart would be very logical. So, if there's definitely less than a box, (75 chips or less), the rarity climbs to R-6, officially the point that a chip becomes "rare." Look this over and get a feel for the numbers. It's not rocket science and you will be better able to evaluate your purchases by having this critical population information.

Rarity Scale	Known Survivors
Unknown	0
Unique	1
R-10 Impossible	2-3
R-9 Exceedingly Rare	4-7
R-8 Extremely Rare	8-15
R-7 Very Rare	16-30
R-6 Rare	31-75
R-5 Very Scarce	76-150
R-4 Scarce	151-350
R-3 Fairly Common	351-750
R-2 Common	751-2000
R-1 Extremely Common	2000+

NOTE: Research confirms that "Unknown" chips were definitely manufactured and used on the tables; but, unfortunately, no surviving examples are known to exist.

The final columns, GD30, VF65, and CS95 refer to grades. The prices listed below each column indicate the value of a chip in that grade. The chapter on grading goes into great detail on how to grade and it is our strongest possible recommendation that you thoroughly understand this information.

Before closing, we need to add that a "*" listed instead of a price means that the chip is almost worthless, not collectible in that condition, or is current and can be redeemed by the casino for face value.

Hopefully, this section has answered all the technical questions. If you feel that any further explanation is needed, write and let us know.

Final Thoughts On Pricing Chips

Before closing this section, we'd like to offer some additional insights on pricing chips, so that our methodology makes sense.

The purpose of this price guide is to show accurate retail values of U.S. casino chips, as of our 2000 publication date. The prices shown in this guide are retail prices—the prices you can actually expect to pay in order to buy these chips at this time. Keep in mind that unique or truly rare chips may actually exceed these prices when they are eventually offered for sale.

The truly rare and better-conditioned chips will always bring top dollar, because there is stiff competition out in the marketplace to acquire quality pieces. However, a common piece in average condition is more difficult to sell, so be careful when you buy that kind of material.

Determining prices for over 10,000 chips is not easy. Most chips are sold often enough that we can arrive at accurate values. However, some chips are so rare that several years may pass without a sale. In most other cases involving the really expensive chips, the transactions are private and the terms may or may not become known. Nevertheless, a value must still be listed. When known, we have just listed the actual price of the transaction, based on the condition of that specific piece. In the situations where no recent sales have occurred, we have estimated the market prices based on what we believe the chip would sell for if one were offered for sale. **Chips that are only known in drilled, notched, cancelled, or damaged condition are shown with an asterisk after the rarity rating. This is considered a theoretical price in case a good-conditioned piece is discovered. The market value of these damaged**

chips is about 30% of the listed prices. This is known as the 30% rule and is detailed throughout the book.

There are five basic factors that determine the price of a chip. Here is an overview of these factors, in order of importance.

1. **Rarity:** The fewer chips available, the higher the price. This economic reality hasn't changed in thousands of years.

2. **Location:** The most popular location to collect is Las Vegas, Nevada. Therefore, if all things are equal, a chip from Las Vegas is more valuable than a chip from anywhere else. Second best is anything else from Nevada, although there is a bit of a pecking order. The ranking of non-Las Vegas Nevada chips goes something like this: Lake Tahoe, followed by all the small towns; Reno; and then Laughlin, the least desirable.

After Nevada, there's a dropoff with Atlantic City leading the non-Nevada chips. Colorado is close behind, followed by the riverboat casinos. In last place, at this time, is Deadwood, South Dakota. This may change eventually, because many of these chips are very difficult to obtain. Chips that elicit little to no interest are card clubs and Indian casinos. Many old, illegal casinos are collectible; but those are way beyond the scope of this book.

Also, some casinos are more collectible than others. A famous, historically significant casino like the Flamingo, Sands, or Dunes is usually much better than an obscure club.

3. **Aesthetic Appeal:** The attractiveness and artistry of a chip has a major impact on the price. Put simply, a chip with a nice picture inlay is far more desirable and valuable than a chip with a simple hot stamp. A chip with an inlay, but not a picture, would be somewhere in between. Of course, a chip with a hot stamped picture is better than one with just hot stamped words.

4. **Mold:** Beginners should not ignore this factor. Serious collectors have definite preferences. The best mold, by far, is the **Arodie**. Second best are the old **C&S,** crest and seal chips. After that is probably **Sm-key** and **Rectl**. Above-average molds

are **Cord, Rcthrt, Diswrl, HHL, HHR**, possibly **HCE**, and a few others. Though common, **C&J** is also popular. The average mold, and the one most frequently encountered, is **H&C,** the hat and cane. This mold is found in all locations and is very common. The **Horshu** mold is probably in this category also. Below-average molds are generally considered to be **Scrown, Nevada, House, and Bud Jones**. Unusual molds are generally a plus.

5. **Condition:** This is very important and applies to every chip ever made. An ACS or CS chip will bring 2-3 times what a well-used, nicked chip will bring. ***Learn how to grade***.

Therefore, by using these factors, it is feasible to arrive at estimates of value for chips that are not commonly sold, or for new discoveries. The most valuable chip would be a unique, uncirculated chip from Las Vegas with an Arodie mold and a great-looking, classic picture from a famous, historically significant casino. The previously unknown Sands Arodie certainly fits this description!

Official Casino Chip Grading System

One of the problems inherent in chip collecting has been the lack of a standardized grading system. Many collectors and dealers have complained about this situation. Often, chips are described as "new" or "almost new" or "average" or "worn" etc. Obviously, these terms have no meaning, because they are too general and undefined. The time has come to be more precise. This grading system quantifies all the defects chippers already look for naturally. This has been done with the utmost care, but time and feedback will undoubtedly cause refinements.

At first glance, you might think the system is complicated, but it really isn't. If you can't master this in a couple of hours, you should start shopping for a dunce hat! The official grading guide for comic books is over 100 pages long. Books on coin grading can also be hundreds of pages. Learning to grade properly in these and other hobbies can literally take years. By comparison, grading chips is easy! Considering the time and money you can potentially spend on your collections, isn't it worth a little effort to learn how to properly evaluate your treasures?

The following grading scale is based on a logical 100-point system. A chip grading 100 is absolutely perfect on both sides in every way—no wear, scratches, discoloration, inlay imperfections, rim dings, etc. The lowest grade, 1, would go to a hideous chip which is barely recognizable.

There are three basic aspects of a chip which must be examined: 1) Wear. How much of the original detail remains? This is usually determined by examining a chip's remaining cross-hatching. The rim is also checked, especially on chips without cross-hatching. **2) Center area of chip**. This is either

the inlay or hot stamp. **3) Edge.** This is where you evaluate the chip's surface, including gouges, nicks, scratches, dings, etc. Of course, you must evaluate both sides of a chip to determine the final grade.

After much debate, a consensus has emerged which thinks that the best way to grade chips accurately is on a defect system. Put simply, you start with the highest possible theoretical grade (CS100) and then deduct points for everything that's wrong with the chip in each of the three areas discussed above. **When you are finished, you will have a single number which represents the chip's overall grade for that side. After the other side is graded you take the average of the two sides in order to arrive at the final overall grade. This is the number which determines the value of a chip in this price guide.**

Wear - Defect Scale

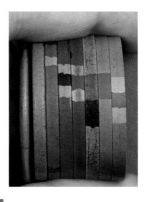

Right: Side view of the eight grading examples that follow.

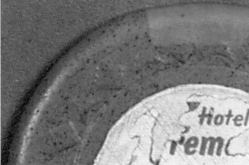

Left: Extreme Wear. Not only is all the cross-hatching worn off, but even the chip's mold details are worn and distorted. The body of the chip may be thin like a coin. -70

No cross-hatching remains outside of the inlay, but all of the chip's basic details retain their integrity. Rims are round and worn. Chip is noticeably thinner. -35

At least 15-20% of the cross-hatching remains, but is weak. Rims are round. -25

Approximately 40-50% of cross-hatching exists and can be plainly seen without magnification. This is also the proper category for chips with a greater percentage of cross-hatching that is weak. Rims are no longer square. -15

At least 70% of cross-hatching exists and is strong. Rims are mostly square, but starting to round. -10

90%+ of cross-hatching boldly exists. Rims are square, but have a slight trace of rounding. -5

Only a slight trace of wear. 100% of cross-hatching exists, but is weak in spots near the edge. (You may require magnification to see this.) -2

UNCIRCULATED. No trace of wear. Sharp rims. 0

Center - Defect Scale (Inlaid)

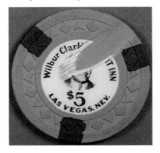

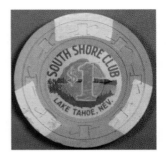

Missing Inlay: This automatically means chip is damaged on one side. -90

Extreme Inlay Damage: A chip is in this category if it has any one of the following extreme defects: large gouges; large stains, or very severe fading which actually affects seeing the details of the inlay. Chip has lost any of its aesthetic appeal. The damage dominates the inlay. -70

Serious Inlay Damage: Similar to above, a chip is in this category if it has any one of the following serious inlay defects: a smaller, but still distracting gouge; stain; cigarette burn or noticeable fade. The basics of the inlay are visible, but very unattractive. -50

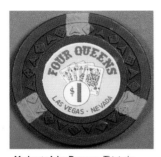

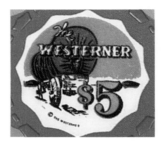

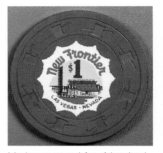

Moderate Inlay Damage. This is the category for chips which have at least **two** of the following moderate defects: light color printing or fading on one side; severely off-center (noticeable and distracting); inlay separation (an actual space between edge of inlay and chip body); or, when the inlay is actually "popping out"; any noticeable distracting mark on the inlay. -25

Minor Problems. Inlay has **one** of the moderate defects listed above **OR** at least **two** of the following: bad color registration (color is noticeably outside the lines); slight color difference between sides or mellowing/yellowing of a light-colored inlay; tiny but noticeable mark on inlay (this includes "inlay bubbles"); inlay off-center to the point where it's distracting. -15

Inlay has **one** minor defect of those listed above. -5

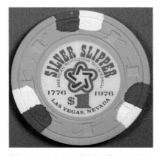

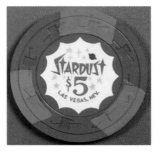

Inlay is nice, but is slightly off-center (not distracting, but noticeable.) Many chips fit into this category. -2

Inlay is perfect and well-centered. No defects whatsoever. -0

Center - Defect Scale (Hot Stamped)

Hot Stamp completely worn off and/or damage to center area. Chip is barely identifiable, even under magnification. Very unattractive. -70

Hot Stamp worn off, but readable by closely examining the grooves. Unattractive. -50

Hot Stamp is readable, but some letters may be weak or missing. -30

Hot Stamp is 100% readable, but only a trace, if that, of original color remains. -20

Hot Stamp is vibrant. Almost all of the original color remains. -10

Hot Stamp is sharp and complete with 100% original color. May be slightly off-center, but can have no other distracting marks. -5

Hot Stamp is complete and vibrant. No distracting defects of any kind is allowed. -0

Edge - Defect Scale

Extreme Damage: This is the category for chips with serious problems. This includes large gouges; severe warping; water damage; fire damage; and chips which have cracked into two or more pieces (repaired or not). -70

Rim Dings: Chip has no nicks at all, but deduct one point for each rim ding (up to a maximum of three.) -1 to -3

Minor Problems: These edges are fairly pleasing, but still have two or three small nicks and rough edges. -10

Large gouge

Small Nick

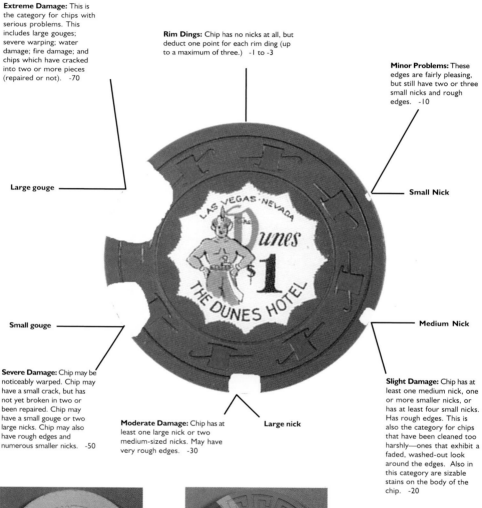

Small gouge

Medium Nick

Severe Damage: Chip may be noticeably warped. Chip may have a small crack, but has not yet broken in two or been repaired. Chip may have a small gouge or two large nicks. Chip may also have rough edges and numerous smaller nicks. -50

Moderate Damage: Chip has at least one large nick or two medium-sized nicks. May have very rough edges. -30

Large nick

Slight Damage: Chip has at least one medium nick, one or more smaller nicks, or has at least four small nicks. Has rough edges. This is also the category for chips that have been cleaned too harshly—ones that exhibit a faded, washed-out look around the edges. Also in this category are sizable stains on the body of the chip. -20

Chip's edges are perfect. No nicks, dings, scratches, or imperfections of any kind. -0

Rough Edges: Chips in this category have a maximum of one small nick. There may be four or more *tiny* rim dings. -5

NOTE: Judge scratches the same as nicks.

Grading Example

Here's a sample of how a proper grade notation is made:

Best Side		Worst Side	
Wear	-20	Wear	-20
Center	-10	Center	-20
Edge	-10	Edge	-20
Total Defects	-40	Total Defects	-60
Best Side=	VF60	Worst Side =	VG40

Therefore, 60 + 40 = 100 ÷ 2 = 50. The final grade of the chip would be called Fine 50 or FN50. Since it is customary to give number grades a name, you should use the following chart:

Chip State (CS)	90-100
Almost Chip State (ACS)	80-89
Extremely Fine (XF)	70-79
Very Fine (VF)	60-69
Fine (FN)	50-59
Very Good (VG)	40-49
Good (GD)	30-39
Used (US)	20-29
Poor (PR)	10-19
Damaged (DM)	1-9

Also, only use whole numbers. For example, if your math makes a chip a VF62.5, just drop the half point. The chip would simply be a VF62. Never round up.

Yes, it is possible that an uncirculated chip with inlay or edge problems may actually be graded as an ACS (Almost Chip State) chip. Unlike coins, chip grading is not concerned solely with wear. Chip grading is about the overall aesthetic appeal of the chip. Terms like ACS or XF are just there as comparative terms. The only thing that matters is the final numerical grade.

NOTE: There are no negative numbers. If you encounter a truly hideous chip which earns a negative rating, just grade it a (1). Damaged 1 (or DM 1) is the lowest grade a chip can have.

Chips which grade less than 30 are just fillers and are worth approximately 25-75% of the GD30 price.

Grading Test - Carson City Nugget $25

Here are both sides, enlarged, so that you can practice grading along with us. Don't look ahead at our answers. Study the pictures and do your best. But first, you must know that it's much easier to grade a chip in person with a good light than by looking at a picture!

In order to make the cross-hatching appear reasonably well, the lighting had to be adjusted for the photograph. In reality, the cross-hatching looks the same on the second side as the first. Also, the nice dark black inlay is just as nice and dark on the second side in reality, but the different lighting causes it to look different in the photograph. Everything else should be clear enough for you to properly evaluate the chip. Good luck.

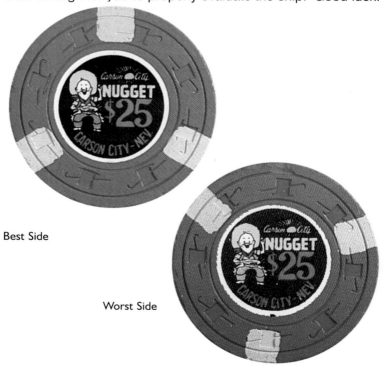

Best Side

Worst Side

Carson City Nugget $25 Grading Evaluation

Best Side		Worst Side	
Wear	-5	Wear	-5
Inlay	-2	Inlay	-7
Edge	-20	Edge	-30
Total	-27	Total	-42
100-27 =	XF73	100-42 =	FN58

The first side totals 73, which must be added to the second-side grade of 58. The total for both sides is 131 points. Divide that by 2, which gives a final grade of 65.5. We discard the half point, leaving us with a **final grade of VF65**.

Here's how we arrived at our evaluation of the chip. First, we look at wear. The chip is obviously used, but the cross-hatching is definitely better than 90%. However, it's definitely not 100%, so we cannot consider placing the chip into the -2 category. Wear is clearly -5 on both sides.

The inlay is solid on the best side. The printing is clear and well registered. There are no noticeable imperfections in terms of marks, dents, or anything else. However, the inlay is just off-centered enough to detract two points. The other side is identical, except for an unfortunate black ink mark at 6:00 on the white border. It is noticeable, but not distracting, so we deduct five points. However, if that mark were twice as big or had the misfortune to be on the character's face, where the eye naturally drifts, then the mark would be considered serious enough to be a fifteen-point deduction. The bottom line is that grading should be logical.

The edge on the first side is clearly rough. There is a noticeable dent at 2:00 and 2 small nicks at 10:00. The dent is more significant than a small nick, but clearly not as bad as a large nick; therefore, a classification of medium nick seems appropriate. This brings the chip into the -20 category. The edge on the second side has a large nick at 12:00, which is an automatic -30 point deduction.

Ultimately, all grading is somewhat subjective, but at least we now have a blueprint over which to argue!

Grading Chips Which Are Drilled, Notched, Or Cancelled

These chips are graded exactly the same way, except that you must signify this condition in the grade description. For example, notched chips are almost always manufacturer's samples. As such, they are usually in excellent condition. A typical example will grade CS90 or CS95. However, you must call the chip: NOTCHED 90 or NOTCHED 95. This gives a truly accurate representation of the chip's true appearance. Drilled chips are done the same way, although many drilled chips have circulated. You may have a chip which grades DRILLED 60 or DRILLED 75. Just make sure you designate this notation, or someone will be demanding a refund in terms none too pleasant! A cancelled chip generally has an overstamp in the inlay, but the same procedure logically follows. Such a chip may grade CANCELLED 65 or CANCELLED 85, for instance. Proper abbreviations are: Drilled (DR); Notched (NT); and Cancelled (CN).

Pricing Chips Which are Drilled, Notched, or Cancelled

A drilled, notched, or cancelled chip is generally worth about 30% of what it would be if it weren't damaged. For example, let's say a chip which grades CS95 is worth $1000. That means a drilled counterpart grading DRILLED 95 would be worth $300. This is the general rule you should go by, given no other information. Having said that, we must point out that there are notable exceptions. A good case in point is chips from the Moulin Rouge.

The vast, overwhelming majority of these chips (99%+) are drilled. There are probably thousands of $5 and $25 chips in this state. They have very little value due to their abundance.

However, an undrilled $5 chip is worth $200-$300 in average condition and the $25 chip has sold for over $1000 several times. Their drilled cousins are lucky to trade for $20-$30, roughly 2-5% of their undrilled value. There are other situations similar to this one, and we have noted these in the guide.

In conclusion, this system standardizes chip grading so that buyers and sellers are able to properly conduct business on a level playing field. This precision is necessary, because chip collecting has grown from a small hobby to a big money endeavor. In the past year, especially, many chippers are cherry-picking better-conditioned pieces for their collections. Price differences are growing wider between chips of unequal condition, so circumstances absolutely demand this kind of careful attention. There will still be minor differences of opinion, but that's fine. Over the course of time, the marketplace itself will iron out the exact standards and definitions as it sees fit.

1999 Casino Chip Market Report

Steve Wells & James Campiglia

Since the publication of our first edition, casino chips have continued to increase in popularity and value. Several million dollars worth of collectible casino chips changed hands in the past year. Price records were set in private transactions and demand for chips on the popular internet auction, eBay, keeps increasing. In fact, according to eBay's own monitoring system, chips are in the upper echelon of their hottest items. What follows is an overview of 1999's most significant market factors.

Price Records

Early Flamingo chips were at the forefront of the most notable sales. A first issue $25 diecut in ACS condition went for $8,000 at mid-year, only to be topped by a $100 Sm-key diecut third issue which set a new confirmed price record of $8,750 in the fall. These chips are not the rarest early Las Vegas pieces, but every time one is offered, big money comes out of the woodwork to buy them. The intriguing fact is that the very best chips are in tightly held private collections and do not come up for sale. There are several chips that could bring $10,000 if they were offered. Perhaps 2000 will see that long-awaited five-figure transaction.

The collection of Jerry Wall, considered to be the second or third best in the United States, was broken up just before summer's national Chip Collecting Convention held at the Orleans in Las Vegas. After two days of near-panic buying with collectors waiting three and four deep at times in lines behind the binders, a reported $200,000+ was sold. Even more impressive, the best pieces were sold off privately before the show even started!

Hoards

On a less pleasant note, some collectors were given the shaft on a wide variety of formerly rare Las Vegas Horseshoe chips. Several unscrupulous individuals sold Horseshoe chips on the market in stages, lying about the quantities they had. This had the effect of brutalizing the first group of people who bought chips and destroyed the market for the rest. What used to be a very rare and desirable set of chips now makes most collectors ill at the mere mention of the word "Horseshoe". We take the position that hoarders will not be rewarded for trying to manipulate the chip market. We will use all our contacts to make sure the interests of collectors are protected as much as possible. We will disclose all known hoards or groups of chips without exception.

Discoveries

Aside from hoards, there were several important discoveries of rare and unknown chips that chippers were able to uncover from all over the U.S. Popular dealer Scott Hartman turned up a first-issue $5 Las Vegas Riviera which now becomes only the second piece known to exist. He has already turned down a reported $6,000 for this chip. CC>CC Club Secretary Barry Weintraub bought a collection which contained a $25 Milton Prell Aladdin Nevada mold which represents an entire issue that was previously unknown. Noted Nevada historian Fred Holabird found the first two chips from "O'Meara's, Mountain City" which were not only unknown, but the only chips in existence with the town name on them. There are many more success stories, but we'll let you discover these for yourself by reading the book! This only goes to prove what we said last year: There are many great, rare, and valuable chips still lurking in drawers, attics, and coffee cans all across the country. It takes effort, but there's still a lot left to discover.

Inlays vs. Hot Stamps

It is becoming clear that attractive inlaid chips are escalating in value, because the new collectors entering the market have a distinct preference for them over hot stamped chips. Of course, there are always exceptions, but the factor of aesthetic appeal is increasing in significance. Rarity is still the most important factor overall, but it means nothing without the accompanying demand.

Las Vegas Chips

Without question, key Las Vegas pieces are in the most demand by far. We expect this to continue as more big money collectors enter the market. These particular buyers are certainly likely to favor the famous casinos with which they're familiar. Also, with the exception of the Horseshoe, a private casino since its inception, there are no hoards of early Las Vegas chips. They simply don't exist. Small out-of-the-way casinos usually had owners who kept the chips as souvenirs or whatever. Every year, chips from smaller places seem to come on the market. The famous early Vegas casinos had owners who destroyed the chips. This is not a stone-cold guarantee that there will never be a hoard of early Vegas chips, but with each passing year, it becomes less and less likely.

Lake Tahoe Chips

Lake Tahoe collectors are a serious bunch known to pay high prices for what they need. Quality Tahoe chips have held or increased their value in the past year. However, the total number of Tahoe collectors is small compared to Las Vegas, so the investor should certainly be choosy and careful.

Reno Chips

The Reno chip market is like a corpse on a moonlit night surrounded by a chanting ring of Voodoo-worshippers. They want the corpse to rise, but there's no logical reason for it to do

so. Reno has an unfortunate lack of classic attractive inlaid chips. Most of the old Reno casinos used hot stamps and the area itself is not very exciting. Exceptions to this are certain Primadonna chips, the Club Harlem $5, all Sunflower chips, and those extremely beautiful Crest and Seal Palace Club roulettes which have increased in demand. In short, action in Reno chips has been mild at best, with no expectation of a turnaround.

Small-Town Chips

Small-town Nevada chips can sell—if they're inlaid and rare. Those chips which meet this criteria are good buys. Many of these pieces are very rare and attractive, but only cost a fraction of a comparable Las Vegas chip. Small-town chips certainly appeal to those who have actually driven around the nooks and crannies of Nevada and experienced a little of this small-town life. Because of this, small towns are fun to collect, as well as challenging. A city type set is one way to do this, which is why some chips have added value if the town itself is rare.

Colorado Chips

This market did nothing last year. Auction prices were down and there are few new Colorado collectors entering the market. There are more than enough chips to meet the demand, but many Colorado chips are subject to market manipulations. Sellers of Colorado chips have tried to keep prices high by limiting supply, much like the famous monopoly that sells diamonds, but it has reached the point where there are just no big buyers of this type of material. One telling sign is that not a single expensive Colorado chip was placed in the Annual Club auction during the National convention. The probable reason is that the auction no longer allows a reserve. This means that all chips sell no matter what the price. This allows all chips to truly seek their real market value, devoid of manipulation. Many Colorado chips would have their prices crushed if they were offered in this type of environment.

Deadwood Chips

Deadwood is a small market, but it's a market free of hype and manipulation. Prices are far lower than the other areas discussed here, but many of these chips are scarce and truly hard to find. Most dealers do not carry Deadwood chips, so it can be hard to collect this series. Serious Deadwood collectors paid some good prices for better chips last year. For example, a rare Capone's $5 brought $500 in a confirmed transaction which coincided with the official price guide price. A set of Goldberg's error chips brought $440 in the national Club Auction, also mirroring full book price. The hard-to-obtain $25 chips are not on the market at any price. If you've ever been to Deadwood and experienced its charms, you might see why collecting this series is fun and has potential.

Atlantic City

The most significant transaction of which we are aware concerned a $20 Resorts baccarat which appeared on eBay last fall. This chip was reportedly sold for about $3000 after the auction failed to meet the reserve. However, as a group, Atlantic City chips are stagnating at best. There are few new collectors for this material, which is bringing downward pressure on prices—as evidenced by the weak prices in the national auction and on eBay. We expect this to continue, as we can find no factors to reverse the trend. New collectors are generally looking for Las Vegas chips.

Molds

The most popular molds, Arodie, C & S,Sm-key, and Rectl retained their popularity among serious and more advanced collectors.

Future Projections

The best Las Vegas chips will continue to get better. This is the area that has the most collectors as well as the area that attracts the majority of new collectors. Therefore, market forces will drive these prices upward. This price guide is now being published by a major publisher and will be available in bookstores throughout the country—unlike the privately-issued first edition. It is reasonable to assume that this additional exposure will create a certain number of new collectors who will buy chips and drive prices upward. eBay should also continue to expand the chip collecting hobby. The next few years will be exciting and we hope you enjoy and profit from them.

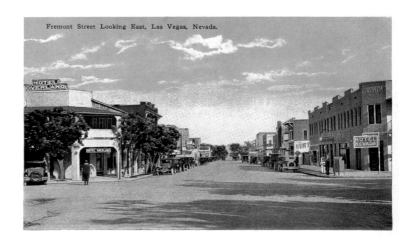

Fremont Street Looking East, Las Vegas, Nevada.

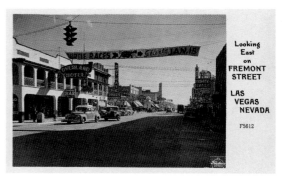

Postcards illustrating Fremont St. through history. (Top) Fremont St. in the 1920s before gambling was legalized. (Center) Fremont St. showing the casino business in the 1940s. (Bottom) Fremont St. in the 1960s, showing where the smaller businesses have become larger casinos.

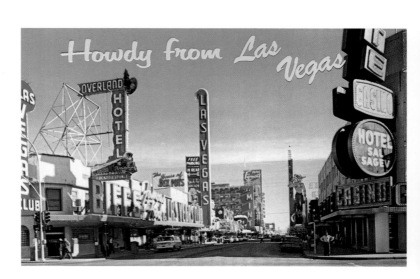

Issue	Den.	Color	Mold	Inserts	Inlay	Rarity	GD30	VF65	CS95

Las Vegas

101 CLUB — N. LAS VEGAS — 1955-68/1969-75

Issue	Den.	Color	Mold	Inserts	Inlay	Rarity	GD30	VF65	CS95
1st	5.00	Red	HCE	None	HS	R-10	200	400	600
2nd	.25	Yellow	C&J	None	HS	R-10	100	200	300
	1.00	Navy	C&J	None	HS	R-8	75	150	225

(Both 1st and 2nd issues are only marked "101".)

Issue	Den.	Color	Mold	Inserts	Inlay	Rarity	GD30	VF65	CS95
3rd	1.00	Pink	C&J	None	HS	R-7	75	150	225
	5.00	Yellow	C&J	3pnk	HS	R-9	125	250	375
4th	5.00	Mustard	H&C	3mar	HS	R-8	100	200	300

(This chip and both 3rd issue chips say "101 Club Bonbeck, Inc.")

101 Club $5 (3rd)

Issue	Den.	Color	Mold	Inserts	Inlay	Rarity	GD30	VF65	CS95
	25.00	Green	H&C	3brn3pch	HS	R-10	100	200	300

(Marked "101", this chip is only attributed to the 101 Club.)

20th CENTURY — LAS VEGAS — 1977-78

Issue	Den.	Color	Mold	Inserts	Inlay	Rarity	GD30	VF65	CS95
1st	1.00	Blue	H&C	None	HS	R-5	30	60	90
	5.00	Red	H&C	4wht	HS	R-5	40	80	120
	25.00	Green	H&C	4fch	HS	R-8	100	200	300
	100.00	Black	H&C	4org	HS	R-8	100	200	300
2nd	5.00	Red	House	4pnk	R-white	R-4	25	50	75
	25.00	Green	House	4fch	R-white	R-4	30	60	90

(BEWARE: There's a H&C set, $1-$100, with inlays that was made by Paulson & Co. for home use and not for the casino. Fortunately, these rarely appear on the market.)

20th Century $5 (1st)

21 CLUB — LAS VEGAS — 1937-38

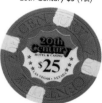

Issue	Den.	Color	Mold	Inserts	Inlay	Rarity	GD30	VF65	CS95
1st	5.00	Yellow	Triang	None	HS	R-8	100	200	300
	25.00	Black	Triang	None	HS	R-8	100	200	300

(This is an old downtown club not to be confused with the 21 Club in the Last Frontier.)

20th Century $25 (2nd)

49 CLUB — N. LAS VEGAS — 1940-41

Issue	Den.	Color	Mold	Inserts	Inlay	Rarity	GD30	VF65	CS95
1st	5.00	Black	Sqsqrt	None	HS	R-10	350	700	1050

(Chip is only marked "49 Club", with no location.)

49'ER CLUB — LAS VEGAS — 1951-53

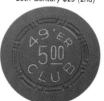

Issue	Den.	Color	Mold	Inserts	Inlay	Rarity	GD30	VF65	CS95
1st	error .10	Orange	HCE	4blu	HS	Unique*	200	400	600

(Harold's Club $20 on back.)

Issue	Den.	Color	Mold	Inserts	Inlay	Rarity	GD30	VF65	CS95
	.25	Beige	HCE	None	HS	R-5	25	50	75
	5.00	Fuchsia	HCE	None	HS	R-5	30	60	90
	5.00	Green	HCE	None	HS	R-6	35	70	105

(Marked "Poker" on the reverse.)

Issue	Den.	Color	Mold	Inserts	Inlay	Rarity	GD30	VF65	CS95
	25.00	Orange	HCE	None	HS	R-4	25	50	75
	100.00	Black	HCE	None	HS	R-5	40	80	120

49'er Club $5 (1st)

ALADDIN, MILTON PRELL'S — LAS VEGAS — 1966-68
ALADDIN — 1968-97

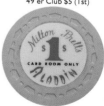

Issue	Den.	Color	Mold	Inserts	Inlay	Rarity	GD30	VF65	CS95
1st	.25	Turq.	Scrown	None	HS	R-10	500	1000	1500
	.50	Purple	Scrown	None	HS	R-10	600	1200	1800
	1.00	White	Scrown	None	OR-white	R-6	125	250	375
	1.00	Yellow	Scrown	None	OR-white	R-10	600	1200	1800

("Card Room Only".)

Aladdin $1 (1st)

Issue	Den.	Color	Mold	Inserts	Inlay	Rarity	GD30	VF65	CS95
	5.00	Red/Brn	Scrown	1/2pie	LHUB-white	R-8	300	600	900
	5.00	Brown	Scrown	None	OR-white	Unique	750	1500	2250

("Card Room Only".)

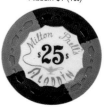

Issue	Den.	Color	Mold	Inserts	Inlay	Rarity	GD30	VF65	CS95
	25.00	Pur/Grn	Scrown	1/2pie	LSCA-white	R-8	500	1000	1500

(There is believed to be no more than eight known.)

Aladdin $25 (1st)

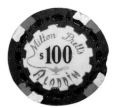
Aladdin $100 (1st)

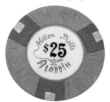
Aladdin $25 (2nd)

Aladdin $5 (3rd)

Aladdin $25 (4th)

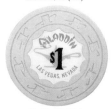
Aladdin $1 (5th)

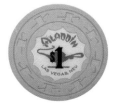
Aladdin $1 (6th)

Issue	Den.	Color	Mold	Inserts	Inlay	Rarity	GD30	VF65	CS95
	100.00	Blk/Wht	Scrown	1/2pie	WHL-white	R-8	500	1000	1500
	100.00	Black	Scrown	4org4wht	WHL-white	R-8	600	1200	1800
	500.00	Org/Yel	Scrown	1/2pie	LSCA-white	R-8	500	1000	1500
	500.00	Red/Yel	Scrown	1/2pie	LSCA-white	R-9	600	1200	1800

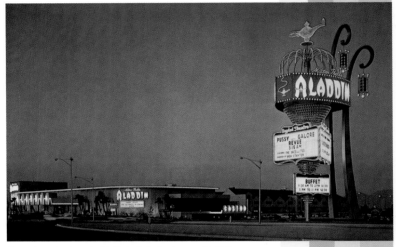

Postcard picturing how the Aladdin looked when it opened in 1966.
©Desert Supply Company, Las Vegas.

Issue	Den.	Color	Mold	Inserts	Inlay	Rarity	GD30	VF65	CS95
2nd	25.00	Green	Nevada	6red3crm	R-white	Unique	1000	2000	3000
3rd	5.00	Brown	HCE	6gry	SCA-white	R-7	200	400	800
	25.00	Green	HCE	6pnk	SCA-white	R-10*	750	1500	2250
	100.00	Black	HCE	6yel	SCA-white	R-10*	900	1800	2700
4th	1.00	Beige	Nevada	None	SCA-white	R-4	15	30	45
	5.00	Red	Nevada	6mst3blu	SCA-white	R-3	30	60	90
(Most are drilled and worth 15% of these prices. Undrilled, this chip is R-6.)									
	25.00	Green	Nevada	6gry3red	SCA-white	R-9	300	600	900
	100.00	Black	Nevada	6org3wht	SCA-white	Unique*	750	1500	2250
5th	.50	Pink	C&J	None	HS	R-7	25	50	75
("Aladdin Hotel Casino".)									
	1.00	Beige	H&C	None	SCA-white	R-8	50	100	150
("Las Vegas, Nevada".)									
	faro n/d	6 diff.	H&C	None	HS	R-6	20	40	60
(Colors: Green, Grey, Mustard, Orange, Pink, and Purple.)									
6th	.50	Pink	H&C	None	HS	R-9	50	100	150
("Aladdin Hotel & Casino" on front; "50cents" in large letters on back.)									
	1.00	Beige	H&C	None	SCA-white	R-7	30	60	90
("Las Vegas, Nev.")									
7th	.50	Pink	H&C	None	HS	R-7	20	40	60
	1.00	Beige	H&C	None	R-white	R-6	10	20	30
(Purple lettering.)									
	bac 5.00	Brown	H&C	3bei	R-white	R-7*	100	200	300
	bac 20.00	Blue	H&C	3wht	R-white	R-8	150	300	450
	25.00	Green	H&C	3pnk	SCA-white	R-5	40	80	120
	100.00	Black	H&C	3blu	HUB-white	R-9	200	400	600
	bac 100.00	Black	H&C	3yel	R-white	R-9	200	400	600

Issue	Den.	Color	Mold	Inserts	Inlay	Rarity	GD30	VF65	CS95
bac 500.00	Pink	H&C	3blu3wht3brn	HUB-white	R-9	350	700	1050	
(All of the chips in this issue have long canes with the denomination in black.)									
8th	.10	Blue	H&C	None	HS	R-10	175	350	525
	.25	Orange	H&C	None	HS	R-5	10	20	30
	1.00	Beige	H&C	None	R-white	R-4	6	12	18
(Orange writing.)									
	1.00	Beige	H&C	None	R-white	R-1	5	10	15
(A huge number of drilled chips exist. Undrilled, chip is R-4. Pink writing.)									
(These chips have short canes.)									
9th	.50	Pink	House	None	HS	R-7	25	50	75
(No location listed.)									
	1.00	Blue	House	None	R-white	R-1	5	10	15
(A huge quantity of drilled chips exist. Undrilled, this chip is R-4.)									
	5.00	Red	House	3gry	R-white	R-5	25	50	75
bac 5.00	Brown	House	3wht	R-white	R-6	50	100	150	
bac 20.00	Orange	House	3pnk3grn3org	R-white	R-5	75	150	225	
(Undrilled, this chip is R-7.)									
	25.00	Green	House	3org	HUB-white	R-8	100	200	300
bac 100.00	Black	House	3yel3pnk3grn	SCA-white	R-9	200	400	600	
	100.00	Black	House	3pur3wht	SCA-white	R-10	250	500	750
bac 500.00	Purple	House	3ltblu3blk3pnk	HUB-white	R-10	300	600	900	
	500.00	White	House	3blu3blk3org	SCA-white	R-9	250	500	750
(This issue has "Aladdin" & "Las Vegas, Nev." in black writing & denomination in red.)									
10th	5.00	Red	House	4nvy4grn	R-white	R-1	25	50	75
(Drilled chips are worth 20%. Undrilled, this chip is R-5.)									
	25.00	Green	House	4yel4org	HUB-white	R-8	125	250	375
	100.00	Black	House	4yel4ltgrn	SCA-white	Unique*	250	500	700
NN 500.00	White	House	3grn3pur3yel	SCA-white	R-5	15	30	45	
(This chip has "Aladdin" & "Las Vegas, Nev." In red writing. Hot stamped in gold on reverse.)									
RLT 1	2 diff.	H&C	None	HS	R-7	7	14	21	
(Colors: Blue and Brown.)									
RLT 3	2 diff.	H&C	None	HS	R-7	7	14	21	
(Colors: Blue and Brown.)									
11th	1.00	Grey	House	None	R-white	R-1	2	4	6
	5.00	Red	House	3grn3brn	HUB-white	R-3	6	12	18
bac 5.00	Red	H&C	4gld4brn	R-white	R-5	10	20	30	
bac 20.00	Green	H&C	3red3brn	R-white	R-5	20	40	60	
	25.00	Green	House	3ltblu3yel	SCA-white	R-5	25	50	75
	100.00	Black	House	6grn3org	COG-white	R-7	80	160	240
bac 100.00	Black	H&C	3gry3lav	R-white	R-7	80	160	240	
	500.00	Lavender	House	3pch3blu3org	HEX-white	R-10	300	600	900
bac 500.00	White	H&C	8pnk	R-white	R-10	300	600	900	
(This is the "A" issue. All Baccarat chips are oversized.)									
RLT 3	6 diff.	Plain	None	R-white	R-5	4	8	12	
(Colors: Lt Brown, Navy, Orange, Pink, Turquoise, and Yellow.)									
RLT 4	6 diff.	Plain	None	R-white	R-5	4	8	12	
(Colors: Lt Brown, Navy, Orange, Pink, Turquoise, and Yellow.)									
NCV 1	Blue	H&C	None	HS	R-9	15	30	45	
NCV 5	Dk Pink	H&C	None	HS	R-6	7	14	21	
NCV 5	Lt Pink	H&C	None	HS	R-8	10	20	30	
NCV 5	Red	H&C	None	HS	R-9	15	30	45	
NCV 25	Green	H&C	None	HS	R-9	15	30	45	
NCV 100	White	H&C	None	HS	R-9	20	40	60	
NCV 500	Purple	H&C	None	HS	R-10	30	60	90	

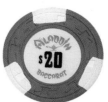

Aladdin $20 (7th)

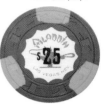

Aladdin $25 (7th)

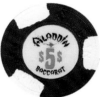

Aladdin $5 (9th)

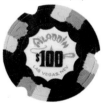

Aladdin $100 (10th)

Aladdin RLT 3 (10th)

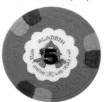

Aladdin $5 (11th)

Issue	Den.	Color	Mold	Inserts	Inlay	Rarity	GD30	VF65	CS95

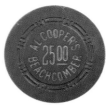

Al Cooper's $25 (1st)

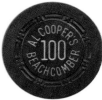

Al Cooper's $100 (1st)

AL COOPER'S BEACHCOMBER LAS VEGAS — 1951-51
AL COOPER'S POLYNESIA

Issue	Den.	Color	Mold	Inserts	Inlay	Rarity	GD30	VF65	CS95
1st	5.00	Red	HCE	None	HS	R-10	400	800	1200
	25.00	Blue	HCE	None	HS	R-9	250	500	750
	100.00	Black	HCE	None	HS	R-7	250	500	750

(First issue is Al Cooper's Beachcomber. Al Cooper was not allowed to use the name "Beachcomber" because it was owned by a California business. The name was changed before he opened, whether or not chips were used is unknown. Before James Campiglia found 22 $100 chips many years ago, only a couple existed. Most of the chips were lightly used by some ladies to play Pan along with old Sans Souci chips.)

2nd	error 5.00	Red	HCE	3lav	HS	Unique	1000	2000	3000

(Binion's .25 on one side. Rare also that this is the only Binion's without the name scratched out.)

	100.00	Black	HCE	3gry	HS	R-10	1200	2400	3600

(Al Cooper's Polynesia was open only from June to October in 1951.)

AL'S LIQUORS — N. LAS VEGAS — 1955-77

Issue	Den.	Color	Mold	Inserts	Inlay	Rarity	GD30	VF65	CS95
1st	.25	Beige	C&J	None	HS	R-10	100	200	300
	.50	Green	C&J	None	HS	R-9	75	150	225
	1.00	Pink	C&J	None	HS	R-6	35	70	105
	5.00	Navy	C&J	None	HS	R-6	35	70	105

Al's Liquors $5 (1st)

AMBASSADOR — LAS VEGAS — 1978-85

Issue	Den.	Color	Mold	Inserts	Inlay	Rarity	GD30	VF65	CS95
1st	1.00	Navy	H&C	None	HS	R-4	8	16	24
	5.00	Red	H&C	3gld	HS	R-4	10	20	30
	25.00	Green	H&C	3blu	HS	R-4	12	24	36
	100.00	Black	H&C	6yel3red	HS	R-4	15	30	45
	NCV 5.00	Purple	H&C	None	HS	R-9	35	70	105
2nd	.25	Navy	H&C	None	HS	R-7	25	50	75
	1.00	Beige	H&C	None	HS	R-7	30	60	90
	5.00	Red	H&C	4blu	HS	R-7	40	80	120

(Above marked "L.V. N.V." in small letters. Others only have casino name.)

	NCV	Pink	H&C	None	HS	R-7	10	20	30

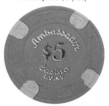

Ambassador $5 (2nd)

ANTHONY'S — LAS VEGAS — 1989-93

Issue	Den.	Color	Mold	Inserts	Inlay	Rarity	GD30	VF65	CS95
1ST	.25	Pink	BJ	None	HS	R-5	12	24	36
	1.00	Lt Blue	BJ	None	HS	R-4	10	20	30
	5.00	Red	BJ	6yel	R-white	R-6	50	100	150
	NCV	White	BJ	None	HS	R-8	10	20	30
	NCV	Yellow	BJ	None	HS	R-8	10	20	30

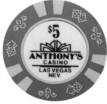

Anthony's $5 (1st)

ARIZONA CHARLIE'S — LAS VEGAS — 1988-

Issue	Den.	Color	Mold	Inserts	Inlay	Rarity	GD30	VF65	CS95
1st	5.00	Red	BJ-2	4blu	COIN	R-3	5	10	15
	25.00	Green	BJ-2	6wht	COIN	R-4	25	45	65
	100.00	Black	BJ-2	6wht	COIN	R-1	*	100	110

(This $100 chip is still in use with the newer Chipco set.)

	NCV	Brown	BJ	None	HS	R-5	3	6	9

("Free Buffet".)

	NCV	Dk Brown	BJ	None	HS	R-5	3	6	9

(Free Drink".)

	NCV	White	BJ	None	HS	R-5	3	6	9

("Free Lounge Show".)

	RLT	3 diff.	BJ-P	None	R-white	R-4	5	10	15

(Colors: Blue, Orange, and Yellow)

	RLT	3 diff.	Diamnd	None	HS	R-5	5	10	15

(Colors: Blue, Brown, and Yellow.)

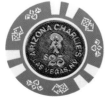

Arizona Charlies $25 (1st)

Issue	Den.	Color	Mold	Inserts	Inlay	Rarity	GD30	VF65	CS95
	NCV 2.50	Beige	H&C	None	HS	R-6	5	10	15
	NCV 5	Red	H&C	None	HS	R-6	5	10	15
	NCV 25	Green	H&C	None	HS	R-7	8	16	24
	NCV 100	Black	H&C	None	HS	R-8	12	24	36
2nd	.50	Pink	Unicorn	None	HS	R-2	2	4	6
	1.00	White	Chipco	None	FG	R-1	*	1	2
	5.00	Red	Chipco	None	FG	R-1	*	5	7
	25.00	Green	Chipco	None	FG	R-1	*	25	30
	RLT	2 diff.	BJ	None	HS	R-5	3	6	9
(Colors: Blue and Red.)									
3rd	.25	Yellow	BJ	None	HS-black	R-2	*	1	2

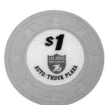
Auto Truck Plaza 76 $1 (1st)

AUTO TRUCK PLAZA, 76			LAS VEGAS		1973-				
1st	.50	White	H&C	None	R-white	R-6	12	24	36
	1.00	Blue	H&C	None	R-white	R-5	10	20	30
	5.00	Orange	H&C	3blue	R-white	R-3	*	5	10
	25.00	Green	H&C	3org	R-white	R-3	*	25	35
	n/d	Blue	H&C	None	R-white	R-9	25	50	75

Auto Truck Plaza 76 45 (1st)

BALLY' S			LAS VEGAS		1986-				
1st	1.00	Blue	House	2grn2pch	R-white	R-2	2	4	6
	5.00	Red	House	2grn2brn	HUB-white	R-3	5	10	15
	20.00	Mustard	House	3brn3org3nvy	SCA-white	R-10	250	500	750
	25.00	Green	House	4blu4wht	HEX-white	R-4	25	50	75
	100.00	Black	House	12pnk	STAR-white	R-8	100	175	225
	500.00	Purple	House	8blu	WHL-white	R-10	500	600	700
	RLT	Brown	House	None	R-white	R-7	7	14	21
	NCV 5	Pink	BJ	None	HS	R-6	5	10	15
	NCV 100	Grey	H&C	None	HS	R-9	15	30	45
2nd	5.00	Red	Chipco	None	FG	R-4	9	18	27
	25.00	Green	Chipco	None	FG	R-8	200	400	600
	100.00	Black	Chipco	None	FG	R-9	350	700	1050
(These "Festival Of Games" chips were used in a designated pit in 1992.)									
3rd	5.00	Red	B et G	8yel	R-white	R-5	10	20	30
	25.00	Green	B et G	8org	R-white	R-7	25	50	75
	100.00	Black	B et G	8wht	R-white	R-8	100	175	250
	500.00	Purple	B et G	8yel	R-white	R-10	500	600	700

Bally's $5 (1st)

Bally's $100 (2nd)

(This set has smaller squares on the edges, a slight variant but different issue.)

	5.00	Red	B et G	8yel	R-white	R-5	10	20	30
	25.00	Green	B et G	8org	R-white	R-7	25	50	75
	100.00	Black	B et G	8wht	R-white	R-8	100	175	250
	500.00	Purple	B et G	8yel	R-white	R-10	500	600	700

(These chips were only used on computerized "21" tables called "Mikohn Safejack".)

Bally's $25 (3rd)

	NCV 10	Aqua	RT plas	6org2pnk	OR-white	R-5	6	12	18
	NCV 25	Lime	RT plas	6red3wht	OR-white	R-3	6	12	18
	NCV 100	Brown	RT plas	6org	OR-white	R-6	12	24	36
	NCV 100	Black	RT plas	12blu	OR-white	R-3	7	14	21
	NCV 500	Orange	RT plas	8grn4blu	OR-white	R-7	10	20	30
	NCV 1000	Orange	RT plas	4wht	OR-white	R-9	30	60	90
	NCV 1000	Orange	RT plas	8grn4blu	OR-white	R-7	20	40	60

(This set of chips was used for the "Let it Ride" tournament. Further information on these chips is listed in the Four Queens section.)

4th	1.00	Blue	House	4pur	R-white	R-1	*	1	2
	5.00	Red	House	2ltgrn2yel	HUB-white	R-1	*	5	7

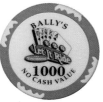
Bally's NCV 1000 (3rd)

Bank Club n/d (1st)

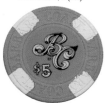

Barbary Coast $5 (2nd)

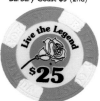

Barbary Coast $25 (5th)

Bar of Music n/d (1st)

Bellagio $20 (1st)

Big 4 (1st)

Issue	Den.	Color	Mold	Inserts	Inlay	Rarity	GD30	VF65	CS95
	25.00	Green	House	4wht4yel	HEX-white	R-1	*	25	30
	100.00	Black	House	4pch4wht4org	OCOG-white	R-1	*	100	110

BANK CLUB — LAS VEGAS — 1932-45

Issue	Den.	Color	Mold	Inserts	Inlay	Rarity	GD30	VF65	CS95
1st	n/d	Red	Lcrown	None	HS	R-8	125	250	375

BARBARY COAST — LAS VEGAS — 1979-

Issue	Den.	Color	Mold	Inserts	Inlay	Rarity	GD30	VF65	CS95
1st	1.00	Lt Brown	House	None	R-lt brown	R-3	1	2	3
	5.00	Red	House	4yel	R-dk red	R-3	5	10	15
	25.00	Green	House	4wht	R-green	R-6	25	50	75
	100.00	Black	House	4gry	R-black	R-9	75	150	225
2nd	5.00	Red	House	4yel	R-red	R-3	5	10	15
	25.00	Green	House	4wht	R-green	R-6	25	50	75
	100.00	Black	House	4gry	R-black	R-9	75	150	225

("85" written below casino name in very small letters, no location.)
(This issue was reordered at least twice. Upon close examination, different shades of brown can be seen in the background.)

3rd	5.00	Red	House	4yel	R-red	R-4	5	10	15
	5.00	Red	House	4yel	R-dk red	R-4	5	10	15

("88, Las Vegas, NV.")

4th	1.00	Lt Brown	House	None	R-lt gold	R-3	1	2	3

(Las Vegas, NV.)

5th	1.00	Lt Brown	House	None	OR-white	R-1	*	1	3
	5.00	Red	House	4yel	OR-white	R-1	*	5	7
	25.00	Green	House	4wht	OR-white	R-1	*	25	30
	100.00	Black	House	4pnk	OR-white	R-1	*	100	110

(This new issue pictures a rose and "Live the Legend".)

	RLT	6 diff.	House	None	R-black	R-4	2	4	6

(Colors: Beige, Blue, Grey, Orange, Purple, and Yellow.)

	RLT	Yellow	House	None	R-white	R-4	2	4	6

BAR OF MUSIC — LAS VEGAS — 1948-54

Issue	Den.	Color	Mold	Inserts	Inlay	Rarity	GD30	VF65	CS95
1st	n/d	Pink	Zigzag	None	HS	Unique	1000	2000	3000

BARCELONA CASINO — LAS VEGAS — 1989-

Issue	Den.	Color	Mold	Inserts	Inlay	Rarity	GD30	VF65	CS95
1st	5.00	Red	BJ	6wht	R-white	R-1	*	5	10
	25.00	Green	BJ	12yel	R-white	R-2	*	25	35
	100.00	Black	BJ	12yel	R-white	R-4	100	125	150
2nd	1.00	Beige	BJ	None	HS	R-1	*	1	3
	RLT	Brown	BJ	None	HS	R-6	3	6	9
	RLT	Dk Blue	BJ	None	HS	R-6	3	6	9

BELLAGIO — LAS VEGAS — 1998-

Issue	Den.	Color	Mold	Inserts	Inlay	Rarity	GD30	VF65	CS95
1st	1.00	Blue	House	4ltblu	OR-beige	R-1	*	1	2
	5.00	Red	House	12wht	OR-beige	R-1	*	5	7
	pok 10.00	Lt Orange	House	4lim4pur	OR-beige	R-1	*	10	13
	pok 20.00	Orange	House	2pur2grn	OR-beige	R-1	*	20	25
	25.00	Green	House	8blk	OR-beige	R-1	*	25	30
	100.00	Black	House	4pch4wht4lav	OR-beige	R-1	*	100	110
	bac 100.00	Black	House	6pch2blk	OR-beige	R-1	*	100	110
	RLT	6 diff.	BJ-P	None	OR-beige	R-4	2	4	6

(Colors: Blue, Lt Brown, Lime, Orange, Red, and Yellow.)
(There are 8 different tables: A, B, C, E, G, H, J, and K. All have the exact colors listed above.)

BIG 4 — LAS VEGAS — 1931-40's

Issue	Den.	Color	Mold	Inserts	Inlay	Rarity	GD30	VF65	CS95
1st	n/d	White	Lcrown	None	HS	R-8	125	250	375

Issue	Den.	Color	Mold	Inserts	Inlay	Rarity	GD30	VF65	CS95
	n/d	5 diff.	Lcrown	None	HS	R-10	200	400	600

(Colors: Blue, Lt Green, Lt Orange, Lavender, and Maroon.)

BIG AL'S SPEAKEASY **LAS VEGAS** **1980-80**

Issue	Den.	Color	Mold	Inserts	Inlay	Rarity	GD30	VF65	CS95
1st	.25	Yellow	H&C	None	HS	R-3	5	10	15
	1.00	Lt Blue	H&C	None	HS	R-3	6	12	18
	5.00	Red	H&C	4pch	HS	R-3	8	16	24
	25.00	Green	H&C	4org	HS	R-4	15	30	45
	100.00	Black	H&C	4blu	HS	R-4	20	40	60

Big Al's Speakeasy $100 (1st)

BIG BONANZA **N. LAS VEGAS** **1967-67**

Issue	Den.	Color	Mold	Inserts	Inlay	Rarity	GD30	VF65	CS95
1st	.25	Yellow	C&J	None	HS	R-6	30	60	90

(A small hoard of 42 pieces was discovered in 1999 by David Sarles.)

	.50	Orange	C&J	None	HS-blue	R-9	150	300	450
	5.00	Green	C&J	4red	R-white	R-10	750	1500	2250

(It's not surprising that chips from this casino are extremely rare. The Big Bonanza was only open from January to March of 1967.)

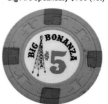

Big Bonanza $5 (1st)

BIG DADDY' S **LAS VEGAS** **1974-78**

Issue	Den.	Color	Mold	Inserts	Inlay	Rarity	GD30	VF65	CS95
1st	5.00	Red	Nevada	3bei	R-white	R-10*	400	800	1200

(The two known pieces are both notched manufacturers samples. At present, no verification has been made as to these chips actually being ordered by Big Daddy's. It's possible that other chips were actually used here instead.)

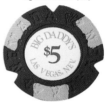

BIG RED'S **LAS VEGAS** **1981-82**

Issue	Den.	Color	Mold	Inserts	Inlay	Rarity	GD30	VF65	CS95
1st	5.00	Red	BJ-2	None	COIN	R-2	15	30	45
	25.00	Green	BJ-2	None	COIN	R-3	15	30	45

(This was located where Sports World Casino is today.)

Big Daddy's $5 (1st)

BIG WHEEL **LAS VEGAS** **1971-73**

Issue	Den.	Color	Mold	Inserts	Inlay	Rarity	GD30	VF65	CS95
1st	1.00	Green	Ewing	None	HS	R-8	60	120	180
	5.00	Red	Ewing	3blu-gry	R-white	R-8	150	300	450

(Located at Sahara and the Strip. Became The Wheel.)

BINGO PALACE **LAS VEGAS** **1976-84**

Issue	Den.	Color	Mold	Inserts	Inlay	Rarity	GD30	VF65	CS95
1st	.25	Navy	Diecar	None	HS	R-5	8	16	24
	.50	Fuchsia	Diecar	None	HS	R-6	12	24	36
	.50	Yellow	Diecar	None	HS	R-5	9	18	27
	1.00	Beige	Diecar	None	R-white	R-6	25	50	75
	5.00	Red	Diecar	3bei	R-white	R-7	75	150	225
	25.00	Green	Diecar	3org	R-white	R-10	250	500	750
	100.00	Black	Diecar	3bei	R-white	R-10*	250	500	750
	500.00	Green	Diecar	None	HS	R-10	150	300	450
2nd	1.00	Beige	Nevada	None	R-white	R-6	20	40	60
	5.00	Red	Nevada	3bei	R-white	R-7	75	150	225
	25.00	Green	Nevada	3org	R-white	R-10	250	500	750
	100.00	Black	Nevada	3bei	R-white	R-10	250	500	750
	NCV	3 diff.	H&C	None	HS	R-6	5	10	15

Bingo Palace $5 (1st)

(Colors: Beige, Orange, and Purple. No location.)

	NCV	3 diff.	H&C	None	HS	R-6	5	10	15

(Colors: Beige, Orange, and Purple. These have a location.)

	RLT A	2 diff.	BJ	None	HS	R-6	7	14	21

(Colors: Brown and Orange.)

	RLT B	Pink	BJ	None	HS	R-6	7	14	21
3rd	1.00	White	BJ-2	12brn	COIN	R-4	10	20	30
	5.00	Red	BJ-2	12blu	COIN	R-5	20	40	60

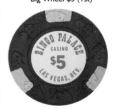

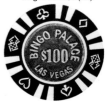

Bingo Palace $100 (3rd)

Issue	Den.	Color	Mold	Inserts	Inlay	Rarity	GD30	VF65	CS95
	25.00	Green	BJ-2	12red	COIN	R-10	200	400	600
	100.00	Black	BJ-2	12wht	COIN	R-3	10	20	30

(Previously was The Casino and became Palace Station.)

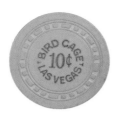

Bird Cage 10¢ (1st)

Bird Cage 25¢ (2nd)

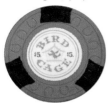

Bird Cage $5 (2nd)

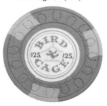

Bird Cage $25 (2nd)

Black Orchid $25 (1st)

Bonaire Club $5 (1st)

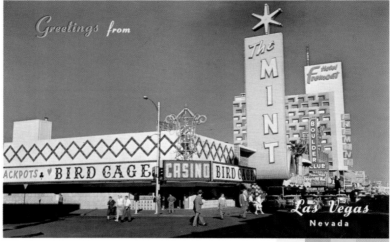

Postcard picturing the Bird Cage, which existed briefly and closed in 1959 due to a gambler hitting two $25,000 Keno tickets within a short time.©Western Resort Publications, Santa Ana, CA.

BIRD CAGE			**LAS VEGAS**			**1958-59**			
1st	.10	Mustard	Sqsqrt	None	HS	R-9	400	800	1200
	n/d	Maroon	Rectl	None	HS	Unique	200	400	600
2nd	.25	Dk Pink	Horshu	None	HS	R-5	40	80	120
	.25	White	Horshu	None	HS	R-9	75	150	225
	5.00	Red	Horshu	3blk	R-white	R-3	30	60	90
	25.00	Lt Green	Horshu	3tan	R-white	R-9	500	1000	1500

(This little club became the Mint and then the Horseshoe.)

BLACK ORCHID			**W. LAS VEGAS**			**1965-69**			
1st	.50	Maroon	C&J	None	HS	R-10	200	400	600
	1.00	Purple	C&J	None	HS	R-10	200	400	600
	5.00	Yellow	C&J	3nvy	HS	Unique	400	800	1200
	25.00	Red	C&J	3grn	HS	R-10	250	500	750

BOARDWALK CASINO			**LAS VEGAS**			**1989-94/1998-**			
1st	5.00	Red	H&C	4pnk	HUB-white	R-3	8	16	24
	25.00	Green	H&C	3org3grn3yel	SCA-white	R-5	25	50	75
2nd	1.00	White	H&C	1pch1grn	OR-multi	R-1	*	1	3
	5.00	Pink	H&C	2yel2red2blu	OR-multi	R-1	*	5	7
	25.00	Green	H&C	4yel4red	OR-multi	R-1	*	25	30
	100.00	Black	H&C	3pnk3wht3grn	OR-multi	R-1	*	100	110

BONAIRE CLUB			**LAS VEGAS**			**1945-46**			
1st	5.00	Turq.	Dots	None	HS	R-10	500	1000	1500

BONANZA CLUB			**LAS VEGAS**			**1956-67**			
1st	.25	Fuchsia	HCE	None	HS	R-5	20	40	60

Issue	Den.	Color	Mold	Inserts	Inlay	Rarity	GD30	VF65	CS95
	5.00	Navy	HCE	2pur	R-white	R-5	30	60	90
	5.00	Green	HCE	3mst	R-white	Unique*	400	800	1200
	25.00	Green	HCE	2pur	R-white	Unique*	400	800	1200
	25.00	Beige	HCE	2red	R-white	R-6	90	180	270
	25.00	Beige	HCE	3blk	R-white	Unique*	400	800	1200
2nd	.25	Brown	C&J	None	HS	R-9	75	150	225

Bonanza Club $5 (1st)

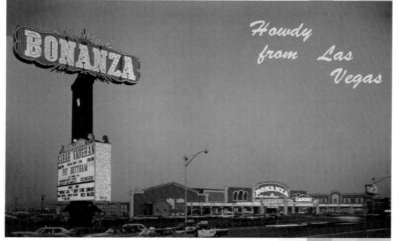

Postcard of the Bonanza, which became the MGM and is now Bally's.
©Las Vegas News Agency, Las Vegas.

Bonanza Hotel $5 (1st)

Bonanza Hotel $25 (1st)

BONANZA HOTEL — LAS VEGAS — 1967-73

Issue	Den.	Color	Mold	Inserts	Inlay	Rarity	GD30	VF65	CS95
1st	1.00	Lt Brown	Scrown	None	R-multi	R-9	100	200	300
(Sam Landy on back)									
	1.00	Lt Brown	Scrown	None	R-multi	R-9	100	200	300
(Si Kriegel on back)									
	1.00	Lt Brown	Scrown	None	R-multi	R-10	150	300	450
(Ted Fogel on back)									
	5.00	Orange	Scrown	3blk	R-multi	R-10	500	1000	1500
	5.00	Red	Scrown	4mst4gry	R-multi	R-8	250	500	750
	25.00	Green	Scrown	4org	R-multi	R-10	500	1000	1500
	25.00	Orange	Scrown	4org	R-multi	Unique*	700	1400	2100
(Inlay missing on obverse)									
	100.00	Black	Scrown	4red4mst	R-multi	R-10	600	1200	1800
	100.00	Turq.	Scrown	None	R-multi	Unique*	700	1400	2100
	RLT A	4 diff.	Scrown	None	HS	R-7	9	18	27
(Colors: Brown, Fuchsia, Pink, and Purple.)									
	RLT B	5 diff.	Scrown	None	HS	R-7	9	18	27
(Colors: Brown, Grey, Orange, Pink, and Yellow.)									
2nd	.25	Beige	C&J	None	HS	R-10	100	200	300
(Card Room)									
	.50	Purple	C&J	None	R-gold	R-8	200	400	600
	1.00	Green	C&J	None	R-gold	R-6	150	300	450
	5.00	Mustard	C&J	3red	R-gold	R-8	400	800	1200
	25.00	Green	C&J	3org	R-gold	Unique*	1000	2000	3000
	100.00	Black	C&J	3wht	R-gold	Unique*	1000	2000	3000
	500.00	Red	C&J	3grn	R-gold	Unique*	1000	2000	3000

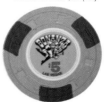
Bonanza Hotel $5 (2nd)

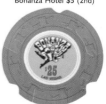
Bonanza Hotel $25 (2nd)

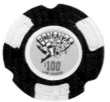
Bonanza Hotel $100 (2nd)

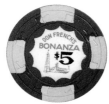
Bonanza, Don French's $5 (2nd)

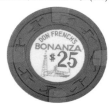
Bonanza, Don French's $25 (3rd)

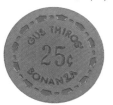
Bonanza, Gus Thiros 25¢ (1st)

Boomtown $100 (1st)

Boulder Club 25¢ (1st)

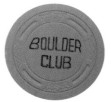
Boulder Club $5 (2nd)

Issue	Den.	Color	Mold	Inserts	Inlay	Rarity	GD30	VF65	CS95
	FP 1.00	Brown	C&J	None	HS	R-9	75	150	225
	FP 5.00	Pink	C&J	None	HS	R-7	50	100	150

(20 of these chips were found along with King's Castle chips of a similar design. There was a common owner - Nate Jacobson.)

BONANZA, DON FRENCH'S N. LAS VEGAS 1955-65

1st	.25	Yellow	C&J	None	HS	R-7	40	80	120
	.50	Fuchsia	C&J	None	HS	R-7	50	100	150
	1.00	Beige	C&J	None	HS	R-4	15	30	45
	5.00	Brown	C&J	None	HS	R-4	20	40	60
2nd	5.00	Brown	C&J	4tan	SCA-white	R-4	25	50	75
3rd	1.00	Green	C&J	4mar	R-white	R-4	20	40	60
	5.00	Mustard	C&J	4blk	R-white	R-8	100	200	300
	25.00	Green	C&J	4org	R-white	R-5	40	80	120
4th	.05	White	Scrown	None	HS	R-8*	100	200	300

(All are lightly overstamped "Non Negotiable" with an Indian Head and worth 15% of listed prices. These chips are usually cleaned and the overstamp is barely noticeable. This also applies to 3rd issue $25.)

	.50	Orange	Scrown	4red	HS	R-10	150	300	450
	1.00	Navy	Scrown	4gry	HS	R-5	20	40	60

(This chip is frequently found overstamped.)

BONANZA, GUS THIROS N. LAS VEGAS 1965-67

1st	.25	Fuchsia	Scrown	None	HS	R-5	100	200	300

(Virtually all known examples are overstamped and worth 10-15% of listed prices. Virgin survivors are considered R-9.)

BOOMTOWN LAS VEGAS 1994-97

1st	1.00	Blue	H&C	3red	OR-multi	R-2	2	4	6
	5.00	Red	H&C	4yel4grn	OR-multi	R-2	5	10	15
	25.00	Green	H&C	4yel4tan	OR-multi	R-4	20	40	60
	100.00	Black	H&C	4pnk4pch4red	OR-multi	R-7	100	150	200
	NCV 1	White	H&C	None	HS	R-5	3	6	9
	NCV 2.50	Lt Blue	H&C	None	HS	R-5	6	12	18
	NCV 5	Pink	H&C	None	HS	R-5	4	8	12
	NCV 25	Green	H&C	None	HS	R-5	5	10	15
	NCV 100	Ochre	H&C	None	HS	R-5	6	12	18
	RLT	6 diff.	H&C	None	HS	R-4	3	6	9

(Picture boot. Colors: Blue, Brown, Grey, Lt Pink, Pink, and Purple.)

	RLT	6 diff.	H&C	None	HS	R-4	3	6	9

(Picture guns. Colors: Navy, Lavender, Orange, Lt Pink, Pink, and Yellow.)

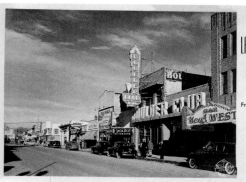

LAS VEGAS
NEVADA

Fremont Street
Looking
West

Great early 1940s postcard of the Boulder Club. Also, a rarely seen view of the New West—a place where no chips are yet known. ©Frashers, Inc., Pomona, CA.

Issue	Den.	Color	Mold	Inserts	Inlay	Rarity	GD30	VF65	CS95
BOULDER CLUB			**LAS VEGAS**		**1929-58**				
BOULDER CLUB, NEW					**1958-60**				
1st	.25	Purple	Diamnd	None	HS	R-5	40	80	120
	5.00	Brown	Diamnd	None	HS	Unique	500	1000	1500
	100.00	Green	Diamnd	None	HS	Unique	500	1000	1500
2nd	5.00	Grey	Lcrown	None	HS	R-5	50	100	150
	25.00	Gry-Grn	Lcrown	None	HS	R-10	350	700	1050

(This issue was made in 1943.)

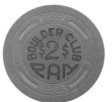
Boulder Club $2 (3rd)

Issue	Den.	Color	Mold	Inserts	Inlay	Rarity	GD30	VF65	CS95
3rd	.25	Purple	Lcrown	None	HS	R-7	100	200	300
	pan 2.00	Red	Lcrown	None	HS	R-10	350	700	1050
	5.00	Red	Lcrown	4org	HS	R-8	125	250	375
	25.00	Cream	Lcrown	4yel	HS	R-8	175	350	525

(This issue was made in 1952.)

Issue	Den.	Color	Mold	Inserts	Inlay	Rarity	GD30	VF65	CS95
4th	.10	Pink	Scrown	None	HS	R-6	75	150	225

("Keno or Bar")

Boulder Club 25¢ (5th)

Issue	Den.	Color	Mold	Inserts	Inlay	Rarity	GD30	VF65	CS95
	.10	Pink	Scrown	None	HS	R-9	250	500	750
	.25	Purple	Scrown	None	HS	R-9	225	450	675
	.25	Purple	Scrown	None	R-white	R-8	250	500	750
	5.00	Red	Scrown	None	SCA-white	R-2	15	30	45
	pan n/d	Blue	Scrown	None	HS	R-4	15	30	45
	pan n/d	Brown	Scrown	None	HS	R-5	25	50	75
5th	.25	Purple	HCE	None	HS	R-8	175	350	525
6th	5.00	Yellow	Arodie	3blk	R-multi	R-9	1500	3000	4500
	RLT	Blue	Hub	None	HS	R-9	100	200	300
	RLT	Red	Hub	None	HS	R-9	100	200	300
7th	5.00	Rose	Arodie	3tan	R-multi	R-10	3500	7000	10500

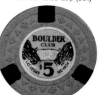
Boulder Club $5 (6th)

(This is considered one of the most attractive chips ever made. It is on or near the top of most collectors' want lists. It is also the only chip marked "New Boulder Club.")

Issue	Den.	Color	Mold	Inserts	Inlay	Rarity	GD30	VF65	CS95
BOULDER STATION			**LAS VEGAS**		**1994-**				
1st	1.00	White	BJ	4gry	OR-white	R-1	*	1	2
	5.00	Red	BJ	4lav	OR-white	R-1	*	5	7
	25.00	Green	BJ	16org8yel	OR-white	R-1	*	25	30
	100.00	Black	BJ	12yel8pur	OR-white	R-10	200	400	600

(This chip was pulled a few weeks after opening and is rare.)

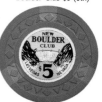
New Boulder Club $5 (7th)

Issue	Den.	Color	Mold	Inserts	Inlay	Rarity	GD30	VF65	CS95
2nd	100.00	Black	BJ	12yel	OR-white	R-1	*	100	110
	NCV 1	Peach	Unicorn	None	HS	R-5	3	6	9

("Win Cards")

Issue	Den.	Color	Mold	Inserts	Inlay	Rarity	GD30	VF65	CS95
	NCV 5	Fuchsia	BJ	None	HS	R-5	5	10	15
	RLT	Lt Blue	BJ	None	HS	R-4	2	4	6
	RLT	Purple	BJ	None	HS	R-4	2	4	6

Boulder Station $25 (1st)

Issue	Den.	Color	Mold	Inserts	Inlay	Rarity	GD30	VF65	CS95
BOURBON STREET			**LAS VEGAS**		**1985-96**				
1st	.25	Orange	H&C	None	HS	R-6	10	20	30
	1.00	Beige	H&C	None	HS	R-3	3	6	9
	5.00	Red	H&C	3wht3brn	HUB-white	R-5	35	70	105
	25.00	Green	H&C	3fch3pnk	SCA-white	R-10	250	500	750
	100.00	Black	H&C	3blu3wht3gry	COG-white	R-9	200	400	600

(First issue has picture of lamppost.)

Issue	Den.	Color	Mold	Inserts	Inlay	Rarity	GD30	VF65	CS95
2nd	5.00	Red	H&C	3yel3brn	OR-white	R-1	5	10	15
	25.00	Green	H&C	3fch3pnk	OR-white	R-2	25	50	75
	100.00	Black	H&C	6blu3ltblu	OR-white	R-2	60	120	180

(Bill Akeman purchased the remaining inventory of these chips and is the primary seller of the above three pieces. The prices on these particular chips reflect his asking prices and not our opinion of their value.)

Bourbon Street $100 (2nd)

Issue	Den.	Color	Mold	Inserts	Inlay	Rarity	GD30	VF65	CS95
	NCV 5	Red	H&C	None	HS	R-8	10	20	30
	NCV 25	Lt Green	H&C	None	HS	R-8	10	20	30
3rd	.25	Grey	BJ	None	HS-red	R-2	2	4	6
error .25		Grey	BJ	None	HS-red	R-10	100	200	300
(No writing on back.)									
	1.00	Blue	BJ	None	HS	R-1	2	4	6
4th	1.00	White	BJ	None	HS-black	R-1	2	4	6

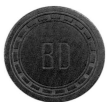
Brown Derby 50¢ (1st)

BOWERY CLUB LAS VEGAS N/A

Issue	Den.	Color	Mold	Inserts	Inlay	Rarity	GD30	VF65	CS95
1st	.25	Yellow	Lcrown	None	HS	R-5	30	60	90
	5.00	Green	Lcrown	None	HS	R-6	30	60	90

(This chip is marked "BC" in large script. This chip is a bit of a mystery. The gaming license for the Bowery Club was denied in 1942 and the club, located on the Strip, never officially opened. However, the chips are all well used - so they were in play somewhere.)

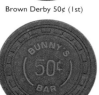
Bunny's Bar 50¢ (1st)

BROWN DERBY W. LAS VEGAS 1944-47/1950-74
NEW BROWN DERBY 1979-83

Issue	Den.	Color	Mold	Inserts	Inlay	Rarity	GD30	VF65	CS95
1st	.50	Black	Rectl	None	HS	R-6	20	40	60
(Marked "BD".)									
2nd	1.00	Grey	C&J	3gld	HS	R-9	125	250	375
(Marked "Brown Derby".)									
3rd	1.00	Yellow	Nevada	None	HS	R-7	40	80	120
	5.00	Black	Nevada	None	HS	R-10	100	200	300
(Marked "BD".)									
4th	1.00	Brown	Diecar	3blu-gry	HS	R-4	15	30	45
	5.00	Mustard	Diecar	3brn	HS	R-4	25	50	75
	25.00	Green	Diecar	3crm	HS	R-9	175	350	525

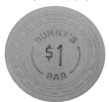
Bunny's Bar $1 (1st)

(Exactly seven chips were found of this New Brown Derby chip.)

BUNNY'S BAR N. LAS VEGAS 1956-75

Issue	Den.	Color	Mold	Inserts	Inlay	Rarity	GD30	VF65	CS95
1st	.50	Navy	Rectl	None	HS	R-9	250	500	750
	1.00	Yellow	Rectl	None	HS	R-9	350	700	1050
	5.00	Orange	Rectl	None	HS	R-10	350	700	1050
2nd	1.00	Beige	C&J	None	HS	Unique	400	800	1200
	5.00	Mustard	C&J	None	HS	Unique	400	800	1200

Bunny's Bar $5 (1st)

Caesar's Palace $5 (1st)

Caesar's Palace $25 (2nd)

Caesars Palace, pictured in this postcard, opened in August 1966 to rave reviews of its striking architecture and overall opulence and has been a world-famous icon ever since. Caesars was the first casino to emphasize and actively solicit high roller action. ©Desert Supply Company, Las Vegas.

Issue	Den.	Color	Mold	Inserts	Inlay	Rarity	GD30	VF65	CS95
CAESARS PALACE			**LAS VEGAS**		**1966-**				
1st	5.00	Brown	HHR	3grn3org	R-white	R-7	200	400	600
	25.00	Green	HHR	3bei3pnk	R-white	R-10	800	1600	2400
2nd	.50	Beige	HCE	None	R-gold	R-5	40	80	120
	5.00	Maroon	HCE	3yel	R-gold	R-8	400	800	1200
	25.00	Green	HCE	3bei	R-gold	R-9	800	1600	2400

(At most, there are only two unnotched survivors presently in collections.)

Issue	Den.	Color	Mold	Inserts	Inlay	Rarity	GD30	VF65	CS95
	100.00	Black	HCE	3bei	R-gold	R-10	1000	2000	3000
	500.00	Yellow	HCE	None	R-gold	Unique*	1250	2500	3750
	RLT	Brown	HCE	None	HS	R-7	35	70	105
	RLT	Green	HCE	3org	HS-orange	R-8	50	100	150
3rd	5.00	Maroon	HCE	6bei3org	R-gold	R-9	500	1000	1500
	25.00	Green	HCE	6yel3ltgrn	R-gold	R-10*	800	1600	2400
	100.00	Black	HCE	6bei3blk	R-gold	R-10	1000	2000	3000
4th	5.00	Red	House	3yel3ltgrn	R-gold	R-6	100	200	300
	25.00	Green	House	3pnk3red	R-gold	R-9	500	1000	1500
	100.00	Black	House	3bei3org	R-gold	R-9	700	1400	2100

(4 known. One of which was stolen from James Campiglia at the 1998 CC>CC convention at the Orleans in Las Vegas. If you are offered this chip it is probably the stolen one. Please contact the authors immediately if you encounter this stolen piece. Reward paid on recovery.)

Issue	Den.	Color	Mold	Inserts	Inlay	Rarity	GD30	VF65	CS95
	500.00	Beige	House	8pnk	R-gold	R-10*	900	1800	2700
	500.00	Lavender	House	3grn3wht	R-gold	R-10*	900	1800	2700

(The first four issues picture Caesar lying on a bed.)

Issue	Den.	Color	Mold	Inserts	Inlay	Rarity	GD30	VF65	CS95
5th	25.00	Black	House	3wht	R-aluminum	R-10	500	1000	1500

(Unusual lightweight chip has Dean Martin on one side and MGM hotel on the other.)

Issue	Den.	Color	Mold	Inserts	Inlay	Rarity	GD30	VF65	CS95
	25.00	Navy	House	3wht	R-silver	R-10	750	1500	2250

(Frank Sinatra.)

Issue	Den.	Color	Mold	Inserts	Inlay	Rarity	GD30	VF65	CS95
	25.00	Navy	House	3wht	R-brass	R-10	500	1000	1500

(MGM lion on one side and MGM hotel on the other - pretty unusual for a Caesars Palace Chip!)

Issue	Den.	Color	Mold	Inserts	Inlay	Rarity	GD30	VF65	CS95
6th	100.00	Black	House	3pnk3grn3org	STAR-white	R-7	125	250	375
	100.00	Black	House	3wht	R-white	R-1	*	100	150

(Above chip is marked "Race and Sports Book". Both of these chips show Caesar on bed with woman feeding grapes.)

Issue	Den.	Color	Mold	Inserts	Inlay	Rarity	GD30	VF65	CS95
	RLT	2 diff.	H&C	None	R-white	R-9	10	20	30

(Colors: Lt Blue and Pink.)

Issue	Den.	Color	Mold	Inserts	Inlay	Rarity	GD30	VF65	CS95
7th	.50	Yellow	H&C	None	HS	R-10	100	200	300
	1.00	Lt Blue	H&C	None	HS	R-4	7	14	21
	1.00	Blue	H&C	None	HS	R-3	6	12	18

(Above three chips are marked "Card Room".)

Issue	Den.	Color	Mold	Inserts	Inlay	Rarity	GD30	VF65	CS95
	5.00	Red	House	3yel3ltblu	R-white	R-4	12	24	36
	5.00	Red	House	3ltblu3dkgry	R-white	R-3	10	20	30
	5.00	Red	House	3wht3nvy	R-white	R-3	8	16	24
	5.00	Red	House	3wht3dkpur	R-white	R-4	11	22	33
	bac 5.00	Red	House	3blu3wht3yel	R-white	R-9	100	200	300
	bac 5.00	Red	House	3brn3wht3pch	R-white	R-6	25	50	75
	bac 20.00	Lt Green	House	3org3blk3brn	R-white	R-10	175	350	525
	bac 20.00	Green	House	3wht3blu3yel	R-white	R-7	50	100	150
	25.00	Green	House	3blu3pch	R-white	R-4	30	60	90
	25.00	Green	House	3nvy3org	R-white	R-6	50	100	150
	25.00	Green	House	3org3yel	R-white	R-7	60	120	180
	25.00	Green	House	3wht3pnk	R-white	R-5	45	90	135
	100.00	Black	House	3brn3org	R-white	R-9	200	400	600
	100.00	Black	House	3org3brn3grn	R-white	R-8	125	250	375
	100.00	Black	House	3wht3red3yel	R-white	R-10	225	450	675
	100.00	Black	House	3ltblu3yel3grn	R-white	R-10	225	450	675

Caesar's Palace $500 (2nd)

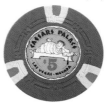

Caesar's Palace $5 (3rd)

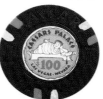

Caesar's Palace $100 (4th)

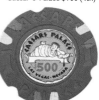

Caesar's Palace $500 (4th)

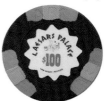

Caesar's Palace $100 (6th)

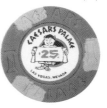

Caesar's Palace $25 (7th)

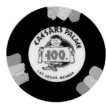

Caesar's Palace $100 (7th)

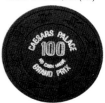

Caesar's NCV $100 (7th)

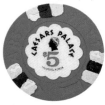

Caesar's Palace $5 (8th)

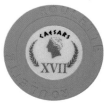

Caesar's Palace RLT VIII (8th)

Caesar's Palace error $5 (9th)

Caesar's Palace error $5/25 (9th)

Issue	Den.	Color	Mold	Inserts	Inlay	Rarity	GD30	VF65	CS95
bac 100.00	Black	House	3grn3yel3red	R-white	R-9	150	300	450	
500.00	White	House	3blu3brn3grn	R-white	Unknown	350	700	1050	

(This chip can be seen in the movie "Rain Man" if you look hard enough. However, we do not know of any in collections at present.)

(This issue pictures Caesar holding a scroll. These chips are grouped together because the actual order is impossible to determine.)

Issue	Den.	Color	Mold	Inserts	Inlay	Rarity	GD30	VF65	CS95
NCV 100	Grey	H&C	3wht3org3brn	R-white	R-9	40	80	120	
NCV 1000	Lt Brown	H&C	3pur3dkbrn	HS	R-9	50	100	150	
NCV 1000	Grey	H&C	3blk	R-white	R-7	35	70	105	

(Jet Set. Picture of an airplane - used for junkets.)

Issue	Den.	Color	Mold	Inserts	Inlay	Rarity	GD30	VF65	CS95
NN 1	Blue	H&C	3pnk3gry	HS	R-8	25	50	75	
NN 5	Red	H&C	3blk3wht	HS	R-6	15	30	45	
NN 25	Green	H&C	3red3blk	HS	R-8	35	70	105	
NN 100	Black	H&C	3blu3org	HS	R-10	50	100	150	
n/d	Lt Blue	H&C	4wht4pur	SCA-white	R-10	75	150	225	
NCV 5	Red	H&C	None	HS	R-6	15	30	45	
NCV 25	Green	H&C	None	HS	R-7	20	40	60	
NCV 100	Black	H&C	None	HS	R-7	25	50	75	

(Above four chips are marked "Grand Prix".)

Issue	Den.	Color	Mold	Inserts	Inlay	Rarity	GD30	VF65	CS95
NCV100	Black	H&C	None	HS	R-6	15	30	45	
NCV 5000	Red	H&C	None	HS	R-6	15	30	45	
RLT VI	2 diff.	H&C	None	HS	R-7	7	14	21	

(Colors: Brown and Orange.)

Issue	Den.	Color	Mold	Inserts	Inlay	Rarity	GD30	VF65	CS95
100.00	3 diff.	H&C	None	HS	R-9	100	200	300	

(Lightweight plastic promo chips. Colors: Cream, Green, and Yellow.)

Issue	Den.	Color	Mold	Inserts	Inlay	Rarity	GD30	VF65	CS95
100.00	Silver	House	None	HS	R-9	100	200	300	

(Looks like the plastic chips, but made out of metal.)

Issue	Den.	Color	Mold	Inserts	Inlay	Rarity	GD30	VF65	CS95
8th 5.00	Red	House	6ltblu3dkblu	HUB-white	R-2	8	16	24	
25.00	Green	House	6pch3blu	SCA-white	R-5	30	60	90	
100.00	Black	House	3blu3gry3org	COG-white	R-6	75	150	225	

(This issue pictures a bust of Caesar.)

Issue	Den.	Color	Mold	Inserts	Inlay	Rarity	GD30	VF65	CS95
NCV 5	Blue	BJ	8gry	HS	R-8	15	30	45	
NCV 500	Grey	BJ	16wht8blk	R-gold/wht	R-10	50	100	150	
RLT IV	Purple	Roulet	None	R-white	R-7	5	10	15	
RLT V	3 diff.	Roulet	None	R-white	R-7	5	10	15	

(Colors: Lt Blue, Brown, and Pink.)

Issue	Den.	Color	Mold	Inserts	Inlay	Rarity	GD30	VF65	CS95
RLT XIV	2 diff.	Roulet	None	R-white	R-7	5	10	15	

(Colors: Lt Blue and Purple.)

Issue	Den.	Color	Mold	Inserts	Inlay	Rarity	GD30	VF65	CS95
RLT XVII	3 diff.	Roulet	None	R-white	R-7	5	10	15	

(Colors: Lt Blue, Green, and Purple.)

Issue	Den.	Color	Mold	Inserts	Inlay	Rarity	GD30	VF65	CS95
1000	Yellow	Plain	12blk	HS	R-10	75	150	225	

(No $ sign or other info. The purpose of this chip is unknown.)

Issue	Den.	Color	Mold	Inserts	Inlay	Rarity	GD30	VF65	CS95
9th 1.00	Blue	House	4lim	R-white	R-1	1	2	3	

(Was briefly used for Caribbean Stud, but is very common.)

Issue	Den.	Color	Mold	Inserts	Inlay	Rarity	GD30	VF65	CS95
5.00	Red	House	6org3brn	R-white	R-1	*	5	7	
error 5.00	Red	House	8org4brn	R-white	R-7	50	100	150	

(There is an extra set of inserts. According to a Caesars Palace dealer, all dealers there are instructed to immediately destroy any of these chips they encounter by snapping them in half on the metal rim of the drop box.)

Issue	Den.	Color	Mold	Inserts	Inlay	Rarity	GD30	VF65	CS95
error $5/$25	Red	House	6org3brn	R-white	Unique	150	300	450	

(Intended to be a $5 chip, but has a $25 inlay on one side. It is possible that more exist, perhaps even a green chip with the other $5 inlay.)

Issue	Den.	Color	Mold	Inserts	Inlay	Rarity	GD30	VF65	CS95
bac 5.00	Red	House	3nvy3yel3grn	R-white	R-1	*	5	10	
bac 20.00	Green	House	6pch3pur	R-white	R-1	*	20	30	
25.00	Green	House	6bei3lav	R-white	R-1	*	25	30	

Issue	Den.	Color	Mold	Inserts	Inlay	Rarity	GD30	VF65	CS95
	100.00	Black	House	3red3yel3lav	R-white	R-1	*	100	110
bac	100.00	Black	House	3blu3yel3grn	R-white	R-2	*	100	120

(This latest issue features a speeding chariot.)

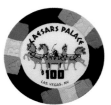

Caesar's Palace $100 (9th)

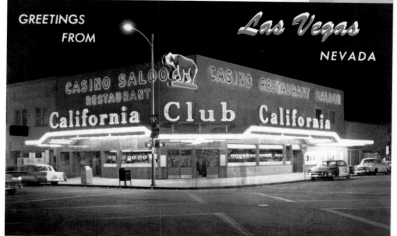

GREETINGS FROM *Las Vegas* NEVADA

This postcard features the neon bear on the California Club, which was identical in design to that found on the California State flag, swiveled its head from left to right. ©Desert Supply Company, Las Vegas.

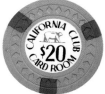

California Club $20 (2nd)

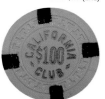

California Club $100 (3rd)

CALIFORNIA CLUB LAS VEGAS 1951–70

Issue	Den.	Color	Mold	Inserts	Inlay	Rarity	GD30	VF65	CS95
1st	.25	Orange	Diamnd	None	HS	R-10	200	400	600
	.25	Purple	Diamnd	None	HS	R-10	200	400	600
("Las Vegas, Nevada" on back.)									
	.25	Dk Red	Diamnd	None	HS	R-10	200	400	600
2nd	.10	Pink	Diamnd	None	HS	R-5	25	50	75
	.25	Red	Diamnd	None	HS	R-10	150	300	450
	.50	White	Diamnd	None	HS	R-9	125	250	375
	1.00	Black	Diamnd	None	HS	R-5	30	60	90
	5.00	Yellow	Diamnd	3grn	R-white	R-3	15	30	45
	20.00	Green	Diamnd	3red	R-white	R-5	60	120	180
(Second issue is marked "Card Room".)									
	faro n/d	3 diff.	Diamnd	None	HS	R-9	100	200	300
(Colors: Brown, Green, and Yellow.)									
	pan n/d	Lavender	Diamnd	None	HS	R-10	75	150	225
	pan n/d	Red	Diamnd	None	HS	R-9	50	100	150
3rd	.25	Purple	T's	None	HS	R-7	60	120	180
	.25	Brown	T's	None	HS-blue	R-10	150	300	450
	100.00	Pink	T's	4blk	HS-blue	R-4	30	60	90
	n/d	Lt Blue	T's	3yel	HS	R-7	50	100	150
(All survivors are overstamped with "25cents".)									
	n/d	Beige	T's	None	HS-blue	R-10*	150	300	450
4th	.25	Red	Hub	2gry	R-white	R-6	50	100	150
	5.00	Orange	Hub	2yel	R-white	R-5	50	100	150
	25.00	Yellow	Hub	2red	R-white	R-10	400	800	1200
	100.00	Black	Hub	2wht	R-white	R-6	80	160	240
(Reverse has picture of a bear facing right.)									
5th	.25	Orange	Sm-key	None	HS	R-9	150	300	450
	5.00	Grey	Sm-key	3grn	R-white	R-10	750	1500	2250

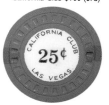

California Club 25¢ obv (4th)

California Club 25¢ rev (4th)

California Club $5 (5th)

California Club $25 (5th)

California Club 25¢ (7th)

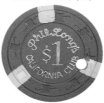

California Club $1 (7th)

California Club 25¢ (8th)

California Hotel $5 (1st)

Cal's $5 (4th)

Issue	Den.	Color	Mold	Inserts	Inlay	Rarity	GD30	VF65	CS95
	25.00	Black	Sm-key	3yel	R-white	R-4	30	60	90
	faro n/d	Blue	Sm-key	None	HS	R-9	150	300	450
6th	.25	Red/Blk	Scrown	1/2pie	HS	R-10	150	300	450
	RLT	4 diff.	Scrown	None	HS	R-9	50	100	150
(Colors: Green, Navy, Orange, and Red.)									
7th	.25	Beige	Diamnd	3blk	HS	R-9	250	500	750
	1.00	Brown	C&J	3bei	HS	R-9	250	500	750
(Above are marked "Phil Long's California Club". Both of the above chips are usually found drilled.)									
8th	.25	Maroon	C&J	None	SCA-white	R-3	8	16	24
(Picture of bear.)									
	5.00	Pink	C&J	3gry	SCA-white	R-4	10	20	30
	25.00	Green	C&J	3blu	SCA-white	R-3	18	36	54
	faro n/d	3 diff.	C&J	None	HS	R-9	75	150	225
(Colors: Lavender, Navy, and Pink.)									
9th	1.00	White	C&J	3blu	R-white	R-2	4	8	12
	5.00	Green	C&J	3blu	R-white	R-3	7	14	21
	5.00	Green	C&J	3lav	R-white	R-4	8	16	24
	5.00	Green	C&J	3tan	R-white	R-3	7	14	21
	5.00	Green	C&J	3brn	R-white	R-4	8	16	24
	5.00	Green	C&J	3sam	R-white	R-4	8	16	24
	5.00	Green	C&J	3org	R-white	R-3	7	14	21
	5.00	Green	C&J	3blk	R-white	R-3	7	14	21
	5.00	Green	C&J	None	R-white	R-4	8	16	24
	FP 1.00	Red	C&J	None	HS	R-8	35	70	105
(Marked "California Club Parking".)									
	RLT	3 diff.	C&J	None	HS	R-9	40	80	120
(Colors: Green, Navy, and Red. Assumed to be roulettes, they may have been used for faro.)									
10th	FP 1.00	Yellow	Nevada	None	HS	R-5	12	24	36
(There are variations with different hot stamp colors.)									
	100.00	Black	Nevada	4org	HS	R-5	25	50	75
	100.00	Black	Nevada	4yel	HS	R-5	25	50	75

CALIFORNIA HOTEL LAS VEGAS 1975-

Issue	Den.	Color	Mold	Inserts	Inlay	Rarity	GD30	VF65	CS95
1st	.25	White	H&C	None	HS	R-1	*	1	3
	1.00	Blue	H&C	3blu	HS	R-1	*	2	4
	5.00	Red	H&C	3ltbrn	R-white	R-1	*	5	10
	25.00	Green	H&C	3pch	R-white	R-1	*	25	35
	100.00	Black	H&C	3gry3grn	SCA-white	R-1	*	100	120
	FP 1.00	Purple	H&C	None	HS	R-7	8	16	24
	NCV 5	Red	H&C	None	HS	R-5	6	12	18
	NCV 25	Green	H&C	None	HS	R-5	8	16	24
	NCV 100	Black	H&C	None	HS	R-5	10	20	30
2nd	.25	White	H&C	None	HS	R-1	*	1	2
	1.00	Blue	H&C	3ltbrn	HS	R-1	*	1	3
(Newer issue with shorter canes, and different "$1".)									

CAL'S, GIN MILL N. LAS VEGAS 1956-86

Issue	Den.	Color	Mold	Inserts	Inlay	Rarity	GD30	VF65	CS95
1st	1.00	Navy	C&J	None	HS	R-7	30	60	90
	5.00	Red	C&J	None	HS	R-9	75	150	225
2nd	1.00	Lavender	Diecar	None	HS	R-6	20	40	60
	5.00	Green	Diecar	None	HS	R-6	15	30	45
	5.00	Orange	Diecar	None	HS	R-7	20	40	60
3rd	5.00	Black	Nevada	None	HS	R-6	20	40	60

Issue	Den.	Color	Mold	Inserts	Inlay	Rarity	GD30	VF65	CS95
4th	5.00	Green	H&C	None	HS	R-7	20	40	60

CAROUSEL LAS VEGAS 1967-74

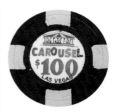

Issue	Den.	Color	Mold	Inserts	Inlay	Rarity	GD30	VF65	CS95
1st	.25	Lt Purple	C&J	None	HS-gold	R-3	8	16	24
	1.00	Maroon	C&J	3grn	R-white	R-2	6	12	18
	5.00	Mustard	C&J	3dkpnk	R-white	R-3	8	16	24
	25.00	Green	C&J	3blu3org	R-white	R-3	12	24	36
	100.00	Black	C&J	4beige	R-white	R-4	15	30	45
	faro n/d	Orange	C&J	None	HS	R-9	100	200	300
	faro n/d	Yellow	C&J	None	HS	R-10	150	300	450
2nd	1.00	Grey	HHR	3grn	R-white	R-2	4	8	12
	5.00	Navy	HHR	3crm	R-white	R-3	6	12	18
	5.00	Navy	HHR	3gry	R-white	R-4	8	16	24
	25.00	Green	HHR	3org	R-white	R-4	25	50	75
	100.00	Black	HHR	3bei	R-white	R-4	40	80	120
3rd	.50	3 diff.	Nevada	None	HS	R-7	10	20	30

Carousel $100 (1st)

("Parking". Colors: Beige, Dk Blue, and Red.)

	1.00	Lt Green	Nevada	None	HS-black	R-5	20	40	60

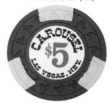

Carousel $5 (2nd)

(Craps, 21, Roulette Match Play. This is the only chip marked "Marty's Carousel".)

CARVER HOUSE W. LAS VEGAS 1961-65

Issue	Den.	Color	Mold	Inserts	Inlay	Rarity	GD30	VF65	CS95
1st	.50	Mustard	C&J	None	HS	R-7	25	50	75
	1.00	Lt Beige	C&J	2red2blu	R-white	R-4	20	40	60
	5.00	Red	C&J	2blu2gry	R-white	R-6	40	80	120
	25.00	Blue	C&J	2red2gry	R-white	R-6	60	120	180

Carver House $5 (1st)

CASINO ROYAL LAS VEGAS 1971-77

Issue	Den.	Color	Mold	Inserts	Inlay	Rarity	GD30	VF65	CS95
1st	.25	Fuchsia	Scrown	None	HS	R-6	20	40	60
	.50	Mustard	Scrown	None	HS	R-7	25	50	75
	1.00	Beige	Scrown	None	OR-white	R-4	7	14	21
	5.00	Red	Scrown	4brn	OR-white	R-4	12	24	36
	25.00	Green	Scrown	4yel	OR-white	R-4	15	30	45
	100.00	Black	Scrown	4sam	OR-white	R-4	15	30	45

Casino Royal $1 (1st)

CASINO ROYALE LAS VEGAS 1992-

Issue	Den.	Color	Mold	Inserts	Inlay	Rarity	GD30	VF65	CS95
1st	.25	Yellow	BJ	None	HS	R-1	*	1	3
	1.00	White	Chipco	None	FG	R-1	*	1	3
	5.00	Red	Chipco	None	FG	R-3	4	8	12
	25.00	Green	Chipco	None	FG	R-4	25	35	50
2nd	5.00	Red	Chipco	None	FG	R-3	5	10	15

("Win a Million".)

3rd	5.00	Red	Chipco	None	FG	R-1	*	5	7

(This newer issue has yellow writing.)

	25.00	Green	Chipco	None	FG	R-1	*	25	30
	RLT A	4 diff.	BJ	None	HS	R-4	2	4	6

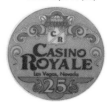

Casino Royale $25 (1st)

(Colors: Brown, Lt Orange, Turquoise, and Yellow.)

CASINO, THE LAS VEGAS 1976-77

Issue	Den.	Color	Mold	Inserts	Inlay	Rarity	GD30	VF65	CS95
1st	.25	Blue	Nevada	None	HS	R-7	50	100	150
	1.00	Cream	Nevada	None	R-white	R-8	500	1000	1500
	5.00	Red	Nevada	3bei	R-white	R-9	750	1500	2250

(Above two chips are Bi-Centennial issues of 1976 and in fierce demand. This tiny casino became the Bingo Palace that became today's larger Palace Station.)

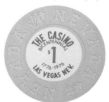

The Casino $1 (1st)

Issue	Den.	Color	Mold	Inserts	Inlay	Rarity	GD30	VF65	CS95
CASTAWAYS			**LAS VEGAS**				**1963-87**		
CASTAWAYS, OLIVER'S							**1967-67**		
1st	5.00	Maroon	HCE	3pnk	R-white	R-3	15	30	45
	25.00	Dk Green	HCE	3blk3yel	R-white	R-3	25	50	75
	100.00	Black	HCE	3wht3red	R-white	R-4	50	100	150

(This issue is frequently encountered with the cancellation "ZAB" or a gold circle.)

Issue	Den.	Color	Mold	Inserts	Inlay	Rarity	GD30	VF65	CS95
2nd	1.00	Lt Grey	Scrown	4org	OR-white	R-5	20	40	60
3rd	5.00	Yellow	C&J	3brn	R-white	R-9	400	800	1200
	25.00	Green	C&J	3red	R-white	R-5	500	1000	1500

(Virtually all known examples are cancelled and worth only 10% of listed values. Uncancelled, this chip is R-10. Beware of removed cancellation.)

Issue	Den.	Color	Mold	Inserts	Inlay	Rarity	GD30	VF65	CS95
	100.00	Black	C&J	3bei	R-white	R-9	500	1000	1500
	FP 1.00	Pnk/Crm	C&J	dovetail-pnk	HS	R-7	25	50	75
	FP 1.00	Pnk/Crm	C&J	dovetail-crm	HS	R-7	25	50	75
4th	.25	Dk Grey	C&J	None	HS	R-8	100	200	300
	1.00	Orange	C&J	None	HS	R-5	125	250	375

(These chips are marked "Oliver's Castaways". The $1 is usually cancelled and worth 10-15% of listed values. Uncancelled, this chip is R-9.)

Issue	Den.	Color	Mold	Inserts	Inlay	Rarity	GD30	VF65	CS95
5th	5.00	Yellow	C&J	3mar	R-white	R-5*	250	500	750
	25.00	Green	C&J	3pnk	R-white	R-10*	400	800	1200

(This issue is "Oliver's New Castaways". We believe all $5 and $25 chips have been lightly cancelled. These chips clean up well, so if you want to see the cancellation, you need to tilt the chip in the light in order to spot the impression. Cancelled chips go for about 15% of these prices.)

Issue	Den.	Color	Mold	Inserts	Inlay	Rarity	GD30	VF65	CS95
6th	1.00	Dk Red	HHL	3dkblu	HS	R-8	125	250	375
7th	.25	Orange	Nevada	None	HS	R-3	4	8	12
	.50	Tan	Nevada	None	HS-black	R-5	10	20	30
	1.00	Dk Red	Nevada	3dkblu	HS	R-7	40	80	120
	1.00	Green	Nevada	None	HS-black	R-4	6	12	18

("Matched Play".)

Issue	Den.	Color	Mold	Inserts	Inlay	Rarity	GD30	VF65	CS95
8th	.25	Orange	Diecar	None	HS	R-3	4	8	12
	.50	Tan	Diecar	None	HS	R-3	4	8	12
	pok 1.00	Orange	H&C	3dkbrn	HS	R-3	6	12	18
9th	5.00	Yellow	BJ-1	3blu	COIN	R-9	150	300	450
10th	5.00	Red	BJ-1	3gry	COIN	R-2	5	10	15
	25.00	Green	BJ-1	6dkgrn	COIN	R-2	8	16	24
	100.00	Black	BJ-1	6dkorg	COIN	R-5	25	50	75
	RLT	5 diff.	HHR	None	HS	R-6	7	14	21

(Colors: Lt Blue, Mustard, Orange, Purple, and White.)

Issue	Den.	Color	Mold	Inserts	Inlay	Rarity	GD30	VF65	CS95
11th	1.00	Brown	BJ-2	6wht	COIN	R-1	2	4	6

(There is a variant with a smaller "$1".)

Issue	Den.	Color	Mold	Inserts	Inlay	Rarity	GD30	VF65	CS95
	5.00	Red	BJ-2	3gry	COIN	R-3	5	10	15
	25.00	Green	BJ-2	6ltgrn	COIN	R-3	10	20	30
	100.00	Black	BJ-2	6org	COIN	R-3	10	20	30
	RLT	6 diff.	BJ	None	HS	R-5	4	8	12

(Colors: Blue, Lt Blue, Pink, Purple, White, and Yellow.)

Issue	Den.	Color	Mold	Inserts	Inlay	Rarity	GD30	VF65	CS95
	500.00	Blue	BJ-2	3ltblu	COIN	R-3	30	60	90
	rs 500.00	Pink	BJ-2	4blk	COIN	R-3	20	40	60
	rs 1000.00	Dk Pink	BJ-2	8blk4wht	COIN	R-3	20	40	60

(Both of the above race and sports chips are oversized.)

Issue	Den.	Color	Mold	Inserts	Inlay	Rarity	GD30	VF65	CS95
	error 1000.00	Dk Pink	BJ-2	8blk4wht	COIN	Unique	200	400	600

(Has $100 inlay on one side.)

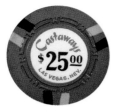

Castaways $25 (1st)

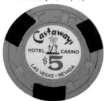

Castaways $5 (3rd)

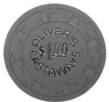

Castaways $1 (4th)

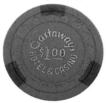

Castaways $1 (6th)

Castaways $5 (10th)

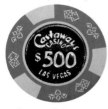

Castaways $500 (11th)

Issue	Den.	Color	Mold	Inserts	Inlay	Rarity	GD30	VF65	CS95
CBS SPORTS WORLD			**LAS VEGAS**		**1997-99**				
SPORTS WORLD					**1999-**				
1ST	1.00	White	BJ	3blu	OR-white	R-1	2	4	6
	5.00	Red	BJ	6yel	OR-white	R-3	5	10	15
	10.00	Lt Orange	BJ	4blu	OR-white	R-5	10	20	30
	20.00	Yellow	BJ	6wht	OR-white	R-5	20	40	60
	25.00	Green	BJ	8grn	OR-white	R-5	25	40	60
	100.00	Black	BJ	12lav	OR-white	R-7	100	125	175
	NCV 10.00	Brown	BJ	8grn	OR-white	R-8	10	20	30

(First issue is marked "CBS Sports World".)

Issue	Den.	Color	Mold	Inserts	Inlay	Rarity	GD30	VF65	CS95
2nd	1.00	White	BJ	3dkblu	OR-white	R-1	*	1	3
	5.00	Red	BJ	6yel	OR-white	R-1	*	5	10
	25.00	Green	BJ	8ltgrn	OR-white	R-2	*	25	30
	100.00	Black	BJ	12pnk	OR-white	R-3	*	100	120
	NCV 10	Brown	BJ	None	HS	R-7	7	14	21
	RLT 1	5 diff.	BJ	None	HS	R-4	3	6	9

(Colors: Blue, Green, Grey, Orange, and Yellow.)
(Second issue is just marked "Sports World".)

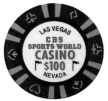

CBS Sportsworld $100 (1st)

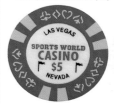

Sportsworld $5 (2nd)

Issue	Den.	Color	Mold	Inserts	Inlay	Rarity	GD30	VF65	CS95
CENTER-FOLD			**LAS VEGAS**		**1975-77**				
1st	.25	Pink	H&C	None	HS	R-6	30	60	90
	.50	White	H&C	None	HS	R-5	25	50	75
	1.00	Blue	H&C	None	HS	R-5	25	50	100
	5.00	Red	H&C	3pnk	HS	R-4	25	50	100
	25.00	Green	H&C	3blu	HS	R-6	50	100	200
2nd	pok 1.00	Mustard	Diecar	None	HS	R-5	25	50	100

(Most of these chips are found in very worn condition, placing a premium on top specimens.)

Center-Fold $1 (1st)

Issue	Den.	Color	Mold	Inserts	Inlay	Rarity	GD30	VF65	CS95
CHESTERFIELD CLUB			**N. LAS VEGAS**		**1954-65**				
1st	.10	Red	C&J	None	HS	R-8	100	200	300
	.25	Yellow	C&J	None	HS	R-10	200	400	600
	1.00	Green	C&J	None	HS	R-10	250	500	750
	5.00	Navy	C&J	None	HS	R-10*	250	500	750

Chesterfield Club $5 (1st)

Issue	Den.	Color	Mold	Inserts	Inlay	Rarity	GD30	VF65	CS95
CINNABAR			**LAS VEGAS**		**1940-48/1951-59**				
1st	5.00	Yellow	HCE	3brn	HS	R-5	50	100	150
	25.00	Red	HCE	3tan	HS	R-10	250	500	750

(These chips are from the second ownership, located on Second Street downtown. Chips from 1940-48 are unknown.)

Postcard of Circus Circus. A disaster when it first opened, the casino was intended to lure high-rollers! The circus theme failed to deliver until they changed their philosophy to attract small bettors. ©Desert Supply Company, Las Vegas.

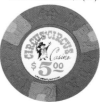

Circus Circus $5 (1st)

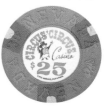

Circus Circus $25 (1st)

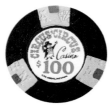

Circus Circus $100 (1st)

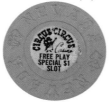

Circus Circus FP 1 (1st)

Circus Circus NCV 20 (1st)

Circus Circus $5 (2nd)

Circus Circus FP 1 (2nd)

Circus Circus $100 (3rd)

Issue	Den.	Color	Mold	Inserts	Inlay	Rarity	GD30	VF65	CS95
CIRCUS CIRCUS			**LAS VEGAS**		**1968-**				
1st	.50	Lavender	Nevada	None	R-white	R-5	20	40	60
	1.00	Grey	Nevada	None	R-white	R-4	12	24	36
	1.00	Beige	Nevada	None	R-white	R-4	15	30	45
	5.00	Red	Nevada	6blu3yel	R-white	R-6	40	80	120
	25.00	Green	Nevada	6pur3wht	R-white	R-9	1000	2000	3000
(Of the five known survivors, two are notched samples.)									
	100.00	Black	Nevada	6gry3red	R-white	R-9	1200	2400	3600
(Of the five known survivors, only one is undamaged.)									
	500.00	Gry-Blu	Nevada	6crm	R-white	Unique*	1500	3000	4500
	FP 1	Dk Blue	Nevada	None	R-white	R-10	15	30	45
	FP 1	Yellow	Nevada	None	R-white	R-9	10	20	30
(These two chips have as an inlay a small sticker which says "Free Play Special $1 Slot".)									
	FP 1	Dk Blue	Nevada	None	R-white	R-9	10	20	30
	FP 1	Brown	Nevada	None	R-white	R-9	10	20	30
	FP 1	Pink	Nevada	None	R-white	R-9	10	20	30
	FP 1	Dk Red	Nevada	None	R-white	R-9	10	20	30
(These four chips are marked like the two above, except the sticker is as big as a normal inlay.)									
	NCV 1	3 diff.	Nevada	None	HS-silver	R-5	3	6	9
(Colors: Brown, Pink, and Yellow.)									
	NCV 5	Dk Blue	Nevada	None	HS-silver	R-6	7	14	21
	NCV 5	Dk Green	Nevada	None	HS-silver	R-10	25	50	75
	NCV 5	Navy	Nevada	None	HS-silver	R-6	7	14	21
(These four chips are marked "Circus-Circus Casino, 1 (or 5) Prize Unit(s)".)									
	NCV 1	Yellow	Nevada	None	HS-silver	R-6	3	6	9
(This chip has "Las Vegas, Nev." Under "Circus-Circus".)									
	NCV 1	Yellow	Nevada	None	R-white	R-4	4	8	12
	NCV 5	Dk Blue	Nevada	None	R-white	R-6	8	16	24
	NCV 20	Maroon	Nevada	None	R-white	R-8	35	70	105
	NCV 100	Black	Nevada	None	R-white	R-10	50	100	150
(Above NCV chips are actually marked "Prize Units".)									
2nd	1.00	Grey	Nevada	None	HS-black	R-8	20	40	60
	1.00	Orange	Nevada	None	HS-black	R-6	8	16	24
	5.00	Gry-Blu	Nevada	None	HS-black	R-7	10	20	30
(These three chips are marked "Special Junket".)									
	NCV 1	2 diff.	Nevada	None	HS-white	R-9	10	20	30
(Marked "Circus Circus One Prize Unit". Colors: Orange and Pink.)									
	FP n/d	Orange	Nevada	None	HS-black	R-5	4	8	12
	FP 1.00	Orange	Nevada	None	HS-black	R-5	5	10	15
(These are marked "Craps or 21 Only".)									
	FP 1.00	Orange	Nevada	None	HS-black	R-5	5	10	15
(This is marked "Craps - 21 Roulette".)									
	FP 1.00	Orange	Nevada	None	HS-black	R-8	10	20	30
("Blackjack or Roulette Only".)									
	FP 1.00	Purple	Nevada	None	HS-black	R-9	25	50	75
("Crap Game Only".)									
3rd	100.00	Yellow	H&C	None	HS-silver	R-5	125	250	375
(This was a chip made for the gift shop key rings. Virtually all examples are drilled and only worth 10% of these listed prices. Undrilled examples are probably R-10.)									
4th	1.00	White	H&C	None	HS	R-1	5	10	15
	5.00	Red	H&C	3gry	HS	R-4	15	30	45
	5.00	Red	H&C	3gry	HS	R-4	10	20	30
(Variant with thicker hot stamp and shorter canes.)									
	25.00	Green	H&C	3yel	HS	R-7	50	100	150
	100.00	Black	H&C	3dkorg3ltblu3org	HS	R-10	100	200	300

Issue	Den.	Color	Mold	Inserts	Inlay	Rarity	GD30	VF65	CS95

(Stamped "Non Negotiable" on back.)

5th	1.00	Beige	H&C	3pnk	R-white	R-1	*	1	3
	5.00	Red	H&C	3gry	HUB-white	R-1	*	5	7
	25.00	Green	H&C	3yel	SCA-white	R-1	*	25	30
	100.00	Black	H&C	3ltorg3blu3org	COG-white	R-1	*	100	110
	NCV 1	Pink	H&C	None	HS	R-7	6	12	18
	NCV 2	Orange	H&C	None	HS	R-6	4	8	12

("Twin Q".)

6th	100.00	Black	Chipco	3ltorg3org3blu	FG	R-1	*	100	110
	n/d	Purple	Chipco	None	FG	R-6	10	20	30

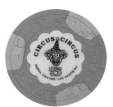

Circus Circus $5 (5th)

("Grand Slam Canyon 2nd Birthday Bash".)

(Circus Circus was completely mismanaged and ill-conceived when they first opened. Developer Jay Sarno was hailed as a genius after the opening of Caesars Palace, but was almost laughed out of town for Circus Circus. This was intended to be another high-roller casino like Caesars, but the circus theme failed to attract big action. There were live circus shows being performed over the heads of people playing, distracting and irritating patrons and dealers alike. In addition, a cute baby elephant was trained to walk around the casino and pull certain slot machine handles. One day, the bored elephant wandered into the blackjack pit and sucked down most of the chips on the table! The casino lost money month after month until William Bennett took over and changed the philosophy of the casino to attract small bettors. Nowadays, Circus Circus enterprises have expanded to become one of the nation's most powerful and successful gaming corporations.)

Club Bingo $100 (1st)

CLUB BINGO — LAS VEGAS — 1947-52

Issue	Den.	Color	Mold	Inserts	Inlay	Rarity	GD30	VF65	CS95
1st	5.00	Navy	Diamnd	None	HS	R-8	150	300	450
	100.00	Yellow	Diamnd	None	HS	R-7	100	200	300
	100.00	Grey	Diamnd	None	HS	R-8	150	300	450

(These $100 chips have red spots all over the surface. The chip was intentionally made this way and we call this the measles issue.)

(This was the first Club Bingo located on the Strip. This casino became the Sahara.)

Club Bingo $5 (1st)

CLUB BINGO — LAS VEGAS — 1962-83

Issue	Den.	Color	Mold	Inserts	Inlay	Rarity	GD30	VF65	CS95
1st	5.00	Grey	C&J	None	R-white	Unique*	300	600	900
	5.00	Red	C&J	3gry	R-white	R-6	50	100	150
	25.00	Brown	C&J	3gry3brn	R-white	R-6	50	100	150
	n/d	Purple	C&J	None	R-white	R-3	10	20	30
2nd	.12 1/2	Green	Scrown	None	HS	R-4	75	150	225
	n/d	Blue	Scrown	None	HS	R-6	20	40	60

(This was located downtown.)

Club Bingo $25 (1st)

CLUB SAVOY, CLUB SAVOY, KHOURY'S — LAS VEGAS — 1945-53

Issue	Den.	Color	Mold	Inserts	Inlay	Rarity	GD30	VF65	CS95
1st	100.00	Cream	Sm-key	None	HS	R-10	650	1300	1950
2nd	n/d	Mustard	Arodie	None	HS	R-5	75	150	225
	5.00	Cream	Arodie	None	HS	R-6	150	300	450
	25.00	Navy	Arodie	None	HS	R-6	175	350	525

(Second issue is marked "Khoury's Club Savoy". The discoverer of these chips claims that there are 8 $5 and 15 $25. We believe there are more, because a mixed box was offered to a collector awhile back.)

Club Savoy $100 (1st)

COIN CASTLE — LAS VEGAS — 1970-

Issue	Den.	Color	Mold	Inserts	Inlay	Rarity	GD30	VF65	CS95
1st	1.00	Red	C&J	None	HS	R-6	20	40	60
2nd	1.00	Beige	Nevada	3mar	R-white	R-5	30	60	90
	5.00	Red	Nevada	3mst	R-white	R-6	50	100	150

(First issue is marked "CCC". This Downtown slot house has not had live games since the 1980's.)

CONTINENTAL — LAS VEGAS — 1981-99

Issue	Den.	Color	Mold	Inserts	Inlay	Rarity	GD30	VF65	CS95
1st	.25	White	H&C	None	HS	R-2	2	4	6
	1.00	Blue	H&C	None	HS	R-3	2	4	6

Coin Castle $5 (2nd)

Continental $5 (1st)

Copa Lounge $1 (1st)

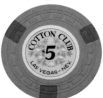

Cotton Club $5 (1st)

Cove Hotel $1 (1st)

Debbie Reynolds $5 (2nd)

Desert Inn $100 (1st)

Issue	Den.	Color	Mold	Inserts	Inlay	Rarity	GD30	VF65	CS95
	5.00	Red	H&C	4blu4nvy	HS	R-4	8	16	24
	25.00	Green	H&C	4red4pnk	HS	R-5	25	50	75
	100.00	Black	H&C	4brn4blu4yel	HS	R-7	100	150	200
	NCV	Brown	H&C	None	HS	R-8	10	20	30

("No Cash Value" on one side only.)

	NCV 1	Brown	H&C	None	HS	R-5	5	10	15
	NCV	4 diff.	H&C	None	HS	R-5	3	6	9

(Colors: Lt Blue, Grey, Orange, and Peach.)

2nd	5.00	Red	Chipco	None	FG	R-2	5	10	15
	NCV 5	Pink	BJ	None	HS	R-7	6	12	18
	NCV 25	Green	BJ	None	HS	R-8	10	20	30

COPA LOUNGE — LAS VEGAS — 1955-64

Issue	Den.	Color	Mold	Inserts	Inlay	Rarity	GD30	VF65	CS95
1st	1.00	Yellow	Rectl	None	R-white	R-10	600	1200	1800
	5.00	Red	Rectl	None	R-white	R-7	250	500	750

(Until 24 of the $5 chips were found in the late 80's, only one or two were in collections at that time. Exactly two $1 chips are known.)

COTTON CLUB — W. LAS VEGAS — 1945-57

Issue	Den.	Color	Mold	Inserts	Inlay	Rarity	GD30	VF65	CS95
1st	5.00	Mustard	Rectl	None	R-white	R-8	550	1100	1650

(This classic $5 issue is one of the premier chips of the segregated Westside clubs. Only 3 were known to exist in 1997. A few more were discovered & now we believe 12-15 are known. This chip has sold for over $3000 at least twice, but that was before the last bunch came on the market. Demand is very strong for this beautiful and historically significant chip.)

2nd	5.00	Yellow	Scrown	None	HS	R-8	150	300	450
	10.00	Blue	Scrown	None	HS	R-8	150	300	450

COVE HOTEL — W. LAS VEGAS — 1965-66

Issue	Den.	Color	Mold	Inserts	Inlay	Rarity	GD30	VF65	CS95
1st	.50	White	Rectl	None	HS	R-8	75	150	225
	1.00	Navy	Rectl	None	HS	R-6	40	80	120
	5.00	Red	Rectl	None	HS	R-6	50	100	150
	25.00	Black	Rectl	None	HS	R-8	75	150	225

DEBBIE REYNOLDS — LAS VEGAS — 1993-96

Issue	Den.	Color	Mold	Inserts	Inlay	Rarity	GD30	VF65	CS95
1st	5.00	Red	H&C	3blu3grn	OR-multi	R-3	10	20	30
	25.00	Green	H&C	3pur3pch3blu	OR-multi	R-5	50	100	150
2nd	5.00	Red	H&C	3blu3grn	OR-multi	R-4	10	20	30

(This variant has the later mold where the hat & cane goes out all the way to the edge.)

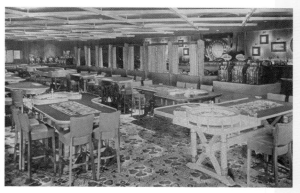

This 1950s Desert Inn postcard pictures a floorplan that was typical of the era—roulette and craps tables outnumbered blackjack. ©Desert Supply Company, Las Vegas.

Issue	Den.	Color	Mold	Inserts	Inlay	Rarity	GD30	VF65	CS95

DESERT INN **LAS VEGAS** **1950-**

Issue	Den.	Color	Mold	Inserts	Inlay	Rarity	GD30	VF65	CS95
1st	5.00	Purple	Diamnd	None	HS	R-10	1000	2000	3000
	25.00	Red	Diamnd	2blu-grn	HS	R-8*	400	800	1200
	25.00	Green	Diamnd	2org	HS	R-10*	1000	2000	3000
	100.00	Tan	Diamnd	2blk	HS	R-8*	750	1500	2250

(Correct spelling of "Wilbur Clark".)

	100.00	Tan	Diamnd	2blk	HS	R-10*	1000	2000	3000

(Misspelled "Wilber Clark".)

	RLT A	4 diff.	Sm-key	None	HS	R-10	100	200	300

(Colors: Beige, Lavender, Red, and Yellow.)

	RLT B	5 diff.	Sm-key	None	HS	R-10	100	200	300

(Colors: Beige, Grey, Lavender, Red, and Yellow.)

	RLT C	5 diff.	Sm-key	None	HS	R-10	100	200	300

(Colors: Beige, Black, Lavender, Red, and Yellow.)

2nd	5.00	Mustard	Arodie	3dkblu	R-white	R-10*	2000	4000	6000

(Of the three known examples, 2 are encased in lucite.)

	100.00	Black	Arodie	3gry	R-white	Unique	2500	5000	7500
3rd	5.00	Maroon	Arodie	3mst	R-white	Unique*	2000	4000	6000
4th	5.00	Maroon	Rcthrt	3blu	R-white	R-10	1500	3000	4500
5th	5.00	Blue	HCE	3aqa3yel	R-white	R-9	750	1500	2500
	25.00	Lt Green	HCE	3red3blk	R-white	R-10*	1200	2400	3600
6th	1.00	Yel-Grn	HCE	None	R-white	R-6	125	250	500
	5.00	Maroon	HCE	3mst3gry-blu	R-white	R-7	400	800	1600
	25.00	Green	HCE	3wht3pur	R-white	R-10	1200	2400	3600
	100.00	Black	HCE	3bei	R-white	R-9	1200	2400	3600

(Four known.)

	RLT A	6 diff.	HCE	None	HS	R-6	25	50	75

(Colors: Beige, Brown, Navy, Purple, Red, and Yellow.)

	RLT B	2 diff.	HCE	None	HS	R-9	50	100	150

(Colors: Brown and Red.)

	RLT 3	Red	HCE	None	HS	Unique*	100	200	300
	RLT 3	Yellow	HCE	None	HS	Unique	100	200	300
7th	500.00	Beige	C&J	3nvy3org	HS	R-9	600	1200	1800
	RLT 1	Red	C&J	None	HS	R-10	50	100	150
	RLT 2	Green	C&J	None	HS	R-9	50	100	150
	RLT 2	Lavender	C&J	None	HS	R-8	35	70	105
	RLT 2	Navy	C&J	None	HS	R-6	25	50	75

(This is the last Wilbur Clark issue.)

8th	1.00	Olive	HCE	None	R-white	R-7	125	250	375
	5.00	Maroon	HCE	3nvy3bei	R-white	R-6	175	350	700
	25.00	Green	HCE	3pur3bei	R-white	R-9	700	1400	2100

(This is the first "Joshua Tree" issue.)

	RLT 1	6 diff.	HCE	None	HS	R-8	15	30	45

(Colors: Beige, Black, Lavender, Navy, Pink, and Yellow.)

	RLT 2	2 diff.	HCE	None	HS	R-8	15	30	45

(Colors: Black and Blue.)

	RLT 3	Navy	HCE	None	HS	R-10	50	100	150
	RLT 4	4 diff.	HCE	None	HS	R-8	15	30	45

(Colors: Black, Green, Grey, and Red.)

	RLT 5	4 diff.	HCE	None	HS	R-8	15	30	45

(Colors: Beige, Black, Lavender, and Yellow.)
(Above roulettes are marked "DI" with the table number between the "D" and "I".)

9th	2.50	Pink	Ewing	None	R-white	R-2	10	20	30
	RLT	Beige	Ewing	None	HS	R-8	30	60	90

Desert Inn $100 (1st)

Desert Inn $5 (2nd)

Desert Inn $5 (4th)

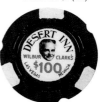

Desert Inn $100 (6th)

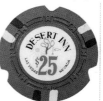

Desert Inn $25 (8th)

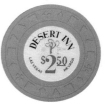

Desert Inn $2.50 (9th)

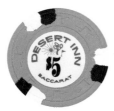

Desert Inn $5 (10th)

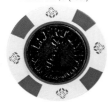

Desert Inn $1 (12th)

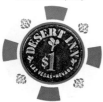

Desert Inn $1 (13th)

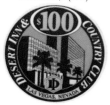

Desert Inn $100 (16th)

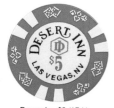

Desert Inn $5 (17th)

Desert Inn NCV 5 (18th)

Issue	Den.	Color	Mold	Inserts	Inlay	Rarity	GD30	VF65	CS95
10th	bac 5	Orange	H&C	3blk3wht	R-white	R-8	200	400	600
	bac 20	Green	H&C	3blu3pnk	R-white	R-10	500	1000	1500
	bac 100	Yellow	H&C	3gry3grn	R-white	R-9	400	800	1200
	1000.00	Blue	H&C	3wht3ltblu3org	HUB-white	R-8	150	300	450
(This once extremely rare chip has been sold on Ebay multiple times, indicating a possible hoard.)									
11th	5.00	Red	BJ-1	3wht	COIN-black	R-8	150	300	450
	25.00	Dk Green	BJ-1	3ltgrn	COIN-black	R-9	200	400	600
	RLT A	White	H&C	None	HS	R-9	20	40	60
12th	1.00	White	BJ-2	4blu	COIN-black	R-6	10	20	30
(Eleventh and twelfth issues have black writing filled in on the coin.)									
13th	1.00	White	BJ-2	4blu	COIN	R-3	5	10	15
	5.00	Red	BJ-2	6wht	COIN	R-4	15	30	45
	25.00	Green	BJ-2	4ltgrn	COIN	R-5	35	70	105
	100.00	Black	BJ-2	6yel	COIN	R-7	100	200	300
	500.00	Purple	BJ-2	12pnk	COIN	R-7	150	300	450
(This is the last "Joshua Tree" issue.)									
14th	bac 5	Red	BJ-2	6yel3grn	COIN	R-7	100	200	300
	bac 20	Green	BJ-2	6pur3org	COIN	R-10	250	500	750
	bac 100	Black	BJ-2	6org3wht	COIN	R-7	125	250	375
	bac 500	Grey	BJ-2	6ltgry3pnk	COIN	R-7	125	250	375
	bac 1000	Pink	BJ-2	6ltblu3blk	COIN	R-7	125	250	375
	bac 5000	Blue	BJ-2	12red	COIN	R-8	200	400	600
(There have been multiple Ebay sales of the above two issues, indicating that there may be a much larger quantity lurking in the shadows.)									
15th	pok 1	Blue	H&C	None	HS	R-6	20	40	60
	RLT 4	7 diff.	H&C	None	HS	R-7	10	20	30
(Colors: Blue, Lt Blue, Green, Grey, Orange, Pink, and Yellow.)									
16th	1.00	White	Chipco	None	FG	R-2	3	6	9
	5.00	Red	Chipco	None	FG	R-6	30	60	90
	25.00	Green	Chipco	None	FG	R-8	250	500	750
	100.00	Black	Chipco	None	FG	R-10	500	1000	1500
(This set was pulled very quickly - except for the $1 that was used with the 17th issue.)									
17th	5.00	Red	BJ-2	6wht	R-white	R-3	8	16	24
	25.00	Green	BJ-2	4ltgrn	R-white	R-6	30	60	90
	100.00	Black	BJ-2	6yel	R-white	R-8	100	200	300
	500.00	Lavender	BJ-2	12pur	R-white	R-10	300	600	900
	NCV 1	Orange	H&C	None	HS	R-7	5	10	15
	NCV 2.50	Lt Blue	H&C	3blu	HS	R-10	50	100	150
	NCV 5	Lt Brown	H&C	4pnk	HS	R-4	4	8	12
	NCV 25	Pink	H&C	4nvy	HS	R-4	6	12	18
	NCV 100	White	H&C	3blu3olv	HS	R-5	10	20	30
(Above five chips are marked "Tounament Chip" on one side.)									
	RLT	6 diff.	H&C	None	HS	R-9	10	20	30
(Colors: Black, Brown, Orange, Pink, Purple, and Red.)									
	RLT	7 diff.	H&C	None	R-white	R-9	12	24	36
(Colors: Blue, Green, Grey, Pink, Purple, White, and Yellow.)									
("DI" in a hexagon on above 2 sets.)									
18th	1.00	White	H&C	4blu	OR-white	R-4	7	14	21
	5.00	Red	H&C	4pnk	OR-white	R-5	10	20	30
	25.00	Green	H&C	4grn	OR-white	R-7	35	70	105
	100.00	Black	H&C	4yel4pnk4grn	OR-white	R-8	100	200	300
	NCV 5	Beige	H&C	None	OR-white	R-9	20	40	60
	NCV 25	Pink	H&C	None	OR-white	R-10	30	60	90
	NCV 500	Brown	H&C	None	OR-white	R-10*	50	100	150

Issue	Den.	Color	Mold	Inserts	Inlay	Rarity	GD30	VF65	CS95

("Poker Tournament".)
(This 18th issue is "Sheraton Desert Inn".)

Issue	Den.	Color	Mold	Inserts	Inlay	Rarity	GD30	VF65	CS95
19th	1.00	White	House	4blu	OR-white	R-3	5	10	15
	5.00	Red	House	4pnk	OR-white	R-4	8	16	24
	25.00	Green	House	4grn	OR-white	R-7	35	70	105
	100.00	Black	House	6yel	OR-white	R-8	100	200	300
	1000.00	Yellow	House	4pnk4blu	OR-white	Unique*	300	600	900

(This issue is also "Sheraton Desert Inn".)

Issue	Den.	Color	Mold	Inserts	Inlay	Rarity	GD30	VF65	CS95
20th	1.00	White	H&C	2dkgrn2yel	OR-green	R-1	*	1	3
	5.00	Red	H&C	2nvy2wht	OR-red	R-1	*	5	7
	25.00	Green	H&C	4ltgrn4pnk	OR-green	R-1	*	25	30
	100.00	Black	H&C	4yel4brn	OR-multi	R-1	*	100	110
rs	100.00	Black	H&C	3fch3grn3pur	OR-multi	R-1	*	100	110
	RLT	6 diff.	Roulet	None	OR-multi	R-6	7	14	21

(Colors: Blue, Fuchsia, Lt Green, Navy, Orange, and Lt Yellow.)

Issue	Den.	Color	Mold	Inserts	Inlay	Rarity	GD30	VF65	CS95
21st	5.00	Red	H&C	2nvy2wht	OR-multi	R-1	*	5	7
	25.00	Green	H&C	4ltgrn4pnk	OR-multi	R-1	*	25	30
	100.00	Black	H&C	4yel4brn	OR-multi	R-1	*	100	110

("Rediscover The Legend" set dated December, 97. Still in use mixed with other chips in 99.)

Desert Inn $100 (19th)

Desert Spa $100 (1st)

DESERT SPA LAS VEGAS 1947-59

Issue	Den.	Color	Mold	Inserts	Inlay	Rarity	GD30	VF65	CS95
1st	5.00	Blue	Rectl	4gry	R-white	R-7	150	300	450
	25.00	Red	Rectl	4gry	R-white	R-9	350	700	1050
	100.00	Black	Rectl	4yel	R-white	R-7	150	300	450
2nd	5.00	Blue	Scrown	3yel	SAW-white	R-3	10	20	30
	25.00	Red	Scrown	3grn	WHL-white	R-4	20	40	60

Desert Spa $25 (2nd)

DEVILLE LAS VEGAS N/A

Issue	Den.	Color	Mold	Inserts	Inlay	Rarity	GD30	VF65	CS95
1st	1.00	Beige	Nevada	None	R-white	R-2	3	6	9
	5.00	Red	Nevada	3gld	R-white	R-2	4	8	12
	25.00	Green	Nevada	3org	R-white	R-3	5	10	15
	100.00	Black	Nevada	3pur	R-white	R-4	10	20	30

(This casino did not open. Became the Sport of Kings across from the LV Hilton.)

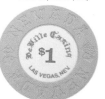

DeVille $1 (1st)

DOC HOLIDAY' S LAS VEGAS 1980's

Issue	Den.	Color	Mold	Inserts	Inlay	Rarity	GD30	VF65	CS95
1st	5.00	Red	H&C	3blu	HS	R-2	20	40	60

(Was on Boulder Highway near Sahara.)

DOMENIC'S LAS VEGAS 1952-53

Issue	Den.	Color	Mold	Inserts	Inlay	Rarity	GD30	VF65	CS95
1st	5.00	Gry-Grn	HCE	None	HS	R-10	500	1000	1500

(Old Italian restaurant on the strip.)

Domenic's $5 (1st)

DOUBLE 00 LAS VEGAS 1905-40

Issue	Den.	Color	Mold	Inserts	Inlay	Rarity	GD30	VF65	CS95
1st	.25	Red	2Hubdi	None	HS	R-10	1000	2000	3000
	1.00	Blue	2Hubdi	None	HS	Unique	1200	2400	3600

(Famous Block 16 club from the very beginnings of modern Las Vegas gaming.)

DUNES CLUB LAS VEGAS 1939-45

Issue	Den.	Color	Mold	Inserts	Inlay	Rarity	GD30	VF65	CS95
1st	n/d	Cream	Sm-key	None	HS	R-8	100	200	300
2nd	5.00	Grey	Lcrown	None	HS	Unknown	350	700	1050
	25.00	Salmon	Lcrown	None	HS	R-8	150	300	450

(This casino is not the Famous Dunes located on the Strip. This small club was out on upper Boulder Highway near the Green Shack. This area contained several small clubs built in the 1930's during the construction of Boulder Dam.)

Double 00 25¢ (1st)

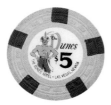

Dunes $5 (1st)

Dunes RLT (1st)

Dunes $1 (3rd)

Dunes $5 (3rd)

Dunes $25 (3rd)

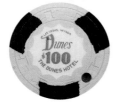

Dunes $100 (4th)

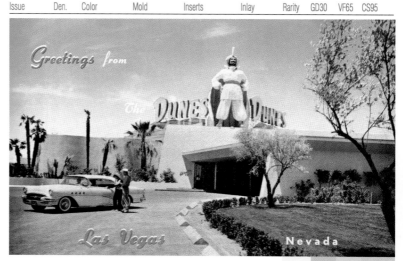

1950s postcard of the Dunes. The Sultan's turban contained a ruby which was always lit; one day it burned out, causing superstitious gamblers to stop playing!©1955 Ferris H. Scott, Santa Ana, CA.

Issue	Den.	Color	Mold	Inserts	Inlay	Rarity	GD30	VF65	CS95

DUNES LAS VEGAS 1956-93

Issue	Den.	Color	Mold	Inserts	Inlay	Rarity	GD30	VF65	CS95
1st	5.00	Beige	Rectl	5brn	R-white	R-9	2000	4000	6000

(Of the five known examples, two are damaged.)

	RLT	3 diff.	C&S	None	R-white	R-4	30	60	90

(Colors: Blu-Gry, Brown, and Pink. The latter two colors were found and distributed to chip collectors by Michele Burk as a result of her buying the 1st edition of this Price Guide!)

	RLT	5 diff.	C&S	None	R-white	R-8	250	500	750

(Colors: Blue, Dk Green, Green, Navy, and Red.)

	RLT	3 diff.	C&S	None	R-white	R-9	300	600	900

(Colors: Grey, Lt Lavender, and Salmon.)

	RLT	5 diff.	C&S	None	R-white	R-10	400	800	1200

(Colors: Cream, Lt Green, Orange, Lavender, and Yellow.)

	RLT	Black	C&S	None	R-white	Unique	500	1000	1500

(These have a great picture of the Sultan and are among the most popular of all roulette chips. Other colors probably exist - along with subtle color gradations.)

Issue	Den.	Color	Mold	Inserts	Inlay	Rarity	GD30	VF65	CS95
2nd	5.00	Black	Rectl	5gry	R-white	R-9	1500	3000	4500
	25.00	Brown	Rectl	5trq	R-white	Unique	2500	5000	7500
3rd	1.00	Blue	C&J	None	SCA-white	R-5	100	200	300
	1.00	Navy	C&J	None	SCA-white	R-6	125	250	375
	5.00	Orange	C&J	3blk	SCA-white	R-7	350	700	1400
	25.00	Green	C&J	3mst	SCA-white	Unique*	1250	2500	3750
	25.00	Green	C&J	1yel1blk1red	SCA-white	Unique*	1250	2500	3750

(First three issues have classic picture of the Sultan.)

Issue	Den.	Color	Mold	Inserts	Inlay	Rarity	GD30	VF65	CS95
4th	.25	Red	C&J	None	HS	R-9	125	250	375
	NN.25	Pink	C&J	None	HS	R-10	150	300	450
	.50	Mustard	C&J	None	HS	R-8	100	200	300
	1.00	Beige	C&J	None	HS	R-10	150	300	450
	NN 5.00	Black	C&J	None	HS	R-10*	150	300	450

(Above five chips are marked "Hotel Dunes Card Room" with denomination on back.)

	100.00	Beige	C&J	3blk	SCA-white	R-10	750	1500	2250
	100.00	Beige	C&J	3red3blk	SCA-white	R-10*	750	1500	2250
	RLT	6 diff.	C&J	None	R-white	R-6	20	40	60

Issue	Den.	Color	Mold	Inserts	Inlay	Rarity	GD30	VF65	CS95

("Dunes Hotel". Colors: Beige, Brown, Dk Brown, Green, Lavender, and Purple.)

5th	1.00	Blue	Diamnd	None	HS	R-10	150	300	450
	1.00	Purple	Diamnd	None	HS	R-9	125	250	375

(These are the first Las Vegas Commemorative chips. The GE (General Electric) logo is pictured, marked "Redeemable at Dunes Hotel Las Vegas June 1962 Only.")

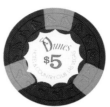

Dunes $5 (6th)

6th	5.00	Brown	HHR	6pnk3mst	SCA-white	R-9	350	700	1050
	25.00	Green	HHR	6pnk3blk	SCA-white	R-10	500	1000	1500
	100.00	Beige	HHR	3dkred3nvy	SCA-white	R-10*	500	1000	1500
7th	25.00	Green	House	6pnk3blk	SCA-white	R-10*	500	1000	1500

(Both 6th and 7th issues say "Hotel and Country Club, Las Vegas".)

8th	5.00	Mustard	C&J	3org	R-white	R-8	600	1200	1800
	25.00	Green	C&J	3blk	R-white	R-10	1000	2000	3000

(Great picture of the building which makes this a very desirable issue.)

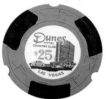

Dunes $25 (8th)

	NN .25	Red	C&J	None	HS	R-10	175	350	525
	NN 5.00	Purple	C&J	3gld	HS	R-10	200	400	600

(Above two chips are marked "Card Room , Non Negotiable" and the denomination on both sides.)

9th	5.00	Red	House	3wht3org	R-white	R-5	40	80	160
	25.00	Green	House	3pnk3blu	SCA-white	R-6	100	200	400
	100.00	Black	House	3org3wht3pnk	HUB-white	R-6	150	300	450
	100.00	Black	House	3lav3yel3blu	HUB-white	R-9	300	600	900

(Most of the chips from this issue are in terrible shape from the "dig".)
(This issue pictures small spades above "Dunes Hotel & Country Club".)

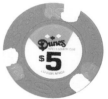

Dunes $5 (9th)

	faro n/d	Blue	House	None	HS	R-9	75	150	225
	faro n/d	2 diff.	House	None	HS	R-5	15	30	45

(Colors: Orange and Yellow.)

10th	5.00	Red	HHR	3yel	R-white	R-6	200	400	600
	25.00	Green	HHR	3org	R-white	R-7	300	600	900
	100.00	Black	HHR	3gry3pnk	R-white	R-4	125	250	375

(Most of the above chips are from the "dig". Undug, the $5 is R-9, the $25 is R-10, and the $100 is R-9. Most have cleaned up reasonably well, but a bit of residual damage is common.)

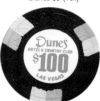

Dunes $100 (10th)

	500.00	Purple	HHR	3gry3blk	R-white	Unique*	600	1200	1800

("Negotiable Only at Dunes Las Vegas".)

	NN .25	Red	HHR	None	HS	R-9	125	250	375
	NN 1.00	Beige	HHR	None	HS	R-9	100	200	300
	NN 5.00	7 diff.	HHR	None	HS	R-9	75	150	225

(Colors: Beige, Black, Brown, Green, Maroon, Orange, and Purple.)
(The above NN chips are all marked "Hotel Dunes Card Room".)

11th	bac 5.00	Brown		2org	R-white	R-9	250	500	750

(This chip has a large denomination.)

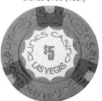

Dunes $5 (13th)

12th	bac 5.00	Brn/Org	House	1/2pie	R-white	R-10	300	600	900
	bac 20.00	Grn/Brn	House	1/2pie	R-white	R-10	400	800	1200
	bac 100.00	Blk/Wht	House	1/2pie	R-white	R-10*	400	800	1200
	bac500.00	Mus/Lav	House	1/2pie	R-white	R-10	400	800	1200
	bac 1000.00	Pnk/Trq	House	1/2pie	R-white	R-10*	400	800	1200

(This set has a small denomination.)

13th	5.00	Olive	House	6grn3yel	SCA-white	R-8	250	500	750
	25.00	Dk Red	House	6wht3blk	SCA-white	R-10*	350	700	1050
	100.00	Tan	House	6dkblu3red	SCA-white	R-10*	400	800	1200

("Dunes Casino". This issue has small denominations and Las Vegas in bigger writing.)

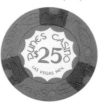

Dunes $25 (14th)

14th	5.00	Brown	House	6org3wht	SCA-white	R-6	150	300	450
	25.00	Green	House	6blu3org	SCA-white	R-9	300	600	900
	100.00	Black	House	6red3yel	SCA-white	R-10	400	800	1200

("Dunes Casino". This issue has a large denomination and Las Vegas in small writing.)
(Many of these chips are damaged from the "dig". High grade examples are rare.)

15th	.10	Brown	House	None	HS	R-4	20	40	60

Dunes $5 (15th)

Dunes $100 (15th)

Dunes $1 (16th)

Dunes $25 (16th)

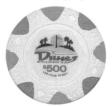

Dunes $500 (17th)

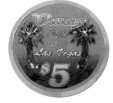

Dunes NCV (18th)

Issue	Den.	Color	Mold	Inserts	Inlay	Rarity	GD30	VF65	CS95
	pok .25	Brown	House	None	HS	R-5	35	70	105
	pok 1.00	Navy	House	None	HS	R-7	40	80	120
	pok 1.00	Lt Blue	House	None	HS	R-7	50	100	150
(These three are marked "Dunes Poker Room".)									
	pok 1.00	Navy	House	None	HS	R-6	30	60	90
	pok 1.00	Lt Blue	House	None	HS	R-9	60	120	180
	pok 1.00	Grey	House	None	HS	R-7	40	80	120
(These three are marked "Dunes Hotel Poker Room".)									
	5.00	Red	House	3org3pnk	HUB-white	R-6	75	150	225
	25.00	Green	House	3org3ltblu	SCA-white	R-8	250	500	750
	100.00	Black	House	3org3wht3blu	HEX-white	R-9	400	800	1200
(This is the popular "Marquee" issue.)									
	NCV 5	Blue	House	4red4wht	R-white	R-8	50	100	150
("Fly AAway Vacations".)									
	NCV 5	Grn/Yel	H&C	1/2pie	HS	R-6	15	30	45
("Match Play".)									
16th	1.00	Lt Blue	House	None	R-white	R-3	20	40	60
(Flesh-toned girl.)									
	1.00	Lt Blue	House	None	R-white	R-5	25	50	75
(White-skinned girl.)									
	1.00	Lt Blue	House	None	R-white	R-8	35	70	105
(One side is flesh-toned - the other is white.)									
	5.00	Red	House	3blu3wht	R-white	R-5	50	100	150
	bac 5.00	Red	House	4yel4tan	R-white	R-9	175	350	525
	bac 20.00	Green	House	8dkgrn	R-white	R-10	300	600	900
	25.00	Green	House	3yel3org	R-white	R-7	175	350	525
	100.00	Black	House	3yel3org3pnk	R-white	R-10	350	700	1050
	500.00	Lavender	House	3blu3gry3wht	R-white	Unique*	500	1000	1500
	bac 5000	Beige	House	4blu4pnk	R-white	Unique*	500	1000	1500
	bac 20000	Gold	House	6blu3ltblu	R-white	Unique*	500	1000	1500
(This popular issue has the Sultan, a girl, and a camel.)									
	NCV 1	Cream	H&C	None	HS	R-6	10	20	30
	NCV 5	Red	H&C	None	HS	R-4	5	10	15
	NCV 5	Orange	H&C	None	HS	R-8	12	24	36
	NCV 25	Green	H&C	None	HS	R-4	6	12	18
	NCV 100	Black	H&C	None	HS	R-5	10	20	30
	NCV 1	Pink	BJ	None	HS	R-6	10	20	30
("Win Cards".)									
17th	1.00	Blue	House	4brn	R-white	R-1	6	12	18
	5.00	Red	House	4ltblu4ltgrn	HUB-white	R-1	10	20	30
	bac 5.00	Red	House	3blu3grn	HUB-white	R-1	10	20	30
	bac 20.00	Green	House	3ltbrn3dkgrn	SCA-white	R-1	15	30	45
	25.00	Green	House	8blu-gry	SCA-white	R-1	15	30	45
	100.00	Black	House	8pnk4grn	COG-white	R-1	18	36	54
	bac 100.00	Black	House	6pnk3grn	COG-white	R-1	18	36	54
	500.00	White	House	8org	HEX-white	R-2	20	40	60
	bac 500.00	White	House	4org4dkorg	R-white	R-2	20	40	60
	1000.00	Yellow	House	2grn2nvy4pnk	NOT-white	R-4	25	50	75
	bac 1000	Yellow	House	2grn2nvy4pnk	R-white	R-4	25	50	75
	bac 5000	Maroon	House	6wht2yel	R-white	R-4	35	70	105
	bac 25000	Orange	House	3pur3brn	R-white	R-4	50	100	150
(This 17th issue pictures a golf course.)									
18th	NCV5.00	Red	H&C	4lav4gry	OR-multi	R-8	50	100	150

("No Cash Value" is almost impossible to see, but it's there. This chip looks like a regular issue, but was never used in a live game.)

Issue	Den.	Color	Mold	Inserts	Inlay	Rarity	GD30	VF65	CS95

(Here's the story of the "Dig": Around 1975, the Dunes poured their obsolete chips into the concrete foundation of the new tower they were building. They remained forgotten until after the casino was imploded. During the process of excavating and clearing the land, the chips were discovered by quick-fingered construction workers. The area was secured, but not before many of these previously rare chips were taken home as "souvenirs".)

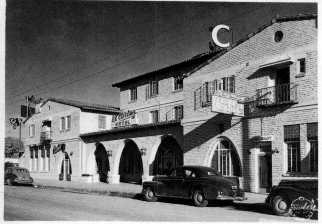

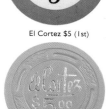

El Cortez $5 (1st)

EL CORTEZ HOTEL

Las Vegas, Nevada

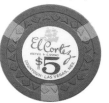

El Cortez $5 (2nd)

El Cortez $5 (3rd)

A rare early 1940s postcard of the El Cortez. Owner Jackie Gaughan is one of Nevada's last remaining private casino owners. ©Frashers, Inc., Pomona, CA.

EL CORTEZ LAS VEGAS 1941-

Issue	Den.	Color	Mold	Inserts	Inlay	Rarity	GD30	VF65	CS95
1st	5.00	Orange	C&S	None	R-white	Unique	1000	2000	3000
2nd	5.00	Blue	Lcrown	None	HS	R-7	100	200	300
	25.00	Pink	Lcrown	None	HS	R-7	125	250	375
3rd	5.00	Red	Arodie	3yel	R-white	R-10	1250	2500	3750
4th	1.00	Mst/Gry	Rectl	1/2pie	SCA-white	R-8	400	800	1200
5th	.50	Lavender	Scrown	3grn	R-white	R-5	100	200	300
	1.00	Mst/Blu	Scrown	1/2pie	LHUB-white	R-10	600	1200	1800
	5.00	Red	Scrown	3grn	SCA-white	R-10	750	1500	2250
	5.00	Red	Scrown	4grn	SCA-white	R-9	400	800	1200

(This is not a mistake. This variant has four inserts as opposed to the above with three inserts. Five 4grn insert chips were found in 1999.)

	25.00	Brown	Scrown	4wht4grn	LSCA-white	R-6	100	200	300
	25.00	Yellow	Scrown	3grn	LSCA-white	R-10*	750	1500	2250
	100.00	White	Scrown	3grn	COG-white	Unique	800	1600	2400

(Fifth issue has nice picture of conquistador.)

	RLT 1	Brown	Scrown	None	HS	R-6	15	30	45
	RLT 1	Green	Scrown	None	HS	R-7	20	40	60
	RLT 2	Green	Scrown	None	HS	R-8	25	50	75
6th	.25	Black	C&J	None	HS	R-5	15	30	45
	1.00	Mst/Gry	C&J	1/2pie	R-white	R-5	40	100	200

(Hard to find in top condition.)

	5.00	Red	C&J	3mst	R-white	R-8	225	450	675
	n/d	Black	C&J	None	R-white	R-6	15	30	45

(This chip was used for a 25cent denomination.)

	n/d	Purple	C&J	None	HS	R-6	10	20	30

("Keno".)

El Cortez $1 (4th)

El Cortez 50¢ (5th)

El Cortez $5 (6th)

. El Cortez $5 (8th)

El Cortez $5 (11th)

Eldorado Club n/d (1st)

Eldorado Club $5 (2nd)

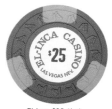

El-Inca $25 (1st)

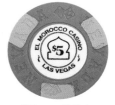

El Morocco $5 (1st)

Issue	Den.	Color	Mold	Inserts	Inlay	Rarity	GD30	VF65	CS95
7th	n/d	Black	H&C	None	HS	R-4	5	10	15
8th	1.00	Blue	H&C	None	MC-silver	R-4	15	30	45
	5.00	Red	H&C	3yel	MC-green	R-4	25	50	100
	25.00	Brown	H&C	3yel3grn	MC-brass	R-1	*	25	35
	100.00	Black	H&C	3pnk3gry	MC-red	R-1	*	100	120
9th	1.00	Blue	H&C	None	HS	R-5	12	24	36
("El Cortez Hotel Casino" in small letters. Short canes.)									
10th	1.00	Blue	H&C	None	HS	R-1	*	1	3
("El Cortez Hotel Casino" in large letters. Short canes.)									
11th	.25	Yellow	H&C	None	HS	R-3	3	6	9
("El Cortez Hotel".)									
	5.00	Red	H&C	3yel	SCA-white	R-1	*	5	8
	100.00	Black	H&C	3pnk3gry	SCA-white	R-2	*	100	115
12th	.10	Orange	H&C	None	HS	R-4	7	14	21
	.25	Yellow	H&C	None	HS	R-4	2	4	6
13th	.50	Pink	H&C	None	HS	R-1	*	1	2
	1.00	Blue	H&C	None	HS	R-1	*	1	3
("Las Vegas, NV".)									
	NCV	Yellow	BJ	None	HS	R-7	5	10	15
	RLT A	4 diff.	HHR	None	HS	R-4	4	8	12
(Colors: Beige, Blue, Orange, and Purple.)									
	RLT B	3 diff.	HHR	None	HS	R-4	4	8	12
(Colors: Grey, Pink, and Orange.)									
14th	RLT B	6 diff.	BJ	None	R-white	R-2	3	6	9
(Colors: Green, Grey, Orange, Pink, Purple, and White.)									
15th	RLT A	6 diff.	BJ	None	HS	R-2	3	6	9
(Colors: Brown, Green, Grey, Pink, Purple, and White.)									

ELDORADO CLUB — LAS VEGAS 1947-51

	Den.	Color	Mold	Inserts	Inlay	Rarity	GD30	VF65	CS95
1st	5.00	Dk Red	Diamnd	None	HS	R-7	100	200	300
	25.00	Green	Diamnd	None	HS	R-8	150	300	450
	100.00	Black	Diamnd	None	HS	Unique	500	1000	1500
	n/d	Black	Diamnd	None	HS	Unique	100	200	300
(White "C" mark in circle like the $100.)									
	n/d	Mustard	Zigzag	None	HS	R-10	125	250	375
2nd	5.00	Maroon	Dots	None	HS	R-5	70	140	210
3rd	n/d	Blue	Scrown	None	HS	R-5	30	60	90
(This early Downtown club became the Horseshoe.)									

EL INCA CASINO — LAS VEGAS 1977-79

	Den.	Color	Mold	Inserts	Inlay	Rarity	GD30	VF65	CS95
1st	5.00	Mustard	HHR	3grn	R-white	R-3	15	30	45
	25.00	Green	HHR	3yel	R-white	R-4	20	40	60
	NCV 1.00	Fuchsia	H&C	None	HS	R-7	10	20	30

ELLIS ISLAND — LAS VEGAS 1988-

	Den.	Color	Mold	Inserts	Inlay	Rarity	GD30	VF65	CS95
1st	1.00	White	H&C	1pur1grn1yel	OR-white	R-1	2	4	6
	5.00	Red	H&C	3gry3nvy	OR-white	R-1	*	5	10
	25.00	Green	H&C	3ltgrn3yel	OR-white	R-1	*	25	35
	100.00	Black	H&C	6grn6red	OR-white	R-2	*	100	120

EL MOROCCO CASINO — LAS VEGAS 1972-83

	Den.	Color	Mold	Inserts	Inlay	Rarity	GD30	VF65	CS95
1st	1.00	Grey	Diecar	None	HS	R-4	10	20	30
	5.00	Orange	Nevada	3grn	R-white	R-4	25	50	100
	25.00	Green	Diecar	3crm	HS	R-4	20	40	60

Issue	Den.	Color	Mold	Inserts	Inlay	Rarity	GD30	VF65	CS95

EL MOROCCO CLUB — W. LAS VEGAS — 1945-55/1957-58
EL MOROCCO, NEW — 1959-64

Issue	Den.	Color	Mold	Inserts	Inlay	Rarity	GD30	VF65	CS95
1st	.25	Maroon	T's	None	HS	R-9	100	200	300
	5.00	Purple	T's	3nvy	HS	R-8	75	150	225

(These are marked "Club El Morrocco".)

Issue	Den.	Color	Mold	Inserts	Inlay	Rarity	GD30	VF65	CS95
2nd	1.00	Beige	Scrown	None	OR-white	R-4	25	50	75
	5.00	Org/Brn	Scrown	1/2pie	LHUB-white	R-7	75	150	225
3rd	.10	Dk Orange	C&J	None	HS	R-5	15	30	45
	.50	Lt Brown	C&J	None	HS	R-8	50	100	150
	5.00	Navy	C&J	3gry	R-black	R-3	10	20	30
	25.00	Grey	C&J	3red	R-black	R-4	18	36	54

(Third issue is "New El Morocco".)

El Morocco $5 (1st)

New El Morocco $25 (3rd)

EL RANCHO — LAS VEGAS — 1982-92

Issue	Den.	Color	Mold	Inserts	Inlay	Rarity	GD30	VF65	CS95
1st	.25	Orange	House	None	HS	R-7	20	40	60
	1.00	Cream	House	None	R-white	R-4	8	16	24
	5.00	Red	House	4org4nvy	HUB-white	R-5	25	50	75
	25.00	Green	House	4brn4org	SCA-white	R-8	125	250	375
	100.00	Black	House	3blu3red3grn	HEX-white	R-8	125	250	375
	500.00	White	House	3brn3pnk	COG-white	R-9	175	350	525
	n/d	3 diff.	H&C	None	HS	R-5	7	14	21

("Tournament Chip". Colors: Grey-Green, Pink, and Purple.)

Issue	Den.	Color	Mold	Inserts	Inlay	Rarity	GD30	VF65	CS95
RLT 1	11 diff.	House	None	HS	R-4	6	12	18	

(Colors: Blue, Brown, Fuchsia, Grey, Navy, Ochre, Dk Orange, Orange, Pink, Tan, and Yellow.)

Issue	Den.	Color	Mold	Inserts	Inlay	Rarity	GD30	VF65	CS95
RLT 2	11 diff.	House	None	HS	R-4	6	12	18	

(Colors: Blue, Brown, Fuchsia, Grey, Navy, Ochre, Dk Orange, Orange, Pink, Tan, and Yellow.)

El Rancho $500 (1st)

EL RANCHO RIO, KHOURY'S — LAS VEGAS — 1949-50

Issue	Den.	Color	Mold	Inserts	Inlay	Rarity	GD30	VF65	CS95
1st	25.00	Black	HCE	None	HS	R-10	1000	2000	3000

(Exactly three known. Khoury also owned the Club Savoy downtown. As a sidelight, there was also an El Rancho Dio, different owners, but none of these chips have been found.)

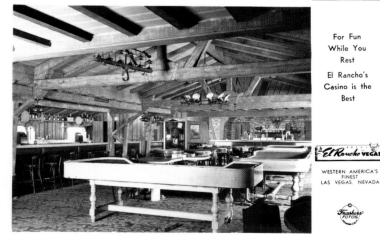

For Fun
While You
Rest

El Rancho's
Casino is the
Best

El Rancho VEGAS

WESTERN AMERICA'S
FINEST
LAS VEGAS. NEVADA

Frashers FOTOS

Postcard of Hotel El Rancho. Opened on April 3, 1941, it was actually the Strip's first successful casino property. It's interesting to note that this large, sprawling resort had a small casino. The conventional "wisdom" of the time was that gambling was just a nice bonus, not the main reason to come to the resort! ©Frashers, Inc., Pomona, CA.

Khoury's El Rancho Rio $25 (1st)

El Rancho Vegas $25 (1st)

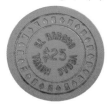
El Rancho Vegas $25 (3rd)

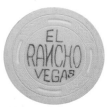

El Rancho Vegas $25 (4th)

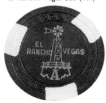

El Rancho Vegas RLT (6th)

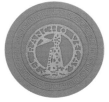

El Rancho Vegas $5 (7th)

El Rancho Vegas $5 (13th)

El Rancho Vegas $25 (15th)

El Rio Club $5 (1st)

Issue	Den.	Color	Mold	Inserts	Inlay	Rarity	GD30	VF65	CS95
EL RANCHO VEGAS			**LAS VEGAS**		**1941-60**				
1st	5.00	Purple	Diamnd	None	HS	R-5	75	150	225
	25.00	Green	Diamnd	None	HS	R-5	100	200	300
2nd	5.00	Red	Diamnd	None	HS	R-5	75	150	225
	25.00	White	Diamnd	None	HS	R-10	400	800	1200
(Both of the above chips are misspelled "Las Vagas".)									
3rd	5.00	Blue	Diasqr	None	HS	R-9	250	500	750
	25.00	Red	Diasqr	None	HS	R-7	125	250	375
4th	5.00	Red	Lcrown	None	HS	R-6	60	120	180
	25.00	Cream	Lcrown	None	HS	R-6	75	150	225
	100.00	Orange	Lcrown	None	HS	R-7	125	250	375
(This issue has "WC" for Wilbur Clark stamped above denomination.)									
5th	5.00	Red	Lcrown	None	HS	Unique	1000	2000	3000
(Picture of cowboy on a horse.)									
6th	5.00	Red	Sm-key	None	Diecut-metal	R-10	1250	2500	3750
	25.00	White	Sm-key	None	Diecut-metal	R-5	200	400	600
	RLT	Navy	Sm-key	3crm	HS	Unique	350	700	1050
(This early Roulette has the windmill logo pictured. For some reason early roulettes are very rare.)									
7th	5.00	Orange	Sm-key	None	Diecut-metal	R-6	225	450	675
	25.00	Lavender	Sm-key	None	Diecut-metal	R-7	300	600	900
8th	5.00	Purple	Lcrown	None	HS	R-7	150	300	450
	25.00	Red	Lcrown	None	HS	R-10*	400	800	1200
9th	5.00	Purple	Lcrown	2red	HS	R-10	350	700	1050
	25.00	Red	Lcrown	2wht	HS	R-10	350	700	1050
	100.00	Grey	Lcrown	2nvy	HS	R-5	75	150	225
(Picture of windmill on one side. Records prove this issue was made in 1948.)									
10th	5.00	Purple	Scrown	3gry	HS	R-1	25	50	100
(Made in 1950, most survivors are fire damaged or badly worn. Nice examples are R-5.)									
11th	25.00	Org/Blu	Scrown	1/2pie	HS	R-3	25	50	100
12th	25.00	Black	Scrown	2org	LHUB-white	R-5	50	100	150
	25.00	Red	Scrown	2blu	LHUB-white	R-7	150	300	450
13th	5.00	Purple	T's	3red	HS	R-9	300	600	900
14th	5.00	Mustard	Hub	3blk	R-white	R-4	35	70	105
	25.00	Gry-Blu	Hub	3red	R-white	R-4	40	80	120
	100.00	Black	Hub	3bei	R-white	R-4	45	90	135
15th	5.00	Mustard	Cord	3grn	R-white	R-2	15	30	45
	25.00	Maroon	Cord	3gry	R-white	R-5	50	125	250
(All of these $25 chips are warped, some severely, from the fire.)									

(BEWARE: Nevada mold chips are fake as well as Lcrown chips that are similar to the 8th issue. The fake Lcrown chips have 3 inserts. This casino burned to the ground in a famous fire on June 17, 1960. A quick-thinking security guard saved a great deal of these El Rancho Vegas chips after the flames died down.)

Issue	Den.	Color	Mold	Inserts	Inlay	Rarity	GD30	VF65	CS95
EL RIO CLUB			**W. LAS VEGAS**		**1954-64/1973-78**				
1st	5.00	Grey	Rectl	4pur	R-white	R-6	60	120	180
2nd	1.00	Blue	Scrown	None	LSCA-white	R-4	20	40	60
3rd	.50	Red	H&C	None	HS	R-6	25	50	75
	1.00	Purple	H&C	None	HS	R-6	40	80	120
	5.00	Maroon	H&C	3pnk	HS	R-5	35	70	105
4th	5.00	Orange	H&C	3brn3yel	HS	R-6	25	50	75
	25.00	Green	H&C	3ltgrn3wht	HS	R-6	35	70	105

Issue	Den.	Color	Mold	Inserts	Inlay	Rarity	GD30	VF65	CS95
EMBASSY CLUB			**N. LAS VEGAS**		**1945-57**				
1st	5.00	Red	HCE	None	HS	R-6	100	200	300
(Located on N. Main St.)									

Issue	Den.	Color	Mold	Inserts	Inlay	Rarity	GD30	VF65	CS95

EXCALIBUR — LAS VEGAS — 1990-

Issue	Den.	Color	Mold	Inserts	Inlay	Rarity	GD30	VF65	CS95
1st	1.00	Cream	House	2blu	R-white	R-1	*	1	2
	5.00	Red	House	4org4tan	HUB-white	R-1	*	5	7
	25.00	Green	House	3wht3org	SCA-white	R-1	*	25	30
	100.00	Black	House	3blu3pnk3yel	COG-white	R-1	*	100	110
	NCV 2	Orange	H&C		HS	R-5	4	8	12

(Both sides are marked "Twin Q 2 No Cash Value, Las Vegas, NV".)

| | RLT A | 4 diff. | BJ-P | None | OR-white | R-5 | 4 | 8 | 12 |

(Colors: Lt Blue, Brown, Fuchsia, and Yellow.)

| 2nd | NCV | Orange | H&C | None | HS | R-5 | 3 | 6 | 9 |
| | NCV 1 | Navy | Unicrn | None | HS | R-7 | 5 | 10 | 15 |

("Win Cards".)

| | NCV 2 | Peach | H&C | None | HS | R-5 | 4 | 8 | 12 |

(This chip, used in the racebook, is marked "Twin Q Only" on the front. The reverse is marked "No Cash Value 2 Las Vegas, NV".)

| | RLT | 3 diff. | Roulet | None | OR-multi | R-4 | 2 | 4 | 6 |

(Colors: Lt Blue, Brown, and Lavender.)

Excalibur $1 (1st)

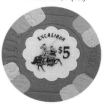
Excalibur $5 (1st)

FIESTA — N. LAS VEGAS — 1995-

Issue	Den.	Color	Mold	Inserts	Inlay	Rarity	GD30	VF65	CS95
1st	.50	Blue	H&C	None	HS	R-3	2	4	6
	1.00	White	H&C	1brn1red	OR-multi	R-1	1	2	4

("North, Las Vegas")

| | 1.00 | White | H&C | 1brn1red | OR-multi | R-1 | 1 | 2 | 4 |

("N. Las Vegas".)

| | 1.00 | White | H&C | 1brn1red | OR-multi | R-1 | 1 | 2 | 4 |

("Royal Flush Capital Of The World". These three $1's were issued at different times but used together.)

	5.00	Red	H&C	6brn3yel	OR-multi	R-2	5	8	12
	25.00	Green	H&C	8blk4yel	OR-multi	R-3	25	35	45
	100.00	Black	H&C	1blu1red1yel	OR-multi	R-5	100	120	140
	NCV	4 diff.	H&C	None	HS	R-7	4	8	12

(Colors: Green, Grey, Pink, and White.)

| | RLT 2 | 3 diff. | BJ-P | None | R-white | R-4 | 2 | 4 | 6 |

(Colors: Blue, Lt Orange, and Orange.)

2nd	1.00	Blue	Chipco	None	FG	R-1	*	1	3
	5.00	Red	Chipco	None	FG	R-1	*	5	8
	25.00	Green	Chipco	None	FG	R-1	*	25	30
	100.00	Black	Chipco	None	FG	R-1	*	100	110
	500.00	Purple	Chipco	None	FG	R-1	*	500	520

(There are actually four sets - each showing a different card suit.)

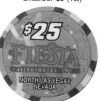
Fiesta $25 (1st)

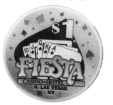
Fiesta $1 (2nd)

FIESTA VILLA — LAS VEGAS — 1946-47

Issue	Den.	Color	Mold	Inserts	Inlay	Rarity	GD30	VF65	CS95
1st	25.00	Green	Sm-key	2red	HS	R-9	500	1000	1500
	100.00	Cream	Sm-key	2red	HS	R-9	600	1200	1800

(Located on the strip.)

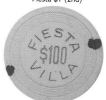
Fiesta Villa $100 (1st)

FITZGERALD'S — LAS VEGAS — 1988-

Issue	Den.	Color	Mold	Inserts	Inlay	Rarity	GD30	VF65	CS95
1st	.25	Green	H&C	None	HS	R-1	*	2	3

(There are light and dark variants.)

	1.00	Grey	H&C	None	OR-white	R-1	*	1	3
	5.00	Red	H&C	4grn	OR-white	R-1	*	5	8
	25.00	Green	H&C	3pnk3pch	OR-white	R-1	*	25	30
	100.00	Black	H&C	12pnk	OR-white	R-10	150	300	450
	RLT	4 diff.	BJ	None	HS	R-6	3	6	9

(Colors: Dk Blue, Green, Navy, and Olive.)

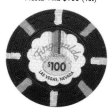
Fitzgerald's $100 (2nd)

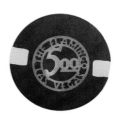

Flamingo $5 (1st)

Flamingo $25 (1st)

Flamingo $5 (2nd)

Flamingo $25 (3rd)

Flamingo $100 (3rd)

Flamingo RLT 2 (4th)

Issue	Den.	Color	Mold	Inserts	Inlay	Rarity	GD30	VF65	CS95
2nd	.25	Lt Green	H&C	None	HS	R-2	*	1	2
	1.00	Grey	H&C	None	OR-white	R-1	*	1	3

(This second issue has a larger center than the first issue.)

	100.00	Black	H&C	4ltblu4org	HUB-white	R-1	*	100	110
3rd	2.50	Pink	H&C	4yel4pur	OR-pink	R-1	*	3	5

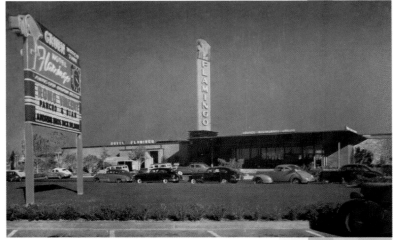

This postcard of the re-opened Flamingo of 1947 features the wonderful sign that was out front for a short time. Note the fancy Gruen clock. ©Desert Souvenir Supply, Boulder City, Nevada.

FLAMINGO LAS VEGAS 1946-73
FLAMINGO HILTON 1973-

1st	5.00	Brown	Plain	2yel	Diecut-metal	R-6	1250	2500	3750

(Of the 35-40 pieces known, about 15 are undrilled.)

	25.00	Pink	Plain	2trq	Diecut-metal	R-8	3000	6000	9000

(Of the 13-15 known survivors, only 7 or 8 are undrilled.)

(These are among the most desirable of all chips, due to the mystique surrounding them, regarding its infamous gangster owner, Bugsy Siegel. A unique $100 white chip is rumored to exist, but we could not confirm this. If true, this would certainly be the Holy Grail of casino chips - a chip which would instantly shatter the $10,000 barrier and then some!)

2nd	5.00	Orange	Sm-key	2blu	Diecut-metal	R-6	600	1200	1800

(This chip may have been used at the crap table.)

3rd	5.00	Brown	Sm-key	2yel	Diecut-metal	R-9*	2500	5000	7500
	25.00	Pink	Sm-key	2trq	Diecut-metal	R-9	3300	6600	9900

(Of the 4 or 5 known survivors, only 1 is undrilled.)

	100.00	Black	Sm-key	2bei	Diecut-metal	R-7	3000	6000	9000

(There are exactly 18 survivors in existence - discovered in 1990 by Janice and Jerry O'Neal when in Michigan. The price was only $85 at this time! Since then, this chip has traded hands for over $5000 several times. The highest price paid to date for this chip is $8,750 in Nov. 99.)

4th	5.00	Navy	Sm-key	3ltgrn	R-black	R-9	900	1800	2700
	25.00	Red	Sm-key	3yel	R-black	R-8	1000	2000	3000

(These chips are usually drilled and worth 20% of these prices. Undrilled, these chips are R-10.)

	RLT 1	Navy	Circls	None	R-wht/blk	R-10*	500	1000	1500
	RLT 2	Brown	Circls	None	R-wht/blk	Unique*	600	1200	1800
	RLT 2	Lavender	Circls	None	R-wht/blk	R-10	500	1000	1500
	RLT 2	Green	Circls	None	R-wht/blk	R-10	500	1000	1500
	RLT 2	Grey	Circls	None	R-wht/blk	R-10	500	1000	1500

(Early bird pictured. Possibly used with original 1st and 2nd Bugsy issues.)

Issue	Den.	Color	Mold	Inserts	Inlay	Rarity	GD30	VF65	CS95
5th	5.00	Blue	HCE	3grn	R-black	R-8	750	1500	2250

(Same inlay as the previous $5 & $25 issue, but with the HCE mold. These are sometimes found in pristine condition, but half the survivors are drilled.)

	RLT 1	Yellow	C&S	None	R-black	R-8	150	300	450
	RLT 1	Cream	C&S	None	R-black	R-10	400	800	1200
	RLT 2	Yellow	C&S	None	R-black	R-8	150	300	450
	RLT 2	Lavender	C&S	None	R-black	R-9	250	500	750
	RLT 2	Cream	C&S	None	R-black	R-10	400	800	1200
	RLT 3	Red	C&S	None	R-black	R-10	400	800	1200
	RLT 3	Blu-Gry	C&S	None	R-black	R-10	400	800	1200

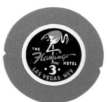

Flamingo RLT 3 (5th)

(These roulettes have the same design with the black bird as the regular issue.)

6th	5.00	Dk Blue	Rectl	5bei	R-black	R-5	500	1000	1500

(All are drilled, except for 1-2 pieces. These drilled chips are worth 10% of these prices.)

	5.00	Red	Rectl	3dkblu	R-black	R-8*	600	1200	1800
	5.00	Yellow	Rectl	3lav	R-black	R-8	600	1200	1800
	25.00	Green	Rectl	3bei	R-black	R-8	600	1200	1800

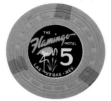

Flamingo $5 (6th)

(Of the 13-15 known examples, only 2-3 are undrilled.)

	25.00	Lavender	Rectl	3yel	R-black	R-7	600	1200	1800

(Exactly 17 known survivors - all drilled except for one piece.)

	100.00	Black	Rectl	?	R-black	Unknown	1500	3000	4500
	500.00	Maroon	Rectl	3pur	R-black	Unique	1500	3000	4500

(This chip disappeared from James Campiglia at the 1999 CC>CC Convention at the Orleans in Las Vegas. If you are offered this chip it is the missing one. Please contact James Campiglia immediately. Reward paid on recovery.)

	RLT	Grey	C&S	None	R-wht/blk	R-6*	200	400	600
	RLT	Lt Orange	C&S	None	R-wht/blk	R-6*	200	400	600
	RLT	Pink	C&S	None	R-wht/blk	R-8	225	450	675
	RLT	Brown	C&S	None	R-wht/blk	R-9	350	700	1050
	RLT	5 diff.	C&S	None	R-wht/blk	R-10	400	800	1200

Flamingo RLT (6th)

(Classic picture of the 1952 champagne hotel tower. Colors: Black, Dk Green, Navy, Red, and Turquoise. Black is only known drilled.)

7th	.50	Pink	HCE	None	HS	R-8	175	350	525
	1.00	Cream	HCE	6gry	R-white	R-7	125	250	375

("Flamingo Hotel" No bird picture.)

	5.00	Maroon	HCE	3org3lav	R-black	R-9	750	1500	2250
	25.00	Green	HCE	3yel3bei	R-black	R-10	1000	2000	3000
	100.00	Cream	HCE	6blk	R-black	R-10*	1000	2000	3000
	100.00	Black	HCE	6crm	R-black	R-10*	1000	2000	3000

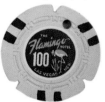

Flamingo $100 (7th)

(These seventh issue chips do not have a $ sign in front of the denomination. Also, flamingo's leg extends between "Vegas" and "Nev.")

	RLT	Red	HCE	None	HS	R-8*	200	400	600
	RLT	Yellow	HCE	None	HS	R-7*	200	400	600
	RLT	Beige	HCE	None	HS	R-10*	300	600	900
8th	100.00	Orange	C&J	4crm	R-black	R-10*	1250	2500	3750

(As with the 7th issue, there's no $ sign and flamingo's leg extends between "Vegas" and "Nev.")

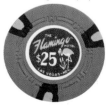

Flamingo $25 (9th)

9th	.50	Lavender	HCE	None	R-black	R-5	75	150	225
	1.00	Lt Grey	HCE	None	R-white	R-6	50	100	150

("Flamingo Hotel" No bird picture.)

	5.00	Maroon	HCE	6yel3red	R-black	R-9	700	1400	2100
	25.00	Green	HCE	6blk3yel	R-black	R-10	1000	2000	3000
	100.00	Black	HCE	6crm3pur	R-black	R-10*	1000	2000	3000
	500.00	Grey	HCE	6org3blk	R-black	R-10*	1000	2000	3000

(This ninth issue has a $ sign. The flamingo's leg is above the "V" in "Nev.")

10th	100.00	Orange	C&J	4crm	R-black	R-10	1250	2500	3750
11th	.50	Lavender	HCE	None	R-white	R-6	100	200	300
	1.00	Beige	HCE	None	R-white	R-6	80	160	240

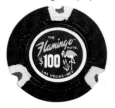

Flamingo $100 (9th)

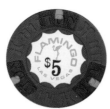

Flamingo Hilton $5 (12th)

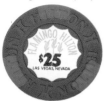

Flamingo Hilton $25 (14th)

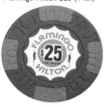

Flamingo Hilton $25 (16th)

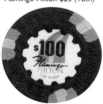

Flamingo Hilton $100 (18th)

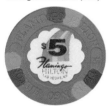

Flamingo Hilton $5 (19th)

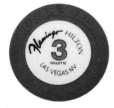

Flamingo Hilton RLT 3 (19th)

Issue	Den.	Color	Mold	Inserts	Inlay	Rarity	GD30	VF65	CS95	
(Pink bird facing left. Chip is marked "Flamingo".)										
12th	5.00	Maroon	House	6dkblu3pnk	SCA-white	R-6	175	350	525	
	25.00	Dk Green	House	6blk3pnk	SCA-white	R-10	600	1200	1800	
	100.00	Black	House	6ltgrn3pnk	SCA-white	R-10	700	1400	2100	
	100.00	Black	House	3lav	SCA-white	Unique	800	1600	2400	
	500.00	Grey	House	6nvy3pnk	SCA-white	R-10*	750	1500	2250	
(Starting with this issue - the Flamingo becomes the Flamingo Hilton.)										
13th	.50	Pink	House	None	R-white	R-8	125	250	375	
	.50	Purple	House	None	R-white	R-7	80	160	240	
	1.00	Beige	House	None	R-white	R-5	60	120	180	
(This pink bird issue is marked "Flamingo Hilton".)										
14th	25.00	Green	House	3dkorg	SCA-white	R-10	800	1600	2400	
(Picturing 3 small pink flamingos above the denomination, this chip is unlike any other. Perhaps this was a backup chip used for a short time and then destroyed, or a regular issue chip that was used for such a short time that almost none walked out of the casino. Of the two known examples, one is cancelled.)										
15th	n/d	Pink	H&C	3blu3lav3grn	SCA-white	R-9	100	200	300	
("Grand Opening Flamingo Hilton July 1, 1977". Many were given away by the casino to a high-roller from Baghdad. The R-9 assumes these chips in Baghdad no longer exist or will come on the market.)										
16th	1.00	Beige	House	None	R-white	R-4	25	50	75	
	1.00	Cream	House	None	R-white	R-5	30	60	90	
	5.00	Maroon	House	3ltorg	R-white	R-5	40	80	120	
	bac 20.00	Lt Green	House	4pnk	SCA-white	Unique*	500	1000	1500	
	25.00	Green	House	4org	SCA-white	R-7	175	350	525	
	100.00	Black	House	6crm3pnk	SCA-white	R-10*	500	1000	1500	
	bac 100.00	Black	House	2pnk	SCA-white	Unique*	600	1200	1800	
(This issue has the denomination in a red circle.)										
17th	1.00	Lt Blue	House	1yel1org1wht	R-white	R-1	*	1	3	
	5.00	Red	House	3pur	HUB-white	R-6	20	40	60	
	25.00	Green	House	4ltorg	SCA-white	R-7	75	150	225	
(This is the first "Rainbow" issue.)										
	NCV 5	Red	H&C	3yel		HS	R-8	6	12	18
18th	5.00	Red	House	3dkgrn3pnk	HUB-white	R-2	5	8	10	
	25.00	Green	House	4lim4pnk	SCA-white	R-1	*	25	30	
	100.00	Black	House	3grn3pch3org	COG-white	R-9	200	400	600	
(Both the 17th and 18th issues are marked "Las Vegas".)										
19th	1.00	Lt Blue	House	1yel1org1wht	R-white	R-1	*	1	3	
	5.00	Red	House	3dkgrn3pnk	HUB-white	R-2	5	8	10	
(This issue is marked "Las Vegas, NV".)										
	RLT 1	2 diff.	Roulet	None	OR-white	R-4	2	4	6	
(Colors: Brown and Navy.)										
	RLT 2	3 diff.	Roulet	None	OR-white	R-4	2	4	6	
(Colors: Brown, Green, and Yellow.)										
	RLT 3	Navy	Roulet	None	OR-white	R-4	2	4	6	
	RLT 4	Brown	Roulet	None	OR-white	R-4	2	4	6	
	RLT 5	2 diff.	Roulet	None	OR-white	R-4	2	4	6	
(Colors: Brown and Orange.)										
	RLT 6	Orange	Roulet	None	OR-white	R-4	2	4	6	
	RLT 7	2 diff.	Roulet	None	OR-white	R-4	2	4	6	
(Colors: Fuchsia and Green.)										
20th	100.00	Black	House	4wht4pnk	COG-white	R-1	*	100	110	
21st	5.00	Red	House	3ltgrn3dkgrn	OR-white	R-1	*	5	8	
(Picture of Bugsy Siegel on obverse. Reverse is marked "Flamingo Hilton 50th anniversary". 50,000 chips were made, but only 5000 are serial-numbered.)										
22nd	5.00	Red	House	3dkgrn3pnk	OR-multi	R-4	15	30	45	

("Radio City Rockettes". This is an interesting chip, made to commemorate the Radio City Rockettes who were featured in

Issue	Den.	Color	Mold	Inserts	Inlay	Rarity	GD30	VF65	CS95

the showroom at the time. However, the right permission to use their likeness was not obtained and the Rockettes threatened a lawsuit. The Flamingo responded by pulling all the chips. About 49,700 chips were officially destroyed, leaving collectors with about 300.)

| 23rd | 5.00 | Red | House | 3dkgrn3pnk | OR-multi | R-1 | * | 5 | 7 |

(Full graphic picture of three pink flamingos.)

Flamingo Capri $1 (1st)

FLAMINGO CAPRI LAS VEGAS 1973–79

Issue	Den.	Color	Mold	Inserts	Inlay	Rarity	GD30	VF65	CS95
1st	.50	Yellow	Diecar	None	HS	R-7	30	60	90
	.50	Yellow	Diecar	None	R-white	R-8	150	300	450
	1.00	Lime	Diecar	None	R-white	R-6	125	250	375
	5.00	Pink	Diecar	3grn	R-white	R-9	400	800	1200
2nd	1.00	Beige	Nevada	None	HS	R-6	50	100	150
	5.00	Red	Nevada	3blk	R-white	R-8	225	450	675
	25.00	Green	Nevada	3blk	R-white	R-10*	500	1000	1500
	100.00	Black	Nevada	3bei	R-white	R-10*	500	1000	1500
	FP	Orange	Nevada	None	HS	R-7	10	20	30

("Match Play $2 for $1 on Winning Bets".)

| | NN1.00 | Beige | Nevada | None | HS | R-10 | 75 | 150 | 225 |

Flamingo Capri $5 (2nd)

(Large initials "FC". Possibly could be a first issue.)

| 3rd | FP | 2 diff. | H&C | None | HS | R-7 | 10 | 20 | 30 |

("Freeplay No Cash Value". Colors: Black and Blue.)

(Beware of various Borland counterfeits.)

FORTUNE CLUB LAS VEGAS 1952–55

Issue	Den.	Color	Mold	Inserts	Inlay	Rarity	GD30	VF65	CS95
1st	.25	Orange	HCE	None	HS	R-5	30	60	90
	.25	Red	HCE	None	HS	R-7	125	250	375
	5.00	Purple	HCE	3nvy	HS	R-7*	350	700	1050

(There are 22 or 23 known survivors - all drilled on the edge.)

Fortune Club 25¢ (1st)

FOUR KINGS LAS VEGAS 1977–80

Issue	Den.	Color	Mold	Inserts	Inlay	Rarity	GD30	VF65	CS95
1st	.50	Yellow	H&C	None	HS	R-5	12	24	36
	1.00	Blue	H&C	None	HS	R-4	8	16	24
	5.00	Red	H&C	3ltblu	HS	R-5	20	40	60
	25.00	Green	H&C	3gry	HS	R-5	30	60	90

Four Kings $5 (1st)

Four Queens 25¢ (1st)

Four Queens $1 (1st)

Postcard from the Four Queens, one casino that hasn't changed much in the 35 years it's been open.

Four Queens $25 (1st)

Four Queens 25¢ (2nd)

Four Queens $25 (4th)

Four Queens $25 (5th)

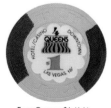

Four Queens $1 (6th)

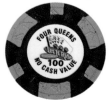

Four Queens NCV 100 (9th)

Issue	Den.	Color	Mold	Inserts	Inlay	Rarity	GD30	VF65	CS95
FOUR QUEENS			**LAS VEGAS**		**1964-**				
1st	.25	Brown	Arodie	None	R-green	R-7	175	350	525
	1.00	Navy	Arodie	3gry	R-green	R-4	75	150	300
	5.00	Red	Arodie	3gry	R-aqua	R-8	500	1000	2000
(Most examples are worn. Only a few AU or better pieces are known.)									
	25.00	Green	Arodie	3gry	R-aqua	R-10	1250	2500	3750
	100.00	Black	Arodie	3gry	R-aqua	Unique*	1500	3000	4500
2nd	.25	Maroon	C&J	None	HS	R-8	40	80	120
	.50	Orange	C&J	None	HS	R-8	60	120	180
	5.00	Yellow	C&J	None	HS	R-10	150	300	450
("Good Only in Card Room".)									
3rd	.25	Brown	Diecar	None	HS	R-3	*	2	3
	1.00	Yellow	Diecar	None	HS	R-6	12	24	36
	1.00	Black	H&C	None	HS	R-6	12	24	36
("Card Room" on above two chips.)									
	5.00	Red	BJ-1	3blu	COIN	R-5	20	40	60
	100.00	Black	BJ-1	3wht	COIN	R-10	300	600	900
4th	5.00	Red	BJ-1	3wht	COIN	R-9	100	200	300
	25.00	Green	BJ-1	3wht	COIN	R-9	125	250	375
	100.00	Black	BJ-1	3red	COIN	R-10	300	600	900
5th	1.00	Pink	BJ-2	6brn	COIN	R-4	7	14	21
	1.00	Lt Pink	BJ-2	6brn	COIN	R-4	7	14	21
	5.00	Red	BJ-2	3blu	COIN	R-5	20	40	60
	25.00	Green	BJ-2	3wht	COIN	R-9	100	200	300
	NCV1.00	White	H&C	None	HS	R-6	5	10	15
	NCV 5	Fuchsia	H&C	None	HS	R-5	4	8	12
	NCV 5	Pink	H&C	None	HS	R-7	4	8	12
	NCV 25	Dk Green	H&C	None	HS	R-8	8	16	24
	NCV 100	Grey	H&C	None	HS	R-8	10	20	30
6th	.25	Maroon	H&C	None	HS	R-3	*	1	3
	1.00	Blue	H&C	2nvy	HUB-white	R-1	*	1	3
	5.00	Red	H&C	3ltblu	HUB-white	R-1	*	5	8
	25.00	Green	H&C	4org	HUB-white	R-1	*	25	30
	100.00	Black	H&C	3grn3blu3red	HUB-white	R-9	100	200	300
7th	2.50	Pink	BJ-P	None	R-white	R-4	5	10	15
("Snapper 1995".)									
8th	2.50	Pink	BJ-P	16wht	OR-white	R-3	3	6	9
("Snapper. Blackjack Bonus. Four different names: Sammy, Sandy, Sonny, and Staci".)									
9th	2.50	Yellow	BJ-P	16blu	OR-white	R-3	3	6	9
("Snapper. Blackjack Bonus. Four different names: Sammy, Sandy, Sonny, and Staci".)									
	NCV 1	Orange	BJ	None	HS	R-5	3	6	9
	NCV 1	Yellow	BJ	None	HS	R-5	3	6	9
	NCV 5	Orange	BJ	None	HS	R-5	3	6	9
	NCV 5	Red	BJ	8yel	HS	R-4	3	6	9
	NCV 25	Turq.	BJ	None	HS	R-9	20	40	60
	NCV 100	Brown	BJ	None	HS	R-5	5	10	15
	NCV 500	Purple	BJ	None	HS	R-6	8	16	24
	NCV 500	Yellow	BJ	None	HS	R-6	8	16	24
	NCV 1000	Navy	BJ	4wht	HS	R-7	10	20	30
	NCV 5	Rose	HHR	6yel	R-white	R-3	7	14	21
	NCV 25	Green	HHR	8pur	R-white	R-3	10	20	30
	NCV 100	Purple	HHR	3pnk3grn	R-white	R-3	15	30	45
	NCV 1000	Beige	HHR	4brn	R-white	R-4	25	50	75

("Let it Ride Tournament Chips". 375 sets were put together by Shuffle Master. After the tournament ended, most of these chips were given away to executives for promotional reasons.)

Issue	Den.	Color	Mold	Inserts	Inlay	Rarity	GD30	VF65	CS95
	NCV	4 diff.	BJ	None	HS	R-5	3	6	9
(Colors: Green, Red, Purple, and Yellow)									
	NCV 100	Red	BJ	8yel	OR-white	R-5	5	10	15
	NCV 500	White	BJ	8blk	OR-white	R-5	5	10	15
	NCV 500	Lavender	BJ	8yel	OR-white	R-5	5	10	15
	NCV 500	Purple	BJ	4wht	OR-white	R-5	5	10	15
(Above three are Poker Classic Buy-in Chips.)									
	RLT 4	7 diff.	BJ	None	R-white	R-4	2	4	6
(Black Train. Colors: Blue, Green, Brown, Lavender, Orange, White, and Yellow.)									
	RLT 4	7 diff.	BJ	None	R-white	R-4	2	4	6
(Red Train. Colors: Blue, Green, Brown, Lavender, Orange, White, and Yellow.)									
10th	100.00	Black	H&C	3yel3org3pur	HEX-white	R-1	*	100	110

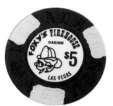

Foxy's Firehouse $5 (1st)

FOXY'S FIREHOUSE LAS VEGAS 1976-88

Issue	Den.	Color	Mold	Inserts	Inlay	Rarity	GD30	VF65	CS95
1st	5.00	Brown	Nevada	3bei	R-white	R-4	25	50	100
(Black Fox Head.)									
	5.00	Brown	Nevada	3bei	R-white	R-4	25	50	100
(Red Fox Head.)									
(These two chips are interesting in the fact that most are in nice condition, but none are uncirculated.)									
	25.00	Green	Nevada	3org	R-white	R-5	40	80	120
2nd	.25	Beige	H&C	None	HS	R-3	7	14	21
	.50	Pink	H&C	None	HS	R-3	7	14	21
	1.00	Blue	H&C	None	HS	R-3	7	20	40
("$1")									
	1.00	Blue	H&C	None	HS	R-3	7	20	40
("$1.00")									
	5.00	Brown	H&C	3wht	HS	R-3	20	50	100
	25.00	Green	H&C	3org	HS	R-3	25	75	150
(Above two chips are almost always found in horrible condition.)									
	FP 1.00	Blue	H&C	None	HS	R-8	30	60	90
	NCV 1.00	Blue	H&C	None	HS	R-7	25	50	75
	NN 1.00	Lt Blue	H&C	None	HS	R-8	25	50	75
(All three of the above chips are marked "Non Negotiable" on the reverse.)									

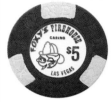

Foxy's Firehouse $5 Red Fox (1st)

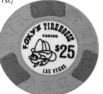

Foxy's Firehouse $25 (1st)

FOXXY LADY N. LAS VEGAS 1974-75

Issue	Den.	Color	Mold	Inserts	Inlay	Rarity	GD30	VF65	CS95
	1.00	Mustard	Nevada	None	HS	R-5	20	40	60
	5.00	Red	Nevada	None	HS	R-5	20	40	60

(Beware of Borland counterfeits. The fakes have a hot stamp which has more of a brass color than a gold color. Some collectors mistakenly believe that all chips from here are counterfeit. However, Phil Jensen has verified that he obtained chips from here in the short time the club was open.)

Foxy's Firehouse $25 (2nd)

FRANKLIN BROS. CASINO LAS VEGAS 1989-92

Issue	Den.	Color	Mold	Inserts	Inlay	Rarity	GD30	VF65	CS95
1st	5.00	Red	H&C	4yel4mar	HS	R-5	50	100	150

(This small downtown casino, formerly Orbit Inn, only had live gaming for a month or two in 1992. In addition, small clubs like this sometimes only had the tables open on weekends. It's doubtful more than a handful of chips ever walked out of this place, but they are seen often enough for sale. We must assume someone bought a small quantity before or after they closed. Nevertheless, the chip might be rarer than R-5.)

Franklin Bros. $5 (1st)

FREMONT LAS VEGAS 1956-

Issue	Den.	Color	Mold	Inserts	Inlay	Rarity	GD30	VF65	CS95
1st	.50	Maroon	Arodie	None	R-white	R-6	125	250	375
	1.00	Purple	Arodie	3grn	R-white	R-9	600	1200	1800
	5.00	Fuchsia	Arodie	3brn	R-white	R-9	800	1600	2400
(Above chips have a picture of a wreath.)									
2nd	Faro 5	Lav/Mst	HCE	½pie	R-white	R-10*	300	600	900
	Faro 5	Grey	HCE	3crm	R-white	R-5	25	50	75

Fremont $5 (1st)

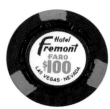

Fremont $100 (2nd)

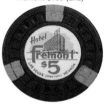

Fremont $5 (4th)

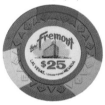

Fremont $25 (5th)

Fremont $25 (6th)

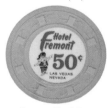

Fremont 50¢ (8th)

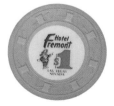

Fremont $1 (8th)

Issue	Den.	Color	Mold	Inserts	Inlay	Rarity	GD30	VF65	CS95
	Faro 25	Dk Green	HCE	3blk	R-white	R-8	175	350	525
	Faro 100	Black	HCE	3pur	R-white	R-8	250	500	750
3rd	.25	Grey	HHL	None	R-white	R-9	100	200	300
	.50	Purple	HHL	None	R-white	R-9	125	250	375
	1.00	Purple	HHL	None	R-white	R-10	150	300	450
(Above are "card room" chips.)									
4th	.10	Maroon	Hub	None	HS	R-7	50	100	150
	1.00	Purple	Hub	None	HS	Unique	200	400	600
(Overstamped on reverse "Habana Madrid Casino $25". Maybe someone will figure out how this chip wound up in Cuba!)									
	2.00	Orange	Hub	None	HS	R-5	40	80	120
(Above are "card room" chips.)									
	.50	Brown	Hub	3gry	R-white	R-5	30	60	90
	5.00	Navy	Hub	3mst	R-white	R-10	750	1500	2250
	25.00	Green	Hub	3mar	R-white	R-10	600	1200	1800
(Beware of counterfeits. The quality of the fake inlay is blurry and a bit crude. Originals are almost never encountered, so if you're offered one, it will be suspect to say the least.)									
	100.00	Tan	Hub	3blk	R-white	R-10	300	600	900
	100.00	Black	Hub	3gry	R-white	R-7	150	300	450
	RLT	White	Scrown	None	HS	R-7	25	50	75
5th	1.00	Grey	Arodie	3red	R-white	R-5	125	250	375
	5.00	Olive	Arodie	3blk	R-white	R-7	450	900	1350
	5.00	Dk Orange	Arodie	3blk	R-white	R-10	700	1400	2100
(This chip is definitely a different-colored regular issue.)									
	25.00	Lt Green	Arodie	1yel1red1crm	R-white	R-10	2250	4500	6750
(This issue pictures the building.)									
6th	.25	Grey	H&C	None	HS	R-4	5	10	15
	.25	Orange	H&C	None	HS	R-6	10	20	30
	1.00	Orange	H&C	3blk	MC-black	R-4	25	50	75
	5.00	Red	H&C	3wht	MC	R-3	20	50	100
(Unlike the other chips in this set, this $5 is usually found very worn.)									
	25.00	Green	H&C	3yel	MC	R-5	70	140	210
	NCV 1.00	Brown	H&C	3crm	HS	R-6	7	14	21
	NCV 25.00	Orange	H&C	3grn	HS	R-9	15	30	45
	NCV 100	Purple	H&C	3org	HS	R-9	15	30	45
(Above three are marked "Fremont Hotel".)									
7th	.50	Brown	H&C	None	HS	R-6	25	50	75
("Card Room".)									
	1.00	Tan	H&C	3brn	R-white	R-4	17	34	51
(Same inlay as the fifth issue, but issued much later.)									
	NCV 1	Brown	H&C	3wht	HS	R-6	7	14	21
8th	.50	Pink	H&C	None	R-white	R-6	10	20	30
(Freddie Fremont's hat has black "F".)									
	.50	Pink	H&C	None	R-white	R-5	7	14	21
(Freddie Fremont's hat has white "F" & Dark Green denomination.)									
	.50	Pink	H&C	None	R-white	R-5	7	14	21
(Freddie Fremont's hat has white "F" & Light Green denomination.)									
	1.00	Blue	H&C	None	R-white	R-5	12	24	36
(Freddie Fremont. Long Canes.)									
9th	1.00	Blue	H&C	None	R-white	R-4	10	20	30
(Freddie Fremont. Short Canes.)									
10th	.25	Orange	BJ	None	HS	R-4	3	6	9
	1.00	White	BJ-2	3pur	COIN	R-1	*	1	3
	5.00	Red	BJ-2	6blu	COIN	R-1	*	5	8
	25.00	Lt Green	BJ-2	8grn	COIN	R-1	*	25	30
	100.00	Black	BJ-2	12turq	COIN	R-1	*	100	110

Issue	Den.	Color	Mold	Inserts	Inlay	Rarity	GD30	VF65	CS95
	500.00	Brown	BJ-2	3yel	COIN	R-1	*	500	525
	NCV 1.00	Grey	BJ	None	HS	R-7	6	12	18
11th	.25	Orange	BJ	None	HS	R-1	*	1	2
	.50	Yellow	BJ	None	HS	R-1	*	1	2

(There are light and dark variants of both these chips.)

	RLT 1	Blue	H&C	None	HS	R-5	3	6	9

(Colors: Blue, Brown, Orange, Pink, and Red.)

	RLT 2	2 diff.	H&C	None	HS	R-5	3	6	9

(Colors: Salmon and Yellow.)

	RLT 3	7 diff	BJ	None	OR-white	R-4	2	4	6

(Colors: Blue, Brown, Green, Peach, Pink, Purple, & Red.)
(This entire issue is marked "Sam Boyd's Fremont".)

12th	.50	Yellow	BJ	None	HS	R-1	*	1	2
	1.00	White	BJ-2	3pur	COIN	R-1	*	1	3

(Same as 11th issue, but is stamped "BJ".)

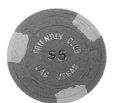

Friendly Club $5 (1st)

FRIENDLY CLUB LAS VEGAS 1978-83

1st	1.00	Cream	H&C	None	HS	R-7	75	150	225
	5.00	Red	H&C	3ltblu	HS	R-9	175	350	525
2nd	1.00	Blue	H&C	None	HS	R-9	125	250	375

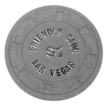

Friendly Club $1 (2nd)

FRONTIER CLUB LAS VEGAS 1935-53

1st	.25	Red	Sqsqrt	None	HS	R-5	50	100	150

(Most of these are drilled.)

	5.00	Green	Sqsqrt	3yel	HS	R-6	75	150	225
	25.00	Black	Triang	None	HS	R-7	75	150	225

(This $25 is only attributed to here.)

Frontier Club 25¢ (1st)

FRONTIER HOTEL LAS VEGAS 1967-98
FRONTIER HOTEL, NEW 1998-

1st	5.00	Maroon	HCE	6blu3yel	R-white	R-9	200	400	600
	25.00	Dk Green	HCE	6blk3pnk	R-white	R-9	400	800	1200
	100.00	Black	HCE	6wht3blk	R-white	Unique	450	900	1350
	500.00	Grey	HCE	6org3blk	R-white	Unique	500	1000	1500
2nd	1.00	Beige	HCE	None	R-white	R-4	40	80	120
	5.00	Maroon	HCE	6grn3pnk	R-white	R-5	75	150	225
	25.00	Dk Green	HCE	6blk3grn	R-white	Unique*	500	1000	1500
	100.00	Black	HCE	6pnk3ltgrn	R-white	R-10	450	900	1350
3rd	pan .25	Green	C&J	None	HS	R-6	20	40	60
	pan .50	Lavender	C&J	None	HS	R-6	15	30	45
	pan 1.00	Orange	C&J	None	HS	R-5	15	30	45
4th	1.00	Navy	Diecar	None	HS	R-9	75	150	225
	5.00	Red	BJ-1	3grn	COIN	R-5	50	100	150
	20.00	Brown	BJ-1	3blu	COIN	Unique*	300	600	900
	25.00	Lt Green	BJ-1	3yel	COIN	R-9	200	400	600
	100.00	Black	BJ-1	3wht	COIN	R-10	250	500	750
	500.00	Orange	BJ-1	3gry	COIN	R-4	35	70	105

(All of the above 4th issues were buried and burned in the desert. Many of the coin centers exist and are confused by non-collectors as valuable coins.)

	NN 5.00	Cream	Diecar	3grn	HS-green	R-9	30	60	90
	NN 25.00	Brown	Diecar	3pnk	HS	R-9	50	100	150
	RLT	5 diff.	Roulet	None	R-red	R-7	5	10	15

(Large "F". Colors: Beige, Blue, Brown, Pink, and Yellow.)

5th	.50	Orange	BJ	None	HS	R-4	5	10	15
	1.00	Blue	House	None	R-multi	R-2	3	6	9

Frontier $25 (1st)

Frontier $1 (3rd)

Frontier $500 (4th)

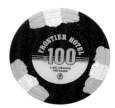

Frontier $100 (5th)

Frontier RLT (5th)

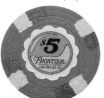

Frontier $5 (6th)

Issue	Den.	Color	Mold	Inserts	Inlay	Rarity	GD30	VF65	CS95
	5.00	Red	House	3yel3gry	R-multi	R-3	10	20	30
	25.00	Green	House	3wht3org	R-multi	R-5	40	80	120
	100.00	Black	House	6pnk3wht	R-multi	R-9	150	300	450
	500.00	Yellow	House	8pur	HEX-white	R-8	175	350	525
	500.00	White	House	6org3yel	R-multi	R-10*	400	800	1200
(The two known are both encased in diamond shaped paperweights.)									
	rs 500.00	Yellow	House	8blu	SCA-white	R-9	200	400	600
	1000.00	Gold	House	6org3wht	HUB-white	R-9	200	400	600
	rs 1000.00	Orange	House	3pur	COG-silver	R-9	250	500	750
	NCV 1	Grey	H&C	None	HS	R-9	10	20	30
	NCV 100	Gold	H&C	4brn	HS	R-9	15	30	45
	NCV 500	Purple	H&C	4grn	HS	R-10	25	50	75
	RLT	3 diff.	House	None	R-white	R-8	5	10	15
(Picture of a Longhorn. Colors: Blue, Orange, and White.)									
6th	1.00	Navy	House	None	R-white	R-2	1	2	3
	5.00	Red	House	4yel4gld	HUB-white	R-3	6	12	18
	25.00	Green	House	3wht3org	SCA-white	R-5	25	50	75
	100.00	Black	House	6gry3pch	COG-white	R-7	100	150	200
	RLT	4 diff.	BJ-2	None	OR-pink	R-6	4	8	12
(Colors: Lt Blue, Pink, Purple, and Yellow.)									
7th	1.00	White	BJ-2	4pnk	OR-white	R-1	*	1	2
	2.50	Blue	BJ-2	4wht	OR-white	R-1	*	3	5
	5.00	Red	BJ-2	4yel	OR-white	R-1	*	5	7
	25.00	Green	BJ-2	4org	OR-white	R-1	*	25	30
	100.00	Black	BJ-2	8blu	OR-white	R-1	*	100	110

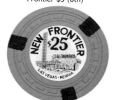

New Frontier $25 (1st)

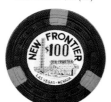

New Frontier $100 (1st)

New Frontier RLT 1 (1st)

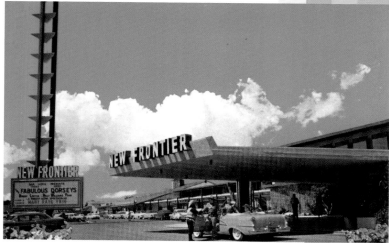

A late 1950s postcard of the New Frontier. ©Ferris H. Scott, Santa Ana, CA.

FRONTIER, NEW			LAS VEGAS		1955-67				
1st	5.00	Mustard	Rectl	3blk	R-white	R-5	50	100	150
	25.00	Fuchsia	Rectl	3blk	R-white	R-6	100	200	300
	100.00	Black	Rectl	3fch	R-white	R-8	600	1200	1800
(All but 1 or 2 are drilled and worth 20-25% of listed prices.)									
	RLT 1	Gry-Blu	Rectl	None	R-white	R-9	150	300	450
	RLT 1	Cream	Rectl	None	R-white	R-9	150	300	450

Issue	Den.	Color	Mold	Inserts	Inlay	Rarity	GD30	VF65	CS95
	RLT 2	Red	Rectl	None	R-white	R-9	150	300	450
	RLT 3	Brown	Rectl	None	R-white	R-9	150	300	450
	RLT 4	Brown	Rectl	None	R-white	R-9	150	300	450

(Most of the above chips are only found drilled.)

	RLT 4	Grey	Rectl	None	R-white	R-6	75	150	225
2nd	1.00	Red	C&J	None	SCA-white	R-5	50	100	150
3rd	5.00	Navy	Hrglas	3yel	R-white	R-6	125	250	375

(Most known examples are drilled and worth about 25% of listed prices. Undrilled, this chip is considered an R-7.)

	25.00	Green	Hrglas	3red	R-white	R-6	125	250	375
	100.00	Purple	Hrglas	3org	R-white	R-5	100	200	300

(New Frontier and Last Frontier were located close to each other and had an outdoor moving sidewalk connecting them. They had the same owners and were open simultaneously from 1958 to 1962. At that point, Last Frontier closed and New Frontier remained open.)

New Frontier $1 (2nd)

FRONTIER, LAST LAS VEGAS 1942-55/1958-62

Issue	Den.	Color	Mold	Inserts	Inlay	Rarity	GD30	VF65	CS95
1st	1.00	White	C&S	None	OR-white	R-5	150	300	450
	5.00	Mustard	C&S	None	OR-white	R-10*	1000	2000	3000
	25.00	Pink	C&S	None	OR-white	R-10*	1000	2000	3000
	100.00	Dk Green	C&S	None	OR-white	R-10*	1000	2000	3000
2nd	5.00	Mustard	Sm-Key	3ltgrn	R-white	R-4	40	80	160
	25.00	Pink	Sm-Key	3crm	R-white	R-4	75	150	350
	100.00	Green	Sm-Key	3red	R-white	R-4	50	100	150
	RLT 1	6 diff.	Lcrown	None	HS	R-5	20	40	60

(Colors: Brown, Cream, Green, Navy, Orange, and Red.)

	RLT 2	6 diff.	Lcrown	None	HS	R-5	20	40	60

(Colors: Brown, Cream, Green, Navy, Orange, and Red.)

	RLT 3	6 diff.	Lcrown	None	HS	R-6	20	40	60

(Colors: Brown, Cream, Green, Navy, Orange, and Red.)

	RLT 6	Orange	Lcrown	None	HS	R-6	20	40	60
	RLT 7	2 diff.	Lcrown	None	HS	R-7	30	60	90

(Colors: Brown and Green.)

3rd	25.00	Lt Green	Sm-key	None	Diecut-metal	Unique	1500	3000	4500

(This rare issue is not marked with the "21 Club".)

4th	5.00	Mustard	Sm-key	None	Diecut-metal	R-10	1250	2500	3750

(At most, there are two known.)

	25.00	Pink	Sm-key	None	Diecut-metal	R-8	700	1400	2100

(Belief is 12 chips were found, and all have the diecut way off center.)

	100.00	Cream	Sm-key	None	Diecut-metal	R-4	100	200	300

(About 150 to 200 chips were found several years ago by Allan Myers. A great find!)

5th	5.00	Pink	S's	None	HS	R-7	100	200	300
	25.00	Lavender	S's	None	HS	R-9	200	400	600

(4th & 5th issues are marked "21 Club" on one side. This 5th set of chips has been attributed to here for many years.)

6th	5.00	Yellow	T's	3red	R-blue	R-3	25	50	75
	25.00	Dk Pink	T's	3yel	R-blue	R-3	30	60	90
	100.00	Green	T's	3yel	R-blue	R-4	50	100	150

("Silver Slipper" on back.)

7th	5.00	Mustard	Diamnd	3blk	R-white	R-3	12	24	36
	25.00	Green	Diamnd	3nvy	R-white	R-3	20	40	60
	100.00	Brown	Diamnd	3gry	R-white	R-4	60	120	180
8th	1.00	Red/Blu	C&J	1/2pie	R-white	R-3	15	30	45
	n/d	Purple	C&J	None	HS	R-10	100	200	300

(Guest Club)

(The Last Frontier was closed from 1955 to October 1958. At the reopening, general manager Richard Taylor ordered a new set of chips with the famous dancing girl logo a la the Can-Can Girl Moulin Rouge chips.)

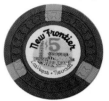

New Frontier $5 (3rd)

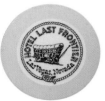

Last Frontier $1 (1st)

Last Frontier $100 (2nd)

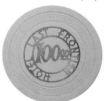

Last Frontier $100 (4th)

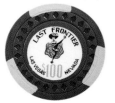

Last Frontier $100 (7th)

Gamblers $1 (1st)

Gamblers $5 (1st)

Goad Coast $5 (1st)

Gold Coast $5 (2nd)

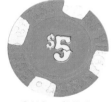

Gold Coast RLT (3rd)

Gold Spike $25 (1st)

Issue	Den.	Color	Mold	Inserts	Inlay	Rarity	GD30	VF65	CS95
GAMBLER'S			**LAS VEGAS**		**1974-76**				
1st	.10	Grey	H&C	None	HS	R-10*	200	400	600
	.25	Yellow	H&C	None	HS	R-8	75	150	225
	.50	Dk Pink	H&C	None	HS	R-8	75	150	225
	1.00	Blue	H&C	None	HS	R-7	75	150	225
	5.00	Red	H&C	3blk	R-white	R-5	60	120	180

(Located on Fremont Street, this club was actually called "Gambler's Hall of Fame" after the poker tournament. Supposedly, Gambler's was run by the "boys" at the Tropicana.)

GAY 90's			**N. LAS VEGAS**		**1964-72**				
	.50	Fuchsia	C&J	None	HS	R-5	25	50	75
	1.00	Beige	Sqincr	3grn	R-white	R-5	40	80	120
	5.00	Mustard	Sqincr	3org	R-white	R-6	50	100	150

(Located on N. Las Vegas Blvd. where there were many small clubs.)

GLITTER GULCH, STUPAK'S			**LAS VEGAS**		**1980-81**				
1st	5.00	Red	H&C	3ltblu3pnk	HS	R-3	30	60	90

GOLD COAST			**LAS VEGAS**		**1986-**				
1st	.25	Grey	House	None	R-grey	R-5	8	16	24
	1.00	Lt Brown	House	None	R-brown	R-5	10	20	30
	5.00	Red	House	4wht	R-red	R-7	30	60	90
2nd	.25	Grey	House	None	R-white	R-4	3	6	9
	.25	Grey	House	None	R-grey	R-4	3	6	9
	1.00	Lt Brown	House	None	R-brown	R-3	2	4	6
	5.00	Red	House	4wht	R-red	R-3	6	12	18
	25.00	Green	House	4yel	R-green	R-5	35	70	105
	100.00	Black	House	4red	R-black	R-8	100	200	300

(All chips were buried in concrete.)

	NCV 5	Pink	House	None	R-white	R-6	6	12	18
	NCV 25	Green	House	None	R-white	R-6	7	14	21
	NCV 100	Brown	House	None	R-white	R-6	8	16	24
3rd	.25	Grey	House	None	OR-lt blue	R-1	*	1	2
	1.00	Lt Brown	House	None	OR-lt blue	R-1	*	1	3
	5.00	Red	House	4wht	OR-lt blue	R-1	*	5	8
	25.00	Green	House	4yel	OR-lt blue	R-1	*	25	30
	100.00	Black	House	4red	OR-lt blue	R-1	*	100	110
	RLT	4 diff.	House	None	R-black	R-4	2	4	6

(Colors: Fuchsia, Navy, Pink, and Yellow.)

	RLT	4 diff.	House	None	R-red	R-4	2	4	6

(Colors: Lt Blue, Navy, Orange, and Red.)

	RLT	5 diff.	House	None	R-white	R-4	2	4	6

(Colors: Fuchsia, Lt Blue, Orange, Red, and Yellow.)

GOLD SPIKE			**LAS VEGAS**		**1981-93**				
1st	.25	Yellow	H&C	None	HS	R-5	6	12	18
	1.00	Blue	H&C	None	HS	R-4	6	12	18
	5.00	Red	H&C	3yel3pnk	HS	R-4	12	24	36
	25.00	Green	H&C	3tan3dkorg	HS	R-7	60	120	180
2nd	5.00	Red	H&C	3yel3blk	R-white	R-1	*	5	8
	25.00	Green	H&C	4nvy4ltyel	SCA-white	R-1	*	25	30
3rd	5.00	Red	H&C	3yel3blk	SCA-white	R-1	*	5	8

Issue	Den.	Color	Mold	Inserts	Inlay	Rarity	GD30	VF65	CS95
GOLDEN GATE			**LAS VEGAS**		**1956-**				
1st	1.00	Dk Blue	Lcrown	None	HS	R-9	200	400	600

(This first issue is marked "Casino" although always known in early days as "Club".)

2nd	.25	Mustard	HCE	None	R-white	R-8	250	500	750
	.25	Navy	HCE	None	R-white	R-9	300	600	900
	.25	Navy	HCE	None	HS	R-7	100	200	300
	5.00	Rose	HCE	3gry3yel	R-white	R-10*	750	1500	2250

(This chip has a different inlay design from the others in this issue, but we list it here out of desperation. This club had to use a $5 chip, and since no others are known, it fits here for now.)

	25.00	Green	HCE	3org	R-white	R-10*	750	1500	2250
	100.00	Grey	HCE	3org	R-white	R-5	125	250	375

(A former casino owner has one original box of chips - most are uncirculated. The first couple pieces that sold went for over $3000. The owner then released five more chips and claimed he wouldn't sell any more. These chips went for around $1500 each in trade through a chip dealer. Unfortunately for these eager buyers, this beautiful $100 classic has recently appeared on a popular internet auction for only $400. It is reasonable to assume that the chips will continue to be released and the price will stabilize or possibly deteriorate even further.)

	n/d	Navy	HCE	None	HS	R-7	25	50	75

(Marked "Casino".)

3rd	.25	Lt Brown	Scrown	None	LSC-white	R-8	150	300	600
	.50	Pnk/Yel	Scrown	1/2pie	OR-white	R-8	200	400	600

(Above two chips usually found well worn.)

	1.00	Blue	Scrown	None	OR-white	R-6	75	150	225
	1.00	Pnk/Fch	Scrown	2pnk	OR-white	Unique	300	600	900
	1.00	White	Scrown	None	OR-white	Unique	300	600	900
	5.00	Red	Scrown	4blu4yel	OR-multi	R-9	500	1000	1500
	FP .25	Orange	Scrown	None	HS	R-10	175	350	525

("Pit - Keno" on one side and "Free Play" on the other.)

4th	.25	Brown	C&J	None	HS	R-5	15	30	45
	.25	Lt Brown	C&J	None	SCA-white	R-6	50	100	150
	1.00	Turq.	C&J	None	SCA-white	R-6	60	120	180
	5.00	Red	C&J	3pnk	SCA-white	R-9	300	600	900
	25.00	Dk Green	C&J	3grn	SCA-white	Unique	600	1200	1800
5th	5.00	Red	House	6blu3wht	R-white	R-6	125	250	375
6th	.25	Brown	House	None	HS	R-5	10	20	30
	1.00	Blue	House	None	MC	R-5	30	60	90
	5.00	Red	House	3pnk	MC	R-9	250	500	750
	25.00	Dk Green	House	3grn	MC	R-4	25	50	75

(This chip was in use for over 20 years.)

7th	1.00	Lt Blue	H&C	None	MC	R-7	50	100	150
8th	.25	Yellow	H&C	None	HS	R-1	*	1	2

(Three versions: Large letters; Small letters & "Downtown", and one marked "LV, NV".)

	1.00	Blue	House	None	HUB-white	R-1	*	1	3
	1.00	Blue	H&C	None	HUB-white	R-1	*	1	3
	5.00	Red	House	3blk3blu	SCA-white	R-1	*	5	8
	100.00	Black	House	3org3pur3yel	SCA-white	R-1	*	100	120
	RLT	Green	Roulet	None	HS	R-5	2	4	6

(Originally, this corner was occupied by the Nevada Hotel since 1905.)

GOLDEN GOOSE			**LAS VEGAS**		**1975-80**				
1st	5.00	Red	H&C	3brn	R-white	Unique	1500	3000	4500

(Primarily a slot joint, this tiny club only had one licensed blackjack table for a few months in 1976-77. There are rumors of $1 and $25 chips also, but none have ever surfaced.)

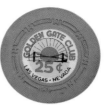

Golden Gate 25¢ (2nd)

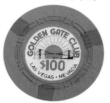

Golden Gate $100 (2nd)

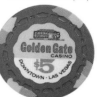

Golden Gate $5 (3rd)

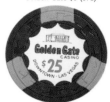

Golden Gate $25 (4th)

Golden Gate $5 (6th)

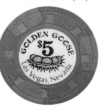

Golden Goose $5 (1st)

Golden Nugget 50¢ (1st)

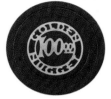

Golden Nugget $100 (1st)

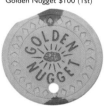

Golden Nugget $5 (3rd)

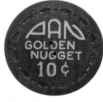

Golden Nugget 10¢ (4th)

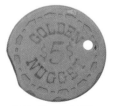

Golden Nugget $5 (4th)

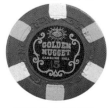

Golden Nugget $5 (7th)

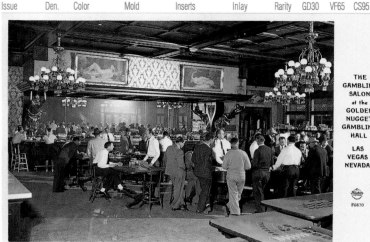

THE GAMBLING SALON at the GOLDEN NUGGET GAMBLING HALL LAS VEGAS NEVADA

F6870

Postcard of the Golden Nugget, as it appeared around opening in August, 1946. ©Frashers, Inc., Pomona, CA.

Issue	Den.	Color	Mold	Inserts	Inlay	Rarity	GD30	VF65	CS95
GOLDEN NUGGET		**LAS VEGAS**			**1946-**				
1st	.50	Green	Sm-key	None	HS	R-9	100	200	300
	1.00	Brown	Sm-key	None	HS	R-9	100	200	300
	5.00	Yellow	Sm-key	None	HS	R-9	100	200	300
(Above only marked "GN".)									
	100.00	Black	Sm-key	None	Diecut-metal	Unique	2500	5000	7500
(This spectacular chip was discovered in the Spring of 1999, proving that some really awesome pieces are still waiting to be unearthed all across the country.)									
2nd	5.00	Purple	Diamnd	None	HS	R-4	10	20	30
	25.00	Navy	Diamnd	None	HS	R-4	10	20	30
("TMc" - Attributed to Guy McAfee, one of the original owners.)									
3rd	5.00	Beige	Diamnd	2red	HS	R-7	500	1000	1500
(R-10 undrilled. Drilled chips are usually in poor condition & only worth 5% of the listed values.)									
	5.00	Lavender	Diamnd	None	HS	R-10	500	1000	1500
	25.00	Dk Grey	Diamnd	2mst	HS	R-7*	500	1000	1500
4th	pan .10	Brown	Scrown	None	HS	Unique*	750	1500	2250
	5.00	Green	Scrown	None	HS	R-10*	500	1000	1500
	5.00	Lavender	Scrown	3red	HS	R-9*	450	900	1350
	pok 5.00	Red	Scrown	3pur	HS	Unique	350	700	1050
	25.00	Pink	Scrown	3blk	HS	R-10*	500	1000	1500
	100.00	Black	Scrown	None	HS	Unique*	750	1500	2250
5th	faro 25.00	Dk Brown	HCE	2wht	HS	R-7	25	50	75
(Marked only "Faro" and attributed to here for many years.)									
	RLT	5 diff.	HCE	None	HS	R-5	7	14	21
("GN". Colors: Brown, Green, Navy, Orange, and Red)									
6th	5.00	Blue	GN	3wht3org	R-black	R-10	750	1500	2250
	RLT 1	3 diff.	HCE	None	HS	R-5	8	16	24
(Colors: Brown, Navy, and Yellow)									
	RLT 2	3 diff.	HCE	None	HS	R-5	8	16	24
(Colors: Green, Navy, and Yellow)									
	RLT 3	Yellow	HCE	None	HS	R-5	8	16	24
	RLT 4	Red	HCE	None	HS	R-5	8	16	24

Issue	Den.	Color	Mold	Inserts	Inlay	Rarity	GD30	VF65	CS95
7th	5.00	Brown	GN	3mst3bei	R-black	R-9	500	1000	1500

(Unusual black inlay marked "Golden Nugget Gambling Hall".)

pok 5.00	Red	GN	3pur	R-white	R-10	750	1500	2250	

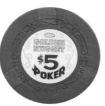

Golden Nugget $5 POK (7th)

Issue	Den.	Color	Mold	Inserts	Inlay	Rarity	GD30	VF65	CS95
8th	5.00	Brn/Org	GN	½pie	R-white	R-9	300	600	900
	25.00	Grn/Blk	GN	½pie	R-white	R-10	500	1000	1500

(Green Nugget and green denomination. Only one exists undamaged. The other two are in paperweights.)

9th	.25	Purple	GN	None	HS	R-6	30	60	90
	.50	Blu/Gry	GN	dovetail-blu	HS	R-8	250	500	750
	.50	Blu/Gry	GN	dovetail-gry	HS	R-8	250	500	750
	1.00	Navy	GN	3bei	HS	R-7	125	250	375
	5.00	Brown	GN	6org3crm	R-white	R-7	150	300	450
	RLT 2	Navy	GN	None	HS	R-10	35	70	105
	RLTA	4 diff.	GN	None	HS	R-7	20	40	60

Golden Nugget $5 (8th)

(Colors: Cream, Lavender, Lt Green, and Red.)

	RLT B	7 diff.	GN	None	HS	R-7	15	30	60

(Colors: Black, Cream, Green, Lavender, Lt Green, Navy, and Red.)

	RLT C	4 diff.	GN	None	HS	R-8	20	40	80

(Colors: Cream, Lt Green, Navy, and Red.)

	RLT D	4 diff.	GN	None	HS	R-7	15	30	60

(Colors: Cream, Mustard, Navy, and Red)

(Most of these above roulettes were found in very used condition.)

Golden Nugget $1 (10th)

10th	1.00	Gry-Blu	C&J	None	R-white	R-5	35	70	105
11th	1.00	Wht/Pur	GN	½pie	R-white	R-2	10	20	40
error 5.00	Wht/Pur	GN	½pie	R-white	R-10	250	500	750	

(2 known. Was supposed to be a $1 chip. Same inlay on both sides.)

	5.00	Red	GN	3yel	R-white	R-4	25	50	75
	25.00	Green	GN	6wht3red	R-white	R-7	125	250	375
	100.00	Black	GN	6yel	R-white	R-6	125	250	375

(This issue has a black scroll and yellow denomination.)

	NCV 5.00	Orange	H&C	3wht	HS	R-9	30	60	90

Golden Nugget $25 (12th)

(Long canes.)

12th	.25	Brown	GN	None	HS	R-6	25	50	75
	5.00	Red	GN	3wht	R-multi	R-5	70	140	210
	25.00	Green	GN	4yel	R-multi	R-9	400	800	1200

("Gambling Hall and Rooming House".)

13th	1.00	Navy	H&C	2wht	R-white	R-4	15	30	45

(Short canes.)

	100.00	Black	H&C	1grn1red1yel	HS	R-7	65	130	195
	NCV	Beige	H&C	None	HS	R-8	15	30	45
14th	1.00	Navy	House	2wht	R-white	R-5	17	34	51
15th	100.00	Yellow	House	6blk	R-yellow	R-8	250	500	750
	NCV 1	Cream	House	2pnk	R-white	R-5	10	20	30
	NCV 5	Red	House	3blu3org	HUB-white	R-7	10	20	30
	NCV 25	Green	House	3ltbrn3dkbrn	SCA-white	R-7	15	30	45
	NCV 100	Black	House	3brn3grn	COG-white	R-8	30	60	90
	NCV 500	Lt Blue	House	3org3blu	HEX-white	R-9	40	80	120
	NCV 1000	Yellow	House	3brn3ltgrn3lav	NOT-white	R-9	40	80	120
	NCV 5000	Gold	House	4brn4pnk	TRI-white	R-9	40	80	120

Golden Nugget $1 (14th)

(This set was used at the Mirage's pre opening VIP party. Upon leaving this exciting fun night gambling party, the chips were supposed to be returned in a box at the door. Most people only played with the 1-100, making the higher denominations scarcer. These chips were obsolete Golden Nugget tournament chips. It is unusual to see chips being used in other places then where they were issued.)

16th	1.00	Blue	House	3yel	R-white	R-2	3	6	9
	5.00	Red	House	4yel	HUB-white	R-3	8	16	24

Golden Nugget $5 (16th)

Golden Nugget $1 (17th)

Golden Nugget $5 (17th)

Golden Slipper 25¢ (1st)

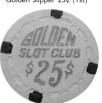

Golden Slot Club $25 (1st)

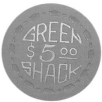

Green Shack $5 (1st)

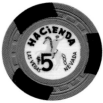

Hacienda $5 (1st)

Issue	Den.	Color	Mold	Inserts	Inlay	Rarity	GD30	VF65	CS95
	25.00	Green	House	4org	SCA-white	R-6	50	100	150
	100.00	Black	House	8yel	COG-white	R-6	90	180	270
17th	1.00	Blue	House	3yel	R-white	R-1	*	1	3
	5.00	Red	House	4gry4yel4blu	HUB-white	R-1	5	8	12
	25.00	Green	House	4grn4pnk	SCA-white	R-1	25	30	35
	100.00	Black	House	12yel	COG-white	R-1	100	125	150
	NCV 1.99	Orange	H&C	None	HS	R-5	4	8	12

("The Great Late Nite Steak".)

18th	1.00	Blue	House	3yel	R-white	R-1	*	1	3

(Same as above issue, except for "®" symbol after Golden Nugget.)

	bac 20.00	Orange	House	4blk2org	R-white	R-2	*	20	30
	bac 100.00	Black	House	4gld	COG-white	R-1	*	100	115
19th	5.00	Red	House	3blk3gld	OR-black	R-1	*	5	8
	25.00	Green	House	4pnk4wht	OR-white	R-1	*	25	30
	100.00	Black	House	12gld	OR-white	R-1	*	100	110

(Above chips are "50th Anniversary" chips & are still in use much after the 50th.)

	RLT B	Yellow	Roulet	None	HS	R-4	3	6	9
	RLT C	Blue	Roulet	None	HS	R-4	3	6	9
20th	RLT	4 diff.	Roulet	None	OR-white	R-3	2	4	6

(Colors: Maroon, Orange, Pink, and Turquoise.)

GOLDEN SLIPPER — LAS VEGAS — 1950-50

Issue	Den.	Color	Mold	Inserts	Inlay	Rarity	GD30	VF65	CS95
1st	.25	Cream	HCE	None	HS	R-8	400	800	1200

(Became the Silver Slipper. This club only lasted 3 months before the Golden Nugget forced them to change their name. For some reason no other denominations have been found. Therefore, this chip is in much demand.)

GOLDEN SLOT CLUB — LAS VEGAS — 1955-58

Issue	Den.	Color	Mold	Inserts	Inlay	Rarity	GD30	VF65	CS95
1st	.10	Black	Scrown	None	HS	R-8	150	300	450
	.25	Lavender	Scrown	None	HS	R-5	40	80	120
	5.00	Blue	Scrown	4yel	HS	R-4	25	50	75
	25.00	Yellow	Scrown	4nvy	HS	R-6	75	150	225

(Downtown Fremont Street, now the Glitter Gulch.)

GREEN SHACK — LAS VEGAS — 1932-56

Issue	Den.	Color	Mold	Inserts	Inlay	Rarity	GD30	VF65	CS95
1st	.50	Grey	Scrown	None	HS	R-8	250	500	750
	5.00	Red	Scrown	None	HS	R-7	200	400	600

(This historic Boulder Highway business was closed in 1999. No old chips were discovered among the inventory that was auctioned off.)

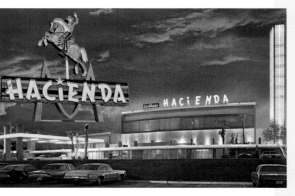

Postcard of the Hacienda, circa 1970. ©Ferris H. Scott, Santa Ana, CA.

94

Issue	Den.	Color	Mold	Inserts	Inlay	Rarity	GD30	VF65	CS95
HACIENDA		**LAS VEGAS**			**1956-96**				
1st	1.00	Beige	Rectl	None	R-white	Unique	1500	3000	4500
	5.00	Mustard	Rectl	3blk	R-white	Unique	2000	4000	6000
	.50	Blu-Gry	Hrglas	None	HS	R-9*	150	300	450

("Hole in one Club".)

	n/d	Yellow	Rectl	None	HS	R-8	40	80	120

("Free Drink".)

2nd	1.00	Beige	Sm-key	None	R-white	R-5	100	200	300
	5.00	Navy	Sm-key	3mst	R-white	R-9	700	1400	2100
	5.00	Navy	Sm-key	None	R-white	R-10	1000	2000	3000
	5.00	Mustard	Sm-key	3blk	R-white	R-9	800	1600	2400
	25.00	Fuchsia	Sm-key	3blk	R-white	R-5	75	150	225
	100.00	Black	Sm-key	3crm	R-white	R-10	1000	2000	3000
	RLT 1	2 diff.	Sm-key	None	HS	R-9	30	60	90

(Colors: Lavender and Red.)

	RLT 2	2 diff.	Sm-key	None	HS	R-9	30	60	90

(Colors: Beige and Green.)

	RLT 3	4 diff.	Sm-key	None	HS	R-9	30	60	90

(Colors: Black, Brown, Green, and Navy.)

3rd	.50	Green	Diamnd	None	HS	R-6	25	50	75
	.50	Brown	Diamnd	None	HS	R-7	40	80	120
	.50	Yellow	Diamnd	None	HS	R-9	75	150	225

(All of the above chips are marked "Good in Resturant" which is misspelled.)

	n/d	Mustard	Diamnd	None	HS	R-7	25	50	75

("Free Drink".)

	FP	Black	Diamnd	None	HS	R-8	25	50	75
4th	1.00	Beige	HHR	None	R-white	R-6	125	250	375
	5.00	Orange	C&J	3grn	R-white	R-7	350	700	1050
	25.00	Lt Green	C&J	3blk	R-white	Unique*	1250	2500	3750
	NN.25	Mustard	C&J	None	HS	R-6	30	60	90
	NN.50	Orange	C&J	None	HS	R-6	30	60	90
	NN1.00	Red	C&J	None	HS	R-9	100	200	300
	NN5.00	Brown	C&J	None	HS	R-9	100	200	300

(Above chips are marked "Card Room".)

	FP	Black	C&J	None	HS	R-7	12	24	36

(Small writing on back. "Freeplay, Craps, 21, Big 6".)

	FP	Black	HHR	None	HS	R-5	7	14	21
	FP	Black	HHR	None	HS-silver	R-5	10	20	30
5th	1.00	Grey	H&C	3gld	R-white	R-3	5	10	15

(This version has a different horse's tail & hand waving in different position.)

	5.00	Red	H&C	3wht3blu	OCT-green	R-3	25	75	200

(Extreme condition rarity.)

	25.00	Green	H&C	3yel3pnk	OCT-gold	R-5	75	150	300
	100.00	Black	H&C	3pur3wht	OCT-red	R-5	125	250	375

(This issue was manufactured in July, 1974 and used until the mid-90's.)

	FP	Black	H&C	None	HS	R-5	6	12	18
	FP	Black	H&C	None	HS	R-5	7	14	21

(Larger writing on reverse.)

	NCV 1	Navy	H&C	None	HS	R-10	15	30	45
	NCV 5	Beige	H&C	3red	HS	R-9	12	24	36
	NCV 25	Pink	H&C	3blu	HS	R-9	13	26	39
	NCV 100	Brown	H&C	3org	HS	R-5	12	24	36

(All four chips above have $ sign.)

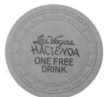

Hacienda n/d (1st)

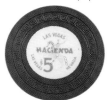

Hacienda $5 (2nd)

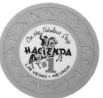

Hacienda $1 (4th)

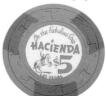

Hacienda $5 (4th)

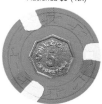

Hacienda $5 (5th)

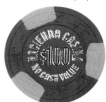

Hacienda NCV 100 (5th)

Issue	Den.	Color	Mold	Inserts	Inlay	Rarity	GD30	VF65	CS95
6th	.25	Orange	H&C	None	HS	R-5	10	20	30
	1.00	Grey	H&C	3gld	R-white	R-2	5	10	15
	2.50	Pink	H&C	2wht2grn	R-white	R-3	7	14	21
	2.50	Pink	H&C	2wht2grn	OR-white	R-4	8	16	24
	5.00	Red	H&C	3blu3wht	HUB-white	R-3	10	20	30

(This issue pictures a rose.)

	NCV 1	Navy	Plain	3bei	HS	R-6	7	14	21
	NCV 1	Navy	HHR	None	HS	R-5	5	10	15
	NCV 5	Beige	H&C	3red	HS	R-5	8	16	24
	NCV 25	Pink	H&C	3blu	HS	R-5	10	20	30
	NCV 5	Navy	H&C	None	HEX-black	R-5	8	16	24
7th	1.00	White	H&C	1pnk1pur	OR-multi	R-2	2	4	6
	2.50	Pink	H&C	1grn1nvy	OR-multi	R-3	5	10	15
	5.00	Red	H&C	2blu2yel	OR-multi	R-2	5	10	15
	25.00	Green	H&C	4brn4wht4yel	OR-multi	R-4	40	80	120
	100.00	Black	H&C	4pur4grn4org	OR-multi	R-5	100	200	300
	100.00	Black	H&C	3wht3pur	OR-multi	R-5	100	200	300

("Final Flight" Exactly 150 chips were bought - all others were destroyed.)

	RLT 1	7 diff.	Roulet	None	HS	R-4	3	6	9

(Colors: Blue, Lt Blue, Fuchsia, Gold, Orange, Peach, and Lt Pink.)

	RLT 2	7 diff.	Roulet	None	HS	R-4	3	6	9

(Colors: Blue, Lt Blue, Fuchsia, Gold, Orange, Peach, and Lt Pink.)

HACIENDA CLUB N. LAS VEGAS 1948-54

Issue	Den.	Color	Mold	Inserts	Inlay	Rarity	GD30	VF65	CS95
1st	1.00	Beige	Sqincr	None	HS	R-9	200	400	600
	5.00	Red	Sqincr	None	HS	R-9	150	300	450
	25.00	Green	Sqincr	None	HS	R-4	50	100	150
	100.00	Yellow	Sqincr	None	HS	R-6	100	200	300
	500.00	Fuchsia	Sqincr	None	HS	Unique	200	400	600

(A man in Texas owns all the $1 and $5 chips and isn't planning on selling. For more information, read Gaming Times of December 1998. Gene Trimble has an article all about these. A 1951 magazine ad had the slogan "mellow music, frisky whiskey, and Aimin' Gamin'". Hacienda Club was owned by Doris Blair.)

HARD ROCK LAS VEGAS 1995-

Issue	Den.	Color	Mold	Inserts	Inlay	Rarity	GD30	VF65	CS95
1st	5.00	Red	H&C	3blk	OR-multi	R-1	*	5	10

(Red Hot Chili Peppers.)

	5.00	Red	H&C	3blk	OR-multi	R-1	*	5	10

(Bob Seger.)

	5.00	Red	H&C	8gld	OR-multi	R-1	*	5	10

(Large Guitar.)

	25.00	Purple	H&C	4blk	OR-multi	R-1	*	25	40

(Jimi Hendrix.)

	100.00	Black	H&C	8org	OR-multi	R-1	*	100	120

(Tom Petty.)

	500.00	Grey	H&C	8pur	OR-multi	R-1	*	500	525

("In Rock We Trust".)

	1000.00	Yellow	H&C	12pur	OR-multi	R-1	*	1000	1025

("All in One.")

	rs 5000.00	Grey	H&C	6org	OR-multi	R-3	*	5000	5025

(Many limited edition $5 chips are house table chips. Some are in use longer than others - all depending on the popularity of the event, holiday, etc. & how many are made. Most of these Limited Editions are dated.)

	RLT 1	2 diff.	House	None	R-black	R-7	7	14	21

(Gold flames. Colors: Green, and Purple. No Location.)

2nd	RLT	7 diff.	House	None	R-black	R-4	2	4	6

(Silver flames. Colors: Lt Blue, Green, Lt Orange, Orange, Pink, Purple, and Yellow.)

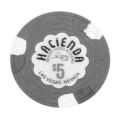

Hacienda $5 (6th)

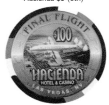

Hacienda $100 (7th)

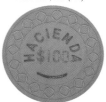

Hacienda Club $100 (1st)

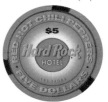

Hard Rock $5 (1st)

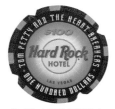

Hard Rock $100 OBV (1st)

Hard Rock $100 REV (1st)

Issue	Den.	Color	Mold	Inserts	Inlay	Rarity	GD30	VF65	CS95
	RLT	7 diff.	House	None	R-black	R-4	2	4	6

(Gold flames. Colors: Lt Blue, Green, Lt Orange, Orange, Pink, Purple, and Yellow.)

| | RLT | 7 diff. | House | None | R-silver | R-4 | 2 | 4 | 6 |

(Black flames. Colors: Lt Blue, Green, Lt Orange, Orange, Pink, Purple, and Yellow.)
(These second issue roulettes are marked "Las Vegas, NV".)

| | 3rd RLT | 7 diff. | House | None | R-blue/black | R-4 | 3 | 6 | 9 |

(Red & Yellow color flames. Colors: Lt Blue, Green, Lt Orange, Orange, Pink, Purple, and Yellow.)

| | RLT | 7 diff. | House | None | R-blue/black | R-4 | 3 | 6 | 9 |

(Purple & white color on flames. Colors same. All above are usually only 6 colors to a table - a 7th color is backup & sometimes brought out. Nearly all casinos have that 7th color.)

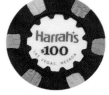

Harrah's $100 (1st)

HARRAH'S — LAS VEGAS — 1992-

Issue	Den.	Color	Mold	Inserts	Inlay	Rarity	GD30	VF65	CS95
1st	1.00	Blue	House	1yel1nvy1pnk	R-white	R-1	*	1	3
	5.00	Red	House	6nvy3red	HUB-white	R-1	*	5	7
	25.00	Green	House	4pur4pch4fch	SCA-white	R-1	*	25	30
	100.00	Black	House	2pnk2gld2lav	COG-white	R-9	200	400	600

(This chip was used very briefly.)

Issue	Den.	Color	Mold	Inserts	Inlay	Rarity	GD30	VF65	CS95
	NCV 1	Purple	H&C	None	HS	R-8	6	12	18
	NCV 5	Pink	H&C	None	HS	R-9	10	20	30
	NCV 25	Lt Green	H&C	None	HS	R-9	15	30	45
	NCV 100	Grey	H&C	None	HS	R-10	20	40	60
	RLT B	Dk Pink	Roulet	None	R-white	R-4	2	4	6
	RLT D	Fuchsia	Roulet	None	R-white	R-4	2	4	6
	RLT G	Orange	Roulet	None	R-white	R-4	2	4	6
2nd	100.00	Black	House	2lav2pnk2gld	R-multi	R-8	150	300	450

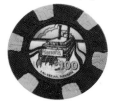

Harrah's $100 (2nd)

(Picture of boat.)

Issue	Den.	Color	Mold	Inserts	Inlay	Rarity	GD30	VF65	CS95
3rd	1.00	Blue	House	1yel1nvy1pnk	R-multi	R-1	*	1	3
	error 1.00	Blue	House	1yel1nvy1pnk	R-multi	Unique	100	200	300

(Jester on both sides. Normal chip has a globe on one side. It's possible that more exist.)

Issue	Den.	Color	Mold	Inserts	Inlay	Rarity	GD30	VF65	CS95
	bac 20	Green	House	4red4yel	R-multi	R-1	*	20	25
	100.00	Black	House	2trq4red2gry	R-blue	R-1	*	100	110

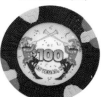

Harrah's $100 (3rd)

("Jester" issue.)

HILTON — LAS VEGAS — 1971-

Issue	Den.	Color	Mold	Inserts	Inlay	Rarity	GD30	VF65	CS95
1st	.50	Purple	HCE	None	R-orange	R-5	20	40	60
	1.00	Tan	HCE	None	R-orange	R-3	15	30	45
2nd	.50	Purple	House	None	R-orange	R-5	20	40	60
	1.00	Tan	House	None	R-orange	R-4	12	24	36
	bac 20.00	Green	House	4pur	SCA-white	R-9	200	400	600
	100.00	Black	House	6red	SCA-white	R-10*	350	700	1050

LV Hilton $1 (1st)

(May not have actually been put in use.)

Issue	Den.	Color	Mold	Inserts	Inlay	Rarity	GD30	VF65	CS95
	bac 100.00	Blk/Pnk	House	1/2pie	SCA-white	R-10	300	600	900
	bac 1000	Brown	House	3grn	SCA-white	R-10*	400	800	1200
3rd	.25	Orange	H&C	None	HS	R-4	12	24	36
	1.00	Lt Grey	House	None	HUB-white	R-2	3	6	9

(Large $1.)

Issue	Den.	Color	Mold	Inserts	Inlay	Rarity	GD30	VF65	CS95
	1.00	Beige	House	None	HUB-white	R-3	4	8	12

(Smaller $1.)

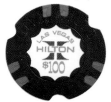

LV Hilton $100 (2nd)

Issue	Den.	Color	Mold	Inserts	Inlay	Rarity	GD30	VF65	CS95
	1.00	Tan	House	None	HUB-white	R-2	3	6	9

(Larger $1.)

Issue	Den.	Color	Mold	Inserts	Inlay	Rarity	GD30	VF65	CS95
	5.00	Maroon	House	6yel	HUB-white	R-3	10	20	30
	25.00	Green	House	6bei3org	HUB-white	R-4	30	60	90
	100.00	Black	House	6pnk3yel	HUB-white	R-6	100	175	200
	500.00	Lt Brown	House	6red3blk	HUB-white	R-10*	300	600	900

(Rainbow issue.)

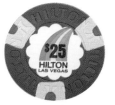

LV Hilton $25 (3rd)

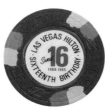

LV Hilton n/d (3rd)

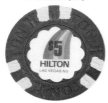

LV Hilton $5 (4th)

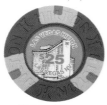

LV Hilton $25 (5th)

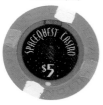

LV Hilton $5 (7th)

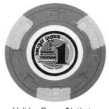

Holiday Queen $1 (1st)

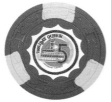

Holiday Queen $5 (1st)

Issue	Den.	Color	Mold	Inserts	Inlay	Rarity	GD30	VF65	CS95
	n/d	Navy	H&C	3pch3pur	R-white	R-9	50	100	150
("Sweet 16th".)									
	RLT A	3 diff.	HHR	None	HS-silver	R-9	15	30	45
(Colors: Aqua, Mustard, and Rust)									
	RLT B	2 diff.	HHR	None	HS	R-8	10	20	30
(Colors: Brown and Purple.)									
	RLT C	3 diff.	HHR	None	HS	R-8	10	20	30
(Colors: Brown, Purple, and Rust)									
	RLT D	3 diff.	HHR	None	HS	R-8	10	20	30
(Colors: Cream, Brown, and Rust)									
4th	1.00	Tan	House	None	HUB-white	R-4	4	8	12
	5.00	Brown	House	6yel	HUB-white	R-4	12	24	36
(Above two marked "Las Vegas, NV".)									
	NCV 5	Pink	H&C	None	HS	R-8	10	20	30
5th	1.00	Beige	House	None	R-blue	R-3	3	6	9
	5.00	Maroon	House	2gry	R-blue	R-3	8	16	24
	bac 20.00	Green	House	3pur	R-white	R-5	20	40	60
	25.00	Green	House	6yel3fch	R-blue	R-5	25	50	75
	bac 100.00	Black	House	2pnk	R-white	R-7	100	175	250
	100.00	Black	House	8grn3pnk	R-blue	R-5	100	150	200
(Building issue.)									
	NCV 5	Red	Wico	3wht	OR-white	R-4	5	10	15
	NCV 25	Green	Wico	6blu3wht	OR-white	R-5	7	14	21
	NCV 100	Black	Wico	8blu	OR-white	R-5	8	16	24
	NCV 100	Turq	Wico	6org	OR-white	R-5	8	16	24
	NCV 1000	Orange	Wico	8nvy4grn	OR-white	R-7	18	36	54
	NCV 1000	White	Wico	4org	OR-white	R-10	35	70	105
("Let it Ride" set.)									
6th	1.00	White	Chipco	6blu3wht	FG-multi	R-1	1	3	5
	5.00	Red	Chipco	6blk6yel	FG-multi	R-3	5	8	12
(Starlight Express: Electra, Greaseball, Pearl, Poppa, and Rusty.)									
	bac 20.00	Green	Chipco	None	FG-multi	R-5	20	40	60
	25.00	Green	Chipco	8blu4yel	FG-multi	R-4	25	30	50
	bac 100.00	Black	Chipco	None	FG-multi	R-6	100	175	250
	100.00	Black	Chipco	None	FG-multi	R-6	100	120	140
7th	5.00	Red	House	2blu2ltblu	R-black	R-1	*	5	10
	25.00	Green	House	3ltgrn3crm	R-black	R-5	25	50	100
	100.00	Black	House	3pnk3gry	R-black	R-7	100	150	250
("Spacequest Casino". The $25 and $100 chips have problem inlays - they peel off easily!)									
	RLT	4 diff.	House	4brn	OR-white	R-6	8	16	24
("Spacequest Casino". Colors: Blue, Brown, Cream, and Yellow.)									
	RLT	Pink	House	4blk	OR-white	R-7	10	20	30
	RLT	5 diff.	Roulet	None	OR-white	R-4	2	4	6
("The Night Club". Colors: Dk Blue, Green, Lavender, Orange, and Purple.)									
8th	bac 20.00	Green	House	4org	OR-multi	R-1	*	20	30
	25.00	Green	House	4pnk	OR-white	R-1	*	25	30
	bac 100.00	Black	House	6blu	OR-multi	R-1	*	100	110
	100.00	Black	House	6blu	OR-white	R-1	*	100	110

HOLIDAY QUEEN		LAS VEGAS			1971-73				
HOLIDAY CASINO					1973-92				
1st	1.00	BluGry	C&J	3tan	SCA-white	R-8	300	600	900
	5.00	Red	C&J	3yel	R-white	R-8	400	800	1200
	25.00	Green	C&J	3pur	COG-white	Unique*	900	1800	2700

Issue	Den.	Color	Mold	Inserts	Inlay	Rarity	GD30	VF65	CS95
	100.00	Black	C&J	8pnk	HUB-white	R-9	700	1400	2100
(Of the five known, two are notched. First issue is "Holiday Queen". This casino is now Harrah's.)									
2nd	5.00	Red	House	3ltbrn3yel	SCA-white	R-7	150	300	450
3rd	5.00	Red	H&C	3brn3gry	MC-green	R-7	100	200	300
	25.00	Green	H&C	3org3pnk	MC-gold	R-10	400	800	1200
	RLT V	Yellow	Roulet	None	R-white	R-8	15	30	45
4th	1.00	Blue	H&C	6wht3red	R-white	R-4	30	75	150
(This is one of the Bi-Centennial issues of 1976. Very hard to find in top condition.)									
5th	1.00	Blue	H&C	6wht3red	R-white	R-3	7	14	21
6th	1.00	Blue	House	6wht3red	R-multi	R-3	5	10	15
	5.00	Red	House	4pch4org	SCA-multi	R-4	12	24	36
	25.00	Green	House	4yel4dkbrn	HUB-multi	R-6	75	150	225
	100.00	Black	House	3gry3org3grn	COG-multi	R-7	100	200	300
	500.00	White	House	6blk3pnk	R-multi	R-8	150	300	450
("Las Vegas, NV".)									
7th	5.00	Red	House	3pch3org	SCA-multi	R-5	15	30	45
	25.00	Green	House	4yel4dkbrn	SCA-multi	R-7	100	200	300
	100.00	Black	House	3grn3org3gry	COG-multi	R-8	100	200	300
	500.00	Dk Purple	House	3grn3brn3pch	R-multi	Unique*	300	600	900
("Las Vegas".)									
	NCV 5	Pink	Clover	None	HS	R-7	10	20	30
	RLT A	5 diff.	House	None	R-red	R-6	5	10	15
(Colors: Blue, Brown, Fuchsia, Orange, and White.)									
	RLT B	2 diff.	House	None	R-white	R-7	8	16	24
(Colors: Blue and Fuchsia.)									
	RLT D	Cream	House	None	R-gold	R-7	7	14	21
	RLT D	Cream	House	None	R-purple	R-7	7	14	21
	RLT E	Brown	House	None	R-blue	R-7	7	14	21
	RLT E	Grey	House	None	R-white	R-7	7	14	21
	RLT F	Lt Blue	House	None	R-white	R-8	10	20	30

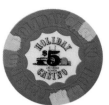

Holiday $5 (2nd)

Holiday $25 (3rd)

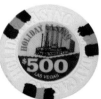

Holiday $500 (7th)

HOLIDAY INN–BOARDWALK LAS VEGAS 1995-98

Issue	Den.	Color	Mold	Inserts	Inlay	Rarity	GD30	VF65	CS95
1st	1.00	White	H&C	1grn1fch1pur	OR-multi	R-3	2	4	6
	5.00	Red	H&C	4pnk	OR-multi	R-4	5	10	15
	25.00	Green	H&C	3yel3grn3org	OR-multi	R-6	25	50	75
	100.00	Black	H&C	4lav4pnk4pur	OR-multi	R-7	100	150	200
	NCV 5	Orange	H&C	None	HS	R-7	6	12	18
	RLT 1	2 diff.	H&C	None	HS	R-6	3	6	9
(Colors: Blue and Grey)									

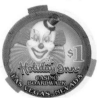

Holiday Inn Boardwalk $1 (1st)

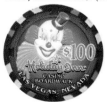

Holiday Inn Boardwalk $100 (1st)

HOLIDAY INTERNATIONAL LAS VEGAS 1977-80

Issue	Den.	Color	Mold	Inserts	Inlay	Rarity	GD30	VF65	CS95
1st	.25	Red	Diecar	None	HS	R-5	6	12	18
	.25	Yellow	Diecar	None	HS	R-5	8	16	24
	.50	Orange	Diecar	None	HS	R-4	5	10	15
	1.00	Blue	BJ-1	3org	COIN	R-1	2	4	6
	5.00	Red	BJ-1	6pnk	COIN	R-2	4	8	12
	25.00	Green	BJ-1	6wht	COIN	R-2	6	12	18
	100.00	Black	BJ-1	6yel	COIN	R-4	10	20	30
	500.00	Lavender	BJ-1	6pur	COIN	R-9	150	300	450
	NN 1.00	Lt Green	Diecar	None	HS	R-5	6	12	18
("Keno".)									
	NN 1.00	Green	Diecar	None	HS	R-4	5	10	15
("Table Games". There are variants of 3 different shades of green - same rarity and price.)									
	pok	3 diff.	Diecar	None	HS	R-5	5	10	15

Holiday International $500 (1st)

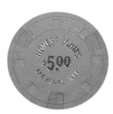

Honest John's $5 (1st)

Honest John's $25 (2nd)

Hoot Gibson's $5 (1st)

Horseshoe 25¢ (2nd)

Horseshoe $5 (2nd)

Horseshoe $5 (3rd)

Issue	Den.	Color	Mold	Inserts	Inlay	Rarity	GD30	VF65	CS95
(Colors: Green, Red, and White.)									
(Became Park Hotel, then Main Street Station.)									

HONEST JOHN'S · LAS VEGAS · 1963-74

Issue	Den.	Color	Mold	Inserts	Inlay	Rarity	GD30	VF65	CS95
1st	5.00	Mustard	C&J	3pnk	HS	R-5	30	60	90
2nd	5.00	Yellow	H&C	3org	R-white	R-6	50	100	250
(Almost all examples are very worn.)									
	25.00	Green	H&C	3grn	HUB-white	R-5	40	80	120
3rd	3.00	Red	Ewing	None	R-white	R-7	20	40	60

(Paper center is stamped blue.)
(This Honest John's was located at Sahara & the Strip next to the Centerfold - now the Bonanza Gift Center. There were four Honest John's around town, but most only had slots.)

HOOT GIBSON'S D4C RANCH LAS VEGAS · 1944-1950

Issue	Den.	Color	Mold	Inserts	Inlay	Rarity	GD30	VF65	CS95
1st	5.00	Red	Diasqr	None	HS	R-9	300	600	900
	25.00	Navy	Diasqr	None	HS	R-5	100	150	250
2nd	5.00	Maroon	HHR	None	HS	R-5	50	100	150

(This dude ranch was near Spring Mountain & the strip, behind the present day Mirage & Treasure Island. Famous hangout for divorcees, which explains the "D4C".)

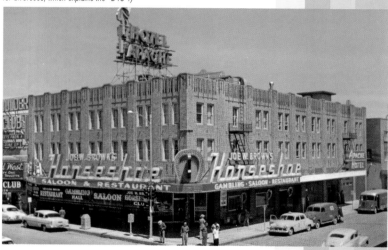

Postcard of the Horseshoe, an infamous downtown landmark since 1951. ©Ferris H. Scott, Santa Ana, CA.

HORSESHOE CLUB · LAS VEGAS · 1951-

Issue	Den.	Color	Mold	Inserts	Inlay	Rarity	GD30	VF65	CS95
1st	.50	Red	Lcrown	None	HS	R-6	125	250	375

(T.R. King's records show that this was ordered by the Horseshoe in 1951. 50 chips uncovered.)

	5.00	Red	Lcrown	3yel	HS	R-10	50	100	150

(This chip is identical in design, but records show that this chip was ordered as a movie prop for Universal Studios! Inserts are painted on.)

2nd	.25	Red	Arodie	None	R-white	R-2	10	20	50
	5.00	Blue	Arodie	3red	R-white	R-2	15	50	100

(This issue pictures just a horseshoe. A large quantity of these two chips appeared on the market in 1999. However, few examples are in top condition.)

3rd	5.00	Mustard	Arodie	3red	R-white	R-1	10	25	100

(A truckload of these pieces appeared on the market in 1999, decimating their previous valuation. However, 99% of the available examples are quite worn and a top example is hard to come by.)

Issue	Den.	Color	Mold	Inserts	Inlay	Rarity	GD30	VF65	CS95
	25.00	Orange	Arodie	3blk	R-white	R-9	750	1500	2250

(Six examples of this previously unknown chip appeared in Las Vegas in early 1999. Since that time, no other pieces have been offered for sale. It is possible that this particular chip is legitimately rare, but only time will tell.)

	100.00	Black	Arodie	3tan	R-white	R-4	100	200	300
	500.00	Grey	Arodie	3lav	R-white	R-5	150	300	450

(This 3rd issue pictures Benny Binion in a horseshoe and is notable for having the only $500 Arodie known for any casino.)

4th	.25	Maroon	Arodie	3mst	R-white	R-6	150	300	450
	1.00	Grey	Arodie	3grn	R-white	R-4	75	150	300
	5.00	Orange	Arodie	3org	R-white	R-2	10	30	100

(At least half of all known pieces are drilled. Most examples are very worn.)

	25.00	Green	Arodie	3mst	R-white	R-3	40	80	120

(Picture of building. The market has been flooded on nearly all Horseshoe chips. Greedy, deceitful non-collectors have placed them everywhere, especially on Ebay & other areas of the internet.)

5th	.25	Tan	HCE	None	HS	R-6	50	100	150
	pan .25	Fuchsia	HCE	None	HS	R-8	75	150	225
	pan 1.00	Navy	HCE	None	HS	R-5	35	70	105
	1.00	Yellow	HCE	None	HS	R-10	30	60	90
	pan 2.00	Brown	HCE	None	HS	R-7	20	40	60

(Above two are marked "PAN" & no casino name, & are attributed to here.)

	5.00	Green	HCE	None	HS	R-7	50	100	150
	faro 5.00	Green	HCE	None	HS	R-10	200	400	600
	pan 10.00	Brown	HCE	None	HS	R-7	75	150	225
	25.00	Orange	HCE	None	HS	R-9	150	300	450

(All above except the faro have "Binions" scratched off with the B & S remaining. This was supposedly done by Joe W. Brown when he ran the Horseshoe.)

	RLT 1	4 diff.	HCE	None	HS	R-5	5	10	15

(Picture of horseshoe. Colors: Beige, Mustard, Navy, and Red)

	RLT 2	2 diff.	HCE	None	HS	R-5	5	10	15

(Colors: Navy and Red)

6th	.25	Red	HHL	None	R-white	R-2	10	20	50
	.50	Red/Yel	C&J	dovetail-red	HS	R-9	200	400	600
	.50	Red/Yel	C&J	dovetail-yel	HS	R-9	200	400	600
	FP 1.00	Pink	C&J	None	R-white	R-7	50	100	150
7th	.25	Red	Horshu	3blu-gry	R-white	R-5	35	70	105
8th	.25	Red	Lg-key	3gry	R-white	R-6	60	120	180
	.50	Mustard	Lg-key	3gry	R-white	R-6	70	140	210
9th	.25	Red	Diswrl	2bei	R-white	R-4	15	30	45
	.50	Purple	Diswrl	None	R-white	R-5	20	40	60
	1.00	Grey	Diswrl	2blk	R-white	R-5	30	60	90
	5.00	Blue	Diswrl	3red	R-white	R-6	75	150	300
	25.00	Green	Diswrl	3grn	R-white	R-10	500	1000	1500
10th	.25	Brown	Horshu	None	HS	R-5	5	10	15
	.25	Brown	Horshu	None	R-white	R-3	4	8	12
	.50	Purple	Horshu	None	R-white	R-4	8	16	24
	1.00	Beige	Horshu	2blk	R-white	R-1	*	1	3
	5.00	Navy	Horshu	3red	R-white	R-6	15	30	45

(This older issue has a slightly lighter color.)

	25.00	Green	Horshu	6mst3grn	R-white	R-2	10	20	30
	100.00	Black	Horshu	6crm3red	R-white	R-3	15	30	45
11th	1.00	Tan	Horshu	2blk	R-white	R-1	*	1	3

(Later reorder with smaller "Benny Binion's".)

	5.00	Navy	Horshu	3red	R-white	R-1	*	5	7
	25.00	Green	Horshu	6mst3red	R-white	R-1	*	25	30
	100.00	Black	Horshu	6mar3crm	R-white	R-1	*	100	110

Horseshoe $25 (3rd)

Horseshoe $1 (4th)

Horseshoe $1 (5th)

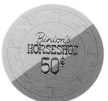

Horseshoe 50¢ (6th)

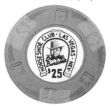

Horseshoe $25 (9th)

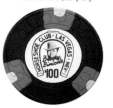

Horseshoe $100 (11th)

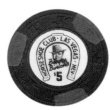
Horseshoe $5 (12th)

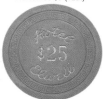
Hotel Elwell $25 (1st)

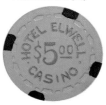
Hotel Elwell $5 (2nd)

Hualapei Men's Club n/d (1st)

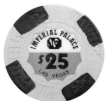
Imperial Palace $25 (1st)

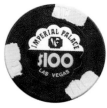
Imperial Palace $100 (1st)

Issue	Den.	Color	Mold	Inserts	Inlay	Rarity	GD30	VF65	CS95
12th	.25	Brown	H&C	None	HS	R-1	*	1	2
	1.00	Beige	H&C	2blk	R-white	R-1	*	1	2
	5.00	Navy	H&C	3red	R-white	R-1	*	5	7
(The reorder is a darker blue.)									
	25.00	Green	H&C	6mst3red	R-white	R-1	*	25	30
	100.00	Black	H&C	3bei6red	R-white	R-1	*	100	110
	25,000.00	Fuchsia	H&C	4blu4pch4pur	OR-multi	R-9*	50	100	150
	FP 1	Rose	H&C	None	R-white	R-8	7	14	21
	FP 1	Tan	H&C	2blk	R-white	R-8	7	14	21
(Marked "Parking" on reverse.)									
	NCV 1	Beige	H&C	None	R-white	R-9	10	20	30
	NCV 5	Dk Pink	H&C	8pur	HUB-white	R-10	25	50	75
	NCV 25	Green	H&C	8org	SCA-white	R-10	30	60	90
	NCV 100	Black	H&C	4blu4org	COG-white	R-10	35	70	105
	RLT 2	Purple	H&C	None	HS	R-5	3	6	9
	RLT 3	Purple	H&C	None	HS	R-5	3	6	9
13th	NCV500	Orange	BJ-P	16wht	R-white	R-5	30	60	90
("Hall of Fame Poker Classic '94".)									
14th	NCV500	Lavender	BJ-P	8blk4pnk	R-silver	R-4	9	18	27
("World Series of Poker '95".)									
	NCV500	Grey	BJ-P	16ltblu	R-silver	R-3	7	14	21
("World Series of Poker - Silver Anniversary".)									
	NCV 500	Yellow	BJ-P	8blu	R-red	R-4	8	16	24
	NCV 500	Yellow	BJ-P	8blu	R-yellow	R-4	8	16	24
("World Series of Poker Hall Of Fame Buy In" on both issues.)									
15th	n/d	Green	Chipco	None	FG-multi	R-10	25	50	75
(Barge VII – Roy Hashimoto 1997.)									
	NCV	Navy	BJ	None	HS	R-9	10	20	30
	NCV	Cream	BJ	None	HS	R-9	10	20	30
16th	.25	Red	Unicorn	None	HS	R-1	*	1	3

HOTEL ELWELL — LAS VEGAS — 1951-65

Issue	Den.	Color	Mold	Inserts	Inlay	Rarity	GD30	VF65	CS95
1st	5.00	Purple	Sm-key	None	HS	R-5	40	80	120
	25.00	Green	Sm-key	None	HS	R-6	100	200	300
2nd	5.00	Orange	Scrown	4nvy	HS	R-5	60	120	180

(Located behind the Pioneer, this became Pioneer Club's Hotel for awhile.)

HUALAPAI MEN'S CLUB — LAS VEGAS — 1950-94

Issue	Den.	Color	Mold	Inserts	Inlay	Rarity	GD30	VF65	CS95
	n/d	5 diff.	Zigzag	None	HS	R-5	15	30	45

(Colors: Black, Cream, Green, Purple, and Red. This men's social club was originally located in the El Cortez - later relocated to the Union Plaza.)

IMPERIAL PALACE — LAS VEGAS — 1980-

Issue	Den.	Color	Mold	Inserts	Inlay	Rarity	GD30	VF65	CS95
1st	.50	Yellow	H&C	None	HS	R-8	30	60	90
	1.00	Dk Blue	House	None	HS	R-7	30	60	90
	5.00	Red	House	3pnk	R-multi	R-6	20	40	60
(This issue has a darker red half circle in center. The later, second issue is lighter.)									
	25.00	Lime	House	4pur	SCA-multi	R-9	200	400	600
	100.00	Black	House	3pch3yel	HUB-multi	R-10	350	700	1050
	100.00	Black	House	4ltblu4blu	R-multi	Unique	100	200	300
(No Cash Value hot stamped on the back where inlay was removed. This may have been a backup.)									
	n/d	Black	H&C	None	HS	R-6	8	16	24
	n/d	White	H&C	None	HS	R-6	8	16	24

("Poker Room" on the above two.)

Issue	Den.	Color	Mold	Inserts	Inlay	Rarity	GD30	VF65	CS95
2nd	1.00	Lt Blue	House	None	HS-blue	R-5	20	40	60
	5.00	Red	House	3pnk	R-multi	R-5	15	30	45
	25.00	Green	House	3org	SCA-multi	R-8	75	150	225
	100.00	Black	House	3ltblu3brn	HUB-multi	R-1	*	100	115

(This old issue is still being used with the 4th issue.)

NCV	Blue	H&C	3blk3wht	R-multi	R-6	12	24	36	

Imperial Palace NCV (2nd)

($3 for 2 Match Play with picture of old car.)

RLT A	Orange	House	None	HS	R-7	5	10	15	
RLT B	Grey	House	None	HS	R-7	5	10	15	
RLT C	Grey	House	none	HS	R-7	5	10	15	
3rd	1.00	Grey	House	None	HS	R-3	4	8	12

(Only marked Las Vegas.)

4th	1.00	Grey	House	None	HS	R-1	*	1	3
	5.00	Red	House	3grn6pnk	R-multi	R-1	*	5	8
	25.00	Green	House	4ltgrn4org	SCA-multi	R-1	*	25	30
bac 100.00	Black	H&C	8pch	R-white	R-1	*	100	120	
rs 100.00	Black	House	8org	R-white	R-1	*	100	110	

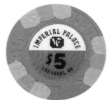

Imperial Palace $5 (4th)

NCV 5	Orange	H&C	2nvy	HS	R-8	7	14	21	
RLT A	Purple	H&C	None	OR-purple	R-5	3	6	9	
5th	RLT A-C	7 diff.	Roulet	None	OR-multi	R-4	2	4	6

(Colors: Blue, Dk Blue, Lt Green, Orange, Pink, Purple, and Yellow. There are three tables, each picturing a different antique car.)

INTERNATIONAL	**LAS VEGAS**	**1969-71**							
INTERNATIONAL – HILTON		**1971-73**							
1st	.50	Purple	HCE	None	R-orange	R-6	40	80	120
	1.00	Beige	HCE	None	R-orange	R-5	25	50	75
	5.00	Maroon	HCE	6yel3org	R-orange	R-8	250	500	750
	25.00	Green	HCE	6org3yel	R-orange	R-9	400	800	1200
	25.00	Green	HCE	6org3grn	R-blue	R-10	500	1000	1500

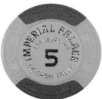

Imperial Palace NCV 5 (4th)

(This chip has a blue background and pink writing.)

	100.00	Black	HCE	6pur3yel	R-orange	R-10	500	1000	1500
	500.00	Grey	HCE	6org3blk	R-orange	R-10*	500	1000	1500
2nd	5.00	Maroon	House	6yel3trq	SCA-white	R-6	50	100	150
	25.00	Green	House	6pnk3trq	SCA-white	R-7	75	150	225
	100.00	Black	House	6org3blu	SCA-white	R-8	200	400	600

("Hilton" on mold.)

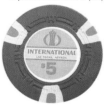

International $5 (1st)

JACKPOT CASINO	**N. LAS VEGAS**	**1961-66**							
1st	.25	Orange	C&J	None	HS	R-7	40	80	120
	1.00	Beige	C&J	3dkred	HS	R-5	30	60	90
	5.00	Navy	C&J	3yel	HS	R-7	60	120	180

(This was one of the only clubs located on E. Lake Mead Blvd.- near the present day Bighorn)

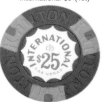

International $25 (2nd)

JACKPOT CASINO	**LAS VEGAS**	**1971-77**							
1st	1.00	Mustard	Ewing	None	HS	R-10	50	100	150

("JC" in double block letters.)

	1.00	Mustard	Ewing	None	HS	R-9	50	100	150
	5.00	Red	Ewing	None	HS	R-10	75	150	225

(Above two marked "Non Refundable" & "JC" in script.)

2nd	.25	Brown	Ewing	None	R-white	R-3	7	14	21
	1.00	Tan	Ewing	3org	R-white	R-3	7	14	21
	5.00	Orange	Ewing	3yel	SCA-white	R-4	15	30	45
	25.00	Green	Ewing	3red6yel	HUB-white	R-5	25	50	75

Jackpot Casino $1 (2nd)

Jerry's Nugget $5 (1st)

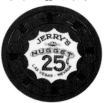

Jerry's Nugget 25¢ (2nd)

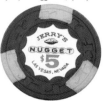

Jerry's Nugget $5 (2nd)

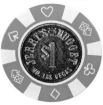

Jerry's Nugget $1 (5th)

Jockey Club $5 (1st)

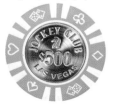

Jockey Club $500 (1st)

Issue	Den.	Color	Mold	Inserts	Inlay	Rarity	GD30	VF65	CS95
(All are made with round gold hot stamps, not cancels.)									
3rd	NN 1.00	Yellow	H&C	None	HS	R-9	50	100	150
(On the strip at Sahara.)									
JENNIE V's CASINO			**LAS VEGAS**			**1976-77**			
1st	1.00	Blue	H&C	None	HS	R-4	10	20	30
	5.00	Red	H&C	3pur	HS	R-5	20	40	60
	25.00	Green	H&C	3brn	HS	R-5	30	60	90
(Located on Ogden Street.)									
JERRY'S NUGGET			**N. LAS VEGAS**			**1964-**			
1st	.25	Rose	Scrown	None	HS	R-10	150	300	450
	1.00	Grey	Scrown	4nvy	HS	R-4	10	30	45
	5.00	Orange	Scrown	4lim	HS	R-7	60	120	180
	25.00	Red	Scrown	4grn4gry	HUB-white	R-10	400	800	1200
2nd	.25	Purple	C&J	None	HS	R-7	35	70	105
	.25	Purple	C&J	None	SCA-white	R-6	30	60	90
	5.00	Maroon	C&J	3mst	SCA-white	R-8	150	300	450
	25.00	Green	C&J	4red	SCA-white	R-6	25	50	75
	NN 1.00	Mustard	Diamnd	None	HS	R-4	4	8	12
	NN 5.00	Black	C&J	None	HS	R-7	15	30	45
3rd	25.00	Green	H&C	4red	SCA-white	R-1	*	25	35
4th	.25	Purple	Diecar	None	HS	R-7	15	30	45
	.50	Mustard	Diecar	None	HS	R-6	10	20	30
	1.00	Brown	BJ-2	6org	COIN	R-5	20	40	60
5th	.50	Yellow	BJ	None	HS	R-1	*	1	3
	1.00	Orange	BJ-2	6wht	COIN	R-1	*	1	3
	1.00	Orange	BJ-2	6wht	COIN	R-1	*	1	3
(Larger $1, "No. Las Vegas" only. One variant is lighter orange & spun metal center.)									
	1.00	Orange	BJ-2	6wht	COIN	R-1	*	1	3
(Smaller $1 & NV. This & above are dice & suits mold.)									
	1.00	Orange	BJ-2	6wht	COIN	R-1	*	1	3
(As above but 6 card suits on mold only & a little darker orange.)									
	5.00	Red	BJ-2	6blu	COIN	R-1	*	5	7
	100.00	Black	BJ-2	6blu	COIN	R-1	*	100	110
	NCV 25	Grey	BJ	None	HS	R-8	6	12	18
	NCV 100	Dk Grey	BJ	None	HS	R-8	7	14	21
	NN 5.00	Turq.	BJ	None	HS	R-5	4	8	12
JOCKEY CLUB			**LAS VEGAS**			**c. 1983**			
1st	1.00	Blue	BJ-2	3brn	COIN	R-1	2	4	6
	5.00	Red	BJ-2	6brn	COIN	R-1	3	6	9
	25.00	Green	BJ-2	6brn	COIN	R-1	3	6	9
	100.00	Black	BJ-2	12brn	COIN	R-1	7	14	21
	500.00	Grey	BJ-2	12wht	COIN	R-2	15	30	45
	bac 500.00	Purple	BJ-2	6brn	COIN	R-2	15	30	45
(This casino never opened.)									
JOE'S LONGHORN CASINO			**N. LAS VEGAS**			**1990-97**			
1st	.50	Yellow	H&C	None	HS	R-2	2	4	6
	5.00	Red	H&C	4pur4yel	HUB-white	R-4	7	14	21
	25.00	Green	H&C	3blu3gry3pnk	SCA-white	R-6	30	60	90
(Currently the Bighorn Casino on Lake Mead Blvd.)									

Issue	Den.	Color	Mold	Inserts	Inlay	Rarity	GD30	VF65	CS95

JOKER CLUB — N. LAS VEGAS — 1973-80

Issue	Den.	Color	Mold	Inserts	Inlay	Rarity	GD30	VF65	CS95
1st	.50	Yellow	H&C	None	HS	R-9	150	300	450
	1.00	Blue	H&C	None	HS	R-9	125	250	375
	5.00	Red	H&C	3pnk	HS	R-10	200	400	600

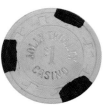

Jolly Trolley $1 (1st)

JOLLY TROLLEY — LAS VEGAS — 1977-78/1981-81

Issue	Den.	Color	Mold	Inserts	Inlay	Rarity	GD30	VF65	CS95
1st	.25	Brown	H&C	None	HS	R-6	8	16	24
	.50	Beige	H&C	None	HS	R-6	9	18	27
	1.00	Yellow	H&C	3blk	HS	R-5	10	20	40
	1.00	Orange	H&C	None	HS	R-4	4	8	12
	pok 1.00	Yellow	H&C	None	HS	R-5	10	20	40
	5.00	Red	H&C	3pnk	HS	R-5	15	30	60
	25.00	Green	H&C	3blu	HS	R-5	20	40	80
	NCV 1.00	Brown	H&C	None	HS	R-7	15	30	45
2nd	.25	Brown	Diecar	None	HS	R-5	5	10	15
	.50	Tan	Diecar	None	HS	R-6	8	16	24
	1.00	Mustard	Diecar	3blk	HS	R-7	20	40	60
	5.00	Red	Diecar	3pnk	HS	R-6	20	40	60
	25.00	Green	Diecar	3blu	HS	R-6	20	40	60
	100.00	Black	Diecar	3pnk	HS	R-4	15	30	45

(On Sahara & the Strip, originally Big Wheel, then The Wheel, then Centerfold.)

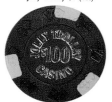

Jolly Trolley $100 (2nd)

KEY LARGO — LAS VEGAS — 1997-

Issue	Den.	Color	Mold	Inserts	Inlay	Rarity	GD30	VF65	CS95
1st	5.00	Red	BJ-2	16wht	OR-white	R-1	*	5	8
	25.00	Green	BJ-2	12wht	OR-white	R-1	*	25	30
	100.00	Black	BJ-2	8wht	OR-white	R-4	*	100	110
	RLT 1	Purple	Triclb	None	HS	R-5	3	6	9

(Was previously Quality Inn.)

Key Largo $25 (1st)

KING 8 — LAS VEGAS — 1974-88

Issue	Den.	Color	Mold	Inserts	Inlay	Rarity	GD30	VF65	CS95
1st	.25	Yellow	H&C	None	HS	R-8	40	80	120
	.50	Pink	H&C	None	HS	R-6	25	50	75
	1.00	Blue	H&C	None	HS	R-5	12	24	36
	5.00	Red	H&C	3pch	HS	R-8	100	200	300
	25.00	Green	H&C	3wht3grn	HS	R-10*	200	400	600
	NN 5.00	Purple	H&C	None	HS	R-6	10	20	30
	RLT	Orange	H&C	None	HS	R-8	10	20	30

(Picture of Crown on all above except $1.)

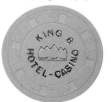

King 8 50¢ (1st)

Issue	Den.	Color	Mold	Inserts	Inlay	Rarity	GD30	VF65	CS95
2nd	1.00	Beige	H&C	4pnk	HS	R-4	5	10	15
	5.00	Red	H&C	3wht	HS	R-10	150	300	450
	25.00	Green	H&C	3wht3lav	HS	R-10	150	300	450
	NCV 1	Beige	H&C	None	HS	R-6	6	12	18
	NCV 5	Purple	H&C	None	HS	R-7	10	20	30
	NCV 25	Green	H&C	None	HS	R-9	15	30	45
3rd	1.00	Navy	H&C	None	HS	R-4	8	16	24
	5.00	Red	H&C	3pnk3yel	SCA-white	R-3	8	20	50

(This chip may be unknown in mint condition!)

Issue	Den.	Color	Mold	Inserts	Inlay	Rarity	GD30	VF65	CS95
	25.00	Green	H&C	4blu4dkgrn	COG-white	R-6	25	50	75
	100.00	Black	H&C	4gry4pnk	HUB-white	R-8	75	150	225

(Located on Tropicana west of the strip, renamed Wild Wild West.)

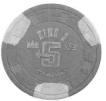

King 8 $5 (1st)

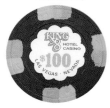

King 8 $100 (3rd)

Kings Crown $25 (1st)

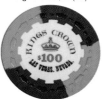

Kings Crown $100 (1st)

Klondike Inn $5 (1st)

Klondike Inn $5 (2nd)

Lady Luck $1 (2nd)

Lady Luck $2.50 (3rd)

Issue	Den.	Color	Mold	Inserts	Inlay	Rarity	GD30	VF65	CS95
KINGS CROWN			**LAS VEGAS**		**1962-64**				
1st	1.00	Beige	Scrown	None	R-white	R-4	3	6	9
	5.00	Red	Scrown	4blu	SCA-white	R-4	8	16	24
	5.00	Yellow	Scrown	3pur	SCA-white	R-4	10	20	30
	25.00	Green	Scrown	4org	HUB-white	R-4	12	24	36
	25.00	Turquoise	Scrown	3ltbrn	HUB-white	R-7	25	50	75
	100.00	Brn/Org	Scrown	2brn2org	COG-white	R-5	20	40	60
	500.00	White	Scrown	4pur4grn	SAW-white	R-10	100	200	300
	n/d	3 diff.	Scrown	None	HS	R-7	10	20	30
(Colors: Blue, Brown, and Lt Brown – overstamped center logo.)									
2nd	1.00	Beige	Scrown	4brn	R-white	R-1	3	6	9
	5.00	Red	Scrown	4blu	R-white	R-1	3	6	9
	25.00	Green	Scrown	4org	R-white	R-1	3	6	9
	100.00	Black	Scrown	4wht	R-white	R-1	3	6	9
	500.00	Orange	Scrown	4yel	R-white	R-1	5	10	15
(Second issue chips were made as movie props and sold by TR King & Co. Other variants & values exist. This casino never opened, but eventually the Aladdin was built on this spot.)									
KIT CARSON			**LAS VEGAS**		**1946-51**				
1st	5.00	Orange	Sm-key	None	HS	Unique	500	1000	1500
(This chip is overstamped with letters LGS over denomination, may be an error chip.)									
	5.00	Mustard	Sm-key	2gry	HS	R-10	500	1000	1500
	100.00	Cream	Sm-key	2red	HS	Unique	700	1400	2100
(Originally one of the early motels on the strip, next to the La Rue. As with other early Vegas chips no town name is given.)									
KLONDIKE INN			**LAS VEGAS**		**1982-83/1996-**				
1st	1.00	Lt Blue	H&C	None	HS	R-3	10	20	30
	5.00	Red	H&C	None	HS	R-3	10	20	30
2nd	5.00	Red	Plain	6grn	HS	R-1	*	5	8
	25.00	Green	Plain	6pnk	HS	R-1	*	25	30
3rd	5.00	Red	Plain	6grn	HS	R-1	*	5	8
(A reorder chip. Same chip as the previous issue, except the writing is slightly different.)									
LADY LUCK			**LAS VEGAS**		**1964-**				
1st	.25	Navy	Diecar	None	HS	R-3	4	8	12
	1.00	Grey	Nevada	None	HS	R-9	200	400	600
	5.00	Red	Nevada	3org	HS	R-9	200	400	600
	25.00	Green	Nevada	3pur	HS	R-10	350	700	1050
	RLT	Red	Diecar	None	HS	R-8	5	10	15
	RLT	Navy	Nevada	None	HS	R-8	5	10	15
(These roulettes are only marked in block letters "LL". Nevada & Diecars were used together.)									
2nd	1.00	Beige	Nevada	3blk	R-white	R-10*	350	700	1050
3rd	.25	Navy	Nevada	None	HS	R-3	5	10	15
	.25	Navy	Nevada	None	HS	R-5	8	16	24
(This variant is a darker shade.)									
	1.00	Tan	Nevada	3pnk	R-white	R-7	125	250	400
	2.50	Mustard	Nevada	3fch	R-white	R-6	100	200	400
	5.00	Red	Nevada	3org	R-white	R-8	250	500	1000
(Most of the above two chips are found well used.)									
	25.00	Green	Nevada	3pur	R-white	R-10*	500	1000	1500
4th	2.50	Mustard	Nevada	3mar	R-white	R-4	25	50	75
(Red heart instead of face.)									
	FP 1.00	Black	Nevada	None	HS	R-6	10	20	30
5th	.25	Navy	H&C	None	HS	R-3	3	6	9
	2.50	Mustard	H&C	3red	R-white	R-5	25	50	75

Issue	Den.	Color	Mold	Inserts	Inlay	Rarity	GD30	VF65	CS95
(No face.)									
	100.00	Black	H&C	4pur4org	HS	R-8	100	200	300
	NCV	2 diff.	H&C	None	HS	R-7	7	14	21
(Colors: Black and Green)									
6th	1.00	White	BJ-2	4org	COIN	R-1	*	1	3
	1.00	White	BJ-2	4dkorg	COIN	R-1	*	1	3
	5.00	Red	BJ-2	4org	COIN	R-1	*	5	8
	25.00	Green	BJ-2	4org	COIN	R-1	*	25	30
	RLT 1	Yellow	BJ	None		R-6	2	4	6
7th	100.00	Black	H&C	3pnk3gry3blu	R-white	R-1	*	100	110
	NCV	Beige	Triclb	None	HS	R-5	3	6	9
	NCV	Beige	HHR	None	HS	R-5	3	6	9

Lady Luck $2.50 (5th)

La Mirage $5 (1st)

LA MIRAGE LAS VEGAS 1986–89

Issue	Den.	Color	Mold	Inserts	Inlay	Rarity	GD30	VF65	CS95
1st	.25	Pink	BJ	None	HS	R-5	12	24	36
	1.00	Lt Blue	BJ	None	HS	R-4	12	24	36
	5.00	Red	BJ-2	6yel	COIN	R-7	60	120	180
	25.00	Green	BJ-2	4yel	COIN	R-10	200	400	600
	100.00	Black	BJ-2	12pnk	COIN	Unique	300	600	900
	NCV	2 diff.	H&C	None	HS	R-7	10	20	30

(Colors: Peach and Red.)
(Originally Ambassador Casino on Flamingo & Paradise, the name was sold to Steve Wynn as he didn't want any confusion of the name for his new mega resort The Mirage. The La Mirage changed to Anthony's for a short time, then became Quality Inn, and now Key Largo.)

Landmark $5 (1st)

LANDMARK LAS VEGAS 1967–90

Issue	Den.	Color	Mold	Inserts	Inlay	Rarity	GD30	VF65	CS95
1st	.50	Tan	C&J	None	HS	R-8	100	200	300
	1.00	Maroon	C&J	None	R-white	R-6	200	400	600
	5.00	Mustard	C&J	3fch	R-white	R-7	400	800	1600
	25.00	Green	C&J	3org	SCA-white	R-9	1250	2500	3750
	100.00	Black	C&J	3crm	SCA-white	R-10*	1500	3000	4500

(This classic first issue has a great picture of the landmark tower and is always in demand. Rumors abound that hoards of these chips exist, but year after year, the chips never surface. Landmark originally opened in the early 60's without a casino.)

2nd	1.00	Green	H&C	None	HS	R-9	300	600	900
	2.00	Blue	H&C	3wht3red	MC-red	R-6	125	250	375
	5.00	Red	H&C	3yel	MC-green	R-7	175	350	525
	25.00	Green	H&C	3crm3pch	MC-gold	R-9	600	1200	1800
	100.00	Black	H&C	3blu3gry	MC-blue	R-10	750	1500	2250

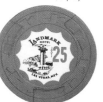

Landmark $25 (1st)

(Above four chips are Paulson metal center pieces. The $2 is considered by many to be a Bi-Centennial issue, but there is controversy on this point. This set is dated 6 of 76.)

	NCV 5	Yellow	H&C	3fch	HS	R-7	40	80	120
	NCV 25	Fuchsia	H&C	3brn	HS	R-10	100	200	300
	NCV 100	Grey	H&C	3brn3yel	HS	R-10	125	250	375
3rd	pan .50	Orange	H&C	None	HS	R-10	200	400	600
	pok 1.00	Tan	H&C	None	HS	R-9	175	350	525
	1.00	Blue	H&C	None	HS	R-4	30	75	150
	5.00	Red	H&C	3ltbrn	HS	R-5	50	125	250

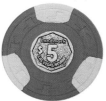

Landmark $5 (2nd)

(Above two chips are usually found in very worn condition.)

	25.00	Green	H&C	3bei	HS	R-9	200	400	600
	100.00	Black	H&C	3yel3blu	HS	R-9	250	500	750
	NCV 1	White	H&C	None	HS	R-9	30	60	90
	NCV 5	Red	H&C	None	HS	R-8	30	60	90
("Tournament" chip.)									
4th	NCV 5	Dk Grey	BJ	None	HS	R-6	20	40	60
	NCV 5	Yellow	BJ	None	HS-red	R-7	25	50	75

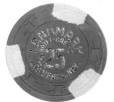

Landmark $25 (3rd)

La Rue 5¢ (1st)

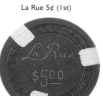

La Rue $5 (1st)

Las Vegas Club RLT (1st)

Las Vegas Club $25 (2nd)

Las Vegas Club $100 (2nd)

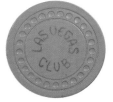

Las Vegas Club $5 (3rd)

Issue	Den.	Color	Mold	Inserts	Inlay	Rarity	GD30	VF65	CS95
LA RUE			**LAS VEGAS**			**1950-51/1952-54**			
1st	.05	Orange	Sm-key	3grn	HS	R-10	700	1400	2100
	5.00	Brown	Sm-key	3tan	HS	R-8	250	500	750
	n/d	Cream	Circls	None	HS-black	R-6	35	70	105

(Marked "Restaurant" and attributed here.)
(La Rue & the Kit Carson that was located next door, became the Sands.)

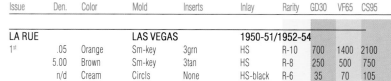

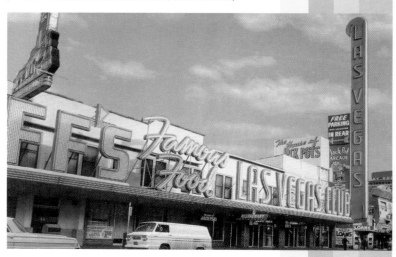

Postcard picturing the Las Vegas Club of the early 1970s, before their sports-themed makeover. ©H.S. Crocker, Co., Los Angeles.

LAS VEGAS CLUB			**LAS VEGAS**			**1931-**			
1st	5.00	Brown	C	None	HS	R-8	200	400	600

(Marked "LVC". This early mold goes back to 1900. This club had gaming as early as 1920 - although not always legal.)

	RLT	Purple	C&S	None	R-white	R-8	100	200	300

("LVC". A few of these early chips were found in the wall of the casino during construction.)

	n/d	2 diff.	Zigzag	None	HS	R-6	30	60	90

("JKH" for owner J.K. Houssels. Colors: Green and Lavender.)

	200.00	Navy	Lcrown	2wht	HS	Unique*	700	1400	2100
	RLT	Grey	Lcrown	None	HS	R-6	30	60	90
	RLT	Beige	Lcrown	None	HS	R-7	40	80	120
	RLT	Red	Lcrown	None	HS	R-7	40	80	120
	RLT	Green	Lcrown	None	HS	R-7	50	100	150

("Las Vegas Club" written in three lines.)

	RLT	Purple	Lcrown	None	HS	R-6	30	60	90
	RLT	Green	Lcrown	None	HS	R-6	30	60	90
	RLT	Red	Lcrown	None	HS	R-10	125	250	375
	RLT	Yellow	Lcrown	None	HS	R-10	125	250	375

("Las Vegas Club" written in two lines.)

2nd	5.00	Maroon	Diamnd	None	HS	R-10	400	800	1200
	25.00	Blue	Diamnd	None	HS	R-7	200	400	800
	100.00	White	Diamnd	None	HS	R-10	500	1000	1500
3rd	5.00	Red	Dots	None	HS	R-6	150	300	450
4th	.25	Mustard	X's	None	HS	R-6	40	80	200
	n/d	Black	Rectl	None	HS	R-8	20	40	60

("LV" in a horseshoe. This chip is only attributed to Las Vegas Club.)

Issue	Den.	Color	Mold	Inserts	Inlay	Rarity	GD30	VF65	CS95
5th	.10	Black	TK	None	HS	R-6	50	100	150
	.25	Lavender	TK	None	HS	R-10	300	600	900
6th	5.00	Orange	T's	None	HS	R-10*	400	800	1200
	25.00	Black	T's	None	HS	R-6	125	250	375
7th	.10	Lavender	Rcthrt	None	HS	R-10*	350	700	1050

(This chip is usually well used & faded to grey.)

	.10	Black	Rcthrt	3red	HS	R-10	300	600	900
	.25	Lavender	Rcthrt	None	HS	R-10	250	500	750
	25.00	Purple	Rcthrt	3crm	R-white	R-10	2000	4000	6000

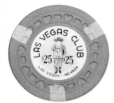

Las Vegas Club $25 (7th)

(Three of these awesome inlaid picture chips were found in the Colorado River!)

8th	5.00	Mustard	Arodie	3red	R-white	R-8	1500	3000	4500

(There are at least eight pieces known of this highly sought after arodie picture chip, one of the top 10 on most collectors want lists! A hard to find chip in premium condition.)

9th	.10	Black	Horshu	None	HS	R-5	50	100	150
	.25	Lavender	Horshu	None	HS	Unique	250	500	750
10th	pan n/d	Navy	Sqsqrt	None	HS	R-3	15	30	45
11th	.10	Dk Green	C&J	None	HS	R-5	30	60	90
	.10	Fuchsia	C&J	None	HS	R-10	250	500	750
	.25	Purple	C&J	None	HS	R-7	50	100	150
	5.00	Mustard	C&J	3nvy	R-white	R-5*	500	1000	1500

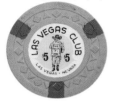

Las Vegas Club $5 (8th)

(Picture of One-Armed Bandit. All known survivors are damaged with a large, ugly, black cancellation and are worth 5% of listed prices.)

	n/d	Blu-Gry	C&J	None	R-white	R-9	75	150	225
	n/d	Lavender	C&J	None	R-white	R-10	100	200	300

(Great picture chips of the famous one-armed bandit!)

	RLT	2 diff.	HCE	None	HS	R-8	20	40	60

(Colors: Brown and Green.)

Las Vegas Club $5 (11th)

	RLT	Red	HCE	None	HS	R-10	50	100	150

("LVC".)

12th	.25	Beige	C&J	None	R-white	R-5	30	60	90
	.25	Grey	C&J	None	R-white	R-6	40	80	120
	5.00	Mustard	C&J	3red	R-white	R-7	225	450	675
	25.00	Dk Green	C&J	6lav3grn	R-white	R-10	700	1400	2100

(Picture of building.)

13th	pan .50	Orange	C&J	None	HS	R-6	25	50	75
14th	.25	Tan	C&J	None	HS	R-7	30	60	90
	1.00	Grey	C&J	None	R-white	R-5	25	50	75
	1.00	Blu-Gry	C&J	None	R-white	R-6	30	60	90

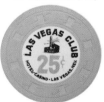

Las Vegas Club 25¢ (12th)

(This issue also has lighter green colored $1 & both are the large $1.)

15th	.25	Grey	C&J	None	HS	R-6	15	30	45
	1.00	Lt Blue	H&C	None	R-white	R-5	20	40	60
16th	.25	White	H&C	None	HS	R-4	5	10	15
	1.00	Navy	H&C	4yel	R-white	R-3	5	10	15
	5.00	Red	H&C	3blu	SCA-white	R-3	15	30	45

("Casino Center" on 14th, 15th & 16th issues.)

17th	1.00	Navy	H&C	4yel	R-white	R-2	3	6	9
	5.00	Red	H&C	3blu	SCA-white	R-3	10	20	30
	25.00	Green	H&C	3blu3pur	HUB-white	R-5	25	50	75
	100.00	Black	H&C	3brn3pnk	COG-white	R-5	50	100	150
	500.00	Beige	H&C	3brn3ltbrn3pur	HEX-white	R-5	150	300	450
	RLT A	5 diff.	H&C	None	R-white	R-6	4	8	12

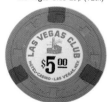

Las Vegas Club $5 (12th)

(Colors: Brown, Grey, Fuchsia, Lt Orange, and Orange.)

	RLT B	5 diff.	H&C	None	R-white	R-6	4	8	12

(Colors: Brown, Grey, Fuchsia, Lt Orange, and Orange.)

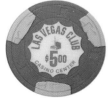

Las Vegas Club $5 (16th)

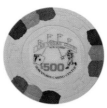

Las Vegas Club $500 (17th)

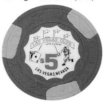

Las Vegas Club $5 (18th)

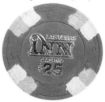

Las Vegas Inn $25 (1st)

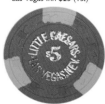

Little Caesar's $5 (1st)

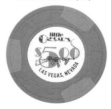

Little Caesar's $5 (2nd)

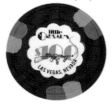

Little Caesar's $100 (2nd)

Issue	Den.	Color	Mold	Inserts	Inlay	Rarity	GD30	VF65	CS95
(Baseball Player. "Downtown Casino Center" on all above including roulettes.)									
18th	.25	Cream	H&C	None	HS	R-3	1	2	3
	1.00	Navy	H&C	4yel	R-white	R-2	2	4	6
	5.00	Red	H&C	3blu	SCA-white	R-3	6	12	18
(Baseball Player. "Las Vegas, Nevada". Bold Print.)									
19th	.25	White	H&C	None	HS	R-3	1	2	3
	1.00	Navy	H&C	4yel	R-white	R-1	2	4	5
	5.00	Red	H&C	3blu	SCA-white	R-3	5	10	15
(Baseball Player. "Las Vegas, Nevada". Fine Print.)									
	rs 20	Lavender	H&C	6pch3nvy	OR-white	R-9	75	150	225
	rs 100	Blue	H&C	4yel4org	OR-white	R-9	75	150	225
	rs 500	Green	H&C	8ltgrn4org	OR-white	R-6	30	60	90
	rs 5000	Black	H&C	4pch4blu	OR-white	R-6	40	80	120
	NCV	2 diff.	H&C	None	HS	R-5	2	4	6
(Colors: Grey and Orange.)									
	RLT A	3 diff.	H&C	None	R-white	R-7	4	8	12
(Colors: Fuchsia, Pink, and Purple)									
	RLT B	2 diff.	H&C	None	R-lt blue	R-7	4	8	12
(Colors: Brown and Pink)									
20th	.25	Orange	BJ	None	HS	R-1	*	1	2
	1.00	Blue	BJ	None	OR-multi	R-1	*	1	3
	5.00	Red	BJ-P	12nvy8wht	OR-multi	R-1	*	5	8
(Variants with picture of baseball batter and football player.)									
	25.00	Green	BJ-P	8yel4blk	OR-multi	R-1	*	25	30
	100.00	Black	BJ-P	12wht8pur	OR-multi	R-1	*	100	110
	RLT	4 diff.	BJ	None	R-yellow	R-4	2	4	6
(Colors: Blue, Brown, Green, and Tan.)									

LAS VEGAS INN LAS VEGAS 1981–85

1st	.50	Yellow	H&C	None	HS	R-5	6	12	18
	1.00	Blue	H&C	None	HS	R-4	8	16	24
	5.00	Red	H&C	4grn4ltbrn	HS	R-5	18	36	54
	25.00	Green	H&C	4blu4pnk	HS	R-5	25	50	75

(Was located a few blocks East of Palace Station by the freeway.)

LITTLE CAESAR'S LAS VEGAS 1970–94

1st	5.00	Red	C&J	3pnk	HS	R-8	200	400	600
2nd	.25	White	H&C	None	HS	R-2	4	8	12
	.25	White	H&C	None	HS	R-5	20	40	60
(Misspelled "Ceasars".)									
	1.00	Blue	H&C	None	HS	R-1	4	8	12
	5.00	Red	H&C	3org	R-white	R-2	15	30	75
	25.00	Green	H&C	3grn	R-white	R-2	25	50	125
(Above two chips are hard to find in top condition, especially the $25.)									
	100.00	Black	H&C	3org3grn	HUB-white	R-2	30	60	90
	rs 1000.00	Peach	H&C	3nvy6wht	NOT-white	R-2	40	80	120
	rs 5000.00	Fuchsia	H&C	8blu	TRI-white	R-5	75	150	225
	rs 10000.00	Orange	H&C	6pur2pnk	R-white	R-5	75	150	225

(This small casino had arguably the highest rolling sports book in Las Vegas. Owner Gene Maday encouraged action and large bets of several thousand dollars were common. The rumor was that Eastern bookies were laying off their bets here. Casino owner Bob Stupak was allowed to make a $1 million bet on the Super Bowl. He won. Professional sports bettors also made this their home.)

Issue	Den.	Color	Mold	Inserts	Inlay	Rarity	GD30	VF65	CS95

LITTLE CASINO — LAS VEGAS — 1953-65

Issue	Den.	Color	Mold	Inserts	Inlay	Rarity	GD30	VF65	CS95
1st	25.00	Orange	HCE	None	HS	R-3	20	40	60
	100.00	Maroon	Cord	3mst	HS	R-7	175	350	525

(This club was located on N. 1st St. Downtown.)

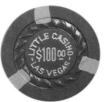

Little Casino $100 (1st)

LITTLE CLUB — LAS VEGAS — 1942-44/1946-52

Issue	Den.	Color	Mold	Inserts	Inlay	Rarity	GD30	VF65	CS95
1st	.10	Tan	HCE	None	HS	R-5	50	100	150
	.25	Rose	HCE	None	HS	R-4	25	50	75
	5.00	Green	HCE	None	HS	R-4	30	60	90

(Located on Main St. near Downtown.)

Little Club $5 (1st)

LOG CABIN — LAS VEGAS — c.late30's-40's

Issue	Den.	Color	Mold	Inserts	Inlay	Rarity	GD30	VF65	CS95
1st	n/d	Green	Lcrown	None	HS	R-7	20	40	60

(Attributed here. This early club was located on lower Fremont St.)

LONG BRANCH SALOON — N. LAS VEGAS — 1977-82

Issue	Den.	Color	Mold	Inserts	Inlay	Rarity	GD30	VF65	CS95
1st	1.00	Tan	Diecar	None	HS	R-3	12	24	36
	5.00	Red	Diecar	None	HS	R-4	15	30	45

LONGHORN CASINO — LAS VEGAS — 1988-

Issue	Den.	Color	Mold	Inserts	Inlay	Rarity	GD30	VF65	CS95
1st	.50	Pink	H&C	None	HS	R-1	*	1	3
	5.00	Red	H&C	4gry4pch	HUB-white	R-1	*	5	8
	25.00	Green	H&C	4org4pur	SCA-white	R-1	*	25	35
	100.00	Black	H&C	4blu4gld	R-multi	R-3	*	100	120

Lotus Inn $5 (1st)

LOTUS INN — LAS VEGAS — 1973-78

Issue	Den.	Color	Mold	Inserts	Inlay	Rarity	GD30	VF65	CS95
1st	5.00	Red	Cord	None	HS	R-8	350	700	1050
	25.00	Green	Cord	None	HS	R-10	800	1600	2400

(After the Lotus Inn closed, all of these pieces were destroyed except for two pairs of chips saved from extermination by a souvenir-seeking security guard. These two $25 chips are the only ones known. A few more $5's exist due to customers/ collectors walking out with them beforehand. Lotus Inn was located on the Strip north of Sahara Avenue along with Sambo's.)

Louigi's Broiler $25 (2nd)

LOUIGI'S BROILER — LAS VEGAS — 1951-71

Issue	Den.	Color	Mold	Inserts	Inlay	Rarity	GD30	VF65	CS95
1st	5.00	Orange	Sm-key	None	HS	Unique*	600	1200	1800
2nd	5.00	Orange	Rectl	4blk	HS	R-5	80	160	240
	25.00	Black	Rectl	4pnk	HS	R-10	600	1200	1800
3rd	5.00	Red	Rectl	3mst	HS	Unique	500	1000	1500
4th	1.00	Navy	C&J	3red	HS	R-7	90	180	270

(Famous gangster hangout on the Strip.)

Louisiana Club 50¢ (1st)

LOUISIANA CLUB — W. LAS VEGAS — 1955-70

Issue	Den.	Color	Mold	Inserts	Inlay	Rarity	GD30	VF65	CS95
1st	.50	Beige	C&J	None	HS-silver	R-10	500	1000	1500
	1.00	Navy	C&J	None	R-white	R-9	1200	2400	3600

(Two more pieces were discovered in 1999, bringing the total to 6 known.)

Issue	Den.	Color	Mold	Inserts	Inlay	Rarity	GD30	VF65	CS95
	5.00	Yellow	C&J	3grn	SCA-white	Unique*	1750	3500	5250
2nd	5.00	Navy	Arodie	3red	HS	R-9	1000	2000	3000

(Four known. This is possibly the last Arodie chip ever made. Stamped "ZL" for Zee Louie, the owner. This club is a real stopper for Las Vegas Type Set collectors.)

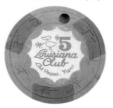

Louisiana Club $5 (1st)

LOVE'S & LEE'S — W. LAS VEGAS — 1970-85

Issue	Den.	Color	Mold	Inserts	Inlay	Rarity	GD30	VF65	CS95
1st	1.00	Red	H&C	None	HS	R-5	50	100	150

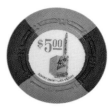
Lucky Casino $5 (1st)

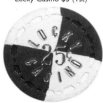
Lucky Casino 25¢ (2nd)

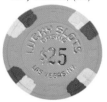
Lucky Slots $25 (1st)

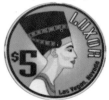
Luxor $5 (1st)

Main Street $100 (1st)

Main Street RLT (1st)

Issue	Den.	Color	Mold	Inserts	Inlay	Rarity	GD30	VF65	CS95
LOW COST GAMES		**W. LAS VEGAS**			**1964-1967**				
1st	.10	Maroon	Diamnd	None	HS	R-9	75	150	225
2nd	.25	Green	C&J	None	HS	R-9	100	200	300
	5.00	Tan	C&J	None	HS	R-6	25	50	75
("LC 21".)									
3rd	1.00	Lavender	C&J	None	HS	Unique	200	400	600
("L.C.G. $1.00 Only".)									
LUCKY CASINO		**LAS VEGAS**			**1963-67**				
1st	5.00	Nvy/Yel	HCE	½ pie	R-white	Unique	1500	3000	4500
	25.00	Grn/Pur	HCE	½ pie	R-white	Unique*	1500	3000	4500
	100.00	Blk/Wht	HCE	½ pie	R-white	Unique*	1500	3000	4500
2nd	.25	Brn/Wht	Scrown	½ pie	HS	R-9	200	400	600
	1.00	Beige	Scrown	None	OR-white	R-5	75	150	225
	RLT	6 diff.	Scrown	None	HS	R-5	7	14	21
(Colors: Blue, Dk Pink, Fuchsia, Purple, Red, and Yellow)									
3rd	.25	Green	H&C	None	HS	R-8	75	150	225
LUCKY SLOTS CASINO		**LAS VEGAS**			**1971-81**				
1st	1.00	Blue	H&C	None	HS	R-4	7	14	21
	5.00	Red	H&C	4blu4ltbrn	HS	R-5	30	60	90
	25.00	Green	H&C	4ltblu4mar	HS	R-6	50	100	150
(Located on the Strip, south of Aladdin, Lucky Slots became Silver Saddle.)									
LUXOR		**LAS VEGAS**			**1993-**				
1st	1.00	White	Chipco	None	FG	R-1	*	1	3
	5.00	Orange	Chipco	None	FG	R-1	*	5	8
	25.00	Green	Chipco	None	FG	R-1	*	25	30
	100.00	Black	Chipco	None	FG	R-1	*	100	110
	RLT A	4 diff.	BJ-P	None	OR-white	R-6	3	6	9
(Colors: Blue, Lime, Purple, and Yellow)									
	RLT B	4 diff.	BJ-P	None	OR-white	R-6	3	6	9
(Colors: Fuchsia, Pink, White, and Yellow)									
	RLT C	5 diff.	BJ-P	None	OR-white	R-6	3	6	9
(Colors: Cream, Pink, Purple, Red, and White)									
	RLT C	Yellow	Roulet	None	OR-white	R-4	2	4	6
2nd	RLT E	2 diff.	Roulet	None	OR-white	R-4	2	4	6
(Colors: Purple and White)									
	RLT F	Purple	Roulet	None	Or-white	R-4	2	4	6
	NCV 2	Mustard	HHR	None	HS	R-6	5	10	15
	bac 100.00	Black	H&C	3blu3yel3pnk	OR-black	R-1	*	100	110
	5000.00	Blue	H&C	2org2yel	FG-multi	R-8*	25	50	75
3rd	RLT 4	6 diff.	H&C	None	HS	R-10*	10	20	30
(Colors: Brown, Green, Grey, Purple, Orange, and Pink.)									
MAIN STREET		**LAS VEGAS**			**1991-92/1996-**				
1st	5.00	Red	Chipco	None	FG	R-4	25	50	75
	25.00	Green	Chipco	None	FG	R-8	250	500	750
	100.00	Black	Chipco	None	FG	R-10*	500	1000	1500
	500.00	Pink	Chipco	None	FG	Unique*	600	1200	1800
(Main Street was one of the first casinos to use Chipcos as their regular issue.)									
	RLT	Blu/Gry	HHR	None	R-white	R-9	10	20	30
2nd	.25	Grey	H&C	None	HS	R-1	*	1	2

Issue	Den.	Color	Mold	Inserts	Inlay	Rarity	GD30	VF65	CS95
	1.00	White	H&C	1mar1grn1org	OR-white	R-1	*	1	3
	5.00	Red	H&C	4wht4pnk	OR-white	R-1	*	5	8
	25.00	Green	H&C	4pnk4pur	OR-white	R-1	*	25	30
	100.00	Black	H&C	3pur3lav	OR-white	R-1	*	100	110
	RLT 1	3 diff.	Roulet	None	HS	R-4	2	4	6

(Colors: Blue, Lt Blue, and Gold.)

| | RLT 2 | Navy | Roulet | None | HS | R-4 | 2 | 4 | 6 |

(Main Street closed and re-opened in the same location.)

Main Street $25 (2nd)

MANDALAY BAY		LAS VEGAS			1999-				
1st	1.00	Blue	House	3pch3red3org	OR-multi	R-1	*	1	3
	5.00	Red	House	6crm6ltgrn	OR-multi	R-1	*	5	8
	bac 5.00	Red	House	6gld6crm	OR-multi	R-1	*	5	10
	bac 25.00	Green	House	4pch4wt4org	OR-multi	R-1	*	25	30
	25.00	Green	House	4sam4wht4org	OR-multi	R-1	*	25	30
	100.00	Black	House	12blu	OR-multi	R-1	*	100	110
	bac 100.00	Black	House	12blu	OR-blue	R-1	*	100	110

Mandalay Bay $5 (1st)

MARINA		LAS VEGAS			1975-90				
1st	.10	Blue	H&C	None	HS	R-10	100	200	300

(A box of 99 chips is rumored to have been found at a yard sale in Las Vegas. To date none have showed up, but if and when they do, this will be a $50 chip at best.)

| | .25 | Pink | H&C | None | HS | R-7 | 30 | 60 | 90 |
| | .50 | Yellow | H&C | None | HS | R-10 | 100 | 200 | 300 |

(Above three chips are marked "Card Room".)

	1.00	Blue	H&C	None	R-white	R-7	75	150	225
	1.00	Beige	H&C	None	R-white	R-4	10	20	30
	1.00	Beige	House	None	R-white	R-4	8	16	24
	5.00	Red	House	3yel	R-white	R-6	40	80	160
	25.00	Green	House	3grn	HUB-white	R-10	350	700	1050
	100.00	Black	House	3blu	SCA-white	R-10	400	800	1200
	NCV 5.00	Orange	H&C	3wht3blk	HS	R-5	10	20	30
	NCV 25.00	Grey	H&C	3brn3pnk	HS	R-6	12	24	36
	NCV 500	White	H&C	6blk3yel	HS	R-7	30	60	90
2nd	5.00	Red	H&C	3grn	HUB-multi	R-5	25	50	75
	25.00	Green	H&C	3yel	SCA-multi	R-5	30	60	90
	100.00	Black	H&C	3pnk	HUB-multi	R-5	50	100	150
	500.00	White	H&C	3yel3grn3pnk	SCA-multi	R-4	45	90	135
	NCV 5	Lt Blue	H&C	None	HS	R-6	7	14	21
	NCV 25	Pink	H&C	None	HS	R-6	10	20	30
3rd	.25	Orange	HHR	None	HS	R-6	20	40	60
	NCV 5	Pink	Clover	None	HS	R-5	7	14	21

Mandalay Bay $25 (1st)

Marina $5 (1st)

MAVERICK		N. LAS VEGAS			1960-71				
1st	.05	Beige	Rectl	None	HS	R-6	25	75	200
	.25	Red	Rectl	None	HS	R-6	15	45	150

(These all have extreme wear.)

| | 1.00 | Navy | Rectl | None | HS | R-8 | 12 | 24 | 36 |
| | 1.00 | Navy | Rectl | None | HS | R-5 | 8 | 16 | 24 |

(Variant in lettering style on this $1- shorter tail on "M".)

| | 5.00 | Brown | Rectl | None | HS | R-6 | 15 | 30 | 45 |
| | 25.00 | Yellow | Rectl | None | HS | R-7 | 20 | 40 | 60 |

(First issue the set is only marked "MCP". Most of these are very worn. Research shows this was Maverick Cowboy Palace. Originally thought to be Maverick Casino Poker.)

Marina $25 (2nd)

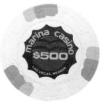

Marina $500 (2nd)

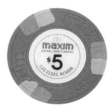

Maxim $5 (1st)

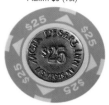

MGM Desert Inn $25 (1st)

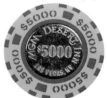

MGM Desert Inn $5000 (1st)

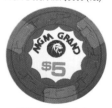

MGM Grand $5 (1st)

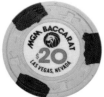

MGM Grand $20 (3rd)

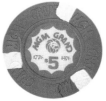

MGM Grand $5 (4th)

Issue	Den.	Color	Mold	Inserts	Inlay	Rarity	GD30	VF65	CS95
2nd	.25	Green	Sqincr	3mst	HS	R-4	15	30	45
	5.00	Red	Sqincr	3mst	HS	R-4	15	30	45

(This issue has the full name spelled out & "No. Las Vegas".)

MAXIM — LAS VEGAS — 1977-99

Issue	Den.	Color	Mold	Inserts	Inlay	Rarity	GD30	VF65	CS95
1st	1.00	Beige	House	None	R-white	R-1	2	3	5
	5.00	Red	House	3org3blu	R-white	R-1	5	10	15
	25.00	Green	House	3org3wht	SCA-white	R-5	25	50	75
	100.00	Black	House	3pur3pch	HUB-white	R-7	100	150	200
2nd	pok 5.00	Maroon	H&C	None	HS	R-8	15	30	45
	NCV	Black	H&C	None	HS	R-7	7	14	21
	NCV	Green	H&C	None	HS	R-7	7	14	21

MGM- DESERT INN — LAS VEGAS — 1988-91

Issue	Den.	Color	Mold	Inserts	Inlay	Rarity	GD30	VF65	CS95
1st	1.00	White	BJ-2	4brn	COIN-brass	R-4	5	10	15
	5.00	Red	BJ-2	8gry	COIN-brass	R-4	15	30	45
	5.00	Red	BJ-2	8yel	COIN-silver	R-10	200	400	600
	25.00	Green	BJ-2	4yel	COIN-brass	R-6	60	120	180
	25.00	Green	BJ-2	8wht	COIN-silver	Unique*	300	600	900
	100.00	Black	BJ-2	4pnk	COIN-brass	R-8	175	350	525
	100.00	Black	BJ-2	4gry	COIN-silver	Unique*	300	600	900
	500.00	Blue	BJ-2	12wht8blu	COIN-brass	R-9	250	500	750
	500.00	Blue	BJ-2	12pnk8blu	COIN-silver	Unique*	350	700	1050
	1000.00	Orange	BJ-2	8blu4wht	COIN-brass	R-10	350	700	1050
	1000.00	Orange	BJ-2	8blu4wht	COIN-silver	Unique*	350	700	1050
	5000.00	Yellow	BJ-2	16blu8ltblu	COIN-brass	R-10	350	700	1050
	5000.00	Yellow	BJ-2	16dkgrn8ltgrn	COIN-silver	Unique*	350	700	1050

(The COIN-silver inlays were the rarely used backup set.)

MGM GRAND — LAS VEGAS — 1973-86

Issue	Den.	Color	Mold	Inserts	Inlay	Rarity	GD30	VF65	CS95
1st	1.00	Grey	C&J	None	R-white	R-4	10	20	30
	5.00	Red	C&J	3trq	SCA-white	R-6	50	100	150
	25.00	Green	C&J	3pnk	COG-white	R-8	200	400	600
	100.00	Black	C&J	3gry	HUB-white	R-9	400	800	1200
	500.00	Fuchsia	C&J	3org	R-white	Unique*	700	1400	2100

(First issue has a larger lion head & barely any spacing of the fur. Also the $ is larger on the $1, $5, and $25.)

2nd	1.00	Grey	H&C	None	R-white	R-5	20	40	60

(Larger lion head but noticeable spacing lines in the fur. Also the $ is larger.)

3rd	1.00	Grey	H&C	None	R-white	R-3	10	20	30

(Smaller head, which measures 1/4 inch with spaces in hair. Also, the $ sign is small. There is a long and short cane version.)

	5.00	Red	H&C	3trq	SCA-white	R-9	100	200	300
	bac 5.00	Purple	H&C	3grn	R-white	R-9	350	700	1050
	bac 20.00	Yellow	H&C	3pur	R-white	R-10	400	800	1200
	25.00	Green	H&C	3pnk	COG-white	R-8	200	400	600
	100.00	Black	H&C	3blu3pnk	HUB-white	R-10	400	800	1200
	100.00	Black	H&C	3bei	HUB-white	R-10	400	800	1200

(These $100 chips have identical heads, but different inserts.)

	bac 100.00	Orange	H&C	3gry	R-white	R-10	400	800	1200
4th	5.00	Red	H&C	3blu3wht	SCA-white	Unique	1000	2000	3000
	5.00	Red	House	3blu3wht	SCA-white	R-5	100	200	300

(Above are Bi-Centennial chips from 1976.)

5th	100.00	Brown	H&C	3red3wht3nvy	R-white	R-7	5	10	15
	500.00	Fuchsia	H&C	3blu	R-white	R-7	5	10	15
	1000.00	Peach	H&C	3brn3yel3blu	R-beige	R-7	5	10	15

Issue	Den.	Color	Mold	Inserts	Inlay	Rarity	GD30	VF65	CS95

(Above three chips are marked "Metro Club". These have paste on inlays and were made specifically for the movie "Lookin! To Get Out" starring Ann-Margaret, shot in 1980. These chips were never used in a live game, which is why the values have been drastically reduced. Underneath the cheap paste-on inlay the chip is actually hot stamped with the movie title and date.)

6th	5.00	Brown	House	3mar3mst	SCA-white	R-4	30	60	90
	25.00	Green	House	3org3blk	COG-white	R-6	100	200	300
	100.00	Black	House	3blu3yel	HUB-white	R-10	400	800	1200
	500.00	Purple	House	3red3brn3bei	R-white	R-10*	500	1000	1500

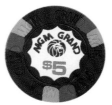

MGM Grand $5 (6th)

(This issue was in use during the famous fire of November 21, 1980.)

7th	5.00	Maroon	House	3org3trq	SCA-white	R-4	25	50	75
	100.00	Tan	House	3blk	COG-white	R-10*	400	800	1200

(This may be a prototype as it's a notched sample. The head is larger than all others.)

8th	5.00	Maroon	House	3pnk	HUB-white	R-6	30	60	90
	25.00	Mustard	House	3blk3ltgrn	COG-white	R-8	125	250	375
	bac 5.00	Green	House	3bei3blk	R-white	R-9	300	600	900
	bac 20.00	Brown	House	3yel3nvy	R-white	R-10	400	800	1200

MGM Grand $100 (6th)

(Much smaller lion head and "MGM Grand".)

9th	5.00	Maroon	House	3pnk	HUB-white	R-4	20	40	60
	25.00	Green	House	3nvy	SCA-white	R-7	150	300	450
	500.00	Purple	House	3org	R-white	R-10	500	1000	1500

(Bigger lion head and "MGM Grand" than the 8th issue.)

MGM-GRAND **LAS VEGAS** **1993-**

1st	1.00	White	BJ-H	None	R-white	R-1	2	4	6

(Green writing on edge.)

	1.00	White	BJ-H	None	R-white	R-9	100	200	300

(Rare issue with blue writing on edge.)

	5.00	Red	BJ-H	2wht	R-white	R-2	5	10	15
	5.00	Red	BJ-H	2wht	R-white	R-1	12	24	36

MGM Grand $25 (8th)

("Grand Opening December 1993".)

	bac 5.00	Red	BJ-H	12wht8lav	R-white	R-5	10	20	30	
	bac 20.00	Green	BJ-H	12yel8pur	R-white	R-6	20	40	60	
	25.00	Green	BJ-H	4yel	R-white	R-4	25	50	75	
	100.00	Black	BJ-H	8pnk	R-white	R-7	100	175	250	
	bac 100.00	Black	BJ-H	16pur8org	R-white	R-9	100	200	300	
	RLT 5.00	Grey	Plain	None			R-6	15	30	45
	RLT 10.00	Blue	Plain	None			R-5	15	30	45
	RLT 10.00	Blue	Plain	4brn			R-7	30	60	90
	RLT 10.00	Blue	Plain	3brn			R-7	30	60	90
	RLT 20.00	Red	Plain	None			R-8	50	100	150
	RLT 50.00	Orange	Plain	None			R-9	75	150	225
	RLT 100.00	Green	Plain	None			R-10	100	200	300

MGM Grand $5 BAC (8th)

(This set was used for French Roulette when the casino first opened. There is no inlay per se. The chips are made of acrylic plastic on which the information is printed.)

	RLT C	Pink	Plain	None	R-white	R-5	5	10	15
	RLT D	2 diff.	Plain	None	R-white	R-5	5	10	15

(Colors: Lime and Purple.)

	RLT L	Orange	Plain	None	R-white	R-5	5	10	15

MGM Grand Hotel RLT $50 (1st)

(This set pictures a Golden Lion like the way the original casino entrance was shaped.)

2nd	1.00	Blue	House	2wht	OR-white	R-1	*	1	3
	5.00	Red	House	2gry	OR-white	R-1	*	5	7
	bac 5.00	Red	House	2gry	OR-white	R-1	*	5	10
	25.00	Green	House	6yel3dkblu	OR-white	R-1	*	25	30
	bac 25.00	Green	House	6yel3dkblu	OR-white	R-1	*	25	32

MGM Grand Hotel RLT $100 (1st)

MGM Grand Hotel RLT P (2nd)

MGM-Marina $1 (1st)

MGM-Marina $5 (1st)

MGM-Sands $5 (1st)

MGM-Sands $25 (1st)

Mickey's 10¢ (1st)

Issue	Den.	Color	Mold	Inserts	Inlay	Rarity	GD30	VF65	CS95
	100.00	Black	House	3gry3org	OR-white	R-7	75	150	225
	NCV 100	Fuchsia	H&C	None	OR-multi	R-10	50	100	150
(Dated 1995, has multiple lion heads pictured on inlay.)									
	RLT A	2 diff.	Plain	None	OR-white	R-5	2	4	6
(Colors: Fuchsia and Blue)									
	RLT B	Lt Blue	Plain	None	OR-white	R-5	2	4	6
	RLT E	Lt Blue	Plain	None	OR-white	R-5	2	4	6
	RLT J	2 diff.	Plain	None	OR-white	R-5	2	4	6
(Colors: Lt.Blue and Orange)									
	RLT K	Brown	Plain	None	OR-white	R-5	2	4	6
	RLT P	Blue	Plain	None	OR-white	R-5	2	4	6
	RLT S	Brown	Plain	None	OR-white	R-5	2	4	6
	RLT T	Lt Blue	Plain	None	OR-white	R-5	2	4	6
	RLT V	Orange	Plain	None	OR-white	R-5	2	4	6
	RLT B	3 diff.	Plain	None	OR-white	R-5	3	6	9
(Colors: Brown, Orange and Purple)									
3rd	100.00	Black	House	3pur3gry	R-white	R-1	*	100	110
	NCV 100.00	Fuchsia	H&C	None	OR-white	R-10	35	70	105
4th	RLT F	2 diff.	BJ-P	None	R-white	R-2	2	4	6
(Colors: Brown and Purple. These have a picture of a golden lion head at bottom of inlay.)									

MGM-MARINA		**LAS VEGAS**			**1990-90**				
1st	1.00	White	H&C	None	R-white	R-4	10	20	30
	5.00	Red	H&C	3grn	HUB-white	R-5	35	70	105
	25.00	Green	H&C	6yel	SCA-white	R-10	300	600	900
	100.00	Black	H&C	12blu	COG-white	R-10	350	700	1050
(This is the last issue of Marina.)									

MGM-SANDS		**LAS VEGAS**			**1988-89**				
1st	5.00	Red	House	4nvy4gry	OR-white	R-5	35	70	105
	bac 5.00	Pink	House	3ltblu3grn	OR-white	R-9	200	400	600
	bac 20.00	Yellow	House	6blu3red	OR-white	R-10	250	500	750
	25.00	Lt Green	House	4yel4grn4org	OR-white	R-8	250	500	750
	100.00	Black	House	6yel3gry	OR-white	R-7	175	350	525
	bac 500.00	White	House	6nvy3tan	OR-white	R-10	350	700	1050
	500.00	White	House	4grn4nvy	OR-white	R-10	400	800	1200
	bac 1000.00	Fuchsia	House	6nvy2yel	OR-white	R-10	400	800	1200
	1000.00	Pink	House	4brn4gry	OR-white	R-10	500	1000	1500
	bac 5000.00	Brown	House	8pch	OR-white	R-10	600	1200	1800

MICKEY'S		**N. LAS VEGAS**			**1978-80**				
1st	.10	Green	HHR	None	HS	R-9	125	250	375
	.25	Black	HHR	None	HS	R-10	150	300	450
	.50	Navy	HHR	None	HS	R-9	100	200	300
	1.00	Mustard	HHR	None	HS	R-9	100	200	300
	1.00	Brown	HHR	None	HS	R-8	50	100	150
	5.00	Orange	HHR	None	HS	R-9	100	200	300
	n/d	Brown	HHR	None	HS	R-8	20	40	60

Issue	Den.	Color	Mold	Inserts	Inlay	Rarity	GD30	VF65	CS95

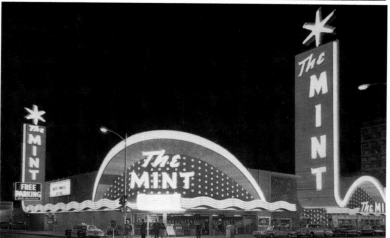

Mint 25¢ (1st)

Mint $5 (1st)

As pictured in this postcard, the Mint was a very busy, popular downtown casino. Despite this, most of the Lcrown chips and all of the Horshu mold chips are virtually unknown! ©Desert Supply Company, Las Vegas.

Mint RLT 1 (1st)

MINT, THE　　　　　**LAS VEGAS**　　　**1958-66**
DEL WEBB'S MINT　　　　　　　　　**1966-89**

Issue	Den.	Color	Mold	Inserts	Inlay	Rarity	GD30	VF65	CS95
1st	.25	Red	Scrown	None	HS	R-9	200	400	600
	1.00	Crm/Pur	Lcrown	1/2pie	R-white	R-9	350	700	1050

(Regular inlay.)

| | 1.00 | Crm/Pur | Lcrown | 1/2pie | R-white | R-8 | 300 | 600 | 900 |

(Linen inlay.)

| | 5.00 | Yel/Blu | Lcrown | 1/2pie | SAW-white | R-10 | 1000 | 2000 | 3000 |
| | 25.00 | ? | Lcrown | 1/2pie | ? | Unknown | 1500 | 3000 | 4500 |

(It is interesting to learn that 5,000 of these $25's were made & so far none have been found today! There were 30,000 $5's. A total of 30,000 $1's also. The.25c was ordered in 1959, & again in 61 & 64. A total of 12,000 chips were ordered. All above were ordered originally in 1959 & reordered until 1964. As you see the large & small crowns were used concurrently.)

Mint 25¢ (2nd)

	RLT 1	Navy	HCE	None	HS-white	R-10	100	200	300
	RLT 1	Green	HCE	None	HS-white	R-10	100	200	300
	RLT 1	Lavender	HCE	None	HS-white	R-10*	100	200	300
	RLT 2	Blue	HCE	None	HS-pink	R-10*	100	200	300
	RLT 2	Green	HCE	None	HS-white	R-10*	100	200	300
2nd	.25	Yellow	Scrown	None	HS	Unique	500	1000	1500

(It's amazing more of these pretty bright yellow chips picturing a detailed drawing of the building didn't walk out back in 1964 & 65 considering that 6,000 were made!)

Mint 50¢ (2nd)

	pan .25	Blue	Scrown	None	HS	R-10	200	400	600
	.50	Fuchsia	Scrown	None	HS	R-6	75	150	225
	pan .50	Fuchsia	Scrown	None	HS	R-9	150	300	450
	pan 1.00	Purple	Scrown	None	HS	Unique	250	500	750

(The .25 & .50 have the denomination on the back, building on front. The "Pan Room" chips have denomination on the front, no building.)

| | 1.00 | Beige | Scrown | None | R-white | R-7 | 45 | 90 | 135 |

(Black $1. Linen inlay. 25,000 chips were ordered in 1964 & 65.)

| | 1.00 | Beige | Scrown | None | R-white | R-6 | 35 | 70 | 105 |

(Black $1. Regular inlay.)

| | 1.00 | Beige | Scrown | None | R-white | R-6 | 35 | 70 | 105 |

(Red $1. Linen inlay. 40,000 chips ordered in 1964 & 65. The 65 order may have been during the transition to the regular paper type inlay. Linen is recognized by the grain lines.)

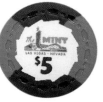

Mint $5 (2nd)

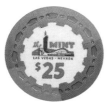

Mint $25 (2nd)

Mint $5 (3rd)

Mint $25 (3rd)

Mint $50 (4th)

Mint $5 (7th)

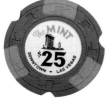

Mint $25 (7th)

Issue	Den.	Color	Mold	Inserts	Inlay	Rarity	GD30	VF65	CS95
	1.00	Beige	Scrown	None	R-white	R-5	30	60	90
(Orange $1. Regular inlay.)									
	5.00	Blk/Red	Scrown	1/2pie	SAW-white	R-6	75	150	225
(This issue with black denomination was ordered in 1964 & again in 65, totaling just 16,000 pieces.)									
	25.00	Grn/Org	Scrown	1/2pie	COG-white	R-6	100	200	300
(Black denomination ordered in 1964 & 65 totaling 5,600.)									
	5.00	Blk/Red	Scrown	1/2pie	SAW-white	R-6	75	150	225
(Red denomination, records show just 6,000 were ordered in 1964.)									
	25.00	Grn/Org	Scrown	1/2pie	COG-white	R-6	100	200	300
(Red denomination ordered in 1964 of only 2,000 chips, the lowest order so far, although approximately the same number are know today on both $25's, as well as the $5's.)									
	NCV 1.00	Pink	Scrown	None	HS	R-6	25	50	75
	NCV 1.00	Yellow	Scrown	None	HS	R-8	40	80	120
(Good for $1 in trade marked on above two. 10,000 pink chips ordered in 1965. 2,000 yellow in 64.)									
	RLT 1	3 diff.	Scrown	None	HS	R-6	15	30	45
(Colors: Blue, Pink, and Yellow)									
	RLT 2	3 diff.	Scrown	None	HS	R-6	15	30	45
(Colors: Brown, Green, and Yellow.)									
	RLT 3	3 diff.	Scrown	None	HS	R-6	15	30	45
(Colors: Green, Pink, and Yellow)									
3ʳᵈ	.25	Red	Horshu	None	HS	R-5	25	50	75
	5.00	Mustard	Horshu	3nvy	R-white	R-10*	700	1400	2100
	25.00	Green	Horshu	3fch	R-white	Unique*	800	1600	2400
	25.00	Navy	Horshu	3fch	R-white	R-9*	500	1000	1500
	RLT A	6 diff.	Scrown	None	OR-white	R-7	10	20	40
(Colors: Blue, Brown, Pink, Purple, White, and Yellow)									
	RLT B	6 diff.	Scrown	None	OR-white	R-7	10	20	40
(Colors: Blue, Brown, Pink, Purple, White, and Yellow)									
	RLT C	6 diff.	Scrown	None	OR-white	R-7	10	20	40
(Colors: Blue, Brown, Pink, Purple, White, and Yellow)									
4ᵗʰ	50.00	Lavender	C&J	3nvy	SCA-white	R-10*	1000	2000	3000
(Picture of building. Three notched samples are known of this odd denomination chip.)									
5ᵗʰ	1.00	Tan	Diasqr	None	R-white	R-8	70	140	210
(All are possibly prototypes as they have that mold seem around the outer edge.)									
6ᵗʰ	1.00	Beige	C&J	3rst	R-white	R-6	20	40	60
	1.00	Brn/Lav	C&J	dovetail-brn	HS	R-8	75	150	225
	1.00	Brn/Lav	C&J	dovetail-lav	HS	R-8	75	150	225
(Redeemable Only at Mint Hotel Casino, Slots, Keno".)									
	2.50	Grn/Pur	C&J	dovetail-grn	HS	R-9	300	600	900
	2.50	Grn/Pur	C&J	dovetail-pur	HS	R-9	300	600	900
	NCV 1.00	4 diff.	C&J	None	HS	R-7	10	20	30
("In Play". Colors: Fuchsia, Lavender, Mustard, and Orange.)									
7ᵗʰ	.25	Purple	C&J	2yel	R-white	R-4	25	50	75
(These are sometimes found with the denomination scratched off)									
	1.00	Tan	C&J	3dkorg	R-white	R-5	15	30	45
	5.00	Red	C&J	3org	R-white	R-9	300	600	900
	25.00	Green	C&J	3pnk	SCA-white	Unique*	1000	2000	3000
	faro	Brown	C&J	None	HS	R-9	75	150	225
(Only 5 were found in this color, making only 5 complete sets possible of this 1998 discovery.)									
	faro	4 diff.	C&J	None	HS	R-8	50	100	150
(Colors: Green, Navy, Orange, and Purple. Up to 10 each were found of all but Purple with 7 found.)									
8ᵗʰ	1.00	Cream	H&C	3org	R-white	R-4	10	20	30
	5.00	Maroon	C&J	3mst3org	COG-white	R-5	35	70	105
	5.00	Red	C&J	3mst3org	COG-white	R-8	50	100	150

Issue	Den.	Color	Mold	Inserts	Inlay	Rarity	GD30	VF65	CS95

(At first glance, this chip looks the same as the one above. However, the color is definitely different and the writing is noticeably thinner. Our guess is that this chip was never reordered, explaining its comparative rarity.)

| | 25.00 | Green | C&J | 3dkgrn3gry | HUB-white | R-7 | 100 | 200 | 300 |
| | 100.00 | Black | C&J | 8pur | SCA-white | R-10* | 500 | 1000 | 1500 |

(Del Webb's Mint.)

| | RLT A | 6 diff. | H&C | None | HS | R-8 | 12 | 24 | 36 |

(Colors: Black, Grey, Pink, Turquoise, White, and Yellow.)

| | RLT B | 6 diff. | H&C | None | HS | R-8 | 12 | 24 | 36 |

(Colors: Black, Fuchsia, Orange, Turquoise, White, and Yellow.)

| | RLT C | 2 diff. | H&C | None | HS | R-8 | 12 | 24 | 36 |

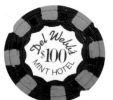

Mint $100 (8th)

(Colors: Orange and White)

9th	.25	Purple	H&C	None	HS	R-4	6	12	18
	5.00	Maroon	H&C	3org3yel	HUB-white	R-4	25	50	75
	25.00	Green	H&C	4blk	SCA-white	R-5	60	120	180
	100.00	Black	H&C	4ltblu8pur	COG-white	R-4	40	80	120
	500.00	Peach	H&C	8grn4lim	HUB-white	R-4	35	70	105

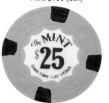

Mint $25 (9th)

(This issue is marked "Del Webb's" except for the $25.)

| | NCV | 2 diff. | H&C | None | HS | R-7 | 10 | 20 | 30 |

("In Play". Pink and Lt Pink.)

	NCV	Green	H&C	None	HS	R-7	20	40	60
10th	.25	Lavender	BJ	None	HS	R-6	10	20	30
	.50	Blue	BJ	None	HS	R-5	6	12	18
	1.00	White	BJ-2	4blu	COIN	R-4	12	24	36
	NCV 2.50	Turq	BJ	None	HS	R-5	6	12	18
	NCV 5	Grey	BJ	None	HS	R-5	4	8	12
	NCV 25	Orange	BJ	None	HS	R-5	5	10	15
	NCV 100	Pink	BJ	None	HS	R-5	6	12	18

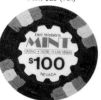

Mint $100 (9th)

MIRAGE			**LAS VEGAS**		**1989-**				
1st	1.00	Navy	House	4wht	R-white	R-2	2	4	6
	5.00	Red	House	12wht	R-white	R-3	5	10	15
	25.00	Green	House	8fch	R-white	R-4	20	40	60
	100.00	Black	House	4org4pur4wht	R-black	R-5	100	150	200
	bac 100.00	Black	House	6org	R-black	R-1	*	100	110
	bac 1000	Yellow	House	4blu	R-black	R-1	*	1000	1025

(Baccarat chips are oversized.)

	RLT H	Turq	BJ-P	None	OR-white	R-4	3	6	9
	RLT M	Orange	BJ-P	None	OR-white	R-4	3	6	9
	1.00	Blue	Chipco	None	FG-multi	R-10*	50	100	150

Mirage $5 (1st)

(Picture Trees and Dolphins. Never put in use.)

| 2nd | 1.00 | Navy | House | 4wht | OR-white | R-1 | * | 1 | 2 |
| | 5.00 | Red | House | 12wht | OR-multi | R-1 | * | 5 | 10 |

(Siegfried and Roy.)

	5.00	Red	House	12wht	OR-white	R-1	*	5	7
	pok 10.00	Orange	H&C	4lim4nvy	OR-white	R-1	*	10	13
	25.00	Green	House	8blk	OR-white	R-1	*	25	30
	100.00	Black	House	4org4pur4wht	OR-black	R-1	*	100	110
	1000.00	Yellow	House	8pur4grn	OR-black	R-5	1000	1000	1025
	5000.00	White	House	8blu4red	OR-white	R-5	*	*	*
	25000.00	Fuchsia	House	3pur3wht	OR-black	R-5	*	*	*

Mirage $1 (1st)

(Tree's below, and "The Mirage".)

| | RLT C | Green | BJ-P | None | OR-white | R-4 | 2 | 4 | 6 |
| | RLT E | Green | BJ-P | None | OR-white | R-4 | 2 | 4 | 6 |

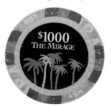

Mirage $1000 (2nd)

119

Mirage RLT (2nd)

Money Tree $5 (1st)

Montana Bar $1 (1st)

Monte Carlo Resort $100 (1st)

Monte Carlo Club 10¢ (2nd)

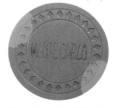

Monte Carlo Club $25 (3rd)

Issue	Den.	Color	Mold	Inserts	Inlay	Rarity	GD30	VF65	CS95
	RLT G	Blue	BJ-P	None	OR-white	R-4	2	4	6
	RLT J	2 diff.	BJ-P	None	OR-white	R-4	2	4	6
(Colors: Blue and Grey.)									
	RLT	4 diff.	Chipco	4wht	OR-white	R-7*	10	20	30
(Colors: Black, Pink, Orange, and Purple.)									
	RLT	White	Chipco	4blk	OR-white	R-7*	10	20	30
	RLT	6 diff.	Chipco		OR-white	R-7*	10	20	30
(Colors: Blue, Lt Blue, Green, Lime, Red, and Yellow.)									
(Above Chipco's are notched samples, but believed to be in use in the high roller area.)									
3rd	RLT B	5 diff.	BJ-P	None	R-white	R-2	2	4	6
(Colors: Blue, Brown, Green, Grey, and Tan.)									

MONEY TREE — LAS VEGAS — 1972-79

Issue	Den.	Color	Mold	Inserts	Inlay	Rarity	GD30	VF65	CS95
1st	1.00	Tan	Nevada	3grn	HS	R-5	40	80	120
	5.00	Red	Nevada	3mst	HS	R-8	125	250	375
	NN1.00	Green	Nevada	None	HS	R-9	75	150	225
2nd	NN1.00	Green	Nevada	None	HS	R-8	50	100	150

(No location listed. Otherwise, chip is identical. Beware Borland counterfeits with the Diecar mold.)
(Located at Sahara & the Strip & was the last casino to occupy this location before Bonanza gifts.)

MONTANA BAR — N. LAS VEGAS — 1965-76

Issue	Den.	Color	Mold	Inserts	Inlay	Rarity	GD30	VF65	CS95
1st	.50	Tan	C&J	None	HS	R-6	25	50	75
	1.00	Orange	C&J	None	HS	R-5	25	50	75
	5.00	Pink	C&J	None	HS	R-9	50	100	150
2nd	5.00	Red	H&C	3pur	HS	R-6	25	50	75

(This old building is still standing on North Las Vegas Blvd. Formerly the Chesterfield & Hacienda.)

MONTE CARLO RESORT — LAS VEGAS — 1996-

Issue	Den.	Color	Mold	Inserts	Inlay	Rarity	GD30	VF65	CS95
1st	1.00	White	H&C	2mar	OR-white	R-1	*	1	3
	5.00	Red	H&C	3gld	OR-white	R-1	*	5	7
	5.00	Red	H&C	3gld	OR-multi	R-1	*	5	10
("Grand Opening".)									
	5.00	Red	H&C	3gld	OR-white	R-1	*	5	10
("Lance Burton".)									
	25.00	Green	H&C	4blk	OR-white	R-1	*	25	30
	100.00	Black	H&C	4blu4pnk	OR-white	R-1	*	100	110
	NCV 5	Red	H&C	2brn2pch	OR-white	R-10	15	30	45
	NCV 25	Green	H&C	2red2yel	OR-white	R-10	15	30	45
	NCV 100	Dk Grey	H&C	2lav2mst	OR-white	R-10	20	40	60
(These are Tournament chips that were very hard to get.)									
	RLT A-I	7 diff.	BJ-P	None	R-white	R-4	2	4	6
(9 tables. Colors: Blue, Lt Blue, Lt Brown, Green, Lavender, Pink, and Purple.)									

MONTE CARLO CLUB — LAS VEGAS — 1945-55

Issue	Den.	Color	Mold	Inserts	Inlay	Rarity	GD30	VF65	CS95
1st	n/d	Lavender	Lcrown	None	HS	R-9	100	200	300
	n/d	Orange	Lcrown	None	HS	R-8	75	150	225
("Monte Carlo".)									
2nd	.10	Black	Diamnd	None	HS	R-5	30	60	90
	.25	Purple	Diamnd	None	HS	R-7	50	100	150
	n/d	Cream	HCE	None	HS	R-8	30	60	90
	n/d	Mustard	HCE	None	HS	R-8	30	60	90
("Monte Carlo Club".)									
3rd	5.00	Pink	Diamnd	2grn	HS	R-8	150	300	450
	25.00	Dk Grey	Diamnd	2org	HS	R-7	100	200	300

Issue	Den.	Color	Mold	Inserts	Inlay	Rarity	GD30	VF65	CS95
	n/d	Dk Pur	Diamnd	None	HS	R-7	50	100	150
("Monte Carlo".)									
	n/d	Purple	Zigzag	None	HS	R-8	50	100	150
	n/d	Red	TK	1blk	HS	R-9	150	300	450
	n/d	Lavender	TK	None	HS	R-9	70	140	210
(Early Downtown club lasting 10 years.)									

Monte Carlo n/d (4th)

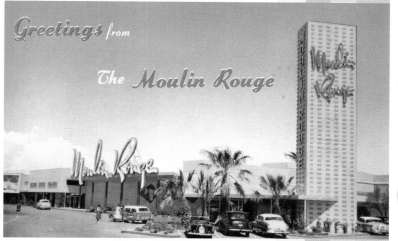

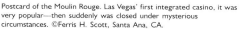

Postcard of the Moulin Rouge. Las Vegas' first integrated casino, it was very popular—then suddenly was closed under mysterious circumstances. ©Ferris H. Scott, Santa Ana, CA.

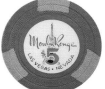

Moulin Rouge $5
(1st-Eiffel Tower)

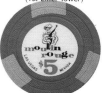

Moulin Rouge $5 (1st-Can Can)

MOULIN ROUGE W. LAS VEGAS 1955-59/1993-96

Issue	Den.	Color	Mold	Inserts	Inlay	Rarity	GD30	VF65	CS95
1st	5.00	Red	Sm-key	3gry	R-white	R-1	125	250	375
(R-8 undrilled. Drilled chips are worth 5% of listed prices.)									
	25.00	Green	Sm-key	3blk	R-white	R-1	300	600	900
(R-8 undrilled. Drilled chips are worth 2% of listed prices. 8 chips presently known undrilled.)									
	100.00	Black	Sm-key	3fch	R-white	R-7	300	600	900
(R-8 undrilled. Drilled chips are worth 3% of listed prices.)									
(This set pictures the Eiffel Tower. Huge quantities of drilled $5 and $25 chips exist.)									
	5.00	Red	Sm-key	3gry	R-white	R-1	125	250	375
(R-8 undrilled. Drilled chips are worth 5% of listed prices.)									
	25.00	Green	Sm-key	3blk	R-white	R-1*	500	1000	1500
(No undrilled chips are presently known! Drilled chips are worth 2% of listed prices.)									
	100.00	Black	Sm-key	3fch	R-white	R-8	350	700	1050
(R-9 undrilled. Drilled chips are worth 2% of listed prices.)									
(This set pictures a Can-Can Girl. Huge quantities of drilled $5 and $25 chips exist.)									
2nd	100.00	Black	Rectl	3crm	R-white	R-7	200	400	600
(Undrilled, chip is R-8. Drilled chips are worth 5% of listed prices.)									
3rd	1.00	Blue	H&C	3grn3pnk	OR-white	R-3	3	6	9
	5.00	Pink	H&C	3grn3trq	OR-white	R-4	6	12	18
	25.00	Green	H&C	3yel3pnk	OR-white	R-5	25	50	75

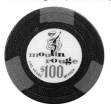

Moulin Rouge $100
(1st-Can Can)

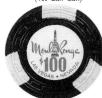

Moulin Rouge $100
(2nd-Eiffel Tower)

NASHVILLE NEVADA CLUB LAS VEGAS 1961-77

Issue	Den.	Color	Mold	Inserts	Inlay	Rarity	GD30	VF65	CS95
1st	1.00	Navy	C&J	None	HS	R-5	30	60	90
	5.00	Brown	C&J	4org	HS	R-4	25	50	75
2nd	1.00	Blue	H&C	None	HS	R-4	7	14	21

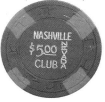

Nashville Nevada Club $5 (1st)

Nevada Biltmore $25 (1st)

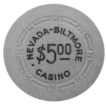

Nevada Biltmore $5 (2nd)

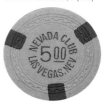

Nevada Club $5 (1st)

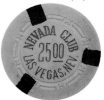

Nevada Club $25 (2nd)

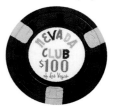

Nevada Club $100 (6th)

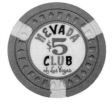

Nevada Club $5 (7th)

Issue	Den.	Color	Mold	Inserts	Inlay	Rarity	GD30	VF65	CS95
	5.00	Red	H&C	3pch	HS	R-4	20	40	60
(Located on Boulder Highway across & down form Showboat.)									
NAFB-NCOOM			**LAS VEGAS**		**1940's**				
	1.00	Red	Flower	None	HS	R-6	50	100	150
	1.00	Blue	Flower	None	HS	R-9	75	150	225
(Nellis Air Force Base Non Commissioned Officers Mess. Military gambling chips.)									
NEVADA BILTMORE			**LAS VEGAS**		**1944-50**				
1st	25.00	Navy	Dots	None	HS	R-7	100	200	400
2nd	5.00	Yellow	HCE	None	HS	R-7	125	250	375
	25.00	Black	HCE	None	HS	R-10	300	600	900
NEVADA CLUB			**LAS VEGAS**		**1952-62**				
NEVADA CLUB, DIAMOND JIM'S					**1962-69**				
NEVADA CLUB, LUCKY					**1969-69**				
1st	5.00	Grey	Zigzag	3nvy	HS	R-9	350	700	1050
2nd	25.00	Yellow	HCE	3blk	HS	R-10	350	700	1050
3rd	.25	Mustard	Sqsqrt	None	R-white	R-8	75	150	225
	.50	Navy	Sqsqrt	None	R-white	R-8	75	150	225
4th	.25	Yellow	HHL	None	R-white	R-7	50	100	150
	10.00	Grey	HHL	3blk3red	R-white	R-5	40	80	120
	20.00	Green	HHL	3nvy3red	R-white	R-5	40	80	120
5th	1.00	White	Scrown	2nvy2pur	LHUB-white	R-5	12	24	36
(Linen inlay, thicker printing than next.)									
	1.00	White	Scrown	2nvy2pur	LHUB-white	R-5	12	24	36
(Regular inlay, thinner printing.)									
6th	.25	Mustard	C&J	None	HS	R-8	50	100	200
	5.00	Red	C&J	3blk	R-white	R-6	35	70	105
(There is a variant with different colored letters - no effect on price.)									
	25.00	Green	C&J	3red	R-white	R-7	200	400	600
(Most have ugly drill hole right through the middle. Undrilled, chip is R-10.)									
	100.00	Black	C&J	3gry	R-white	R-4	45	90	135
	n/d	Tan	C&J	None	HS	R-10	50	100	150
7th	5.00	Grey	Diasqr	3bei	R-white	R-5	125	250	375
(Virtually all survivors are drilled through the center and worth only 5% of these prices. Undrilled survivors are R-9.)									
	NN 500.00	Yellow	Diasqr	None	R-white	R-5	20	40	60
("Gold Player".)									
	NN 500.00	Yellow	Diasqr	None	R-white	R-4	15	30	45
("Souvenir Chip".)									
8th	.25	Mustard	HHL	3red	R-white	R-9	200	400	600
	1.00	Purple	HHL	3bei	R-white	R-1	3	6	9
	5.00	Red	HHL	3nvy	R-white	R-2	4	8	12
	25.00	Green	HHL	3org	R-white	R-3	12	24	36
(This set of chips is serial numbered - done by the casino to prevent counterfeits.)									
(This issue is Diamond Jim's Nevada Club.)									
	FP .50	Mst/Red	C&J	dovetail-mst	HS	R-5	10	20	30
	FP .50	Mst/Red	C&J	dovetail-red	HS	R-5	10	20	30
	FP .50	Grn/Red	C&J	dovetail-grn	HS	R-5	10	20	30
	FP .50	Grn/Red	C&J	dovetail-red	HS	R-5	10	20	30
	FP .50	Green	C&J	None	HS	R-5	7	14	21
9th	.25	Mustard	Nevada	None	HS	R-5	10	20	30
	25.00	Green	Nevada	3org	R-white	R-4	20	40	60
	FP .50	Red/Yel	C&J	dovetail-red	HS	R-6	20	40	60

Issue	Den.	Color	Mold	Inserts	Inlay	Rarity	GD30	VF65	CS95
	FP .50	Red/Yel	C&J	dovetail-yel	HS	R-5	15	30	45
10th	25.00	Green	Nevada	3org	R-white	R-10	200	400	600

(Only 2 pieces are known of this "Lucky" in script version - both found by James Campiglia.)
(9th & 10th issues are Lucky Nevada Club.)

	5.00	Red	Nevada	None	HS	R-6	3	6	9

(Marked "Starter Chip". Very possibly a Borland forgery & not made for the casino.)
(This early club was originally on 1st Street in 1932, becoming the Nevada Bar. No chips are known unless the first issue zigzags were used here & then moved to the club on Fremont which was formerly the Santa Anita Turf Club.)

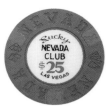

Nevada Club $25 (10th)

NEVADA HOTEL CASINO LAS VEGAS 1974-88/1992-95

Issue	Den.	Color	Mold	Inserts	Inlay	Rarity	GD30	VF65	CS95
1st	.25	Grey	H&C	None	HS	R-5	7	14	21
	.50	Pink	H&C	None	HS	R-5	8	16	24
	1.00	Blue	H&C	None	HS	R-5	10	20	30

(There is a variant with different size lettering.)

	5.00	Red	H&C	3blu	R-white	R-5	20	40	60
	25.00	Green	H&C	3pur3yel	R-white	R-4	15	30	45
	100.00	Black	H&C	3pnk3red	R-white	R-4	18	36	54
	NN 1.00	Mustard	Diecar	None	HS-black	R-3	3	6	9
	NN 1.00	Orange	H&C	None	HS	R-7	9	18	27
2nd	5.00	Red	H&C	3ltblu3yel	HUB-white	R-3	5	10	15
	25.00	Green	H&C	3pch3org3pnk	SCA-white	R-5	25	50	75
	100.00	Black	H&C	3wht3gry3blu3pnk	COG-white	R-7	75	150	225
3rd	NN	Beige	H&C	None	HS	R-6	5	10	15
	FP/NN	Yellow	BJ	None	HS	R-4	2	4	6
	NN	Orange	BJ	None	HS	R-4	2	4	6

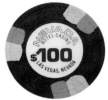

Nevada Hotel $100 (1st)

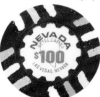

Nevada Hotel $100 (2nd)

NEVADA PALACE LAS VEGAS 1979-

Issue	Den.	Color	Mold	Inserts	Inlay	Rarity	GD30	VF65	CS95
1st	.25	Yellow	H&C	None	HS	R-4	5	10	15
	.50	Pink	H&C	None	HS	R-5	10	20	30

(No "NV" and different lettering.)

	1.00	Beige	H&C	None	HS	R-4	5	10	15

(Only initialed "NP" in block letters.)

	1.00	Blue	H&C	None	R-multi	R-1	*	1	3
	2.50	Dk Pink	H&C	None	HS	R-4	20	40	80
	5.00	Red	H&C	3nvy	HUB-multi	R-1	*	5	10
	25.00	Green	H&C	3org	SCA-multi	R-1	*	25	35
	100.00	Black	H&C	3mst3wht	COG-multi	R-1	*	100	125

(This casino is still using their first set of chips that are now 20 years old!)

	RLT NP	3 diff.	Plain	None	HS	R-4	2	4	6

(Colors: Green, Pink, and White)

	NCV 1	Orange	H&C	None	HS	R-8	10	20	30
	NCV 5	Fuchsia	H&C	None	HS	R-8	10	20	30
	NCV 25	Green	H&C	None	HS	R-10	20	40	60

(These were used in a tournament in the 1980's and are rarely seen for sale.)

2nd	.25	Yellow	H&C	None	HS	R-2	1	2	3
	.50	Pink	H&C	None	HS	R-4	4	8	12
	RLT 1	Dk Grey	H&C	None	HS	R-6	2	4	6
	RLT 1	Cream	H&C	None	HS	R-6	2	4	6

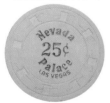

Nevada Palace 25¢ (1st)

Nevada Palace 25¢ (2nd)

NEW YORK-NEW YORK LAS VEGAS 1997-

Issue	Den.	Color	Mold	Inserts	Inlay	Rarity	GD30	VF65	CS95
1st	1.00	White	H&C	2blu2ltblu	OR-white	R-1	*	1	2
	5.00	Red	H&C	3blu3lttrq	OR-white	R-1	*	5	7
	25.00	Green	H&C	8pnk	OR-multi	R-1	*	25	30

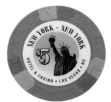

New York-New York $5 (1st)

123

Issue	Den.	Color	Mold	Inserts	Inlay	Rarity	GD30	VF65	CS95
	100.00	Black	H&C	4pur4pnk4grn	OR-multi	R-1	*	100	110
	n/d	Cream	H&C	None	OR-multi	R-9	25	50	100

("Derby Day". These were given out in the sportsbook and are rarely seen for sale.)

	RLT 1	6 diff.	Roulet	None	HS	R-4	2	4	6

(Colors: Lt Blue, Green, Lt Green, Grey, White, and Yellow.)

	RLT 2	6 diff.	Roulet	None	HS	R-4	2	4	6

(Colors: Lt Blue, Green, Lt Green, Grey, White, and Yellow.)

	RLT 3	6 diff.	Roulet	None	HS	R-4	2	4	6

(Colors: Lt Blue, Green, Lt Green, Grey, White, and Yellow.)

	RLT 4	6 diff.	Roulet	None	HS	R-4	2	4	6

(Colors: Lt Blue, Green, Lt Green, Grey, White, and Yellow.)

	RLT 5	6 diff.	Roulet	None	HS	R-4	2	4	6

(Colors: Lt Blue, Green, Lt Green, Grey, White, and Yellow.)

	RLT 6	6 diff.	Roulet	None	HS	R-4	2	4	6

(Colors: Lt Blue, Green, Lt Green, Grey, White, and Yellow.)

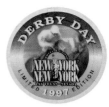
New York-New York n/d (1st)

NOB HILL — LAS VEGAS — 1979-90

Issue	Den.	Color	Mold	Inserts	Inlay	Rarity	GD30	VF65	CS95
1st	25	White	H&C	None	HS	R-4	8	16	24
	1.00	Blue	H&C	3org6wht	R-white	R-4	15	30	45
	5.00	Red	H&C	3brn3yel	R-white	R-6	50	100	200
	25.00	Green	H&C	3grn3org	R-white	R-10	400	800	1200
	100.00	Black	H&C	3pkn3wht3pur	HUB-white	Unique	500	1000	1500

(All of these chips were positively destroyed right after the casino closed. Bo Maceich & James Campiglia were in Nob Hill trying to get chips, matchbooks, etc. up until the last closing minutes when security asked them to leave. James thought he had a deal going to get a set of chips for his collection at a reduced price, but this fell through. Back then, spending $25 or $100 was a lot for a chip. Luckily, Bo didn't take a chance on waiting and bought the $25. One other collecting buddy had the foresight to pick up the whole set to the $100. Now Casino Royale.)

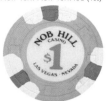
Nob Hill $1 (1st)

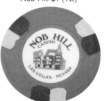
Nob Hill $5 (1st)

Nob Hill $25 (1st)

OPRY HOUSE CASINO — N. LAS VEGAS — 1978-85
OPERA HOUSE CASINO — — 1985-

Issue	Den.	Color	Mold	Inserts	Inlay	Rarity	GD30	VF65	CS95
1st	.25	Brown	H&C	None	HS	R-4	5	10	15
	1.00	Blue	H&C	None	HS	R-4	5	10	15
	5.00	Red	H&C	3ltorg	HS	R-4	8	16	24
	25.00	Green	H&C	3fch	HS	R-5	15	30	45
	100.00	Black	H&C	3grn3pch	HS	R-5	20	40	60
2nd	1.00	Blue	H&C	None	HS	R-3	4	8	12
	5.00	Maroon	HHR	None	HS	R-3	6	12	18
	25.00	Green	HHR	3mst	R-white	R-5	20	40	60
	100.00	Black	HHR	3wht	R-white	R-8	80	160	240
	NCV 5	Pink	Unicrn	None	HS	R-5	3	6	9
	NCV 25	Green	Unicrn	None	HS	R-5	3	6	9
3rd	5.00	Pink	H&C	3lim3yel	OR-multi	R-1	*	5	8
	25.00	Green	H&C	4nvy4lav	OR-multi	R-1	*	25	35
	100.00	Black	H&C	8yel4red	OR-multi	R-2	*	100	125

(2nd & 3rd issues are "Opera". The name had to be changed because of the Grand Ol Opry.)

Opry House $100 (1st)

ORBIT INN — LAS VEGAS — 1964-87

Issue	Den.	Color	Mold	Inserts	Inlay	Rarity	GD30	VF65	CS95
1st	.10	Brown	H&C	None	HS	R-7	25	50	75

(There are two variants: one with large letters and one with small letters.)

	.25	White	H&C	None	HS	R-5	7	14	21

(No location.)

	.25	White	H&C	None	HS	R-5	8	16	24

(Same chip, except marked "Las Vegas, NV.")

	1.00	Blue	H&C	None	HS	R-3	5	10	25
	5.00	Red	H&C	None	HS	R-4	10	20	60

Opera House $5 (2nd)

Issue	Den.	Color	Mold	Inserts	Inlay	Rarity	GD30	VF65	CS95
	25.00	Green	H&C	3org3gry	HS	R-5	25	50	90
	FP 1.00	Pink	H&C	None	HS	R-4	3	6	9
	NCV 5	Yellow	H&C	None	HS	R-4	5	10	15
	NCV 25	Brown	H&C	None	HS	R-7	10	20	30
	RLT 1	5 diff.	H&C	None	HS	R-6	4	8	12

(Colors: Brown, Grey, Navy, Orange, and White)

2nd	FP 1	Orange	BJ	None	HS	R-5	4	8	12
	NCV 5	Yellow	BJ	None	HS	R-4	4	8	12
	NCV 25	Brown	BJ	None	HS	R-4	7	14	21
	NCV 100	Pink	BJ	None	HS	R-4	7	14	21
	.25	Tan	Diecar	None	HS	R-4	3	6	9
	5.00	Red	Diecar	3grn3org	HS	R-5	20	40	60
	100.00	Black	Diecar	3pnk3gry	R-white	R-4	35	70	105
	RLT	6 diff.	Diecar	None	HS	R-5	4	8	12

(Colors: Brown, Gold, Mustard, Navy, Rust, and Yellow.)

Orbit Inn $100 (2nd)

ORLEANS LAS VEGAS 1996-

1st	1.00	Brown	House	None	OR-white	R-1	*	1	3
	5.00	Red	House	4blu	OR-white	R-1	*	5	8
	5.00	Red	House	4blu	FG-white	R-1	5	10	15

("Grand Opening".)

	25.00	Green	House	4org	OR-white	R-1	*	25	30
	100.00	Black	House	4wht	OR-white	R-1	*	100	110
	NCV 1	Yellow	House	None	R-white	R-8	5	10	15
	NCV 5	Pink	House	None	R-white	R-8	5	10	15
	NCV 25	Green	House	None	R-white	R-8	8	16	24
	NCV 100	Grey	House	None	R-white	R-8	12	24	36
	RLT B	2 diff.	H&C	None	HS	R-7	10	20	30

(Colors: Blue and White. Used only briefly upon opening and is very scarce.)

2nd	RLT	6 diff.	Roulet	None	OR-white	R-4	3	6	9

(Gator with Saxaphone. Colors: Blue, Green, Pink, Purple, White and Yellow.)

	RLT	6 diff.	Roulet	None	OR-white	R-4	3	6	9

(Gator with Fiddle. Colors: Blue, Green, Pink, Purple, White, and Yellow.)

	RLT	6 diff.	Roulet	None	OR-white	R-4	3	6	9

(Gator with Guitar. Colors: Blue, Green, Pink, Purple, White, and Yellow.)

	RLT	6 diff.	Roulet	None	OR-white	R-4	3	6	9

(Gator with Trumpet. Colors: Blue, Green, Pink, Purple, White and Yellow.)

3rd	1.00	Brown	House	None	OR-white	R-1	*	1	3
	5.00	Red	House	4blu	OR-white	R-1	*	5	8

(Same as 1st issue, but dated 1999.)

	RLT	6 diff.	Roulet	None	OR-white	R-4	3	6	9

(Gator with beads. Colors: Blue, Green, Pink, Purple, White, and Yellow.)

Orleans $5 (1st)

Orleans RLT (2nd)

Orleans $5 (3rd)

OSHEAS LAS VEGAS 1989-

1st	1.00	Blue	House	None	R-white	R-1	*	1	3
	5.00	Red	House	3blu3pur	HUB-white	R-1	*	5	10
	25.00	Green	House	4pur4org	SCA-white	R-1	*	25	35
	25.00	Green		4pur4org	SCA-white	R-9	100	200	300

(Bicycle Club (California) house mold chip and inserts with Oshea's inlay. 3 or 4 known.)

	100.00	Black	House	4pnk4yel	COG-white	R-1	*	100	120

Oshea's $25 (1st)

OXFORD CLUB N. LAS VEGAS 1948-58

1st	25.00	Black	Zigzag	3yel	HS	R-9	175	350	525
2nd	5.00	Red	Cord	3crm	HS-black	R-5	50	100	150

(Only Marked in large block letters "OXC". This club was located near Jerry's Nugget on Main St.)

Oxford Club $5 (2nd)

Paddlewheel $5 (1st)

Paddlewheel $100 (1st)

Palace Station $1 (1st)

Palace Station RLT (3rd)

Paradise Hotel $5 (1st)

Paradise Hotel $25 (1st)

Issue	Den.	Color	Mold	Inserts	Inlay	Rarity	GD30	VF65	CS95
PADDLEWHEEL			**LAS VEGAS**		**1983-91**				
1st	1.00	Grey	H&C	None	HS	R-2	4	8	12
	5.00	Red	H&C	3dkgry3tan	HS	R-3	10	20	30
	25.00	Green	H&C	3lim3ltblu	HS	R-4	20	40	60
	100.00	Black	H&C	3fch3ltblu3wht	COG-white	R-10	400	800	1200
	NCV 1	Blue	H&C	None	HS	R-4	4	8	12
	NCV 5	Pink	H&C	None	HS	R-4	5	10	15
	NCV 25	Gold	H&C	None	HS	R-5	10	20	30
(Only 1 box was actually made.)									
2nd	NCV 2.50	White	Clover	None	HS	R-5	5	10	15
	NCV 5	Orange	Clover	None	HS	R-5	3	6	9
	NCV 25	Green	Clover	None	HS	R-5	3	6	9
	NCV 100	Brown	Clover	None	HS	R-5	5	10	15
(Originally Royal Inn, became Royal Americana (no chips known), then Debbie Reynolds.)									
PALACE STATION			**LAS VEGAS**		**1984-**				
1st	.25	Navy	Diecar	None	HS	R-5	6	12	18
	1.00	White	BJ-2	3tan	COIN	R-1	*	1	3
	25.00	Green	BJ-2	3pur6yel	COIN	R-1	*	25	30
	100.00	Black	BJ-2	3red6wht	COIN	R-1	*	100	110
	500.00	Orange	BJ-2	12brn	COIN	R-1	*	500	525
	RLT A	6 diff.	BJ	None	HS	R-6	4	8	12
(Colors: Blue, Brown, Grey, Orange, Pink, and Purple)									
	RLT B	6 diff.	BJ	None	HS	R-6	4	8	12
(Colors: Blue, Brown, Grey, Lime, Orange, and Purple)									
2nd	.25	Navy	BJ	None	HS-silver	R-5	3	6	9
	NCV 5	5 diff.	H&C	None	HS	R-7	5	10	15
(Colors: Brown, Green, Maroon, Orange, and Purple.)									
	RLT A	Blue	H&C	None	HS	R-7	5	10	15
	RLT B	2 diff.	H&C	None	HS	R-7	5	10	15
(Colors: Blue and Green)									
3rd	.25	Blue	H&C	None	HS	R-4	3	6	9
	RLT	2 diff.	Roulet	None	R-white	R-5	5	10	15
(Colors; Brown and Grey – Red Train)									
	RLT	2 diff.	Roulet	None	R-white	R-5	5	10	15
(Colors: Grey and Orange – Black Train)									
4th	5.00	Red	BJ-2	6blu	COIN	R-1	*	5	8
(Variant with no dice on mold.)									
5th	1.00	White	BJ-2	3tan	COIN	R-1	*	1	3
("Las Vegas, NV." and "BJ" marked on this new issue)									
	RLT A	6 diff.	BJ-P	None	OR-white	R-6	2	4	6
(Colors: Brown, Lt Green, Grey, Pink, Purple, and Yellow.)									
	RLT B	6 diff.	BJ-P	None	OR-white	R-6	2	4	6
(Colors: Brown, Lt Green, Grey, Pink, Purple, and Yellow.)									
	NCV 5	Red	BJ	None	HS	R-4	5	10	15
	NCV 5	Red	BJ-P	4blu	OR-white	R-6	8	16	24
	NCV 25	Green	BJ-P	4yel	OR-white	R-8	20	40	60
PARADISE HOTEL			**LAS VEGAS**		**1976-76**				
1st	1.00	Blue	H&C	None	HS	R-4	10	20	30
	5.00	Red	H&C	3mst	R-white	R-8	300	600	900
	25.00	Green	H&C	3yel	R-white	R-10	600	1200	1800
	100.00	Black	H&C	?	?	Unique	700	1400	2100
	500.00	White	H&C	3brn3org	HUB-white	Unique	700	1400	2100

Issue	Den.	Color	Mold	Inserts	Inlay	Rarity	GD30	VF65	CS95
PARIS			**LAS VEGAS**		**1999-**				
1st	1.00	Blue	H&C	4brn	OR-white	R-1	*	1	3
	5.00	Red	H&C	3blu3yel	OR-white	R-1	*	5	8
	bac 5.00	Red	H&C	3blu3yel	OR-white	R-1	*	5	8
	bac 20.00	Green	H&C	2ltblu2crm	OR-white	R-1	*	20	25
	25.00	Green	H&C	4crm4brn	OR-white	R-1	*	25	30
	100.00	Black	House	8pnk4trq	OR-white	R-1	*	100	110
	bac 100.00	Black	House	8pnk4trq	OR-white	R-1	*	100	110
	RLT 5.00	Red	Plain	None		R-1	*	5	10
	RLT 5.00	Red	Plain	4yel		R-1	*	5	10
	RLT 5.00	Red	Plain	3yel		R-1	*	5	10
	RLT 10.00	Blue	Plain	None		R-1	*	10	15
	RLT 10.00	Blue	Plain	4pur		R-1	*	10	15
	RLT 10.00	Blue	Plain	3pur		R-1	*	10	15
	RLT 20.00	Lt Green	Plain	None		R-1	*	20	25
	RLT 20.00	Lt Green	Plain	4blu		R-1	*	20	25
	RLT 20.00	Lt Green	Plain	3blu		R-1	*	20	25
	RLT 50.00	Purple	Plain	None		R-1	*	50	60
	RLT 50.00	Purple	Plain	3wht		R-1	*	50	60
	RLT 100.00	Grey	Plain	None		R-1	*	100	110
	RLT 100.00	Grey	Plain	3grn		R-1	*	100	110

(These are for the French Roulette table. Higher denominations exist along with rectangular plaques.)

	RLT 5	6 diff.	Plain	None	R-white	R-1	*	3	6

(Colors: Dk Blue, Green, Lt Gold, Pink, Purple, and Turquoise.)

Issue	Den.	Color	Mold	Inserts	Inlay	Rarity	GD30	VF65	CS95
PARK			**LAS VEGAS**		**1987-90**				
1st	.25	Dk Pink	BJ	None	HS	R-5	8	16	24
	.50	Yellow	BJ	None	HS	R-5	9	18	27
	1.00	White	BJ-2	6trq	R-white	R-4	15	30	45
	5.00	Red	BJ-2	3wht	R-white	R-6	40	80	120
	25.00	Green	BJ-2	8wht	R-white	R-9	200	400	600
	100.00	Black	BJ-2	6yel	R-white	Unique	400	800	1200
	FP 1	Blue	BJ	None	HS	R-6	5	10	15
	NCV 1	Beige	BJ	None	HS	R-7	10	20	30

Issue	Den.	Color	Mold	Inserts	Inlay	Rarity	GD30	VF65	CS95
PATIO, THE			**LAS VEGAS**		**1954-54**				
1st	5.00	Dk Blue	Sm-key	3pur	HS	R-10	500	1000	1500
	25.00	Mustard	Sm-key	3blk	HS	R-10	500	1000	1500
	100.00	Black	Sm-key	3gry	HS	Unique*	750	1500	2250

(This small club on the strip was only open for five months. Formerly the Red Rooster, it became the Rendezvous.)

Issue	Den.	Color	Mold	Inserts	Inlay	Rarity	GD30	VF65	CS95
PEOPLE'S CHOICE			**LAS VEGAS**		**1980-82**				
1st	1.00	Navy	H&C	None	HS	R-6	20	40	60
	5.00	Red	H&C	None	HS	R-6	20	40	60
	25.00	Green	H&C	None	HS	R-6	25	50	75
2nd	1.00	Navy	H&C	4pnk	R-white	R-2	4	8	12
	5.00	Red	H&C	4crm4grn	HUB-white	R-2	5	10	15
	25.00	Green	H&C	4blu4fch	SCA-white	R-5	30	60	90

Issue	Den.	Color	Mold	Inserts	Inlay	Rarity	GD30	VF65	CS95
PEPPERMILL			**LAS VEGAS**		**1982-89**				
1st	5.00	Red	H&C	3blu3grn	HUB-white	R-3	10	20	40
	25.00	Green	H&C	3brn3yel	SCA-white	R-3	20	40	60
	NCV	Orange	BJ	None	HS	R-5	4	8	12
	NCV	Turq.	BJ	None	HS	R-10	15	30	45

(Was previously Big Reds, now Sports World across from the Stardust.)

Paris $1 (1st)

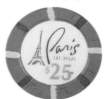
Paris $25 (1st)

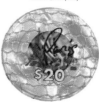
Paris RLT $20 (1st)

Park $5 (1st)

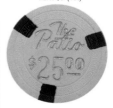
Patio $25 (1st)

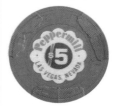
Peppermill $5 (1st)

127

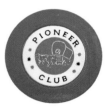

Pioneer Club RLT (1st)

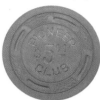

Pioneer Club $5 (2nd)

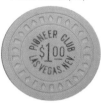

Pioneer Club $1 (5th)

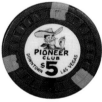

Pioneer Club $5 (7th)

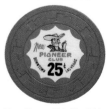

New Pioneer Club 25¢ (8th)

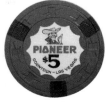

Pioneer Club $5 (10th)

Issue	Den.	Color	Mold	Inserts	Inlay	Rarity	GD30	VF65	CS95
PIONEER CLUB			**LAS VEGAS**			**1942-56/1983-95**			
PIONEER CLUB, NEW						**1956-67**			
PIONEER, FAMOUS						**1967-83**			
1st	1.00	Lt Orange	Sm-key	None	HS	Unique	500	1000	1500
	5.00	Yellow	Sm-key	None	HS	R-6	75	150	225
	20.00	Green	Sm-key	None	HS-black	Unique	500	1000	1500
	25.00	Dk Pink	Sm-key	2grn	HS	Unique*	500	1000	1500
	25.00	Red	Sm-key	None	HS	Unique*	500	1000	1500
	100.00	Yellow	Sm-key	None	HS	R-10*	500	1000	1500
	n/d	Mustard	Sm-key	3pur	HS	R-5	50	100	150
("Payroll".)									
	RLT	Black	Circls	None	R-red	Unique*	700	1400	2100
	RLT	Red	Circls	None	R-white	Unique	700	1400	2100
(Unknown until late 1999, these classic roulettes picture an oxen-drawn covered wagon.)									
2nd	.25	Purple	Lcrown	None	HS	R-6	75	150	225
	5.00	Blue	Lcrown	None	HS	R-4	60	120	180
3rd	25.00	Orange	HCE	4blu	HS	R-4	50	100	150
	25.00	Black	HCE	4crm	HS	Unique*	500	1000	1500
(Pictures oxen-drawn wagon on reverse.)									
	RLT	Orange	HCE	None	HS	R-7	35	70	105
	RLT	Tan	HCE	None	HS	R-7	25	50	75
	RLT 2	Red	HCE	None	HS	R-7	25	50	75
4th	.25	Yellow	Diamnd	None	HS	R-10	300	600	900
	5.00	Purple	Diamnd	None	HS	R-7*	200	400	600
	5.00	Purple	Diamnd	None	HS	R-8*	225	450	675
(This variant has slightly larger lettering.)									
	25.00	Green	Diamnd	2yel	HS	R-10*	400	800	1200
	n/d	Cream	Diamnd	None	HS-silver	R-8	40	80	120
("Payroll".)									
5th	.25	Red	Scrown	None	HS	R-9	250	500	750
	1.00	Beige	Diasqr	None	HS	R-8	175	350	525
6th	5.00	Red	Arodie	3yel	R-white	R-10	2500	5000	7500
7th	5.00	Fuchsia	Hub	3nvy	R-white	R-5	125	250	375
	5.00	Navy	Hub	3mst	R-white	R-9	750	1500	2250
	25.00	Green	Hub	3red	R-white	R-6	400	800	1200
	FP 1.00	Salmon	Sm-key	None	HS	R-7	25	50	75
	FP 1.00	Orange	Sm-key	None	HS	R-6	20	40	60
	FP 1.00	Orange	C&J	None	HS	R-6	15	30	45
(Above three chips all say "Pioneer Club Parking".)									
	FP 1.00	Orange	C&J	None	HS	R-7	20	40	60
("Pioneer Parking" - larger writing.)									
8th	.25	Grey	Horshu	None	HS	R-8	150	300	450
	.25	Orange	C&J	None	SCA-white	R-8	200	400	600
(This is the only issue marked "New Pioneer".)									
9th	.10	Green	C&J	3org	HS	R-4	15	30	45
("Pioneer Hotel".)									
10th	.25	Orange	C&J	None	SCA-white	R-10	750	1500	2250
	1.00	Dk Green	C&J	4red	SCA-white	R-5	100	200	300
	5.00	Fuchsia	C&J	3nvy	SCA-white	R-9	500	1000	1500
	5.00	Navy	C&J	None	HS	R-4	10	20	30
(California Club also listed on reverse.)									
11th	.25	Orange	Scrown	None	SCA-white	R-7	160	320	480
	.25	Brown	Scrown	4grn	SCA-white	Unique	350	700	1050
(No inlay on one side, might be a prototype.)									

Issue	Den.	Color	Mold	Inserts	Inlay	Rarity	GD30	VF65	CS95
	RLT	Red	Scrown	None	HS	Unique	150	300	450
12th	.10	Navy	C&J	3red	HS	R-8	150	300	600
	.10	Black	C&J	None	HS	R-6	30	60	90
	25.00	Black	C&J	3tan	HS	R-4	30	60	90

(This issue is "Famous Pioneer".)

| | n/d | Brown | C&J | None | HS | R-10 | 150 | 300 | 450 |

(Picture of "Vegas Vic" on both sides.)

| | n/d | Mustard | C&J | None | HS | R-10 | 100 | 200 | 300 |

(Picture of "Vegas Vic" on one side and "Payroll" on the other.)

13th	.50	Dk Grey	Lg-key	None	HS	R-7	35	70	105
	.50	Purple	Lg-key	None	HS	R-7	35	70	105
	n/d	Red	Lg-key	None	HS	R-10	60	120	180

(No city location given.)

| | NN1.00 | Brown | Nevada | None | HS | R-7 | 35 | 70 | 105 |
| | NN1.00 | Orange | Nevada | None | HS | R-9 | 50 | 100 | 150 |

("Good Only At Pioneer Club".)

14th	.25	Pink	H&C	None	HS	R-2	3	6	9
	1.00	Beige	H&C	None	HS	R-3	5	10	15
	1.00	Tan	H&C	None	HS	R-3	5	10	15
	5.00	Red	H&C	3mst3nvy	R-white	R-3	15	30	75
	25.00	Green	H&C	3lim3wht	R-white	R-5	50	100	200
	100.00	Black	H&C	3blu3grn3org	R-white	R-8	200	400	600

(This issue is marked "Downtown Las Vegas".)

15th	.25	Pink	H&C	None	HS	R-2	3	6	9
	.50	Purple	H&C	None	HS	R-3	4	8	12
	1.00	Beige	H&C	None	HS	R-3	4	8	12

("$1".)

| | 1.00 | Beige | H&C | None | HS | R-3 | 4 | 8 | 12 |

("$1.00".)
(This issue is marked "Las Vegas, NV".)

Famous Pioneer 10¢ (12th)

Pioneer Club $5 (14th)

Pioneer Club $100 (14th)

PLAYERS CLUB LAS VEGAS 1945-50

| 1st | 5.00 | Dk Blue | Zigzag | None | HS | R-9 | 75 | 150 | 225 |

("PC" in fancy script writing. Chip is only attributed here.)

| | 25.00 | Green | Zigzag | None | HS | R-9 | 75 | 150 | 225 |
| | 100.00 | Brown | Zigzag | None | HS | R-10 | 100 | 200 | 300 |

("PC" in block letters on above two.)

| 2nd | 5.00 | Fuschia | Lcrown | None | HS | R-7 | 200 | 400 | 600 |
| | 25.00 | Green | Lcrown | None | HS | R-8 | 250 | 500 | 750 |

(This casino was opened by Wilbur Clark. For a short time it operated as Wagon Wheel but soon changed back to Players Club.)

Players Club $25 (1st)

POKER PALACE N.LAS VEGAS 1974-

| 1st | .50 | Green | H&C | 4pnk | R-white | R-9 | 100 | 200 | 300 |
| | 1.00 | Blue | H&C | 4gry | R-white | R-9 | 100 | 200 | 300 |

(Above two are now questionable if from Nevada or California. Marked "Brass Elephant Saloon".)

2nd	1.00	Lt Blue	H&C	None	HS	R-6	20	40	60
	5.00	Red	H&C	3ltblu3yel	HS	R-7	30	60	90
3rd	1.00	Grey	H&C	None	HS	R-2	*	2	6
	5.00	Red	H&C	4ltbrn4org	HS	R-3	*	5	15
	25.00	Green	H&C	4pnk	HS	R-3	*	25	40

("N. Las Vegas".)

| 4th | 1.00 | Grey | H&C | None | HS | R-1 | * | 2 | 5 |
| | 5.00 | Red | H&C | 4ltbrn4org | HS | R-2 | * | 5 | 15 |

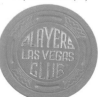
Players Club $5 (2nd)

Players Club $25 (2nd)

Issue	Den.	Color	Mold	Inserts	Inlay	Rarity	GD30	VF65	CS95
	25.00	Green	H&C	4pnk	HS	R-3	*	25	40

("N. Las Vegas, NV.")

(3rd and 4th issues are current, but very worn and hard to find in nice condition.)

Pussycat A' Go Go $1 (1st)

Issue	Den.	Color	Mold	Inserts	Inlay	Rarity	GD30	VF65	CS95
PUSSYCAT A' GO GO			**LAS VEGAS**			**1964-71**			
1st	1.00	Lavender	C&J	None	HS	R-8	125	250	375
	5.00	Mustard	C&J	3nvy	HS	R-8	150	300	450
	5.00	Navy	C&J	None	HS	R-10*	200	400	600
	25.00	Green	C&J	4blk	HS	R-10*	200	400	600
2nd	5.00	Fuchsia	Nevada	3grn	R-white	R-3	25	50	75

(Located on the Strip near Spring Mountain, on the DI side.)

Quality Inn $25 (1st)

Issue	Den.	Color	Mold	Inserts	Inlay	Rarity	GD30	VF65	CS95
QUALITY INN			**LAS VEGAS**			**1993-95**			
1st	5.00	Red	BJ-2	4wht	R-white	R-4	7	14	21
	25.00	Green	BJ-2	4yel	R-white	R-7	35	70	105
	100.00	Black	BJ-2	16crm8pnk	R-white	R-9	100	200	300

(Became Key Largo Casino.)

Rancho Inn $1 (1st)

Issue	Den.	Color	Mold	Inserts	Inlay	Rarity	GD30	VF65	CS95
RANCHO INN			**N. LAS VEGAS**			**1956-66**			
1st	.50	Fuchsia	C&J	None	HS	R-6	25	50	75

(Marked only "RI" on obverse - the reverse has the denomination.)

	1.00	Navy	C&J	3bei	HS	R-6	30	60	90
	5.00	Tan	C&J	2yel	HS	R-5	25	50	75

Red Rooster $5 (1st)

Issue	Den.	Color	Mold	Inserts	Inlay	Rarity	GD30	VF65	CS95
RED GARTER			**LAS VEGAS**			**1972-75**			
1st	.25	Pink	H&C	None	HS	R-8	50	100	150

(Marked "RG" on obverse - reverse has the denomination.)

	1.00	Dk Grey	C&J	None	HS	R-7	90	180	270
	5.00	Blue	C&J	3red	HS	R-9	150	300	450
	5.00	Fuchsia	C&J	3yel	HS	R-10	200	400	600

(Downtown.)

Issue	Den.	Color	Mold	Inserts	Inlay	Rarity	GD30	VF65	CS95
RED ROOSTER			**LAS VEGAS**			**1930's-56**			
1st	5.00	Navy	Zigzag	None	HS	R-6	35	70	105
	25.00	Yellow	Zigzag	None	HS	R-6	40	80	120

(These chips are only marked "FD" for owner Felix DeVere. Felix DeVere ran games in various clubs, one of them being the Red Rooster as told to James Campiglia by Eve - Felix's Wife.)

	n/d	Blue	Zigzag	None	HS	Unique	1000	2000	3000
	n/d	Red	Zigzag	None	HS	Unique	1000	2000	3000

(These chips are marked "Red Rooster" and have a picture of a rooster.)

Red Rooster n/d (1st)

(The Red Rooster began as a café in 1931. After prohibition ended, they received a liquor license and eventually installed a few slots. Live gaming is confirmed for 1949, but the Red Rooster may have operated as the Grace Hayes Lodge from 1946 to 1948. The Red Rooster changed its name to the Hi-Ho club from 1953-54, which became The Patio for five months in 1954.)

Issue	Den.	Color	Mold	Inserts	Inlay	Rarity	GD30	VF65	CS95
REEL DEAL CASINO, THE			**LAS VEGAS**			**1992-93**			
1st	.25	Orange	Plain	3bei	HS	R-4	6	12	18
	5.00	Maroon	HHR	3mst	R-white	R-4	15	30	45
	25.00	Green	HHR	3blk3pnk	R-white	R-4	25	50	75

(Previously Orbit Inn, then Franklin Bros, now a motel again. This little place had .50c blackjack.)

Reel Deal $5 (1st)

Issue	Den.	Color	Mold	Inserts	Inlay	Rarity	GD30	VF65	CS95
RENDEZVOUS			**LAS VEGAS**			**1977-78**			
1st	.25	Mustard	Diecar	None	HS	R-5	12	24	36
	.50	Purple	Diecar	None	HS	R-5	15	30	45
	1.00	Blue	BJ-1	3wht	COIN	R-1	3	6	9

Issue	Den.	Color	Mold	Inserts	Inlay	Rarity	GD30	VF65	CS95
	1.00	Blue	BJ-1	3wht	COIN	R-5	5	10	15
(Black lettering.)									
	5.00	Red	BJ-1	3brn	COIN	R-2	5	10	15
	25.00	Green	BJ-1	3pnk	COIN	R-4	12	24	36
	100.00	Black	BJ-1	6org	COIN	R-4	18	36	54
	NCV 5	Red	H&C	4grn	HS	R-7	15	30	45
	NCV 25	Grey	H&C	3org	HS	R-7	15	30	45
(Downtown on Ogden Street, now Gold Spike.)									

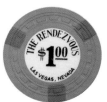

Rendezvous $1 (1st)

RENDEZVOUS, THE LAS VEGAS 1948-64

Issue	Den.	Color	Mold	Inserts	Inlay	Rarity	GD30	VF65	CS95
1st	.25	Mustard	C&J	None	HS	R-6	25	50	75
	.25	Mustard	C&J	None	HS	R-6	25	50	75
(This variant has no city location listed.)									
	1.00	Orange	Rectl	3grn	R-white	R-4	25	50	75
	5.00	Navy	Rectl	3gry	R-white	R-5	50	100	150
	5.00	Green	Rectl	3yel	R-white	R-9	300	600	900
	25.00	Black	Rectl	3wht	R-white	R-9	300	600	900
(This casino was located on the Strip.)									

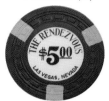

Rendezvous $5 (1st)

RESORT AT SUMMERLIN LAS VEGAS 1999-

Issue	Den.	Color	Mold	Inserts	Inlay	Rarity	GD30	VF65	CS95
1st	.50	Orange	BJ	None	HS	R-1	*	1	2
	1.00	White	BJ-2	None	R-white	R-1	*	1	2
	5.00	Red	BJ-2	4wht	R-white	R-1	*	5	8
	25.00	Green	BJ-2	4yel	R-white	R-1	*	25	30
	25.00	Green	BJ-2	4yel	OR-multi	R-1	*	25	30
(Picture of building and mountains on one side. Supposed to be an opening chip, but not marked.)									
	100.00	Black	BJ-2	8blu4wht	R-white	R-1	*	100	110

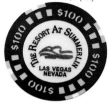

Resort at Summerlin $100 (1st)

RIATA CASINO LAS VEGAS 1973-74

Issue	Den.	Color	Mold	Inserts	Inlay	Rarity	GD30	VF65	CS95
1st	1.00	Tan	HCE	None	R-gold	R-4	12	24	36
	5.00	Red	HCE	3crm3mst	R-gold	R-5	25	50	75
	25.00	Green	HCE	6org	R-gold	R-5	30	60	90
	100.00	Black	HCE	3grn3yel	R-white	R-4	30	60	90
	100.00	Black	HCE	3grn3yel	R-white	Unique*	150	300	450
(Same as above chip, but inserts are split.)									
2nd	.50	Mustard	C&J	None	HS	R-7	25	50	75
	.50	Yellow	H&C	None	HS	R-7	20	40	60
3rd	.25	Brown	HHR	None	HS	R-7	20	40	60
	.50	Yellow	HHR	None	HS	R-9	50	100	150
	1.00	Beige	HHR	None	HS	R-3	6	12	18
	5.00	Red	HHR	None	HS	R-4	8	16	24
	25.00	Green	HHR	None	HS	R-5	20	40	60
	100.00	Blue	HHR	None	HS	R-6	30	60	90
	faro n/d	Red	HHR	None	HS	R-9	30	60	90
	faro n/d	Orange	HHR	None	HS	R-9	35	70	105
	faro n/d	Green	HHR	3bei	HS	R-9	35	70	105
	faro n/d	Red	HHR	3bei	HS	R-9	35	70	105

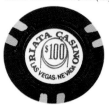

Riata $100 (1st)

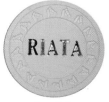

Riata $1 (3rd)

RIO LAS VEGAS 1989-

Issue	Den.	Color	Mold	Inserts	Inlay	Rarity	GD30	VF65	CS95
1st	.50	Peach	H&C	None	HS	R-3	*	1	3
	.50	Peach	H&C	None	R-white	R-3	2	4	6
	1.00	White	H&C	4gry	R-white	R-1	*	1	2
	5.00	Red	H&C	8pnk	HUB-white	R-1	*	5	7
	25.00	Green	H&C	12wht	SCA-white	R-1	*	25	30

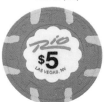

Rio $5 (1st)

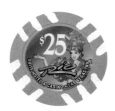

Rio $25 (2nd)

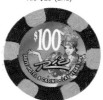

Rio $100 (2nd)

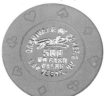

Rio NCV500 (3rd)

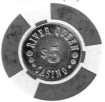

River Queen $5 (1st)

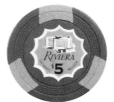

Riviera $5 (1st)

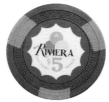

Riviera $5 (2nd)

Issue	Den.	Color	Mold	Inserts	Inlay	Rarity	GD30	VF65	CS95
	100.00	Black	H&C	6pur	WHL-white	R-1	*	100	110
	RLT	Lavender	H&C	None	OR-red	R-5	3	6	9
	RLT	Yellow	H&C	None	OR-yellow	R-5	3	6	9
2nd	RLT	Lime	Roulet	None	R-white	R-4	2	4	6
	RLT	Green	Roulet	None	OR-white	R-4	2	4	6
(Marked "Las Vegas, NV")									
	NCV 1	Cream	H&C	None	HS	R-7	5	10	15
	NCV 5	Pink	H&C	None	HS	R-6	5	10	15
	NCV 25	Green	H&C	None	HS	R-6	6	12	18
	NCV 100	Grey	H&C	None	HS	R-6	7	14	21
2nd	1.00	White	H&C	4gry	OR-multi	R-1	*	1	2
	5.00	Red	H&C	8pnk4org	OR-multi	R-1	*	5	7
	25.00	Green	H&C	12wht	OR-white	R-1	*	25	30
	100.00	Black	H&C	6pur	OR-white	R-1	*	100	110
(This set issued for the new gaming area expansion. Pictures Rio Rita.)									
3rd	5.00	Red	H&C	8pnk4org	OR-multi	R-1	*	5	7
(This issue has larger inlays.)									
	NCV 5	Red	BJ	None	HS	R-6	5	10	15
	NCV 5	Orange	BJ	None	HS	R-6	5	10	15
	NCV 25	Green	BJ	None	HS	R-6	6	12	18
	NCV 25	Lt Green	BJ	None	HS	R-6	6	12	18
	NCV 100	Brown	BJ	None	HS	R-6	7	14	21
	NCV 100	Grey	BJ	None	HS	R-6	7	14	21
	NCV 500	Purple	BJ	None	HS	R-7	10	20	30
	NCV 1000	Orange	BJ	None	HS	R-8	15	30	45
(Above NCV's are all marked "Carnivale of Poker".)									

RIVER QUEEN — LAS VEGAS — 1972-73

1st	5.00	Red	BJ-1	3wht	COIN	R-10	750	1500	2250

(Only two examples are known of this controversial chip. Not everyone is convinced that these chips were actually used in live casino play. This place became the Holiday Queen.)

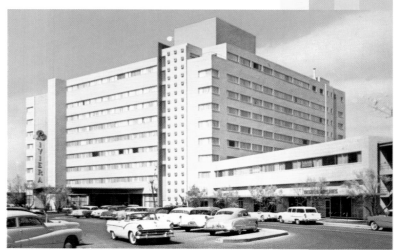

Postcard of the Riviera. The first few issues of chips picturing the building and "balloons" were on the table for about seven years, but less than ten examples are known today. ©Desert Supply Company, Las Vegas.

Issue	Den.	Color	Mold	Inserts	Inlay	Rarity	GD30	VF65	CS95
RIVIERA		**LAS VEGAS**			**1955-**				
1st	5.00	Brown	Sm-key	3mst	SCA-orange	R-10	2250	4500	6750

(Picture of Hotel. Chip was unique until the summer of 1999, when dealer Scott Hartman discovered the second known example. He proved once again that some really great chips are out there buried away and waiting to be discovered.)

Riviera $5 (3rd)

Issue	Den.	Color	Mold	Inserts	Inlay	Rarity	GD30	VF65	CS95
	RLT A	2 diff.	C&S	None	R-cream	R-6	25	50	75

(Colors: Navy and Mustard)

| | RLT B | 2 diff. | C&S | None | R-cream | R-6 | 25 | 50 | 75 |

(Colors: Maroon and Tan)

Issue	Den.	Color	Mold	Inserts	Inlay	Rarity	GD30	VF65	CS95
2nd	5.00	Brown	Sm-key	3mst	SCA-white	R-10	1500	3000	4500
3rd	5.00	Maroon	C&J	3org	SCA-white	R-9	1250	2500	3750
	25.00	Blue	C&J	3gry	SCA-white	R-10	1750	3500	5250

(The second and third issues picture three different colored balloons.)

Riviera 50¢ (4th)

Issue	Den.	Color	Mold	Inserts	Inlay	Rarity	GD30	VF65	CS95
4th	.50	Pink	C&J	None	HS	R-10	150	300	450
	.50	Red/Grn	C&J	dovetail-red	HS	R-10	300	600	900
	.50	Red/Grn	C&J	dovetail-green	HS	R-10	300	600	900
	1.00	Purple	C&J	4mst	HS	R-8	150	300	600
	100.00	Red/Yel	C&J	dovetail	HS	R-9*	300	450	600

("Hotel Riviera". This is the first issue to use lower case writing, but the first "R" curls up like the previous three issues.)

Issue	Den.	Color	Mold	Inserts	Inlay	Rarity	GD30	VF65	CS95
5th	.50	Mustard	C&J	None	R-white	R-8	125	250	375
	.50	Pink	C&J	None	R-white	R-6	40	80	120
	5.00	Red	C&J	3mst	R-white	R-9	300	600	900
	25.00	Green	C&J	3mst	R-white	R-9	500	1000	1500

("The Riviera Hotel". Of the four known $25 chips, one is notched.)

Riviera $25 (5th)

Issue	Den.	Color	Mold	Inserts	Inlay	Rarity	GD30	VF65	CS95
6th	5.00	Red	C&J	3mst	R-white	R-8	200	400	600
	5.00	Brown	C&J	3crm	R-white	R-10	300	600	900
	25.00	Green	C&J	3yel	R-white	R-10	400	800	1200
	25.00	Green	C&J	3nvy3pnk	SCA-white	R-7	100	200	300
	100.00	Grey	C&J	3org3blk	SCA-white	Unique*	500	1000	1500

("Riviera Las Vegas".)

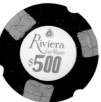
Riviera $500 (7th)

Issue	Den.	Color	Mold	Inserts	Inlay	Rarity	GD30	VF65	CS95
7th	1.00	Navy	HHR	3org	R-white	R-5	20	40	80
	5.00	Brown	HHR	3gry	R-white	R-7	125	250	375
	25.00	Green	HHR	3pur	R-white	R-9	350	700	1050
	500.00	Black	HHR	6pnk3grn	R-white	R-10*	500	1000	1500
8th	1.00	Lt Blue	C&J	None	R-white	R-5	30	60	90
	500.00	Lavender	C&J	3grn3org	R-white	R-10	500	1000	1500

(Only known examples come from a souvenir money clip.)

| 9th | 1.00 | Navy | C&J | 3org | R-white | R-5 | 25 | 50 | 75 |

(Small red crest. The 8th and 9th issues have the same inlay design.)

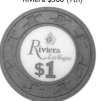
Riviera $1 (10th)

Issue	Den.	Color	Mold	Inserts	Inlay	Rarity	GD30	VF65	CS95
	NCV 500	Purple	H&C	3grn3org	R-white	R-10	200	400	600

(Oversized.)

| 10th | 1.00 | Blue | H&C | None | R-white | R-9 | 100 | 200 | 300 |

(Rare transitional piece used very briefly after Christy & Jones was sold to Paulson. At first glance, this chip appears to be a C&J, but closer examination tells otherwise. This inlay design is continued with the 11th issue.)

Issue	Den.	Color	Mold	Inserts	Inlay	Rarity	GD30	VF65	CS95
11th	.50	Pink	H&C	None	R-white	R-4	6	12	18
	1.00	Navy	H&C	3org	R-white	R-4	8	16	24

(Long canes, larger red crest background. Red denomination.)

| 12th | 5.00 | Red | H&C | 3grn3yel | R-white | R-5 | 15 | 30 | 60 |

(Long canes, white crest background. Black denomination.)

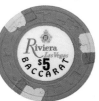
Riviera $5 bac (12th)

| | bac 5.00 | Orange | H&C | 3yel3gry3blu | R-white | R-7 | 100 | 200 | 300 |
| 13th | 5.00 | Red | H&C | 3grn3yel | R-white | R-4 | 15 | 30 | 45 |

(Short canes, white crest. Black denomination.)

| 14th | .25 | White | Plain | None | HS-red | R-7 | 35 | 70 | 105 |

(Early style writing. "Las Vegas, Nevada".)

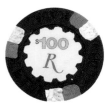

Riviera $100 (16th)

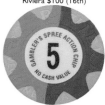

Riviera NCV5 (16th)

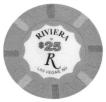

Riviera $25 (17th)

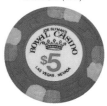

Royal Casino $5 (1st)

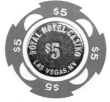

Royal Hotel $5 (2nd)

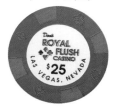

Dan's Royal Flush $25 (1st)

Issue	Den.	Color	Mold	Inserts	Inlay	Rarity	GD30	VF65	CS95
	.50	Pink	H&C	None	HS	R-3	2	4	6
(Normal size writing.)									
	.50	Pink	H&C	None	HS	R-3	2	4	6
(Large writing.)									
	1.00	Dk Blue	H&C	3org	R-white	R-3	4	8	12
15th	1.00	Lt Blue	H&C	3org	R-white	R-3	2	4	6
	bac 5.00	Orange	H&C	3yel3gry3blu	R-white	R-1	*	5	10
	bac 25.00	Green	H&C	3blk3pnk3yel	R-white	R-1	*	25	32
	25.00	Green	H&C	3pnk3pur	SCA-white	R-7	50	100	150
	100.00	Black	H&C	3blu3wht	R-white	R-9	100	200	300
	bac 100.00	Black	H&C	3ltblu3wht	R-white	R-2	*	100	115
	bac 500.00	White	H&C	3brn3org3blk	R-white	R-2	*	500	525
(Above Baccarats are oversized, unlike the regular-sized earlier issue.)									
	NCV 1	Purple	H&C	None	HS	R-8	10	20	30
	NCV 5	Green	H&C	None	HS	R-9	15	30	45
	NCV 25	Brown	H&C	None	HS	R-9	15	30	45
	NCV 5	Gold	H&C	None	HS-blue	R-5	6	12	18
	RLT A	4 diff.	H&C	None	R-white	R-8	7	14	21
(Colors: Beige, Gold, Green, and Orange.)									
16th	1.00	Lt Blue	House	3org	R-white	R-1	*	1	3
	5.00	Red	House	3lim3yel	HUB-white	R-4	5	10	15
	25.00	Green	House	3pnk3pur	SCA-white	R-5	25	50	75
	100.00	Black	House	3blu3wht	COG-white	R-7	100	150	200
(Large "R" issue.)									
	NCV 5	Org/Brn	House	1/2pie w/8pch	R-white	R-6	10	20	30
	NCV 25	Grn/Pnk	House	1/2pie w/8ltblu	R-white	R-8	20	40	60
17th	5.00	Red	House	3wht3pch	HUB-white	R-1	*	5	7
	25.00	Lt Green	House	4lav4pch	SCA-white	R-1	*	25	30
	100.00	Black	House	3red3org	COG-white	R-1	*	100	110
	rs 1000.00	Yellow	H&C	4brn4org	R-white	R-2	*	1000	1025
	rs 5000.00	Brown	H&C	8ltblu4yel	R-white	R-3	*	5000	5025

ROYAL CASINO/JOE SLYMAN'S LAS VEGAS　　1971-88
ROYAL HOTEL CASINO　　　　　　　　　　　1990-91/1992-97

1st	.25	Fuchsia	H&C	None	HS	R-5	10	20	30
	1.00	Blue	H&C	None	HS	R-5	12	24	36
	1.00	Blue	H&C	None	R-white	R-5	15	30	45
	5.00	Red	H&C	4brn4org	R-white	R-4	15	30	60
(The above 1st issue is "Joe Slyman's Royal Casino." For some reason a $25 has yet to be found.)									
	100.00	Black	H&C	3pnk3wht	SCA-white	R-4	15	30	45
	500.00	White	H&C	3brn3pnk3blu	HUB-white	R-6	40	80	120
	NCV 5	Purple	H&C	None	HS	R-8	25	50	75
(Above marked "Royal Casino" & no Slyman's.)									
2nd	1.00	White	BJ-2	None	HS	R-6	25	50	75
	5.00	Red	BJ-2	4wht	COIN	R-6	30	60	90
	25.00	Green	BJ-2	8yel	COIN	R-10	150	300	450
3rd	5.00	Red	H&C	2dkgry2lim	FG-multi	R-3	5	10	15
	25.00	Green	H&C	4brn4pnk	FG-multi	R-5	20	40	60
	100.00	Black	H&C	3blu3grn3yel	FG-white	R-7	50	100	150

ROYAL FLUSH, DAN'S　　　　LAS VEGAS　　1991-96

1st	5.00	Red	BJ-2	8yel	R-white	R-4	8	16	24
	25.00	Green	BJ-2	4red	R-white	R-7	40	80	120
(Became CBS Sports World Casino - that is now just Sports World.)									

Issue	Den.	Color	Mold	Inserts	Inlay	Rarity	GD30	VF65	CS95
ROYAL INN CASINO			**LAS VEGAS**		**1970-79**				
1st	1.00	Grey	Scrown	None	OR-white	R-4	15	30	45
	1.00	Black	Scrown	4wht	OR-white	Unique*	250	500	750
	5.00	Red	Scrown	3blu3yel	OR-white	R-5	20	40	60
	25.00	Green	Scrown	3fch3wht	OR-white	R-6	35	70	105
	100.00	White	Scrown	3fch3blk	OR-white	R-7	75	150	225
	100.00	Red	Scrown	4blu	OR-white	R-10	250	500	750
	500.00	Black	Scrown	3red3wht	OR-white	R-7	75	150	225
	500.00	Fuchsia	Scrown	3blk	OR-white	R-10	300	600	900
	n/d	Blue	Scrown	None	OR-white	R-4	7	14	21
	FP	Black	C&J	None	HS-white	R-8	10	20	30
2nd	1.00	Grey	H&C	None	R-white	R-6	20	40	60
3rd	.50	Yellow	House	None	R-white	R-7	60	120	180
	1.00	Blue	House	None	R-white	R-6	40	80	120
	5.00	Red	House	3pur3wht3grn	SCA-white	R-7	100	200	300
	25.00	Green	House	3nvy3pnk3org	HUB-white	R-9	200	400	600
	NN 5.00	Red	House	3blu3yel3pch	R-white	Unique	150	300	450
	NN 25.00	Green	House	3wht3blu3gry	R-white	R-10	150	300	450
	NN 100.00	Black	House	3red3pur3yel	R-white	Unique	200	400	600

(Inlay only on one side. Reverse marked "Non Neg. No Cash Value.")
(Became Royal Americana (no known chips), Paddlewheel, then Debbie Reynolds, which is also closed.)

Royal Inn Casino $1 (2nd)

Royal Inn Casino 50¢ (3rd)

Royal Nevada Hotel $5 (1st)

Royal Nevada Hotel $100 (1st)

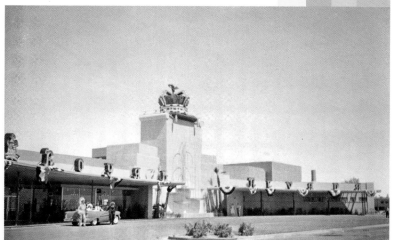

Postcard picturing the Royal Nevada. It was replaced by the Stardust in
1958, and part of the original building is now the convention center.
©Ferris H. Scott, Santa Ana, CA.

Royal Nevada Hotel 50¢ obv
(2nd)

Issue	Den.	Color	Mold	Inserts	Inlay	Rarity	GD30	VF65	CS95
ROYAL NEVADA HOTEL			**LAS VEGAS**		**1955-59**				
1st	5.00	Navy	Rectl	4yel	R-multi	R-3	25	50	75
	25.00	Green	Rectl	4fch	R-multi	R-4	35	70	105
	25.00	Red	Rectl	4nvy	R-multi	R-4	35	70	105
	100.00	Black	Rectl	4yel	R-multi	R-6	125	250	375
2nd	.50	Yellow	Diamnd	3pnk	R-white	R-4	175	350	525

(Virtually all survivors are drilled and worth 5% of these prices. Undrilled pieces are R-9 with only 4 known.)

	5.00	Pink	Diamnd	3nvy	R-white	R-2	250	500	750

(Well over 99% of all survivors are drilled and only worth 3% of these prices! Undrilled, this chip is R-10 and almost impossible to find.)

Royal Nevada Hotel 50¢ rev
(2nd)

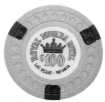

Royal Nevada Hotel $100 obv (2nd)

Saddle Club $5 (1st)

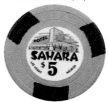

Sahara $5 (2nd)

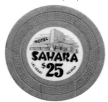

Sahara $25 (2nd)

Sahara $5 (3rd)

Sahara $5 (4th)

Issue	Den.	Color	Mold	Inserts	Inlay	Rarity	GD30	VF65	CS95
	25.00	Navy	Diamnd	3gry	R-white	R-3	225	450	675
(Undrilled, this chip is an R-9. The drilled pieces are worth 5% of these prices.)									
	100.00	Tan	Diamnd	3grn	R-white	R-7	200	400	600
	RLT 1	Red	Sm-key	None	HS	R-8	20	40	60
	RLT 1	Yellow	Sm-key	None	HS	R-8	25	50	75
	RLT 2	Yellow	Sm-key	None	HS	R-7	15	30	45
	RLT 2	Maroon	Sm-key	None	HS	R-8	25	50	75
	RLT 2	Tan	Sm-key	None	HS	R-8	25	50	75
	RLT 3	3 diff.	Sm-key	None	HS	R-8	25	50	75
(Colors: Navy, Red, and Yellow)									

SADDLE CLUB — LAS VEGAS — 1944-60

Issue	Den.	Color	Mold	Inserts	Inlay	Rarity	GD30	VF65	CS95
1st	5.00	Black	C&J	None	HS	R-10	500	1000	1500
	25.00	Yellow	C&J	None	HS	Unique*	600	1200	1800

(This is from the last issue of the club. Earlier issues are unknown. Located at Charleston & Fremont, became Silver Dollar Saloon, now Silver Saddle Saloon.)

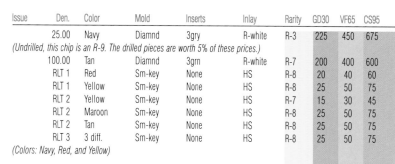

This postcard illustrates how the Sahara looked in the early 1950s.
©Ferris H. Scott, Santa Ana, CA.

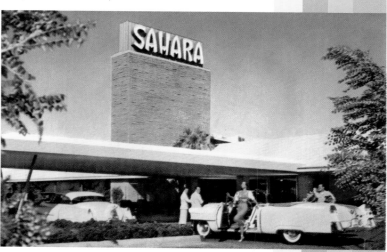

SAHARA — LAS VEGAS — 1952-

Issue	Den.	Color	Mold	Inserts	Inlay	Rarity	GD30	VF65	CS95
1st	5.00	Blue	C&S	None	R-white	Unique	3500	7000	10500
	100.00	Black	Sm-key	3org	R-lt grey	Unique*	3500	7000	10500
(Both chips have same great inlay of the Sphinx and Pyramids. Unless further discoveries prove otherwise, we will assume they were issued together.)									
2nd	5.00	Mustard	Sm-key	3blk	R-white	R-10	2250	4500	6750
	25.00	Grey	Sm-key	3red	R-white	Unique	2750	5500	8250
	25.00	Red	Sm-key	3gry	R-white	Unique*	2750	5500	8250
(Ironically, there are two different $25's for this issue, but no $25 found for the third.)									
3rd	5.00	Navy	Sm-key	3fch	R-white	R-9	2000	4000	6000
4th	5.00	Navy	Sm-key	3mst	R-white	R-8	700	1400	2100
	25.00	Green	Sm-key	3gry	R-white	Unique*	1500	3000	4500
(Camel faces right.)									
5th	.50	Purple	HCE	None	R-white	R-5	30	60	90
	1.00	Beige	HCE	None	R-white	R-4	15	30	45

Issue	Den.	Color	Mold	Inserts	Inlay	Rarity	GD30	VF65	CS95
	5.00	Brick	HCE	3blk	R-white	R-9	300	600	900
	25.00	Green	HCE	3wht	R-white	R-10	750	1500	2250

(Dark Camel faces left.)

RLT 1	5 diff.		HCE	None	HS	R-5	7	14	21

(Colors: Grey, Lavender, Navy, Orange, and Yellow.)

RLT 2	5 diff.		HCE	None	HS	R-5	7	14	21

(Color: Green, Grey, Maroon, Navy, and Orange.)

RLT 3	5 diff.		HCE	None	HS	R-7	10	20	30

(Colors: Brown, Grey, Lavender, Navy, and Yellow.)

RLT 4	2 diff.		HCE	None	HS	R-7	10	20	30

(Colors: Grey and Green.)

RLT B	3 diff.		HCE	None	HS	R-6	10	20	30

(Colors: Navy, Red, and Yellow.)

RLT C	Orange		HCE	None	HS	R-8	10	20	30
6th	1.00	Turq.	Scrown	None	HS	R-9	100	200	300

("Good For $1.00 in Trade.")

7th	.25	Grey	HCE	None	HS	R-6	20	40	60
	.50	Lavender	HCE	None	HS	R-8	100	200	300
	1.00	Gry-Blu	HCE	None	HS	R-9	125	250	375

(Above three chips marked "Pan Game".)

	1.00	Beige	HCE	None	R-white	R-3	10	20	30
	5.00	Red	HCE	6mst3blk	R-white	R-7	150	300	450

(Light camel faces left.)

8th	5.00	Red	HCE	6mst3blk	R-white	R-1	6	12	18
	25.00	Green	HCE	3crm3red	R-white	R-3	200	400	600

(Most are drilled and are worth 5% of listed prices. Undrilled, chip is R-10.)

	100.00	Black	HCE	3crm	R-white	R-10	300	600	900

(Genie with face.)

9th	1.00	Green	Nevada	None	R-white	R-4	12	24	36

("Christmas Party '68".)

10th	5.00	Red	C&J	3mst3pur	COG-white	R-3	10	20	30
	25.00	Green	C&J	3mar3gry	HUB-white	R-1	7	14	21
	100.00	Black	C&J	3grn3red	SCA-white	R-3	10	20	30

("Del Webb's Sahara Hotel" Small Genie face.)

11th	1.00	Beige	H&C	None	R-white	R-1	4	8	12
	5.00	Red	H&C	3nvy3wht	R-white	R-6	125	250	500

(This is one of the Bi-Centennial issues of 1976. Rare in top condition.)

12th	bac 20	Lt Blue	Plain	None		R-4	15	30	45
	bac 50	Lt Green	Plain	None		R-6	75	150	225
	bac 100	Blue	Plain	None		R-4	30	60	90
	bac 500	Red	Plain	None		R-6	80	160	240
	bac 1000	Gold	Plain	None		R-9	350	700	1050

(These are rectangular shaped baccarat plaques.)

13th	.25	Pink	H&C	None	HS	R-1	2	4	6
	.50	Orange	H&C	None	HS	R-2	2	4	6
	1.00	Blue	H&C	None	HS	R-1	2	4	6

("Card Room".)

	1.00	Tan	BJ-2	12brn	COIN	R-1	1	2	3
	5.00	Red	BJ-2	12wht	COIN	R-1	2	4	6

(Variants are spun metal center with lighter red & smooth center. This hasn't been seen on others.)

	25.00	Green	BJ-2	12red	COIN	R-1	4	8	12
	100.00	Black	BJ-2	12gld	COIN	R-1	7	14	21
	100.00	Black	BJ-2	12blu	COIN	R-1	7	14	21

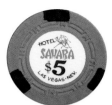

Sahara $5 (5th)

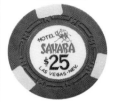

Sahara $25 (5th)

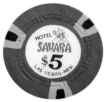

Sahara $5 (7th)

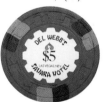

Sahara $5 (10th)

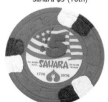

Sahara $5 (11th)

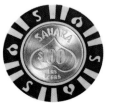

Sahara $100 (13th)

Issue	Den.	Color	Mold	Inserts	Inlay	Rarity	GD30	VF65	CS95
	500.00	Pink	BJ-2	12wht	COIN	R-4	25	50	75
14th	.25	Pink	H&C	None	HS	R-1	1	2	4
	1.00	Grey	H&C	4org	R-white	R-1	1	3	5
	2.00	Navy	H&C	2org	HS	R-4	5	10	15
	5.00	Red	H&C	3pnk	R-white	R-2	5	10	15
	25.00	Green	H&C	4fch	R-white	R-5	30	60	90
	100.00	Black	H&C	4grn4wht	R-white	R-7	75	150	225
	500.00	White	H&C	6nvy3pnk	R-white	Unique	300	600	900

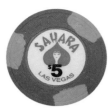
Sahara $5 (14th)

(Genie face. Forgeries with painted edges are known which were made to fool the casino.)

	NCV	Navy	H&C	None	HEX-black	R-5	5	10	15
	NCV 25	Orange	H&C	None	R-white	R-8	12	24	36
	RLT 2	4 diff.	H&C	None	HS	R-5	3	6	9

(Colors: Brown, Navy, Orange, and Yellow.)

15th	1.00	Grey	H&C	4org	R-white	R-2	2	4	6
	2.50	Pink	H&C	2nvy	R-white	R-4	5	10	15

(No face inside the heart.)

	NCV	3 diff.	H&C	None	HS	R-7	4	8	12

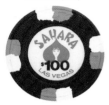
Sahara $100 (14th)

(Colors: Red, White, and Yellow.)

	NCV 5	Aqua	BJ	None	HS	R-6	5	10	15
	NCV 25	Pink	BJ	None	HS	R-6	5	10	15
	RLT 1	Blue	BJ	None	HS	R-4	2	4	6
16th	1.00	Grey	H&C	4fch4nvy	OR-grey	R-1	*	1	2
	2.00	Blue	H&C	None	OR-grey	R-1	*	2	4
	2.50	Pink	H&C	1lim1pur	OR-grey	R-1	*	3	5
	5.00	Red	H&C	2org2pur	OR-grey	R-1	*	5	8
	25.00	Green	H&C	4lim4yel	OR-grey	R-1	*	25	30
	100.00	Black	H&C	3yel3grn3org	OR-grey	R-1	*	100	110
	RLT	Maroon	BJ	None	R-pink	R-4	2	4	6
	RLT	Blue	BJ	None	R-pink	R-4	2	4	6
	RLT	Blue	BJ	None	R-white	R-4	2	4	6
	RLT	Fuchsia	BJ	None	R-yellow	R-4	2	4	6

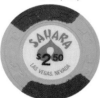
Sahara $2.50 (15th)

SAHARA - THUNDERBIRD LAS VEGAS 1972-74

1st	1.00	White	HCE	None	R-white	R-6	100	200	300
	5.00	Brick	HCE	6blk	R-white	R-8	300	600	1200

(At best, only a couple chips exist in top condition.)

	25.00	Green	HCE	6gry	R-white	Unique*	1000	2000	3000

(This was the same location as the Thunderbird.)

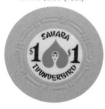
Sahara-Thunderbird $1 (1st)

SAM'S TOWN LAS VEGAS 1979-

1st	.25	Yellow	H&C	None	HS	R-2	3	6	9
	1.00	Blue	H&C	3fch3org	HS	R-3	7	14	21
	1.00	Brown	H&C	None	HS	R-8	30	60	90

("Card Room Only".)

	5.00	Red	H&C	3brn3wht	R-white	R-3	10	25	50

(This chip is hard to find in top condition.)

	25.00	Green	H&C	3lim3yel	R-white	R-4	25	50	75

(This 1st issue has no location listed.)

2nd	.25	Yellow	H&C	None	HS	R-2	2	4	6
	1.00	Blue	H&C	3fch3org	HS	R-1	*	1	3

(This issue marked "$1".)

	1.00	Fuchsia	H&C	None	HS	R-7	12	24	36

(Obverse marked "Poker Tournament", reverse marked "Poker Room Only".)

	5.00	Red	H&C	3brn3wht	R-white	R-4	8	16	24

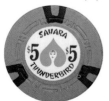
Sahara-Thunderbird $5 (1st)

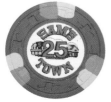
Sam's Town $25 (1st)

Issue	Den.	Color	Mold	Inserts	Inlay	Rarity	GD30	VF65	CS95
	NCV	Fuchsia	H&C	None	HS	R-7	10	20	30
	NCV 5	Green	H&C	None	HS	R-8	10	20	30
	RLT 1	Orange	HHR	None	HS	R-5	3	6	9
3rd	1.00	Blue	H&C	3fch3org	HS	R-1	*	1	3
	5.00	Red	H&C	3brn3wht	R-white	R-4	8	16	24
	25.00	Green	H&C	3lim3yel	R-white	R-4	25	50	75

(2nd & 3rd sets are marked "Las Vegas, NV." $5 is the same - only reissued.)

Issue	Den.	Color	Mold	Inserts	Inlay	Rarity	GD30	VF65	CS95
4th	5.00	Red	H&C	4pnk4pur	OR-multi	R-1	*	5	8
	25.00	Green	H&C	4org4yel	OR-multi	R-1	*	25	30
	100.00	Black	H&C	6pnk6pur	OR-multi	R-1	*	100	110
	NCV 1	Turq.	BJ	None	HS	R-5	4	8	12

Sam's Town $5 (2nd)

Sands $5 (1st)

Sands $100 (2nd)

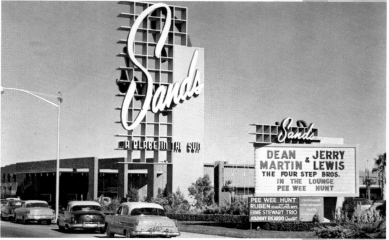

Postcard from the Sands. In its glory days the Sands was known for name entertainment, culminating in 1960 with the famous "Rat Pack" shows. The tickets to see Frank Sinatra, Dean Martin, Sammy Davis Jr; Joey Bishop, and Peter Lawford only cost $5! ©Colourpicture Publishers, Inc., Boston, MA.

Sands RLT 4 (2nd)

Sands $5 (4th)

SANDS LAS VEGAS 1952-1996

Issue	Den.	Color	Mold	Inserts	Inlay	Rarity	GD30	VF65	CS95
1st	5.00	Blue	Arodie	3red	R-white	R-10	4000	8000	12000
	25.00	?	Arodie	?	R-white	Unknwn	4000	8000	12000

(In what was easily the most exciting chip discovery of the year, the previously unknown $5 Arodie was purchased from an elderly woman in Idaho, who kept the chip as a souvenir of a big blackjack win in late 1952! This also dates the Arodie as the first issue. Incredibly, a second, but very worn piece was found at a Vegas yard sale shortly after.)

Issue	Den.	Color	Mold	Inserts	Inlay	Rarity	GD30	VF65	CS95
2nd	5.00	Blue	Sm-key	3gry	R-aqua	R-10*	3000	6000	9000
	25.00	Lt Green	Sm-key	3red	R-aqua	Unique*	3500	7000	10500

(The only known example of this chip is embedded in a large lucite display board.)

Issue	Den.	Color	Mold	Inserts	Inlay	Rarity	GD30	VF65	CS95
	100.00	Black	Sm-key	4pnk	R-aqua	R-10*	3500	7000	10500
	RLT 4	2 diff.	Sm-key	None	HS	R-10	175	350	525

(Colors: Pink and Yellow.)

Issue	Den.	Color	Mold	Inserts	Inlay	Rarity	GD30	VF65	CS95
3rd	5.00	Red	Scrown	4nvy	LSCA-white	R-10	600	1200	1800
4th	pan .25	White	Scrown	None	HS	Unique	350	700	1050
	5.00	Blue	Scrown	3red	LSCA-white	R-10	600	1200	1800
	5.00	Red	Scrown	3org	LSCA-white	R-10	600	1200	1800
5th	5.00	Red	Scrown	3org	OR-white	R-6	75	150	225
	25.00	Green	Scrown	3pnk	HUB-white	R-6	100	200	300
	100.00	White	Scrown	3blk	OWHL-white	R-7	150	300	450
6th	5.00	Blue	Diamnd	4mst	R-white	Unique*	2500	5000	7500
	5.00	Bei/Pur	Diamnd	1/2pie	R-white	R-10*	2500	5000	7500

Sands $5 (6th)

Issue	Den.	Color	Mold	Inserts	Inlay	Rarity	GD30	VF65	CS95
	25.00	Brown	Diamnd	4grn	R-white	R-10*	2500	5000	7500
	100.00	Beige	Diamnd	4blk	R-white	R-10*	2500	5000	7500
7th	bac 5.00	Yellow	Plain	None		R-8	150	300	450
	bac 20.00	Dk Pink	Plain	None		R-8	150	300	450
	bac 50.00	Orange	Plain	None		R-8	150	300	450
	bac 100.00	Pink	Plain	None		R-8	175	350	525
	bac 500.00	Yellow	Plain	None		R-8	200	400	600
	bac 1000	Grey	Plain	None		R-8	250	500	750
	bac 5000	Red	Plain	None		R-10	1000	2000	3000

Sands $25 (6th)

(The $5, $20, and $50 are round. $100 and up are all rectangular shaped plaques. There is no inlay per se. The information is printed on the plastic.)

Issue	Den.	Color	Mold	Inserts	Inlay	Rarity	GD30	VF65	CS95
8th	1.00	Brown	HCE	None	R-white	R-6	200	400	600
	5.00	Yellow	HCE	3blu	R-white	R-10	2500	5000	7500
	25.00	Green	HCE	3red	R-white	R-10*	2500	5000	7500
	100.00	Black	HCE	3gry	R-white	R-10*	2500	5000	7500
	RLT	Dk Blue	HCE	None	HS	Unique	200	400	600
	RLT	2 diff.	HCE	None	HS	R-7	60	120	180

Sands $5 (8th)

("The Sands". Colors: Green and Maroon.)

Issue	Den.	Color	Mold	Inserts	Inlay	Rarity	GD30	VF65	CS95
9th	5.00	Blue	C&J	3mst	R-white	R-9	2000	4000	6000
	25.00	Red	C&J	3org	R-white	Unique*	2500	5000	7500
	25.00	Red	C&J	3grn	R-white	Unique*	2500	5000	7500
	25.00	Beige	C&J	3blk	R-white	R-10*	2250	4500	6750

(This chip was probably a sample, because the colors and inserts match the $100 chip listed below that was used on the tables.)

| | 100.00 | Beige | C&J | 3blk | R-white | Unique | 2750 | 5500 | 8250 |

Sands $5 (9th)

(Above four issues, except for the $1, all picture a cowgirl leaning on a big hourglass - a classic design desired by all serious chip collectors.)

Issue	Den.	Color	Mold	Inserts	Inlay	Rarity	GD30	VF65	CS95
10th	5.00	Red	Scrown	4blk4org	OR-white	R-9	400	800	1200
	5.00	Red	Scrown	4blk4org	LSCA-white	Unique*	600	1200	1800
	25.00	Navy	Scrown	4grn4yel	LSCA-white	R-10	600	1200	1800
	100.00	Black	Scrown	4pnk4wht	OWHL-white	R-10	600	1200	1800
	RLT 1	3 diff.	HCE	None	HS	R-10	100	200	300

Sands $25 (11th)

(Marked "Hotel Sands". Colors: Blue, Lavender, and Yellow.)

Issue	Den.	Color	Mold	Inserts	Inlay	Rarity	GD30	VF65	CS95
11th	5.00	Yellow	C&J	4nvy	R-white	R-7	500	1000	1500
	25.00	Green	C&J	4red	R-white	R-10*	1000	2000	3000
	100.00	Black	C&J	4crm	R-white	R-10*	1100	2200	3300

("A Place in the Sun".)

Issue	Den.	Color	Mold	Inserts	Inlay	Rarity	GD30	VF65	CS95
12th	5.00	Red	C&J	4grn	R-white	R-6	200	400	600
	25.00	Navy	C&J	4mst	R-white	R-10	1100	2200	3300
	100.00	Beige	C&J	4blk	R-white	R-10	1200	2400	3600

Sands $5 (12th)

("HNO" - small building. "HNO" stands for Hughes Nevada Operations.)

Issue	Den.	Color	Mold	Inserts	Inlay	Rarity	GD30	VF65	CS95
13th	5.00	Red	House	4gry4pnk	R-multi	R-6	50	100	150
	bac 5.00	Blue	House	3red3yel	R-multi	R-10	250	500	750
	bac 20.00	Yellow	House	3org3brn	R-multi	R-10	300	600	900
	25.00	Green	House	4lav4pur	R-multi	R-10	400	800	1200
	100.00	Black	House	3grn3pur	R-multi	R-7	150	300	450
	bac 100.00	Grey	House	3ltblu3org	R-multi	R-10	300	600	900
	500.00	White	House	3org3pur3blu	R-multi	Unique	500	1000	1500
	bac 1000	Brown	House	3blu3yel	R-multi	R-10	400	800	1200
14th	5.00	Red	House	4blu	R-multi	R-4	20	40	80
	bac 5.00	Blue	House	3pch3nvy	R-multi	R-10	225	450	675
	25.00	Lime	House	4brn4grn	R-multi	R-6	125	250	375
	100.00	Black	House	3brn3ltblu	R-multi	R-8	250	500	750

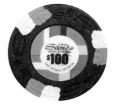

Sands $100 (14th)

(Above two sets are considered the "Pinwheel" issues.)

Issue	Den.	Color	Mold	Inserts	Inlay	Rarity	GD30	VF65	CS95
	NCV 5	Red	House	None	HS	R-8	20	40	60
	NCV 50	Blue	House	2red	HS	R-10	50	100	150
15th	1.00	Blue	House	None	R-white	R-4	15	30	45
	5.00	Red	House	3wht	R-white	R-4	25	50	75
	bac 5.00	Blue	House	3pur3org	R-white	R-9	150	300	450
	bac 5.00	Blue	House	3blu3brn	R-white	R-10	200	400	600
	bac 20.00	Yellow	House	3gry3blk	R-white	R-10	250	500	750
	bac 20.00	Yellow	House	3grn3brn	R-white	R-10	250	500	750
	25.00	Green	House	3wht	R-white	R-6	75	150	225
	100.00	Black	House	3wht	R-white	R-9	200	400	600
	bac 100.00	Grey	House	3pnk3blu	R-white	R-10	300	600	900
	100.00	Red	H&C	3blu	R-white	R-7	25	50	75

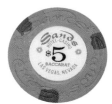

Sands $5 (15th)

(These were found only in money clips.)

	500.00	White	House	3blu3pnk	R-white	R-10	300	600	900
	bac 500.00	Orange	House	4nvy4pch	R-white	R-10	400	800	1200
	1000.00	Pink	House	4lim4tan	R-white	R-9	300	600	900
	bac 1000	Brown	House	4pch4grn	R-white	R-10	400	800	1200
	bac 5000	Lt Brown	House	4pur4org	R-white	R-10	500	1000	1500
	NCV 5	Red	House	None	HS	R-5	10	20	30
	NCV 25	Green	House	None	HS	R-5	12	24	36
	NCV 100	Black	House	None	HS	R-5	15	30	45

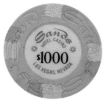

Sands $1000 (15th)

("Tournament Chip" on front. Hotel & Casino on back & denomination.)

16th	1.00	Turq.	House	None	HS	R-6	10	20	30
	5.00	Red	House	3grn3yel	COG-white	R-4	25	50	75
	bac 5.00	Blue	House	3grn3ltblu	COG-white	R-9	200	400	600
	25.00	Lime	House	4aqa4gry	HEX-white	R-7	80	160	240
	100.00	Black	House	6brn3grn	SCA-white	R-9	200	400	600
	bac 100.00	Grey	House	3org3blu	SCA-white	R-10	300	600	900
	500.00	White	House	3brn3org3nvy	R-white	R-10	350	700	1050
	rs 1000	Brown	H&C	4yel4grn	NOT-white	R-9	250	500	750
	NCV 1	Navy	H&C	None	R-white	R-6	10	20	30

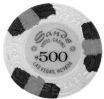

Sands $500 (16th)

("Win Cards".)

17th	1.00	Blue	House	None	HS	R-1	3	6	9
	1.00	Blue	House	4crm4pnk	R-white	R-1	4	8	12
	1.00	Orange	House	4blu	R-white	R-1	4	8	12

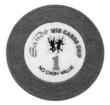

Sands NCV 1(16th)

(The Sands sold out of all their $1 chips {50,000+} before closing. This hints at the potential number of collectors out there!)

	5.00	Red	House	3org	R-white	R-2	10	20	40
	bac 5.00	Red	House	3pnk3grn	HUB-white	R-5	10	20	30
	bac 20.00	Yellow	House	3brn3pur3blu	SCA-white	R-5	20	40	60
	25.00	Green	House	4yel4pnk	SCA-white	R-5	35	70	105
	100.00	Black	House	3grn6fch	COG-white	R-6	100	200	300
	bac 100.00	Black	House	4wht2gry2brn	COG-white	R-7	100	200	300
	500.00	White	House	8blk4brn	HEX-white	R-10	500	1000	1500
	1000.00	Pink	House	4red4pur	NOT-white	R-10	600	1200	1800

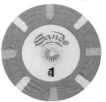

Sands $1 (17th)

(Two $1000 chips were bought by collectors at closing. One other chip exists because it was found by a bum. The casino, knowing it wasn't his, refused to cash it!)

	RLT A	Orange	H&C	None	R-white	R-6	5	10	15
	RLT B	Orange	H&C	None	R-white	R-6	5	10	15
	RLT C	Orange	H&C	None	R-white	R-6	5	10	15

SAN REMO HOTEL LAS VEGAS 1989-

1st	1.00	White	H&C	None	R-white	R-1	*	1	2
	5.00	Red	H&C	3blk3pnk	HUB-white	R-1	*	5	7

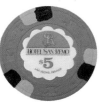

San Remo $5 (1st)

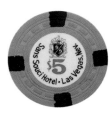

Sans Souci $5 (1st)

Sans Souci 25¢ (2nd)

Sans Souci $5 (3rd)

Santa Anita $5 (1st)

Santa Fe $1 (1st)

Shamrock Hotel $5 (1st)

Issue	Den.	Color	Mold	Inserts	Inlay	Rarity	GD30	VF65	CS95
	25.00	Green	H&C	3blu3grn3wht	SCA-white	R-1	*	25	30
	100.00	Black	H&C	3yel3wht	COG-white	R-1	*	100	110
	NCV	5 diff.	H&C	None	HS	R-7	5	10	15
(Colors: Black, Grey, Lime, Pink, and Red.)									
SANS SOUCI			**LAS VEGAS**		**1955-62**				
1st	.25	White	Rectl	None	HS	R-7	125	250	375
	.50	Blue	Rectl	None	HS	R-10	200	400	600
	1.00	Red	Rectl	None	HS	R-7	125	250	375
	5.00	Mustard	Rectl	4blk	R-white	R-4	25	50	75
	25.00	Rose	Rectl	4gry-grn	R-white	R-5	60	120	180
	100.00	Black	Rectl	4mst	R-white	R-5	75	150	225
2nd	.12 ½	Salmon	C&J	None	HS	R-5	35	70	105
	.25	Red	C&J	None	HS	R-6	25	50	75
	.50	Mustard	C&J	None	HS	R-10	125	250	375
	1.00	Navy	C&J	None	HS	R-9	175	350	525
(This issue is marked "Card Room.")									
	100.00	Black	C&J	None	HS	R-8	150	300	450
3rd	5.00	Green	Scrown	3red	SCA-white	R-4	25	50	75
	25.00	Black	Scrown	3mst	COG-white	R-9	250	500	750
	100.00	Blue	Scrown	3blk	HS	R-8	150	300	450
(This last issue was made in 1960. 300 $100 chips were originally produced.)									
SANTA ANITA			**LAS VEGAS**		**1948-52**				
1st	5.00	Orange	Scrown	None	HS	R-8	125	250	375
	25.00	Green	Scrown	4org	HS	R-8	125	250	375
	100.00	Rust	Scrown	4org	HS	R-8	125	250	375
(This Downtown club focused around a race book and was located on Fremont St.)									
SANTA FE			**LAS VEGAS**		**1991-**				
1st	.25	Turq	HHR	None	HS	R-1	5	10	15
	1.00	Grey	HHR	None	HS	R-1	*	1	2
(One variety has large print and one has small print.)									
	error 1.00	Grey	HHR	None	HS	R-9	30	60	90
(No writing on reverse.)									
	5.00	Red	HHR	3crm	R-white	R-1	*	5	7
	25.00	Green	HHR	4pnk	R-white	R-1	*	25	30
	100.00	Black	HHR	6org	R-white	R-1	*	100	110
	NCV	Black	BJ	None	HS-silver	R-7	4	8	12
	NCV 5	Lavender	BJ	None	HS	R-6	5	10	15
	RLT 1	Purple	H&C	None	HS	R-5	3	6	9
	RLT B	Rust	HHR	None	HS	R-6	4	8	12
2nd	RLT E	Fuchsia	H&C	None	HS	R-5	3	6	9
SCARLET WAGON			**N. LAS VEGAS**		**1973-77**				
1st	1.00	Blue	H&C	None	HS	R-5	50	100	150
	5.00	Red	H&C	3org	HS	R-8	200	400	600
SHAMROCK HOTEL			**LAS VEGAS**		**1951-53**				
1st	5.00	Yellow	HCE	None	HS	R-5	25	50	75
	25.00	Red	HCE	None	HS	R-6	50	100	150
SHENANDOAH			**LAS VEGAS**		**c. early 80's**				
1st	1.00	White	BJ-2	None	COIN	R-1	2	4	6
	5.00	Red	BJ-2	6tan	COIN	R-1	3	6	9

Issue	Den.	Color	Mold	Inserts	Inlay	Rarity	GD30	VF65	CS95
	25.00	Green	BJ-2	6org	COIN	R-2	5	10	15
	100.00	Black	BJ-2	6tan	COIN	R-3	7	14	21

(Casino never opened. License denied to entertainer Wayne Newton. Became Bourbon Street. Beware of Weave mold Borland counterfeits which were not ordered by the casino.)

Showboat $5 (1st)

SHOWBOAT			LAS VEGAS		1954-				
1st	5.00	Navy	Rectl	3mst	R-multi	R-9	1250	2500	3750

(Only 1-2 pieces are known undrilled of the 5 or 6 in existence.)

	RLT	Lavender	Plain	None	HS	R-10	10	20	30
	RLT	Brown	Plain	None	HS	R-10	10	20	30

(Both of the above RLT's have a Pilots Wheel. This generic style could have been used anywhere, but these are definitely from here - probably in play only until the Rectl chips came in.)

	RLT 1	Purple	Rectl	None	HS	R-8	30	60	90
	RLT 2	Beige	Rectl	None	HS	R-7	25	50	75
	RLT 2	3 diff.	Rectl	None	HS	R-9	40	80	120

(Colors: Green, Mustard and Purple.)

Showboat RLT 2 (2nd)

2nd	1.00	Blue	C&J	3red	R-multi	R-9	700	1400	2100

(Classic reverse has great interior casino scene; obverse pictures Showboat riverboat.)

	RLT	Orange	HHR	None	R-white	R-10	50	100	150
3rd	.50	Pnk/Pur	Scrown	1/2pie	LSCA-white	R-4	20	40	60
	1.00	Orange	Scrown	None	HS	R-8	125	250	375
	25.00	Black	Scrown	None	HS	Unique	350	700	1050
	FP 1.00	Dk Purple	Scrown	None	HS	R-8	50	100	150
	RLT 1	7 diff.	Scrown	None	HS	R-5	10	20	30

(Colors: Blue, Green, Lt Green, Peach, Pink, Purple and Yellow. These chips were originally ordered in 1958 and reordered in '59, '64, '66, and '68. From 200 to 1058 ordered!)

Showboat $1 obv (2nd)

	RLT 2	3 diff.	Scrown	None	HS	R-5	10	20	30

(Colors: Purple, Red, and Yellow.)

4th	1.00	Dk Grey	C&J	3red	R-white	R-5	15	30	45
	5.00	Orange	C&J	3dkgrn	R-white	R-5	25	50	75
	5.00	Orange	H&C	3dkgrn	R-white	R-5	15	30	45
	25.00	Brown	C&J	3grn	R-white	R-7	75	150	225

(This issue has bold printing & strong color contrast.)

Showboat $1 rev (2nd)

5th	1.00	Grey	C&J	3red	R-white	R-5	10	20	30
	5.00	Orange	C&J	3dkgrn	R-white	R-5	15	30	45
	25.00	Brown	C&J	3grn	R-white	R-7	50	100	150

(Lighter color in sunburst, writing is bold.)

6th	.50	Pink	H&C	3pur	R-white	R-5	10	20	30

(This .50 has bolder writing.)

	1.00	Grey	H&C	1grn3red	R-white	R-4	8	16	24
7th	.50	Pink	H&C	3pur	R-white	R-4	5	10	15
	1.00	Grey	H&C	3red	R-white	R-4	3	6	9

(Variant has larger misshapen center - a reorder.)

Showboat $5 (4th)

	5.00	Orange	H&C	3dkgrn	R-white	R-4	12	24	36
	25.00	Brown	H&C	3grn	R-white	R-5	25	50	75
	100.00	Black	H&C	8org	R-white	R-7	100	200	300

(This 7th issue has thinner writing.)

	RLT 1	6 diff.	H&C	None	HS	R-7	6	12	18

(Colors: Blue, Brown, Green, Mustard, Pink, and Yellow.)

	RLT 2	3 diff.	H&C	None	HS	R-7	6	12	18

(Colors: Lt Blue, Green and White.)

8th	.25	Tan	BJ	None	HS	R-4	3	6	9
	RLT 2	5 diff.	BJ	None	HS	R-4	3	6	9

(Colors: Blue, Brown, Green, Pink and White.)

Showboat $5 (7th)

Silver Bird $500 (1st)

Silver Bird $1000 (1st)

Silver City $5 (1st)

Silver City $25 (1st)

Silver City $5 (2nd)

Silver City $5 (4th)

Issue	Den.	Color	Mold	Inserts	Inlay	Rarity	GD30	VF65	CS95
	NCV 5	Red	BJ	None	HS-silver	R-7	5	10	15
	NCV 25	Green	BJ	None	HS	R-7	6	12	18
9th	1.00	White	H&C	None	OR-blue	R-1	*	1	2
	5.00	Pink	H&C	3ltblu3ltgrn	OR-red	R-1	*	5	7
	25.00	Green	H&C	4gry4mar	OR-green	R-1	*	25	30
	100.00	Black	H&C	3gry3ltblu3pur	OR-black	R-1	*	100	110

SILVER BIRD — LAS VEGAS — 1976-82

1st	.25	Rust	Diecar	None	HS	R-4	6	12	18
	.50	Brown	Diecar	None	HS	R-4	7	14	21
	.50	Maroon	Diecar	None	HS	R-5	8	16	24
	1.00	Blue	BJ-1	3yel	COIN	R-2	3	6	9
	5.00	Red	BJ-1	6wht	COIN	R-3	5	10	15
	20.00	Lavender	BJ-1	6blk	COIN	R-4	15	30	45
	25.00	Green	BJ-1	6wht	COIN	R-3	9	18	27
	100.00	Black	BJ-1	6pnk	COIN	R-5	35	70	105
	500.00	Grey	BJ-1	6blk	COIN	R-5	50	100	150
	1000.00	Yellow	BJ-1	6blk	COIN	R-5	50	100	150

(Beware of BJ-2 {Non-Incused} issues that are all counterfeit.)

SILVER CITY — LAS VEGAS — 1975-99

1st	.50	Navy	Nevada	None	HS	R-7	20	40	60

(There is a variant with a thinner silver hot stamp.)

	1.00	Grey	Nevada	None	R-white	R-4	15	30	45
	5.00	Red	Nevada	3grn	R-white	R-8	100	200	300
	25.00	Green	Nevada	3red	R-white	Unique*	250	500	750
	25.00	Green	Nevada	3mst	R-white	R-9	175	350	525
	100.00	Black	Nevada	3org	R-white	Unique*	300	600	900
	500.00	Purple	Nevada	3bei	R-white	R-10*	300	600	900
2nd	.25	Mustard	Diecar	None	HS	R-7	30	60	90
	.50	Navy	Diecar	None	HS	R-6	15	30	45
	5.00	Red	BJ-1	3grn	COIN	R-5	25	50	75
3rd	.10	Grey	H&C	None	HS	R-3	10	20	30
	.25	Pink	H&C	None	HS	R-6	7	14	21

(Not marked "Casino.")

	1.00	Dk Blue	H&C	None	HS	R-4	5	10	15
	1.00	Blue	H&C	None	HS	R-1	1	3	5
	1.00	Lt Blue	H&C	None	HS	R-3	2	4	6

(Above are marked "$1".)

4th	.25	Pink	H&C	None	HS	R-3	2	4	6
	.25	Lt Pink	H&C	None	HS	R-4	4	8	12
	1.00	Blue	H&C	None	HS	R-2	1	3	5

(Marked "$1.00".)

	5.00	Red	H&C	4org4yel	HS	R-1	5	10	15
	25.00	Green	H&C	4blu4org	HS	R-5	25	50	75
	100.00	Black	H&C	3grn3fch3yel	HS	R-7	100	175	225
	NCV	Yellow	Plain	None	HS	R-7	5	10	15
5th	.25	Rose	Unicrn	None	HS	R-3	3	6	9
	1.00	Blue	Unicrn	None	HS	R-3	3	6	9

(When Silver City closed October 31, all .25 & $1 chips had been sold out as the crap table was pulled a couple months prior.)

SILVER CLUB — LAS VEGAS — 1932-33/1934-56

1st	.10	Yellow	Diamnd	None	HS	Unique	350	700	1050

(Marked "Silver Club".)

Issue	Den.	Color	Mold	Inserts	Inlay	Rarity	GD30	VF65	CS95
	.25	Red	Diamnd	None	HS	R-10	200	400	600
2nd	25.00	Yellow	Sm-key	None	HS	R-8	150	300	450
	n/d	Red	Sm-key	None	HS	R-8	75	150	225
3rd	5.00	Brown	Lcrown	None	HS	R-8	150	300	450
	25.00	Green	Lcrown	None	HS	R-8	150	300	450
	25.00	Beige	Lcrown	None	HS	R-5	25	50	75

(Marked "JLY" for owner James L. Young)

Issue	Den.	Color	Mold	Inserts	Inlay	Rarity	GD30	VF65	CS95
	n/d	Lavender	Lcrown	None	HS	Unknown	100	200	300

(This 3rd issue was made in 1945.)

Issue	Den.	Color	Mold	Inserts	Inlay	Rarity	GD30	VF65	CS95
4th	5.00	Yellow	HCE	None	HS	R-8	125	250	375

(Early Downtown club on 1st Street next to the Golden Camel Bar.)

Silver Club $5 (3rd)

SILVER DOLLAR SALOON LAS VEGAS 1964-69/1973-96

Issue	Den.	Color	Mold	Inserts	Inlay	Rarity	GD30	VF65	CS95
1st	.25	Orange	Rectl	None	HS	R-10*	100	200	300

(Marked only "SDS".)

Issue	Den.	Color	Mold	Inserts	Inlay	Rarity	GD30	VF65	CS95
2nd	5.00	Yellow	C&J	3org	R-white	R-7	125	250	375
	25.00	Green	C&J	3red	R-white	R-9	175	350	525
3rd	1.00	Navy	C&J	None	HS	R-7	50	100	150
	5.00	Green	C&J	3nvy	HS	R-10	125	250	375
	5.00	Mustard	C&J	4nvy	HS	R-8	75	150	225
4th	1.00	Blue	H&C	None	HS	R-5	10	20	30
	5.00	Red	H&C	3pnk	HS	R-5	20	40	60
5th	5.00	Red	H&C	3wht	HS	R-5	15	30	45
	5.00	Red	H&C	3wht	HS	R-5	20	40	60

Silver Dollar Saloon $5 (1st)

(This is a variant with a $ sign & smaller "5.00".)

Issue	Den.	Color	Mold	Inserts	Inlay	Rarity	GD30	VF65	CS95
	25.00	Green	H&C	4blk	HS	R-5	30	60	90
6th	5.00	Red	BJ-2	4wht	COIN	R-2	5	10	15
	25.00	Green	BJ-2	6wht	COIN	R-3	25	35	45

Silver Dollar Saloon $5 (3rd)

SILVER NUGGET N. LAS VEGAS 1965-88
MAHONEY'S SILVER NUGGET 1989-

Issue	Den.	Color	Mold	Inserts	Inlay	Rarity	GD30	VF65	CS95
1st	.50	Maroon	C&J	None	HS	R-7	50	100	150
	5.00	Red/Mst	C&J	½pie	R-white	R-9	200	400	600
	NN .25	Maroon	C&J	None	HS	R-9	50	100	150
	NN .50	Maroon	C&J	3grn	HS	R-6	25	50	75
	NN 1.00	Tan	C&J	None	HS	R-5	7	14	21
	NN 5.00	Black	C&J	None	HS	R-5	7	14	21

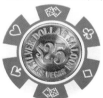

Silver Dollar Saloon $25 (6th)

(The above three chips are all marked "Card Room".)

Issue	Den.	Color	Mold	Inserts	Inlay	Rarity	GD30	VF65	CS95
2nd	1.00	Blue	C&J	None	R-white	R-1	8	16	24
	5.00	Orange	C&J	3nvy	R-white	R-3	20	40	60
	25.00	Purple	C&J	3org	R-white	R-5	35	70	105
	100.00	Beige	C&J	3blk	R-white	R-5	45	90	135

(Beware - some inlays are overstamped and cleaned.)

Issue	Den.	Color	Mold	Inserts	Inlay	Rarity	GD30	VF65	CS95
3rd	.25	Mustard	Nevada	None	HS-black	R-8	20	40	60
	.25	Mustard	Diecar	None	HS-black	R-6	15	30	45
	.50	Maroon	Diecar	None	HS	R-7	25	50	75
	25.00	Green	BJ-2	3dkgrn	COIN	R-5	30	60	90
4th	.50	Brown	H&C	None	HS	R-7	20	40	60
5th	.50	Orange	H&C	None	HS	R-6	10	20	30
6th	.25	Yellow	H&C	None	HS	R-6	15	30	5
	NCV	Orange	H&C	None	HS	R-5	4	8	12
7th	1.00	Blue	H&C	4pur	R-white	R-1	*	1	3
	5.00	Red	H&C	4lim4yel	HUB-white	R-1	*	5	8
	25.00	Green	H&C	3mst3nvy3pnk	SCA-white	R-2	*	25	30

Silver Nugget $5 (1st)

Silver Nugget $25 (7th)

Issue	Den.	Color	Mold	Inserts	Inlay	Rarity	GD30	VF65	CS95
	100.00	Black	H&C	4blu4yel4pnk	WHL-white	R-2	*	100	110

(This 7th issue pictures a face.)

Issue	Den.	Color	Mold	Inserts	Inlay	Rarity	GD30	VF65	CS95
8th	.25	Orange	H&C	None	HS	R-1	*	1	3
	1.00	Blue	H&C	4pur	R-white	R-1	*	1	2
	5.00	Red	H&C	3lim3yel	HUB-white	R-1	*	5	8
	25.00	Green	H&C	3mst3org3pur	SCA-white	R-1	*	25	30
	NCV 1	Blue	H&C	None	HS	R-5	2	4	6
	NCV 5	Red	H&C	None	HS	R-5	5	10	15
	NCV 25	Grey	H&C	None	HS	R-5	5	10	15
	NCV 100	Brown	H&C	None	HS	R-6	7	14	21
9th	.25	Orange	H&C	None	HS	R-4	1	2	3
	2.50	Yellow	BJ-P	12blk	OR-white	R-1	*	3	5

Silver Palace $5 (1st)

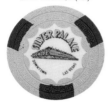

Silver Palace n/d (1st)

SILVER PALACE　　　LAS VEGAS　　　1956-56/1958-64

Issue	Den.	Color	Mold	Inserts	Inlay	Rarity	GD30	VF65	CS95
1st	5.00	Red	Sm-key	3grn	SCA-white	R-9	750	1500	2250
	n/d	Beige	Sm-key	3blu	SCA-white	R-9	300	600	900

(Classic picture of the Silver Palace building. Only 1 or 2 of each is undrilled. There are also five different and presumably unique $5 sample chips with the same classic building picture, but with different color schemes.)

Issue	Den.	Color	Mold	Inserts	Inlay	Rarity	GD30	VF65	CS95
2nd	.10	Mustard	C&J	None	HS	R-8	75	150	225
	.25	Orange	C&J	None	HS-silver	R-10	150	300	450

(Smaller building & shaped different with squared off corner.)

| | .25 | Orange | C&J | None | HS-silver | R-9 | 100 | 200 | 300 |

(Larger building picture.)

	1.00	Blu-Grn	C&J	3crm	SCA-white	R-3	15	30	45
	5.00	Navy	C&J	3mst	R-white	R-3	18	36	54
	25.00	Red	C&J	3grn	R-white	R-4	35	70	105
	100.00	Beige	C&J	3blk	R-white	R-4	50	100	150
	RLT	4 diff.	C&J	None	HS-silver	R-9	40	80	120

(Building outlined. Colors: Green, Purple, Tan, and Yellow.)

| 3rd | 1.00 | Grey | C&J | 3blk | R-grey | R-7 | 100 | 200 | 300 |

("Peace Dollar" face.)

| | NCV | Black | C&J | None | HS | R-10 | 25 | 50 | 75 |

(Dusty Springston. "Good For One Drink At Our Bar".)

| | RLT | Navy | C&J | None | HS | R-7 | 20 | 40 | 60 |

(Smaller picture of the building.)

| 4th | .10 | Yellow | Scrown | None | HS | R-7 | 75 | 150 | 225 |
| | RLT | Pink | H&C | None | HS | R-8 | 25 | 50 | 75 |

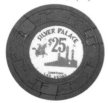

Silver Palace $25 (2nd)

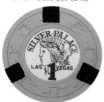

Silver Palace $1 (3rd)

SILVER SADDLE CASINO　　　LAS VEGAS　　　1981-83

Issue	Den.	Color	Mold	Inserts	Inlay	Rarity	GD30	VF65	CS95
1st	.25	Pink	H&C	None	HS	R-5	10	20	30
	5.00	Red	H&C	4ltgrn4tan	HS	R-5	25	50	75
	25.00	Green	H&C	4ltblu4mar	HS	R-6	45	90	135

(This casino, previously called Lucky Slots, was located on the "Strip", near the Aladdin. Originally, this property opened in 1951 as Louigi's Broiler.)

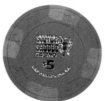

Silver Saddle Casino $5 (1st)

SILVER SADDLE SALOON　　　LAS VEGAS　　　1996-

Issue	Den.	Color	Mold	Inserts	Inlay	Rarity	GD30	VF65	CS95
1st	5.00	Red	H&C	2blu2pch	R-white	R-1	*	5	7
	25.00	Green	H&C	4blu4crm	R-white	R-1	*	25	30
	100.00	Black	H&C	4pur4yel4blu	R-white	R-4	*	100	120

Silver Saddle Casino $25 (1st)

Issue	Den.	Color	Mold	Inserts	Inlay	Rarity	GD30	VF65	CS95

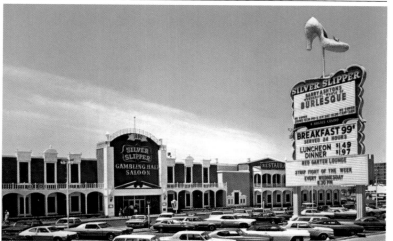

Silver Slipper RLT 1 (1st)

Silver Slipper $100 (2nd)

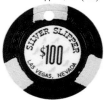

Silver Slipper $100 (3rd)

Postcard of the Silver Slipper, a famous landmark with many very desirable chips, but a less successful budget buffet. One survivor described the baked chicken: "under the heat lamp, it appeared to turn various hues of green, blue, and a rose-pink. Very pretty, but not good eatin'." ©Allen Photographers, Las Vegas

SILVER SLIPPER LAS VEGAS 1950-88

Issue	Den.	Color	Mold	Inserts	Inlay	Rarity	GD30	VF65	CS95
1st	.25	Purple	T's	2org	HS-silver	R-5	35	70	105
	5.00	Yellow	T's	3red	R-blue	R-3	25	50	75
	25.00	Pink	T's	3yel	R-blue	R-3	30	60	90
	100.00	Green	T's	3yel	R-blue	R-4	50	100	150

(One side says "Last Frontier" and the other is marked "Silver Slipper Gambling Hall.")

	RLT 1	6 diff.	Lcrown	None	HS	R-6	15	30	45

("Silver Slipper". Colors: Beige, Brown, Green, Navy, Orange, and Red.)

2nd	5.00		Zigzag		R-black	Unknown	2000	4000	6000
	25.00		Zigzag		R-black	Unknown	2000	4000	6000
	100.00	Beige	Zigzag	3blk	R-black	Unique	2000	4000	6000
3rd	5.00	Purple	Sm-key	3bei	R-white	R-9	1250	2500	3750
	25.00	Red	Sm-key	3blk	R-white	Unique*	1750	3500	5250
	100.00	Black	Sm-key	3wht	R-white	Unique*	2000	4000	6000
	RLT	Green	Sm-key	None	HS	Unique*	150	300	450

(Chip has a picture of a slipper.)

4th	1.00	Rose	C&J	3red	SCA-white	R-7	200	400	600
	5.00	Green	C&J	3bei	SCA-white	R-9	750	1500	2250
5th	25.00	Navy	HCE	3mst	R-white	R-7	400	800	1200
6th	1.00	Grey	C&J	None	R-white	R-10	200	400	600
	5.00	Maroon	C&J	3pnk	R-white	R-10	250	500	750
	25.00	Lt Green	C&J	3dkgrn	R-white	Unknown	700	1400	2100
	100.00	Black	C&J	8yel	R-white	Unknown	700	1400	2100

(No $ sign, of which was added later.)

7th	1.00	Grey	C&J	None	R-white	R-5	65	130	195
	5.00	Maroon	C&J	3pnk	R-white	R-6	100	200	400
	25.00	Lt Green	C&J	3dkgrn	R-white	Unique*	500	1000	1500
	100.00	Black	C&J	8yel	R-white	R-7	200	400	600

(1 line through $ sign. Line is black hot stamp.)

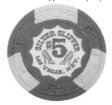

Silver Slipper $5 (4th)

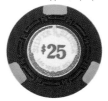

Silver Slipper $25 (5th)

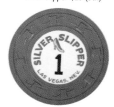

Silver Slipper $1 (6th)

Silver Slipper 50¢ (9th)

Silver Slipper $5 (12th)

Silver Slipper $1 (14th)

Silver Slipper $25 (17th)

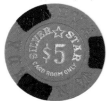
Silver Star $5 (3rd)

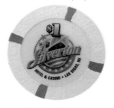
Silverton $1 (1st)

Issue	Den.	Color	Mold	Inserts	Inlay	Rarity	GD30	VF65	CS95
8th	1.00	Grey	C&J	None	R-white	R-5	60	120	180
	5.00	Maroon	C&J	3pnk	R-white	R-6	90	180	350
(2 lines through $ sign. This is printed in the inlay so a reordered issue.)									
	RLT	Navy	C&J	None	HS	R-8	40	80	120
	RLT	4 diff.	C&J	None	HS	R-9	60	120	180
(Colors: Beige, Green, and Lavender.)									
9th	.50	Beige	Nevada	None	R-white	R-7	75	150	225
	.50	Tan	Nevada	None	R-silver	R-7	75	150	225
10th	.50	Yellow	HHL	None	HS-silver	R-10	200	400	600
	1.00	Red	HHL	None	HS-silver	R-9	150	300	450
	5.00	Blue	HHL	None	HS-silver	R-10	250	500	750
11th	.50	Tan	Diecar	None	HS	R-3	5	10	15
12th	5.00	Black	Scrown	None	R-white	R-10	250	500	750
13th	1.00	Red	Diecar	None	R-white	R-10	250	500	750
	5.00	Black	Diecar	None	R-white	R-10	250	500	750
	RLT	5 diff.	Triclb	None	HS	R-7	15	30	45
(Colors: Green, Grey-Grn, Navy, Purple, and Rose.)									
14h	1.00	Blue	H&C	3red3wht	R-white	R-6	100	200	300
(This is one of the Bi-Centennial chips issued in 1976.)									
15th	5.00	Red	BJ-1	3yel	COIN	R-8	100	200	300
	25.00	Dk Green	BJ-1	3wht	COIN	Unique	500	1000	1500
	error 25.00	Dk Green	BJ-1	3wht	COIN	Unique	600	1200	1800
(One side has a coin "Silver Slipper" inlay. The other side has a "Frontier Hotel" coin inlay with green writing.)									
	100.00	Black	BJ-1	3wht	COIN	Unique	500	1000	1500
(This very early 15th issue BJ-1 style has a greater "plastic feel" and slightly different color shading than the next issue. Also, the coin lettering is black on the $5 only.)									
16th	5.00	Red	BJ-1	3yel	COIN	R-5	40	80	120
	25.00	Green	BJ-1	3wht	COIN	R-9	200	400	600
	100.00	Black	BJ-1	3org	COIN	R-8	200	400	600
	RLT	Yellow	BJ	None	HS	R-7	10	20	30
17th	1.00	Brown	BJ-2	6wht	COIN	R-3	6	12	18
	5.00	Red	BJ-2	3yel	COIN	R-5	45	90	135
	25.00	Green	BJ-2	3wht	COIN	R-8	175	350	525

SILVER STAR			LAS VEGAS		1978-78				
1st	.50	Pink	H&C	HS	None	R-1	3	6	9
	1.00	Beige	H&C	3blu	HS	R-1	4	8	12
	5.00	Red	H&C	3blu3pch	HS	R-1	5	10	15
	25.00	Green	H&C	3lim3yel	HS	R-4	15	30	45
	NCV 1	Peach	H&C	None	HS	R-1	3	6	9
2nd	1.00	Tan	Nevada	3dkorg	HS	R-2	4	8	12
	5.00	Maroon	Nevada	3grn	HS	R-2	7	14	21
3rd	1.00	Yellow	Nevada	None	HS	R-2	3	6	9
	5.00	Rust	Nevada	3blk	HS	R-2	5	10	15
('Card Room".)									
	25.00	Green	Nevada	3pur	HS	R-4	20	40	60
(Less than 200 of each $25 existed when the inventory was sold off.)									
(Originally, this downtown casino was built by Benny Binion for his daughter, Becky.)									

SILVERTON			LAS VEGAS		1997-				
1st	.25	Blue	BJ	None	HS	R-2	*	2	3
	1.00	White	House	2org2pur	OR-white	R-1	*	1	2
	5.00	Red	House	2blu2lim	OR-white	R-1	*	5	7

Issue	Den.	Color	Mold	Inserts	Inlay	Rarity	GD30	VF65	CS95
	5.00	Red	Chipco	None	FG	R-2	5	10	15

("Grand Opening, July 1, 1997".)

Issue	Den.	Color	Mold	Inserts	Inlay	Rarity	GD30	VF65	CS95
	25.00	Green	House	2pnk2pur	OR-white	R-1	*	25	30
	100.00	Blach	House	4blu4gld	OR-white	R-1	*	100	110
	RLT A	Grey	Roulette	None	OR-white	R-4	3	6	9

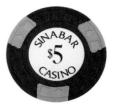

Sinabar $5 (1st)

SINABAR CASINO — LAS VEGAS — 1972-72
SINABAR, BOB STUPAK'S — LAS VEGAS — 1974-75

Issue	Den.	Color	Mold	Inserts	Inlay	Rarity	GD30	VF65	CS95
1st	1.00	Tan	Ewing	3pnk	R-white	R-6	70	140	210
	5.00	Navy	Ewing	3mst	R-white	R-8	125	250	375
	25.00	Green	Ewing	3org	R-white	R-8	125	250	375
2nd	.25	Orange	Ewing	None	HS	R-6	25	50	75
	1.00	Black	Ewing	None	HS	R-6	30	60	90
3rd	.25	Pink	H&C	None	HS	R-9	150	300	450
	1.00	Blue	H&C	3wht	HS	R-6	25	50	75
	5.00	Brown	H&C	3org3yel	HS	R-6	40	80	120
	25.00	Green	H&C	3blu3yel	HS	R-7	50	100	150
	25.00	Green	H&C	3red3wht	HS	R-8	60	120	180
	100.00	Black	H&C	3wht3yel	HS	R-8	100	200	300

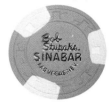

Sinabar $1 (3rd)

(Downtown off Fremont on Ogden.)

SLOTS-A-FUN — LAS VEGAS — 1973-

Issue	Den.	Color	Mold	Inserts	Inlay	Rarity	GD30	VF65	CS95
1st	25	Navy	Nevada	None	HS	R-6	12	24	36
	1.00	Tan	Nevada	None	R-white	R-7	60	120	180
	5.00	Brown	Nevada	None	R-white	R-9	150	300	450
2nd	.25	Navy	Diecar	None	HS	R-6	12	24	36
	1.00	White	BJ-1	6yel	COIN	R-5	25	50	75
	5.00	Red	BJ-1	6blu	COIN	R-5	30	60	90
	RLT	Mustard	C&J	None	R-white	R-7	15	30	45
3rd	.25	Pink	H&C	None	HS	R-5	6	12	18
	1.00	Beige	H&C	None	HS	R-4	10	20	30
	5.00	Red	H&C	3gry3wht	HS	R-6	25	50	75
	25.00	Green	H&C	3pch3wht	HS	R-10	250	500	750
	RLT A	Purple	H&C	None	HS	R-7	8	16	24
4th	1.00	White	BJ-2	6pur	COIN	R-1	*	1	3
	5.00	Red	BJ-2	6yel	COIN	R-1	*	5	8
	25.00	Green	BJ-2	6ltgrn3blk	COIN	R-1	*	25	30
	100.00	Black	BJ-2	3fch3pnk	COIN	R-1	*	100	110
	RLT	6 diff.	HHR	None	R-white	R-7	6	12	18

Slots-A-Fun $1 (1st)

Slots-A-Fun $5 (2nd)

(Colors: Blue, Brown, Lt Green, Orange, Pink, and Yellow.)

Issue	Den.	Color	Mold	Inserts	Inlay	Rarity	GD30	VF65	CS95
5th	.25	Purple	BJ	None	HS	R-3	2	4	6
	1.00	White	BJ-2	6pur	COIN	R-1	*	1	3
	5.00	Red	BJ-2	6yel	COIN	R-1	*	5	8

(The $1 and $5 are identical to the 4th issue, except the mold has card suits only - no dice.)

Issue	Den.	Color	Mold	Inserts	Inlay	Rarity	GD30	VF65	CS95
	RLT	6 diff.	Plain	None	R-white	R-5	2	4	6

Slots-a-Fun $25 (3rd)

(Colors: Blue, Fuchsia, Lime, Orange, Turquoise, and Yellow.)

SNEAK JOINT, THE — LAS VEGAS — 1970-77/1979-80

Issue	Den.	Color	Mold	Inserts	Inlay	Rarity	GD30	VF65	CS95
1st	.50	Purple	C&J	None	HS	R-9	150	300	450
	1.00	Tan	C&J	3org	HS	R-9	200	400	600
	5.00	Red	C&J	3tan	HS	R-9	200	400	600
2nd	5.00	Red	H&C	3grn3wht	R-white	R-10	500	1000	1500

(Was located off the strip on Spring Mountain by the Mirage.)

Sneak Joint $5 (1st)

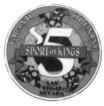

Sport of Kings $5 (1st)

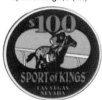

Sport of Kings $100 (1st)

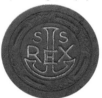

SS Rex $25 (1st)

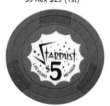

Stardust $5 (1st)

Stardust $25 (1st)

Stardust $100 (2nd)

Issue	Den.	Color	Mold	Inserts	Inlay	Rarity	GD30	VF65	CS95
SPEEDWAY CASINO & CAFE		**LAS VEGAS**			**1999-**				
1st	1.00	Blue	H&C	3red3yel	OR-white	R-3	2	4	6
	5.00	Red	H&C	3ltblu3dkblu	OR-white	R-1	*	5	8
	25.00	Green	H&C	3pnk3blk	OR-white	R-1	*	25	30
	100.00	Black	H&C	4org4gld	OR-white	R-2	*	100	110
SPORT OF KINGS		**LAS VEGAS**			**1992-93**				
1st	5.00	Red	Chipco	None	FG	R-5	20	40	60
	100.00	Black	Chipco	None	FG	R-8	75	150	225
	500.00	Purple	Chipco	None	FG	R-8	75	150	225
	1000.00	Orange	Chipco	None	FG	R-8	100	200	300
	5000.00	White	Chipco	None	FG	R-8	100	200	300
	10000.00	Grey	Chipco	None	FG	R-8	100	200	300

(After the place closed, only 12-15 sets of these beautiful chips got out to collectors. This ill-fated race and sports book had no live gaming. Desperate for business, the book offered odds and promotions so favorable to the players that the professional gamblers they attracted absolutely crushed them and they were forced out of business.)

SS REX		**LAS VEGAS**			**1945-46**				
1st	5.00	Red	Lcrown	None	HS	R-5	80	160	240
	25.00	Navy	Lcrown	None	HS	R-5	100	200	300
2nd	25.00	Blue	Lcrown	None	HS	R-5	125	250	375
3rd	5.00	Dk Pink	Diamnd	None	HS	R-5	100	200	300
	n/d	Navy	Diamnd	None	HS	R-5	20	40	60
	n/d	Red	Diamnd	None	HS	R-4	15	30	45

(These "n/d's" are just marked "Rex". $5 is marked "Rex Club".)

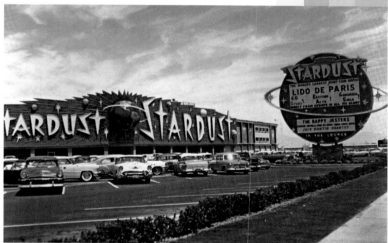

Postcard picturing the Stardust shortly after opening in 1958. ©Ferris H. Scott, Santa Ana, CA.

STARDUST		**LAS VEGAS**			**1958-**				
1st	5.00	Maroon	Sm-key	3nvy	SCA-white	R-9	700	1400	2100
	25.00	Green	Sm-key	3bei	SCA-white	R-7	175	350	525
	100.00	Black	Sm-key	3mar	SCA-white	R-8	275	550	825
2nd	25.00	Green	Sm-key	3blk	SCA-white	R-7	150	300	450
	100.00	Black	Sm-key	3crm	SCA-white	R-8	250	500	750

Issue	Den.	Color	Mold	Inserts	Inlay	Rarity	GD30	VF65	CS95
	faro	4 diff.	T's	None	HS	R-8	75	150	225
("Faro Bank". Colors: Black, Brown, Green, and Mustard.)									
3rd	.25	Maroon	C&J	None	HS	R-10	500	1000	1500
	.50	Green	C&J	None	HS	R-10	500	1000	1500
	1.00	Tan	C&J	None	HS	R-10	500	1000	1500
	25.00	Green	C&J	3pnk	HS	R-7	150	300	600
	500.00	Beige	C&J	3org3blk	HS	Unique*	500	1000	1500
4th	1.00	Fuchsia	C&J	3grn	SCA-white	R-6	50	100	150
	5.00	Lavender	C&J	3mst	SCA-white	R-5	40	80	120
	20.00	Purple	C&J	3tan	SCA-white	R-3	15	30	45
	25.00	Green	C&J	3red	SCA-white	R-7	175	350	525
5th	1.00	Pink	C&J	3grn	SCA-white	R-4	25	50	75
(There are variants to this with different colored stars.)									
	5.00	Mustard	C&J	4red	SCA-white	R-8	200	400	600
	faro	2 diff.	Scrown	None	HS	R-6	50	100	150
("Faro Bank". Colors: Black and Blue.)									
	RLT A	7 diff.	Scrown	None	HS	R-7	10	20	30
(Colors: Grey, Lavender, Navy, Peach, Pink, White, and Yellow.)									
	RLT B	6 diff.	Scrown	None	HS	R-7	10	20	30
(Colors: Black, Brown, Green, Orange, Pink, and Yellow.)									
	RLT C	3 diff.	Scrown	None	HS	R-7	10	20	30
(Colors: Brown, White, and Yellow.)									
	RLT D	3 diff.	Scrown	None	HS	R-8	15	30	45
(Colors: Brown, White, and Yellow.)									
(A total of 12 different colors were made for "A" - in numbers from 250 black to 1290 lavender! We can assume that all sets were made with the same colors. These were made in 1959 & reordered in 1962 & 1966.)									
6th	5.00	Grey	HCE	4brn	SCA-white	R-8	200	400	600
	RLT A	2 diff.	HCE	None	HS	R-6	10	20	30
(Colors: Yellow and White.)									
	RLT B	2 diff.	HCE	None	HS	R-6	10	20	30
(Colors: Beige and Black.)									
	RLT C	3 diff.	HCE	None	HS	R-6	10	20	30
(Colors: Navy, Red, and Yellow.)									
	RLT D	2 diff.	HCE	None	HS	R-6	10	20	30
(Colors: Red and White.)									
7th	5.00	Yel-Grn	HHR	4red	SCA-white	R-7	150	300	450
	RLT A	4 diff.	HHR	None	HS	R-6	5	10	15
(Colors: Blue, Brown, Green, and Fuchsia.)									
	RLT E	7 diff.	HHR	None	HS	R-6	5	10	15
(Colors: Blue, Brown, Burnt-Orange, Green, Mustard, Navy, and Pink.)									
8th	5.00	Red	House	3blu3pnk	MC-green	R-4	40	80	160
	25.00	Green	House	3pur3org	MC-gold	R-7	100	200	300
	100.00	Black	House	3blu3org	MC-black	R-9	200	400	600
	500.00	Purple	House	3grn3blu	MC-blue	R-10	400	800	1200
(These chips are dated. The $5 is 1-74; $25 is 1-73; $100-nothing; and $500-unknown. These also have the shallow centers.)									
9th	5.00	Red	House	4blu4pnk	MC-green	R-5	50	100	200
	25.00	Green	House	3pur3org	MC-gold	R-7	125	250	375
	100.00	Black	House	3pnk3wht	MC-red	R-9	200	400	600
	500.00	White	House	3grn3blu	MC	R-10	400	800	1200
(All chips in this issue are dated 4-76, and have deep centers.)									
	NCV 5	Yellow	House	3pnk	HS	R-9	50	100	150
	NCV 25	Orange	House	3brn	HS	R-7	30	60	90
	RLT A	5 diff.	Triclb	None	HS	R-6	5	10	15

Stardust $25 (4th)

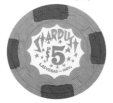

Stardust $5 (5th)

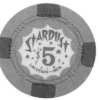

Stardust $5 (6th)

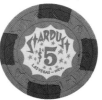

Stardust $5 (7th)

Stardust $5 (8th)

Stardust NCV $5 (9th)

Stardust NCV $25 (9th)

Stardust $1 (10th)

Stardust $5 (10th)

Stardust $1000 (10th)

Stork Club $5 (1st)

Stratosphere $25 (1st)

Issue	Den.	Color	Mold	Inserts	Inlay	Rarity	GD30	VF65	CS95
(Colors: Blue, Brown, Green, Navy, and Pink.)									
RLT B	6 diff.	Triclb	None	HS	R-6	5	10	15	
(Colors: Blue, Brown, Green, Mustard, Navy, and Red.)									
RLT C	7 diff.	Triclb	None	HS	R-6	5	10	15	
(Colors: Blue, Brown, Green, Mustard, Navy, Pink, and Rust.)									
RLT D	7 diff.	Triclb	None	HS	R-6	5	10	15	
(Colors: Blue, Brown, Green, Mustard, Navy, Pink, and Rust.)									
RLT E	7 diff.	Triclb	None	HS	R-5	5	10	15	
(Colors: Blue, Brown, Green, Mustard, Navy, Pink, and Red.)									
10th	1.00	Grey	House	3org	R-white	R-2	7	14	21
(There are at least 3 variants to this chip with different colored stars.)									
	5.00	Red	House	3pnk3pur	R-white	R-3	15	30	45
	25.00	Green	House	3nvy3yel	SCA-white	R-6	50	100	150
	100.00	Black	House	3pur3yel	HUB-white	R-9	200	400	600
	500.00	White	House	3fch3ltblu	COG-white	R-10	350	700	1050
	1000.00	Brown	House	3blu3pnk3wht	R-white	R-9	300	600	900
	1000.00	Brown	H&C	4blu	HS	R-10	40	80	120
("Myrna Rogers" and a picture of a greyhound.)									
	1000.00	Black	H&C	3wht3yel	HS	R-9	30	60	90
("Mark Swain" and a picture of a greyhound. Both of these unusual chips functioned as business cards. We doubt if these could actually be played.)									
	faro	5 diff.	H&C	None	HS	R-7	25	50	75
("Faro". Colors: Green, Grey, Lavender, Navy, and Pink.)									
11th	1.00	White	BJ-2	3mst	COIN	R-1	*	1	2
	5.00	Red	BJ-2	6wht	COIN	R-1	*	5	8
	25.00	Green	BJ-2	8yel	COIN	R-1	*	25	30
	100.00	Black	BJ-2	12pnk	COIN	R-1	*	100	110
rs	100.00	Yellow	BJ-2	12nvy	COIN	R-1	*	100	110
	NCV 1.00	Yellow	H&C	None	HS	R-9	20	40	60
("Stardust Hotel".)									
RLT A	Pink	H&C	None	HS	R-6	4	8	12	
RLT B	Blue	H&C	None	HS	R-4	2	4	6	
RLT C	Orange	H&C	None	HS	R-6	4	8	12	
RLT D	Blue	H&C	None	HS	R-6	4	8	12	
(This issue marked "Las Vegas, NV.")									

STORK CLUB LAS VEGAS 1947-50

	Den.	Color	Mold	Inserts	Inlay	Rarity	GD30	VF65	CS95
1st	5.00	Red	Lcrown	None	HS	R-6	150	300	450
	25.00	Navy	Lcrown	None	HS	R-6	160	320	480
	100.00	Mustard	Lcrown	None	HS	R-6	175	350	525

STRATOSPHERE LAS VEGAS 1996-

	Den.	Color	Mold	Inserts	Inlay	Rarity	GD30	VF65	CS95
1st	1.00	White	H&C	1lim1pur	OR-multi	R-1	*	1	2
	5.00	Pink	H&C	1grn1pur1wht	OR-multi	R-1	*	5	7
	5.00	Red	H&C	1crm1grn1pur	OR-multi	R-1	*	8	10
(Grand Opening April, 96)									
	25.00	Green	H&C	4brn	OR-multi	R-1	*	25	30
	100.00	Black	H&C	6yel6pur	OR-multi	R-1	*	100	110
	NCV	Gry/Pnk	H&C	½pie	OR-white	R-7	5	10	15

Issue	Den.	Color	Mold	Inserts	Inlay	Rarity	GD30	VF65	CS95
	NCV	Crm/Pnk	H&C	½pie	OR-white	R-7	5	10	15
	NCV	Brn/Tan	H&C	½pie	OR-white	R-7	5	10	15
NCV	1.00	Blue	H&C	None	OR-white	R-6	5	10	15
NCV	5.00	Pink	H&C	None	OR-white	R-7	6	12	18
NCV	25.00	Gold	H&C	None	OR-white	R-7	10	20	30
RLT B		2 diff.	RLT	None	OR-white	R-5	2	4	6
(Colors: Green and Navy)									
RLT C		Blue	RLT	None	OR-white	R-4	2	4	6
RLT E		Orange	RLT	None	OR-white	R-4	2	4	6

Sundance $25 (1st)

SUNDANCE　　LAS VEGAS　　1980-88

Issue	Den.	Color	Mold	Inserts	Inlay	Rarity	GD30	VF65	CS95
1st	1.00	Grey	House	3brn	R-white	R-2	3	6	9
	1.00	Blue	House	3fch3pnk	R-white	R-1	2	4	6
	5.00	Red	House	3org3pur	R-white	R-1	3	6	9
	25.00	Green	House	3blu3pnk	SCA-white	R-1	4	8	12
	100.00	Black	House	3pnk3red3yel	HUB-white	R-3	9	18	27
	500.00	White	House	3nvy3org3pnk	COG-grey	R-4	20	40	60
2nd	.25	Pink	H&C	None	HS	R-2	2	4	6
	1.00	Grey	H&C	3brn	R-white	R-4	7	14	21

(The Sundance became Fitzgeralds.)

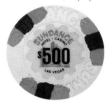

Sundance $500 (1st)

SUNDANCE WEST　　LAS VEGAS　　1976-80

Issue	Den.	Color	Mold	Inserts	Inlay	Rarity	GD30	VF65	CS95
1st	1.00	Blue	C&J	None	HS	R-4	7	14	21
	5.00	Red	C&J	3yel	HS	R-3	6	12	18
	25.00	Green	C&J	3gry3yel	HS	R-3	7	14	21
	100.00	Black	C&J	3blu3pnk	HS	R-4	10	20	30

(Located downtown, Sundance West replaced the Carousel.)

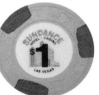

Sundance $1 (2nd)

TEXAS STATION　　N. LAS VEGAS　　1996-

Issue	Den.	Color	Mold	Inserts	Inlay	Rarity	GD30	VF65	CS95
1st	1.00	White	BJ-P	4pur	OR-white	R-1	*	1	3
	5.00	Red	BJ-P	16blu8yel	OR-white	R-1	*	5	8
	5.00	Red	BJ-P	16blu8yel	OR-multi	R-1	5	10	15
(Grand Opening July 95.)									
	25.00	Green	BJ-P	8org16yel	OR-white	R-1	*	25	30
	100.00	Black	BJ-P	4pnk8wht	OR-white	R-1	*	100	110
	NCV	4 diff.	BJ	None	HS	R-7	5	10	15
(Tournament Chips. Colors: Black, Green, Red, and Yellow.)									
	NCV 5	Red	HHR	None	HS	R-4	4	8	12
	NCV 25	Green	BJ-P	4blk	OR-white	R-8	15	30	45
	RLT A	7 diff.	BJ-P	None	R-white	R-4	2	4	6
(Colors: Dk Brown, Lt Brown, Grey, Orange, Pink, Purple, and Turquoise.)									
	RLT B	7 diff.	BJ-P	None	R-white	R-4	2	4	6
(Colors: Dk Brown, Lt Brown, Grey, Orange, Pink, Purple, and Turquoise.)									
	RLT C	7 diff.	BJ-P	None	R-white	R-4	2	4	6

(Colors: Dk Brown, Lt Brown, Grey, Orange, Pink, Purple, and Turquoise.)

Sundance West $1 (1st)

Texas Station $5 (1st)

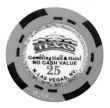

Texas Station NCV 25 (1st)

153

Thunderbird $5 (1st)

Thunderbird $5 (4th)

Thunderbird $5 (5th)

Thunderbird 50¢ (6th)

Thunderbird $1 (6th)

Thunderbird $5 (6th)

Issue	Den.	Color	Mold	Inserts	Inlay	Rarity	GD30	VF65	CS95

This early Thunderbird postcard should convince skeptics of the legitimacy of the first issue chip. Compare the bird on the hotel tower with the bird on the chip. ©Ferris H. Scott, Santa Ana, CA.

THUNDERBIRD			LAS VEGAS			1948-76			
1st	5.00	Mustard	Sm-key	8blk	HS	R-10	400	800	1200
	25.00	Green	Sm-key	8red	HS	Unique	500	1000	1500
	100.00	Black	Sm-key	8bei	HS	Unique	500	1000	1500

(No location listed, but design of bird is an exact match to the huge metal bird erected for the hotel's opening.)

2nd	25.00	Lt Green	Sm-key	4red	SS-black	Unique*	750	1500	2250
	25.00	Lt Green	Sm-key	4red	SS-red	Unique*	750	1500	2250
3rd	5.00	Red	Sm-key	4mst	R-cream	R-10	1500	3000	4500
	RLT 2	5 diff.	Sm-key	None	HS	R-6	12	24	36

(Colors: Brown, Cream, Navy, Red, and Yellow.)

	RLT 3	5 diff.	Sm-key	None	HS	R-6	12	24	36

(Colors: Brown, Cream, Navy, Red, and Yellow.)

4th	5.00	Yellow	Arodie	None	HS	R-6	150	300	450
	25.00	Green	Arodie	None	HS	Unique	1000	2000	3000
	100.00	Black	Arodie	None	HS	R-10	1000	2000	3000
5th	5.00	Maroon	HCE	6yel3blk	R-white	R-9	750	1500	2250
	25.00	Green	HCE	6blk3wht	R-white	R-10*	1000	2000	3000
	100.00	Black	HCE	6gry3org	R-white	R-10	1000	2000	3000
6th	.50	Grn-Red	C&J	dovetail-grn	HS	R-9	175	350	525
	.50	Grn-Red	C&J	dovetail-red	HS	R-9	175	350	525

(Bird on obverse; 50c on reverse.)

	.50	Grn-Red	C&J	dovetail-grn	HS	R-9	150	300	450
	.50	Grn-Red	C&J	dovetail-red	HS	R-9	150	300	450

(No bird on either side.)

	.50	Grn-Red	C&J	dovetail-red	HS	R-10	200	400	600

("Hotel Thunderbird .50" on obverse. Bird on reverse.)

	.50	Grn-Red	C&J	dovetail-red	HS	Unique*	250	500	750

(This chip has smaller lettering; a smaller bird; Nevada spelled out & .50 on reverse.)

	1.00	Purple	C&J	4red	SCA-white	R-7	200	400	600
	5.00	Brown	C&J	4mst	SCA-white	R-8	300	600	900
	25.00	Grey	C&J	4grn	SCA-white	R-10	1000	2000	3000

Issue	Den.	Color	Mold	Inserts	Inlay	Rarity	GD30	VF65	CS95
7th	.50	Tan	C&J	None	HS	R-9	100	200	300
	5.00	Red	C&J	3grn	SCA-white	R-7	250	500	750
	25.00	Green	C&J	3yel	SCA-white	R-9	500	1000	1500
	100.00	Black	C&J	3crm	SCA-white	R-10	1000	2000	3000
8th	1.00	Red	C&J	None	R-white	R-7	20	40	60

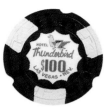

Thunderbird $100 (7th)

(Orange "$1". Common names: Morrey Brodsky, Maury Stevens, and Joe Yip.)

	1.00	Red	C&J	None	R-white	R-8	35	70	105

(Orange "$1", with names in black on reverse. Names: Bob Coyner, Bill Deer, Lee Deer, Art Grant, Bill Hicks, Everett McCarlie, Al Proctor, Monte Proser, Ash Resnick, Jimmy Schuyler, Dave Victorson, Jack Walsh, and Joe Wells.)

	1.00	Red	C&J	None	R-white	R-8	40	80	120

(Black "$1", with red names on reverse. Names: Vince Anselmo, Sammy Boss, Murray Dubow, Pat Foust, Fred Glass, Sam Landy, Larry Rosen, Bob Taylor, Dave Victorson, and Rick Williams.)

Thunderbird $1 (8th)

	FP 1.00	Purple	C&J	None	HS	R-3	5	10	15
	FP 1.00	Pink	C&J	None	HS	R-3	5	10	15
	NCV 5.00	Red	C&J	None	HS	R-9	75	150	225
9th	1.00	Tan	HHR	None	HS	R-3	5	10	15
	1.00	Grey	HHR	None	R-white	R-2	4	8	12
	5.00	Brown	HHR	3grn3yel	R-white	R-1	7	14	21
	25.00	Green	HHR	3gry3pnk	R-white	R-1	7	14	21
	100.00	Black	HHR	6mar3gry	R-white	R-3	12	24	36
	500.00	Navy	HHR	3pnk3yel	R-white	R-10*	400	800	1200
	RLT 1	6 diff.	Scrown	None	HS	R-5	7	14	21

Thunderbird $5 (11th)

(Colors: Dk Pink, Navy, Peach, Pink, Purple, and Yellow)

	RLT 2	Pink	Scrown	None	HS	R-7	10	20	30
	RLT 3	Brown	Scrown	None	HS	R-7	10	20	30
10th	bac 100	Orange	H&C	None	SCA-white	R-10	200	400	600
	bac 1000	Orange	H&C	None	SCA-white	R-10	200	400	600
11th	5.00	Red	BJ-1	3blu	COIN	Unique*	1000	2000	3000

(This unique Bicentennial chip dated 1976 is probably a sample. As of now we don't know if these were actually made for table play or not. The T-Bird closed on Dec. 31, 1976 & possibly made a limited number in July.)

TOWER CLUB N. LAS VEGAS 1944-57

1st	25	Grey	Hub	3red	R-white	R-7	40	80	120

(This chip has not been positively attributed to Las Vegas. This club did have all types of games, and dice have been found. This club was located at 1838 N. Main & may have been open in the 30's.)

Tower Club $25 (1st)

TOWN HALL CASINO LAS VEGAS 1985-

1st	5.00	Red	BJ	4wht	COIN	R-1	*	5	7
	25.00	Green	BJ	4yel	COIN	R-2	*	25	30
	100.00	Black	BJ	?	COIN	R-4	100	200	300

(Chip is "current", but is never brought out to play. You cannot obtain one by asking and none are in collectors' hands as of the end of 1999.)

TOWN HALL ROUND-UP N. LAS VEGAS 1962-64

1st	.25	Red	C&J	None	HS	R-10	200	400	600

(There is a variant with slightly thinner writing.)

	.50	Yellow	C&J	None	HS	R-10	200	400	600
	5.00	Navy	C&J	3mst	R-white	R-6	35	70	105
	25.00	Green	C&J	3red	R-white	R-6	35	70	105

Town Hall Round Up 25¢ (1st)

TOWN TAVERN W. LAS VEGAS 1955-59
TOWN TAVERN, NEW 1959-70/1981-93
TOWN TAVERN, ULTRA NEW 1998-

1st	5.00	Red	Arodie	2crm	HS	R-8	175	350	525

Town Tavern $5 (1st)

New Town Tavern $5 (5th)

New Town Tavern $1 (6th)

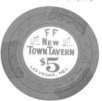

New Town Tavern $5 (6th)

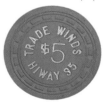

Trade Winds $5 (1st)

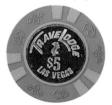

Travelodge $5 (1st)

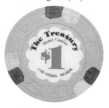

Treasury $1 (1st)

Issue	Den.	Color	Mold	Inserts	Inlay	Rarity	GD30	VF65	CS95
2nd	5.00	Black	Arodie	2pnk	HS-white	R-10	400	800	1200
3rd	5.00	Purple	Scrown	4yel	HS	R-4	35	70	105
4th	.25	Beige	C&J	None	HS	R-8	100	200	300
	1.00	Navy	C&J	None	HS	R-8	100	200	300
	5.00	Red	C&J	3grn	HS	R-8	125	250	375

(First four issues are "Town Tavern".)

Issue	Den.	Color	Mold	Inserts	Inlay	Rarity	GD30	VF65	CS95
5th	5.00	Brown	C&J	4yel	R-white	R-10*	600	1200	1800
6th	1.00	Grey	HHL	None	R-white	R-8	250	500	750
	5.00	Orange	HHL	3grn	R-white	R-9	500	1000	1500
7th	.25	Yellow	HHR	None	HS	R-7	30	60	90
	1.00	Orange	HHR	None	HS	R-7	40	80	120
	5.00	Green	HHR	3red	HS	R-8	100	200	300

(Fifth through seventh issues are "New Town Tavern".)

Issue	Den.	Color	Mold	Inserts	Inlay	Rarity	GD30	VF65	CS95
8th	1.00	Blue	H&C	None	HS	R-8	60	120	180
9th	1.00	Blue	H&C	4pnk	HS	R-6	25	50	75
	5.00	Red	H&C	3grn	HS	R-7	40	80	120
	25.00	Green	H&C	3ltblu3org	HS	Unique	300	600	900

(This 1981 issue is "Town Tavern".)

Issue	Den.	Color	Mold	Inserts	Inlay	Rarity	GD30	VF65	CS95
10th	1.00	Blue	H&C	3wht3pur	HS	R-1	*	3	5
	5.00	Red	H&C	3brn3grn	HS	R-1	*	5	10

("The Ultra New Town Tavern".)

TRADE WINDS — LAS VEGAS — 1955-55

Issue	Den.	Color	Mold	Inserts	Inlay	Rarity	GD30	VF65	CS95
1st	5.00	Red	Rectl	None	HS	R-8	250	500	750
	25.00	Black	Rectl	None	HS	R-9	300	600	900

(Only 7 $25's were found by James & Bo, acquired through an antique dealer friend. The assumed location on Highway 95, out towards Reno, may not be accurate. There is evidence to suggest that the true location of the Trade Winds was closer to Boulder Dam at the site of the Hacienda, previously Gold Strike which opened in 1955. Boulder Highway is Hwy. 95.)

TRAVELODGE — LAS VEGAS — 1982-90

Issue	Den.	Color	Mold	Inserts	Inlay	Rarity	GD30	VF65	CS95
1st	.25	Pink	H&C	None	HS	R-9	150	300	450
	1.00	Brown	BJ-2	12tan	COIN	R-7	125	250	375
	5.00	Red	BJ-2	6grn	COIN	R-7	125	250	375

TREASURE ISLAND — LAS VEGAS — 1993-

Issue	Den.	Color	Mold	Inserts	Inlay	Rarity	GD30	VF65	CS95
1st	1.00	Navy	House	2wht	OR-black	R-1	2	4	6
	5.00	Red	House	8wht	OR-black	R-2	5	10	15
	25.00	Green	House	12wht	OR-black	R-1	*	25	32
	100.00	Black	House	8yel	OR-black	R-1	*	100	110
	bac 100.00	Black	House	3blu3ltblu	OR-black	R-1	*	100	115
	RLT E	Red	BJ	None	HS	R-7	4	8	12
	RLT F	3 diff.	BJ	None	HS	R-6	4	8	12

(Colors: Navy, Orange, and White.)

Issue	Den.	Color	Mold	Inserts	Inlay	Rarity	GD30	VF65	CS95
2nd	1.00	Navy	House	None	OR-black	R-1	*	1	2
	5.00	Red	House	8wht	OR-black	R-1	*	5	7

("Mystere".)

Issue	Den.	Color	Mold	Inserts	Inlay	Rarity	GD30	VF65	CS95
	RLT D	4 diff.	BJ-P	None	R-white	R-4	2	4	6

(Color: Green, Navy, Orange, and White. "Treasure Island".)

Issue	Den.	Color	Mold	Inserts	Inlay	Rarity	GD30	VF65	CS95
3rd	RLT C	White	BJ-P	None	OR-white	R-4	2	4	6

(Picture of swords, etc. "Treasure Island at the Mirage".)

TREASURY, THE — LAS VEGAS — 1979-82

Issue	Den.	Color	Mold	Inserts	Inlay	Rarity	GD30	VF65	CS95
1st	1.00	Lt Blue	H&C	3pch3pur	HUB-white	R-6	50	100	150

Issue	Den.	Color	Mold	Inserts	Inlay	Rarity	GD30	VF65	CS95
2nd	1.00	Blue	BJ-2	6wht	COIN	R-4	10	20	30
	5.00	Red	BJ-2	6pnk	COIN	R-7	125	250	375
	5.00	Red	BJ-2	6wht	COIN	R-10	225	450	675
	25.00	Green	BJ-2	6yel	COIN	R-10	250	500	750
	100.00	Black	BJ-2	6grn	COIN	R-4	12	24	36

(Now the San Remo.)

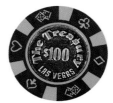

Treasury $100 (2nd)

TRENKLE CASINO — N. LAS VEGAS — 1966-67

Issue	Den.	Color	Mold	Inserts	Inlay	Rarity	GD30	VF65	CS95
1st	.50	Green	H&C	None	HS	R-6	15	30	45
	1.00	Tan	H&C	None	HS	R-4	7	14	21
	5.00	Black	H&C	None	HS	R-6	25	50	75

(These chips were used at the Roadrunner Inn by the Trenkle Brothers.)

Trenkle Casino $1 (1st)

TROPICANA — LAS VEGAS — 1957–

Issue	Den.	Color	Mold	Inserts	Inlay	Rarity	GD30	VF65	CS95
1st	.50	Pnk/Yel	Scrown	1/2pie	R-white	R-8	200	400	600
	1.00	Blu/Wht	Scrown	1/2pie	R-white	R-6	100	200	300
	5.00	Peach	Scrown	4blu	SCA-white	R-4	40	80	120
	25.00	Red	Scrown	4blk	HUB-white	R-5	45	90	135
	25.00	Green	Scrown	4wht	HUB-white	R-6	50	100	150
	100.00	Black	Scrown	4red4wht	COG-white	R-5	75	150	225
	100.00	Blk/Pch	Scrown	1/2pie	COG-white	R-9	300	600	900
	100.00	Dk Grey	Scrown	4ltgry	COG-white	R-6	150	300	450
	100.00	Green	Scrown	None	R-white	R-6	10	20	30

(This chip was made by T.R. King as souvenirs for money clips, etc.)

Tropicana 50¢ (1st)

	RLT A	3 diff.	Scrown	None	HS	R-5	7	14	21

(Colors: Cream, Green, and Yellow.)

	RLT B	10 diff.	Scrown	None	HS	R-5	7	14	21

(Colors: Blue, Lt Blue, Brown, Cream, Fuchsia, Green, Orange, Purple, Red, and Yellow.)

	RLT C	3 diff.	Scrown	None	HS	R-5	7	14	21

(Colors: Cream, Fuchsia, and Yellow.)

	100.00	Green	C&J	None	R-white	R-7	30	60	90

(Above chip only used in souvenir money clips, marked "Void" on back.)

Tropicana $1 (1st)

	RLT	2 diff.	Diamnd	None	HS	R-9	25	50	75

(Colors: Green and Olive.)

	.25	Brown	C&J	None	HS	R-10	300	600	900
	.50	Navy	C&J	None	HS	R-10	300	600	900
	1.00	Purple	C&J	None	HS	R-10	300	600	900

("Card Room". This is a very rare set with only 2 known of each denomination.)

	RLT	3 diff.	C&J	None	HS	R-9	30	60	90

(Colors: Dk Green, Purple, and Red.)

2nd	1.00	Navy	House	None	R-white	R-10*	200	400	600
	1.00	Lt Blue	House	None	R-white	R-4	10	20	30
	5.00	Red	House	3org	R-white	R-5	30	60	120
	25.00	Green	House	3brn	SCA-white	R-8	150	300	450
	100.00	Black	House	3wht3pnk	HUB-white	Unique	500	1000	1500
	NCV 5	Orange	House	3grn	HS	R-8	20	40	60

Tropicana $25 (2nd)

3rd	5.00	Red	H&C	3lav	HS	R-8	80	160	240
	25.00	Green	H&C	3pch	HS	R-10	175	350	525
	100.00	Black	H&C	3wht3org	HS	R-9	150	300	450
	500.00	White	H&C	4pnk	HS	R-9	150	300	450
4th	1.00	Beige	House	None	R-white	R-1	2	4	6
	1.00	Beige	House	None	R-white	R-3	3	6	9

(This issue is the only one marked "Las Vegas, NV.")

	5.00	Red	House	3pur	R-white	R-2	6	12	18

Tropicana $5 (3rd)

Issue	Den.	Color	Mold	Inserts	Inlay	Rarity	GD30	VF65	CS95
	25.00	Green	House	3brn3yel	R-white	R-4	25	50	75
	bac 25.00	Green	House	6wht	STAR-white	R-1	*	25	35
	100.00	Black	House	6org3red	R-white	R-10	200	400	600
	bac 100.00	Black	House	3org3wht3red	R-white	R-9	150	300	450
	1000.00	Fuchsia	House	3grn6yel	R-white	R-10*	200	400	600

(Fourth issue is marked "Ramada" and pictures the building.)

Tropicana $25 (4th)

Issue	Den.	Color	Mold	Inserts	Inlay	Rarity	GD30	VF65	CS95
	NCV	3 diff.	H&C	None	HS	R-7	5	10	15

("Ramada" Colors: Green, Grey and Orange.)

	NCV 1.00	Lt Brown	H&C	None	R-white	R-9	20	40	60
	NCV 2.50	Orange	H&C	None	R-white	R-9	25	50	75
	NCV 5	Dk Pink	H&C	None	R-white	R-8	10	20	30

("Tournament chip" with pic of diamond on above two.)

	NCV 5	Dk Pink	House	3blu3yel	R-white	R-5	10	20	30
	NCV 5	3 diff.	House	1/2pie	HS	R-7	20	40	60

(Colors: Green/White, Blue/White, and Red/White.)

Tropicana NCV 5 (4th)

	RLT A	2 diff.	House	None	R-white	R-6	6	12	18

(Colors: Brown and Yellow.)

	RLT B	Fuchsia	House	None	R-white	R-6	6	12	18
5th	100.00	Black	House	3pur3grn3pnk	COG-white	R-7	150	300	450

(This chip has hologram center. These were used with the building chips.)

6th	1.00	Beige	House	None	R-white	R-1	*	1	2
	5.00	Red	House	3pur	HUB-white	R-1	*	5	8
	25.00	Green	House	3brn3yel	SCA-white	R-1	*	25	30
	100.00	Black	House	3pnk3grn	WHL-white	R-1	*	100	110
	bac 100.00	Black	House	3org3wht3red	R-white	R-1	*	100	110
	NCV 1	Fuchsia	Dragon	None	HS	R-7	5	10	15

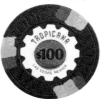
Tropicana $100 (5th)

("Island Money".)

	NCV 5	3 diff.	Clover	None	HS	R-7	5	10	15

(Colors: Aqua, Blue, and Fuchsia.)

	NCV 25	Green	H&C	None	R-white	R-10	50	100	150
	NCV 100	Dk Grey	H&C	None	R-white	R-9	30	60	90
	NCV 500	Lavender	H&C	None	R-white	R-9	50	100	150

(These three NCV chips have the expiration date "12-23-95".)

Tropicana NCV 100 (7th)

	RLT 1	5 diff.	H&C	None	HS	R-4	2	4	6

(Colors: Lt Blue, Brown, Orange, Pink, and Yellow.)

	RLT 2	5 diff.	H&C	None	HS	R-4	2	4	6

(Colors: Lt Blue, Brown, Orange, Pink, and Yellow.)

	RLT 3	5 diff.	H&C	None	HS	R-4	2	4	6

(Colors: Lt Blue, Brown, Orange, Pink, and Yellow.)

	RLT 4	5 diff.	H&C	None	HS	R-4	2	4	6

(Colors: Lt Blue, Brown, Orange, Pink, and Yellow.)

7th	NCV 100	Brown	H&C	None	OR-multi	R-10	50	100	150

("Conmemoracion de la Independencia de Mexico". Three known.)

Turf $5 (1st)

TURF LAS VEGAS 1943-53

	Den.	Color	Mold	Inserts	Inlay	Rarity	GD30	VF65	CS95
1st	5.00	Black	Arodie	None	HS	R-8	200	400	600

(Sports betting club located in the Frontier Club Downtown.)

UNION PLAZA LAS VEGAS 1971-92
PLAZA, JACKIE GAUGHAN'S 1992-

	Den.	Color	Mold	Inserts	Inlay	Rarity	GD30	VF65	CS95
1st	.25	Black	Scrown	None	HS	R-6	15	30	45
	.50	Dk Pink	Scrown	None	HS	R-7	30	60	90
	1.00	Blue	Scrown	3yel	OR-gold	R-3	10	20	30
	5.00	Red	Scrown	3blu3wht	OR-gold	R-4	17	34	51

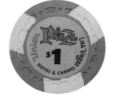
Union Plaza $1 (1st)

Issue	Den.	Color	Mold	Inserts	Inlay	Rarity	GD30	VF65	CS95
	25.00	Green	Scrown	3blk3org	OR-gold	R-9	200	400	600
	100.00	White	Scrown	3red3grn	OR-gold	R-8	175	350	525
	500.00	Brown	Scrown	3fch3tan	OR-gold	R-9	200	400	600
	n/d	Green	C&J	None	HS	R-5	3	6	9

(No one knows what this chip marked "Plaza" was used for, but it is from the Union Plaza.)

Issue	Den.	Color	Mold	Inserts	Inlay	Rarity	GD30	VF65	CS95
2nd	.25	Black	H&C	None	HS	R-5	5	10	15
	.50	Purple	H&C	None	HS	R-4	3	6	9
	.50	Purple	H&C	None	HS	R-8	30	60	90

("Good Only in Card Room" written in 5 lines.)

Issue	Den.	Color	Mold	Inserts	Inlay	Rarity	GD30	VF65	CS95
	bac 3.00	Lt Brown	H&C	3crm6brn	R-white	R-4	8	16	24
3rd	.25	Grey	H&C	None	HS	R-3	2	4	6
	.50	Purple	H&C	None	HS	R-7	25	50	75
	1.00	Blue	H&C	None	HS	R-4	3	6	9
	5.00	Yellow	H&C	None	HS	R-9	50	100	150

(Above 4 chips are marked "Good Only in Card Room" in a circle around the denomination.)

Issue	Den.	Color	Mold	Inserts	Inlay	Rarity	GD30	VF65	CS95
	5.00	Red	H&C	3blu6wht	R-white	R-3	15	30	75

(This is one of the Bi-Centennial chips of 1976. Very difficult to locate in top condition, because these were used on the table for many years after 1976.)

Issue	Den.	Color	Mold	Inserts	Inlay	Rarity	GD30	VF65	CS95
	NCV 1.00	Orange	H&C	None	HS	R-5	3	6	9

("Playable Only At Union Plaza". Two versions: Long canes and Short canes.)

Issue	Den.	Color	Mold	Inserts	Inlay	Rarity	GD30	VF65	CS95
	NCV 1	Orange	H&C	None	HS	R-4	3	6	9

("Playable Only At Union Plaza" and "Table Games Only".)

Issue	Den.	Color	Mold	Inserts	Inlay	Rarity	GD30	VF65	CS95
4th	.70	Brown	H&C	None	HS	R-4	5	10	15
	1.00	Pink	H&C	None	HS	R-7	8	16	24

(The above two chips are marked "Keno".)

Issue	Den.	Color	Mold	Inserts	Inlay	Rarity	GD30	VF65	CS95
5th	pan 1.00	Purple	H&C	None	HS	R-8	15	30	45
	pan 5.00	Orange	H&C	None	HS	R-8	15	30	45
	pan 20.00	Yellow	H&C	None	HS	R-9	20	40	60
	pan 25.00	White	H&C	None	HS	R-8	15	30	45
	pan NCV	Orange	H&C	None	HS	R-8	10	20	30
	pan NCV	White	H&C	None	HS	R-8	10	20	30
	pan NCV.25	White	H&C	None	HS-blue	R-9	20	40	60
	pan NCV 5	Orange	H&C	None	HS-blue	R-9	15	30	45
	pan NCV 20	Yellow	H&C	None	HS-blue	R-9	15	30	45

("Good Only in Union Plaza Pan Tournament".)
(Changes name to "Jackie Gaughan's Plaza" in 1992.)

Issue	Den.	Color	Mold	Inserts	Inlay	Rarity	GD30	VF65	CS95
6th	.25	Black	House	None	HS	R-5	8	16	24
	.25	Peach	House	None	HS	R-3	2	4	6
	.25	Peach	House	None	HS	R-3	2	4	6
	.50	Lt Purple	House	None	HS	R-3	2	4	6
	.50	Purple	House	None	HS	R-3	2	4	6
	1.00	Blue	House	3fch	R-white	R-2	2	4	6
	1.00	Orange	House	None	HS	R-3	3	6	9

("Table Games Only".)

Issue	Den.	Color	Mold	Inserts	Inlay	Rarity	GD30	VF65	CS95
	1.00	Pink	House	None	HS	R-6	4	8	12

("For Keno".)

Issue	Den.	Color	Mold	Inserts	Inlay	Rarity	GD30	VF65	CS95
	5.00	Red	House	3blu3pch	SCA-white	R-4	10	20	30
	25.00	Green	House	3org3pur	HUB-white	R-6	25	50	75
	100.00	Black	House	4ltblu4wht	COG-white	R-7	100	150	200
	NCV 2.50	Pink	House	2ltblu	HS	R-7	10	20	30
	NCV 5	Red	House	4dkgrn4ltgrn	HS	R-9	15	30	45
	NCV 100	Brown	House	4org4pch	HS	R-8	20	40	60
	NCV 500	Grey	House	8pnk	HS	R-10	20	40	60
	NCV 500	Dk Grey	House	3yel	HS	R-10	20	40	60

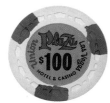

Union Plaza $100 (1st)

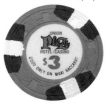

Union Plaza $3 (2nd)

Union Plaza $5 (3rd)

Union Plaza $1 (5th)

Union Plaza $5 (6th)

Union Plaza NCV 100 (6th)

Union Plaza $5 (7th)

Union Plaza $1 (8th)

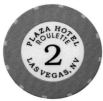

Union Plaza RLT 2 (8th)

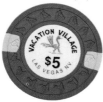

Vacation Village $5 (1st)

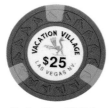

Vacation Village $25 (1st)

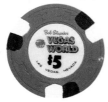

Vegas World $5 (1st)

Issue	Den.	Color	Mold	Inserts	Inlay	Rarity	GD30	VF65	CS95
(This NCV set is marked "Good Only For Union Plaza Poker Tournament".)									
pan NCV 25		Lime	House	4ltblu	HS	R-10	20	40	60
7th	.25	Orange	H&C	None	HS	R-3	1	2	3
	1.00	Blue	H&C	3fch	R-white	R-3	2	4	6
	5.00	Red	H&C	3blu3pch	SCA-white	R-3	5	10	15
(This issue does not have higher denominations and is marked "Plaza".)									
8th	.25	Orange	House	None	HS	R-1	*	1	2
	1.00	Blue	H&C	4nvy4wht	OR-multi	R-1	*	1	3
	5.00	Red	H&C	4blu4pch	OR-multi	R-1	*	5	8
	25.00	Green	H&C	4org4pur	OR-multi	R-1	*	25	30
	100.00	Black	H&C	4ltblu4wht	OR-multi	R-1	*	100	110
(25th Anniversary 1971-96: Jackie Gaughan, J.K. Houssels, and John Jones. Supposedly, all three owners are on each denomination because the men could not agree who would go on what denomination!)									
	RLT 1	6 diff.	BJ-P	12bei	R-white	R-10	10	20	30
(Colors: Blue, Brown, Lt Brown, Lavender, Pink, and Yellow.)									
	RLT 2	6 diff.	BJ-P	12bei	R-white	R-10	10	20	30
(Colors: Blue, Brown, Lt Brown, Lavender, Pink, and Yellow.)									
	RLT 3	6 diff.	BJ-P	12bei	R-white	R-10	10	20	30
(Colors: Blue, Brown, Lt Brown, Lavender, Pink, and Yellow.)									
(These three sets of roulettes were pulled because the inlays were depressed too much. This created a small suction that caused the chips to stick together. The new replacement chips are the same, except for a few different colors. However, all Yellow chips have Grey edge inserts. Now these have been pulled, and the casino uses a new set.)									
	RLT 1	3 diff.	BJ	None	R-white	R-4	2	4	6
(Colors: Brown, White, and Yellow.)									
	RLT 2	3 diff.	BJ	None	R-white	R-4	2	4	6
(Colors: Brown, Lavender, and Blue.)									
9th	.25	Orange	House	None	HS	R-1	*	1	2
(This new issue has a hot stamped top hat & cane, the Paulson Co. logo.)									
	2.00	Tan	BJ	None	HS	R-5	3	6	9
	3.00	Lt Brown	BJ	None	HS	R-5	4	8	12
(Above marked Poker & Pan. This new issue is rarely used.)									

VACATION VILLAGE		**LAS VEGAS**				**1990-**			
1st	1.00	Tan	H&C	4org	HS	R-4	3	6	9
	5.00	Rose	HHR	2crm	R-white	R-1	*	5	10
	25.00	Green	HHR	3org	R-white	R-7	35	70	105
	100.00	Black	HHR	3pnk3wht	R-white	R-1	*	100	115
2nd	25.00	Green	H&C	3blu3ltblu	OR-white	R-1	*	25	35

VAULT, THE		**LAS VEGAS**				**1974-76**			
	FP 1.00	Blue	H&C	None	HS	R-10	200	400	600
	FP 1.00	Blue	H&C	None	HS	R-10	75	150	225
(Only "VC" on obverse. Located Downtown.)									

VEGAS WORLD		**LAS VEGAS**				**1979-95**			
1st	.25	Fuchsia	H&C	None	HS	R-5	8	16	24
	1.00	Blue	H&C	None	HS	R-4	5	10	15
	5.00	Red	H&C	3blk3wht	R-white	R-3	10	20	60
	25.00	Green	C&J	3blk3wht	SCA-white	R-5	40	80	120
	100.00	Black	H&C	3blu3grn3pur	HUB-white	R-8	150	300	450
	NCV 1.00	Blue	H&C	3ltblu	HS	R-6	5	10	15
	NCV 3.00	Grey	H&C	None	HS	R-9	30	60	90
	NCV 5.00	Orange	H&C	4gry	HS	R-9	20	40	60
	NCV 25	Lime	H&C	4brn4gry	R-yellow	R-8	35	70	105

Issue	Den.	Color	Mold	Inserts	Inlay	Rarity	GD30	VF65	CS95

(Above four chips have a $ sign.)

| | NCV 10000 | Black | Nevada | None | HS | R-7 | 100 | 200 | 300 |

("Million Dollar Museum". This was Bob Stupak's Museum before Vegas World. This chip was made in case anyone was lucky enough to hit the $100,000 jackpot.)

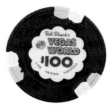
Vegas World $100 (2nd)

| 2nd | 1.00 | Blue | H&C | None | HS | R-3 | 2 | 4 | 6 |

("Las Vegas, NV.")

| | 5.00 | Red | H&C | 3blk3wht | R-white | R-3 | 10 | 20 | 50 |

(Nearly identical to the 1st issue with different color shades on the lettering.)

	25.00	Green	H&C	3pch3wht	SCA-white	R-5	30	60	90
	100.00	Black	H&C	3wht3yel	HUB-white	R-5	40	80	120
	500.00	White	H&C	3brn3pur	COG-white	R-5	50	100	150
	1000.00	Yellow	BJ-2	6blu	COIN	R-6	60	120	180
	5000.00	Purple	BJ-2	12wht	COIN	R-6	70	140	210
	100,000	Yellow	H&C	3gry3pnk3pur	R-white	R-9	500	1000	1500
	NCV	Dk Blue	H&C	3blu	HS	R-5	2	4	6
	NCV	Lavender	H&C	3pur	HS	R-9	15	30	45
	NCV 5	Red	H&C	None	HS	R-6	7	14	21
	NCV 25	Fuchsia	H&C	None	HS	R-7	10	20	30
	NCV 25	Green	H&C	None	HS	R-10	20	40	60

Vegas World $1000 (2nd)

(Above three are "Casino Play Or Cash".)

| | NCV | Blue | H&C | 3blu | HS | R-6 | 3 | 6 | 9 |
| | NCV 5 | Orange | H&C | 4dkgry | HS | R-7 | 7 | 14 | 21 |

(Above two are "Good For One Play".)

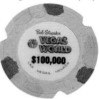
Vegas World $100,000 (2nd)

	NCV 25	Lime	H&C	4blk	R-yellow	R-8	35	70	105
3rd	NCV 5	Red	H&C	None	HS	R-5	3	6	9
	NCV 25	Green	H&C	None	HS	R-5	4	8	12
	NCV 100	Black	H&C	None	HS	R-5	5	10	15
	NCV 500	Purple	H&C	None	HS	R-5	6	12	18
	NCV 1000	Yellow	H&C	None	HS	R-5	6	12	18

(Above 5 chips are all marked "Tournament Chip" on reverse.)

| | NCV 100 | Pink | H&C | 3blk3blu | HS | R-5 | 5 | 10 | 15 |

("100 Fabulous Frequency Machines".)

Vegas World NCV 5 (2nd)

VENETIAN LAS VEGAS 1999-

1st	1.00	White	H&C	2red2gld	OR-multi	R-1	*	1	3
	5.00	Red	H&C	1pnk1crm1org	OR-multi	R-1	*	5	8
	25.00	Green	House	4brn4pch	OR-multi	R-1	*	25	30
	100.00	Black	House	4org4blu	OR-multi	R-1	*	100	110
	RLT	Various	House	None	R-(6 diff.)	R-2	3	6	9

(10 tables have different inlay design. Inlay/chip Colors: Blue, Brown, Gold, Grey, Orange, & Pink.)

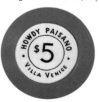
Villa Venice $5 (1st)

VILLA VENICE LAS VEGAS 1949-59

1st	5.00	Red	Circls	None	R-white	Unique	1250	2500	3750
	25.00	Dk Blue	Circls	None	R-white	R-10	1000	2000	3000
	100.00	Green	Circls	None	R-white	Unique*	1250	2500	3750
2nd	5.00	Blue	Diamnd	None	HS	R-9	400	800	1200

WESTERN CLUB LAS VEGAS 1956-60s

	.25	Red	Scrown	None	HS	R-10	20	40	60
	1.00	Blue	Scrown	None	HS	R-5	10	20	30
	20.00	Yel/Blk	Scrown	1/2pie	HS	R-7	20	40	60

(These were ordered for Gardena, California, but may have possibly been used in Las Vegas also. Oddly enough, a $20 piece was found in the Western Club in Lovelock, Nevada.)

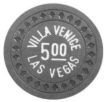
Villa Venice $5 (2nd)

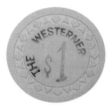

Westerner $1 (1st)

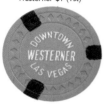

Westerner RLT (1st)

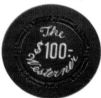

Westerner $100 (4th)

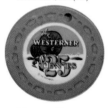

Westerner 25¢ (5th)

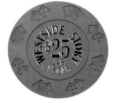

Westside Story $25 (1st)

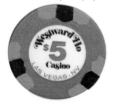

Westward Ho $5 (1st)

Issue	Den.	Color	Mold	Inserts	Inlay	Rarity	GD30	VF65	CS95
WESTERN HOTEL			**LAS VEGAS**		**1965-**				
1st	.50	Pink	H&C	None	HS	R-4	5	10	15
	1.00	Grey	H&C	None	HS	R-1	*	1	3
	5.00	Red	H&C	3blk3org	R-white	R-1	*	5	10
	25.00	Green	H&C	3pnk3yel	R-white	R-1	*	25	35
	100.00	Black	H&C	6pch3blu	SCA-white	R-2	*	100	120
	RLT 1	7 diff.	H&C	None	HS	R-5	3	6	9
(Colors: Blue, Brown, Gold, Pink, Purple, White, and Yellow.)									
WESTERNER, THE			**LAS VEGAS**		**1950-1960**				
1st	1.00	Beige	Arodie	None	HS	Unique	750	1500	2250
	n/d	Orange	Diamnd	3pur	HS-silver	R-6	20	40	100
	RLT	Tan	Diamnd	None	HS	R-9	60	120	180
2nd	.25	Purple	Zigzag	None	HS	R-10	200	400	600
3rd	.25	Navy	Horshu	3bei	HS	R-8	125	250	375
4th	5.00	Beige	HCE	None	HS	R-6	40	80	120
	5.00	Red	HCE	None	HS	R-4	30	60	90
	20.00	Yellow	HCE	None	HS	R-5	25	50	75
	25.00	Green	HCE	None	HS	R-5	25	50	75
	100.00	Black	HCE	None	HS	R-5	45	90	135
	n/d	Red	HCE	None	HS	R-10	50	100	150
(Marked "EG" for owner Emilio Giorgetti.)									
5th	.25	Purple	Scrown	None	R-white	R-10*	500	1000	1500
	5.00	Red	Scrown	4blu	SCA-white	R-4	40	80	120
	25.00	Green	Scrown	4blk	HUB-white	R-5	60	120	180
6th	.25	Purple	Scrown	None	HS	R-9	200	400	600
	.25	Grey	Scrown	None	HS	R-9	200	400	600
	n/d	Dk Blue	Scrown	None	HS	R-9	75	150	225

(Opened as Binion's Westerner. He was partners with George Giorgetti. Giorgetti after three months of partnership wanted his own club & made Binion an offer he couldn't refuse. This early club sure had a lot of different chips & many were probably used together, but you should see how many pairs of dice they had!)

Issue	Den.	Color	Mold	Inserts	Inlay	Rarity	GD30	VF65	CS95
WESTSIDE STORY			**LAS VEGAS**		**1981-82**				
1st	1.00	Tan	Diecar	None	HS	R-6	60	120	180
	5.00	Red	Diecar	None	HS	R-10	300	600	900
	25.00	Green	Diecar	None	HS	R-7	100	200	300
WESTWARD HO			**LAS VEGAS**		**1971-**				
1st	.50	Navy	H&C	None	R-white	R-1	*	1	3
	1.00	Grey	H&C	None	R-white	R-1	*	1	3
(There is a variant with a slightly larger inlay and color shade.)									
	5.00	Red	H&C	3blk6org	R-white	R-1	*	5	10
	25.00	Green	H&C	4org4pch	R-white	R-1	*	25	35
	100.00	Black	H&C	6grn3wht	R-white	R-1	*	100	120
	NCV 5	Blue	H&C	None	HS	R-8	7	14	21
	NCV 5	Red	H&C	None	HS	R-8	7	14	21
	NCV 5	Green	H&C	None	HS	R-8	7	14	21
	RLT	2 diff.	H&C	None	R-white	R-7	4	8	12
(Only marked "WH". Colors: Green and Yellow.)									
2nd	5.00	Red	H&C	3blk6org	OR-multi	R-1	*	5	7
("Puttin' on the Ritz".)									
	5.00	Red	H&C	3blk6org	OR-multi	R-1	*	5	7
("Ho Waiian".)									

Issue	Den.	Color	Mold	Inserts	Inlay	Rarity	GD30	VF65	CS95
	5.00	Red	H&C	3blk6org	OR-multi	R-1	*	5	7
("Grubstake".)									
	25.00	Green	H&C	4org4pch	OR-multi	R-6	25	50	75
("Puttin' on the Ritz".)									
	25.00	Green	H&C	4org4pch	OR-multi	R-6	25	50	75
("Ho Waiian".)									
	25.00	Green	H&C	4org4pch	OR-multi	R-6	25	50	75
("Grubstake".)									
2nd	n/d	Grey	H&C	8blk	R-white	R-6	30	60	90
("1984 2nd Anniversary" This club opened in 1971 as a slot house. Live gaming began in 1982.)									
3rd	NCV 5	Lt Orange	H&C	None	HS	R-6	5	10	15
(Non Reedemable)									
	RLT A	4 diff.	Roulet	None	OR-white	R-4	2	4	6
(Colors: Blue, Brown, Orange, Yellow.)									

Westward Ho n/d obv (2nd)

Westward Ho n/d rev (2nd)

THE WHEEL — LAS VEGAS — 1974-75

Issue	Den.	Color	Mold	Inserts	Inlay	Rarity	GD30	VF65	CS95
1st	.25	Purple	Nevada	None	HS	R-10	10	20	30
(This chip does not have any markings other than .25, but is from The Wheel.)									
	1.00	Mustard	Nevada	None	HS-black	R-5	25	50	75
	1.00	Black	Nevada	3crm	HS-white	R-9	150	300	450
	5.00	Orange	Nevada	3blk	HS-black	R-10	200	400	600
	25.00	Green	Nevada	None	HS	R-10	200	400	600
	25.00	White	Nevada	3org	HS	R-10	200	400	600

(Located at Sahara Ave. & the Strip in what is now the Bonanza Gift Center. Started as the Big Wheel with a big ferris wheel shaped sign on top of the building. Later, this was also the Centerfold Casino sign. This big billboard is still there.)

The Wheel $1 (1st)

WILD WILD WEST — LAS VEGAS — 1998-

Issue	Den.	Color	Mold	Inserts	Inlay	Rarity	GD30	VF65	CS95
1st	1.00	White	H&C	2org2pur	OR-grey	R-1	*	1	3
	5.00	Red	H&C	2gry2ltblu	OR-red	R-1	*	5	8
	25.00	Green	H&C	4pnk4lav	OR-green	R-1	*	25	30
	100.00	Black	H&C	4blu4yel	OR-black	R-1	*	100	110

(This casino was formerly the King 8.)

The Wheel $5 (1st)

WINNER'S CIRCLE — LAS VEGAS — N/A

Issue	Den.	Color	Mold	Inserts	Inlay	Rarity	GD30	VF65	CS95
	1.00	Blue	H&C	2grn2yel	OR-multi	R-1	2	4	6
	5.00	Red	H&C	1blu1gry1yel	OR-multi	R-1	2	4	6
	25.00	Green	H&C	4tan4pnk	OR-multi	R-1	2	4	6
	100.00	Black	H&C	4grn4pnk	OR-multi	R-1	2	4	6

(This casino never opened - it was going to follow the Sport of Kings. A gaming license was not granted, but these chips were made by the Paulson Company and sold there.)

Zanzibar $25 (2nd)

ZANZIBAR — N. LAS VEGAS — 1945-65

Issue	Den.	Color	Mold	Inserts	Inlay	Rarity	GD30	VF65	CS95
1st	5.00	Green	Hub	2org	HS	R-8	90	180	270
2nd	5.00	Green	Rectl	2blk	R-white	R-5	40	80	120
	25.00	Black	Rectl	2gry	R-white	R-5	50	100	150
3rd	.10	Orange	Sqincr	None	HS	R-8	125	250	375
	.25	Red	Sqincr	None	HS	R-6	40	80	120
	1.00	Beige	Sqincr	3grn	R-white	R-4	25	50	75

Zanzibar 10¢ (3rd)

Bal Tabarin $1 (1st)

Barney's $1 (3rd)

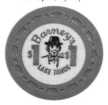

Barney's $1 (4th)

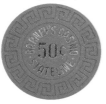

Barney's 50¢ (6th)

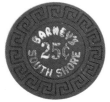

Barney's 25¢ (7th)

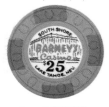

Barney's $25 (10th)

Lake Tahoe

Issue	Den.	Color	Mold	Inserts	Inlay	Rarity	GD30	VF65	CS95
BAL TABARIN			**LAKE TAHOE**		**1955-60**				
1st	1.00	Black	Sm-key	3red	R-pink	R-3	10	20	30
	1.00	Black	Sm-key	3red	R-salmon	R-4	15	30	45

(This club featured many famous entertainers like Tony Bennett, the Mills Brothers, Frankie Lane, and Nat King Cole.)

Issue	Den.	Color	Mold	Inserts	Inlay	Rarity	GD30	VF65	CS95
BARNEY' S			**LAKE TAHOE**		**1961-67 / 1967-88**				
1st	1.00	Yellow	Sm-key	None	HS	R-7	75	150	225
	5.00	Red	Sm-key	None	HS	R-5	60	120	180

(Chip only marked "Barney" with a gold circle.)

2nd	.25	Grey	Sm-key	None	HS	Unique	300	600	900
	.50	Blue	Sm-key	None	HS	Unique	300	600	900
	.50	Mustard	Sm-key	None	HS	R-10	250	500	750
	1.00	Brown	Sm-key	None	HS	Unique	500	1000	1500
	5.00	Purple	Sm-key	3crm	R-white	R-9	450	900	1350
	25.00	Green	Sm-key	3red	R-white	Unique	600	1200	1800
	100.00	Black	Sm-key	3crm	R-white	R-10	600	1200	1800

(Second issue has no city location. Except for one chip, all known $100 chips have the following overstamp on the reverse: "Souvenir, T.R. King & Co." One chip is known with an overstamp so light it is barely noticeable. Some would argue that the 30% rule doesn't apply here. You be the judge.)

3rd	1.00	Mustard	Sm-key	3red	R-white	R-8	225	450	675
	5.00	Purple	Sm-key	3gry	R-cream	R-9	450	900	1350

(Third issue says "Lake Tahoe.")

	RLT	8 diff.	Plain	None	HS	R-7	25	50	75

(Colors: Brown, Dk Brown, Grey, Dk Green, Green, Orange, Purple, and Yellow.)

4th	1.00	Dk Tan	Scrown	None	R-white	R-5	40	80	120
	1.00	Gold	Scrown	None	R-white	R-10	250	500	750

(Both chips have the same picture of a leprechaun.)

5th	.25	Navy	Diasqr	None	HS	R-7	50	100	150
6th	.10	Grey	Lg-key	None	HS	R-10	300	600	900
	.50	Orange	Lg-key	None	HS	R-8	100	200	300
	2.50	Purple	Lg-key	None	HS	R-10	350	700	1050

(These chips are marked "Barney's Casino, Stateline.")

7th	.25	Navy	Lg-key	None	HS	R-6	15	30	45
	1.00	Beige	Lg-key	None	HS	R-4	10	20	30

(These chips are marked "Barney's, South Shore.")

	RLT	5 diff.	Lg-key	None	HS	R-7	15	30	45

(Colors: Fuchsia, Green, Grey, Pink, and Yellow.)

8th	1.00	Blue	Diecar	None	HS	R-10	150	300	450

(Beware Borland Counterfeits. R-10 is a guess. We have not yet confirmed a legitimate example.)

9th	1.00	Grey	H&C	None	HS	R-5	12	24	36
10th	.25	Navy	Horshu	None	HS	R-7	20	40	60
	1.00	Brown	Horshu	4grn	R-white	R-8	200	400	600
	1.00	Mustard	Horshu	4blk	R-white	R-10	400	800	1200
	5.00	Lavender	Horshu	4blk	R-white	R-4	40	80	120
	25.00	Green	Horshu	4fch	R-white	R-10	400	800	1200
	NN 1.00	Mustard	Horshu	None	HS	R-6	12	24	36
	NN 1.00	Green	Horshu	None	HS	R-5	7	14	21
	NN 5.00	Red	Horshu	None	HS	R-5	7	14	21
	RLT	2 diff.	BJ	None	HS	R-5	5	10	15

(Colors: Red and Lime.)

	RLT	4 diff.	Horshu	None	HS	R-7	15	30	45

(Colors: Blue, Orange, Red, and Yellow. Chip marked "Barney's Casino" in an oval.)

Issue	Den.	Color	Mold	Inserts	Inlay	Rarity	GD30	VF65	CS95
	RLT	Green	Horshu	3blk	HS	R-9	25	50	75

(Chip marked "Barney's Casino" in an oval.)

| | RLT | 3 diff. | Horshu | None | HS | R-7 | 15 | 30 | 45 |

(Colors: Blue, Red, and Yellow. Chip marked "Barney's Casino, Lake Tahoe" in a circle.)

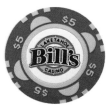

Bill's $5 (1st)

BILL' S LAKE TAHOE 1988-

Issue	Den.	Color	Mold	Inserts	Inlay	Rarity	GD30	VF65	CS95
1st	.25	Blue	BJ	None	HS	R-2	*	1	3
	5.00	Red	BJ-2	12gry	R-white	R-1	*	5	10
	25.00	Green	BJ-2	4pnk	R-white	R-1	*	25	35
	100.00	Blue	BJ-2	16wht	R-white	R-2	*	100	120
	NCV 1	Dk Grey	H&C	4pnk	HS	R-5	8	16	24
	NCV 5	Pink	H&C	4gry	HS	R-5	10	20	30
	NCV 25	Yellow	H&C	None	HS	R-7	15	30	45
	NCV 100	Navy	H&C	None	HS	R-7	20	40	60
	RLT	4 diff.	Plain	None	R-navy	R-4	3	6	9

(Colors: Blue, Green, Navy, and Orange.)

| | RLT | 4 diff. | Plain | None | R-orange | R-4 | 3 | 6 | 9 |

(Colors: Blue, Green, Navy, and Orange.)

| | RLT | 4 diff. | Plain | None | R-purple | R-4 | 3 | 6 | 9 |

(Colors: Blue, Green, Navy, and Orange. These three sets of roulettes use different colored inlays denoting the different tables instead of being marked with table letters or numbers.)

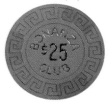

Bonanza Club $25 (1st)

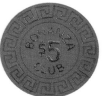

Bonanza Club $5 (2nd)

BONANZA CLUB STATELINE 1966-67

Issue	Den.	Color	Mold	Inserts	Inlay	Rarity	GD30	VF65	CS95
1st	1.00	Mustard	Lg-key	None	HS	R-5	15	30	45
	5.00	Red	Lg-key	3blu	HS	R-6	35	70	105
	25.00	Grn-Gry	Lg-key	3ltlav	HS	R-6	40	80	120
	n/d	Dk Grey	Lg-key	None	HS	R-5	8	16	24
	n/d	Green	Lg-key	None	HS	R-6	12	24	36
2nd	5.00	Red	Lg-key	3pur	HS	R-5	20	40	60
	25.00	Green	Lg-key	3lav	HS	R-5	30	60	90

CAESARS LAKE TAHOE 1969-71

Issue	Den.	Color	Mold	Inserts	Inlay	Rarity	GD30	VF65	CS95
1st	1.00	Gray	Lg-key	3blk	HS	R-5	15	30	45
	5.00	Navy	Lg-key	3org	HS	R-5	25	50	75
	25.00	Black	Lg-key	3grn	HS	R-6	35	70	105
	n/d	Purple	Lg-key	None	HS	R-5	20	40	60
	n/d	Brown	Lg-key	None	HS	R-6	25	50	75

(Both chips are marked "Dollar Token.")

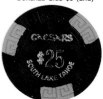

Caesars $25 (1st)

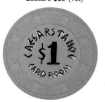

Caesars Tahoe $1 (1st)

CAESARS TAHOE LAKE TAHOE 1980-

Issue	Den.	Color	Mold	Inserts	Inlay	Rarity	GD30	VF65	CS95
1st	1.00	Lt Blue	House	None	HS	R-5	10	20	30
	1.00	Blue	H&C	None	HS	R-6	15	30	45

("Card Room." Gives Lake Tahoe as location.)

	5.00	Red	House	3nvy3yel	R-white	R-4	12	24	36
	bac 5.00	Red	House	3blu3grn3pur	R-white	R-2	5	10	15
	bac 20.00	Green	House	3brn3blk3pch	R-white	R-3	20	40	60
	25.00	Green	House	3pur3ltblu	R-white	R-6	50	100	150
	100.00	Black	House	6org3grn	R-white	R-9	150	300	450
	bac 100.00	Black	House	3pch3wht3yel	R-white	R-3	*	100	150

(First issue has Caesar holding a scroll. $5 and $25 chip molds say "Caesars Palace".)

| | NCV 1 | Dk Brown | H&C | 4tan | HS | R-8 | 20 | 40 | 60 |

(Reverse states "Tournament Chip Only.")

| | NCV 500 | Purple | Plain | 3pnk3gry3fch | R-white | R-10 | 200 | 400 | 600 |

(Stamped "Baccarat," which is unusual for a No Cash Value chip.)

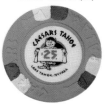

Caesars Tahoe $25 (1st)

Issue	Den.	Color	Mold	Inserts	Inlay	Rarity	GD30	VF65	CS95
2nd	1.00	Blue	H&C	None	HS	R-5	10	20	30

("Card Room." Large "$1", no city location.)

	5.00	Red	House	4blu4ltblu	R-white	R-3	5	10	15
	25.00	Green	House	4yel4ltblu	R-white	R-4	*	25	35
	100.00	Black	House	6org3pch	R-white	R-7	100	200	300
	100.00	Black	House	6grn3yel	R-white	R-9	200	400	600

(Second issue has just a scroll, and is marked "Caesars Tahoe Resort.")

	NCV	Brown	House	4yel	HS	R-7	10	20	30
	NCV	Green	House	4pnk	HS	R-7	10	20	30
3rd	1.00	Blue	Chipco	3yel	FG	R-4	5	10	15

(Used for four or five months on Caribbean Stud. Now destroyed.)

	1.00	Gold	H&C	None	OR-gold	R-1	*	1	3
	5.00	Red	H&C	2blu2ltblu	OR-red	R-1	*	5	10
	25.00	Green	H&C	8crm4lav	OR-green	R-1	*	25	35
	100.00	Black	H&C	4yel4grn	OR-black	R-2	*	100	120
	NCV	Navy	H&C	4blu	HS	R-7	7	14	21
	NCV 5	Navy	H&C	8pnk	HS	R-7	7	14	21
	NCV 25	Green	Chipco	None	FG	R-9	25	50	75
	NCV 50	Fuchsia	Chipco	None	FG	R-9	30	60	90
	NCV 100	Black	Chipco	None	FG	R-9	35	70	105
	NCV 200	Lt Blue	Chipco	None	FG	R-9	50	100	150
	NCV 500	Lime	Chipco	None	FG	R-10	100	200	300
	NCV 500	Purple	Chipco	None	FG	R-9	50	100	150
	NCV 500	Turq	Chipco	None	FG	R-9	50	100	150
	NCV 1000	Grey	Chipco	None	FG	R-9	75	150	225
	NCV 1000	Aqua	Chipco	None	FG	R-9	100	200	300
	NCV 1000	Orange	Chipco	None	FG	R-9	100	200	300

(Above two chips are marked "Julio Iglesias Invitational Weekend, July 26-31, 1993." These dated chips are rare, as they were sent only to high rollers. Most survivors are manufacturer's samples.)

	RLT A	Pink	BJ	None	HS	R-5	3	6	9
	RLT B	Fuchsia	House	None	HS	R-5	3	6	9
	RLT B	Green	House	None	HS	R-5	3	6	9
	RLT B	Peach	Roulet	None	R-white	R-5	3	6	9
	RLT D	Green	Roulet	None	R-white	R-5	3	6	9

CAL-NEVA BILTMORE LAKE TAHOE 1952-56

1st	1.00	White	Arodie	None	R-white	R-4	50	100	150
	5.00	Red	Arodie	3nvy	R-white	R-6	150	300	450
	25.00	Blue	Arodie	3red	R-white	R-6	350	700	1050
	100.00	Fuchsia	Arodie	3mst	R-white	R-6	275	550	825

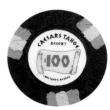
Caesars Tahoe $100 (2nd)

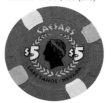
Caesars Tahoe $5 (3rd)

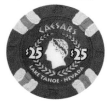
Caesars Tahoe $25 (3rd)

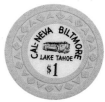
Cal-Neva Biltmore $1 (1st)

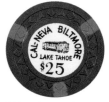
Cal-Neva Biltmore $25 (1st)

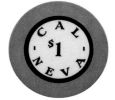
Cal-Neva $1 (1st)

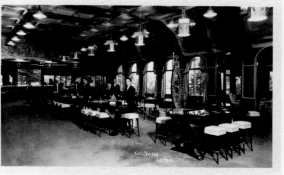

This postcard provides a rare interior view of gaming in the late 1930s.

Issue	Den.	Color	Mold	Inserts	Inlay	Rarity	GD30	VF65	CS95
CAL NEVA LODGE			**CRYSTAL BAY**		**1927-80 / 1986-**				
CLOUD'S			**CAL NEVA**		**1980-83**				
1st	1.00	Lavender	C&S	None	R-white	R-6	100	200	300
	5.00	Black	C&S	None	R-white	R-9	600	1200	1800
	25.00	Orange	C&S	None	R-white	R-9	500	1000	1500
	RLT	Blue	C&S	None	R-blk/wht	R-9	350	700	1050
	RLT	6 diff.	C&S	None	R-blk/wht	R-10	400	800	1200

(Colors: Brown, Green, Pink, Red, White, and Yellow.)

Issue	Den.	Color	Mold	Inserts	Inlay	Rarity	GD30	VF65	CS95
	RLT	Red	C&S	None	R-red/wht	R-9	300	600	900
	RLT	5 diff.	C&S	None	R-red/wht	R-10	400	800	1200

(Colors: Blue, Brown, Green, White, and Yellow.)

Issue	Den.	Color	Mold	Inserts	Inlay	Rarity	GD30	VF65	CS95
	RLT	2 diff.	C&S	None	R-yel/wht	R-8	250	500	750

(Colors: Blue and Brown.)

Issue	Den.	Color	Mold	Inserts	Inlay	Rarity	GD30	VF65	CS95
	RLT	4 diff.	C&S	None	R-yel/wht	R-9	300	600	900

(Colors: Green, Red, White, and Yellow.)

(A few of the above roulette chips listed as R-10 may be unique. In all, we believe that only about 60 chips are known for the entire set! This first issue dates from 1937 when the club re-opened after a fire. Pre-1937 issues are all unknown.)

Issue	Den.	Color	Mold	Inserts	Inlay	Rarity	GD30	VF65	CS95
2nd	.25	Purple	T's	None	HS	R-10	300	600	900
	1.00	Red	T's	None	HS	R-9*	300	600	900
	5.00	Mustard	T's	None	HS-black	R-9*	300	600	900
	25.00	Black	T's	None	HS	R-8	175	350	525
	25.00	Beige	T's	None	HS-blue	R-10	300	600	900
3rd	5.00	Blue/Gry	T's	3yel	HS	R-6	50	100	150
4th	.25	Maroon	Sm-key	None	HS	Unique	350	700	1050
	.50	Navy	Sm-key	None	HS	R-9	175	350	525
	1.00	Maroon	Sm-key	None	HS	R-10	200	400	600
	50.00	Green	Sm-key	None	HS	R-9	250	500	750
	100.00	White	Sm-key	None	HS	R-10	400	800	1200
5th	1.00	Black	Diamnd	None	HS	R-9	50	100	150

(Initially, this was a $100 chip, but the denomination was scratched off and replaced with a silver hot stamp "$1.00 token".)

Issue	Den.	Color	Mold	Inserts	Inlay	Rarity	GD30	VF65	CS95
	5.00	Red	Diamnd	None	HS	R-5	50	100	150
	25.00	Tan	Diamnd	None	HS	R-6	100	200	300

(In the Cal-Neva in Reno, there are around fifty undrilled chips of each denomination sitting in an old display. Unfortunately, the casino will not sell any to chip collectors. Outside of this display, all known examples are drilled, except for three pieces found by Steve Cutler. These chips were probably used in Reno when the club opened in 1948.)

Issue	Den.	Color	Mold	Inserts	Inlay	Rarity	GD30	VF65	CS95
6th	5.00	Maroon	Zigzag	None	HS	R-7*	200	400	600
7th	1.00	Cream	Sm-key	None	HS-black	R-5	75	150	225
8th	100.00	Lime	Sm-key	None	HS-black	R-7	125	250	375

(This issue marked only "CNL".)

Issue	Den.	Color	Mold	Inserts	Inlay	Rarity	GD30	VF65	CS95
9th	5.00	Red	Hub	None	HS	R-5*	100	200	300
	100.00	Black	Hub	None	HS	R-7	125	250	375
10th	5.00	Lt Orange	T's	3blu	HS-blue	R-10	300	600	900
	25.00	Orange	T's	3grn	HS-blue	R-6*	200	400	600

(James Campiglia acquired 60 pieces from Robert Peccole, former owner and gaming pioneer.)

Issue	Den.	Color	Mold	Inserts	Inlay	Rarity	GD30	VF65	CS95
	100.00	Cream	T's	3blk	HS-blue	R-6	100	200	300

(Approximately 20 undrilled pieces were found in November, 1999.)

Issue	Den.	Color	Mold	Inserts	Inlay	Rarity	GD30	VF65	CS95
11th	5.00	Red	T's	3nvy	HS	R-8	150	300	450
	25.00	Green	T's	3org	HS	R-8	175	350	525
12th	1.00	Black	Rectl	3red	R-white	R-4	50	100	200

(About 200 chips were discovered in November, 1999 - most of which were drilled.)

Issue	Den.	Color	Mold	Inserts	Inlay	Rarity	GD30	VF65	CS95
13th	1.00	Navy	S's	4tan	R-white	R-3	25	50	75

(The only verified chip from the Sinatra era. At least half of the 400 known chips are drilled.)

Issue	Den.	Color	Mold	Inserts	Inlay	Rarity	GD30	VF65	CS95
14th	5.00	Purple	Sm-key	3crm	HS	R-6*	100	200	300

Cal-Neva $5 (1st)

Cal-Neva RLT (1st)

Cal-Neva $5 (3rd)

Cal-Neva $5 (5th)

Cal-Neva $1 (12th)

Cal-Neva $5 (14th)

Issue	Den.	Color	Mold	Inserts	Inlay	Rarity	GD30	VF65	CS95
15th	5.00	Navy	T's	3red	R-white	R-5	50	100	150
	25.00	Lt Orange	T's	3gry-grn	R-white	R-9	350	700	1050
	100.00	Tan	T's	3blk	R-black	R-7	150	300	450
16th	1.00	Mustard	C&J	3red	HS	R-6	40	80	120
17th	NN 1.00	Red	Scrown	None	HS	R-8	75	150	225
18th	NN1.00	Green	Lg-key	None	HS	R-5	6	12	18
	NN 5.00	Pink	Lg-key	None	HS	R-9	35	70	105

Cal-Neva $100 (15th)

(Above two chips say "Playable For Fun only.")

	RLT A	Black	Lg-key	None	HS	R-9	25	50	75
19th	1.00	Grey	H&C	None	HS	R-4	6	12	18
20th	.50	Yellow	H&C	None	HS	R-5	30	60	90
	1000.00	Blue	H&C	3red3wht3pch	R-wht/blu	R-6	150	300	450

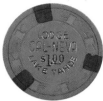
Cal-Neva $1 (16th)

(Above 20th issue is "Cloud's Cal-Neva." Reportedly had a $500 chip also. These chips were brought out for high rollers. Chips say "Redeemable only at Cloud's Cal-Neva.")

	NCV	2 diff.	H&C	None	HS	R-6	10	20	30

(Colors: Fuchsia and White.)

21st	5.00	Red	H&C	3lim3pur	R-white	R-5	25	50	75
	25.00	Green	H&C	3wht3org	SCA-white	R-7	75	150	225
	100.00	Black	H&C	3bei3brn	HUB-white	R-8	200	400	600

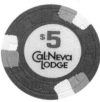
Cal-Neva $5 (22nd)

(Denomination in Black. It's quite possible these chips were used with Cloud's 20th issue.)

	NN 5.00	Brown	H&C	None	HS	R-6	15	30	45
	NN 25.00	Dk Brown	H&C	None	HS	R-10	50	100	150
22nd	5.00	Red	H&C	3wht3blu	R-white	R-5	30	60	90
	25.00	Green	H&C	3pur3pch	SCA-white	R-8	100	200	300

(Denomination in Red.)

23rd	NN 1.00	Green	H&C	None	HS	R-6	15	30	45
24th	1.00	Blue	H&C	None	HS	R-1	*	1	3
	5.00	Red	H&C	4grn	R-white	R-1	*	5	10
	25.00	Green	H&C	3wht3yel	HUB-white	R-2	*	25	35
	100.00	Black	H&C	12org	HEX-white	R-3	*	100	120
	100.00	Black	H&C	3gry3wht3yel	HEX-white	R-9	150	300	450

Cal-Neva $5 (25th)

(Backup chip. Rarely used and hard to acquire - all chips having supposedly been destroyed.)

25th	5.00	Red	Chipco	None	FG	R-2	5	10	15

("Since 1926, America's Oldest Operating Casino.")

26th	RLT	7 diff.	Chipco	None	FG	R-4	5	10	15

(Colors: Blue, Green, Grey, Orange, Purple, White, and Yellow.)

(NOTE: As a reminder, an "" after the rarity means that all known survivors are drilled, notched, or damaged. These are the theoretical values of an undamaged piece. In reality, expect to pay about 30% of these prices for the damaged pieces.)*

CAL VADA LODGE		LAKE TAHOE		1935-51					
NEW CAL VADA LODGE				1951-55					
1st	1.00	Blue	Hub	None	HS	R-9	75	150	225
	5.00	Red	Hub	None	HS	R-9	60	120	180
	10.00	Orange	Hub	None	HS	R-9	75	150	225
	20.00	Brown	Hub	None	HS	R-8	75	150	225
	n/d	Mustard	Hub	None	HS	R-8	40	80	120

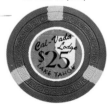
Cal-Vada $25 (2nd)

(First issue only marked "C-VL." Mason Co. records indicate that these chips were ordered in 1935.)

2nd	1.00	Black	Sm-key	3red	R-multi	R-2	10	20	30
	5.00	Green	Sm-key	3tan	R-multi	R-4	25	50	75
	25.00	Navy	Sm-key	3gry	R-multi	R-5	50	100	150
3rd	5.00	Yellow	Sm-key	2nvy	HS	R-6	50	100	150
	25.00	Brown	Sm-key	2org	HS	R-6	75	150	225
	100.00	White	Sm-key	2blk	HS	R-8	125	250	375
4th	5.00	Red	Sm-key	3bei	HS	R-9	200	400	600

New Cal-Vada $100 (3rd)

Issue	Den.	Color	Mold	Inserts	Inlay	Rarity	GD30	VF65	CS95
	25.00	Navy	Sm-key	3yel	HS	R-6	75	150	225
	100.00	Tan	Sm-key	3grn	HS	R-8	125	250	375

(Third and fourth issues are "New Cal Vada Lodge.")

CAPY RIX — CRYSTAL BAY — 1948-49

Issue	Den.	Color	Mold	Inserts	Inlay	Rarity	GD30	VF65	CS95
1st	n/d	Mustard	Diamnd	None	HS	R-7	125	250	375

Capy Rix (1st)

CASINO DE PARIS — LAKE TAHOE — 1952-54

Issue	Den.	Color	Mold	Inserts	Inlay	Rarity	GD30	VF65	CS95
1st	5.00	Rose	Sm-key	None	HS	R-5	75	150	225
	25.00	Yellow	Sm-key	3blu	HS	R-10	600	1200	1800

(In January 1996, this chip was auctioned for $1090.)

| | 100.00 | Green | Sm-key | 3red | HS | R-10 | 800 | 1600 | 2400 |

Casino de Paris $5 (1st)

CIRCUS ROOM — LAKE TAHOE — 1952-60

Issue	Den.	Color	Mold	Inserts	Inlay	Rarity	GD30	VF65	CS95
1st	5.00	Red	Zigzag	None	HS	R-5	40	80	120
	5.00	Navy	Zigzag	None	HS	R-5	35	70	105
	25.00	Black	Zigzag	None	HS	R-10	750	1500	2250
2nd	5.00	Mustard	Sm-key	3blk	HS	R-9	300	600	1200

(Most of these are water damaged.)
(The Circus Room became Barney's. The Colonial was next door.)

Circus Room $5 (1st)

COLONIAL CLUB — LAKE TAHOE — 1949-56

Issue	Den.	Color	Mold	Inserts	Inlay	Rarity	GD30	VF65	CS95
	n/d	Mustard	Rectl	None	HS	R-6	15	30	45
	n/d	Red	Rectl	None	HS	R-7	20	40	60
	n/d	Red	Sm-key	None	HS	R-6	15	30	45

(Became Tahoe Colonial. These chips may not be from Tahoe - some have attributed these to an illegal casino.)

COUNTRY CLUB — LAKE TAHOE — 1930's-42
SAHATI'S STATELINE CC — 1942-48
STATELINE COUNTRY CLUB STATELINE — 1948-56

Issue	Den.	Color	Mold	Inserts	Inlay	Rarity	GD30	VF65	CS95
1st	RLT 7	2 diff.	C&S	None	R-white	R-6	30	60	90

(Colors: Grey and Dk Yellow.)

| | RLT 7 | 7 diff. | C&S | None | R-white | R-8 | 60 | 120 | 180 |

(Colors: Beige, Green, Navy, Purple, Salmon, Turquoise, and Yellow.)

| | RLT 8 | 2 diff. | C&S | None | R-white | R-6 | 30 | 60 | 90 |

(Colors: Grey and Dk Yellow.)

| | RLT 8 | 7 diff. | C&S | None | R-white | R-8 | 60 | 120 | 180 |

(Colors: Beige, Green, Navy, Purple, Salmon, Turquoise and Yellow.)

| | RLT 9 | 2 diff. | C&S | None | R-white | R-6 | 30 | 60 | 90 |

(Colors: Grey and Dk Yellow.)

| | RLT 9 | 7 diff. | C&S | None | R-white | R-8 | 60 | 120 | 180 |

(Colors: Beige, Green, Navy, Purple, Salmon, Turquoise, and Yellow. Picturing an Indian Chief, these very attractive chips date from the 1930's. These same chips ended up being used in various locations around Nevada - one of the last being the International Hotel in Austin.)

| | n/d | Green | Lcrown | None | HS | R-7 | 30 | 60 | 90 |

(This chip is marked "MEC" for Miles E. Custer - one of the original owners.)

| 2nd | RLT 1 | Red (6 diff.) | Sm-key | None | HS | Unique | 200 | 400 | 600 |

(These unusual chips are all red and marked "1", meaning table 1. However, instead of using colors, these roulettes use additional numbers to differentiate between the players' chips. Six different numbers are known, all of which are unique.)

| 3rd | .25 | Green | T's | | HS | R-8 | 275 | 550 | 825 |

(Chip marked "Sahati's Stateline Country Club." Very desirable, because this is the only chip marked with Sahati's name. Only 2 were known until Scott Hartman found an additional 8 pieces. Most of the chips were sold at $775.)

| | .50 | Blue | T's | 4red | HS | R-9 | 100 | 200 | 300 |
| | 1.00 | Green | T's | 4org | HS | R-5 | 15 | 30 | 45 |

Country Club RLT 7 (1st)

Country Club RLT 9 (1st)

Country Club RLT 1 (2nd)

169

Country Club $100 (3rd)

Crystal Bay Club $1 (1st)

Crystal Bay Club $5 (4th)

Crystal Bay Club $100 (5th)

Crystal Bay Club $5 (7th)

Dopey Norman's 25¢ (1st)

Issue	Den.	Color	Mold	Inserts	Inlay	Rarity	GD30	VF65	CS95
	5.00	Orange	T's	4grn	HS	R-4	15	30	45
	25.00	Black	T's	6yel	HS	R-3	15	30	45
	100.00	Brown	T's	5org	HS	R-10	350	700	1050
	100.00	Beige	T's	8brn	R-white	R-6	125	250	375
	RLT	Grey	T's	None	HS	R-7	75	150	225
4th	100.00	Lavender	HHL	3crm	R-white	Unique	600	1200	1800
5th	n/d	Beige	Sm-key	None	HS	R-8	20	40	60
	n/d	Red	Sm-key	None	HS	R-8	20	40	60
	n/d	Navy	Sm-key	None	HS	R-8	20	40	60

(These are only marked "SC Club." They are attributed here, but nothing has been proven.)

6th	1.00	Navy	Hub	3bei	HS	R-3	12	24	36
7th	5.00	Red	HCE	None	HS	Unique	500	1000	1500
	25.00	Mustard	HCE	4blu	HS	Unique	500	1000	1500

CRYSTAL BAY CLUB LAKE TAHOE 1953-

Issue	Den.	Color	Mold	Inserts	Inlay	Rarity	GD30	VF65	CS95
1st	1.00	Mustard	Zigzag	3blk	HS	R-5	20	40	60
	5.00	Red	Zigzag	3bei	HS	R-7	50	100	150
	RLT	Tan	Zigzag	None	HS	R-8	35	70	105
2nd	1.00	Orange	Zigzag	3nvy	HS	R-4	15	30	45
	5.00	Grey	Zigzag	3red	HS	R-4	15	30	45
	RLT 1	Navy	Zigzag	None	HS	R-8	20	40	60
	RLT 1	Yellow	Zigzag	None	HS	R-7	15	30	45
	RLT 1	7 diff.	Zigzag	None	HS	R-5	7	14	21

(Colors: Beige, Brown, Fuchsia, Green, Maroon, Mustard, and Red.)

	RLT 2	Navy	Zigzag	None	HS	R-8	20	40	60
	RLT 2	5 diff.	Zigzag	None	HS	R-5	7	14	21

(Colors: Beige, Fuchsia, Green, Mustard, and Red.)

3rd	1.00	Tan	Sm-key	None	HS	R-2	6	12	18
4th	1.00	Beige	Lg-key	None	HS	R-1	*	2	4

(This chip is still in use!)

	5.00	Purple	Lg-key	3mst	R-white	R-7	100	200	300
	25.00	Green	Lg-key	3org	R-white	R-9	250	500	750
	RLT	5 diff.	Lg-key	None	HS	R-5	6	12	18

(Colors: Brown, Dk Green, Green, Dk Orange, and Red.)

5th	5.00	Orange	PMSC	3brass	Brass	R-8	250	500	750
	25.00	Green	PMSC	3brass	Brass	R-8	250	500	750
	25.00	Blue	PMSC	3brass	Brass	R-10	400	800	1200
	100.00	Brown	PMSC	3brass	Brass	R-8	300	600	900

(Most of these chips are drilled through the edge.)

6th	.25	Lt Brown	H&C	None	HS	R-6	8	16	24
	5.00	Red	H&C	3org3yel	SCA-white	R-2	*	5	10
7th	5.00	Red	H&C	3org3yel	SCA-white	R-1	*	5	10

(This variant lists NV. with North Lake Tahoe.)

	25.00	Green	H&C	3org3brn	HUB-white	R-1	*	25	35
	100.00	Black	H&C	3grn3pch	COG-white	R-2	*	100	125
8th	.25	Yellow	BJ	None	HS	R-6	6	12	18

(This chip is very hard to get, despite its recent mintage.)

DOPEY NORMAN'S LAKE TAHOE 1953-54

Issue	Den.	Color	Mold	Inserts	Inlay	Rarity	GD30	VF65	CS95
1st	.10	Lt Blue	Arodie	None	HS	R-10	500	1000	1500
	.25	Red	Arodie	None	HS	R-9	350	700	1050

(Some of these were painted over - supposedly by casino owners too cheap to order new chips!)

2nd	.25	Red	Sqsqrt	None	HS	R-10	200	400	600
	5.00	Yellow	Sqsqrt	None	HS	R-5	25	50	75

Issue	Den.	Color	Mold	Inserts	Inlay	Rarity	GD30	VF65	CS95
	20.00	Black	Sqsqrt	None	HS	R-5	35	70	105

ED'S TAHOE NUGGET LAKE TAHOE 1991-93

1st	.25	Blue	H&C	None	HS	R-5	4	8	12
	.25	Gold	H&C	None	HS-black	R-5	4	8	12

(There is a variant with thicker lettering, appearing larger.)

	1.00	White	H&C	3fch	R-multi	R-4	10	20	30
	5.00	Pink	H&C	4blu	HUB-multi	R-6	35	70	105
	25.00	Lt Green	H&C	4lav4fch	SCA-multi	R-9	250	500	750
	100.00	Black	H&C	3ltgrn3lim	COG-green	R-10	400	800	1200
	NCV 1	Lavender	Unicrn	None	HS	R-5	5	10	15
	NCV 5	Yellow	Unicrn	None	HS	R-5	5	10	15
	NCV 25	Red	Unicrn	None	HS	R-5	5	10	15
	NCV 100	Purple	Unicrn	None	HS	R-5	7	14	21
	NCV 500	Green	Unicrn	None	HS	R-5	7	14	21
	NCV 1000	Orange	Unicrn	None	HS	R-5	7	14	21

FORTY GRAND TREASURE ROOM LAKE TAHOE 1960's?

1st	.25	Grey	HHL	3grn	R-white	R-5	15	30	45
	1.00	Maroon	HHL	3red	R-white	R-5	20	40	60
	5.00	Purple	HHL	3tan	R-white	R-5	20	40	60

(This chip is believed to be from a casino near the Circus Room in Lake Tahoe, but positive verification has not yet been found. Years ago, a set of these was given to a long-time collector who was told that these were from Tahoe. A club called Forty Grand was in Sacramento, CA in the 1970's, but the HHL mold usually dates from the early 1960's.)

GARY'S CASINO LAKE TAHOE 1976-78

1st	.25	Mustard	Horshu	None	HS	R-5	25	50	75
	.25	Maroon	Horshu	None	HS	R-8	60	120	180
	2.00	Beige	Nevada	2red2nvy	R-white	R-9	1000	2000	3000

(This is the rarest and most desirable of the Bi-Centennial chips issued in 1976. A perfect example of one of the 7 known survivors of this tiny casino sold at auction in 1998 for $3900.)

	5.00	Red	Nevada	3bei	R-white	R-8	200	400	600
	5.00	Black	Nevada	3red	R-white	R-10	500	1000	1500
	25.00	Cream	Nevada	3grn	R-white	R-10	600	1200	1800

GATEWAY CLUB (GEORGE'S) LAKE TAHOE 1949-55

1st	5.00	Fuchsia	Sqsqrt	None	HS	R-5	25	50	75
	25.00	Mustard	Sqsqrt	None	HS	R-6	40	80	120
	100.00	Black	Sqsqrt	None	HS	R-6	50	100	150
2nd	5.00	Red	Hub	None	HS	R-3	20	40	60
	25.00	Mustard	Hub	None	HS	R-3	25	50	75
	100.00	Black	Hub	None	HS	R-4	40	80	120

(Quite a few of these second issue chips were used in a card club in California with scratched off denominations.)

3rd	n/d	Red	Arodie	None	HS	R-10	200	400	600

(Chip only marked "Gateway.")

4th	.05	Rose	Diasqr	None	HS	R-7	25	50	75
	n/d	Yellow	Diasqr	None	HS	R-7	20	40	60
	n/d	Fuchsia	Diasqr	None	HS	R-6	15	30	45

(This fourth issue only marked "GG.")

GLASS CRUTCH LAKE TAHOE 1962-67

1st	1.00	Mustard	Sm-key	3gry	R-white	R-5	75	150	225

Ed's Tahoe Nugget $5 (1st)

Ed's Tahoe Nugget $100 (1st)

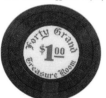

Forty Grand $1 (1st)

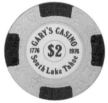

Gary's Casino $2 (1st)

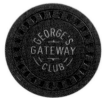

George's Gateway $100 (2nd)

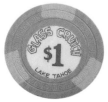

Glass Crutch $1 (1st)

Issue	Den.	Color	Mold	Inserts	Inlay	Rarity	GD30	VF65	CS95
	5.00	Black	Sm-key	3lav	R-white	R-4	75	150	225
	25.00	Green	Sm-key	3org	R-white	R-9	600	1200	1800
2nd	1.00	Mustard	C&J	3tan	R-white	R-5	75	150	225
	5.00	Black	C&J	3fch	R-white	R-6	125	250	375
	5.00	Yellow	C&J	3org	R-white	R-10	500	1000	1500
	25.00	Green	C&J	3org	R-white	R-9	400	800	1200
3rd	5.00	Mustard	Hub	3red	R-white	R-10	600	1200	1800

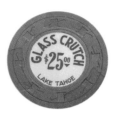

Glass Crutch $25 (2nd)

HARRAH'S — LAKE TAHOE — 1955-

Issue	Den.	Color	Mold	Inserts	Inlay	Rarity	GD30	VF65	CS95
1st	.10	Red	Sm-key	3grn	HS	R-7	100	200	300

(Chip marked "Harrah's Club, Reno/Lake Tahoe" on obverse.)

	2.50	Grey	Sm-key	3nvy	R-white	R-10	500	1000	1500
	5.00	Dk Orange	Sm-key	3mst	R-white	Unique	1000	2000	3000
	5.00	Gry-Blu	Sm-key	3red	R-white	R-10	750	1500	2250
	25.00	Brown	Sm-key	3crm	R-white	R-8	350	700	1050
	25.00	Brown	Sm-key	3mst	R-white	Unique	1000	2000	3000
	100.00	Purple	Sm-key	3gry	R-white	R-5	100	200	300

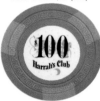

Harrah's $100 (1st)

(Great picture of Sultan and Harem. First issue chips say "Reno/Lake Tahoe.")

2nd	.10	Yellow	Sm-key	3blu	HS-blue	R-6	60	120	225

(Chip marked "Harrah's Club" on obverse, "Reno and Lake Tahoe" on reverse.)

	5.00	Dk Orange	Sm-key	3brn	R-white	R-10	500	1000	1500
	25.00	Brown	Sm-key	3crm	R-white	Unique	1000	2000	3000

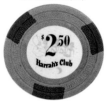

Harrah's $2.50 (3rd)

(Sultan and Harem. Second issue is marked "Reno and Lake Tahoe." Jerry Wall's tip for distinguishing between the second and third issues: "The "and" in the second issue is noticeably smaller than the "and" on the third issue. Also, the "and" is bolder on the third issue.")

3rd	2.50	Grey	Sm-key	3blu	R-white	R-10	500	1000	1500
	5.00	Gry-Blu	Sm-key	3red	R-white	R-10	500	1000	1500
	5.00	Dk Orange	Sm-key	3mst	R-white	Unique	1000	2000	3000
	25.00	Maroon	Sm-key	3mst	R-white	Unique	1000	2000	3000
	100.00	Cream	Sm-key	3nvy3org	R-white	R-9	700	1400	2100

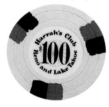

Harrah's $100 (3rd)

(Third issue is also marked "Reno and Lake Tahoe." This is the last issue of the "Harem" chips.)

	RLT	8 diff.	Sm-key	None	R-cream	R-7	50	100	150

(Colors: Black, Blue, Cream, Navy, Dk Pink, Pink, Red, and Yellow.)

	RLT	9 diff.	Sm-key	None	R-lt blue	R-7	50	100	150

(Colors: Blue, Brown, Cream, Green, Navy, Orange, Pink, Red, and Yellow.)

	RLT	Pink	Sm-key	None	R-lt green	R-8	60	120	180
	RLT	3 diff.	Sm-key	None	R-pink	R-7	50	100	150

(Colors: Green, Red, and Yellow.)

	RLT	Brown	Sm-key	None	R-yellow	R-7	50	100	150
	RLT	Green	Sm-key	None	R-yellow	R-7	50	100	150
	RLT A	Pink	Sm-key	None	R-lt blue	R-8	60	120	180
	RLT A	White	Sm-key	None	R-lt blue	R-8	60	120	180
	RLT A	Navy	Sm-key	None	R-lt green	R-8	60	120	180
	RLT B	Orange	Sm-key	None	R-cream	R-8	60	120	180
	RLT B	Yellow	Sm-key	None	R-cream	R-8	60	120	180
4th	.10	Yellow	Sm-key	3nvy	HS-blue	R-8	100	200	300
	.10	Yellow	Sm-key	3nvy	HS-gold	R-7	90	180	270

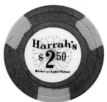

Harrah's $2.50 (4th)

(Chips marked "Harrah's" on obverse; "Reno and Lake Tahoe" on reverse. Both chips are identical, except for the hot stamp.)

	2.50	Brown	Sm-key	3yel	R-white	R-8	250	500	750
	5.00	Blu-Gry	Sm-key	3red	R-white	R-4	25	50	75
	5.00	Grn-Gry	Sm-key	3red	R-white	R-4	20	40	60
	5.00	Green	Sm-key	3red	R-white	R-4	20	40	60
	5.00	Cream	Sm-key	3nvy3yel3red	R-white	R-9	350	700	1050

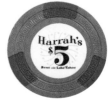

Harrah's $5 (4th)

Issue	Den.	Color	Mold	Inserts	Inlay	Rarity	GD30	VF65	CS95
	25.00	Orange	Sm-key	3crm3grn	R-white	R-5	100	200	300
	25.00	Orange	Sm-key	3tan3brn	R-white	R-10	500	1000	1500
	25.00	Red	Sm-key	3blk3mst	R-white	Unique	600	1200	1800
	25.00	Black	Sm-key	3wht3yel	R-white	R-5	250	500	750

(All but a few are drilled through the center and these are worth about 5% of listed values.)

| | 100.00 | White | Sm-key | 3pnk3grn | R-white | R-9 | 300 | 600 | 900 |
| | 100.00 | White | Sm-key | 3blu3yel3red | R-white | R-9 | 300 | 600 | 900 |

(This issue has a lower case "and". These chips are grouped together because their order is impossible to determine.)

| 5th | 1.00 | Mustard | C&J | None | HS | R-6 | 30 | 60 | 90 |
| | 5.00 | Orange | C&J | 3dkblu | R-white | R-5 | 100 | 200 | 300 |

(All but a few are drilled through the center and these are worth about 5% of listed values.)

	25.00	Green	C&J	3dkblu3red	R-white	R-8	175	350	525
	100.00	White	C&J	3blk3org	R-white	R-10	350	700	1050
	RLT	Lavender	C&J	None	R-lt green	R-9	20	40	60
	RLT	Pink	C&J	None	R-lt green	R-8	15	30	45
	RLT	Red	C&J	None	R-lt green	R-10	25	50	75
6th	.10	Red	Sm-key	4gry	HS	R-7	90	180	270
	.10	Yellow	Sm-key	3dkblu	HS	R-6	50	100	150

(Chips marked "Harrah's, Reno & Lake Tahoe" on both sides.)

	1.00	Dk Blue	Sm-key	3wht	R-white	R-5	25	50	75
	1.00	Purple	Sm-key	3wht	R-white	R-4	20	40	60
	5.00	Orange	Sm-key	3dkgrn	R-white	R-7	75	150	225

(This issue has an upper case "AND".)

7th	.25	Pink	Sm-key	6dkblu3gry	R-white	R-6	40	80	120
	5.00	Yellow	Sm-key	6org3gry	R-white	R-7	75	150	225
	25.00	Green	Sm-key	3org3blu	R-white	R-8	150	300	450
	100.00	Cream	Sm-key	3org3blk	R-white	R-9	250	500	750
8th	.10	Yellow	Scrown	3blu	HS	R-6	40	80	175
	.25	Pink	Scrown	6pur3wht	R-white	R-5	10	20	30
	5.00	Orange	Scrown	3dkblu	R-white	R-6	40	80	120
	25.00	Green	Scrown	3dkblu3org	R-white	R-9	150	300	450
	RLT	5 diff.	Scrown	None	R-white	R-6	6	12	18

(Colors: Dk Brown, Grey, Dk Lavender, Red, and Yellow.)
("AND" is upper case and of identical size as the words around it.)

| | pan n/d | Red | Scrown | None | HS | R-9 | 100 | 200 | 300 |
| 9th | 5.00 | Green | Scrown | 3pnk | R-white | R-7 | 60 | 120 | 180 |

("and" is lower case and smaller than the words around it.)

	RLT	Green	Lg-key	None	R-yellow	R-6	6	12	18
	RLT	White	Lg-key	None	R-white	R-6	6	12	18
	RLT	Yellow	Lg-key	None	R-white	R-6	6	12	18

(Above three roulettes have a black star.)

| | RLT | Green | Lg-key | None | R-lt blue | R-6 | 6 | 12 | 18 |
| | RLT | Red | Lg-key | None | R-lt blue | R-6 | 6 | 12 | 18 |

(Blue star.)

| | RLT | 4 diff. | Lg-key | None | R-lt brown | R-6 | 6 | 12 | 18 |

(Brown star. Colors: Brown, Lavender, Navy, and Yellow.)

| | RLT | 3 diff. | Lg-key | None | R-lt green | R-6 | 6 | 12 | 18 |

(Green star. Colors: Green, Pink, and White.)

| | RLT | Mustard | Lg-key | None | R-yellow | R-6 | 6 | 12 | 18 |
| | RLT | Red | Lg-key | None | R-yellow | R-6 | 6 | 12 | 18 |

(Orange star.)

| | RLT | 4 diff. | Lg-key | None | R-pink | R-6 | 6 | 12 | 18 |

(Red star. Colors: Lavender, Navy, Red, and White.)

| | RLT | Red | Lg-key | None | R-red | R-6 | 6 | 12 | 18 |

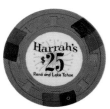

Harrah's $25 (5th)

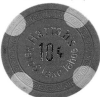

Harrah's 10¢ (6th)

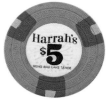

Harrah's $5 (7th)

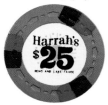

Harrah's $25 (8th)

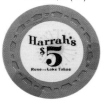

Harrah's $5 (9th)

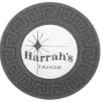

Harrah's RLT (9th)

Issue	Den.	Color	Mold	Inserts	Inlay	Rarity	GD30	VF65	CS95
(Red star.)									
10th	RLT	Green	Diecar	None	R-grey	R-6	5	10	15
(Black star.)									
	RLT	Brown	Diecar	None	R-tan	R-6	5	10	15
(Brown star.)									
	RLT	6 diff.	Diecar	None	R-peach	R-6	5	10	15
(Orange Star. Colors: Dk Brown, Grey, Dk Lavender, Mustard, Red, and Yellow.)									
	RLT	Navy	Diecar	None	R-lavender	R-6	5	10	15
(Purple star.)									
11th	.25	Pink	H&C	6nvy3gry	R-white	R-4	7	14	21
12th	1.00	Dk Grey	H&C	4wht4ltblu	HS	R-5	10	20	30
	5.00	Orange	H&C	8wht	HS	R-5	7	14	21
	25.00	Purple	H&C	4pnk	HS	R-5	15	30	45
	NCV 5	Grey	H&C	3brn3org	HS	R-4	7	14	21
("Redeemable Only at Harrah's Tahoe.")									
	RLT	Mustard	H&C	None	R-dk yellow	R-5	5	10	15
(Brown star.)									
	RLT	Mustard	H&C	None	R-yellow	R-5	5	10	15
(Orange star.)									
13th	.25	Pink	H&C	6pur3wht	R-white	R-4	4	8	12
(Marked "Reno and Lake Tahoe.")									
	100.00	Blue	H&C	4red	R-white	R-7	75	150	225
	NCV 1	Blue	H&C	None	HS	R-4	4	8	12
	NCV 1	Mustard	H&C	None	HS	R-5	7	14	21
	NCV 5	Red	H&C	4gry	R-white	R-6	10	20	30
	NCV 5	Grey	H&C	3yel	R-white	R-7	12	24	36
	NCV 5	Purple	H&C	None	HS	R-5	7	14	21
	NCV 25	Blue	H&C	4ltblu	R-white	R-7	20	40	60
	NCV 25	Grey	H&C	3pur	R-white	R-6	15	30	45
	NCV 100	Purple	H&C	4wht	R-white	R-6	15	30	45
	NCV 500	Orange	H&C	4pnk	R-white	R-7	20	40	60
	RLT	7 diff.	H&C	None	R-white	R-5	3	6	9
(Colors: Lt Blue, Green, Lt Orange, Orange, Lt Pink, Pink, and White.)									
	RLT 2	Orange	H&C	None	R-white	R-5	3	6	9
14th	1.00	Yellow	PMSC	16brass	Brass	R-1	3	6	9
	error 2.50	Yellow	PMSC	16brass	Brass	R-6	50	100	150
(This chip was supposed to be a $1. After the error was discovered, Harrah's searched out and destroyed the offenders, resulting in a scarce chip today.)									
	2.50	Green	PMSC	8brass	Brass	R-3	4	8	12
(No location.)									
	2.50	Green	PMSC	8brass	Brass	R-4	5	10	15
(Marked "Lake Tahoe, Nevada.")									
	5.00	Red	PMSC	3brass	Brass	R-2	5	10	15
	bac 5.00	Green	PMSC	4brass	Brass	R-1	*	5	7
	25.00	Black	PMSC	3brass	Brass	R-4	25	50	75
	bac 25.00	Fuchsia	PMSC	10brass	Brass	R-1	*	25	30
	100.00	White	PMSC	4brass	Brass	R-6	75	150	225
	bac 100.00	Lt Blue	PMSC	4brass	Brass	R-1	*	100	110
	bac 500.00	Orange	PMSC	6brass	Brass	R-2	*	500	525
(There are variants on the above $5, $25, and $100 denominations. Some have serifs on tail of first "H" in "Harrah's." Also, between the "h" and "s" in "Harrah's", there is either an apostrophe or a star instead of an apostrophe. More research is needed to determine whether or not there is a significant effect on rarity.)									
15th	5.00	Red	Chipco	None	FG	R-1	10	20	30
(First modern commemorative. Picture of a sailboat, "Collectors Series 1990.")									

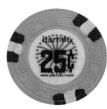

Harrah's 25¢ (11th)

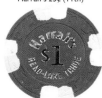

Harrah's $1 (12th)

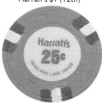

Harrah's 25¢ (13th)

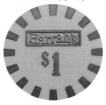

Harrah's $1 (14th)

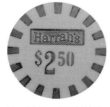

Harrah's Error $2.50 (14th)

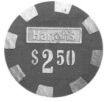

Harrah's $2.50 (14th)

Issue	Den.	Color	Mold	Inserts	Inlay	Rarity	GD30	VF65	CS95
16th	5.00	Blue	Chipco	None	FG	R-10	150	300	450

(Oversized octagon shape. "100% Satisfaction Guaranteed. Good Only at Harrah's Lake Tahoe.")

Issue	Den.	Color	Mold	Inserts	Inlay	Rarity	GD30	VF65	CS95
17th	1.00	White	BJ-P	4pnk4pur	OR-white	R-1	*	1	2
error	1.00	White	BJ-P	4pnk3pur	OR-white	R-5	20	40	60

(Chip has 3 instead of 4 purple inserts.)

	5.00	Red	BJ-P	4ltgry4nvy	OR-white	R-1	*	5	7
error	5.00	Red	BJ-P	4ltgry3nvy	OR-white	R-5	20	40	60

(Chip has 3 instead of 4 navy inserts.)

	25.00	Green	BJ-P	8yel4org	OR-multi	R-5	25	50	75

(Glossy inlay.)

	25.00	Dk Green	BJ-P	8ltgrn4red	OR-multi	R-1	*	25	35

(Matte finish inlay.)

	100.00	Black	BJ-P	4blu4pnk	OR-white	R-8	100	200	300

(Glossy inlay. This variety was only used for 30 days because the inlays flaked off!)

	100.00	Black	BJ-P	4blu4pnk	OR-white	R-1	*	100	120

(Matte finish inlay.)

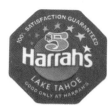

Harrah's $5 (16th)

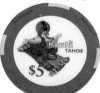

Harrah's $5 (17th)

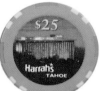

Harrah's $25 (17th)

Harvey's 25¢ obv (3rd)

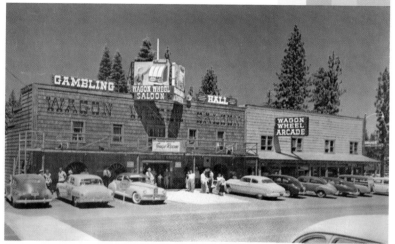

This postcard captures Harvey's when it was called the Wagon Wheel Saloon in the late 40s or early 50s. ©John L. Corbett, Berkley, CA.

HARVEY'S LAKE TAHOE 1944-

Issue	Den.	Color	Mold	Inserts	Inlay	Rarity	GD30	VF65	CS95
1st	.25	Orange	Horshu	None	HS	R-6	30	60	90

(According to Howard Herz, "Most likely the first check issued for the crap game in 1945.")

2nd	.25	Yellow	T's	None	HS-silver	R-5	30	60	90

(Chip is marked "Wagon Wheel, Lake Tahoe.")

3rd	.25	Red	Sm-key	None	HS-yellow	R-4	20	40	60
	.25	Lavender	Sm-key	None	HS-yellow	R-4	20	40	60
4th	5.00	Yellow	Sqsqrt	3red	HS	Unique	750	1500	2250
5th	5.00	Yellow	HCE	3red	HS	R-10	500	1000	1500
	RLT	Orange	HCE	None	HS	R-4	15	30	45
	RLT	4 diff.	HCE	None	HS	R-10	50	100	150

(Colors: Black, Blue, Green, and Yellow.)
(Third through fifth issues are marked "Wagon Wheel Saloon." The HCE no denomination chips are also marked "HAG" in the center - the initials for owner Harvey A. Gross.)

6th	5.00	Orange	HCE	2blk	HS	R-10	600	1200	1800
	25.00	Black	HCE	4red	HS	R-7	150	300	450

Harvey's 25¢ rev (3rd)

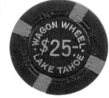

Harvey's $25 (6th)

Harvey's $5 (9th)

Harvey's $100 (11th)

Harvey's $2 (14th)

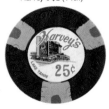

Harvey's 25¢ (17th)

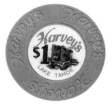

Harvey's $1 (18th)

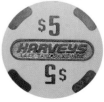

Harvey's $5 (19th)

Issue	Den.	Color	Mold	Inserts	Inlay	Rarity	GD30	VF65	CS95
7th	25.00	Black	Sm-key	3red	HS	R-6	50	100	150
8th	5.00	Grey	Sm-key	3red	R-blk/wht	R-8	400	800	1200
9th	5.00	White	Sm-key	3red	R-white	R-8	350	700	1050
	25.00	Purple	Sm-key	3yel	R-white	R-10	750	1500	2250
	100.00	Maroon	Sm-key	3blk3grn	R-white	Unique	1000	2000	3000
10th	.25	Navy	Lg-key	6yel3org	R-white	R-5	30	60	90
	.50	Grey	Lg-key	3brn	HS	R-4	10	20	30

(Chip marked "Harvey's Resort Hotel.")

11th	2.50	Grey	Lg-key	3pnk3nvy	R-white	R-4	25	50	75
	5.00	Beige	Lg-key	6red3yel	R-white	R-3	10	20	30
	25.00	Green	Lg-key	6yel3red	R-white	R-4	18	36	54
	100.00	Red	Lg-key	6grn3gry	R-white	R-7	150	300	450
12th	.10	Yellow	Lg-key	None	HS-red	Unique	350	700	1050
	.25	Brown	Lg-key	None	HS	R-8	50	100	150
13th	1.00	Mustard	Lg-key	3pur	R-white	R-1	3	6	9
	25.00	Green	Lg-key	3pnk3yel	R-white	R-8	100	200	300

(Not marked "South Shore.")

14th	2.00	Red/Wht	House	4blu	R-white	R-2	8	16	24

(This is one of the more common and obtainable Bi-Centennial chips issued in 1976.)

15th	2.00	Red/Wht	House	1/2pie w/4blu	SCA-white	R-3	8	16	24
	error 2.00	Red/Wht	House	1/2pie w/4blu	SCA-white	R-8	100	200	300

(One side mistakenly has a $2.50 inlay.)

	2.50	Grey	House	3pnk3nvy	SCA-white	R-4	10	20	30
	5.00	Beige	House	6red3yel	SCA-white	R-3	10	20	30
	100.00	Maroon	House	3grn3bei	SCA-white	R-7	75	150	225

(This issue shows the hotel without window panes.)

16th	.25	Navy	House	None	HS	R-4	4	8	12
	2.00	Red/Wht	House	1/2pie w/4blu	SCA-white	R-3	8	16	24
	2.50	Grey	House	3pnk3nvy	SCA-white	R-4	10	20	30
	5.00	White	House	6red3yel	SCA-white	R-3	10	20	30
	25.00	Green	House	6yel3red	SCA-white	R-4	20	40	60
	100.00	Red	House	3wht3grn	SCA-white	R-7	75	150	225

(This issue shows the hotel with window panes.)

	500.00	Pink	House	3wht3blk	R-white	R-10	250	500	750

(No picture of hotel.)

17th	.25	Navy	House	6yel3org	R-white	R-6	20	40	60
18th	1.00	Mustard	House	3pur	R-white	R-1	2	4	6
	1.00	Blue	House	None	HS	R-7	12	24	36

("Good Only At".)

19th	1.00	Yellow	PMSC	4brass	Brass	R-1	2	4	6
	2.00	Brown	PMSC	4brass	Brass	R-3	10	20	30
	2.50	Green	PMSC	4brass	Brass	R-2	5	10	15
	5.00	Lt Blue	PMSC	4brass	Brass	R-2	5	10	15
	bac 5	Red	PMSC	4brass	Brass	R-5	10	20	30
	25.00	Orange	PMSC	4brass	Brass	R-4	30	60	90
	bac 25	Black	PMSC	4brass	Brass	R-5*	40	80	120

(Outside of Sharkey's table, this is an R-6.)

	100.00	Blue	PMSC	4brass	Brass	R-7	100	200	300
	bac 100	White	PMSC	4brass	Brass	R-5*	150	300	450

(Outside of Sharkey's table, this is an R-8.)

	500.00	Maroon	PMSC	4brass	Brass	R-8	200	400	600

(Probable back-up chip.)

	500.00	Pink	PMSC	4brass	Brass	R-5*	400	800	1200

(Outside of Sharkey's table, this is an R-10.)

176

Issue	Den.	Color	Mold	Inserts	Inlay	Rarity	GD30	VF65	CS95
	bac 500	Grey	PMSC	4brass	Brass	R-10	500	1000	1500
	1000.00	Blue	PMSC	8brass	Brass	R-8*	600	1200	1800

(Outside of Sharkey's table, this chip is believed to be unique.)

	bac 1000	Blue	PMSC	4brass	Brass	R-6*	*500	*1000	*1500

(Unknown outside of Sharkey's table.)

(All baccarats are oversized.)

**(Okay, now you're dying to know: "What the hell is Sharkey's table?" In Sharkey's casino in Gardnerville, Nevada, the owner (Sharkey), acquired a fairly large quantity of obsolete Harvey's chips and chips from other casinos. He decided to have some tables custom made for his restaurant. These rare and valuable chips are now encased in lucite in these tables! The chips cannot be removed, so it's hard to evaluate them. We decided to account for these chips because technically they do exist, but the chips are priced as though they don't exist. In case you can't get up there for a look or a bite to eat, here's a picture of the table.)*

Harvey's $5 bac (19th)

Harvey's $25 bac (19th)

Harvey's NN 2 (19th)

Harvey's NCV 100 (20th)

	NCV 2	Green	H&C	None	HS	R-7	10	20	30
	NCV 2	Black	Chipco	None	FG	R-6	8	16	24
	NN 2	Black	Chipco	None	FG	R-6	10	20	30

(Above three chips say "Party Ace.")

20th	NCV 5	Pink	H&C	None	HS	R-5	6	12	18
	NCV 5	Pink	H&C	8ltgrn	HS	R-5	6	12	18
	NCV 25	Green	H&C	8pnk	HS	R-6	12	24	36
	NCV 25	Lavender	H&C	4pnk	HS	R-6	10	20	30
	NCV 100	Yellow	H&C	8red	HS	R-6	15	30	45
21st	1.00	White	H&C	2blk2gry	OR-multi	R-1	*	1	3
	2.50	Pink	H&C	1lim1pur	OR-multi	R-1	*	3	5
	5.00	Red	H&C	3grn3tan	OR-multi	R-1	*	5	10
	25.00	Green	H&C	4crm4mar	OR-multi	R-1	*	25	35
	100.00	Black	H&C	2pch2pnk2org2yel	OR-multi	R-1	*	100	120

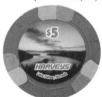

Harvey's $5 (21st)

HARVEY'S ROULETTE SECTION

1st	RLT	8 diff.	Horshu	None	HS	R-7	20	40	60

(Colors: Beige, Green, Grey, Lavender, Maroon, Navy, Peach, and Yellow.)

	RLT	Red	TK	None	HS	R-10	50	100	150

(Chip has a picture of a big wheel - same style as the 25 cent Horshu chip. No name or city.)

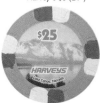

Harvey's $25 (21st)

177

Harvey's RLT (2ⁿᵈ)

Harvey's RLT (3ʳᵈ)

Harvey's RLT (5ᵗʰ)

Harvey's RLT (6ᵗʰ)

Harvey's RLT (8ᵗʰ)

Harvey's RLT D (10ᵗʰ)

Issue	Den.	Color	Mold	Inserts	Inlay	Rarity	GD30	VF65	CS95
2ⁿᵈ	RLT	Purple	Sm-key	None	HS	R-8	25	50	75
	RLT	Red	Sm-key	None	HS	R-8	25	50	75
(These roulettes say "Wagon Wheel Saloon," with two little wheels.)									
3ʳᵈ	RLT	White	Lg-key	None	HS	R-7	10	20	30
	RLT	Yellow	Sm-key	None	HS-blue	R-8	20	40	60
	RLT	6 diff.	Sm-key	None	HS-gold	R-7	15	30	45
(Colors: Blue, Green, Lavender, Red, White, and Yellow. The green chip has a thicker, filled in hot stamp; but the design is the same.)									
	RLT	White	HCE	None	HS	R-10	30	60	90
(All above roulettes have a picture of a pilot's wheel.)									
4ᵗʰ	RLT	Red	C&S	None	HS	Unique	50	100	150
	RLT	Yellow	C&S	None	HS	Unique	50	100	150
	RLT	3 diff.	HCE	None	HS	R-8	30	60	90
(Colors: Brown, Green, and Navy.)									
	RLT	7 diff.	Lg-key	None	HS	R-9	30	60	90
(Colors: Beige, Blue, Green, Lavender, Red, White, and Yellow.)									
	RLT	7 diff.	Sm-key	None	HS	R-6	15	30	45
(No writing. Picture of small skull, bigger wheel, and what appears to be a plow.)									
(Colors: Green, Lavender, Navy, Orange, Red, White, and Yellow.)									
5ᵗʰ	RLT	5 diff.	C&S	None	R-white	R-9	50	100	150
(Colors: Beige, Green, Lavender, Red, and Yellow.)									
	RLT	Red	Lg-key	None	HS	R-9	30	60	90
	RLT	9 diff.	Sm-key	None	HS	R-8	25	50	75
(Colors: Green, Lt. Green, Lavender, Maroon, Navy, Orange, Red, White, and Yellow.)									
	RLT	4 diff	HCE	None	HS	R-6	20	40	60
(Colors: Beige, Brown, Green, and Yellow.)									
(All above roulettes say "Harvey's Wagon Wheel" with identical picture of a skull & wheel.)									
6ᵗʰ	RLT	5 diff.	HCE	None	HS	R-9	35	70	105
(Colors: Beige, Brown, Orange, Pink, and Yellow. Marked "Harvey's" with picture of skull & wheel.)									
7ᵗʰ	RLT	3 diff.	HCE	None	HS	R-6	6	12	18
(Colors: Beige, Brown, and Yellow. Marked only with Harvey's style "H.")									
	RLT	3 diff.	HCE	None	HS	R-8	12	24	36
(Colors: Aqua, Orange, and Pink. Marked only with Harvey's style "H.")									
8ᵗʰ	RLT	3 diff.	House	None	Inlaid	R-8	15	30	45
(Inlaid Anchor. Colors: Beige, Green, and Yellow.)									
	RLT	6 diff.	House	None	Inlaid	R-6	8	16	24
(Inlaid Diamond. Colors: Beige, Dk Brown, Green, Navy, Red, and Yellow.)									
	RLT	8 diff.	House	None	Inlaid	R-7	10	20	30
(Inlaid Heart. Colors: Beige, Black, Blue, Brown, Green, Navy, Red, and Yellow.)									
	RLT	3 diff.	House	None	Inlaid	R-7	12	24	36
(Inlaid Spade. Colors: Black, Navy, and Red.)									
	RLT	4 diff.	House	None	Inlaid	R-7	12	24	36
(Inlaid Star. Colors: Beige, Green, Maroon, and Yellow.)									
9ᵗʰ	RLT A	Green	House	None	HS	R-5	3	6	9
	RLT A	Red	House	None	HS	R-5	3	6	9
	RLT B	Yellow	House	None	HS	R-5	3	6	9
10ᵗʰ	RLT B	Yellow	Roulet	None	R-white	R-5	3	6	9
	RLT D	4 diff.	Roulet	None	R-white	R-5	3	6	9
(Colors: Blue, Grey, Red, and Yellow.)									
11ᵗʰ	RLT H	Pink	H&C	None	HS	R-5	3	6	9
12ᵗʰ	RLT A	Blue	BJ-P	None	R-white	R-4	3	6	9
	RLT A	Yellow	BJ-P	None	R-white	R-4	3	6	9
	RLT B	Blue	BJ-P	None	R-white	R-4	3	6	9

Issue	Den.	Color	Mold	Inserts	Inlay	Rarity	GD30	VF65	CS95
RLT B		Yellow	BJ-P	None	R-white	R-4	3	6	9
RLT C		Blue	BJ-P	None	R-white	R-4	3	6	9
RLT C		Yellow	BJ-P	None	R-white	R-4	3	6	9

(This roulette set is marked "Harvey's, So. Lake Tahoe, NV.")

| 13th | RLT B | Maroon | BJ-P | None | R-white | R-3 | 3 | 6 | 9 |

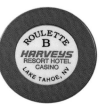

Harvey's RLT B (13th)

("Harvey's Resort Hotel Casino." This is the current issue.)

(NOTE: The order of the regular-issue denominated chips was taken from Howard Herz' Nevada Gaming Checks & Chips. Howdy is the authority on Harvey's chips and we accept his findings without reservations. Unfortunately, no one can be sure of the order of the numerous roulette chips. The brutal fact about Harvey's is that the same design was used for several different molds. Therefore, which came first - the mold or the design? If that isn't bad enough, the roulettes don't match the regular issue. Trying to put a given roulette chip with the regular-issues just doesn't work. We found that our attempts were leading us into the area of total speculation. Facing this impossible task, we decided to place all roulettes together in their own section, grouped by design. The reader may draw his own conclusion as to issue order.)

Harvey's Inn $1 (2nd)

HARVEY'S INN LAKE TAHOE 1972-85

Issue	Den.	Color	Mold	Inserts	Inlay	Rarity	GD30	VF65	CS95
1st	1.00	Orange	House	None	HS	R-4	10	20	30
2nd	1.00	Dk Orange	Nevada	None	HS	R-4	10	20	30

HIGH SIERRA LAKE TAHOE 1983-90

Issue	Den.	Color	Mold	Inserts	Inlay	Rarity	GD30	VF65	CS95
1st	.25	Gold	H&C	None	HS-black	R-5	6	12	18
	1.00	Beige	H&C	None	R-white	R-2	4	8	12
	2.50	Yellow	H&C	4org	R-white	R-5	20	40	60
	5.00	Red	H&C	3wht3blu	HUB-white	R-2	6	12	18
	25.00	Green	H&C	6wht	SCA-white	R-3	15	30	45
	100.00	Black	H&C	4red4wht4blu	NOT-white	R-4	25	50	75
	500.00	Pink	H&C	6blk	HEX-white	R-4	40	80	120
	1000.00	Blue	H&C	6org3ltblu	R-white	R-4	40	80	120
	NCV 1	Orange	H&C	None	R-white	R-6	8	16	24

("Win Cards" chip.)

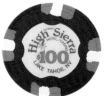

High Sierra $100 (1st)

	RLT A	3 diff.	BJ	None	HS	R-4	3	6	9

(Colors: Orange, Pink, and Purple.)

| | RLT B | 2 diff. | BJ | None | HS | R-4 | 3 | 6 | 9 |

(Colors: Green and Purple.)

	RLT C	Purple	BJ	None	HS	R-4	3	6	9
	RLT D	Brown	BJ	None	HS	R-4	3	6	9
	RLT E	7 diff.	BJ	None	HS	R-4	3	6	9

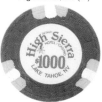

High Sierra $1000 (1st)

(Colors: Brown, Green, Orange, Pink, Purple, Turquoise and Yellow.)

	NCV 1	Brown	H&C	2org	HS	R-5	5	10	15
	NCV 1	Lt Blue	H&C	None	HS	R-5	5	10	15
	NCV 1	Red	H&C	None	R-white	R-5	6	12	18
	NCV 5	Pink	H&C	None	HS	R-5	5	10	15

High Sierra RLT E (1st)

HORIZON LAKE TAHOE 1990-

Issue	Den.	Color	Mold	Inserts	Inlay	Rarity	GD30	VF65	CS95
1st	1.00	Blue	H&C	None	R-white	R-1	*	1	3
	2.50	Pink	H&C	3pur	STAR-white	R-2	*	3	5
	5.00	Red	H&C	2org2lim	HUB-white	R-1	*	5	10
	25.00	Green	H&C	4fch4ltorg	SCA-white	R-1	*	25	35
	100.00	Black	H&C	6org3blu	COG-white	R-3	*	100	120
	NCV 5	Fuchsia	H&C	8wht	HS	R-4	4	8	12
	NCV 5	Purple	H&C	1wht	HS	R-4	4	8	12
	NCV 5	Rust	H&C	None	HS	R-4	4	8	12
	NCV	Purple	H&C	1wht	HS	R-4	3	6	9

Horizon $5 (1st)

Hyatt $25 (1ˢᵗ)

Hyatt $5 (2ⁿᵈ)

Hyatt RLT III (2ⁿᵈ)

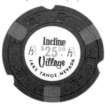

Incline Village $25 (1ˢᵗ)

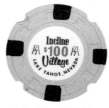

Incline Village $100 (1ˢᵗ)

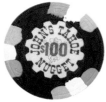

John's Tahoe Nugget $100 (1ˢᵗ)

Issue	Den.	Color	Mold	Inserts	Inlay	Rarity	GD30	VF65	CS95
HYATT LAKE TAHOE			**LAKE TAHOE**		**1976-90**				
HYATT REGENCY					**1990-**				
1ˢᵗ	1.00	Blue	H&C	None	R-white	R-2	4	8	12
	5.00	Red	H&C	3gry	R-white	R-3	7	14	21
	25.00	Green	H&C	3yel	SCA-white	R-5	30	60	90
	FP/NN 1.00	Blue	H&C	None	HS	R-6	8	16	24
	NCV 1	Green	H&C	4pch	HS	R-6	5	10	15
	NCV 5	Peach	H&C	None	HS	R-6	7	14	21
	NCV 5	Red	H&C	4brn	HS	R-6	7	14	21
2ⁿᵈ	1.00	White	Chipco	None	FG	R-1	*	1	3
	2.50	Purple	PMSC	5brass	Brass	R-1	*	3	5
	5.00	Red	PMSC	5brass	Brass	R-1	*	5	10
	25.00	Blue	PMSC	5brass	Brass	R-1	*	25	35
	100.00	Black	PMSC	5brass	Brass	R-1	*	100	120
	500.00	White	PMSC	5white	Brass	R-1	*	500	500
	RLT I	7 diff.	Chipco	None	FG	R-3	4	8	12
(Colors: Blue, Green, Orange, Pink, Purple, White, and Yellow.)									
	RLT II	6 diff.	Chipco	None	FG	R-3	4	8	12
(Colors: Blue, Green, Pink, Purple, White, and Yellow.)									
	RLT III	6 diff.	Chipco	None	FG	R-3	4	8	12
(Colors: Blue, Green, Pink, Purple, White, and Yellow.)									
3ʳᵈ	1.00	Grey	Chipco	None	FG	R-1	2	4	6
	5.00	Red	Chipco	None	FG	R-2	5	10	15
	25.00	Green	Chipco	None	FG	R-2	*	25	40
(This set marked "20ᵗʰ Birthday - Jan 95.")									
	RLT B	Yellow	H&C	None	HS	R-5	3	6	9
	NCV 100	Black	Chipco	None	FG	R-9	25	50	75
	NCV 500	Blue	Chipco	None	FG	R-9	35	70	105
	NCV 500	White	Chipco	None	FG	R-10	50	100	150
	NCV 1000	Pink	Chipco	None	FG	R-10	50	100	150
4ᵗʰ	RLT A	Blue	Roulet	None	HS	R-4	3	6	9
	RLT A	Green	Roulet	None	HS	R-4	3	6	9
INCLINE VILLAGE			**INCLINE VILLAGE**		**1966-69**				
1ˢᵗ	25.00	Dk Green	C&J	3red	R-white	R-10	600	1200	1800
	100.00	Beige	C&J	4blk	R-white	R-6*	250	500	750
(Both chips are marked "Incline Village, Lake Tahoe.")									
JOHN'S TAHOE NUGGET			**LAKE TAHOE**		**1983-91**				
			ZEPHYR COVE						
1ˢᵗ	5.00	Red	H&C	4grn4yel	R-white	R-5	30	60	90
	25.00	Green	H&C	4ltgrn4pch	R-white	R-10	250	500	750
	100.00	Black	H&C	3pnk3wht3org	COG-white	R-9	200	400	600
	NCV 1	Beige	Ewing	None	HS	R-5	4	8	12
	NCV 5	Dk Red	Ewing	None	HS	R-5	6	12	18
	NCV 25	Dk Green	Ewing	None	HS	R-5	6	12	18
	NCV 100	Black	Ewing	None	HS	R-5	6	12	18
	NCV 100	Black	Ewing	None	HS	R-5	6	12	18
	NCV 500	Navy	Ewing	None	HS	R-5	6	12	18
	NCV 500	Black	Ewing	None	HS	R-5	6	12	18
	NCV 500	Maroon	Ewing	None	HS	R-5	6	12	18
	NCV 500	Navy	Ewing	None	HS	R-5	6	12	18
(Above three chips are marked "Caesars" on reverse.)									

Issue	Den.	Color	Mold	Inserts	Inlay	Rarity	GD30	VF65	CS95
2nd	NCV 5	Rose	BJ	None	HS	R-6	7	14	21
	NCV 25	Green	BJ	None	HS	R-6	10	20	30

(These chips are marked "Zephyr Cove".)

JOBY'S MONTE CARLO CRYSTAL BAY 1955-56

Issue	Den.	Color	Mold	Inserts	Inlay	Rarity	GD30	VF65	CS95
1st	1.00	Black	Zigzag	None	HS	R-7	125	250	375

(Faded hot stamp on most examples.)

Issue	Den.	Color	Mold	Inserts	Inlay	Rarity	GD30	VF65	CS95
	n/d	Grn-Gry	Zigzag	None	HS	R-6	50	100	150
	n/d	Red	Zigzag	None	HS	R-9	125	250	375
2nd	5.00	Beige	Hub	3red	HS	R-7	125	250	375
	25.00	Orange	Hub	3grn	HS	R-8	150	300	450
	100.00	Lavender	Hub	3blk	HS	Unknown	500	1000	1500

(Old photographic evidence of this chip exists, but no example is known today.)

Issue	Den.	Color	Mold	Inserts	Inlay	Rarity	GD30	VF65	CS95
3rd	1.00	Mustard	C&J	None	HS-turq	R-8	125	250	375
4th	.25	Dk Maroon	Sm-key	None	HS	R-8	125	250	375
	.50	Lavender	Sm-key	None	HS	R-7	75	150	225

(This chip says "Lake Tahoe.")

Issue	Den.	Color	Mold	Inserts	Inlay	Rarity	GD30	VF65	CS95
	5.00	Navy	Sm-key	3crm	HS	R-8	150	300	450
	25.00	Green	Sm-key	None	HS	R-10	600	1200	1800
	100.00	Grey	Sm-key	3blk	HS	R-9	350	700	1050
	n/d	Grey	Sm-key	None	HS	R-7	40	80	120

(After Joby's closed in 1956, the same owners opened up the Monte Carlo in Hawthorne. We believe all of these 4th issue Sm-key chips were then used in Hawthorne, except the fifty-center which specifically states "Lake Tahoe." Also, the $100 denomination makes sense in Tahoe, but is not logical for 1958 Hawthorne.)

KING'S CASTLE LAKE TAHOE 1969-74

Issue	Den.	Color	Mold	Inserts	Inlay	Rarity	GD30	VF65	CS95
1st	.50	Mustard	Scrown	None	R-white	R-5	15	30	45
	1.00	Grey	Scrown	None	R-white	R-2	4	8	12
	5.00	Red	Scrown	6yel3red	R-white	R-2	7	14	21
	25.00	Green	Scrown	6org3grn	R-white	R-3	8	16	24
	100.00	Black	Scrown	6wht3org	R-white	R-3	12	24	36
	500.00	Fuchsia	Scrown	6trq3fch	R-white	R-5	30	60	90
	RLT A	5 diff.	Scrown	None	HS	R-7	10	20	30

(Colors: Blue, Brown, Peach, Pink, and Yellow.)

Issue	Den.	Color	Mold	Inserts	Inlay	Rarity	GD30	VF65	CS95
	RLT B	2 diff.	Scrown	None	HS	R-7	10	20	30

(Colors: Brown and Peach.)

Issue	Den.	Color	Mold	Inserts	Inlay	Rarity	GD30	VF65	CS95
2nd	FP 1.00	Grey	C&J	None	HS	R-5	15	30	45
	FP 5.00	Pink	C&J	None	HS	R-6	20	40	60

(This club was actually located in Incline Village and is now the Hyatt Regency.)

LAKESIDE INN LAKE TAHOE 1985-

Issue	Den.	Color	Mold	Inserts	Inlay	Rarity	GD30	VF65	CS95
1st	.10	Brown	H&C	None	HS	R-3	5	10	15
	.50	Orange	H&C	None	HS	R-5	8	16	24
	1.00	Blue	H&C	None	R-white	R-1	*	1	3
	5.00	Red	H&C	3ltblu3dkblu	HUB-white	R-1	*	5	10
	25.00	Green	H&C	3org3yel	SCA-white	R-1	*	25	35
	100.00	Black	H&C	3org3grn3pur	COG-white	R-2	*	100	120
	NCV	Fuchsia	H&C	3blu	HS	R-5	5	10	15
	NCV	Beige	H&C	3red	HS	R-5	5	10	15
	NCV	Mustard	H&C	3grn	HS	R-5	5	10	15
2nd	.25	Purple	BJ	None	HS-silver	R-6	10	20	30
	.50	Purple	BJ	None	HS	R-5	5	10	15
	5.00	Red	Chipco	None	FG	R-2	10	20	30

(Used in 1991, this is one of the first regular-issue Chipco chips.)

Joby's Monte Carlo $1 (1st)

Joby's Monte Carlo $25 (2nd)

Joby's Monte Carlo $1 (3rd)

King's Castle $500 (1st)

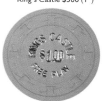
King's Castle FP $1 (2nd)

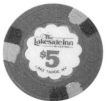
Lakeside Inn $5 (1st)

Nevada Club n/d black

Nevada Club n/d yellow

Nevada Club $1 (2nd)

Nevada Lodge $5 (2nd)

Issue	Den.	Color	Mold	Inserts	Inlay	Rarity	GD30	VF65	CS95
RLT L		Navy	H&C	None	HS	R-5	3	6	9
RLT L		Yellow	H&C	None	HS	R-5	3	6	9

(Formerly Sky Harbor, Caesars, and then Harvey's Inn.)

NAVAJO SALOON — LAKE TAHOE 1953-53

Issue	Den.	Color	Mold	Inserts	Inlay	Rarity	GD30	VF65	CS95
1st	25.00	Black	Rcthrt	None	HS	Unique	1000	2000	3000

(This small club was licensed for one blackjack and one poker table. Recently, some dice were found, proving that craps were also offered. The Navajo Saloon only lasted 8 months before closing their doors for good. The only known example sold at auction in Jan. 1998 for $2794.)

NEVADA CLUB — LAKE TAHOE 1932-56

Issue	Den.	Color	Mold	Inserts	Inlay	Rarity	GD30	VF65	CS95
	n/d	Yellow	Zigzag	None	HS	R-5	25	50	75
	n/d	Black	Zigzag	None	HS	R-8	90	180	270
	n/d	Blue	Zigzag	None	HS	R-9	100	200	300

(These were chips from the original club owned by Beecher between 1932-1956. This club was across the street from George's Gateway, which is now Harrah's.)

NEVADA CLUB — CRYSTAL BAY 1958-86
NEVADA LODGE

Issue	Den.	Color	Mold	Inserts	Inlay	Rarity	GD30	VF65	CS95
1st	n/d	White	C&S	None	R-white	R-4	10	20	30

(Marked "CC" and was used as a $1 chip. Originated from the Chesterfield Club in Detroit.)

Issue	Den.	Color	Mold	Inserts	Inlay	Rarity	GD30	VF65	CS95
2nd	1.00	White	Scrown	None	R-white	R-2	4	8	12
	1.00	Grn/Pnk	Scrown	1/2pie	R-white	R-8	50	100	150
	1.00	Blu/Blk	Scrown	1/2pie	R-white	R-2	4	8	12

(These three dollars are marked "Nevada Club, Nevada Lodge.")

Issue	Den.	Color	Mold	Inserts	Inlay	Rarity	GD30	VF65	CS95
	5.00	Green	Scrown	4yel	SCA-white	Unique*	300	600	900
	5.00	Green	Scrown	4fch	SCA-white	Unique*	300	600	900
	5.00	Fuchsia	Scrown	4brn	SCA-white	Unique*	300	600	900
	5.00	Orange	Scrown	4grn4blk	SCA-white	R-2	7	14	21
	5.00	Orange	Scrown	4crm	SCA-white	R-3	10	20	30
	5.00	Orange	Scrown	3blk	SCA-white	R-3	8	16	24
	25.00	Brn/Blu	Scrown	1/2pie	WHL-white	R-3	10	20	30

(This chip is marked "Nevada Club, Nevada Lodge.")

Issue	Den.	Color	Mold	Inserts	Inlay	Rarity	GD30	VF65	CS95
	1000.00	Nvy/Pnk	Scrown	1/2pie	SAW-white	R-4	25	50	75

(Second issue says "Nevada Lodge, Lake Tahoe," except where noted. It's believed that all these second issue chips were used together.)

Issue	Den.	Color	Mold	Inserts	Inlay	Rarity	GD30	VF65	CS95
	RLT	Fuchsia	Scrown	None	R-white	R-5	10	20	30
3rd	5.00	Red	Scrown	4brn4org	SCA-white	R-2	8	16	24
	25.00	Purple	Scrown	4blu4pnk	SCA-white	R-3	12	24	36
	500.00	Org/Pnk	Scrown	1/2pie	WHL-white	R-4	20	40	60
	1000.00	Blu/Pnk	Scrown	1/2pie	SAW-white	R-4	20	40	60

(Third issue only marked "Nevada Lodge.")

Issue	Den.	Color	Mold	Inserts	Inlay	Rarity	GD30	VF65	CS95
4th	20.00	Multi	Scrown	2blk2wht2pur2yel	LHUB-white	R-3	12	24	36
	100.00	Green	Scrown	4org	SAW-white	R-4	15	30	45
	100.00	Orange	Scrown	1blu1brn1yel	WHL-white	R-3	10	20	30
	100.00	Lime	Scrown	3dkpur	WHL-white	R-4	15	30	45
	500.00	Orange	Scrown	1blu1brn1yel	WHL-white	R-4	25	50	75
	500.00	Pur/Red	Scrown	1/2pie	WHL-white	R-4	20	40	60

(Fourth issue marked "Reno and Crystal Bay.")

Issue	Den.	Color	Mold	Inserts	Inlay	Rarity	GD30	VF65	CS95
	RLT AA	9 diff.	Scrown	None	OR-white	R-4	5	10	15

(Colors: Black, Brown, Grey, Navy, Orange, Pink, Purple, Red, and Yellow.)

Issue	Den.	Color	Mold	Inserts	Inlay	Rarity	GD30	VF65	CS95
	RLT CC	Mustard	Scrown	None	OR-white	R-4	5	10	15
	RLT DD	6 diff.	Scrown	None	OR-white	R-4	5	10	15

(Colors: Black, Blue, Grey, Pink, Purple, and Yellow.)

Nevada Lodge $25 (2nd)

Nevada Lodge $25 (3rd)

Issue	Den.	Color	Mold	Inserts	Inlay	Rarity	GD30	VF65	CS95
RLT 0	6 diff.	Scrown	None		OR-white	R-4	5	10	15

(Colors: Black, Blue, Grey, Pink, Purple, and Yellow.)

North Shore Club $5 (1st)

NORTH SHORE CLUB · LAKE TAHOE · 1949-70 / 1974-80
SMITH'S NORTH SHORE CLUB · 1970-74

Issue	Den.	Color	Mold	Inserts	Inlay	Rarity	GD30	VF65	CS95
1st	5.00	Orange	Diamnd	None	HS	R-9	450	900	1350
	RLT 1	6 diff.	Zigzag	None	HS	R-8	75	150	225

(Colors: Brown, Maroon, Navy, Purple, Red, and Yellow.)

| | RLT 2 | 6 diff. | Zigzag | None | HS | R-8 | 75 | 150 | 225 |

(Colors: Beige, Blue, Maroon, Purple, Red, and Yellow.)
(Above roulettes are marked "NSC" with a picture of an anchor and roulette table number.)

North Shore Club $1 (4th)

	Den.	Color	Mold	Inserts	Inlay	Rarity	GD30	VF65	CS95
2nd	1.00	Red	Sm-key	3gry	HS	R-10	450	900	1350

(This chip marked "North Shore Club Hotel" on obverse. Reverse has "NSC" and picture of anchor.)

| | 5.00 | Purple | Sm-key | 3nvy | HS | R-9 | 400 | 800 | 1200 |

(Obverse just says "North Shore Club." Reverse has "NSC" and picture of anchor.)

| | RLT A | 4 diff. | Sm-key | None | HS | R-8 | 75 | 150 | 225 |

(Marked "Hotel" Colors: Blue, Cream, Grey, and Red.)

	Den.	Color	Mold	Inserts	Inlay	Rarity	GD30	VF65	CS95
3rd	5.00	Purple	Sm-key	3nvy	HS	R-8	350	700	1050

(Picture of anchor on both sides.)

4th	1.00	Red	Scrown	4gry	HS	R-8	200	400	600
5th	5.00	Navy	Lg-key	3bei	HS	R-2	5	10	15
	5.00	Navy	Lg-key	3bei	HS	R-4	3	6	9

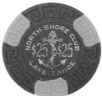

North Shore Club $25 (5th)

(Same chip, but overstamped with "Non-Negotiable.")

	25.00	Maroon	Lg-key	3pnk	HS	R-3	8	16	24
6th	1.00	Navy	Nevada	3mst	SCA-white	R-3	10	20	30
	error 2.50	Black	Nevada	3org	SCA-white	Unique	300	600	900

(One side has $100 denomination.)

	2.50	Purple	Nevada	3crm	SCA-white	R-8	100	200	300
	5.00	Mustard	Nevada	3nvy	SCA-white	R-3	10	20	30
	25.00	Red	Nevada	3grn	SCA-white	R-3	15	30	45
	100.00	Black	Nevada	3org	SCA-white	R-3	15	30	45

(This sixth issue is "Smith's North Shore Club.")

7th	5.00	Red	BJ-1	3ltpnk	COIN	R-1	4	8	12
	25.00	Green	BJ-1	3crm	COIN	R-2	8	16	24
	100.00	Black	BJ-1	3blu	COIN	R-3	10	20	30

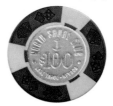

North Shore Club $100 (7th)

NUGGET, JIM KELLEY'S · LAKE TAHOE · 1962-97

Issue	Den.	Color	Mold	Inserts	Inlay	Rarity	GD30	VF65	CS95
1st	1.00	Brown	Lg-key	3tan	R-white	R-5	20	40	60
	5.00	Pink	Lg-key	4ltgrn4grn	R-white	R-5	30	60	90
2nd	1.00	Grey	Lg-key	3red3nvy	R-white	R-4	10	20	30

(There is a variant with slightly darker printing - same rarity and price. These first two issues were also used in Reno.)

| 3rd | 5.00 | Pink | H&C | 4lim8wht | OR-multi | R-4 | 7 | 14 | 21 |

(This chip was replaced by the manufacturer because it matched one used in a California club.)

	25.00	Green	H&C	4yel4tan	OR-multi	R-5	15	30	45
	100.00	Black	H&C	3pur3ltorg3gld	OR-multi	R-8	70	140	210
4th	5.00	Pink	H&C	4blu8wht	OR-multi	R-1	5	10	15

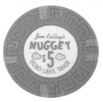

Jim Kelley's Nugget $5 (1st)

NUGGET, SOUTH TAHOE · LAKE TAHOE · 1965-83

Issue	Den.	Color	Mold	Inserts	Inlay	Rarity	GD30	VF65	CS95
1st	.25	Yellow	Lg-key	None	HS	R-5	12	24	36
	.25	Brown	Lg-key	None	HS	R-7	20	40	60
	.25	Orange	Lg-key	None	HS	R-7	20	40	60
	1.00	Mustard	Lg-key	3blk3red	R-white	R-6	75	150	225
	5.00	Navy	Lg-key	3crm3org	R-white	R-7	175	350	700
	25.00	Green	Lg-key	3brn3yel	R-white	R-10	600	1200	1800

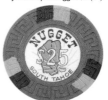

South Tahoe Nugget $25 (1st)

183

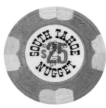

South Tahoe Nugget $25 (4th)

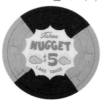

Tahoe Nugget $5 (1st)

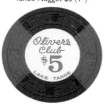

Oliver's $5 (2nd)

Park Tahoe $1 (1st)

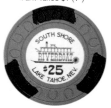

Riverboat $25 (1st)

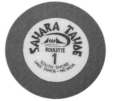

Sahara Tahoe RLT 1 (1st)

Issue	Den.	Color	Mold	Inserts	Inlay	Rarity	GD30	VF65	CS95
	100.00	Brown	Lg-key	8crm	R-white	Unique*	600	1200	1800
	RLT	Cream	Lg-key	None	HS	R-9	30	60	90
	RLT	3 diff.	Lg-key	None	HS	R-6	10	20	30
(Colors: Orange, Rose, and Yellow.)									
2nd	.25	Pink	Scrown	None	HS	R-7	40	80	120
	1.00	Green	Scrown	None	HS	R-6	35	70	105
(Reverse says, "Good Luck $1, Must be Played on Table.")									
	RLT	7 diff.	Plain	None	R-white	R-7	20	40	60
(Colors: Brown, Dk Green, Grey, Grey-Green, Orange, Purple, and Yellow.)									
3rd	.50	Red	Plastc	None	HS	R-6	5	10	15
4th	.25	Lt Brown	H&C	None	HS	R-7	15	30	45
	5.00	Red	H&C	4grn4yel	R-white	R-5	35	70	105
	25.00	Green	H&C	4ltgrn4pch	R-white	R-8	250	500	750

NUGGET, TAHOE — LAKE TAHOE — 1962-80

Issue	Den.	Color	Mold	Inserts	Inlay	Rarity	GD30	VF65	CS95
	1.00	Red	C&J	None	HS	R-6	35	70	105
	5.00	Brn/Yel	C&J	1/2pie	SCA-white	R-6	40	80	120
	RLT	6 diff.	Diamnd	None	HS	R-5	10	20	30
(Colors: Dk Blue, Brown, Grey, Maroon, Navy and Pink. Marked "The Nugget.")									

OLIVER'S — LAKE TAHOE — 1958-63

Issue	Den.	Color	Mold	Inserts	Inlay	Rarity	GD30	VF65	CS95
1st	1.00	Tan	Sm-key	None	HS	R-3	10	25	75
2nd	.25	Orange	C&J	None	HS	R-3	5	10	15
(537 chips were recently discovered, lowering the price.)									
	5.00	Red/Nvy	C&J	1/2pie	R-white	R-10	500	1000	1500

PARK TAHOE — LAKE TAHOE — 1978-79

Issue	Den.	Color	Mold	Inserts	Inlay	Rarity	GD30	VF65	CS95
1st	.25	Navy	Diecar	None	HS	R-5	6	12	18
	1.00	Dk Grey	Diecar	None	HS	R-4	5	10	15
	1.00	Orange	Diecar	None	HS	R-9	30	60	90
("Payable Only at Gaming Areas".)									
	pok 1.00	Dk Grey	Diecar	None	HS	R-7	20	40	60
	2.50	Lavender	BJ-2	None	COIN	R-8	100	200	300
	2.50	White	BJ-2	None	COIN	R-9	175	350	525
	5.00	Red	BJ-2	3blk	COIN	R-3	10	20	30
	25.00	Green	BJ-2	3yel	COIN	R-5	40	80	120
	100.00	Black	BJ-2	6org	COIN	R-4	15	30	45
	500.00	Grey	BJ-2	12blk	COIN	R-4	18	36	54
	RLT	6 diff.	Diecar	None	HS	R-5	4	8	12
(Colors: Brown, Green, Pink, Purple, Tan, and Yellow.)									

RIVERBOAT — LAKE TAHOE — 1970-70

Issue	Den.	Color	Mold	Inserts	Inlay	Rarity	GD30	VF65	CS95
1st	1.00	Brown	Horshu	3sal	R-white	R-5	40	80	120
	5.00	Mustard	Horshu	3pur	R-white	R-4	30	60	90
	25.00	Green	Horshu	3blk	R-white	R-7	100	200	300

SAHARA TAHOE — LAKE TAHOE — 1965-83

Issue	Den.	Color	Mold	Inserts	Inlay	Rarity	GD30	VF65	CS95
1st	5.00	Maroon	HCE	3mar6yel	R-white	R-3	6	12	18
	25.00	Dk Green	HCE	6crm3pnk	R-white	R-10	300	600	900
(For some reason this denomination is impossible to obtain and the others in the set are fairly common!)									
	100.00	Black	HCE	3grn6red	R-white	R-3	10	20	30
	NN 1.00	Blue	Plain	None	HS	R-10	35	70	105
	NN 1.00	Green	Plain	None	HS	R-10	35	70	105

Issue	Den.	Color	Mold	Inserts	Inlay	Rarity	GD30	VF65	CS95
	RLT 1	5 diff.	Plain	None	R-white	R-7	12	24	36
(Colors: Brown, Dk Green, Grey, Orange, and Purple.)									
	RLT 2	8 diff.	Plain	None	R-white	R-7	12	24	36
(Colors: Blue-Green, Brown, Dk Green, Grey, Navy, Orange, Purple, and Yellow.)									
	RLT 3	8 diff.	Plain	None	R-white	R-7	12	24	36
(Colors: Blue-Green, Brown, Dk Green, Green, Grey, Orange, Purple, and Yellow.)									
	RLT 4	4 diff.	Plain	None	R-white	R-7	12	24	36
(Colors: Brown, Grey, Green, and Orange.)									
	RLT 5	7 diff.	Plain	None	R-white	R-7	12	24	36
(Colors: Brown, Dk Green, Green, Grey, Orange, Pink, and Yellow.)									
2nd	1.00	Tan	HCE	None	R-white	R-1	5	10	15
	2.50	Purple	HCE	None	R-white	R-7	80	160	240
	5.00	Orange	HCE	6blk3ltgrn	R-white	R-4	15	30	45
	25.00	Lt Green	HCE	6bei3mar	R-white	R-3	7	14	21
	100.00	Black	HCE	3ltgrn6org	R-white	R-3	10	20	30
3rd	.25	Red	Scrown	None	HS	R-7	40	80	120
	.25	Red	Scrown	None	HS	R-8	50	100	150
("Card Room.")									
	.50	Lt Blue	Scrown	None	HS	R-7	30	60	90
	.50	Lt Blue	Scrown	None	HS	R-7	40	80	120
("Card Room.")									
	.60	Pink	Scrown	None	HS	R-9	100	200	300
("Good for One Keno Ticket" on reverse.)									
	1.00	Grey	Scrown	None	HS	R-6	20	40	60
("Card Room.")									
	RLT A	5 diff.	Lg-key	None	HS	R-5	4	8	12
(Colors: Brown, Grey, Navy, Orange, and Red.)									
	RLT B	Red	Lg-key	None	HS	R-5	4	8	12
	RLT C	Navy	Lg-key	None	HS	R-5	4	8	12
	RLT D	4 diff.	Lg-key	None	HS	R-5	4	8	12
(Colors: Grey, Mustard, Navy, and Red.)									
	RLT E	4 diff.	Lg-key	None	HS	R-5	4	8	12
(Colors: Mustard, Navy, Pink, and Red.)									
4th	20.00	Blue	Diecar	3brn	COIN	R-10	300	600	900
	100.00	Black	Diecar	3grn	R-white	R-10*	350	700	1050
(Of the three pieces known, two are imbedded in lucite paperweights. The other chip is notched.)									
	NN 1.00	Mustard	Horshu	None	HS	R-5	7	14	21
	NN 5.00	Purple	Horshu	None	HS	R-5	10	20	30
(Reverse of $1 and $5 says "Table Games Only.")									
	NN 25.00	Brown	Lg-key	None	HS	R-5	15	30	45
	NN 100.00	Orange	Lg-key	None	HS	R-6	25	50	75
	RLT	Blue	Diecar	None	HS	R-5	5	10	15
	RLT	Red	Diecar	None	HS	R-5	5	10	15
5th	.50	Blue	H&C	None	HS	R-5	10	20	30
	2.50	Yellow	H&C	4pch	R-white	R-6	40	80	120
	NN 100.00	Black	H&C	3grn3red	R-white	R-9	50	100	150
	100.00	Black	H&C	3grn	R-white	R-9	300	600	900
(All known survivors, except for one specimen, are found embedded in lucite paperweights.)									
6th	5.00	Red	BJ-2	6wht	COIN	R-1	4	8	12
	25.00	Green	BJ-2	6wht	COIN	R-8	175	350	525
	100.00	Black	BJ-2	6wht	COIN	R-4	10	20	30
	500.00	Pink	BJ-2	6blk	COIN	R-4	15	30	45
	1000.00	Orange	BJ-2	3blu6blk	COIN	R-4	20	40	60

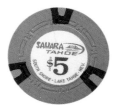

Sahara Tahoe $5 (2nd)

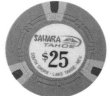

Sahara Tahoe $25 (2nd)

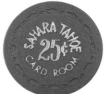

Sahara Tahoe 25c (3rd)

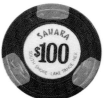

Sahara Tahoe $100 (5th)

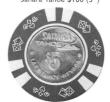

Sahara Tahoe $5 (6th)

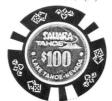

Sahara Tahoe $100 (6th)

The Shack $5 (1ˢᵗ)

Sierra Lodge $25 (3ʳᵈ)

Sierra Tahoe $5 (1ˢᵗ)

Sierra Tahoe $25 (1ˢᵗ)

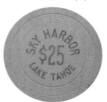

Sky Harbor $25 (1ˢᵗ)

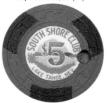

South Shore Club $5 (1ˢᵗ)

Issue	Den.	Color	Mold	Inserts	Inlay	Rarity	GD30	VF65	CS95
SHACK, THE			**STATE LINE**			**1975-75**			
	5.00	Red	Diasqr	None	HS	R-5	35	70	105
(Chip is marked "State Line, Nev.")									
SIERRA LODGE			**CRYSTAL BAY**			**1953-62**			
1ˢᵗ	5.00	Maroon	Sm-key	3org	HS	R-5	50	100	150
2ⁿᵈ	.25	Tan	Arodie	None	HS	R-6	35	70	105
3ʳᵈ	5.00	Mustard	HCE	2ltgrn	HS	R-9	250	500	750
	25.00	Navy	HCE	4red	HS	R-7	150	300	450
	100.00	Gray	HCE	3blk	HS	R-10	300	600	900
	n/d	Cream	HCE	None	HS	R-6	25	50	75
	n/d	Green	HCE	None	HS	R-6	25	50	75
	n/d	Orange	HCE	None	HS	R-8	40	80	120
4ᵗʰ	5.00	Lavender	C&J	None	HS	R-6	75	150	225
SIERRA TAHOE			**INCLINE VILLAGE**			**1965-66**			
1ˢᵗ	1.00	Red	C&J	None	R-white	R-8	250	500	750
	5.00	Mustard	C&J	3dkpnk	R-white	R-6	500	1000	1500

(All known examples are water damaged or drilled, except the one shown here! The others are worth 10-15% of these prices.)

	5.00	Lavender	C&J	3nvy	R-white	R-8	400	800	1200

(Compared to the previous $5 Mustard chip, there are fewer total pieces of this Lavender $5 chip. However, the Lavender pieces that do exist are in pretty nice condition, making the Mustard chip actually much rarer in top condition.)

	25.00	Green	C&J	3org	R-white	R-7	600	1200	1800

(Most examples are badly damaged or holed through the center. The best known example sold for $1800 in 1998. The rest are worth about 10-15% of these prices.)

	100.00	Black	C&J	4bei	R-tan	R-6	500	1000	1500

(Virtually all of these chips are holed in the center or have severe water damage. These unattractive specimens are only worth 10-15% of the listed price. All Sierra Tahoe chips are important to type collectors, because these are the only chips actually marked "Incline Village.")

SKY HARBOR			**LAKE TAHOE**			**1947-54**			
1ˢᵗ	.25	Orange	Sm-key	None	HS	R-5	25	50	75
	25.00	Yellow	Sm-key	None	HS	R-5	40	80	120
2ⁿᵈ	5.00	Navy	Scrown	4gry	HS	R-7	75	150	225
	25.00	Salmon	Scrown	4gry	HS	R-7	75	150	225
	100.00	Yellow	Scrown	4gry	HS	R-8	150	300	450
3ʳᵈ	5.00	Mustard	Arodie	3red	HS	R-5	30	60	90
	25.00	Red	Arodie	3mst	HS	R-5	40	80	120
	100.00	White	Arodie	3blk	HS	R-6	100	200	300
SOUTH SHORE CLUB			**LAKE TAHOE**			**1965-66**			
1ˢᵗ	.10	Yellow	C&J	None	HS	R-9	150	300	450
	1.00	Lavender	C&J	3bei	R-white	R-4	30	60	150

(Almost all examples are badly faded or discolored on one side. Extremely difficult to find mint.)

	5.00	Red	C&J	3nvy	R-white	R-9	400	800	1200
	25.00	Green	C&J	3org	R-white	Unique*	750	1500	2250
	pok n/d	Black	C&J	None	HS	R-10	50	100	150
	pok n/d	3 diff.	C&J	None	HS	R-6	20	40	60

(Colors: Tan, Purple, and Red.)

	pan n/d	Orange	C&J	None	HS	R-7	30	60	90

Issue	Den.	Color	Mold	Inserts	Inlay	Rarity	GD30	VF65	CS95

SOUTH TAHOE CASINO — LAKE TAHOE — 1966-67

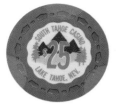

South Tahoe Casino $25 (4th)

Issue	Den.	Color	Mold	Inserts	Inlay	Rarity	GD30	VF65	CS95
1st	.25	Brt Org	Hub	None	HS-green	R-6	25	50	75
2nd	.25	Orange	Diasqr	None	HS	R-6	25	50	75
3rd	.10	Yellow	C&J	None	HS	R-8	100	200	300
	.25	Orange	C&J	None	HS	R-8	60	120	180
	.50	Grey	C&J	None	HS	R-7	35	70	105
4th	1.00	Lt Grey	Scrown	3yel	OR-white	R-2	5	10	15
	5.00	Red	Scrown	3blu	OR-white	R-2	7	14	21
	25.00	Green	Scrown	3org	LHUB-white	R-3	10	20	30

STARDUST — LAKE TAHOE — 1957-58

Issue	Den.	Color	Mold	Inserts	Inlay	Rarity	GD30	VF65	CS95
1st	5.00	Navy	Arodie	3bei	R-white	R-5	50	100	150
	25.00	Mustard	Arodie	3grn	R-white	R-6	80	160	240

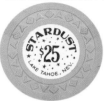

Stardust $25 (1st)

TAHOE BILTMORE — CRYSTAL BAY — 1946-57/1986-

Issue	Den.	Color	Mold	Inserts	Inlay	Rarity	GD30	VF65	CS95
1st	100.00	Cream	Zigzag	None	HS	Unique	300	600	900

("TBH" in circle. It is odd that no lesser denominations have ever been found to match.)

2nd	1.00	Mustard	Sqsqrt	None	HS	R-8	100	200	300
3rd	.25	Brown	H&C	None	HS	R-3	3	6	9
	.50	Peach	H&C	None	HS	R-6	7	14	21
	1.00	Blue	H&C	None	HS	R-1	*	1	3

(There is a variant with $1 as opposed to $1.00. Same rarity and price.)

	5.00	Red	H&C	3ltblu3tan	HS	R-1	*	5	10
	25.00	Lt Green	H&C	3org	SCA-white	R-1	*	25	35
	100.00	Black	H&C	6org	COG-white	R-3	*	100	125
4th	5.00	Red	H&C	3ltblu3yel	OR-multi	R-2	5	10	15

(50th Anniversary 1946-1996.)

	NCV 1	Navy	H&C	1grn	HS	R-5	5	10	15
	NCV 1	Orange	Chipco	None	FG	R-7	20	40	60

("Win cards" chip from 1992.)

	NCV 5	Lavender	H&C	2yel	HS	R-5	5	10	15

(The club originally opened as Tahoe Biltmore, but it was taken over by Nevada Club/Lodge in 1958. Twenty eight years later, the casino was again named Tahoe Biltmore.)

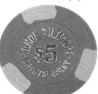

Tahoe Biltmore $5 (3rd)

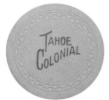

Tahoe Colonial $1 (1st)

TAHOE COLONIAL — CRYSTAL BAY — 1954-55

Issue	Den.	Color	Mold	Inserts	Inlay	Rarity	GD30	VF65	CS95
1st	1.00	Cream	Zigzag	None	HS	R-7	75	150	225
	5.00	Orange	Zigzag	None	HS	R-10	400	800	1200
	100.00	Yellow	Zigzag	None	HS	Unique	500	1000	1500
2nd	5.00	Orange	Diamnd	None	HS	R-10	20	40	60

(Only marked "TC." Could be from Tonopah Club in Tonopah - or anywhere else for that matter! This casino originally opened as the Colonial Club from 1949-1954, near what is now Caesars Tahoe.)

TAHOE PALACE — LAKE TAHOE — 1956-59

Issue	Den.	Color	Mold	Inserts	Inlay	Rarity	GD30	VF65	CS95
1st	5.00	Navy	Hrglas	3bei	HS	R-6	80	160	240

(Many examples are overstamped with "$1." The club must have needed extra dollars.)

	25.00	Mustard	Hrglas	3blk	HS	R-6	80	160	240
	100.00	Beige	Hrglas	3red	HS	R-10	350	700	1050

(These chips have a nice hot stamped pine tree on the reverse.)

	n/d	Mustard	HCE	None	HS	R-7	40	80	120

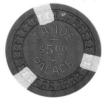

Tahoe Palace $5 (1st)

TAHOE PLAZA — LAKE TAHOE — 1954-61

Issue	Den.	Color	Mold	Inserts	Inlay	Rarity	GD30	VF65	CS95
1st	5.00	Navy	C&J	3tan	R-white	R-5	200	400	600

(Almost all survivors are overstamped with "$1" and these examples are only worth 15% of listed prices. Chips without the overstamp are probably R-10.)

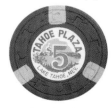

Tahoe Plaza $5 (1st)

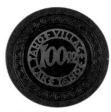

Tahoe Village $100 (1st)

Tahoe Village RLT (F)

Tahoe Village RLT (HP)

Tahoe Village RLT (SB)

Tahoe Village RLT (S)

Tahoe Village RLT (HB)

Issue	Den.	Color	Mold	Inserts	Inlay	Rarity	GD30	VF65	CS95
TAHOE VILLAGE			**LAKE TAHOE**		**1946-51**				
1st	5.00	Red	Sm-key	None	Diecut-metal	R-5	100	200	300
	25.00	Green	Sm-key	None	Diecut-metal	R-7*	700	1400	2100

(Note: This price is theoretical. All known examples have the metal centers ripped out and are worth only about 3-5% of the listed prices! In other words, an average piece is worth about $50-$75. Find an undamaged piece and you've got a super chip.)

| | 100.00 | Black | Sm-key | None | Diecut-metal | R-7 | 450 | 900 | 1350 |

(Exactly 26 pieces were originally found by John Rauzy in Oregon.)

	RLT	Brown	Plain	None	Diecut-metal	R-9	200	400	600
	RLT	Cream	Plain	None	Diecut-metal	R-8	150	300	450
	RLT	Red	Plain	None	Diecut-metal	R-6	75	150	225
	RLT	Turq.	Plain	None	Diecut-metal	R-6	75	150	225

(Fisherman)

	RLT	Brown	Plain	None	Diecut-metal	R-6	75	150	225
	RLT	Cream	Plain	None	Diecut-metal	R-9	200	400	600
	RLT	Navy	Plain	None	Diecut-metal	Unique*	300	600	900
	RLT	Red	Plain	None	Diecut-metal	R-6	75	150	225
	RLT	Yellow	Plain	None	Diecut-metal	Unique	300	600	900

(Hockey Player.)

| | RLT | Brown | Plain | None | Diecut-metal | R-6 | 60 | 120 | 180 |

(This is the 2nd most common of these roulettes with about 60-70 pieces known. The other R-6 chips listed here have populations of 30-50.)

	RLT	Cream	Plain	None	Diecut-metal	R-10	250	500	750
	RLT	Navy	Plain	None	Diecut-metal	R-10	250	500	750
	RLT	Red	Plain	None	Diecut-metal	R-7	100	200	300
	RLT	Yellow	Plain	None	Diecut-metal	R-10	300	600	900
	RLT	Turq.	Plain	None	Diecut-metal	R-6	75	150	225

(Horseback Rider.)

	RLT	Brown	Plain	None	Diecut-metal	R-9	200	400	600
	RLT	Cream	Plain	None	Diecut-metal	R-7	100	200	300
	RLT	Pink	Plain	None	Diecut-metal	R-5	50	100	150

(This is now the most common of all these roulettes with a reported 82 pieces.)

| | RLT | Red | Plain | None | Diecut-metal | R-7 | 100 | 200 | 300 |
| | RLT | Yellow | Plain | None | Diecut-metal | Unique | 300 | 600 | 900 |

(Sailboat.)

	RLT	Brown	Plain	None	Diecut-metal	R-6	75	150	225
	RLT	Cream	Plain	None	Diecut-metal	R-6	75	150	225
	RLT	Navy	Plain	None	Diecut-metal	R-8	150	300	450
	RLT	Pink	Plain	None	Diecut-metal	R-7	100	200	300
	RLT	Red	Plain	None	Diecut-metal	R-7	100	200	300
	RLT	Yellow	Plain	None	Diecut-metal	Unique*	300	600	900

(Skier.)

| | RLT | Red | Sm-key | None | Diecut-metal | Unique | 350 | 700 | 1050 |

(Fisherman.)

| | RLT | Any | Sm-key | None | Diecut-metal | Unknown | 400 | 800 | 1200 |

(Hockey Player. All colors are unknown in any collection.)

Issue	Den.	Color	Mold	Inserts	Inlay	Rarity	GD30	VF65	CS95
	RLT	Red	Sm-key	None	Diecut-metal	Unique	350	700	1050
	RLT	Yellow	Sm-key	None	Diecut-metal	Unique	350	700	1050
(Horseback Rider.)									
	RLT	Brown	Sm-key	None	Diecut-metal	Unique	350	700	1050
	RLT	Lavender	Sm-key	None	Diecut-metal	Unique	350	700	1050
	RLT	Turq.	Sm-key	None	Diecut-metal	R-10	300	600	900
(Sailboat.)									
	RLT	Brown	Sm-key	None	Diecut-metal	Unique	350	700	1050
	RLT	Lavender	Sm-key	None	Diecut-metal	Unique	350	700	1050
	RLT	Navy	Sm-key	None	Diecut-metal	Unique	350	700	1050
	RLT	Yellow	Sm-key	None	Diecut-metal	R-10	350	700	1050
(Skier.)									

Tahoe Village RLT (SB)

(Note: As you can see from the extreme rarity of these pieces, assembling a complete set is probably impossible. Diecut specialist, Lynn Brooks, has come the closest with 28 pieces. He also helped with this section.)

Issue	Den.	Color	Mold	Inserts	Inlay	Rarity	GD30	VF65	CS95
2nd	25.00	Lavender	Sm-key	None	HS	R-6	75	150	225
3rd	25.00	Pink	Scrown	4gry	HS	R-5	75	150	225

Tahoe Village $25 (2nd)

TA-NEVA-HO			**LAKE TAHOE**		**1937-53**				
1st	5.00	Red	Lcrown	None	HS	R-3	15	30	45
	25.00	Navy	Lcrown	None	HS	R-4	25	50	75
	50.00	Green	Lcrown	None	HS	R-7	75	150	225
	100.00	Yellow	Lcrown	None	HS	R-4	50	100	150
2nd	1.00	Orange	Zigzag	3nvy	HS	R-5	20	40	60
	5.00	Grey	Zigzag	3red	HS	R-3	15	30	45
	5.00	Purple	Zigzag	None	HS	R-3	15	30	45
	100.00	Maroon	Zigzag	3ltgrn	HS	R-8	300	600	900

Ta-Neva-Ho $100 (1st)

TONY'S CLUB			**LAKE TAHOE**		**1954-57**				
1st	.25	Brown	Sm-key	None	HS	R-8	350	700	1050
(Exactly 12 chips are known - all found by collectors John Rauzy and John Johannes.)									
	5.00	Mustard	Arodie	3grn	HS-green	R-6	75	150	225
	25.00	Green	Arodie	3red	HS	R-7	125	250	375
	100.00	Black	Arodie	3gry	HS	R-9	600	1200	1800
(Exactly 7 chips are known to exist.)									

Tony's Club 25c (1st)

Tony's Club $5 (1st)

Tony's Club $25 (1st)

Issue	Den.	Color	Mold	Inserts	Inlay	Rarity	GD30	VF65	CS95

Reno

Nevada Promo 1932 obv

Nevada Promo 1932 rev

Allan Boyd Club $5 (1ˢᵗ)

Kent Anderson $1 (1ˢᵗ)

Atlantis $1 (1ˢᵗ)

Atlantis $25 (1ˢᵗ)

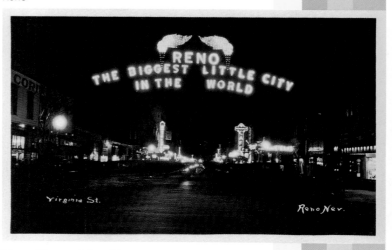

This rare 1931 postcard photo of downtown Reno was taken shortly after Nevada legalized gaming. This first incarnation of the famous Reno Arch had two torches above "Reno", but these were removed soon after.

NEVADA GAMING PROMOTION CHIP Issued Jan. 12, 1932

	n/d	Gry-Grn	C&S	None	R-white	R-9	1200	2400	3600

(According to Howard Herz, this chip was issued on January 12, 1932, by the The United States Playing Card Company - the foremost chip manufacturer in the country at that time. This chip was not made for any specific casino, but is important in that it can be considered Nevada's first commemorative chip. Records indicate that 2000 chips were made, but only five are known today. Two chips were found in a Reno antique shop in 1999, proving that valuable treasures still exist waiting to be discovered.)

ALLAN BOYD CLUB RENO c.1940's

1ˢᵗ	5.00	Cream	Hub	None	HS	R-7	20	40	60
	10.00	Red	Hub	None	HS	R-7	25	50	75

(Marked simply "ABC" in script on obverse with Chinese writing & denomination on rev.)

2ⁿᵈ	1.00	Mustard	2Hubdi	None	HS	R-9	20	40	60

(This issue has Chinese writing only.)

ANDERSON, KENT RENO c.1940's
(BRAND-K-BAR)

1ˢᵗ	1.00	Mustard	Zigzag	None	HS	R-6	20	40	60
	5.00	Green	Zigzag	None	HS	R-7	25	50	75

ATLANTIS CASINO RESORT RENO 1996-

1ˢᵗ	1.00	White	BJ-2	4blu	OR-multi	R-1	*	1	3
	2.50	Aqua	BJ-2	8pnk	OR-multi	R-1	*	3	5
	5.00	Red	BJ-2	8blu	OR-multi	R-1	*	5	8
	25.00	Green	BJ-2	4org	OR-blue	R-1	*	25	30
	100.00	Black	BJ-2	16yel8pur	OR-multi	R-1	*	100	110
	NCV 5	Pink	BJ	None	HS	R-6	3	6	9
	RLT A	Orange	BJ	None	OR-white	R-5	3	6	9
	RLT B	Blue	BJ	None	OR-white	R-5	3	6	9
	RLT B	Tan	BJ	None	OR-white	R-5	3	6	9

Issue	Den.	Color	Mold	Inserts	Inlay	Rarity	GD30	VF65	CS95
B&C			RENO		c.1950's				
1st	.05	Black	Sm-key	None	HS	R-6	40	80	120

(This place was probably a small card club whose history has been lost.)

Issue	Den.	Color	Mold	Inserts	Inlay	Rarity	GD30	VF65	CS95
BALLY' S			RENO		1986-92				
1st	1.00	Blue	House	2pch2nvy	R-white	R-3	4	8	12
	1.00	Blue	House	4pnk	R-white	R-3	4	8	12
	5.00	Red	House	2yel2wht	HUB-white	R-3	6	12	18
	5.00	Red	House	4pur	HUB-white	R-9	200	400	600
	25.00	Green	House	8yel	HEX-white	R-5	25	50	75
	100.00	Black	House	12yel	STAR-white	R-9	200	400	600
	500.00	Purple	House	4brn4gry	WHL-white	R-9	200	400	600
	NCV	Purple	BJ	None	HS	R-3	2	4	6
	NCV 5	Dk Pink	H&C	None	HS	R-5	5	10	15
	NCV 5	Purple	H&C	8wht	HS	R-6	5	10	15
	NCV25	Lt Green	H&C	None	HS	R-5	6	12	18
	NCV100	Grey	H&C	None	HS	R-5	6	12	18
	NCV500	Navy	H&C	None	HS	R-5	7	14	21
	NN	Blue	Chipco	None	FG	R-10	100	200	300

(Oversized. Advertises Kruse Car Auction 1990. Many were given away, but only a few are accounted for.)

| | RLT | 4 diff. | House | None | R-white | R-6 | 5 | 10 | 15 |

(Colors: Green, Grey, Dark Orange, and Orange.)

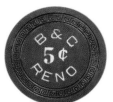

B&C 5c (1st)

Bally's $5 (1st)

Bank Palace Club $1 (1st)

Bank Palace Club $1 obv (1st)

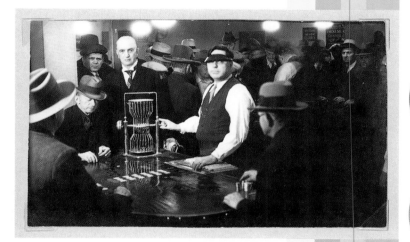

Postcard of the Bank Club. This infamous Reno club was something of a money-laundering operation for its owners Bill Graham and Jim McKay. Reno's strong pro-gambling mayor, E.E. Roberts, is pictured directly behind a chuck-a-luck game, which is no longer played in Nevada's casinos.

Bank Palace Club $1 rev (1st)

Issue	Den.	Color	Mold	Inserts	Inlay	Rarity	GD30	VF65	CS95
BANK PALACE CLUB			RENO		1931-35				
BANK CLUB					1935-53				
1st	.50	Red	C&S	None	R-white	R-10	600	1200	1800
	1.00	Green	C&S	None	R-white	R-9	500	1000	1500
	1.00	Cream	C&S	None	R-white	Unique	800	1600	2400
	5.00	Black	C&S	None	R-white	R-10	700	1400	2100

(This 1st issue is marked "Bank-Palace Club.")

| 2nd | 5.00 | Dk Grey | Diamnd | None | HS | R-7 | 100 | 200 | 300 |
| | n/d | Aqua | Diasqr | None | HS | R-6 | 20 | 40 | 60 |

Bank Club $5 (2nd)

Bank Club $5 (3ʳᵈ)

Bank Club $1 (4ᵗʰ)

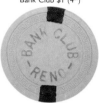

Bank Club $5 (6ᵗʰ)

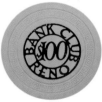

Bank Club $100 (7ᵗʰ)

Barboot n/d (1ˢᵗ)

Bill's Corner Bar 50c (1ˢᵗ)

Issue	Den.	Color	Mold	Inserts	Inlay	Rarity	GD30	VF65	CS95
3ʳᵈ	1.00	Black	Dots	None	HS	R-6	50	100	150
	5.00	Red	Dots	None	HS	R-4	25	50	75
	25.00	Blue	Dots	None	HS	R-4	25	50	75
4ᵗʰ	.05	Red	S's	None	HS	Unique	250	500	750
	.12 ½	Purple	S's	None	HS	R-8	200	400	600

(All known examples of this previously unknown chip are in horrible condition, having been dug from the yard of a former owner's house.)

Issue	Den.	Color	Mold	Inserts	Inlay	Rarity	GD30	VF65	CS95
	.25	Cream	S's	None	HS	R-8	75	150	225
	.25	Purple	S's	None	HS	R-8	100	200	300
	1.00	Black	S's	None	HS	R-5	40	80	120
5ᵗʰ	.25	Purple	Lcrown	None	HS	R-5	25	50	75
	.50	Green	Lcrown	None	HS	R-6	40	80	120
	5.00	Brown	Lcrown	None	HS	R-7	60	120	180
	RLT	2 diff.	Lcrown	None	HS	R-8	40	80	120

(Colors: Red and White.)

Issue	Den.	Color	Mold	Inserts	Inlay	Rarity	GD30	VF65	CS95
6ᵗʰ	.05	Black	Sm-key	None	HS	R-10	250	500	750
	.10	Red	Sm-key	None	HS	R-8	100	200	300
	.10	Red	Sm-key	3yel	HS	Unique	300	600	900
	.25	Cream	Sm-key	2blk	HS	R-7	50	100	150
	.25	Purple	Sm-key	3blk	HS	R-8	100	200	300
	5.00	Fuchsia	Sm-key	2blk	HS	R-10	250	500	750
	5.00	Lavender	Sm-key	3grn	HS	R-8	175	350	525
	5.00	Green	Sm-key	None	HS	R-5	35	70	105
	5.00	Green	Sm-key	None	HS	R-10	100	200	300

(Variant with smaller $5.)

Issue	Den.	Color	Mold	Inserts	Inlay	Rarity	GD30	VF65	CS95
	25.00	Orange	Sm-key	None	HS	R-4	20	40	60
	25.00	Orange	Sm-key	None	HS	R-10	100	200	300

(Variant with smaller $25.)

Issue	Den.	Color	Mold	Inserts	Inlay	Rarity	GD30	VF65	CS95
	100.00	Cream	Sm-key	None	HS	R-7	80	160	240
	n/d	3 diff.	Plain	None	Inlaid-white	R-5	35	70	105

(Colors: Brown, Navy, and Yellow. Interlocked "BC".)

Issue	Den.	Color	Mold	Inserts	Inlay	Rarity	GD30	VF65	CS95
7ᵗʰ	100.00	Yellow	Sm-key	None	Diecut-metal	R-5	175	350	525
8ᵗʰ	n/d	Cream	Plain	None	HS	R-7	75	150	225
	n/d	Yellow	Plain	None	HS	Unique	125	250	375

(One side says "Bank Club Reno." Other side says "Golden Bank Club.")
(In 1953, the Bank Club expanded and became the Golden Bank Club.)

BARBOOT COFFEE HOUSE　　RENO　　　　　c.1965
AND CASINO

Issue	Den.	Color	Mold	Inserts	Inlay	Rarity	GD30	VF65	CS95
1ˢᵗ	n/d	Blue	Rectl	None	HS	R-10	50	100	150
	n/d	Grey	Rectl	None	HS	R-9	35	70	105

(Marked "BB" on both sides for "Barbouti." The first Barbouti game was licensed in Reno on November 24, 1965 at this casino. Barbouti was derived from an ancient dice game played in the Middle East. Unlike craps, in Barbouti the players bet against each other and the house takes a 3-5% cut of the action.)

BARN CLUB　　　　　　RENO　　　　　1941-44

Issue	Den.	Color	Mold	Inserts	Inlay	Rarity	GD30	VF65	CS95
1ˢᵗ	n/d	3 diff.	Diasqr	None	HS	R-10	150	300	450

(Colors: Brown, Red, and Yellow.)

	Den.	Color	Mold	Inserts	Inlay	Rarity	GD30	VF65	CS95
	n/d	Cream	Diasqr	None	HS	R-8	100	200	300

(These chips were found and attributed by John Johannes.)

BILL'S CORNER BAR　　RENO　　　　　1939-65

Issue	Den.	Color	Mold	Inserts	Inlay	Rarity	GD30	VF65	CS95
1ˢᵗ	.10	Beige	Sqincr	2grn	HS	R-10	100	200	300

Issue	Den.	Color	Mold	Inserts	Inlay	Rarity	GD30	VF65	CS95
	.25	Red	Sqincr	2grn	HS	R-9	50	100	150
	.50	Navy	Sqincr	2grn	HS	R-5	20	40	60
	1.00	Mustard	Sqincr	2grn	HS	R-4	20	40	60
	5.00	Purple	Sqincr	2grn	HS	R-5	20	40	60
	25.00	Black	Sqincr	2grn	HS	R-7	30	60	90

(This set of chips is from the last issue. Earlier chips are unknown.)

Bill's Corner Bar $1 (1st)

BONANZA CASINO RENO 1980-

Issue	Den.	Color	Mold	Inserts	Inlay	Rarity	GD30	VF65	CS95
1st	.25	Yellow	H&C	None	HS	R-4	3	6	9
	.25	Yellow	BJ'	None	HS	R-1	*	1	3
	5.00	Red	BJ-2	8wht	COIN	R-1	*	5	10
	25.00	Green	BJ-2	6blk	COIN	R-2	*	25	35
	100.00	Black	BJ-2	4wht	COIN-brass	R-4	*	100	150
	NCV 1	Lt Blue	BJ	None	HS	R-5	5	10	15
	NN 25.00	Fuchsia	H&C	None	HS	R-8	10	20	30
	NN 1000.00	White	H&C	3blu	HS	R-8	20	40	60

Bonanza Casino $25 (1st)

BONANZA INN CASINO RENO 1973-80

Issue	Den.	Color	Mold	Inserts	Inlay	Rarity	GD30	VF65	CS95
1st	1.00	Blue	H&C	None	HS	R-5	10	20	30
	5.00	Red	H&C	3gry	HS	R-6	20	40	60

BORDERTOWN RENO 1955-78/1980-

Issue	Den.	Color	Mold	Inserts	Inlay	Rarity	GD30	VF65	CS95
2nd	5.00	Red	H&C	4pnk8wht	HUB-white	R-2	*	5	10
	25.00	Green	H&C	4ltblu8org	SCA-white	R-3	*	25	35

(Chips from the first ownership (1955-78) are unknown. First issue chips from the second ownership are listed under the city of Bordertown, because that's the location given on the chip. These above chips are current.)

Bordertown $5 (2nd)

BRAD'S PALACE CLUB RENO 1950's

Issue	Den.	Color	Mold	Inserts	Inlay	Rarity	GD30	VF65	CS95
	.10	Red	Sm-key	None	HS	R-7	75	150	225

(Many people believe this was used in the Palace Club, but no one knows for sure.)

CARLTON HOTEL RENO 1943-66

Issue	Den.	Color	Mold	Inserts	Inlay	Rarity	GD30	VF65	CS95
1st	1.00	Grey	Sm-key	None	HS	R-4	20	40	60
	5.00	Navy	Sm-key	3gry	HS	R-9	75	150	225

($1 chips exist in the hands of a former owner who rarely parts with them! About 20 dollars are actually in collections. This hotel was demolished in 1976 for the Money Tree expansion and eventually became Eddie's Fabulous 50's.)

Carlton Hotel $1 (1st)

CHINA MINT RENO 1960-63

Issue	Den.	Color	Mold	Inserts	Inlay	Rarity	GD30	VF65	CS95
1st	.10	Lt Orange	Scrown	None	HS	R-6	35	70	150
	5.00	Navy	Sm-key	3mst	R-white	R-8	275	550	825

(Previously Happy Buddha Club, this was a segregated casino for minorities only. About ten $5 chips exist.)

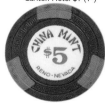

China Mint $5 (1st)

CHRISTMAS TREE RENO 1947-67/1969-78

Issue	Den.	Color	Mold	Inserts	Inlay	Rarity	GD30	VF65	CS95
1st	1.00	Black	Sm-key	None	R-white	R-7	250	500	750
	5.00	Maroon	Sm-key	None	R-white	R-10	700	1400	2100
2nd	5.00	Red	Horshu	3mst	R-white	R-4	50	100	150
	25.00	Green	Horshu	3blk	R-white	R-5	80	160	240
3rd	1.00	Tan	Lg-key	None	HS	R-6	30	60	90
	5.00	Red	Lg-key	None	HS	R-6	35	70	105
	25.00	Green	Lg-key	None	HS	R-7	100	200	300

(Located on Mount Rose Highway en route to Lake Tahoe. This club, a famous steak house, had a blackjack table in the back. Closed in 1966 due to loaded dice at the crap table. In 1967, the club, and all the original chips, was incinerated in a fire. Reopened in 1969 and run by various people until 1978. Remains open today as a restaurant.)

Christmas Tree $5 (1st)

193

Issue	Den.	Color	Mold	Inserts	Inlay	Rarity	GD30	VF65	CS95
CIRCUS CIRCUS			**RENO**		**1978-**				
1st	.50	Peach	H&C	None	HS	R-4	3	6	9
	1.00	Lt Grey	H&C	None	HS	R-2	3	6	9

(The first variant is marked "$1." The second variant is marked "$1.00".)

	5.00	Red	H&C	3mst	HS	R-3	8	16	24
	25.00	Green	H&C	3fch	HS	R-7	35	70	105
	100.00	Black	H&C	3grn3red3org	HS	R-8	75	150	225

Circus Circus $5 (1st)

(This 1st issue says "Reno" only.)

2nd	.25	Peach	H&C	None	HS	R-4	3	6	9
	.50	Pink	H&C	None	HS	R-4	3	6	9
	1.00	Lt Grey	H&C	None	HS	R-3	2	4	6
	5.00	Red	H&C	3mst	HS	R-4	5	10	15
	25.00	Green	H&C	3fch	HS	R-7	35	70	105

Circus Circus $5 (2nd)

	NCV	Yellow	H&C	None	HS	R-5	4	8	12
	NCV	Lt Green	H&C	3dkgrn	HS	R-5	4	8	12
	NCV	Navy	H&C	3ltblu	HS	R-5	4	8	12
	RLT A	2 diff.	Plain	None	R-white	R-3	2	4	6

(Colors: Fuchsia and Navy.)

	RLT B	2 diff.	Plain	None	R-white	R-3	2	4	6

(Colors: Green, and Aqua.)

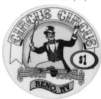

Circus Circus $1 (3rd)

3rd	1.00	White	Chipco	None	FG	R-1	*	1	3
	5.00	Red	Chipco	None	FG	R-1	*	5	7
	25.00	Green	Chipco	None	FG	R-1	*	25	30
	100.00	Black	Chipco	None	FG	R-1	*	100	110
	500.00	Purple	Chipco	None	FG	R-2	*	500	525
4th	.50	Navy	Unicrn	None	HS	R-2	*	1	3

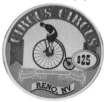

Circus Circus $25 (3rd)

CLARION HOTEL			**RENO**		**1991-96**				
1st	1.00	Blue	H&C	None	OR-white	R-2	2	4	6
	2.50	Orange	H&C	4nvy	OR-white	R-4	4	8	12
	5.00	Red	H&C	4pnk4yel	OR-white	R-3	5	10	15
	25.00	Green	H&C	4ltgrn	OR-white	R-6	15	30	45
	100.00	Black	H&C	4blu4wht	OR-white	R-8	70	140	210
	500.00	White	H&C	8grn4blk	COG-white	R-8	75	150	225

(Exactly 11 chips were unaccounted for when this issue of chips was poured into the concrete.)

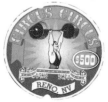

Circus Circus $500 (3rd)

	NCV 5	Fuchsia	H&C	None	R-white	R-4	4	8	12

CLOVER CLUB			**RENO**		**1945-57**				
	n/d	Black	Lcrown	None	HS	R-10	30	60	90
	n/d	Blk/Wht	Lcrown	None	HS	R-10	30	60	90
	n/d	Green	Lcrown	None	HS	R-10	30	60	90

(These chips are only attributed to Reno.)

Clarion Hotel $5 (1st)

Issue	Den.	Color	Mold	Inserts	Inlay	Rarity	GD30	VF65	CS95

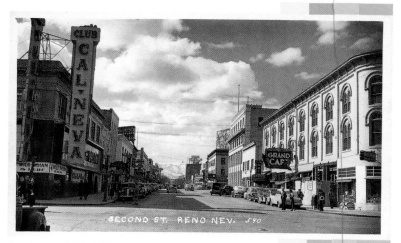

Club Cal-Neva $1 (5th)

Club Cal-Neva $25 (5th)

An early postcard of the Cal-Neva, currently known for attracting a rough low-income crowd. This is not a place for socialites.

CLUB CAL-NEVA RENO 1948-

Issue	Den.	Color	Mold	Inserts	Inlay	Rarity	GD30	VF65	CS95
1st	5.00	Red	Diamnd	None	HS	R-5	100	200	300
	25.00	Tan	Diamnd	None	HS	R-6	125	250	375
2nd	.10	Mustard	Sm-key	None	HS	R-5	30	60	90
	1.00	Brown	Lzydia	None	HS	R-9	250	500	750
	n/d	5 diff.	Sm-key	None	HS	R-6	25	50	75

(Colors: Beige, Mustard, Navy, Red, and Turquoise.)

Issue	Den.	Color	Mold	Inserts	Inlay	Rarity	GD30	VF65	CS95
3rd	.10	Mustard	HCE	None	HS	R-9	125	250	400
4th	1.00	Dk Grey	T's	None	HS	R-5	10	20	30

(Overstamped "Big 6 Only" on one side.)

	1.00	Dk Grey	T's	None	HS	R-8	35	70	105

(No overstamp.)

5th	1.00	Dk Grey	Hub	None	HS	R-5	7	14	21

(Overstamped "Big 6 Only" on one side.)

	1.00	Dk Grey	Hub	None	HS	R-6	15	30	45

(No overstamp.)

	n/d	Dk Grey	Hub	None	HS	R-7	6	12	18

(Same as above chips, except the casino cut out the denomination.)

	5.00	Green	Hrglas	3red	R-white	R-5	35	70	105
	5.00	Lt Green	Hrglas	3red	R-white	R-5	30	60	90
	25.00	Fuchsia	Hrglas	3blk	R-white	R-5	25	50	75
	100.00	Beige	Hrglas	3blk	R-white	R-8	150	300	450
6th	.10	Mustard	C&J	3red	R-white	R-10	300	600	900
	.25	Grey	C&J	3grn	R-white	R-6	75	150	225
7th	.10	Mustard	Lg-key	None	HS	R-6	25	50	75
	.25	Navy	Lg-key	None	HS	R-5	15	30	45
	RLT	4 diff.	Lg-key	None	HS	R-6	15	30	45

(Colors: Blue, Mustard, Red, and White. Picture of Indian logo.)

	RLT A	Red	Lg-key	None	HS	R-5	6	12	18
	RLT B	Red	Lg-key	None	HS	R-5	6	12	18
8th	pan .50	Yellow	H&C	None	HS	R-10	100	200	300

(Marked "Club Cal-Neva, Reno.")

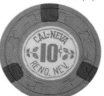

Club Cal-Neva 10c (6th)

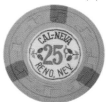

Club Cal-Neva 25c (6th)

Club Cal-Neva 10c (7th)

Club Cal-Neva RLT (7th)

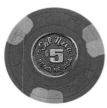

Club Cal-Neva $5 (9th)

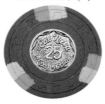

Club Cal-Neva $25 (9th)

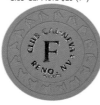

Club Cal-Neva RLT F (11th)

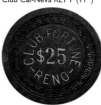

Club Fortune $25 (1st)

Club Fortune RLT (1st)

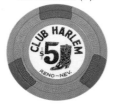

Club Harlem $5 (2nd)

Issue	Den.	Color	Mold	Inserts	Inlay	Rarity	GD30	VF65	CS95
9th ("Reno".)	.25	Navy	H&C	None	HS	R-4	4	8	12
	1.00	Blue	H&C	None	HS	R-1	*	1	3
	5.00	Red	H&C	3blu3org	MC	R-1	*	5	10
	25.00	Green	H&C	3org3yel	MC	R-1	*	25	35
	100.00	Black	H&C	3org3wht	MC	R-3	*	100	125
(The above Paulson metal center chips, made in 1977, are still in use.)									
	NCV 1	Brown	H&C	4blu	HS	R-8	10	20	30
	NCV 5	Pink	H&C	4ltblu	HS	R-8	10	20	30
	RLT A	5 diff.	H&C	None	HS	R-4	3	6	9
(Colors: Navy, Orange, Pink, Purple, and White.)									
	RLT B	8 diff.	H&C	None	HS	R-4	3	6	9
(Colors: Green, Navy, Ochre, Orange, Peach, Purple, White, and Yellow.)									
	RLT C	2 diff.	H&C	None	HS	R-4	3	6	9
(Color: Pink, Maroon.)									
	RLT D	6 diff.	H&C	None	HS	R-4	3	6	9
(Colors: Brown, Dk Brown, Green, Grey, Orange, and Yellow.)									
	RLT E	6 diff.	H&C	None	HS	R-4	3	6	9
(Colors: Lt Blue, Brown, Grey, Orange, Peach, and Yellow.)									
10th ("Reno, NV.")	.25	Navy	H&C	None	HS	R-3	*	2	4
	2.50	Grey	H&C	3fch3nvy	HS	R-5	15	30	45
	NCV 5.00	Fuchsia	H&C	4lav	R-white	R-9	10	20	30
	NCV 25.00	Orange	H&C	4grn	R-white	R-9	10	20	30
("Tournament Only".)									
	NCV 1	Blue	BJ	None	HS	R-9	7	14	21
	NCV 2.50	Brown	BJ	None	HS	R-9	15	30	45
	NCV 5	Green	BJ	None	HS	R-9	10	20	30
	NCV 25	Pink	BJ	None	HS	R-9	12	24	36
11th	.25	Blue	HHR	None	HS	R-4	3	6	9
	NCV	4 diff.	HHR	None	HS	R-6	5	10	15
(Colors: Brown, Green, Lavender, and Tan.)									
	RLT B	Dk Green	HHR	None	HS	R-4	3	6	9
	RLT F	7 diff.	HHR	None	HS	R-4	3	6	9
(Colors: Dk Green, Lt Green, Peach, Pink, Purple, White, and Yellow.)									
(Both 9th issue H&C and 11th issue HHR roulettes were used simultaneously on different tables in 1997.)									

CLUB FORTUNE　　　　RENO　　　　1937–48

	1st	25.00	Black	Sm-key	None	HS	R-8	175	350	525
		RLT	4 diff.	C&S	None	R-blk/wht	R-7	40	80	120

(Black letters around ring. Colors: Blue, Green, Pink, and Yellow.)

		RLT	4 diff.	C&S	None	R-red/wht	R-7	40	80	120

(Red letters around ring. Colors: Blue, Green, Pink, and Yellow.)

CLUB HARLEM　　　　RENO　　　　1948–68

		Den.	Color	Mold	Inserts	Inlay	Rarity	GD30	VF65	CS95
1st		.25	Blue	Arodie	None	HS	Unique	300	600	900
2nd		.50	Purple	Sm-key	None	HS	R-10	250	500	750
		1.00	Yellow	Sm-key	3pur	HS	R-10	275	550	825
		5.00	Beige	Sm-key	3red	R-white	R-8	400	800	1200
		25.00	Black	Sm-key	3pur	HS	R-10	300	600	900

(Like the China Mint, Club Harlem was a segregated casino.)

CLUB RENO　　　　RENO　　　　1931–40

1st	20.00	Beige	Zigzag	None	HS	R-9	175	350	525

Issue	Den.	Color	Mold	Inserts	Inlay	Rarity	GD30	VF65	CS95
COLBRANDT'S FLAMINGO CLUB			**RENO**		**1937-56**				
1st	5.00	Yellow	Hub	None	HS	R-8	30	60	90
	25.00	Brown	Hub	None	HS	R-8	30	60	90
(Initialed "VTS" for Virgil T. Smith.)									
2nd	50.00	Green	Lcrown	None	HS	R-4	75	150	225
	100.00	Navy	Lcrown	None	HS	R-4	75	150	225
("Colbrandt's Reno.")									
COLONIAL CASINO			**RENO**		**1978-98**				
1st	1.00	Blue	H&C	None	HS	R-4	7	14	21
	5.00	Red	H&C	3yel	HS	R-2	*	5	10
COLONY CASINO			**RENO**		**1967-70**				
1st	5.00	Navy	Sm-key	3red	R-white	R-9	150	300	450
	25.00	Black	Sm-key	3grn	R-white	R-5	50	100	150
COLONY CLUB			**RENO**		**1946-64**				
1st	.10	White	Arodie	None	HS	R-10	350	700	1050
	.50	Grey	Arodie	None	HS	R-10	250	500	750
	1.00	Mustard	Arodie	None	HS	R-10	350	700	1050
	5.00	Brown	Arodie	None	HS	R-8	100	200	300
(There are exactly 12 known pieces - all of which have been painted green by the former owners!)									
2nd	5.00	Navy	Sm-key	3red	R-white	R-6	35	70	105
	25.00	Black	Sm-key	3grn	R-white	R-6	40	80	120
	25.00	Black	Sm-key	3grn	R-white	R-6	40	80	120
(Larger "$25".)									
	100.00	Green	Sm-key	3blk	R-white	R-7	60	120	180
	n/d	Orange	Sm-key	None	HS	R-5	15	30	45
(Line between "Colony" and "Club".)									
(Even though the Colony Club and Colony Casino have similar names and identical chips, they are not from the same location! The Colony Club was located at 254 N. Virginia St. and the address of the Colony Casino was 280 N. Center St.)									
COMSTOCK			**RENO**		**1978-**				
1st	1.00	Orange	Lg-key	None	HS	R-1	*	1	3
	RLT	White	Lg-key	None	HS	R-7	10	20	30
2nd	.25	Purple	H&C	None	HS	R-3	2	4	6
	.50	Yellow	H&C	None	HS	R-6	10	20	30
	5.00	Red	H&C	3wht3yel	MC	R-6	30	60	90
	RLT C	3 diff.	H&C	None	HS	R-5	3	6	9
(Colors: Blue, Burnt Orange, and Pink.)									
3rd	5.00	Red	H&C	3pch3wht	R-white	R-1	*	5	10
	25.00	Lime	H&C	6dkgrn3grn	HEX-white	R-1	*	25	30
	100.00	Black	H&C	4pur4yel	COG-gold	R-2	*	100	110
	NCV I	Lt Blue	H&C	8nvy	HS	R-3	2	4	6
	NCV 5	Purple	H&C	8yel	HS	R-4	5	10	15
	NCV V	Gold	H&C	6brn	HS	R-5	5	10	15
	RLT A	Brown	H&C	None	HS	R-4	3	6	9
4th	1.00	Beige	H&C	None	HS	R-5	4	8	12
	NCV 1	Yellow	H&C	None	HS	R-7	3	6	9
("Keno".)									

Colbrandt's $5 (1st)

Colonial Casino $5 (1st)

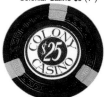

Colony Casino $25 (1st)

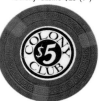

Colony Club $5 (2nd)

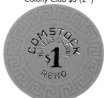

Comstock $1 (1st)

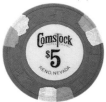

Comstock $5 (3rd)

Cosmo Club 10c (1st)

Cosmo Casino $25 (3rd)

Diamond's Casino $5 (1st)

Dog House n/d (1st)

Eddie's Fabulous 50's $100 (1st)

Eldorado $25 (2nd)

Issue	Den.	Color	Mold	Inserts	Inlay	Rarity	GD30	VF65	CS95
COSMO CLUB			**RENO**		**1956-66**				
COSMO CASINO			**RENO**		**1970-74**				
1st	.10	Yellow	Sm-key	None	HS	R-5	30	60	90
	5.00	Orange	Diasqr	3blk	HS	R-6	12	24	36
	20.00	Black	Diasqr	3crm	HS	R-7	20	40	60
(Above two chips have Chinese writing.)									
2nd	.10	Fuchsia	Scrown	None	HS	R-9	100	200	400
	1.00	Navy	Scrown	3yel	HS	R-3	6	12	18
	1.00	Lt Blue	Scrown	None	HS	R-5	10	20	30
("Good For One Bet Only.")									
3rd	5.00	Red	Ewing	3dkgry	SCA-white	R-2	5	10	15
	25.00	Dk Green	Ewing	3tan	SCA-white	R-3	8	16	24
(This last issue only is "Cosmo Casino.")									
COUNTRY CLUB			**RENO**		**1930-36**				
1st	5.00	Brown	Hub	None	R-white	R-6	35	70	105
	25.00	Black	Hub	None	R-white	R-8	100	200	300
DIAMOND'S CASINO			**RENO**		**1995-**				
1st	5.00	Red	Chipco	3yel	FG	R-1	*	5	8
	25.00	Green	Chipco	8yel4pnk	FG	R-1	*	25	30
	100.00	Black	Chipco	12pur6yel	FG	R-3	*	100	120
DOG HOUSE, THE			**RENO**		**1935-44**				
1st	n/d	Black	Diasqr	None	HS	R-7	50	100	150
EDDIE'S FABULOUS 50's			**RENO**		**1987-89**				
1st	.25	Gold	H&C	None	HS-black	R-4	5	10	15
	1.00	Blue	H&C	None	R-white	R-4	10	20	30
	5.00	Red	H&C	3tan	SCA-white	R-4	25	50	75
	25.00	Green	H&C	4lim8yel	HUB-white	R-7	100	200	300
	100.00	Black	H&C	4blu4gry	COG-white	R-4	12	24	36
	500.00	White	H&C	4grn4pnk	PENTA-wht	R-4	18	36	54
	n/d	Navy	H&C	None	HS	R-6	10	20	30
	n/d	Red	H&C	None	HS	R-7	12	24	36
(Both chips say "Grand Opening '87")									
	RLT A	3 diff.	H&C	None	HS	R-5	5	10	15
(Colors: Brown, Orange, and White.)									
	RLT B	4 diff.	H&C	None	HS	R-5	4	8	12
(Colors: Blue, Burnt Orange, Brown, and Orange.)									
ELDORADO			**RENO**		**1973-**				
1st	1.00	Bnt Org	Lg-key	None	HS	R-6	30	60	90
	5.00	Maroon	Lg-key	3trq3tan	R-white	R-6	60	120	180
(This 1st issue is marked "Eldorado Club" with "Reno, Nev." in tall letters.)									
2nd	5.00	Maroon	Lg-key	3trq3tan	R-white	R-6	60	120	180
	25.00	Orange	Lg-key	8grn	R-white	R-10	250	500	750
(The 2nd issue is "Eldorado Club" with "Reno, Nevada" in shorter letters.)									
	NN 1.00	Maroon	Lg-key	None	HS	R-8	30	60	90
	NN 5.00	Purple	Lg-key	2yel	HS	R-8	30	60	90
	RLT	Dk Red	Lg-key	None	HS	R-8	15	30	45
3rd	1.00	Dk Orange	Lg-key	None	HS	R-7	35	70	105
	5.00	Orange	Lg-key	6trq3wht	R-white	R-9	100	200	300
	25.00	Yellow	Lg-key	8grn	R-white	R-10	250	500	750

Issue	Den.	Color	Mold	Inserts	Inlay	Rarity	GD30	VF65	CS95
	100.00	Black	Lg-key	6bei3brn	R-white	Unique	300	600	900
(Third issue is "Hotel Casino".)									
4th	5.00	Red	H&C	6grn3bei	R-white	R-6	30	60	90
	NN 5.00	Dk Brown	H&C	None	HS	R-7	15	30	45
5th	.25	Pink	House	None	HS	R-8	30	60	90
	1.00	Blue	House	None	HS	R-5	15	30	45
	1.00	Blue	House	None	R-white	R-6	20	40	60
	5.00	Red	House	4crm4grn	HUB-white	R-7	40	80	120
	500.00	Purple	House	3pch3ltblu3org	R-white	Unique	300	600	900
	NCV 5	Blue	House	3pnk3wht	R-white	R-7	35	70	105
("FlyAAway American Airlines.")									
	RLT G	5 diff.	House	None	R-pink	R-6	5	10	15
(Colors: Blue, Brown, Gold, Green, and Pink.)									
	RLT H	Green	House	None	R-pink	R-6	5	10	15
	RLT H	Orange	House	None	R-pink	R-6	5	10	15
	RLT E	Orange	Roulet	None	OR-white	R-6	6	12	18
6th	1.00	Blue	BJ-2	6wht	COIN	R-1	*	1	3
	5.00	Red	BJ-2	8grn12wht	COIN	R-1	*	5	7
	25.00	Green	BJ-2	4wht	COIN	R-6	25	50	75
	100.00	Black	BJ-2	3red6wht	COIN	R-7	100	150	200
	bac 100.00	Brown	Plain	None	Rectangle	R-3	*	100	125
(This is an acrylic plastic plaque. The only Monte Carlo style in use in Reno.)									
	RLT I	3 diff.	Chipco	None	FG	R-6	4	8	12
(Colors: Green, Red, and Yellow.)									
	RLT II	5 diff.	Chipco	None	FG	R-6	4	8	12
(Colors: Blue, Grey, Green, Red, and Yellow.)									
	RLT IV	2 diff.	Chipco	None	FG	R-6	4	8	12
(Colors: Pink and Yellow.)									
	RLT VI	2 diff.	Chipco	None	FG	R-6	4	8	12
(Colors: Lt Brown and Purple.)									
	RLT VIII	Purple	Chipco	None	FG	R-6	4	8	12
7th	25.00	Green	BJ-P	8yel4blk	R-red	R-1	*	25	30
	100.00	Black	BJ-P	4red2wht2yel	R-red	R-1	*	100	110
	RLT II	Brown	BJ-P	None	R-white	R-4	3	6	9
	RLT V	Pink	BJ-P	4blk	OR-white	R-4	3	6	9
	RLT VI	Green	BJ-P	12blk	OR-white	R-4	3	6	9
	RLT VI	Yellow	BJ-P	12blk	OR-white	R-4	3	6	9

Eldorado $5 (4th)

Eldorado $5 (5th)

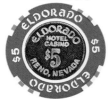

Eldorado $5 (6th)

Eldorado RLT VI (7th)

EL RANCHO BAR　　　RENO　　　1953-60

1st	5.00	Aqua	Diasqr	None	HS	R-9	75	150	225
	25.00	Brown	Diasqr	None	HS	R-10	100	200	300

(These chips are attributed here by Phil Jensen. They are marked only "RB".)

ERNIE AND HAROLDS　　　RENO　　　c.1940's-50's

1st	20.00	Orange	Sm-key	3blk3grn	HS	R-8	20	40	60

(This chip was found in Reno, but may not be from there.)

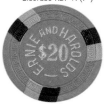

Ernie and Harold's $20 (1st)

ERNIE PRIMM'S CLUB　　　RENO

1st	n/d	2 diff	Zigzag	None	HS	R-9	60	120	180
(Colors: Black and Green.)									
2nd	.25	Red	Lcrown	None	HS	Unique	100	200	300
3rd	.25	Red	Arodie	None	HS	R-4	25	50	75

Ernie Primm's Club 25c (3rd)

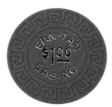

Fan-Tan $1 (1st)

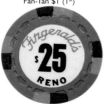

Fitzgeralds $25 (1st)

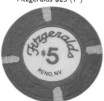

Fitzgeralds $5 (3rd)

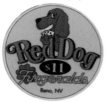

Fitzgeralds $11 (4th)

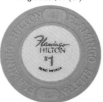

Flamingo Hilton $1 (1st)

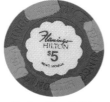

Flamingo Hilton $5 (1st)

Issue	Den.	Color	Mold	Inserts	Inlay	Rarity	GD30	VF65	CS95
4th	n/d	5 diff.	Sm-key	None	HS	R-8	50	100	150

(Colors: Blue, Brown, Green, Ivory, and Red.)
(Some controversy exists over whether or not these chips are actually from Reno. The .25 Arodies were found by James Campiglia who bought them with Primadonna roulettes from a former long time employee who received them from management upon retiring.)

Issue	Den.	Color	Mold	Inserts	Inlay	Rarity	GD30	VF65	CS95
FAN-TAN CASINO			**RENO**		**1967-68**				
1st	1.00	Red	Lg-key	None	HS	R-4	10	20	30
	25.00	Green	Lg-key	3pur	HS	R-4	12	24	36
FITZGERALDS			**RENO**		**1976-**				
1st	5.00	Red	Scrown	4blu4yel	OR-white	R-5	12	24	36
	25.00	Green	Scrown	4nvy4org	OR-white	R-6	30	60	90
	100.00	Dk Purple	Scrown	4grn4trq	OR-white	R-6	50	100	150
	RLT FF	3 diff.	Scrown	None	OR-white	R-5	6	12	18

(Colors: Blue, Green, and Yellow.)

Issue	Den.	Color	Mold	Inserts	Inlay	Rarity	GD30	VF65	CS95
	RLT HH	Salmon	Scrown	None	OR-white	R-6	7	14	21
2nd	.25	Blue	H&C	None	HS	R-7	7	14	21
	.25	Pink	H&C	None	HS	R-6	6	12	18
	1.00	Blue	BJ-2	None	COIN	R-3	4	8	12
	RLT A	5 diff.	H&C	None	HS	R-5	3	6	9

(Colors: Dark Red, Green, Purple, Tan, and Yellow.)

Issue	Den.	Color	Mold	Inserts	Inlay	Rarity	GD30	VF65	CS95
3rd	.25	Gold	H&C	None	HS	R-4	4	8	12
	.50	Blue	H&C	None	HS	R-5	5	10	15
	1.00	Lt Blue	H&C	2pch	R-white	R-1	*	1	3
	5.00	Red	H&C	4yel	R-white	R-1	*	5	8
	25.00	Green	H&C	3blk3wht	HUB-white	R-1	*	25	30
	100.00	Black	H&C	8pur	SCA-white	R-1	*	100	110
4th	11.00	Yellow	Chipco	None	FG	R-3	11	16	21

(This odd denomination is used at the Red Dog table.)

Issue	Den.	Color	Mold	Inserts	Inlay	Rarity	GD30	VF65	CS95
FLAMINGO HILTON			**RENO**		**1989-**				
1st	.50	Pink	H&C	None	HS	R-3	2	4	6
	1.00	Blue	House	None	R-white	R-1	*	1	3
	5.00	Red	House	2grn2pnk	HUB-white	R-1	*	5	7
	25.00	Green	House	4fch4yel	SCA-white	R-1	*	25	30
	100.00	Black	House	6ltblu3pnk	HEX-white	R-1	*	100	110
	NCV 1	Dk Grey	Clover	6wht	HS	R-4	2	4	6

("Win Cards.")

Issue	Den.	Color	Mold	Inserts	Inlay	Rarity	GD30	VF65	CS95
	NCV 5	Orange	H&C	4yel	HS	R-7	5	10	15
	NCV 25	Lt Green	H&C	3pnk	HS	R-7	7	14	21
	NCV 100	Dk Grey	H&C	4pnk	HS	R-8	12	24	36
	NCV 500	Lt Blue	H&C	6dkblu	HS	R-8	15	30	45
	NCV 1000	Lt Purple	H&C	4wht	HS	R-8	20	40	60
	RLT A	7 diff.	Roulet	None	OR-white	R-5	3	6	9

(Colors: Lt Green, Grey, Lavender, Dk Orange, Orange, Peach, and Yellow.)

Issue	Den.	Color	Mold	Inserts	Inlay	Rarity	GD30	VF65	CS95
	RLT B	7 diff.	Roulet	None	OR-white	R-5	3	6	9

(Colors: Blue, Lt Brown, Green, Orange, Dk Purple, White, and Yellow.)

Issue	Den.	Color	Mold	Inserts	Inlay	Rarity	GD30	VF65	CS95
	RLT C	2 diff.	Roulet	None	R-white	R-5	3	6	9

(Colors: Lt Blue and Brown.)

Issue	Den.	Color	Mold	Inserts	Inlay	Rarity	GD30	VF65	CS95
2nd	NCV 50	Blue	Chipco	None	FG	R-9	50	100	150

(Oversized. Picture of Flamingo. Very hard to find as few got out to collectors.)

Issue	Den.	Color	Mold	Inserts	Inlay	Rarity	GD30	VF65	CS95
	RLT	7 diff.	Roulet	None	OR-white	R-4	3	6	9

(Colors: Lt Blue, Lt Brown, Green, Navy, Orange, Pink, and Yellow. Picture of flamingo giving "OK" sign.)

Issue	Den.	Color	Mold	Inserts	Inlay	Rarity	GD30	VF65	CS95
	RLT	7 diff.	Roulet	None	OR-white	R-4	3	6	9

(Colors: Lt Blue, Lt Brown, Green, Navy, Orange, Pink, and Yellow. Picture of flamingo's face only.)

| | RLT | 7 diff. | Roulet | None | OR-white | R-4 | 3 | 6 | 9 |

(Colors: Lt Blue, Green, Orange, Pink, Purple, and Yellow. Picture of flamingo reclining, wearing sunglasses.)

FRISCO CLUB — RENO — 1951-52

Issue	Den.	Color	Mold	Inserts	Inlay	Rarity	GD30	VF65	CS95
1st	5.00	Navy	T's	3mst	HS	R-7	60	120	180
	25.00	Black	T's	3gry	HS	R-9	150	300	450
	100.00	Beige	T's	3red	HS	R-10	200	400	600
	n/d	Orange	T's	3brn	HS	R-10	50	100	150

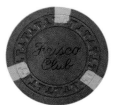
Frisco Club $5 (1st)

FRONTIER CLUB — RENO — 1946-56

Issue	Den.	Color	Mold	Inserts	Inlay	Rarity	GD30	VF65	CS95
1st	1.00	Blu-gry	Sm-key	None	HS	R-9	75	150	225
	5.00	Yellow	Sm-key	None	HS	R-9	75	150	225
	20.00	Lt Green	Sm-key	None	HS	R-9	100	200	300

(Reno not marked on above chips.)

	RLT	Lavender	TK	3gry	HS	R-10	75	150	225
	RLT	Red	TK	3gry	HS	R-10	75	150	225
	RLT	Yellow	TK	3grn	HS	R-10	75	150	225
	RLT	Green	TK	3org	HS	R-10	75	150	225
	RLT	Yellow	TK	3pur	HS	R-10	75	150	225
	RLT	10 diff.	TK	None	HS	R-10	60	120	180

(Colors: Beige, Black, Blue, Grey, Green, Lavender, Orange, Purple, Red, and Yellow.)

2nd	.10	Cream	Sm-key	None	HS	R-5	30	50	100
	5.00	Red	Sm-key	None	HS	R-6	30	60	90
	25.00	Orange	Sm-key	None	HS	R-5	30	60	90
	100.00	Black	Sm-key	None	HS	R-6	50	100	150
	RLT	3 diff.	Sm-key	None	HS	R-8	15	30	45

(Colors: Lt Grey, Mustard, and White.)

| 3rd | 5.00 | Lt Orange | Scrown | 4blk | LSCA-white | R-7 | 50 | 100 | 150 |
| | RLT | 8 diff. | Scrown | None | OR-white | R-5 | 15 | 30 | 45 |

(Colors: Beige, Brown, Green, Navy, Pink, Purple, Red, and Yellow.)

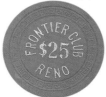
Frontier Club $25 (2nd)

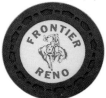
Frontier Club RLT (3rd)

GAMBLER (CARL GIUDICI'S) — RENO — 1993-97

Issue	Den.	Color	Mold	Inserts	Inlay	Rarity	GD30	VF65	CS95
1st	5.00	Red	H&C	3gry3org3grn	OR-multi	R-4	5	10	15
	25.00	Green	H&C	3pur3grn3yel	OR-multi	R-7	50	100	150
	100.00	Black	H&C	3wht3pur3lav	OR-multi	R-7	100	125	175

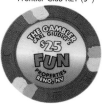
Gambler $25 (1st)

GAY NINETY'S (STEVE'S) — RENO — 1960's

Issue	Den.	Color	Mold	Inserts	Inlay	Rarity	GD30	VF65	CS95
1st	.10	Cream	Diasqr	None	HS	R-5	15	30	45
	.25	Purple	Diasqr	None	HS	R-5	10	20	30
	.50	Yellow	Diasqr	None	HS	R-5	10	20	30
	10.00	Brown	Diasqr	None	HS	R-7	25	50	75

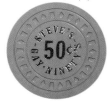
Gay Ninety's 50c (1st)

GEM CASINO — RENO — 1987-88

Issue	Den.	Color	Mold	Inserts	Inlay	Rarity	GD30	VF65	CS95
1st	1.00	Blue	H&C	None	HS	R-8	50	100	150
	5.00	Red	H&C	4wht4gld	HS	R-9	125	250	375

GOLD DUST — RENO — 1976-82

Issue	Den.	Color	Mold	Inserts	Inlay	Rarity	GD30	VF65	CS95
1st	.25	White	H&C	None	HS	R-6	10	20	30
	1.00	Pink	H&C	None	HS	R-7	8	16	24
	5.00	Red	H&C	3wht3blu	MC	R-5	40	80	120

(This is one of the Bi-Centennial chips issued in 1976.)

| | 25.00 | Green | H&C | 3pnk3wht | MC | R-9 | 125 | 250 | 375 |

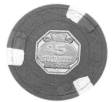
Gold Dust $5 (1st)

201

Gold Dust $100 (1st)

Golden Club $5 (1st)

Golden Gulch $5 (2nd)

Club Golden $5 (3rd)

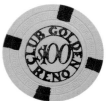

Club Golden $100 (3rd)

Golden Bank Club 10c (6th)

Issue	Den.	Color	Mold	Inserts	Inlay	Rarity	GD30	VF65	CS95
	100.00	Black	H&C	3wht3pch	MC	Unique	350	750	1050
	NN 1.00	Orange	H&C	None	HS	R-7	8	16	24
	NN 1.00	Yellow	H&C	None	HS	R-8	10	20	30
	NCV 1	Black	H&C	None	HS-white	R-10	20	40	60

(This club opened four days before the Bi-Centennial on July 1, 1976. Became Riverboat.)

GOLD DUST WEST — RENO — 1977-90

1st	NCV	Peach	H&C	None	HS	R-6	7	14	21
	NN	3 diff.	H&C	None	HS	R-6	6	12	18

(Colors: Blue, Navy, and Peach.)

	RLT	6 diff.	H&C	None	HS	R-7	6	12	18

(Colors: Blue, Brown, Grey, Pink, Tan, and Yellow.)

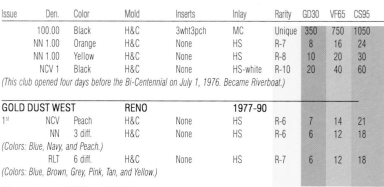

A nice postcard shot of the Golden Club and its surroundings. Of particular interest is the Bonanza that was owned by Wilbur Clark. They definitely had table games and chips, but no examples whatsoever have ever been found.

GOLDEN CLUB — RENO — 1935-47/1948-52
GOLDEN GULCH — 1947-48
GOLDEN BANK — 1953-c.55
GOLDEN BANK CLUB — c.1955-62
GOLDEN CASINO — 1963-66

1st	5.00	Mustard	C&S	None	R-white	R-8	300	600	1200
	25.00	Green	C&S	None	R-white	R-9	600	1200	1800

(This 1st issue is marked "Golden Club.")

	n/d	Black	C	None	HS	Unique	300	600	900

(Early "C" mold chip has an intertwined "GC".)

2nd	5.00	Mustard	Lcrown	None	HS	R-7	150	300	450

(Second issue is "Golden Gulch".)

3rd	5.00	Lavender	Sm-key	2ltgrn	HS	R-9	150	300	600
	25.00	Red	Sm-key	2mst	HS	R-10	300	600	900
	100.00	Yellow	Sm-key	4blk	Diecut-metal	R-10	1500	3000	4500

(Of the three known examples, one is drilled. This 3rd issue is "Club Golden.")

4th	5.00	Navy	Scrown	4yel	HS	R-8	125	250	375

("Golden Club".)

5th	5.00	Grey	Sm-key	None	HS	R-9	175	350	525
	RLT	3 diff.	Lcrown	None	HS	R-8	40	80	120

Issue	Den.	Color	Mold	Inserts	Inlay	Rarity	GD30	VF65	CS95
(Colors: Navy, Red, and White.)									
	RLT	Yellow	Lcrown	None	HS	R-9	50	100	150
	RLT	Black	Scrown	None	HS	R-9	45	90	135
(Fifth issue is marked "Golden Bank.")									
6th	.10	Red	Arodie	None	HS	R-6	125	250	500
(May not exist in top condition.)									
	.10	Red	Sm-key	None	HS (SS)	R-10	250	500	750
	5.00	Blue	Sm-key	4yel	HS-wht(SS)	R-9	200	400	600
	25.00	Green	Sm-key	4red	HS-blk(SS)	R-8	175	350	525
(Sixth issue is "Golden Bank Club.")									
	RLT	Navy	Sm-key	None	HS	R-6	20	40	60
	RLT	2 diff.	Sm-key	None	HS	R-8	40	80	120
(Picture of nugget with glow marks. Colors: Red, and Yellow.)									
7th	5.00	Black	Sm-key	3yel	R-yellow	R-2	10	20	30
	25.00	Red	Sm-key	3yel	R-yellow	R-3	15	30	45
	100.00	Tan	Sm-key	3yel	R-yellow	R-5	40	80	120
	RLT 3	5 diff.	Sm-key	None	HS	R-6	15	30	45
(No picture. Colors: Brown, Lavender, Navy, Orange, and White.)									
	RLT 4	5 diff.	Sm-key	None	HS	R-6	15	30	45
(No picture. Colors: Brown, Lavender, Navy, Orange, and White.)									
8th	.10	Orange	Scrown	None	HS	R-6	30	60	100
	n/d	3 diff.	Horshu	None	HS	R-6	15	30	45
(Colors: Mustard, Navy, and Red.)									
	n/d	Green	S's	None	HS	R-8	75	150	225
("Lucky Buck, 21, Craps, Only.")									
	RLT	Beige	Scrown	None	HS	R-10	25	50	75
(Eighth issue is "Tomerlin's Golden Bank".)									
9th	1.00	Red	C&J	None	R-red	R-4	20	40	60
(Marked "Good Only at the Golden, Jim Tomerlin, in Reno.")									
10th	.10	Red	Sm-key	None	HS	R-4	12	24	36
	n/d	Orange	Sm-key	None	HS	R-4	5	10	15
	n/d	Black	Sm-key	None	HS	R-4	5	10	15
(Tenth issue on is just marked "Golden.")									
	n/d	Purple	Diasqr	None	HS	Unique	50	100	150
(Only marked with large "G". Used as a shill chip.)									
11th	.10	Red	C&J	3nvy	R-brown	R-10	300	600	900
	1.00	Brown	C&J	3grn	R-brown	R-5	15	30	45
	5.00	Orange	C&J	3brn	R-brown	R-5	25	50	75
	25.00	Brown	C&J	3grn	R-brown	R-10	250	500	750
	100.00	Beige	C&J	3org	R-brown	R-5	35	70	105
12th	.10	Maroon	C&J	None	HS	R-9	125	250	375
	.25	Dk Blue	C&J	None	HS	R-9	100	200	300
	.25	Dk Green	C&J	None	HS	R-10*	150	300	450
	1.00	Brown	C&J	None	HS	R-10	100	200	300
	1.00	Lavender	C&J	None	HS	R-8	60	120	180
	1.00	Orange	C&J	None	HS	R-5	20	40	60
	5.00	Black	C&J	None	HS	R-5	15	30	45
	5.00	Grey	C&J	None	HS	R-9	75	150	225
	RLT A	5 diff.	C&J	None	HS	R-7	10	20	30
(Colors: Brown, Cream, Lt Green, Purple, and Red.)									
	RLT B	5 diff.	C&J	None	HS	R-7	10	20	30
(Colors: Brown, Cream, Lt Green, Purple, and Red.)									
	RLT C	5 diff.	C&J	None	HS	R-7	10	20	30
(Colors: Cream, Lt Green, Purple, Red, and Yellow.)									

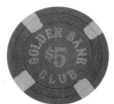

Golden Bank Club $5 (6th)

Golden Bank Club RLT (6th)

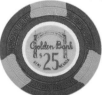

Golden Bank $25 (7th)

Golden 10c (10th)

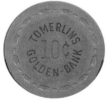

Tomerlin's Golden Bank 10c (8th)

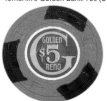

Golden $5 (11th)

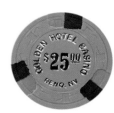

Golden Hotel $25 (1st)

Issue	Den.	Color	Mold	Inserts	Inlay	Rarity	GD30	VF65	CS95
13th	25.00	Grey	C&J	3grn	HS	R-5	15	30	45
(Denomination on back, unlike 12th issue.)									
14th	1.00	Beige	C&J	None	HS	R-4	8	16	24

("Good Only at the Golden in Reno.")

(This location had an interesting 30-year run, with several ownership changes. From the mid-1930's on, the Golden Hotel was located next to the Bank Club. For some reason lost to history, the casino was named Golden Gulch from 1947-48. These casinos competed with each other for about two decades. In 1953, the Bank Club merged with the Golden Hotel to form the Golden Bank that became the Golden Bank Club a couple years later. This lasted until 1963 when the name changed to Golden Casino. In 1966, this Reno mainstay shut its doors for good.)

Great Provider $100 (1st)

GOLDEN HOTEL RENO 1980-81

1st	5.00	Red	H&C	3lim3blu	HS	R-4	12	24	36
	25.00	Green	H&C	3org3brn	HS	R-4	18	36	54

(Previously the Reef Casino.)

GREAT PROVIDER RENO 1930's

1st	.50	Beige	C&S	None	R-white	R-9	200	400	600
	1.00	Red	C&S	None	R-white	R-10	250	500	750
	5.00	Grey	C&S	None	R-white	Unique	300	600	900
	10.00	Brown	C&S	None	R-white	R-10	250	500	750
	50.00	Yellow	C&S	None	R-white	R-10	250	500	750
	100.00	Black	C&S	None	R-white	R-10	250	500	750

(Attributed to Reno, but the research is inconclusive. Some of these chips were found as far away as Iowa.)

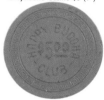

Greyhound Casino $5 (1st)

GREYHOUND CASINO RENO 1961-c.65

1st	.10	Dk Green	Sm-key	None	SS-orange	R-10	250	500	750
	5.00	Blue	Sm-key	None	SS-gold	R-5	35	70	105
	25.00	Black	Sm-key	None	SS-gold	R-8	100	200	300

HAPPY BUDDHA CLUB RENO 1958-60

1st	5.00	Red	Sm-key	None	HS	R-10	350	700	1050

Happy Buddha Club $5 (1st)

Harolds Club $2.50 (N/A)

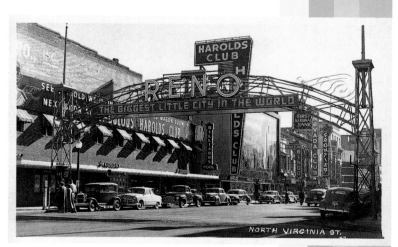

In the 1940s when this postcard picture was taken, Harolds Club was the most famous casino in the world due to extensive advertising.

Harold Smith Sr. #1 $5 (2nd)

Issue	Den.	Color	Mold	Inserts	Inlay	Rarity	GD30	VF65	CS95

HAROLDS CLUB — RENO — 1935-95

Issue	Den.	Color	Mold	Inserts	Inlay	Rarity	GD30	VF65	CS95
N/A	2.50	Pink	Web	None	HS	Unique	400	800	1200

(This somewhat controversial chip was unknown until fairly recently. There is no record of any Web mold chips ever actually being used for table play in Nevada. The condition of this chip is uncirculated, which almost ensures that this piece was a sample or prototype. Nevertheless, we felt it worth listing as an interesting historical specimen.)

Issue	Den.	Color	Mold	Inserts	Inlay	Rarity	GD30	VF65	CS95
1st	5.00	Black	Sm-key	2yel	HS	Unique*	1000	2000	3000

(Unfortunately, this fabulous chip is encased in lucite. One side is marked "Harold's Club $5" and the other has a nice hot stamped picture of a racing stagecoach. It does answer the question of what chips were used before the portrait series chips, which certainly date from later than 1935.)

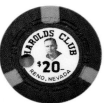
Ray A. Smith #1 $20 (2nd)

Issue	Den.	Color	Mold	Inserts	Inlay	Rarity	GD30	VF65	CS95
2nd	5.00	Maroon	HCE	3yel	R-white	R-5*	250	500	750

(All known survivors are drilled and worth about 10% of this listed price.)

Issue	Den.	Color	Mold	Inserts	Inlay	Rarity	GD30	VF65	CS95
	20.00	Green	HCE	3yel	R-white	Unknown	500	1000	1500
	100.00	Yellow	HCE	3dkgrn	R-white	Unknown	500	1000	1500

(First Portrait of Harold Smith, Sr.)

Issue	Den.	Color	Mold	Inserts	Inlay	Rarity	GD30	VF65	CS95
	5.00	Maroon	HCE	3yel	R-white	Unknown	500	1000	1500
	20.00	Green	HCE	3yel	R-white	R-10*	400	800	1200
	100.00	Yellow	HCE	3dkgrn	R-white	R-5*	250	500	750

(All known survivors are drilled and worth about 10% of this listed price.)
(First portrait of Raymond A. Smith.)

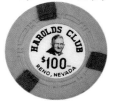
Pappy Smith #1 $100 (2nd)

Issue	Den.	Color	Mold	Inserts	Inlay	Rarity	GD30	VF65	CS95
	5.00	Maroon	HCE	3yel	R-white	R-7	75	150	225
	20.00	Green	HCE	3yel	R-white	R-5*	250	500	750
	100.00	Yellow	HCE	3dkgrn	R-white	R-5	40	80	120

(First portrait of Raymond I. "Pappy" Smith.)
(We assume that all three issues of these portrait chips circulated together and were not released in stages, but there is no way to confirm or deny this contention.)

Issue	Den.	Color	Mold	Inserts	Inlay	Rarity	GD30	VF65	CS95
3rd	1.00	Turq.	Lcrown	None	HS	R-10	50	100	150

(Initialed "FAB" for Fred A. Beck. This chip dates from around 1952.)

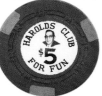
Harold Smith Sr. #2 $5 (4th)

Issue	Den.	Color	Mold	Inserts	Inlay	Rarity	GD30	VF65	CS95
	pan n/d	Blue	Lcrown	None	HS	R-8	100	200	300
	pan n/d	Red	Lcrown	None	HS	R-8	75	150	225
4th	5.00	Maroon	HCE	3yel	R-white	R-5	20	40	60
	20.00	Green	HCE	3yel	R-white	Unknown	500	1000	1500
	100.00	Yellow	HCE	3dkgrn	R-white	R-7	75	150	225

(Second portrait of Harold Smith, Sr.)

Issue	Den.	Color	Mold	Inserts	Inlay	Rarity	GD30	VF65	CS95
	5.00	Maroon	HCE	3yel	R-white	R-9	150	300	450
	20.00	Green	HCE	3yel	R-white	R-10	300	600	900
	100.00	Yellow	HCE	3dkgrn	R-white	Unknown	500	1000	1500

(Second portrait of Raymond A. Smith.)

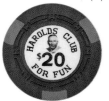
Ray A. Smith #2 $20 (4th)

Issue	Den.	Color	Mold	Inserts	Inlay	Rarity	GD30	VF65	CS95
	5.00	Maroon	HCE	3yel	R-white	R-4	9	18	27
	20.00	Green	HCE	3yel	R-white	R-7	100	200	300
	100.00	Yellow	HCE	3dkgrn	R-white	R-5	20	40	60

(Second portrait of Raymond I. "Pappy" Smith.)

Issue	Den.	Color	Mold	Inserts	Inlay	Rarity	GD30	VF65	CS95
	RLT 1	7 diff.	HCE	None	HS	R-5	5	10	15

(Colors: Beige, Green, Lavender, Navy, Orange, Red, and Yellow.)

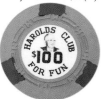
Pappy Smith #2 $100 (4th)

Issue	Den.	Color	Mold	Inserts	Inlay	Rarity	GD30	VF65	CS95
	RLT 2	6 diff.	HCE	None	HS	R-5	5	10	15

(Colors: Beige, Green, Orange, Pink, Red, and Yellow.)

Issue	Den.	Color	Mold	Inserts	Inlay	Rarity	GD30	VF65	CS95
	RLT 3	7 diff.	HCE	None	HS	R-6	6	12	18

(Colors: Beige, Green, Lavender, Navy, Pink, Red, and Yellow.)

Issue	Den.	Color	Mold	Inserts	Inlay	Rarity	GD30	VF65	CS95
	RLT 4	7 diff.	HCE	None	HS	R-6	6	12	18

(Colors: Beige, Green, Lavender, Navy, Pink, Red, and Yellow.)

Issue	Den.	Color	Mold	Inserts	Inlay	Rarity	GD30	VF65	CS95
	RLT 5	7 diff.	HCE	None	HS	R-5	5	10	15

(Colors: Beige, Green, Lavender, Navy, Orange, Red, and Yellow.)

Harolds Club RLT 10 (4th)

Issue	Den.	Color	Mold	Inserts	Inlay	Rarity	GD30	VF65	CS95
	RLT 6	8 diff.	HCE	None	HS	R-5	5	10	15

(Colors: Beige, Green, Lavender, Navy, Orange, Pink, Red, and Yellow.)

Issue	Den.	Color	Mold	Inserts	Inlay	Rarity	GD30	VF65	CS95
	RLT 10	7 diff.	HCE	None	HS	R-7	6	12	18

(Colors: Beige, Green, Lavender, Navy, Orange, Red, and Yellow.)

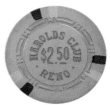

Harolds Club $2.50 (5th)

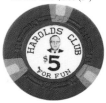

Harold Smith Sr. #3 $5 (6th)

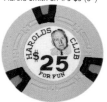

Ray A. Smith #3 $25 (6th)

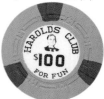

Pappy Smith #3 $100 (6th)

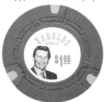

Harold Smith Jr. #1 $1 (7th)

Harolds Club $1 (8th)

Issue	Den.	Color	Mold	Inserts	Inlay	Rarity	GD30	VF65	CS95
	RLT 11	7 diff.	HCE	None	HS	R-7	6	12	18
(Colors: Beige, Green, Lavender, Navy, Orange, Red, and Yellow.)									
	RLT 12	7 diff.	HCE	None	HS	R-7	6	12	18
(Colors: Beige, Green, Lavender, Navy, Orange, Red, and Yellow.)									
	RLT 13	Beige	HCE	None	HS	R-7	6	12	18
	RLT 14	5 diff.	HCE	None	HS	R-6	6	12	18
(Colors: Beige, Green, Lavender, Red, and Yellow.)									
	RLT 15	2 diff.	HCE	None	HS	R-7	6	12	18
(Colors: Lavender and Yellow.)									
	RLT 71	6 diff.	HCE	None	HS	R-7	6	12	18
(Colors: Beige, Green, Lavender, Navy, Orange, and Red.)									
	RLT 101	Orange	HCE	None	HS	R-7	6	12	18
	RLT 401	Beige	HCE	None	HS	R-7	6	12	18
(This entire series of roulettes is marked "HC" with a numbered hexagonal.)									
5th	.25	Purple	HCE	2pnk	HS	R-4	12	24	36
	2.50	Lavender	HCE	3blk3yel	HS	R-8	100	200	300
	20.00	Dk Green	HCE	3yel	HS	R-6	40	80	120
(All of these chips may have a tiny "cc" cancellation mark near the edge.)									
	25.00	Red	HCE	None	HS	Unique	400	800	1200
	100.00	Yellow	HCE	3mar	HS-blue	R-10	350	700	1050
	RLT	2 diff.	HCE	2blk	HS	R-7	15	30	45
("Harolds Club." Colors: Grey-Blue and Yellow.)									
(This fifth issue is not a portrait issue.)									
6th	1.00	Pink	HCE	3gry	R-white	Unique	500	1000	1500
	5.00	Maroon	HCE	6yel3gry	R-white	R-5	25	50	75
	25.00	Green	HCE	6blk3pnk	R-white	R-4	9	18	27
	100.00	Yellow	HCE	6mar3dkgrn	R-white	R-9	125	250	375
(Third portrait of Harold Smith, Sr.)									
	1.00	Pink	HCE	3gry	R-white	R-4	5	10	15
	5.00	Maroon	HCE	6yel3gry	R-white	Unknown	500	1000	1500
	25.00	Beige	HCE	6blk3pnk	R-white	R-4	9	18	27
	100.00	Yellow	HCE	6mar3dkgrn	R-white	Unknown	500	1000	1500
(Third portrait of Raymond A. Smith.)									
	1.00	Pink	HCE	3gry	R-white	R-4	7	14	21
	5.00	Maroon	HCE	6yel3gry	R-white	R-4	9	18	27
	25.00	Tan	HCE	6blk3pnk	R-white	R-6	50	100	150
	100.00	Yellow	HCE	6mar3dkgrn	R-white	R-4	15	30	45
(Third portrait of Raymond I. "Pappy" Smith.)									
7th	.25	Dk Blue	HCE	3pnk	R-white	R-5	20	40	60
	1.00	Green	HCE	6org3yel	R-white	R-4	12	24	36
(Portraits of Harold Smith, Jr.)									
	500.00	Lt Green	HCE	3org3red	R-white	R-4	17	34	51
	1000.00	Orange	HCE	3yel3red	R-white	R-4	25	50	75
(First portrait of Harold Smith, Sr. on one side and first portrait of Raymond A. Smith on the other. Even though these inlays are the same as the first issue, they were made much later. The first issue chips have an unusual semi-plastic texture, but these two chips are clearly the result of more modern production techniques.)									
	RLT 4	2 diff.	Scrown	None	HS	R-7	15	30	45
(Colors: Blue and Orange.)									
	RLT H	Purple	Scrown	None	HS	R-7	15	30	45
8th	1.00	Black	HCE	2wht	HS	R-3	10	20	30
(Chip marked "Good Luck, HC" on one side and "Good Luck, HG" on the other. Possibly also used at Harold's Gun Club in Pyramid Lake.)									
9th	1.00	White	BJ-2	6blu	COIN	R-1	3	6	9
	5.00	Red	BJ-2	12pnk	COIN	R-2	5	10	15

Issue	Den.	Color	Mold	Inserts	Inlay	Rarity	GD30	VF65	CS95
	25.00	Green	BJ-2	4wht	COIN	R-5	25	50	75
	100.00	Black	BJ-2	6pnk3wht	COIN	R-5	20	40	60
	100.00	Black	BJ-2	6org3yel	COIN	R-8	125	250	375
	500.00	Purple	H&C	8yel4ltorg	COG-white	R-8	300	600	900

(There are exactly 8 known survivors. The remainder was definitely destroyed.)

Issue	Den.	Color	Mold	Inserts	Inlay	Rarity	GD30	VF65	CS95
	NCV 1	Blue	H&C	1brn	HS	R-5	5	10	15
	NCV 5	Purple	H&C	2ltblue	HS	R-5	7	14	21
	NCV 25	Lt Green	H&C	3dkgrn	HS	R-5	10	20	30
	NCV 100	Grey	H&C	4org	HS	R-8	20	40	60
	Pan .50	Orange	H&C	None	HS	R-7	30	60	90
	RLT 1	Yellow	H&C	None	HS	R-7	6	12	18

(No picture on either side.)

Issue	Den.	Color	Mold	Inserts	Inlay	Rarity	GD30	VF65	CS95
	RLT 1	2 diff.	H&C	None	HS	R-6	5	10	15

(Colors: Blue and Yellow.)

Issue	Den.	Color	Mold	Inserts	Inlay	Rarity	GD30	VF65	CS95
	RLT 8	2 diff.	H&C	None	HS	R-6	5	10	15

(Colors: Orange and Yellow.)

Issue	Den.	Color	Mold	Inserts	Inlay	Rarity	GD30	VF65	CS95
	RLT 1	2 diff.	Roulet	None	HS	R-6	5	10	15

(Colors: Blue and Yellow.)

Issue	Den.	Color	Mold	Inserts	Inlay	Rarity	GD30	VF65	CS95
	RLT 2	2 diff.	Roulet	None	HS	R-6	5	10	15

(Colors: Blue and Green.)
(Above roulettes, both molds, have the same identical picture of a covered wagon on one side - unless otherwise noted.)

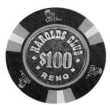
Harolds Club $100 (9th)

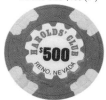
Harolds Club $500 (9th)

Harolds Club RLT 1 obv (9th)

Harolds Club RLT 1 rev (9th)

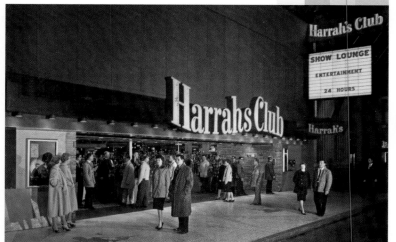
Postcard from Harrah's Club, early 1960s.

Harrah's Club 10c (1st)

HARRAH'S RENO 1946-

Issue	Den.	Color	Mold	Inserts	Inlay	Rarity	GD30	VF65	CS95
1st	.10	Grey	Sm-key	None	HS	Unique	600	1200	1800
	5.00	Yellow	Sm-key	None	HS	Unique	750	1500	2250

(This chip was given to Phil Jensen many years ago by a Harrah's executive who happened to have it laying around in his desk!)

Issue	Den.	Color	Mold	Inserts	Inlay	Rarity	GD30	VF65	CS95
	25.00	Brown	Sm-key	2grn	HS	Unique	750	1500	2250
	100.00	White	Sm-key	2red	HS	R-10*	750	1500	2250
2nd	5.00	Pink	Sm-key	None	R-white	R-7	350	700	1050
	5.00	Orange	Sm-key	None	R-white	R-10*	750	1500	2250
3rd	.25	Dk Blue	Sm-key	None	HS	R-10	400	800	1200
	.25	Red	Sm-key	None	HS	Unique*	500	1000	1500

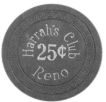
Harrah's Club 25c (3rd)

Harrah's 10c (4th)

Harrah's $2 (5th)

Harrah's $1 (6th)

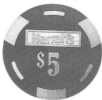

Harrah's $5 (7th)

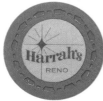

Harrah's RLT (7th)

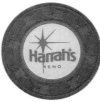

Harrah's RLT (8th)

Issue	Den.	Color	Mold	Inserts	Inlay	Rarity	GD30	VF65	CS95
	25.00	Dk Red	Sm-key	None	R-white	R-10*	750	1500	2250
4th	.10	Yellow	Hub	2nvy	HS-blue	R-5	30	60	90
	n/d	Yellow	Hub	2nvy	HS-blue	Unique	100	200	300
5th	.10	Purple	Sm-key	None	HS	R-3	8	16	24
	2.00	Yellow	Sm-key	3blk	HS	R-5	25	50	75
	RLT	Grey	C&J	None	R-grey	R-8	10	20	30

(Has a Black Star.)

Issue	Den.	Color	Mold	Inserts	Inlay	Rarity	GD30	VF65	CS95
6th	1.00	Yellow	Lg-key	None	HS	R-6	12	24	36

("For Pit Play at Harrah's Reno Only.")

Issue	Den.	Color	Mold	Inserts	Inlay	Rarity	GD30	VF65	CS95
	RLT	4 diff.	Lg-key	None	R-green	R-5	5	10	15

(Black Star. Colors: Beige, Brown, Green, and Mustard.)

	RLT	8 diff.	Lg-key	None	R-lt blue	R-5	5	10	15

(Black Star. Colors: Beige, Blue, Brown, Green, Orange, Red, Turquoise, and Yellow.)

	RLT	7 diff.	Lg-key	None	R-white	R-5	5	10	15

(Black Star. Colors: Beige, Green, Lavender, Navy, Orange, Red, and Yellow.)

	RLT	2 diff.	Lg-key	None	R-green	R-5	5	10	15

(Navy Star. Colors: Green and Mustard.)

	RLT	5 diff.	Lg-key	None	R-lt blue	R-5	5	10	15

(Navy Star. Colors: Beige, Orange, Purple, Red, and White.)

	RLT	2 diff.	Lg-key	None	R-lt purple	R-5	5	10	15

(Navy Star. Colors: Beige and Yellow.)

	RLT	10 diff.	Lg-key	None	R-yellow	R-5	5	10	15

(Orange Star. Colors: Beige, Blue, Brown, Grey, Lavender, Mustard, Orange, Red, Turquoise, and Yellow.)

	RLT	7 diff.	Lg-key	None	R-pink	R-5	5	10	15

(Red Star. Colors: Beige, Brown, Green, Navy, Orange, Red, and Yellow.)

Issue	Den.	Color	Mold	Inserts	Inlay	Rarity	GD30	VF65	CS95
7th	1.00	Yellow	PMSC	16brass	Brass	R-1	1	2	3
	error 2.50	Yellow	PMSC	16brass	Brass	R-6	50	100	150

(This chip was supposed to be green. After the error was discovered, Harrah's searched out and destroyed the offenders, resulting in a scarce chip today.)

	2.50	Green	PMSC	8brass	Brass	R-3	4	8	12
	2.50	Dk Green	PMSC	8brass	Brass	R-4	5	10	15
	5.00	Red	PMSC	3brass	Brass	R-2	5	10	15
	bac 5	Green	PMSC	4brass	Brass	R-4	8	16	24
	25.00	Black	PMSC	3brass	Brass	R-4	25	50	75
	bac 25	Fuchsia	PMSC	10brass	Brass	R-6	40	80	120
	100.00	White	PMSC	4brass	Brass	R-6	75	150	225
	bac 100	White	PMSC	4brass	Brass	R-7	100	200	300
	bac 500	Orange	PMSC	6brass	Brass	R-10	500	600	700

(No location given on above. These exact same chips were used in Lake Tahoe simultaneously.)

	RLT	2 diff.	H&C	None	R-lt blue	R-5	5	10	15

(Blue Star. "Harrah's". Colors: Orange and Peach.)

	RLT	5 diff.	H&C	None	R-Blue	R-5	5	10	15

(Navy Star. "Harrah's". Colors: Beige, Navy, Pink, Red, and White.)

	RLT	7 diff.	Scrown	None	R-blue	R-5	5	10	15

(Blue Star. Colors: Blue, Brown, Green, Orange, Pink, Red, and White.)

Issue	Den.	Color	Mold	Inserts	Inlay	Rarity	GD30	VF65	CS95
8th	1.00	Blue	H&C	None	HS	R-9	35	70	105
	1.00	Orange	H&C	None	HS	R-6	20	40	60

(Above two marked "Reno Only".)

	NCV 1	Blue	H&C	4yel	R-white	R-6	10	20	30
	RLT	2 diff.	H&C	None	R-white	R-5	5	10	15

(Brown Star. Colors: White and Yellow.)

	RLT	5 diff.	H&C	None	R-yellow	R-5	5	10	15

(Orange Star. Colors: Brown, Green, Navy, Red, and Yellow.)

	RLT	6 diff.	H&C	None	R-pink	R-5	5	10	15

(Red Star. Colors: Green, Grey, Navy, Orange, Pink, and Yellow.)

Issue	Den.	Color	Mold	Inserts	Inlay	Rarity	GD30	VF65	CS95
	RLT	4 diff.	H&C	None	R-brown	R-5	5	10	15

(White Star. Colors: Brown, Orange, White, and Yellow.)

Issue	Den.	Color	Mold	Inserts	Inlay	Rarity	GD30	VF65	CS95
9th	.50	Yellow	H&C	4dkblu	HEX-white	R-5	15	30	45
	1.00	Dk Blue	H&C	4yel	HEX-white	R-7	40	80	120
	5.00	Purple	H&C	8wht4grn	HEX-white	R-8	75	150	225
	NCV 25	Green	H&C	4pnk	R-white	R-8	10	20	30
	RLT B	Lavender	H&C	None	R-white	R-5	4	8	12
	RLT D	7 diff.	H&C	None	R-white	R-5	4	8	12

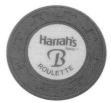

Harrah's RLT B (9th)

(Colors: Dk Blue, Lt Blue, Green, Grey, Orange, Pink, and Purple.)

Issue	Den.	Color	Mold	Inserts	Inlay	Rarity	GD30	VF65	CS95
10th	5.00	Navy	Chipco	None	FG	R-5	15	30	45

(Chip has an octagon shape. Says "100% Satisfaction guaranteed.")

Issue	Den.	Color	Mold	Inserts	Inlay	Rarity	GD30	VF65	CS95
11th	.10	Brown	BJ	None	HS	R-2	5	10	15
	1.00	White	BJ-P	2grn2pur4trq	OR-white	R-3	2	4	6
	2.50	Orange	BJ-P	4wht	OR-white	R-1	*	3	5
	5.00	Red	BJ-P	8yel	OR-white	R-1	*	5	7
	25.00	Green	BJ-P	4wht	OR-white	R-6	30	60	90

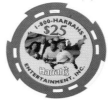

Harrah's $25 (11th)

(Picture map with faces.)

Issue	Den.	Color	Mold	Inserts	Inlay	Rarity	GD30	VF65	CS95
	100.00	Black	BJ-P	16gry	OR-wht/gry	R-8	100	200	300

(Picture of Old Harrah's Club on one side.)

Issue	Den.	Color	Mold	Inserts	Inlay	Rarity	GD30	VF65	CS95
	NCV 1	Purple	BJ	None	HS	R-2	1	2	3
	NCV 5	Red	BJ	None	HS	R-4	3	6	9
	NCV 25	Black	BJ	None	HS	R-4	5	10	15
	RLT B	Blue	House	None	R-white	R-2	3	6	9
	RLT D	Navy	House	None	R-white	R-2	3	6	9
	RLT E	Blue	House	None	R-white	R-2	3	6	9
12th	25.00	Green	BJ-P	4wht	OR-white	R-1	*	25	30

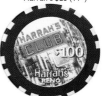

Harrah's $100 (11th)

(Picture building.)

Issue	Den.	Color	Mold	Inserts	Inlay	Rarity	GD30	VF65	CS95
	100.00	Black	BJ-P	16gry	OR-wht/gry	R-8	100	200	300

(Sheik on flying carpet.)

Issue	Den.	Color	Mold	Inserts	Inlay	Rarity	GD30	VF65	CS95
	NCV 1	Blue	BJ	None	HS	R-7	5	10	15
13th	100.00	Black	BJ-2	4gry4red	R-white	R-1	*	100	110

(This chip has a red hologram center. Harrah's changed their $100 chips frequently due to problems with counterfeiters.)

Issue	Den.	Color	Mold	Inserts	Inlay	Rarity	GD30	VF65	CS95
14th	2.50	Lavender	BJ	8trq	R-blue	R-1	*	3	5

Harrah's $100 (12th)

(Note: Chips marked "Reno and Lake Tahoe" are listed only in the Lake Tahoe section.)

HENRY'S			**RENO**			**1940-45**			
1st	.25	Blue	Lcrown	None	HS	R-8	175	350	525
	1.00	Beige	Lcrown	None	HS	R-9	200	400	600

(Henry Garrett informs us that the population of these chips are 9 (25cent) and 6 ($1.)

Henry's $1 (1st)

HILTON			**RENO**			**1981-89**			
HILTON RESORT			**RENO**			**1992-**			
1st	.25	Brown	H&C	None	HS	R-5	4	8	12
	1.00	Blue	House	None	R-white	R-3	6	12	18
	5.00	Red	House	3gry3pnk	HUB-white	R-5	20	40	60
	25.00	Green	House	4yel4ltgrn	SCA-white	R-9	200	400	600
	100.00	Black	House	3ltblu3brn3pnk	COG-white	R-10	300	600	900
	NCV 5	Orange	House	4mst	HS	R-6	10	20	30
	NCV 25	Green	House	4grn	HS	R-8	20	40	60
2nd	5.00	Red	House	3yel3nvy	HUB-white	R-5	20	40	60
	25.00	Lt Green	House	4org4lav	SCA-white	R-8	150	300	450
	100.00	Black	House	3pnk3wht3org	COG-white	R-10	300	600	900
3rd	1.00	Blue	House	None	R-white	R-1	*	1	3
	5.00	Red	House	2pnk2lav	HUB-white	R-1	*	5	8
	25.00	Green	House	4pch4pnk	SCA-white	R-1	*	25	30

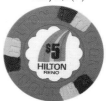

Hilton $5 (2nd)

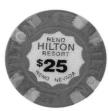

Hilton Resort $25 (3rd)

Holiday $100 (1st)

Holiday $5 (3rd)

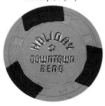

Holiday $100 (4th)

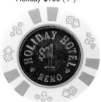

Holiday $1 (6th)

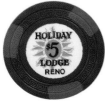

Holiday Lodge $5 (1st)

Issue	Den.	Color	Mold	Inserts	Inlay	Rarity	GD30	VF65	CS95
	RLT A	6 diff.	H&C	None	OR-white	R-3	3	6	9
(Colors: Dk Brown, Lime, Lt Orange, Orange, Pink, and Purple.)									
	RLT B	6 diff.	H&C	None	OR-white	R-3	3	6	9
(Colors: Dk Brown, Lime, Lt Orange, Orange, Pink, and Purple.)									
	RLT D	6 diff.	H&C	None	OR-white	R-3	3	6	9
(Colors: Dk Brown, Lime, Lt Orange, Orange, Pink, and Purple.)									
	RLT E	6 diff.	H&C	None	OR-white	R-3	3	6	9
(Colors: Dk Brown, Lime, Lt Orange, Orange, Pink, and Purple.)									
	RLT F	6 diff.	H&C	None	OR-white	R-3	3	6	9
(Colors: Dk Brown, Lime, Lt Orange, Orange, Pink, and Purple.)									
(Third issue is "Reno Hilton Resort." Roulettes are marked "Reno Hilton.")									

HOLIDAY — **RENO** — **1956-98**

Issue	Den.	Color	Mold	Inserts	Inlay	Rarity	GD30	VF65	CS95
1st	5.00	Rust	Sm-key	4brn	R-yellow	R-8	200	400	600
	25.00	Mustard	Sm-key	4org	R-orange	R-10	500	1000	1500
	100.00	Brown	Sm-key	4mst	R-brown	R-10	500	1000	1500
	100.00	Salmon	Sm-key	None	HS-white	R-4	35	70	105
	RLT	6 diff.	Sm-key	None	HS	R-5	10	20	30
(Colors: Blue, Brown, Green, Lavender, Red, and White.)									
2nd	1.00	Tan	Scrown	4red	OR-white	R-6	30	60	90
	100.00	Pink	Scrown	3blu-grn	WHL-white	R-7	100	200	300
	RLT	2 diff.	C&S	None	R-white	R-5	7	14	21
(Colors: Cream and Navy.)									
3rd	5.00	Grey	HCE	3nvy	R-white	R-9	200	400	600
	5.00	Dk Red	HCE	3yel	R-white	R-4	15	30	45
	25.00	Olive	HCE	3red	R-white	R-5	35	70	105
4th	100.00	Mustard	C&J	3nvy	HS	R-8	100	200	300
	RLT	6 diff.	C&J	None	HS	R-6	10	20	30
(Colors: Beige, Fuchsia, Green, Orange, Purple, and Yellow.)									
5th	.50	Purple	Lg-key	None	HS	R-5	10	20	30
	.60	Pink	Lg-key	None	HS	R-6	25	50	75
("Good For One Keno Ticket.")									
	100.00	Black	Lg-key	6bei3org	R-white	R-9*	300	600	900
("Tom Moore's Holiday.")									
	NN .50	Maroon	Lg-key	None	HS	R-6	15	30	45
	NN 1.00	Gry-Grn	Lg-key	None	HS	R-5	8	16	24
	NN 1.00	Green	Lg-key	None	HS	R-5	8	16	24
	NN 1.00	White	Lg-key	None	HS	R-6	10	20	30
6th	.25	Grey	BJ	None	HS	R-4	2	4	6
	1.00	White	BJ-2	6blu	COIN	R-3	2	3	5
	RLT	6 diff.	BJ	None	HS	R-6	4	8	12

(Picture of clover design. Colors: Black, Blue, Green, Red, White, and Yellow.)
(Until closing in November, 1998; the Holiday was still using the third issue $5 & $25 HCE mold chips from approximately the mid 1960's! The fourth issue $100 was technically current at the closing, but was rarely used and hard to obtain.)

HOLIDAY LODGE — **RENO** — **1963-68**

Issue	Den.	Color	Mold	Inserts	Inlay	Rarity	GD30	VF65	CS95
1st	5.00	Navy	Sm-key	3org	R-white	R-9	300	600	900
	20.00	Maroon	Sm-key	3mst	R-white	R-5	75	150	225
	n/d	Green	Sm-key	None	HS	R-5	15	30	45
	NN 1.00	Brown	Sm-key	None	HS	R-8	35	70	105
2nd	1.00	Grey	Scrown	None	HS	R-10	100	200	300
	25.00	Orange	Scrown	3mst	LSCA-white	R-10	300	600	900

Issue	Den.	Color	Mold	Inserts	Inlay	Rarity	GD30	VF65	CS95
HOLIDAY SPA CASINO			**RENO**		**1971-78**				
1st	.50	Black	Lg-key	None	HS	R-6	10	20	30
	1.00	Grey	Lg-key	None	HS	R-4	5	10	15
	5.00	Maroon	Lg-key	3grn	HS	R-4	10	20	30
	25.00	Green	Lg-key	3pnk	HS	R-4	15	30	45
HORSESHOE CLUB			**RENO**		**1956-95**				
1st	2.50	Red	Sm-key	3yel	R-white	R-7	125	250	375
	NN 1.00	Grey	Sm-key	None	HS	R-8	30	60	90
	NN 1.00	Red	Sm-key	None	HS-black	R-5	12	24	36
	RLT	4 diff.	Sm-key	None	HS	R-7	15	30	45
(Colors: Maroon, Mustard, Navy, and Pink.)									
2nd	5.00	Salmon	Hub	3blk	R-white	R-6	35	70	105
	25.00	Green	Hub	3blk	R-white	R-4	10	20	30
	100.00	Beige	Hub	3red	R-white	R-7	60	120	180
	500.00	Red	Hub	3yel	R-white	R-5	50	100	150
3rd	.10	Grey	Scrown	None	HS	R-8	75	150	300
	.50	Orange	Scrown	None	HS	R-6	15	30	45
	1.00	Green	Scrown	None	HS	R-8	25	50	75
("Non Redeemable, Must Be Played"..)									
	5.00	Red	Scrown	3nvy	LSCA-white	R-4	8	16	24
	pan n/d	3 diff.	Scrown	None	HS	R-5	15	30	45
(Colors: Blue, Brown, and White.)									
4th	.10	Yellow	Lg-key	None	HS-black	R-9	125	250	375
	.50	Yellow	Lg-key	None	HS	R-6	12	24	36
	1.00	Orange	Lg-key	None	HS	R-4	5	10	15
	RLT	2 diff.	Lg-key	None	HS	R-7	12	24	36
("Horseshoe club Roulette, Reno." Colors: Pink and Maroon.)									
	RLT	10 diff.	Lg-key	None	HS	R-4	6	12	18
("Reno Horseshoe" inside Horseshoe. Colors: Brown, Dark Maroon, Grey-Blue, Lt Maroon, Mustard, Orange, Pink, Purple, Rose, and Yellow.)									
5th	.25	Purple	Lg-key	None	HS-black	R-7	25	50	75
	.50	Navy	Lg-key	3org	R-white	R-8	75	150	225
	1.00	Purple	Lg-key	3yel	R-white	R-7	75	150	225
	1.00	Black	Lg-key	3ltyel	R-white	R-5	10	20	30
6th	.50	Yellow	Diecar	None	HS	R-5	10	20	30
	.50	Yellow	Nevada	None	HS	R-6	12	24	36
	1.00	Orange	Diecar	None	HS	R-6	8	16	24
	1.00	Orange	Nevada	None	HS	R-6	8	16	24
7th	1.00	Yellow	BJ-1	3brn	COIN	R-2	3	6	9
	1.00	Black	BJ-1	3wht	COIN	R-5	10	20	30
	5.00	Red	BJ-1	3blu	COIN	R-2	4	8	12
	5.00	Red/Blu	BJ-1	3wht	COIN	R-1	5	10	15
(One of the Bi-Centennials issued in 1976. Red on one side - blue on the other.)									
8th	.25	Grey	H&C	None	HS	R-6	10	20	30
	.50	Yellow	H&C	None	HS	R-6	10	20	30
("Reno's New; Reno, NV.")									
9th	.10	Peach	H&C	None	HS	R-4	5	10	15
	.50	Orange	H&C	None	HS	R-5	5	10	15
	1.00	Blue	H&C	None	HS	R-3	2	4	6
	5.00	Red	H&C	4nvy4pnk	HUB-white	R-2	5	10	15
	25.00	Green	H&C	3pnk3red	SCA-white	R-2	7	14	21

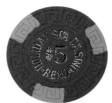

Holiday Spa Casino $5 (1st)

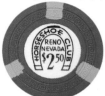

Horseshoe Club $2.50 (1st)

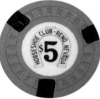

Horseshoe Club $5 (2nd)

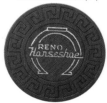

Horseshoe Club RLT (4th)

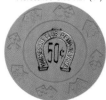

Horseshoe Club 50c (6th)

Horseshoe Club $5 (9th)

Horseshoe Club $100 (9th)

Jimmie's Casino Club n/d (1st)

Kings Inn $5 (1st)

Lawton Springs $5 (1st)

Mac's Club $5 (1st)

Mac's $5 (3rd)

Issue	Den.	Color	Mold	Inserts	Inlay	Rarity	GD30	VF65	CS95
	100.00	Black	H&C	3gry3red3org	COG-white	R-4	10	20	30
10th	.25	Lt Brown	BJ	None	HS	R-4	2	4	6
	1.00	Navy	H&C	None	HS	R-4	2	4	6
	5.00	Red	H&C	2blu2org	HUB-white	R-5	8	16	24
	25.00	Green	H&C	4ltgry4ltgrn	SCA-white	R-7	25	50	75

(Above three are "Bob Cashell's" from his 1989-95 ownership.)

	RLT A	3 diff.	H&C	None	HS	R-7	6	12	18

(Colors: Brown, Grey, and Green.)

JIMMIE'S CASINO CLUB RENO 1931

1st	n/d	2 diff.	C&S	None	R-white	R-9	250	500	750

(Colors: Navy and Yellow.)

	n/d	4 diff.	C&S	None	R-white	R-10	300	600	900

(Colors: Black, Green, Red, and White.)
(Licensed for one 21 table in 1931. The bar closed in 1933.)

KINGS INN RENO 1975-82

1st	.25	Black	Lg-key	None	HS	R-5	10	20	30
	5.00	Yellow	Diasqr	3blu	R-white	R-1	10	20	50
	25.00	Dk Red	Diasqr	3wht	R-white	R-5	40	80	120
	100.00	Purple	Diasqr	3blk	R-white	R-5	50	100	150
	NN 1.00	Purple	H&C	None	HS	R-6	12	24	36
	NN 2.00	Orange	H&C	None	HS	R-6	15	30	45

(NN chips marked "Al Bergendahl's Kings Inn.".)
(The word on the street is that one of the owners married a religious fanatic opposed to gambling. Her nagging caused him to sell out. The casino announced a redemption and gamblers turned in their chips. At the same time, a relative took these chips around town and redeemed them in other casino cages that hadn't got the word yet! Of course, the Gaming Commission found out and went ballistic. They searched the entire property and confiscated every chip they could get their hands on. These chips were then buried on Center St. in the bridge across the Truckee River! Our source swears that this is fact, and if so, this would put the rumors of a waiting hoard to rest.)
(Press Time Flash! The long rumored hoard has just surfaced. Possibly many chips were buried, but now sets are available of this very nice chip. Estimates of rarities have changed, new pricing should be the standard.)

LAWTON SPRINGS RENO 1931-61

1st	1.00	Red	Sm-key	None	HS	R-5	30	60	125
	5.00	Black	Sm-key	None	HS-white	R-8	100	200	300
	25.00	Green	Sm-key	None	HS	R-9	125	250	375

(Became Holiday Lodge, located outside of Reno on 4th street.)

MAC'S RENO 1950-63

1st	5.00	Lavender	Arodie	None	HS	Unique	500	1000	1500

("Mac's Club".)

2nd	.10	Green	Sm-key	None	HS	R-9	150	300	450
	.25	Green	Sm-key	None	HS	R-10	200	400	600
3rd	5.00	Red	Arodie	3wht	HS	R-10	450	900	1350
4th	.50	Blue	C&J	None	HS	R-9	100	200	300

(Second through Fourth issues are marked "Mac's.")

Issue	Den.	Color	Mold	Inserts	Inlay	Rarity	GD30	VF65	CS95

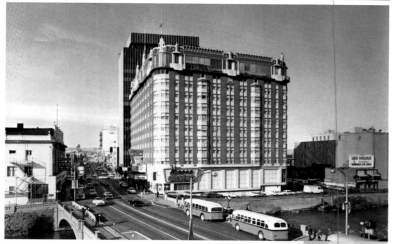

Postcard of the Mapes Hotel. Finally completed in 1947, it was the last major building completed in the art deco style. ©Mike Roberts, Berkeley, CA.

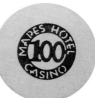

Mapes $100 (1st)

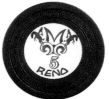

Mapes $5 obv (2nd)

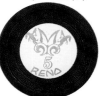

Mapes $5 rev (2nd)

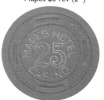

Mapes $25 (4th)

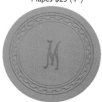

Mapes n/d (5th)

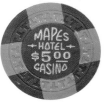

Mapes $5 (6th)

MAPES — RENO — 1947-82

Issue	Den.	Color	Mold	Inserts	Inlay	Rarity	GD30	VF65	CS95
1st	5.00	Brown	Plain	None	Diecut-metal	R-1	10	20	30
	error 5.00	Brown	Plain	None	Diecut-metal	Unique	250	500	750

(No metal diecut was stamped into one side.)

	25.00	Aqua	Plain	None	Diecut-metal	R-3	20	40	60
	100.00	White	Plain	None	Diecut-metal	R-3	35	70	105

(This 1st issue is the same style as the Flamingo "Bugsy" chips. However, these chips are very common because a huge inventory of Mapes Chips (all issues) was auctioned off years ago. This explains why this series, though old and historical, has few rarities.)

2nd	.10	Purple	Sm-key	None	HS	R-3	10	20	30
	5.00	Black	Sm-key	None	R-white	R-10	150	300	450

(Above chip has no name or location - just the Mapes picture logo. One side has black printing; the other side has red printing.)

3rd	5.00	Brown	Sm-key	3org	SS-orange	R-3	15	30	45
	5.00	Purple	Sm-key	3red	SS-gold	R-3	12	24	36
4th	5.00	Purple	Lcrown	None	HS	R-3	10	20	30
	25.00	Red	Lcrown	None	HS	R-3	12	24	36
5th	n/d	Orange	Zigzag	None	HS	R-8	25	50	75

(Initialed "M" and used in the high roller room - according to noted Nevada historian Fred Holabird.)

	n/d	Mustard	Zigzag	None	HS	R-6	10	20	30
	n/d	Purple	Zigzag	None	HS	R-5	5	10	15

(A bigger, wider Initialed "M.")

6th	5.00	Brown	T's	None	HS	R-3	10	20	30
	5.00	Purple	T's	None	HS	R-3	10	20	30
	5.00	Purple	T's	4red	HS	R-3	10	20	30
	5.00	Brick	T's	4grn	HS	R-4	12	24	36
	5.00	Brick	T's	4org	HS	R-4	12	24	36
	25.00	Maroon	T's	4gry	HS	R-4	15	30	45
	25.00	Green	T's	4wht	HS	R-2	8	16	24
	100.00	Tan	T's	4org	HS	R-4	20	40	60

Issue	Den.	Color	Mold	Inserts	Inlay	Rarity	GD30	VF65	CS95
7th	5.00	Brown	Hrglas	1yel1grn1blk	R-black	R-3	10	20	30
	5.00	Blue	Hrglas	1red1yel1wht	R-black	R-3	10	20	30
	25.00	Red	Hrglas	1blu1yel1gry	R-black	R-3	12	24	36
	25.00	Green	Hrglas	1red1yel1gry	R-black	R-3	12	24	36
8th	n/d	Beige	Lg-key	None	HS	R-9	35	70	105

Mapes $5 (7th)

(One side says "No Cash Value," the other says "Non-Negotiable.")

9th	1.00	Yellow	Scrown	1red1blk1blu1grn	R-black	R-2	4	8	12

(There are three variations of opposite inserts: Red-Black, Red-Blue, and Red-Green.)
(Another variant has one green, one red & two blue inserts.)

	5.00	Orange	Scrown	1grn1yel1blk	R-black	R-2	6	12	18
	25.00	Green	Scrown	1red1yel1gry	R-black	R-2	6	12	18
10th	5.00	Red-Brn	Scrown	1grn1yel1blk	R-black	R-3	7	14	21
	25.00	Turq.	Scrown	1wht1red1brn	R-black	R-2	10	20	30
	100.00	Black	Scrown	1brn1grn1blu	R-black	R-3	20	40	60
	RLT	10 diff.	Scrown	None	HS	R-2	3	6	9

Mapes NCV (8th)

(Colors: Brown, Grey, Green, Navy, Orange, Peach, Pink, Red, White, and Yellow.)

MAPES-MONEY TREE — RENO — 1969-82
MONEY TREE — RENO

Issue	Den.	Color	Mold	Inserts	Inlay	Rarity	GD30	VF65	CS95
1st	.25	Grey	Scrown	None	HS	R-4	3	6	9
	.50	Pink	Scrown	None	HS	R-3	3	6	9
	5.00	Brown	Scrown	1grn1blk1yel	R-gold	R-2	5	10	15
	5.00	Orange	Scrown	1blk1grn1yel	R-gold	R-2	5	10	15
	25.00	Green	Scrown	1red1yel1wht	R-gold	R-2	7	14	21
	25.00	Turq.	Scrown	1wht1tan1red	R-gold	R-3	7	14	21
	100.00	Tan	Scrown	4org	R-gold	R-4	15	30	45
	100.00	Black	Scrown	1blu1org1yel	R-gold	Unique	150	300	450

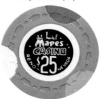

Mapes $25 (10th)

(Discovered late in 1999, this chip shows very slight use. It may have been a back-up chip that was used for only a short time.)

2nd	5.00	Red	Scrown	1gry1org1fch	WHL-gold	R-3	5	10	15
	25.00	Green	Scrown	1dkbrn1org1red	WHL-gold	R-2	6	12	18
	100.00	Black	Scrown	1blu1wht1pnk	WHL-gold	R-4	10	20	30
3rd	pok 1.00	Orange	H&C	None	HS	R-3	3	6	9

(First three issues are marked "Money Tree.")

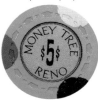

Mapes Money Tree $5 (1st)

4th	NN 1.00	Yellow	H&C	None	HS	R-2	3	6	9

("Cocktail.")

	NN 1.00	Grey	H&C	None	HS	R-2	3	6	9

("Pit, 3 for 2.")

	NN 1.00	Pink	H&C	None	HS	R-3	3	6	9

("Restaurant.")

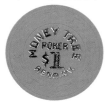

Mapes Money Tree $1 (3rd)

	NN 1.00	Ochre	H&C	None	HS	R-3	3	6	9

("Slots.")

	NN 5.00	Orange	H&C	None	HS	R-2	3	6	9
	NN 25.00	Green	H&C	None	HS	R-2	4	8	12
	NN 100.00	White	H&C	None	HS	R-2	5	10	15

(Above three are marked "Pit." This fourth issue is marked "Mapes-Money Tree.")

MGM GRAND — RENO — 1978-86

Issue	Den.	Color	Mold	Inserts	Inlay	Rarity	GD30	VF65	CS95
1st	.50	Peach	House	None	HS	R-8	50	100	150
	1.00	Blue	House	None	HS	R-4	10	20	30
	5.00	Dk Red	House	3mst3grn	R-white	R-4	15	30	45
	25.00	Dk Green	House	3yel3pnk	R-white	R-8	150	300	450
	100.00	Black	House	3pnk3grn3wht	HUB-white	R-8	200	400	600
2nd	1.00	Blue	House	None	R-wht/blu	R-6	35	70	105

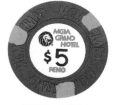

MGM Grand $5 (1st)

Issue	Den.	Color	Mold	Inserts	Inlay	Rarity	GD30	VF65	CS95
	5.00	Red	House	3pnk3org	R-wht/red	R-4	15	30	45
	25.00	Green	House	3grn3yel	SCA-wht/grn	R-8	100	200	300
	100.00	Black	House	3grn3mst	R-white	R-8	200	400	600
	500.00	Purple	House	3org3wht3pnk	COG-pur/wht	R-9	200	400	600

MINT CLUB RENO 1958-60

Issue	Den.	Color	Mold	Inserts	Inlay	Rarity	GD30	VF65	CS95
1st	.10	Red	C&J	None	HS	R-9	75	150	300
	.50	Brown	C&J	None	HS	R-7	25	50	75
	1.00	Beige	C&J	None	HS	R-4	8	16	24

(Reverse of above two chips is marked "For Trade Only.")

Issue	Den.	Color	Mold	Inserts	Inlay	Rarity	GD30	VF65	CS95
	5.00	Lt Green	C&J	None	HS	R-4	8	16	24
	20.00	Navy	C&J	None	HS	R-4	10	20	30
	100.00	Black	C&J	None	HS	R-5	25	50	75
2nd	5.00	Mustard	C&J	3red	R-white	R-3	5	10	15
	25.00	Purple	C&J	3ltgry	R-white	R-3	7	14	21

MONTE CARLO RENO 1974-95

Issue	Den.	Color	Mold	Inserts	Inlay	Rarity	GD30	VF65	CS95
1st	1.00	Mustard	Lg-key	None	R-white	R-2	4	8	12
	2.50	Red	Lg-key	None	R-white	R-9	125	250	375
	5.00	Dk Orange	Lg-key	None	R-white	R-3	7	14	21
	20.00	Navy	Lg-key	None	R-white	R-5	25	50	75
	25.00	Green	Lg-key	None	R-white	R-5	15	30	45
	RLT	Grey	Plain	None	R-white	R-8	20	40	60
2nd	1.00	Mustard	Lg-key	3pur	R-white	R-4	5	10	15
	2.50	Red	Lg-key	3bei	R-white	R-5	20	40	60
	5.00	Dk Orange	Lg-key	3grn	R-white	R-4	10	20	30
	25.00	Brown	Lg-key	3grn	R-white	R-5	20	40	60
	25.00	Green	Lg-key	3blk	R-white	R-3	15	30	45
	100.00	Beige	Lg-key	3red	R-white	R-5	35	70	105
3rd	NN 1.00	Purple	Lg-key	None	HS	R-6	10	20	30
4th	NN 1.00	Red	Diecar	None	HS	R-6	7	14	21
5th	NCV 1	Fuchsia	H&C	None	HS	R-4	3	6	9
	NN 1.00	Fuchsia	H&C	None	HS	R-5	5	10	15
	NN 1.00	Red	H&C	None	HS	R-5	5	10	15

(Most chips were overstamped in small letters "No Cash Value." Beware.)

MR. C's RENO 1981-90

Issue	Den.	Color	Mold	Inserts	Inlay	Rarity	GD30	VF65	CS95
1st	5.00	Red	H&C	4brn4pnk	SCA-white	R-5	30	60	90
	25.00	Green	H&C	4yel4blu	HUB-white	R-6	50	100	150

(Next door to and owned by Sands owner Mr. Peter Cladianos, Sr. Rumors persist of a quantity ready to come out of both denominations.)

MGM Grand $25 (2nd)

Mint Club $5 (3rd)

Monte Carlo $2.50 (1st)

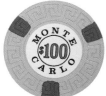

Monte Carlo $100 (2nd)

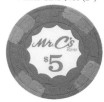

Mr. C's $5 (1st)

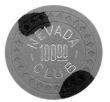

Nevada Club $100 (2nd)

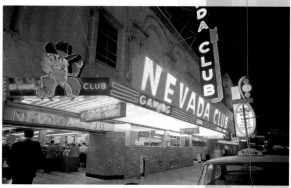

Postcard of the Nevada Club. This small casino lasted over 50 years. Upstairs, one could play antique slot machines that were probably as old as the club itself! ©Mike Roberts, Berkeley, CA.

Issue	Den.	Color	Mold	Inserts	Inlay	Rarity	GD30	VF65	CS95

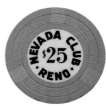

Nevada Club $25 (3rd)

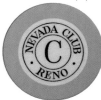

Nevada Club RLT C (3rd)

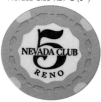

Nevada Club $5 (4th)

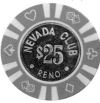

Nevada Club $25 (5th)

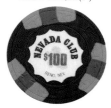

Nevada Club $100 (6th)

New China Club 50c (1st)

NEVADA CLUB — **RENO** — **1946-98**

Issue	Den.	Color	Mold	Inserts	Inlay	Rarity	GD30	VF65	CS95
1st	5.00	Black	Dots	None	HS	R-5	15	30	45
	RLT	7 diff.	Dots	None	HS	R-5	10	20	30

(First issue marked simply "NC." Colors: Brown, Green, Navy, Dk Red, Red, White, and Yellow.)

2nd	5.00	Grey	Diamnd	2bei	HS	R-4	15	30	45
	5.00	Brown	Diamnd	2yel	HS	R-4	15	30	45
	100.00	Orange	Diamnd	2blk	HS	R-5	30	60	90
3rd	25.00	Green	Sm-key	3gry	R-white	R-4	12	24	36
	RLT A	7 diff.	C&S	None	OR-white	R-4	8	16	24

(Colors: Blue, Cream, Grey, Green, Pink, Red, and Yellow.)

	RLT B	7 diff.	C&S	None	OR-white	R-4	8	16	24

(Colors: Blue, Cream, Grey, Green, Pink, Red, and Yellow.)

	RLT C	7 diff.	C&S	None	OR-white	R-4	8	16	24

(Colors: Blue, Cream, Grey, Green, Pink, Red, and Yellow.)

	RLT D	7 diff.	C&S	None	OR-white	R-4	8	16	24

(Colors: Blue, Cream, Grey, Green, Pink, Red, and Yellow.)

4th	.25	Pink	Scrown	None	HS	R-3	5	10	15
	5.00	Pink	Scrown	4yel	LSCA-white	R-4	6	12	18
	5.00	Red	Scrown	4blu4blk	LSCA-white	R-3	5	10	15
	100.00	Brown	Scrown	4grn	OR-white	R-4	15	30	45
	500.00	Red/Pur	Scrown	1/2pie	SAW-white	R-4	25	50	75
	RLT E	6 diff.	Scrown	None	OR-white	R-4	5	10	15

(Colors: Black, Blue, Grey, Green, Pink, and Yellow.)

	RLT F	6 diff.	Scrown	None	OR-white	R-4	5	10	15

(Colors: Black, Blue, Grey, Green, Pink, and Yellow.)

	RLT G	6 diff.	Scrown	None	OR-white	R-4	5	10	15

(Colors: Black, Blue, Grey, Green, Pink, and Yellow.)

	RLT H	6 diff.	Scrown	None	OR-white	R-4	5	10	15

(Colors: Black, Blue, Grey, Green, Pink, and Yellow.)

	RLT I	6 diff.	Scrown	None	OR-white	R-4	5	10	15

(Colors: Black, Blue, Grey, Green, Pink, and Yellow.)

	RLT J	6 diff.	Scrown	None	OR-white	R-4	5	10	15

(Colors: Black, Blue, Grey, Green, Pink, and Yellow.)

5th	25.00	Green	BJ-2	12pnk	COIN	R-3	8	16	24
6th	.25	Pink	H&C	None	HS	R-3	2	4	6
	1.00	Blue	H&C	2grn	R-white	R-2	2	4	6

(There is a variant with "Nevada Club" in larger writing.)

	5.00	Red	H&C	2pch2brn	R-white	R-3	5	10	15
	25.00	Green	H&C	4tan4org	HUB-white	R-6	25	50	75
	100.00	Black	H&C	6org3blu	SCA-white	R-10	150	300	450
	500.00	White	H&C	3nvy3yel3grn	COG-white	R-10	300	600	900
	RLT A	8 diff.	H&C	None	HS	R-6	6	12	18

(Colors: Brown, Lt Brown, Green, Navy, Orange, Pink, Purple, and Yellow.)
(This casino closed quickly in Jan. 1998, but quantities of the last issue have not appeared.)
(NOTE: Chips marked "Reno and Crystal Bay" are listed in the Lake Tahoe section.)

NEW CHINA CLUB — **RENO** — **1952-71**

Issue	Den.	Color	Mold	Inserts	Inlay	Rarity	GD30	VF65	CS95
1st	.10	Red	Scrown	None	HS-silver	R-9	125	250	375

(Denomination written on back.)

	.50	Blk/Blu	Scrown	1/2pie	HS-silver	R-4	5	10	15
	1.00	Green	Scrown	3red	HS-silver	R-3	5	10	15
	5.00	Yellow	Scrown	3red	HS-silver	R-6	20	40	60
2nd	1.00	Tan	Scrown	4red	HS-silver	R-4	4	8	12
	1.00	Tan	Scrown	4red	HS-gold	R-4	4	8	12

(Both chips say "Non Redeemable" on reverse.)

Issue	Den.	Color	Mold	Inserts	Inlay	Rarity	GD30	VF65	CS95
3rd	.10	Salmon	Scrown	None	HS-silver	R-4	20	40	60
	.50	Purple	Scrown	4wht	HS-silver	R-5	20	40	60
	1.00	Dk Green	Scrown	3red	HS-silver	R-3	5	10	15
	5.00	Yel/Gry	Scrown	1/2pie	LSCA-white	R-5	15	30	45
4th	5.00	Yel/Gry	Scrown	1/2pie	LSCA-white	R-5	25	50	75

(Fourth issue has picture of dancing lady; third issue has Chinese writing.)

New China Club $5 (4th)

NUGGET, THE			**RENO**			**1953-53/1990-97**			
NUGGET, JIM KELLEY' S						**1954-90**			
1st	5.00	Navy	Sm-key	3pur	R-lt blue	R-10	700	1400	2100
	25.00	Black	Sm-key	3gry	R-lt blue	R-5	200	400	600

(The previous owner has some $25's but none have been offered in years. It is believed an original box exists. So far only about a dozen are out in collections.)

The Nugget $25 (1st)

2nd	1.00	Green	C&J	3red	HS	R-5	30	60	90

(The 1st and 2nd issues are marked "The Nugget".)

3rd	1.00	Tan	C&J	3brn	SCA-white	R-5	25	50	75
	5.00	Grn/Org	C&J	1/2pie	SCA-white	R-7*	150	300	450
	5.00	Red/Mst	C&J	1/2pie	SCA-white	R-8	200	400	600
4th	1.00	Brown	Lg-key	3tan	R-white	R-5	20	40	60
	5.00	Pink	Lg-key	4ltgrn4grn	R-white	R-5	30	60	90
5th	1.00	Grey	Lg-key	3red3nvy	R-white	R-4	10	20	30

(There is a variant with slightly darker printing - same rarity and price. The 4th and 5th issues were also used in Lake Tahoe.)

The Nugget $5 (5th)

6th	5.00	Red	H&C	2yel2blk	R-white	R-5	10	20	30
	25.00	Green	H&C	4wht4gry	R-white	R-5	25	50	75

(This 6th issue, 1992-97, is marked "Nugget Casino".)

(Originally, the Nugget was owned by Jim Kelley and Dick Graves from 1953 to 1955. Graves left in 1955 and went on to open the Nugget in Sparks and in Carson City. Jim Kelley held ownership and expanded into Lake Tahoe.)

OAK ROOM CASINO			**RENO**			**1953-73**			
1st	5.00	Blue	Sm-key	3sam	R-white	R-2	10	20	30
2nd	1.00	Mustard	C&J	3grn	R-white	R-2	6	12	18

(From 1971 to 1973 this was a slot only casino run by IGT founder Si Redd.)

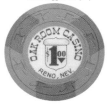

Oak Room casino $1 (2nd)

OLD RENO CASINO			**RENO**			**1973-**			
1st	2.50	Yellow	Lg-key	4pur	R-white	R-5	20	40	60
	5.00	Brown	Lg-key	4org	R-white	R-3	30	60	90
	25.00	Green	Lg-key	4blu-gry	R-white	R-3*	100	200	300

(Most of the $2.50 and $5 chips are notched. Unnotched rarity is approximately R-6. All of the $25 chips known are notched. Notched chips are worth about 15% of the listed values. This casino has been slots only since about 1988.)

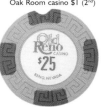

Old Reno $25 (1st)

ONSLOW			**RENO**			**1977-89**			
1st	1.00	Orange	Lg-key	None	HS-blue	R-5	12	24	36
	5.00	Brown	Lg-key	3yel	R-white	R-7	40	80	120
	25.00	Cream	Lg-key	3dkgrn	R-white	R-10	150	300	450
	NCV 5	Purple	Lg-key	None	HS	R-5	10	20	30
	NCV 25	Green	Lg-key	None	HS	R-5	10	20	30
	RLT	5 diff.	Lg-key	None	R-white	R-5	6	12	18

(Colors: Green, Navy, Orange, Purple, and Yellow.)

2nd	.25	Pink	H&C	None	HS	R-5	7	14	21
	1.00	Lt Blue	H&C	3org	HS	R-4	5	10	15
	NCV 5	Dk Blue	H&C	None	HS	R-5	5	10	15
	NN 1	Lt Blue	Plain	None	HS	R-4	5	10	15
	NN 5	Pink	Plain	None	HS	R-4	10	20	30
	NN 25	Green	Plain	None	HS	R-4	10	20	30

(Many of the above issues are generally drilled and finding nice examples is the challenge.)

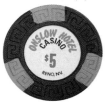

Onslow $5 (1st)

217

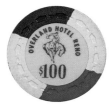

Overland Hotel $100 (2nd)

Overland Hotel $5 (3rd)

Overland Hotel 10c (4th)

Pacos $5 (1st)

Palace Club RLT 1 (1st)

Palace Club RLT 3 (1st)

Issue	Den.	Color	Mold	Inserts	Inlay	Rarity	GD30	VF65	CS95
OVERLAND HOTEL			**RENO**		**1931-31/1960-77**				
1st	.10	Fuchsia	Scrown	None	HS	R-3	7	14	21
2nd	.10	Purple	Scrown	None	HS	R-3	7	14	21
	1.00	Grey	Scrown	4grn	OR-white	R-2	4	8	12
	5.00	Red	Scrown	4blk	LSCA-white	R-2	6	12	18
	20.00	Dk Green	Scrown	3wht	SAW-white	R-3	12	24	36
	25.00	Orange	Scrown	4dkgrn	SAW-white	R-3	12	24	36
	25.00	Green	Scrown	4dkpnk	R-white	R-2	6	12	18
	100.00	White	Scrown	1red1blu	R-white	R-3	10	20	30
	1.00	Blue	Scrown	None	HS	R-4	5	10	15
("Non Redeemable, Good For One Bet, Win 1 only.)									
	RLT	6 diff.	Scrown	None	R-white	R-4	6	12	18
(Colors: Brown, Green, Navy, Red, White, and Yellow.)									
3rd	5.00	Pink	Scrown	4blk4blu	R-white	R-1	5	10	15
	RLT	7 diff.	C&S	None	R-white	R-4	5	10	15
(Colors: Brown, Green, Navy, Pink, Red, White, and Yellow. All these chips say "Overland Gold Club, Topaz Lodge".)									
4th	.10	Purple	Diasqr	None	HS	R-3	8	16	24
	NN 1.00	Blu-Grn	Diasqr	None	HS	R-5	6	12	18
("Non Redeemable, Good For One Bet Only.")									
OWL CLUB			**RENO**		**1931-55**				
1st	n/d	7 diff.	Hub	None	HS	R-7	30	60	90
(Colors: Black, Brown, Green, Purple, Red, White, and Yellow. Only marked "OWL". Some issues could be rarer - these prices represent a reasonable average. This was an early club located on Commercial Row.)									
PACOS			**RENO**		**1989-92**				
1st	.25	Brown	H&C	None	HS	R-7	15	30	45
	1.00	Blue	H&C	None	R-white	R-6	20	40	60
	5.00	Red	H&C	2yel2pur	HUB-white	R-7	50	100	150
	25.00	Green	H&C	4ltgrn4org	SCA-white	Unique	300	600	900
	RLT	7 diff.	Roulet	None	R-white	R-7	10	20	30
(Colors: Lt Blue, Brown, Lime, Orange, Pink, Purple, and Yellow. This club was owned by the Flamingo Hilton and located in back of the main casino.)									

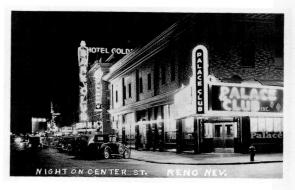

Early postcard of the Palace Club. On May 1, 1936, The Palace became Reno's and probably the world's first legal casino to introduce the game of keno—then called "horse-race keno," as names of horses were called out along with the numbers by a colorful barker.

Issue	Den.	Color	Mold	Inserts	Inlay	Rarity	GD30	VF65	CS95
PALACE CLUB			**RENO**		**1934-79**				
1st	RLT 1	4 diff.	C&S	None	OR-white	R-9	200	400	600
(Colors: Black, Brown, Green, and Pink.)									

Issue	Den.	Color	Mold	Inserts	Inlay	Rarity	GD30	VF65	CS95
RLT 3	4 diff.		C&S	None	OR-white	R-9	250	500	750

(Colors: Black, Blue, Green, and Maroon. Nearly all of these great-looking classic roulettes are drilled and worth 30% of these prices.)

2nd	.10	Red	Rcthrt	None	HS	R-9	150	300	450
	5.00	Black	Rcthrt	3wht	HS	R-6	100	200	400

(These are usually found drilled through the center.)

	RLT	Purple	Diamnd	None	HS	R-5	15	30	45

(No picture.)

3rd	.10	Blue	Hrglas	None	HS	R-10	175	350	525
	.10	Red	Hrglas	None	HS	R-8	100	200	300
	.10	Yellow	Hrglas	None	HS	R-9	150	300	450
4th	.10	Red	C&J	None	HS	R-10	175	350	525

(Issues two through four have great picture of a cowboy hitting a slot machine on reverse.)

5th	25.00	Dk Green	Sm-key	None	HS	R-5	35	70	105
	100.00	Brown	Sm-key	None	HS	R-5	50	100	150
	RLT	Yellow	Sm-key	None	HS	R-5	20	40	60
6th	.10	Yellow	C&J	None	HS	R-9	100	200	300
	1.00	Purple	C&J	3yel	R-white	R-2	5	10	15
	5.00	Red	C&J	3yel	R-white	R-3	10	20	30
	5.00	Orange	C&J	3blk	R-white	R-2	7	14	21
	25.00	Green	C&J	3yel	R-white	R-4	30	60	90
	100.00	Cream	C&J	3blk3dkorg	R-white	R-5	45	90	135

($1 through $100 has two lines through the dollar sign.)

7th	1.00	Purple	C&J	3yel	R-white	R-4	6	12	18
	5.00	Orange	C&J	3blk	R-white	R-4	12	24	36

(Seventh issue has only one line partially through the dollar sign - and a smaller denomination.)

8th	.10	Grey	C&J	3nvy	SCA-white	R-5	25	50	125

(Chip marked "Famous Palace Club.")

9th	20.00	Mustard	Nevada	3grn	R-white	R-4	12	24	36
10th	.10	Black	Scrown	None	HS	R-7	35	70	105
	.10	Yellow	Scrown	None	HS	R-4	10	20	30
	.25	Pink	Scrown	3nvy	OR-white	R-5	10	20	30
	1.00	Purple	Scrown	3yel	OR-white	R-3	5	10	15
	2.50	Brown	Scrown	3yel	OR-white	R-7	30	60	90
	5.00	Orange	Scrown	3blk	OR-white	R-3	7	14	21
	25.00	Green	Scrown	3red	OR-white	R-3	9	18	27
	RLT	6 diff.	Scrown	None	HS	R-4	7	14	21

(Colors: Blue, Brown, Lt Red, Tan, White, and Yellow.)

11th	.25	Grey	H&C	None	HS	R-4	4	8	12

(Marked "Palace Club Card Room.")

	RLT	6 diff.	H&C	None	HS	R-4	6	12	18

(Colors: Blue, Brown, Green, Pink, White, and Yellow.)

(Palace Club actually opened in 1888. They had gaming for many years before the modern era of legalized gaming began in 1931. This club has the record for the most dimes - with nine!)

PAL'S CLUB RENO c.1930's

1st	.05	Cream	C&S	None	R-gry/blk	R-9	225	450	675
	.25	Blue	C&S	None	R-white	R-9	200	400	600
	1.00	Lavender	C&S	None	R-white	Unique	350	700	1050

(Very attractive chips. Reno is just pure speculation as regards the location. Several researchers have tried to positively attribute these chips, but to no avail. We list them because they're great-looking, old classic pieces probably of Nevada origin. A group of two .05's and five .25's were found by an Iowa farmer in 1999 mixed with other chips, many of which were Nevada.)

Palace Club $25 (5th)

Palace Club $5 (6th)

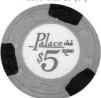

Palace Club $5 (7th)

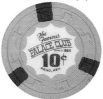

Palace Club 10c (8th)

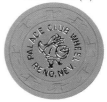

Palace Club RLT (11th)

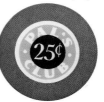

Pal's Club 25c (1st)

219

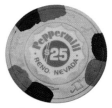

Peppermill $25 (1ˢᵗ)

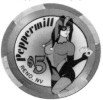

Peppermill $5 (2ⁿᵈ)

Pioneer Inn $5 (2ⁿᵈ)

Pioneer Inn $1 (5ᵗʰ)

Players $100 (1ˢᵗ)

Ponderosa $5 (1ˢᵗ)

Issue	Den.	Color	Mold	Inserts	Inlay	Rarity	GD30	VF65	CS95
PEPPERMILL			**RENO**		**1980-**				
1ˢᵗ	.25	Yellow	H&C	None	HS	R-6	7	14	21
	1.00	Blue	H&C	None	HS	R-3	2	4	6
	5.00	·Red	H&C	3yel3org	HUB-white	R-4	10	20	30
	25.00	Green	H&C	3pur3brn	SCA-white	R-6	35	70	105
	100.00	Black	H&C	3org3brn	COG-white	R-8	100	200	300
	RLT A	Brown	Roulet	None	R-white	R-5	4	8	12
	RLT A	Orange	Roulet	None	R-white	R-5	4	8	12
	RLT D	Brown	Roulet	None	R-white	R-5	4	8	12
2ⁿᵈ	.25	Gold	H&C	None	HS-black	R-4	3	6	9
	1.00	Blue	H&C	None	HS	R-1	*	1	3
(This reordered issue is more of a powder blue color than the first issue.)									
	5.00	Red	H&C	8lim4pnk	FG-multi	R-1	*	5	7
	25.00	Green	H&C	8bei	FG-multi	R-1	*	25	30
	100.00	Black	H&C	6yel3org	FG-multi	R-1	*	100	110
	n/d	Grey	H&C	None	HS	R-5	3	6	9
("Tournament Chip.")									
	NCV 5	Red	Plain	3wht	HS	R-6	4	8	12
	RLT A	Gold	Roulet	None	HS	R-4	3	6	9
PIONEER INN/HOTEL			**RENO**		**1968-**				
1ˢᵗ	5.00	Brown	Lg-key	3org	HS	R-7	40	80	120
2ⁿᵈ	5.00	Brown	Lg-key	3ltbrn	R-white	R-4	20	40	60
	25.00	Yellow	Lg-key	3dkgrn	R-white	R-9	100	200	300
	NN 5.00	Red	H&C	None	HS	R-7	15	30	45
3ʳᵈ	1.00	Brown	H&C	None	HS	R-5	7	14	21
	1.00	Yellow	H&C	None	HS	R-5	7	14	21
(Above two chips say "Good Only At..")									
4ᵗʰ	.25	Orange	H&C	None	HS	R-7	15	30	45
	1.00	Blue	H&C	None	R-white	R-3	2	4	6
	1.00	Pink	H&C	None	HS	R-6	7	14	21
("Keno Only.")									
	5.00	Brown	H&C	3tan	R-white	R-4	10	20	30
	25.00	Green	H&C	6yel6grn	R-white	R-1	*	25	35
	100.00	Black	H&C	3org3blu	SCA-white	R-2	*	100	120
("Downtown Reno.")									
5ᵗʰ	1.00	Blue	H&C	None	OR-multi	R-1	*	1	3
	5.00	Red	H&C	8pur4yel	OR-multi	R-1	*	5	8
(Fourth issue is marked "Pioneer Hotel-Casino." Fifth issue has reverted to "Pioneer Inn." This property actually opened in 1968 with just a hotel. In 1972, slots were added. In 1974, live gaming commenced.)									
PLAYERS HOTEL CASINO			**RENO**		**1980-**				
1ˢᵗ	.25	Purple	H&C	None	HS	R-10	100	200	300
	1.00	Grey	H&C	8yel	R-white	R-7	30	60	90
	5.00	Red	H&C	8wht4blu	SCA-white	R-7	35	70	105
	25.00	Green	H&C	8org4wht	HUB-white	R-8	50	100	150
	100.00	Black	H&C	8wht4yel	COG-white	R-5	25	50	75
(Casino never opened. This location became Eddie's Fabulous Fifties, and eventually - Gamblers. Both have closed. Rumors say that former owners have quantities of these chips.)									
PONDEROSA			**RENO**		**1965-80/1982-90**				
1ˢᵗ	1.00	Navy	Lg-key	3pnk	HS	R-5	15	30	45
	5.00	Maroon	Lg-key	3dkgrn	HS	R-7	50	100	150

Issue	Den.	Color	Mold	Inserts	Inlay	Rarity	GD30	VF65	CS95
	25.00	Green	Lg-key	3mar	HS	R-10	200	400	600
2nd	.50	Red	Horshu	None	HS	R-9	75	150	225
3rd	1.00	Purple	Lg-key	None	HS	R-5	10	20	30
	2.50	Dk Pink	Lg-key	3org	R-white	R-9	150	300	450
	5.00	Green	Lg-key	8red	R-white	R-7	50	100	150
	25.00	Grey	Lg-key	8nvy	R-white	R-6	50	100	150
	RLT	3 diff.	Lg-key	None	HS	R-7	12	24	36

(Colors: Brown, Green, and Mustard.)

4th	5.00	Red	H&C	2blu2blk	R-white	R-4	12	24	36
	25.00	Green	H&C	4trq4lim	HUB-white	R-6	30	60	90

(Opened in 1965 with slots only. Live gaming was added in 1967. Closed in 1980 for two years by the Gaming Commission. In 1988, became the first non-smoking casino.)

Ponderosa $25 (3rd)

POOR PETE'S CASINO — RENO — 1963-64

Issue	Den.	Color	Mold	Inserts	Inlay	Rarity	GD30	VF65	CS95
1st	1.00	Lt Brown	Sm-key	None	HS	R-7	25	50	75
	5.00	Blue	Sm-key	3gry	HS	R-5	15	30	45

Poor Pete's Casino $1 (1st)

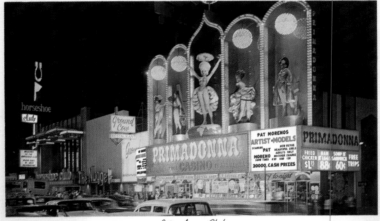

Postcard of the Primadonna Club. These showgirls were installed in 1964. The girl in the middle is 35 feet tall. ©Reno News Agency, Reno.

Primadonna $20 obv (2nd)

Primadonna $20 rev (2nd)

PRIMADONNA — RENO — 1955-78

Issue	Den.	Color	Mold	Inserts	Inlay	Rarity	GD30	VF65	CS95
1st	.10	Dk Blue	Diamnd	3wht	HS	R-9	125	250	375
2nd	20.00	Dk Green	HCE	3blk3wht3red	R-white	R-10*	750	1500	2250
3rd	.10	Dk Red	Scrown	None	HS	R-6	60	120	180
	.10	Purple	Scrown	None	HS	Unique	250	500	750
	.50	Purple	Scrown	None	SCA-white	R-7	90	180	270
	.50	Purple	Scrown	None	SCA-white	Unique	250	500	750

(Rare error with same inlay on both sides.)

	1.00	Red	Scrown	4brn4wht	R-white	R-6	75	150	225
	2.50	Blu/Yel	Scrown	1/2pie	R-white	R-6	75	150	225
	5.00	Tan	Scrown	4pnk	LSCA-white	R-6	75	150	225
	5.00	Mustard	Scrown	3grn3org	LSCA-white	R-9	200	400	600

(On above two chips, the reverse with the lady has a round white inlay.)

	NCV 1.00	Black	Scrown	None	HS	R-5	15	30	45

(Marked "No Value" instead of "No Cash Value".)

Primadonna 50c (3rd)

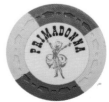

Primadonna $2.50 (3rd)

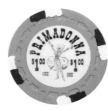

Primadonna $1 (4th)

Primadonna $2.50 (5th)

Primadonna $5 (6th)

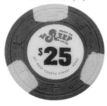

Reef Casino $25 (1st)

Regal Service Stations $1 (1st)

Reno Casino $10 (1st)

Issue	Den.	Color	Mold	Inserts	Inlay	Rarity	GD30	VF65	CS95
RLT A	4 diff.		Scrown	None	HS	R-6	8	16	24
(Colors: Black, Fuchsia, Red, and Yellow.)									
RLT E	4 diff.		Scrown	None	HS	R-6	6	12	18
(Colors: Blue, Brown, Purple, and Yellow.)									
RLT P	6 diff.		Scrown	None	HS	R-6	6	12	18
(Colors: Brown, Navy, Orange, Pink, Purple, and Red.)									
RLT P3	5 diff.		Scrown	None	HS	R-7	10	20	30
(Colors: Blue, Brown, Orange, Purple, and White.)									
RLT P4	4 diff.		Scrown	None	HS	R-7	10	20	30
(Colors: Blue, Orange, Purple, and White.)									
4th	1.00	Pink	Scrown	4brn4wht	R-white	R-7	100	200	300
(Girl with black skirt. Same picture on both sides.)									
	1.00	Pink	Scrown	4brn4wht	R-white	R-8	150	300	450
(Girl with red skirt.)									
	1.00	Pink	Scrown	4brn4wht	R-white	R-9	100	200	300
(Overstamped "One Dollar" on one side only.)									
5th	.25	Pink	H&C	None	HS	R-6	15	30	45
	1.00	Blue	H&C	None	R-white	R-5	25	50	75
	2.50	Purple	H&C	None	R-white	R-9	250	500	750
	5.00	Red	H&C	3pnk3gry	R-white	R-8	150	300	450
(Fifth issue says "Del Webb's Prima Donna." These chips date from 1974.)									
RLT 1	3 diff.		C&S	None	R-white	R-8	25	50	75
(Colors: Beige, Tan, and Yellow.)									
6th	.25	White	H&C	None	HS	R-6	20	40	60
	1.00	Blue	H&C	None	HS	R-6	25	50	75
	5.00	Red	H&C	6blu3pnk	R-white	R-8	200	400	600
(Sixth issue says "Del Webb's Primadonna.")									
RLT 1	Tan		H&C	None	HS	R-6	10	20	30
RLT 2	4 diff.		H&C	None	HS	R-6	10	20	30
(Colors: Beige, Blue, Green, and Lavender.)									
(Prima Donna became the Sahara Reno.)									

REEF CASINO RENO 1974-79

1st	1.00	Blue	H&C	None	HS	R-5	12	24	36
	5.00	Red	H&C	3yel	R-white	R-3	10	20	30
	25.00	Green	H&C	3yel	R-white	R-3	15	30	45

REGAL SERVICE STATIONS RENO 1950's

1st	1.00	Green	Sm-key	None	HS	R-5	7	14	21
	1.00	Purple	Sm-key	None	HS	R-8	15	30	45
	1.00	Blue	Sm-key	None	HS	R-9	18	36	54

(A gas station chain that was around Nevada. These chips were probably promotional in nature as live gaming hasn't been verified.)

RENO CASINO RENO 1944-47

1st	5.00	Blu-Gry	C	None	HS	R-6	125	250	375
	10.00	Black	C	None	HS	R-6	125	250	375

(About 30-35 $5 chips were found along with 40-45 $25 chips. This is a very early mold style first appearing around the turn of the century. Also, the casino might be older than 1944.)

2nd	.05	Brown	Lcrown	None	HS	R-6	60	120	180
	.10	Beige	Lcrown	None	HS	R-6	60	120	180
	.25	Red	Lcrown	None	HS	R-10	125	250	375
	.50	Navy	Lcrown	None	HS	R-9	100	200	300
	1.00	Green	Lcrown	None	HS	R-9	100	200	300
	5.00	Mustard	Lcrown	None	HS	R-6	30	60	90

Issue	Den.	Color	Mold	Inserts	Inlay	Rarity	GD30	VF65	CS95
	20.00	Purple	Lcrown	None	HS	R-6	35	70	105
	100.00	Brown	Lcrown	None	HS	Unknown	150	300	450

(Above are only marked "RC".)

RENO RAMADA RENO 1980-93

Issue	Den.	Color	Mold	Inserts	Inlay	Rarity	GD30	VF65	CS95
1st	.10	Mustard	Horshu	None	HS	R-4	10	20	30
	.25	Brown	Horshu	None	HS	R-6	12	24	36
	.25	Brown	Lg-key	None	HS	R-5	10	20	30
	1.00	Blue	PMSC	6brass	Brass	R-4	10	20	30
	5.00	Red	PMSC	6brass	Brass	R-5	15	30	45
	25.00	Green	PMSC	6brass	Brass	R-5	35	70	105
	100.00	White	PMSC	4brass	Brass	R-5	80	160	240
	NCV 1	Yellow	H&C	None	R-white	R-6	7	14	21

Reno Ramada 10c (1st)

("Win Cards.")

Issue	Den.	Color	Mold	Inserts	Inlay	Rarity	GD30	VF65	CS95
	NCV 5	Pink	H&C	4blk	HS	R-5	6	12	18
	RLT	Lt Brown	Lg-key	None	HS	R-6	10	20	30
	RLT	5 diff.	H&C	None	HS	R-6	8	16	24

(Colors: Dk Blue, Brown, Green, Navy, and White. "Ramada Roulette" around logo.)

| | RLT | 4 diff. | H&C | None | HS | R-6 | 8 | 16 | 24 |

(Colors: Brown, Lime, Orange, and Purple. "Roulette" around "Ramada & logo.")

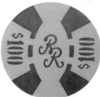

Reno Ramada $100 (1st)

RING SIDE RENO 1965-72

Issue	Den.	Color	Mold	Inserts	Inlay	Rarity	GD30	VF65	CS95
1st	10.00	Red	Sm-key	None	HS	R-10	300	600	900

RIVERBOAT RENO 1988-98

Issue	Den.	Color	Mold	Inserts	Inlay	Rarity	GD30	VF65	CS95
1st	.25	Cream	H&C	None	HS	R-3	1	2	4
	1.00	Blue	H&C	4wht2dkblu	R-white	R-4	4	8	12
	5.00	Red	H&C	6wht	HUB-white	R-3	5	10	15
	25.00	Green	H&C	4wht4org	SCA-white	R-8	35	70	105
	100.00	Black	H&C	3yel3red3org	COG-white	R-9	100	200	300
	NCV 1	Lt Blue	H&C	8wht	HS	R-5	3	6	9
	NCV 5	Fuchsia	H&C	8wht	HS	R-6	6	12	18
	NCV 25	Lime	H&C	8wht	HS	R-7	10	20	30

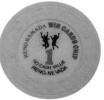

Reno Ramada NCV 1 (1st)

(These NCV's picture a Canadian Maple Leaf.)

Issue	Den.	Color	Mold	Inserts	Inlay	Rarity	GD30	VF65	CS95
	NCV 1	Yellow	H&C	8pnk	HS	R-6	6	12	18
	NCV 5	Orange	H&C	8wht	HS	R-5	5	10	15
	NCV 25	Lime	H&C	8dkgrn	HS	R-5	6	12	18
	NCV 100	Dk Grey	H&C	8org	HS	R-7	10	20	30
	RLT A	Lime	H&C	None	HS	R-5	4	8	12
	RLT A	Orange	H&C	None	HS	R-5	4	8	12
2nd	1.00	Blue	H&C	4wht	R-white	R-2	2	4	6
	RLT	Brown	H&C	None	HS	R-4	3	6	9
	RLT	Orange	H&C	None	HS	R-4	3	6	9

Riverboat RLT A (1st)

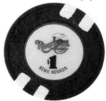

Riverboat $1 (2nd)

RIVERSIDE HOTEL RENO 1927-67
RIVERSIDE (JESSIE BECK'S) 1971-78
RIVERSIDE (PICK HOBSON'S) 1978-86

Issue	Den.	Color	Mold	Inserts	Inlay	Rarity	GD30	VF65	CS95
1st	25.00	Black	Lcrown	None	HS	R-4	15	30	60
	100.00	White	Lcrown	None	HS-blue	R-10	250	500	750
2nd	25.00	Black	Scrown	4yel	HS	R-4	15	30	45
3rd	5.00	Orange	Sm-key	3grn	HS	R-6	40	80	120
	25.00	Red	Sm-key	None	HS	R-5	25	50	75

($25 chip has a spun center and spin circles around the edges - a brief style which appeared in the mid-late 1940's and is also seen on a few Mapes chips.)

| 4th | 1.00 | Green | Lcrown | None | HS | R-9 | 125 | 250 | 375 |

Riverside $25 (3rd)

Riverside $100 (5ᵗʰ)

Riverside $5 (6ᵗʰ)

Riverside $5 (8ᵗʰ)

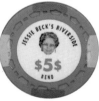

Riverside $5 (9ᵗʰ)

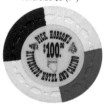

Riverside $100 (11ᵗʰ)

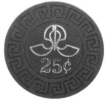

Sahara Reno 25c (1ˢᵗ)

Issue	Den.	Color	Mold	Inserts	Inlay	Rarity	GD30	VF65	CS95
5ᵗʰ	5.00	Orange	Lcrown	3blk	HS	R-8	150	300	600
	100.00	Yellow	Lcrown	3brn	HS	R-8	175	350	525

(The $5 and $100 have a hot stamped picture of the hotel. The $25 chip to match is unknown.)

6ᵗʰ	5.00	Orange	Sm-key	3grn	SCA-white	R-2	10	20	30

(Classic picture of the hotel. Similar to the ultra-rare and expensive first issue Las Vegas Riviera. However, unlike the Riviera, this piece is not rare. Also, the difference in demand between Las Vegas and Reno is very large, which is why Reno chips of equal rarity and aesthetic appeal are worth much less than their Las Vegas counterparts.)

7ᵗʰ	1.00	Blue	Scrown	None	HS	R-5	10	20	30

("Good Only at." There's a variant with thicker, larger writing.)

	1.00	Green	Scrown	None	HS	R-8	35	70	105

("Good For One Bet Only".)

	NCV .25	Red	Scrown	None	HS	R-3	6	12	18
8ᵗʰ	1.00	Grey	Scrown	None	HS	R-5	15	30	45
	5.00	Blue	Scrown	3grn	R-white	R-4	10	20	30
	25.00	Tan	Scrown	3brn	LSCA-white	R-4	10	20	30
	100.00	Pink	Scrown	3blk	LHUB-white	R-4	20	40	60
9ᵗʰ	1.00	Tan/Nvy	Scrown	½pie	OR-white	R-5	25	50	75
	2.50	Brown	Scrown	2yel	OR-white	R-10	200	400	600
	5.00	Fuchsia	Scrown	2grn2yel	OR-white	R-6	40	80	120

(Chip shows owner Jessie Beck on one side and a crest logo on the other.)

	error 5.00	Fuchsia	Scrown	2grn2yel	OR-white	Unique	200	400	600

(Jessie Beck on both sides.)

	error 5.00	Fuchsia	Scrown	2grn2yel	OR-white	Unique	200	400	600

(Crest logo on both sides.)

	25.00	Blue	Scrown	2red2yel	OR-white	R-6	50	100	150
	pan n/d	5 diff.	Scrown	None	HS	R-8	40	80	120

(Colors: Brown, Green, Navy, Red, and White.)

	RLT 2	6 diff.	Scrown	None	HS	R-7	10	20	30

(Colors: Green, Grey, Lavender, Mustard, Red, and Yellow.)

	RLT	6 diff.	Scrown	None	HS	R-7	10	20	30

(Colors: Green, Grey, Lavender, Mustard, Red, and Yellow.)

	NN 1.00	Black	Scrown	None	HS	R-5	12	24	36
10ᵗʰ	NN 1.00	Black	H&C	None	HS	R-6	15	30	45

(Ninth and tenth issues are "Jessie Beck's Riverside.")

11ᵗʰ	.25	Orange	H&C	None	HS	R-6	10	20	30
	.50	Yellow	Scrown	4blu4pnk	OR-white	R-3	5	10	15
	5.00	Pink	Scrown	4blk4blu	OR-white	R-2	4	8	12
	25.00	Green	Scrown	4pnk	OR-white	R-2	6	12	18
	100.00	White	Scrown	1red1blu	OR-white	R-3	12	24	36

(Eleventh issue has Pick Hobson's name on them.)

	RLT	8 diff.	Scrown	None	HS	R-4	4	8	12

(Colors: Blue, Brown, Green, Pink, Purple, Red, White, and Yellow. This historic hotel originally opened in 1880, but burned down in 1910. The Riverside was rebuilt on the same spot and became one of Reno's major casinos after the 1931 legalization.)

SAHARA RENO — RENO — 1979-81

Issue	Den.	Color	Mold	Inserts	Inlay	Rarity	GD30	VF65	CS95
1ˢᵗ	.10	Pink	Lg-key	None	HS	R-6	20	40	60
	.25	Brown	Lg-key	None	HS	R-6	20	40	60

(Above two chips have no writing, just the Sahara Reno logo and denomination.)

	.50	Pink	H&C	None	HS	R-5	8	16	24
	1.00	Tan	H&C	None	HS	R-3	3	6	9
	2.50	Purple	BJ-2	None	COIN	R-8	125	250	375
	5.00	Red	BJ-2	3yel	COIN	R-3	8	16	24
	5.00	Red	H&C	3brn	HS	R-9	50	100	150

("Tournament Chip.")

Issue	Den.	Color	Mold	Inserts	Inlay	Rarity	GD30	VF65	CS95
	25.00	Green	BJ-2	6yel	COIN	R-6	75	150	225
	100.00	Black	BJ-2	6red	COIN	R-3	10	20	30
	500.00	White	BJ-2	12blk	COIN	R-10	150	300	450
	RLT 1	6 diff.	Diecar	None	HS	R-5	4	8	12

(Colors: Beige, Dk Blue, Green, Orange, Red, and Yellow.)

	RLT 3	Maroon	Diecar	None	HS	R-5	4	8	12
	RLT 4	7 diff.	Diecar	None	HS	R-5	4	8	12

(Colors: Beige, Green, Mustard, Navy, Orange, Rust, and White.)

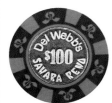
Sahara Reno $100 (1st)

SANDS RENO 1965-

Issue	Den.	Color	Mold	Inserts	Inlay	Rarity	GD30	VF65	CS95
1st	.25	Grey	Lg-key	None	HS	R-7	25	50	75
	2.50	Purple	Lg-key	3grn	R-white	R-7	75	150	225
	5.00	Green	Lg-key	3org	R-white	R-5	30	60	90

(Above chip marked "$5".)

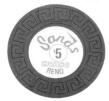
Sands $5 (1st)

	5.00	Green	Lg-key	3org	R-white	R-5	30	60	90

(Above chip marked "$5.00".)

	NN 100.00	White	Lg-key	3nvy	R-white	R-6	40	80	120
2nd	1.00	White	BJ-2	6brn	COIN	R-1	*	1	3
	5.00	Red	BJ-2	6wht	COIN	R-1	*	5	8
	25.00	Green	BJ-2	4wht	COIN	R-1	*	25	30
	100.00	Black	BJ-2	6yel	COIN	R-1	*	100	110
	NCV 1	Green	BJ	None	HS	R-3	2	4	6
	NCV 1	Red	BJ	None	HS	R-3	2	4	6
	NCV 1	White	BJ	None	HS	R-3	2	4	6

(Above two chips picture a maple leaf.)

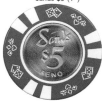
Sands $5 (2nd)

	NN 1.00	Green	BJ	None	HS	R-3	2	4	6
	NN 1.00	Green	H&C	None	HS	R-3	2	4	6
	NN 5.00	Purple	H&C	None	HS	R-4	4	8	12

(Opened in 1965, but didn't have table games until 1970.)

SHADOWS RENO 1935-45/1961-62

Issue	Den.	Color	Mold	Inserts	Inlay	Rarity	GD30	VF65	CS95
1st	1.00	Yellow	Sm-key	3brn	HS	R-4	15	30	45
	5.00	Black	Sm-key	3gry	HS	R-4	20	40	60
	25.00	Salmon	Sm-key	3blk	HS	R-5	30	60	90

(These chips date from the 1961-62 period when this was called the Shadows Supper Club.)

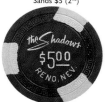
Shadows $5 (1st)

SILVER DOLLAR CASINO RENO 1934-41/1959-74
HARLEY'S SILVER DOLLAR 1960-65

Issue	Den.	Color	Mold	Inserts	Inlay	Rarity	GD30	VF65	CS95
1st	.50	Black	Rectl	None	HS	R-10	150	300	450
	1.00	Beige	Rectl	None	HS	R-9	100	200	300
	5.00	Red	Rectl	3grn	HS	R-8	75	150	225
2nd	.10	Mustard	Sm-key	None	HS	Unique	300	600	900
	5.00	Navy	Sm-key	3ltred	HS	R-4	15	30	45
	25.00	Lt Green	Sm-key	3red	HS	R-6	30	60	90
3rd	.10	Grey	Sm-key	None	HS	R-4	15	30	45
	.25	Black	Sm-key	None	HS	R-7	25	50	75
	1.00	Purple	Sm-key	None	HS	R-6	20	40	60
	5.00	Lavender	Sm-key	3yel	HS	R-4	15	30	45
4th	5.00	Blk/Pur	C&J	½pie	SCA-white	R-4	30	60	90

(Third and Fourth issues are "Harley's Silver Dollar.")

Silver Dollar 10c (2nd)

SILVER LEGACY RENO 1995-

Issue	Den.	Color	Mold	Inserts	Inlay	Rarity	GD30	VF65	CS95
1st	1.00	White	H&C	2blk2lav	OR-multi	R-1	*	1	3
	5.00	Red	H&C	3grn3pnk	OR-multi	R-1	*	5	8
	25.00	Green	H&C	4pnk4pur	OR-multi	R-1	*	25	30

Silver Legacy $25 (1st)

225

Silver Legacy RLT A (1st)

Silver Spur $25 (1st)

Silver Spur $100 (1st)

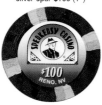

Speakeasy $100 (1st)

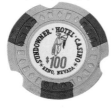

Sundowner $100 (1st)

Sundowner $5 (3rd)

Issue	Den.	Color	Mold	Inserts	Inlay	Rarity	GD30	VF65	CS95
	100.00	Black	H&C	6tan6blu	OR-multi	R-1	*	100	110
	500.00	Purple	H&C	4yel4brn	OR-multi	R-2	*	500	525
	RLT A	Blue	H&C	None	OR-grey	R-4	3	6	9
	RLT A	Grey	H&C	None	OR-grey	R-4	3	6	9
	RLT C	Green	H&C	None	OR-grey	R-4	3	6	9
	RLT C	Yellow	H&C	None	OR-grey	R-4	3	6	9
	RLT G	6 diff.	H&C	None	OR-grey	R-4	3	6	9

(Colors: Blue, Green, Grey, Orange, Pink, and Rust.)

SILVER SLIPPER		RENO			1931-37/37-41				
1st	n/d	Mustard	Diamnd	None	HS	R-8	75	150	225

(Marked only "SS." For a short time in 1937, club was closed and renamed Black Derby, due to the black musicians that played there. Then, just as quickly, the club changed the name back to Silver Slipper. In 1941, this club became the Sphynx until it burned down on Jan 1, 1943.)

SILVER SPUR		RENO			1968-81				
1st	.25	Black	Lg-key	None	HS	R-5	12	24	36
	.50	Orange	Lg-key	3grn	HS	R-8	35	70	105
	1.00	Grey	Lg-key	None	HS	R-3	5	10	15
	5.00	Mustard	Lg-key	3red	R-white	R-3	12	24	36
	25.00	Dk Grey	Lg-key	3org	R-white	R-3	15	30	45
	100.00	Beige	Lg-key	6blk3pnk	R-white	R-4	25	50	75
	NCV	Orange	Lg-key	None	HS	R-5	5	10	15
	NN 1.00	Orange	Scrown	None	HS	R-10	75	150	225
	RLT	5 diff.	Lg-key	None	HS	R-5	3	6	9

(Colors: Dk Brown, Cream, Mustard, Orange, and Pink.)

SPEAKEASY CASINO		RENO			1999-				
1st	1.00	Blue	H&C	3red3wht	OR-multi	R-1	*	1	3
	5.00	Red	H&C	3nvy3ltblu	OR-multi	R-1	*	5	8
	25.00	Green	H&C	3blk3pnk	OR-multi	R-1	*	25	30
	100.00	Black	H&C	4gld4pch	OR-multi	R-2	*	100	120

STAG		RENO			1933-60				
	n/d	Navy	Sqincr	None	HS	R-6	25	50	75

(This chip undoubtedly dates from a later period of operation.)

SUNDOWNER		RENO			1975-				
1st	5.00	Brown	Diasqr	3blk	R-white	R-7	100	200	300
	25.00	Brown	Diasqr	3mst	R-white	R-10	400	800	1200
	100.00	Beige	Diasqr	3red	R-white	R-9	300	600	900
	RLT	3 diff.	Lg-key	None	HS	R-7	10	20	30

(Colors: Brown, Cream, and Lavender.)

2nd	2.50	Orange	H&C	3yel	R-wht/org	R-4	10	20	30
	5.00	Red	H&C	3blu	R-wht/red	R-6	25	50	75
	25.00	Green	H&C	3yel3brn	R-wht/grn	R-8	50	100	150
	NN 1.00	Blue	H&C	None	HS	R-4	3	6	9
	NN 5.00	Yellow	H&C	None	HS	R-7	10	20	30
3rd	5.00	Red	H&C	3blu	R-white	R-9	100	200	300
	100.00	Black	H&C	3wht3grn3pnk	R-white	R-9	100	200	300

("Sundowner" within a circle.)

4th	2.50	Lt Org	H&C	3yel	R-wht/org	R-3	8	16	24
	5.00	Red	H&C	4wht4brn	R-wht/red	R-4	8	16	24
	25.00	Green	H&C	3pch3brn	R-wht/grn	R-6	30	60	90

Issue	Den.	Color	Mold	Inserts	Inlay	Rarity	GD30	VF65	CS95
	25.00	Green	H&C	3red	HS	R-5*	80	160	240

(For some reason this recent issue is only known notched. 30% rule applies here.)

	NCV 1	Orange	HHR	None	HS	R-2	1	2	3
error NCV 1		Orange	HHR	None	HS	R-8	10	20	30

(Obverse is "Sundowner" and reverse is "Virginian".)

5th	5.00	Red	HHR	4wht4nvy	R-wht/red	R-1	*	5	10
	RLT	3 diff.	Roulet	None	OR-white	R-5	3	6	9

(Colors: Lime, Orange, and Pink.)

Sundowner $5 (5th)

SUNFLOWER RENO 1949-50

	Den.	Color	Mold	Inserts	Inlay	Rarity	GD30	VF65	CS95
1st	5.00	Pink	Sm-key	None	R-blk/yel	Unique	1000	2000	3000
	25.00	Green	Sm-key	None	R-blk/yel	Unique	1000	2000	3000
	100.00	Cream	Sm-key	None	R-blk/yel	Unique	1000	2000	3000

Sunflower $25 (1st)

SUPPER CLUB RENO 1955-59

	Den.	Color	Mold	Inserts	Inlay	Rarity	GD30	VF65	CS95
1st	n/d	Cream	Sm-key	None	HS	Unique	200	400	600

SWEDE'S RENO 1963-65

	Den.	Color	Mold	Inserts	Inlay	Rarity	GD30	VF65	CS95
1st	1.00	Yellow	Scrown	None	HS	R-10	225	450	675
	5.00	Black	Scrown	4ltblu4yel	HS	R-9	200	400	600
	n/d	Red	Scrown	None	HS	R-9	100	200	300
	n/d	White	Scrown	None	HS	R-9	100	200	300

Town Club $1 (1st)

TOWN CLUB RENO 1972-73

	Den.	Color	Mold	Inserts	Inlay	Rarity	GD30	VF65	CS95
1st	1.00	Mustard	Lg-key	None	HS	R-5	30	60	90
	5.00	Dk Red	Lg-key	3wht	HS	R-7	40	80	120
	RLT	Yellow	Lg-key	None	HS	R-5	6	12	18
	RLT	2 diff.	Lg-key	None	HS	R-7	12	24	36

(Colors: Beige and Navy.)

TOWN HOUSE RENO 1932-55

	Den.	Color	Mold	Inserts	Inlay	Rarity	GD30	VF65	CS95
1st	5.00	Yellow	Dots	None	HS	R-6	25	50	75
2nd	5.00	Orange	Hub	None	R-white	R-4	35	70	105
	25.00	Black	Hub	None	R-white	R-8	125	250	375

(Reverse has picture of bow-legged cowboy at bar known as "riding lesson".)

Town House $5 (1st)

TROCADERO RENO 1941-55

	Den.	Color	Mold	Inserts	Inlay	Rarity	GD30	VF65	CS95
1st	5.00	Green	Zigzag	None	HS	R-7	150	300	450
	25.00	Black	Zigzag	None	HS	R-10	300	600	900
2nd	5.00	Red	Rectl	None	HS	R-5	75	150	225
	25.00	Yellow	Rectl	None	HS	R-9	250	500	750

Trocadero $5 (2nd)

UNITED CLUB RENO 1962-64

	Den.	Color	Mold	Inserts	Inlay	Rarity	GD30	VF65	CS95
1st	.10	Green	Sm-key	None	HS	R-5	25	50	125
	.25	Purple	Sm-key	None	HS	R-4	10	20	30
	1.00	Red	Sm-key	3grn	HS	R-5	20	40	60
	20.00	Mustard	Sm-key	3dkpur	HS	R-5	30	60	90

Val's $5 (1st)

VAL'S RENO 1966-67

	Den.	Color	Mold	Inserts	Inlay	Rarity	GD30	VF65	CS95
1st	1.00	Red	Scrown	None	HS	R-10	300	600	900
	5.00	Navy	Scrown	None	HS	R-9	250	500	750

(Exactly four known at present.)

	25.00	Black	Scrown	None	HS	Unique	350	700	1050

Virginian $5 (1st)

Waldorf Club n/d (1st)

Waldorf Club $5 (2nd)

Willows $25 (1st)

Zimba's $5 (1st)

Zimba's $25 (2nd)

Issue	Den.	Color	Mold	Inserts	Inlay	Rarity	GD30	VF65	CS95
VILLA SIERRA			RENO		**1941-41/44-45/46-52**				
RENO CHICKEN HUT					**1945-45**				
1st	5.00	Yellow	Arodie	None	HS	R-7	75	150	225

(Marked simply "VS," the chip is attributed here by discoverers Mel Jung and Armin Pfaender, but no concrete evidence exists. Closed initially in 1941 due to WWII shortages. In Feb. 1945, the owner committed suicide. The place was reopened by a husband and wife as the Reno Chicken Hut for a short time later that year. In 1946, the casino was renamed Villa Sierra until it closed in 1952.)

Issue	Den.	Color	Mold	Inserts	Inlay	Rarity	GD30	VF65	CS95
VIRGINIAN			RENO		**1988-97/99-**				
1st	.25	Mustard	Clover	None	HS	R-4	2	4	6
	NN 1.00	Pink	Clover	None	HS	R-4	4	8	12
(This is a "Win Cards" chip.)									
	NCV 1	Orange	HHR	None	HS	R-5	3	6	9
	NCV 5	Pink	HHR	None	HS	R-5	3	6	9
	5.00	Red	H&C	2gry2pnk	HUB-white	R-3	5	10	20
	25.00	Green	H&C	4org4wht	SCA-white	R-6	25	50	75
	100.00	Black	H&C	6pnk3wht	COG-white	R-8	75	150	225
	RLT V	Brown	H&C	None	HS	R-5	3	6	9

(The Virginian was purchased by the neighboring Cal-Neva and is using their chips until new ones get made.)

Issue	Den.	Color	Mold	Inserts	Inlay	Rarity	GD30	VF65	CS95
WALDORF CLUB			RENO		**1931-56**				
1st	n/d	Lt Green	Plain	None	HS	R-9	125	250	375
	n/d	White	Plain	None	HS	R-9	125	250	375
(Very early style with thin hot stamps.)									
2nd	5.00	Navy	T's	3red	HS	R-5	40	80	160
3rd	25.00	Black	Diamnd	None	HS	R-10	100	200	300
	100.00	Green	Diamnd	None	HS	R-8	60	120	180

(Third issue marked "CVL." These are also attributed to Lake Tahoe, but were definitely used in Reno, possibly by same owners. These chips were discovered by Phil Jensen.)

Issue	Den.	Color	Mold	Inserts	Inlay	Rarity	GD30	VF65	CS95
WILLOWS			RENO		**1953-56**				
1st	5.00	Green	Arodie	None	HS	R-6	60	120	180
	25.00	Black	Arodie	None	HS	R-5	50	100	150

(This club should not be confused with the Willows Roadhouse that was open from 1931-32 and located several miles away.)

Issue	Den.	Color	Mold	Inserts	Inlay	Rarity	GD30	VF65	CS95
ZIMBA'S			RENO		**1969-72**				
1st	.10	Red	Lg-key	None	HS	R-6	20	40	60
	.25	Green	Lg-key	None	HS	R-8	35	70	105
	1.00	Orange	Lg-key	None	HS	R-7	25	50	75
	5.00	Grey	Lg-key	None	HS	R-7	25	50	75
	100.00	Black	Lg-key	None	HS	R-5	30	60	90
(The 1st issue is marked "Zimba, Reno.")									
2nd	.10	Orange	Lg-key	None	HS	R-5	12	24	36
	.50	Purple	Lg-key	3grn	R-white	R-4	10	20	30
	1.00	Blue	Lg-key	3gry	R-white	R-4	10	20	30
	5.00	Mustard	Lg-key	3pnk	R-white	R-4	12	24	36
	25.00	Green	Lg-key	3org	R-white	R-5	20	40	60
	n/d	Black	Horshu	None	HS	R-5	8	16	24

(Second issue is marked "Zimba's Casino".)

Issue	Den.	Color	Mold	Inserts	Inlay	Rarity	GD30	VF65	CS95
				SMALL TOWNS					
LONGSTREET INN			**AMARGOSA VLY**		1996-				
1st	5.00	Red	Chipco	None	FG	R-1	*	5	10
	25.00	Green	Chipco	None	FG	R-2	*	25	35
	100.00	Black	Chipco	None	FG	R-3	*	100	120
STATELINE SALOON			**AMARGOSA VLY**		1984-				
1st	1.00	Blue	H&C	3tan3brn	R-white	R-2	8	16	24
	5.00	Red	H&C	3yel3pnk	R-white	R-2	10	20	30
	25.00	Green	H&C	3ltgrn3pch	R-white	R-4	40	80	120
2nd	.25	Orange	H&C	3dkgrn3gld	R-multi	R-4	2	4	6
	.50	Yellow	H&C	3aqa3ltpur	R-multi	R-4	2	4	6
	1.00	Blue	H&C	3ltbrn3dkbrn	R-multi	R-2	*	2	4
	2.50	Pink	H&C	3ltgrn3brn	R-multi	R-4	5	10	15
	5.00	Red	H&C	3pnk3yel	R-multi	R-3	*	5	10
	25.00	Dk Green.	H&C	3org3ltgrn	R-multi	R-4	*	25	35
	100.00	Black	H&C	3blu3grn3lav	R-multi	R-5	*	100	125

(Above set pictures desert scene on reverse; Doris Jackson, owner, obverse.)

Issue	Den.	Color	Mold	Inserts	Inlay	Rarity	GD30	VF65	CS95
FRONTIER TAVERN			**AUSTIN**		1953-80				
1st	1.00	Green	Sqincr	None	HS	R-7	30	60	90
	n/d	Beige	Sm-key	3blk	HS	R-6	25	50	75

(Above are only marked "FT." This small casino eliminated live gaming for about the last ten years of operation. The Frontier Tavern burned to the ground in 1980. This business was located out on Highway 50 heading towards Eureka. 300 $1 green chips were ordered on 6-20-60.)

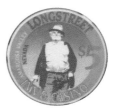
Long Street Inn $5 (1st)

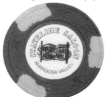
Stateline Saloon $25 (1st)

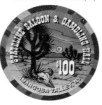
Stateline Saloon $100 (2nd)

Frontier Tavern n/d (1st)

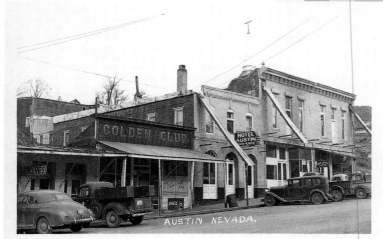

The Golden Club, pictured here on this postcard, is one of the few casinos Austin ever produced. For you city type set collectors, the Golden Club has the only casino chip marked "Austin." Today, there is no live gaming in Austin—or much of anything else for that matter.

Golden Club $5 (1st)

Golden Club $25 (1st)

Issue	Den.	Color	Mold	Inserts	Inlay	Rarity	GD30	VF65	CS95
GOLDEN CLUB (MOM'S)			**AUSTIN**		1943-50's				
GOLDEN CLUB					1950's-91				
1st	5.00	Red	Arodie	None	HS	R-6	75	150	225
	25.00	Beige	Arodie	3blk	HS	R-6	80	160	240

(Used in the 1950's. Rumor was that these chips were used in Mom's Club at Fallon first, but this is highly unlikely. The Fallon

Golden Club $10 (2ⁿᵈ)

Great Basin $5 (1ˢᵗ)

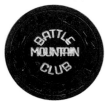

Battle Mountain Club $5 (1ˢᵗ)

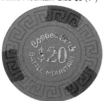

Copper Club $20 (1ˢᵗ)

Hotel Nevada n/d (1ˢᵗ)

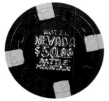

Hotel Nevada $50 (3ʳᵈ)

Issue	Den.	Color	Mold	Inserts	Inlay	Rarity	GD30	VF65	CS95

Mom's opened in 1961 and Arodie mold chips almost always date from 1948-1956. The Golden Club opened in 1943 and they used silver dollars until the 1950's. The casino had live gaming until November of 1990 and slots until 1991. This building is now an antique store with the original back bar. This hoard of chips has not yet hit the market. Rarity ratings reflect the quantity known to exist, but it's been years and they are still being held - therefore value now is high.)

Issue	Den.	Color	Mold	Inserts	Inlay	Rarity	GD30	VF65	CS95
2ⁿᵈ	1.00	Mustard	Diasqr	3mar	HS	R-4	30	60	90
	5.00	Maroon	Diasqr	3mst	HS	R-4	35	70	105
	10.00	Blue	Diasqr	3mst	HS	R-5	50	100	150
3ʳᵈ	1.00	Mustard	Diasqr	None	HS	R-4	25	50	75

BORDER INN — BAKER — 1979-81

Issue	Den.	Color	Mold	Inserts	Inlay	Rarity	GD30	VF65	CS95
1ˢᵗ	1.00	Beige	Diecar	None	HS	R-3	15	30	45
	5.00	Maroon	Diecar	3pnk	HS	R-4	20	40	60

GREAT BASIN CASINO — BAKER — 1981-82

Issue	Den.	Color	Mold	Inserts	Inlay	Rarity	GD30	VF65	CS95
1ˢᵗ	1.00	Grey	H&C	None	HS	R-3	20	40	60
	5.00	Red	H&C	4yel 4ltgrn	R-white	R-3	50	100	150

(These are the only chips that say "Baker, NV.")

BATTLE MOUNTAIN CLUB — BATTLE MTN — 1931-64

Issue	Den.	Color	Mold	Inserts	Inlay	Rarity	GD30	VF65	CS95
1ˢᵗ	1.00	Beige	C&J	None	HS	R-6	75	150	225
	5.00	Black	C&J	None	HS	R-6	80	160	240

COMMERCIAL HOTEL — BATTLE MTN — 1948-70

Issue	Den.	Color	Mold	Inserts	Inlay	Rarity	GD30	VF65	CS95
1ˢᵗ	.25	Mustard	Diasqr	None	HS	R-5	12	24	36
	.50	Green	Diasqr	None	HS	R-5	12	24	36
	1.00	Navy	Diasqr	None	HS	R-5	20	40	60
	5.00	Red	Diasqr	None	HS	R-5	20	40	60

COPPER CLUB — BATTLE MTN — 1931-70

Issue	Den.	Color	Mold	Inserts	Inlay	Rarity	GD30	VF65	CS95
1ˢᵗ	.50	Orange	Lg-key	None	HS	R-8	50	100	150
	1.00	Beige	Lg-key	None	HS	R-4	14	28	42
	1.00	Beige	Lg-key	3grn	HS	R-4	16	32	48
	5.00	Green	Lg-key	None	HS	R-4	20	40	60
	5.00	Green	Lg-key	3lav	HS	R-4	25	50	75
	20.00	Red	Lg-key	3pur	HS	R-5	40	80	120

HOTEL NEVADA — BATTLE MTN — 1948-

Issue	Den.	Color	Mold	Inserts	Inlay	Rarity	GD30	VF65	CS95
1ˢᵗ	n/d	Green	Arodie	None	HS	R-6	20	40	60

(Above are only marked "NHB" for Nevada Hotel Bar.)

Issue	Den.	Color	Mold	Inserts	Inlay	Rarity	GD30	VF65	CS95
2ⁿᵈ	1.00	Yellow	Sqincr	4grn	HS	R-5	20	40	60
	5.00	Blue	Sqincr	4grn	HS	R-5	20	40	60
	20.00	Red	Sqincr	4grn	HS	R-5	25	50	75

(Second issue is marked "WCW" for owner William C. Warren.)

Issue	Den.	Color	Mold	Inserts	Inlay	Rarity	GD30	VF65	CS95
3ʳᵈ	1.00	Mustard	C&J	4grn	HS	R-4	15	30	45
	5.00	Blue	C&J	4grn	HS	R-4	20	40	60
	20.00	Red	C&J	4grn	HS	R-4	40	80	120
	50.00	Black	C&J	4grn	HS	R-6	50	100	150
4ᵗʰ	1.00	Mustard	Nevada	4grn	HS	R-3	12	24	36
	5.00	Blue	Nevada	4grn	HS	R-4	18	36	54
5ᵗʰ	.25	Beige	Diecar	None	HS	R-4	8	16	24
	.50	Beige	Diecar	None	HS	R-7	15	30	45
	.50	Green	Diecar	None	HS	R-5	8	16	24

Issue	Den.	Color	Mold	Inserts	Inlay	Rarity	GD30	VF65	CS95
	1.00	Mustard	Diecar	4grn	HS	R-4	12	24	36
	5.00	Blue	Diecar	4grn	HS	R-6	15	30	45
6th	.50	Grey	H&C	None	HS	R-6	12	24	36
	1.00	Yellow	H&C	4blu	HS	R-2	*	5	10
	5.00	Pink	H&C	4grn	HS	R-2	*	10	15
	25.00	Green	H&C	4org	HS	R-3	*	25	40

(These last three chips are rather hard to get off the tables, especially in good condition.)

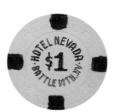

Hotel Nevada $1 (6th)

OWL CLUB — BATTLE MTN — 1948-99

Issue	Den.	Color	Mold	Inserts	Inlay	Rarity	GD30	VF65	CS95
1st	1.00	Orange	Sm-key	None	HS	R-3	15	30	45
	5.00	Grey	Sm-key	None	HS	R-3	15	30	45

(This first issue only has "OWL" in small letters.)

	RLT	3 diff.	Hub	None	HS	R-5	20	40	60

(Colors: Red, Purple, and Yellow. There's a picture of an owl on a perch.)

2nd	1.00	Orange	Sm-key	None	HS	R-4	15	30	45
	5.00	Grey	Sm-key	None	HS	R-4	15	30	45

("OWL CLUB" in circle.)

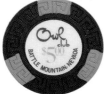

Owl Club $5 (4th)

3rd	1.00	Navy	Lg-key	None	HS	R-5	20	40	60
	5.00	Green	Lg-key	None	HS	R-5	25	50	75
4th	5.00	Blue	Lg-key	3grn	R-white	R-10	150	300	450
5th	.25	Yellow	Diecar	None	HS	R-9	100	200	300
	5.00	Navy	H&C	3grn	R-white	R-6	50	100	200
	25.00	Green	H&C	3org	R-white	R-10	300	600	900
6th	5.00	Red	H&C	6pnk3pur	R-white	R-4	6	12	20
	25.00	Green	H&C	4lim4yel	R-white	R-6	30	60	90

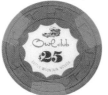

Owl Club $25 (5th)

SILVER DOLLAR — BATTLE MTN — 1948-69

Issue	Den.	Color	Mold	Inserts	Inlay	Rarity	GD30	VF65	CS95
1st	.50	Mar/Grn	C&J	½pie	HS	R-8	50	100	150
	1.00	Beige	C&J	3blk	HS	R-5	25	50	75
	5.00	Red	C&J	3yel	HS	R-5	30	60	90
	25.00	Lt Pink	C&J	3blu	HS	R-6	40	80	120

BEATTY CLUB — BEATTY — 1952-76

Issue	Den.	Color	Mold	Inserts	Inlay	Rarity	GD30	VF65	CS95
1st	1.00	Green	C&J	None	HS	R-10	200	400	600
	5.00	Lavender	C&J	None	HS	R-10	200	400	600
	25.00	Pink	C&J	None	HS	R-9	100	200	300

(Owner Ray May burned all these chips many years ago.)

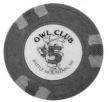

Owl Club $5 (6th)

BURRO INN — BEATTY — 1982-

Issue	Den.	Color	Mold	Inserts	Inlay	Rarity	GD30	VF65	CS95
1st	5.00	Red	H&C	6yel3brn	HUB-white	R-6	25	50	75
	25.00	Green	H&C	6gry3grn	SCA-white	R-8	200	400	600
2nd	5.00	Red	H&C	6yel3pnk	HUB-yellow	R-2	*	5	10
	25.00	Green	H&C	6gry3grn	SCA-yellow	R-4	*	25	40

(The first issue has the burro facing left. The second issue has the burro facing right.)

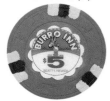

Burro Inn $5 (1st)

CLUB ATOMIC — BEATTY — 1958-59

Issue	Den.	Color	Mold	Inserts	Inlay	Rarity	GD30	VF65	CS95
1st	5.00	Yellow	Rectl	None	HS	R-9	250	500	750

(This was formerly the Horseshoe Hotel, and then became the Burro Inn.)

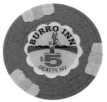

Burro Inn $5 (2nd)

Exchange Club $1 (2nd)

Exchange Club $5 (3rd)

Exchange Club $5 (4th)

Exchange Club $5 (5th)

Bordertown $1 (1st)

Fort Lucinda $5 (1st)

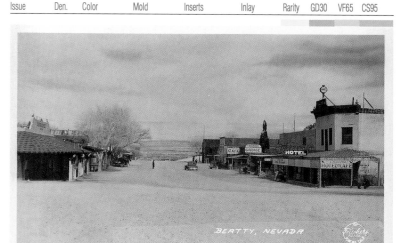

A6455

This postcard shows the Exchange Hotel in Beatty shortly before the legalization of gaming, when the name became the Exchange Club. ⓕFrasher's, Inc., Pomona, CA.

Issue	Den.	Color	Mold	Inserts	Inlay	Rarity	GD30	VF65	CS95
EXCHANGE CLUB			**BEATTY**		1905-				
1st	25.00	Brown	Lgsmcr	None	HS	R-9	300	600	1200
	100.00	Green	Lgsmcr	None	HS	R-10	500	1000	1500
(These chips are marked "Exchange Bar" as it was known from 1931-1954.)									
2nd	1.00	Blue	Diamnd	None	HS	R-7	100	200	300
	5.00	Mustard	Horshu	None	HS	R-8	100	200	300
3rd	5.00	Red	C&J	3bei	HS	R-8	150	300	450
4th	5.00	Red	BJ-2	6yel	COIN	R-4	5	10	15
	25.00	Green	BJ-2	12yel	COIN	R-7	35	70	105
5th	5.00	Red	BJ-P	4gry	OR-multi	R-1	*	5	10
	25.00	Green	BJ-P	4wht	OR-multi	R-2	*	25	35
STAGECOACH			**BEATTY**		1983-				
1st	.25	Yellow	H&C	None	HS	R-2	*	2	5
	1.00	Beige	H&C	None	R-white	R-1	*	2	4
	5.00	Red	H&C	3blu3pnk	HUB-white	R-2	*	5	10
	25.00	Green	H&C	3yel3pur	SCA-white	R-2	*	25	35
	100.00	Black	H&C	3grn3pur3org	COG-white	R-4	*	100	120
BORDERTOWN			**BORDERTOWN**		1977				
1st	1.00	Blue	H&C	None	HS	R-5	20	40	60
	5.00	Red	H&C	3wht3yel	HS	R-5	22	44	66
(Located outside of Reno.)									
FORT LUCINDA			**BOULDER DAM**		1964-67				
1st	.25	Purple	C&J	None	HS	R-7	60	120	180
	.50	Grn/Mar	C&J	½pie	HS	R-5	25	50	75
	1.00	Red	C&J	None	HS	R-5	25	50	75
	5.00	Mustard	C&J	None	HS	R-7	75	150	225
(These are the only chips marked "Boulder Dam." Fort Lucinda became Gold Strike Inn in 1967.)									

Issue	Den.	Color	Mold	Inserts	Inlay	Rarity	GD30	VF65	CS95
GOLD STRIKE INN			HOOVER DAM		1955-64				
			BOULDER CITY		1967-98				
1st	.25	Green	C&J	None	HS	R-7	60	120	180
	.50	Fuchsia	C&J	None	HS	R-8	75	150	225
	1.00	Navy	C&J	None	HS	R-7	60	120	180
	5.00	Yellow	C&J	3nvy	HS	R-6	50	100	150

Gold Strike Inn 50c (1st)

(This issue gives the location as "Near Hoover Dam." Only 12 complete sets were found, including 25 dollar chips and 35 $5 chips.)

2nd	1.00	Beige	H&C	None	HS	R-3	5	10	15

(This issue also marked "Near Hoover Dam.")

3rd	.25	Pink	H&C	None	HS	R-4	4	8	12
	5.00	Red	H&C	3blu3org	HS	R-4	8	15	30
	25.00	Green	H&C	3gry3pnk	HS	R-5	25	50	75

Gold Strike Inn $5 (3rd)

(Third issue is marked Gold Strike Inn, but lacks a town name.)

4th	.25	Pink	H&C	None	HS	R-3	2	4	6
	1.00	Beige	H&C	None	HS	R-3	2	4	6
	5.00	Red	H&C	3blu3org	HS	R-4	5	10	15
	25.00	Green	H&C	3gry3pnk	HS	R-4	20	40	60

(Fourth set marked Boulder City, NV.)

	NCV 5	Orange	H&C	None	HS	R-6	10	20	30
	NCV 25	Purple	H&C	None	HS	R-6	10	20	30
	NCV 100	Blue	H&C	None	HS	R-6	10	20	30
	RLT 2	6 diff.	HHR	None	R-white	R-6	5	10	15

Gold Strike Inn 25c (4th)

(Colors: Brown, Maroon, Navy, Orange, Purple, and Yellow. The Gold Strike Inn burned to the ground in June 1998. An order of roulette chips was made and never put in use. Although gaming is not legal in Boulder City, the Gold Strike did state "Boulder City" on the last set of chips. Rumor was that these were to be recalled, but that did not happen. Gold Strike first opened in 1955 as a western-themed playground for kids, without any live gaming. In 1964, Gold Strike became Fort Lucinda until about 1967 when the name changed back to Gold Strike. Live gaming continued briefly, then stopped. Sometime around 1975, live gaming resumed and continued until the 1998 fire. Originally, this location was the Trade Winds.)

HACIENDA			BOULDER CITY		1999-				
1st	1.00	White	BJ-P	3blu	OR-white	R-1	*	1	2
	5.00	Red	BJ-P	6yel	OR-white	R-1	*	5	8
	25.00	Green	BJ-P	4org	OR-white	R-1	*	25	30
	100.00	Black	BJ-P		OR-white	R-2	*	100	110

93 Club $5 (1st)

93 CLUB			CALIENTE		1948-57				
1st	5.00	Purple	Lcrown	None	HS	R-9	70	140	210
	n/d	Orange	Lcrown	None	HS	R-9	30	60	90
	n/d	Green	Lcrown	None	HS	R-10	40	80	120

(Above two chips are marked "CLAB". This club was in with the Scott Hotel - now being restored.)

CALIENTE CLUB			CALIENTE		1946- 61				
1st	5.00	Orange	Arodie	None	HS	R-6	75	150	225

Caliente Club $5 (1st)

(James Campiglia acquired all known 51 surviving pieces from the original owners. Most of the chips have nicks and wear. Chip is initialed "TAC" for Tommy A. Costanzo. Interestingly enough, the five dice that were found with the chips, which were being used for Yahtzee, were marked "Caliente Club." Unfortunately, the chips have no location.)

CORNER CLUB			CALIENTE		1950's				
1st	n/d	Lavender	Diamnd	None	HS	R-6	15	30	45
	n/d	Blue	Diamnd	None	HS	R-6	12	24	36

(Chips marked "CC" only. These are attributed here because they were found with other chips from this same area. This club was located on a downtown corner and is now a furniture store.)

Corner Club n/d (1st)

Cal-Nev-Ari $25 (1st)

Humboldt Club $5 (1st)

Nevada Club $5 (1st)

Overland Bar $1 (1st)

Artichoke Joe's HB $1 (1st)

Artichoke Joe's HB $25 (1st)

Issue	Den.	Color	Mold	Inserts	Inlay	Rarity	GD30	VF65	CS95
CAL-NEV-ARI			**CAL-NEV-ARI**		**1967-**				
1st	1.00	Beige	HHR	3red	HS	R-4	20	40	60
	5.00	Red	HHR	3bei	HS	R-5	25	50	75
	25.00	Blue	HHR	3bei	HS	R-6	50	100	150
2nd	1.00	Yellow	BJ-2	8yel	COIN	R-3	5	10	15
	5.00	Red	BJ-2	12wht	COIN	R-3	7	14	21
CITY CLUB			**CARLIN**		**1948-66**				
1st	RLT	6 diff.	Dots	None	HS	R-7	35	70	105
(Colors: Red, Green, Blue, Aqua, Brown, and Yellow.)									
HUMBOLDT CLUB			**CARLIN**		**1948-59**				
1st	5.00	Black	Arodie	None	HS	R-6	50	100	150
	25.00	Red	TK	4bei	HS	R-5	40	80	120
(Located right next to Overland Hotel.)									
NEVADA CLUB			**CARLIN**		**1953-69**				
1st	.25	White	Sqincr	4pnk	HS	Unknown	200	400	600
	1.00	Green	Sqincr	4pnk	HS	Unknown	250	500	750
	5.00	Red	Sqincr	4pnk	HS	R-7	125	250	375
(This chip is one of only two that is marked "Carlin.")									
2nd	1.00	Maroon	Lg-key	None	HS	R-4	10	20	30
	5.00	Green	Lg-key	None	HS	R-4	10	20	30
(Second issue chips are marked "NAW." This stands for the owner, Nancy A. Wright.)									
OVERLAND BAR			**CARLIN**		**1958-78**				
1st	1.00	Brown	Sm-key	None	HS	R-5	100	200	400
(Chip marked "Overland Bar Carlin". About a box was found in 1999. All but about 6 chips are quite worn and well used of this great old small town chip. This club had "21", poker, and pan. This $1 denomination may have been the only chip used here, which would account for the worn condition on most of these.)									
ARTICHOKE JOE'S			**CARSON CITY**		**1980-82**				
HORSE BOOK									
PEANUT HOUSE SALOON					**1992-97**				
POKER PALACE					**1997-**				
1st	.01	Orange	H&C	4brn	HS	R-7	20	40	60
	.05	Green	H&C	4pnk	HS	R-7	15	30	45
	.10	Pink	H&C	4gld	HS	R-6	12	24	36
	.25	Pink	H&C	None	HS	R-6	5	10	15
	.50	Yellow	H&C	None	HS	R-6	5	10	15
	1.00	Blue	H&C	4yel	R-yellow	R-5	12	24	36
	5.00	Red	H&C	4pur	HUB-yellow	R-7	40	80	120
	25.00	Green	H&C	3ltblu3org	SCA-blue	R-10	150	300	450
(BEWARE - These are not on the market yet, but a huge hoard is believed to exist which would destroy the value of these chips. The above numbers reflect what is available today.)									
	NCV 1	Grey	H&C	4pnk	HS	R-5	10	20	30
	NCV 5	Brown	H&C	4org	HS	R-5	10	20	30
	NCV 25	Purple	H&C	4grn	HS	R-5	15	30	45
(This first issue is marked "Artichoke Joe's Horse Book.")									
2nd	.25	Lt Pink	H&C	None	R-white	R-4	3	6	9
(This variant has dark printing.)									
	.25	Lt Pink	H&C	None	R-white	R-3	2	4	6
(This variant has light printing.)									
	.50	Yellow	H&C	4ltblu	R-white	R-4	4	8	12

Issue	Den.	Color	Mold	Inserts	Inlay	Rarity	GD30	VF65	CS95
	1.00	Blue	H&C	4yel	R-white	R-3	5	10	15
	4.00	Gold	H&C	4grn	HUB-white	R-5	12	24	36
	5.00	Red	H&C	4pur	SCA-white	R-4	10	20	30
	20.00	Grey	H&C	4pnk	COG-white	R-5	30	60	90
	NCV 1	Purple	H&C	None	HS	R-4	5	10	15
	NCV 5	Brown	H&C	None	HS	R-4	5	10	15
	NCV 10	Orange	H&C	None	HS	R-4	5	10	15
	NCV 25	Yellow	H&C	None	HS	R-4	5	10	15
	NCV 50	Orange	H&C	None	HS	R-5	7	14	21
	NCV 100	Purple	H&C	None	HS	R-5	7	14	21
	NCV 500	Brown	H&C	None	HS	R-5	7	14	21

Artichoke Joe's PH $20 (2nd)

(Second issue is marked "Artichoke Joe's Peanut House Saloon.")

Issue	Den.	Color	Mold	Inserts	Inlay	Rarity	GD30	VF65	CS95
3rd	.01	Orange	H&C	None	HS	R-4	10	20	30
	.05	Green	H&C	None	HS	R-4	8	16	24
	.25	Lt Pink	H&C	None	R-white	R-3	1	2	3
	1.00	Blue	H&C	4yel	R-white	R-3	1	2	3
	5.00	Red	H&C	4pur	R-white	R-3	*	5	10
	10.00	Brown	H&C	3pnk3blu	R-white	R-4	*	10	20

Artichoke Joe's PP 1c (3rd)

(Third issue is marked "Artichoke Joe's Poker Palace." Penny and Nickel chips are used for the ante in low stakes poker that is only open occasionally.)

BLACK GOLD CARSON CITY 1950's

Issue	Den.	Color	Mold	Inserts	Inlay	Rarity	GD30	VF65	CS95
1st	5.00	Black	Sm-key	3gry	R-black	R-4	25	50	75
	25.00	Lt Green	Sm-key	3pur	R-black	R-7	150	300	450

Black Gold $25 (1st)

BRODERICKS BAR CARSON CITY 1945-54

Issue	Den.	Color	Mold	Inserts	Inlay	Rarity	GD30	VF65	CS95
1st	5.00	Lavender	Scrown	None	HS	R-5	15	30	45
2nd	5.00	Lavender	Sm-key	None	HS	R-5	20	40	60
	25.00	Black	Sm-key	None	HS	R-5	20	40	60

(All of the above chips are initialed "EB" for owner Ella Broderick.)

Broadericks Bar $25 (2nd)

CACTUS JACKS, SENATOR CARSON CITY 1971

Issue	Den.	Color	Mold	Inserts	Inlay	Rarity	GD30	VF65	CS95
1st	1.00	Grey	Sm-key	3red	HS	R-5	20	40	60
	5.00	Blue	Sm-key	3yel	HS	R-7	75	150	300
	25.00	Green	Sm-key	3red	HS	R-9	100	200	400
2nd	.25	Orange	Lg-key	None	HS	R-10	60	120	180

(This chip is just marked "CJS.")

	5.00	Blue	Lg-key	3yel	HS	R-6	75	150	225
3rd	1.00	Yellow	C&J	None	HS	R-7	50	100	150
	1.00	Green	C&J	3pur	HS	R-7	50	100	150

(Above two are marked Pete Piersanti on back.)

| | 1.00 | Purple | C&J | None | HS | R-6 | 40 | 80 | 120 |

(Above marked Ron Wills on back.)

| | 1.00 | Pink | C&J | None | HS | R-6 | 40 | 80 | 120 |

(Above marked Rich Dieto on back.)

| | 1.00 | Red | C&J | None | HS | R-6 | 40 | 80 | 120 |

(Above marked "Presented by Gib Cattanach" on back. These four pieces are advertising chips, listing owners and bosses. They could have been played, but most were kept as souvenirs.)

	1.00	Grey	C&J	3red	HS	R-4	15	30	45
	5.00	Navy	C&J	3yel	HS	R-6	50	100	150
4th	.25	Yellow	H&C	None	HS	R-4	10	20	30

(All above are marked with Senator Club.)

| | .50 | Purple | H&C | None | HS | R-2 | 2 | 4 | 6 |
| | .50 | Navy | H&C | None | HS | R-4 | 3 | 6 | 9 |

Cactus Jack's $5 (1st)

Cactus Jack's $1 (3rd)

Cactus Jack's $5 (4th)

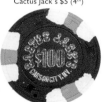

Cactus Jack's $100 (4th)

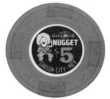

Carson City Nugget $5 (2nd)

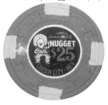

Carson City Nugget $25 (2nd)

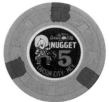

Carson City Nugget $5 (1st)

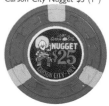

Carson City Nugget $25 (1st)

Issue	Den.	Color	Mold	Inserts	Inlay	Rarity	GD30	VF65	CS95
	1.00	Grey	H&C	3red	HS	R-2	5	10	15
	1.00	Pink	H&C	None	HS	R-10	50	100	150
	1.00	Yellow	H&C	3pur	HS	R-5	20	40	60
(Above marked Pete Piersanti on back with two phone numbers.)									
	5.00	Red	H&C	3wht3org	HS	R-2	8	16	24
	25.00	Green	H&C	3pnk3pch	HS	R-3	15	30	45
	100.00	Black	H&C	6yel3blu	HS	R-4	35	70	105
(300 of these chips were found, 200 were drilled, undrilled chips were sold for face value, although soon made obsolete by casino. These drilled examples are worth about 20% of the listed price.)									
	100.00	Black	H&C	8blu4pch	HS	R-5	35	70	105
	NCV	4 diff.	H&C	None	HS	R-5	5	10	15
(Colors: Cream, Fuchsia, Green, and Grey.)									

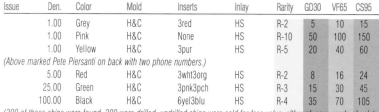

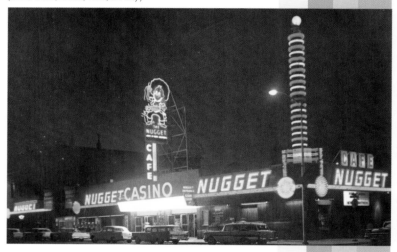

A 1960s postcard view of Carson City's most successful gaming operation. ©Mike Roberts, Berkeley, CA.

CARSON CITY NUGGET		CARSON CITY			1954-				
1st	n/d	4 diff.	Lcrown	None	HS	R-8	35	70	105
(Colors: Beige, Green, Orange, and Lt Red.)									
	.25	Lt Purple	C&J	None	HS	R-7	60	120	180
	1.00	Brown	C&J	None	HS	R-7	60	120	180
	1.00	Yellow	C&J	None	HS	R-6	45	90	135
	5.00	Mustard	C&J	3red	R-black	R-7	150	300	450
	25.00	Maroon	C&J	3bei	R-black	R-8	250	500	750
2nd	1.00	Yellow	C&J	None	R-black	R-6	75	150	225
	5.00	Orange	C&J	4grn	R-black	R-5	60	120	180
	25.00	Green	C&J	4yel	R-black	R-6	125	250	375
	RLT 1	8 diff.	Plain	None	R-white	R-6	10	20	30
(Colors: Beige, Blue, Brown, Dk Green, Grey, Purple, Red, and Yellow.)									
	RLT 2	10 diff.	Plain	None	R-white	R-6	10	20	30
(Colors: Beige, Blue, Lt Blue, Dk Green, Lt Green, Grey, Orange, Purple, Red, and Yellow.)									
3rd	2.50	Blue	H&C	3wht3red	R-black	R-4	10	20	30
(Chip discontinued because no line was placed under the 2.50.)									
	5.00	Orange	H&C	4grn	R-black	R-4	25	50	75

Issue	Den.	Color	Mold	Inserts	Inlay	Rarity	GD30	VF65	CS95
	25.00	Green	H&C	4yel	R-black	R-2	*	25	50
	RLT	7 diff.	H&C	None	R-white	R-3	5	10	15

(Colors: Purple, Green, Orange, White, Brown, Dk Blue, Lt Blue.)

Issue	Den.	Color	Mold	Inserts	Inlay	Rarity	GD30	VF65	CS95
4th	.25	Purple	Horshu	None	HS	R-1	*	2	4
	RLT	4 diff.	Horshu	None	HS	R-10	25	50	75

(Colors: Black, Blue, Brown, and Lime.)

Issue	Den.	Color	Mold	Inserts	Inlay	Rarity	GD30	VF65	CS95
5th	1.00	Yellow	Lg-key	2blk	COIN	R-1	*	2	4
	5.00	Orange	Lg-key	2grn	COIN	R-1	*	5	10
	5.00	Pink	Lg-key	None	HS-blue	R-10	100	200	300

("Good only at" on both sides.)

Issue	Den.	Color	Mold	Inserts	Inlay	Rarity	GD30	VF65	CS95
	2.50	Blue	H&C	3wht3red	R-black	R-2	*	4	8

(Two variants exist, one has a thick line under the .50 & other is thin.)

Issue	Den.	Color	Mold	Inserts	Inlay	Rarity	GD30	VF65	CS95
	100.00	Black	H&C	3wht	R-white	R-3	*	100	120
6th	.25	Purple	Unicrn	None	HS	R-1	*	2	4
7th	RLT	Blue	Roulet	None	OR-blue	R-3	3	6	9

(The $25 from the 3rd issue has been in use since about the late 1970's. This casino may have the record for most different molds in use at one time!)

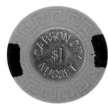
Carson City Nugget $1 (5th)

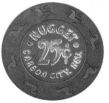
Carson City Nugget 25c (6th)

CARSON HORSESHOE CLUB CARSON CITY 1973

Issue	Den.	Color	Mold	Inserts	Inlay	Rarity	GD30	VF65	CS95
1st	5.00	Yellow	Diasqr	None	HS	R-5	40	80	120

CARSON HOT SPRINGS CARSON CITY 1945-66

Issue	Den.	Color	Mold	Inserts	Inlay	Rarity	GD30	VF65	CS95
1st	5.00	Lavender	Sm-key	3pur	HS	R-7	50	100	150
	25.00	Lt Green	Sm-key	3red	HS	R-8	100	200	300

(This 1st issue is initialed "CHSC" for Carson Hot Springs Casino.)

Issue	Den.	Color	Mold	Inserts	Inlay	Rarity	GD30	VF65	CS95
2nd	1.00	Red	Sm-key	None	HS	R-6	75	150	225
	5.00	Gry/Blu	Sm-key	None	HS	R-6	75	150	225
	25.00	Lt Green	Sm-key	None	HS	R-7	125	250	375

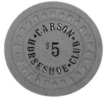
Carson Horseshoe Club $5 (1st)

CARSON STATION CARSON CITY 1989

Issue	Den.	Color	Mold	Inserts	Inlay	Rarity	GD30	VF65	CS95
1st	.25	Grey	H&C	None	HS	R-1	1	2	3
	5.00	Red	H&C	2dkorg2ltorg	R-white	R-1	*	5	7
	25.00	Green	H&C	4grn4blu	SCA-white	R-2	*	25	30
	100.00	Black	H&C	6yel3org	HUB-white	R-4	*	100	125
	n/d	Pink	H&C	None	HS	R-5	5	10	15

CARSON VICTORY CLUB CARSON CITY 1975-91

Issue	Den.	Color	Mold	Inserts	Inlay	Rarity	GD30	VF65	CS95
1st	1.00	Blue	H&C	None	HS	R-4	10	20	30
	5.00	Red	H&C	4pnk4yel	HS	R-3	15	30	45
	25.00	Green	H&C	3blu3org3pur	HS	R-4	25	50	75

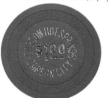
Carson Hot Springs $1 (2nd)

CAVE CARSON CITY 1966-68

Issue	Den.	Color	Mold	Inserts	Inlay	Rarity	GD30	VF65	CS95
1st	1.00	Yellow	Horshu	None	HS	R-4	25	50	75
	5.00	Black	Horshu	None	HS	R-4	25	50	75

CHUCK'S GOLDEN SPIKE CARSON CITY 1976-80

Issue	Den.	Color	Mold	Inserts	Inlay	Rarity	GD30	VF65	CS95
1st	.25	Yellow	H&C	None	HS	R-2	3	6	12
	1.00	Blue	H&C	None	HS	R-2	3	6	12
	5.00	Red	H&C	3org	R-white	R-1	5	10	15
	25.00	Green	H&C	3pur	R-white	R-1	7	14	21
	100.00	Black	H&C	3red3blu	R-white	R-3	12	24	36
	NN 1.00	Pink	H&C	None	HS	R-3	5	10	15
	NN 5.00	Orange	H&C	None	HS	R-3	5	10	15

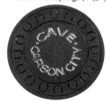
Cave $5 (1st)

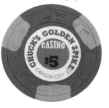
Chuck's Golden Spike $5 (1st)

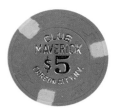

Club Maverick $5 (1st)

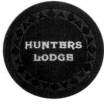

Hunters Lodge $5 (1st)

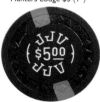

JJV $5 (1st)

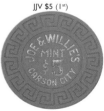

Joe & Willie's Mint $5 (1st)

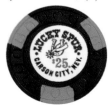

Lucky Spur $25 (1st)

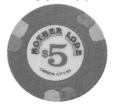

Mother Lode $5 (1st)

Issue	Den.	Color	Mold	Inserts	Inlay	Rarity	GD30	VF65	CS95
CLUB MAVERICK			CARSON CITY		1981-82				
1st	1.00	White	H&C	None	HS	R-4	15	30	45
	5.00	Red	H&C	3pnk	HS	R-6	30	60	90
EMBERS			CARSON CITY		1965-65				
1st	1.00	Maroon	Lg-key	3lav	HS	R-5	10	20	30
	5.00	Navy	Lg-key	3grn	HS	R-5	10	20	30
(Initialed "MD" for Mike Demas.)									
HAL DORN (K-BAR)			CARSON CITY		1981-81				
1st	1.00	Grey	Lg-key	None	HS	R-3	5	10	15
	5.00	Red	Lg-key	None	HS	R-3	5	10	15
HUNTERS LODGE			CARSON CITY		1939-67				
1st	5.00	Black	Arodie	None	HS	R-6	60	120	180
2nd	5.00	Maroon	Sm-key	None	HS	R-9	150	300	450
	20.00	Red	Sm-key	None	HS	R-5	40	80	120
3rd	1.00	Mustard	Lg-key	None	HS	R-8	50	100	150
	5.00	Navy	Lg-key	None	HS	R-9	100	200	300
JJV			CARSON CITY		1940'S				
1st	5.00	Black	Arodie	2red	HS-white	R-5	25	50	75

(Found years ago, only two chips were given out. The remainder of the box has not hit the market yet. The discoverers attributed this chip to a club in Carson City. Later information shows owner Joe Vialani, but no club affiliation. He may have operated games in the area.)

Issue	Den.	Color	Mold	Inserts	Inlay	Rarity	GD30	VF65	CS95
JOE & WILLIE'S MINT			CARSON CITY		1970-77				
1st	5.00	Red	Lg-key	None	HS	R-9	250	500	750
KIT CARSON CLUB			CARSON CITY		1960-68				
1st	1.00	Maroon	Sm-key	None	HS	R-4	20	40	60
	5.00	Purple	Sm-key	3grn	HS	R-4	25	50	75
	25.00	Mustard	Sm-key	3pur	HS	R-5	35	70	105
2nd	5.00	Green	C&J	3org	HS	R-3	10	20	30
	25.00	Orange	C&J	3grn	HS	R-4	15	30	45
LUCKY SPUR			CARSON CITY		1973-78				
1st	5.00	Brown	Horshu	3yel	R-white	R-5	30	60	90
	25.00	Black	Horshu	3pnk	R-white	R-5	30	60	90

(A quantity of $5 chips hit the market on eBay in 1999 which has lowered the value from last year.)

Issue	Den.	Color	Mold	Inserts	Inlay	Rarity	GD30	VF65	CS95
MINT, THE			CARSON CITY		1977-80				
1st	.25	Purple	Scrown	None	HS	R-4	10	20	30
	1.00	Orange	Scrown	4grn	R-white	R-3	12	24	36
	5.00	Yellow	Scrown	4blu	R-white	R-4	12	24	36
	25.00	Red	Scrown	4gry	R-white	R-8	60	120	180

(Many of above are cancelled by a small drill hole that goes just part way through.)

Issue	Den.	Color	Mold	Inserts	Inlay	Rarity	GD30	VF65	CS95
MOTHER LODE			CARSON CITY		1983-89				
1st	5.00	Red	H&C	3ltblu3yel	R-white	R-7	50	100	150
	25.00	Lt Green	H&C	3org3blu	SCA-white	Unique	400	800	1200
ORMSBY HOUSE			CARSON CITY		1972-				
1st	.50	Orange	Scrown	None	HS	R-7	50	100	150

Issue	Den.	Color	Mold	Inserts	Inlay	Rarity	GD30	VF65	CS95
	1.00	Blue	Scrown	None	R-white	R-3	10	20	30
	5.00	Red	Scrown	4grn	R-white	R-4	17	34	51
	25.00	Green	Scrown	4red	R-white	R-6	60	120	180
	25.00	Grey	Scrown	4brn	R-white	R-6	50	100	150
	100.00	Black	Scrown	4yel	R-white	R-6	70	140	210
	RLT	3 diff.	Scrown	None	HS	R-7	10	20	30

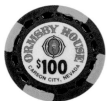

Ormsby House $100 (1st)

(Colors: Purple, Pink, and Yellow.)

Issue	Den.	Color	Mold	Inserts	Inlay	Rarity	GD30	VF65	CS95
2nd	.25	Yellow	H&C	None	HS	R-4	6	12	18
	5.00	Red	Chipco	None	FG	R-2	8	16	24

(Above marked 1860-1991 and was used on the tables.)

Issue	Den.	Color	Mold	Inserts	Inlay	Rarity	GD30	VF65	CS95
	NCV	Purple	H&C	4ltblu	HS	R-5	8	16	24
	NCV	Green	H&C	4org	HS	R-5	8	16	24
3rd	1.00	Grey	H&C	None	R-white	R-1	*	2	4
	5.00	Red	H&C	4yel4pch	R-white	R-1	*	5	10
	5.00	Red	Chipco	None	FG	R-2	*	5	10

(Above marked 1996 and was issued when the casino reopened.)

Issue	Den.	Color	Mold	Inserts	Inlay	Rarity	GD30	VF65	CS95
	25.00	Green	H&C	8tan	R-white	R-2	*	25	35
	100.00	Black	H&C	4grn4pur4org	R-white	R-3	*	100	120
	RLT	3 diff.	Scrown	None	HS	R-3	2	4	6

Ormsby House $5 (3rd)

(Colors are Fuchsia, Pink, and Yellow.)

PINON PLAZA			**CARSON CITY**		**1995-**				
1st	.25	Dk Pink	H&C	None	HS	R-2	*	2	4
	5.00	Red	H&C	3lav3pur	R-white	R-1	*	5	10
	25.00	Green	H&C	2lav2gld	R-white	R-1	*	25	35
	100.00	Black	H&C	6org6grn	R-white	R-3	*	100	125

Pinon Plaza $5 (1st)

SENATOR BAR			**CARSON CITY**		**1948-59**				
1st	.50	Red	Hub	None	HS	R-8	100	200	300
	5.00	Yellow	Hub	None	HS	R-4	20	40	60

(Most of above are cancelled by scraping off the demnomination on the reverse.)

SENATOR CLUB			**CARSON CITY**		**1955-70**				
1st	5.00	Black	Sm-key	None	HS	R-7	100	200	300
	n/d	Red	Arodie	None	HS	R-5	40	80	120

Senator Club $5 (1st)

(Senator Club became Cactus Jacks in 1971. Originally, this was a bar and café located 2 blocks South on the opposite side of the street.)

SILVER SPUR			**CARSON CITY**		**1955-73**				
1st	.25	Green	Hub	None	HS-silver	R-6	30	60	90
	1.00	Pink	Diamnd	None	HS-silver	R-4	15	30	45
	5.00	Black	Hub	2gry	HS-silver	R-5	30	60	90
	25.00	Beige	Hub	2red	HS-silver	R-5	35	70	105
	n/d	Grey	Hub	None	HS-silver	R-4	10	20	30
2nd	1.00	Orange	Sm-key	None	HS-silver	R-5	20	40	60

Silver Spur $1 (2nd)

(This chip pictures a spur on one side and the denomination on the other.)

TOMMY'S VICTORY CLUB			**CARSON CITY**		**1933-54**				
1st	1.00	Purple	T's	None	HS	R-9	150	300	450
2nd	.25	Red	Lcrown	None	HS	R-10	100	200	300

(This chip, initialed "VC," was obtained from owner Jack Scoles by Phil Jensen.)

TRAVELODGE			**CARSON CITY**		**1978-79**				
1st	5.00	Red	H&C	4grn	R-white	R-9	350	700	1050

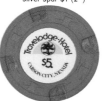

Travelodge $5 (1st)

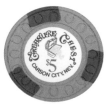

Treasure Chest $5 (1st)

Zieglers Carson Inn $5 (1st)

Desert Inn n/d (1st)

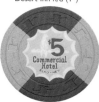

Commercial Hotel $5 (2nd)

Crumley Hotels RLT (1st)

Crumley Hotels RLT (3rd)

Issue	Den.	Color	Mold	Inserts	Inlay	Rarity	GD30	VF65	CS95
TREASURE CHEST			**CARSON CITY**		**1970-73**				
1st	1.00	Cream	Diasqr	None	HS	R-9	50	100	150
	5.00	Red	Diasqr	None	HS	R-10	50	100	150

(Above are only attributed here. This mold was used in the Carson City area but no records prove that these two chips were used here.)

2nd	5.00	Lime	Horshu	3grn	R-white	R-5	40	80	200
	25.00	Black	Horshu	3red	R-white	R-6	100	200	300

(Chip dealer Bob Feeney discovered close to a box of $5 chips, mostly very worn; and exactly 32 $25 chips. Fortunately, most of the $25 pieces are in nice condition. Rumors of large quantities of these chips have been proven to be complete nonsense. If true, these attractive and desirable chips would be widely available, and they are not.)

ZIEGLERS CARSON INN			**CARSON CITY**		**1961-61**				
1st	5.00	Black	Sm-key	None	HS	R-7	40	80	120

(This chip is marked "ZCI".)

DESERT INN			**CONTACT**		**1951-60s**				
1st	.25	Green	Sqincr	None	HS	Unique	250	500	750
	5.00	Yellow	Sqincr	None	HS	Unknown	250	500	750
	25.00	Black	Sqincr	None	HS	Unknown	250	500	750
	n/d	Red	Sqincr	None	HS	R-10	200	400	600

(This new find was made by Bud Meyer in 1999. Records show that only 50 of the $25's were made. There were also 200 $5 chips and 600 quarters made. This area was called Mineral Hot Springs, Contact, Nevada and was near Highway 93 down from Jackpot. Gambling originated here before Jackpot existed.)

COMMERCIAL HOTEL			**ELKO**		**1955-**				
1st	1.00	Lt Green	C&J	None	HS	R-10	250	500	750

(This new discovery is probably the 1st issue with the 2 bears logo. One found mint, one holed.)

2nd	1.00	Dk Blue	C&J	3bei	R-blue	R-8	200	400	600
	5.00	Pur/Gry	C&J	½pie	SCA-lt blue	R-9	250	500	750
3rd	5.00	Orange	C&J	3grn	SCA-lt blue	R-8	200	400	600
	25.00	Grn/Blk	C&J	½pie	SCA-lt blue	R-2	25	50	100

(Above $25 {1960's issue} is probably the oldest chip still in use in Nevada. Rare in top condition.)

4th	5.00	Orange	Horshu	3blk	R-blue	R-9	200	400	600
5th	5.00	Orange	Nevada	3grn	SCA-blue	R-7	100	200	400
6th	5.00	Red	BJ-2	6yel	COIN	R-1	*	5	10
7th	1.00	White	H&C	2pur2grn	R-green	R-1	*	2	4

(This old hotel originally opened Oct. 1, 1925. The casino was known as the Monte Carlo.)

CRUMLEY HOTELS			**ELKO**		**1931-55**				
1st	5.00	Blue	Sm-key	3grn	HS-wht (SS)	R-4	20	40	50
	25.00	Black	Sm-key	3crm	HS-wht (SS)	R-4	25	50	75
	RLT	Red	S's	None	HS	R-7	30	60	90
	RLT	4 diff.	S's	None	HS	R-10	50	100	150

(Colors: Blue, Green, White, and Yellow.)

2nd	5.00	Blue	Sm-key	3grn	HS	R-3	15	30	45

(There are two versions of this chip - both with large and small "5".)

	25.00	Black	Sm-key	3crm	HS	R-4	20	40	60
3rd	n/d	Red	Arodie	None	HS	R-7	30	75	150
	RLT	5 diff.	HCE	None	R-white	R-6	20	40	60

(Colors: Blue, Green, Red, White, and Yellow.)

(Great picture chips of Newt Crumley ownership, possibly used at the Ranch Inn. Later, this old hotel was owned by Bing Crosby. The Crumley, Inc. chips were used by the company at their two hotels, Ranch Inn & Commercial. Oddly enough, there never was a Crumley Hotel - this was just the company name!)

Issue	Den.	Color	Mold	Inserts	Inlay	Rarity	GD30	VF65	CS95
GOLD COUNTRY MOTOR INN			**ELKO**		**1994-**				
1st	.50	Purple	BJ	None	HS	R-1	*	2	4
	5.00	Red	BJ-2	4grn	COIN- brass	R-1	*	5	10
	25.00	Green	BJ-2	4yel	COIN- brass	R-1	*	*	25
	100.00	Black	BJ-2	8yel4grn	COIN- brass	R-2	*	*	100
JACKPOT CLUB			**ELKO**		**1954-c.1957**				
1st	5.00	Blue	Arodie	3red	HS	R-5	75	150	225
NEW DEAL CLUB			**ELKO**		**1931-53**				
1st	5.00	Yellow	Sm-key	None	HS	R-5	30	60	90
	10.00	Green	Sm-key	None	HS	R-5	35	70	105
	25.00	Black	Sm-key	None	HS	R-6	40	80	120

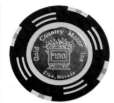
Gold Country MI $100 (1st)

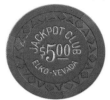
Jackpot Club $5 (1st)

Ranchinn $5 (1st)

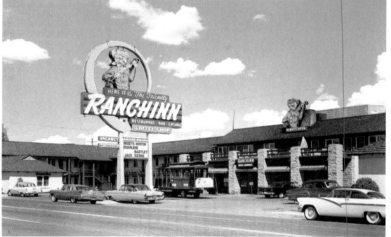
Late 1950s postcard of the Ranchinn, in Elko, celebrating their new sign, which resembles the desirable inlaid chips of this period. ©Eric J. Seaich Co., Salt Lake City, UT.

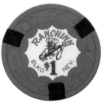
Ranchinn $1 (2nd)

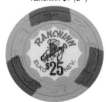
Ranchinn $25 (2nd)

Issue	Den.	Color	Mold	Inserts	Inlay	Rarity	GD30	VF65	CS95
RANCHINN			**ELKO**		**1946-79**				
1st	5.00	Blue	Hub	None	HS	R-6	50	100	150
	100.00	Mustard	Hub	None	HS	Unique	200	400	600
	100.00	Mustard	Zigzag	None	HS	R-10	200	400	600
2nd	.50	Dk Green	C&J	None	HS	R-10	100	200	300
	1.00	Orange	C&J	None	HS	R-9	50	100	150
	1.00	Red	C&J	3blk	SCA-white	R-6	100	200	300
	5.00	Brown	C&J	3yel	SCA-white	R-7	140	280	420
	25.00	Grey	C&J	3red3grn	SCA-white	R-10	400	800	1200
	RLT	Brown	C&J	None	SCA-white	R-10	100	200	300
	RLT	Lt Green	C&J	None	SCA-white	R-10	100	200	300
	RLT	Navy	C&J	None	SCA-white	R-10	100	200	300
3rd	1.00	Red	Horshu	3grn	R-white	R-4	20	40	60
	5.00	Brown	Horshu	3ltbrn	R-white	R-3	15	30	45
	25.00	Grey	Horshu	3pur	R-white	R-3	25	50	75
4th	1.00	Black	Lg-key	None	HS	R-7	75	150	225
	5.00	Mustard	Lg-key	None	HS	R-8	100	200	300

(Ranchinn became Royal Crest in 1981, but it all burned down in the early 90's and is now a bank.)

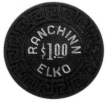
Ranchinn $1 (4th)

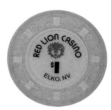

Red Lion Casino $1 (1st)

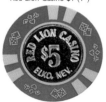

Red Lion Casino $5 (2nd)

Red Lion Motor Inn $5 (1st)

Royal Crest Ranchinn $1 (1st)

Silver Dollar $25 (1st)

Issue	Den.	Color	Mold	Inserts	Inlay	Rarity	GD30	VF65	CS95
RED LION CASINO & INN			**ELKO**		**1982-**				
1st	1.00	Yellow	H&C	None	HS	R-5	8	16	24
	5.00	Pink	H&C	None	HS	R-6	12	24	36

(These first issue chips were used in the poker room several years after their release. In 1997, the entire remaining group was buried in concrete.)

2nd	5.00	Red	BJ-2	6grn	COIN	R-1	*	5	10
	25.00	Green	BJ-2	12yel	COIN	R-1	*	25	32
	100.00	Black	BJ-2	6wht3red	COIN	R-2	*	100	115
3rd	1.00	Blue	H&C	None	R-white	R-1	*	2	4
RED LION MOTOR INN			**ELKO**		**1972-94**				
1st	5.00	Green	BJ-2	12red	COIN- brass	R-6	20	40	60
	25.00	Yellow	BJ-2	4grn	COIN- brass	R-8	50	100	150

(Note: The Red Lion Motor Inn is not the same place as the Red Lion Casino & Inn.)

ROSE'S LUCKY STRIKE			**ELKO**		**1969-69**				
1st	5.00	Yellow	Sqincr	None	HS	Unknown	125	250	375
	10.00	Red	Sqincr	None	HS	Unique	100	200	300
	15.00	Green	Sqincr	None	HS	Unique	100	200	300
	20.00	Black	Sqincr	None	HS	R-10	100	200	300

(These interesting chips come from a brothel that is now called PJ's - still in Elko behind the Stockmen's. Originally 500 each of the $10 & $15 chips were ordered as well as 100 of the $20's. These unusually odd denominations were probably enough for a table or two but no records show live gaming here. Maybe these were used for something else? Burned down 11-13-69.)

ROYAL CREST RANCHINN			**ELKO**		**1981-84**				
1st	1.00	Grey	H&C	None	HS	R-4	10	20	30
	5.00	Red	H&C	4wht4ltblu	HS	R-5	25	50	75
	25.00	Green	H&C	4pch4gry	HS	R-5	25	50	75
SILVER DOLLAR CLUB			**ELKO**		**1931-55**				
1st	n/d	Red	Sm-key	None	HS	R-5	25	50	75
	n/d	Blue	Sm-key	None	HS	R-5	25	50	75
	n/d	Black	Sm-key	None	HS	R-7	30	60	90
	n/d	White	Sm-key	None	HS	R-5	25	50	75
SILVER DOLLAR SALOON			**ELKO**		**1991-96**				
1st	5.00	Red	HHR	2yel	R-white	R-2	5	10	15
	25.00	Green	HHR	3bei	R-white	R-2	12	24	36
STAGE-COACH INN			**ELKO**		**1955-64**				
1st	1.00	Lavender	Diamnd	None	HS	R-9	200	400	600

(Only 4 chips were found in 1995 - by a couple cleaning out their drawers. They had been married here.)

Stage-Coach Inn $1 (1st)

Issue	Den.	Color	Mold	Inserts	Inlay	Rarity	GD30	VF65	CS95

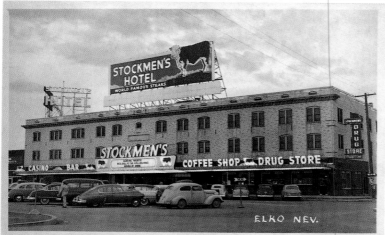

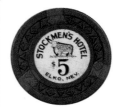

Stockmen's Hotel $5 (1st)

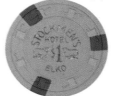

Stockmen's Hotel $1 (2nd)

A postcard from a small-town club that has produced a lot of classic chips, Stockmen's Hotel in Elko. The unique $5 Arodie specimen is arguably the best small-town chip in existence.

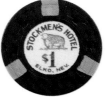

Stockmen's Hotel $1 (3rd)

STOCKMEN'S HOTEL ELKO 1944-

Issue	Den.	Color	Mold	Inserts	Inlay	Rarity	GD30	VF65	CS95
1st	1.00	Black	Diamnd	None	HS	R-8	175	350	525
	5.00	Blue	Arodie	3red	R-white	Unique	1250	2500	3750
2nd	1.00	Grey	C&J	3grn	HS	R-8	150	300	450
3rd	1.00	Black	C&J	3yel	R-white	R-9	250	500	750
	5.00	Mustard	C&J	3red	R-white	R-9	300	600	900
4th	5.00	Orange	C&J	3blk	R-white	R-8	200	400	600
	25.00	Red	Horshu	3mst	R-white	R-10	400	800	1200
	RLT	Beige	Horshu	None	HS	R-10	20	40	60
	RLT	Blue	Horshu	None	HS	R-10	20	40	60
	RLT	Brown	Horshu	None	HS	R-10	20	40	60
5th	5.00	Orange	H&C	3blk	MC-black	R-4	10	20	30
	5.00	Blue	H&C	3pur3org	MC-black	R-10	50	100	150
	25.00	Blue	H&C	2org2yel	MC-blue	R-10	50	100	150
	25.00	Red	H&C	4gry4blu	MC-silver	R-10	50	100	150

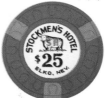

Stockmen's Hotel $25 (4th)

(Above three chips are sample prototypes, although not notched.)

	25.00	Pink	H&C	3ltblu	MC-blue	R-5	25	50	75
	100.00	White	H&C	3pur3blu	R-white	R-4	*	100	125
	RLT	Yellow	H&C	None	R-white	R-5	5	10	15
	RLT	Purple	H&C	None	R-white	R-5	5	10	15

(Other colors on tables, 6 or 7 in all. Very hard to acquire as table is usually not busy.)

6th	1.00	Blue	H&C	None	R-blue	R-2	4	8	12

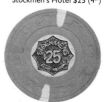

Stockmen's Hotel $25 (5th)

(This $1 chip, misspelled "Stockman's", was ordered around 1995. When this was found, the 5th issue $5 Orange and $25 Pink were finally changed. They had been in use since March of 1977. The $100 chip remains current.)

7th	.25	Orange	H&C	None	HS	R-2	*	2	4
	1.00	Blue	H&C	None	OR-multi	R-1	*	2	3
	5.00	Red	H&C	2pnk2grn	R-multi	R-1	*	5	7
	25.00	Green	H&C	4ltblu4pur	R-multi	R-1	*	25	30

(Released in 1977, seventh issue chips are marked "Stockmen's Motor Hotel.")

AIRPORT LODGE ELY 1942-70

Issue	Den.	Color	Mold	Inserts	Inlay	Rarity	GD30	VF65	CS95
1st	5.00	Brown	Diasqr	None	HS	R-7	100	200	300

(Located a few miles out on Hwy. 50 toward the airport; eventually became Fireside Inn.)

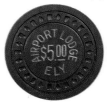

Airport Lodge $5 (1st)

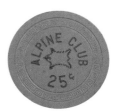

Alpine Club 25c (1st)

Alpine Club $5 (1st)

Bank Club $5 (1st)

Bank Club RLT (1st)

Bank Club $5 (2nd)

Bank Club RLT (2nd)

Issue	Den.	Color	Mold	Inserts	Inlay	Rarity	GD30	VF65	CS95
ALPINE CLUB			**ELY**			**1944-55**			
1st	.25	Orange	Sm-key	None	HS	R-10	400	800	1200
	5.00	Lt Green	Sm-key	3red	R-yellow	Unique	1250	2500	3750
	25.00	Black	Sm-key	3pur	R-yellow	R-9	750	1500	3000

(This is without doubt one of the nicest small town chips, due to the small key mold and classic picture. This club burned down in June of 1955. The remains were taken to the dump where years ago some burned chips were found, mostly of the $25 denomination, of which about 5 are known.)

2nd	1.00	Brown	TK	None	HS	R-10	250	500	750

ANTLERS CLUB			**EAST ELY**			**1918-38**			
1st	n/d	Blue	Hub	None	HS	R-6	25	50	75

(These well used chips were found in Nevada with chips from the 1940's Reno Casino. These chips were originally ordered in 1938 from Kansas City - a then-common area for chip manufacture and distribution. As we know throughout gaming history, licensed and unlicensed game owners carried their chips around! Just because a chip was sent to a home or bar doesn't necessarily mean those chips were used there. Most likely, these chips were used in Ely and very possibly other Nevada clubs.)

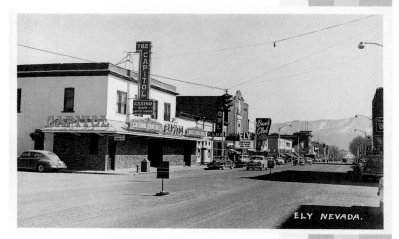

A good 1950s postcard view of downtown Ely, clearly showing the Bank Club, Capitol Club, and Owl Club.

BANK CLUB			**ELY**			**1937-68**			
1st	5.00	Black	Sm-key	3red	HS	R-5	20	40	80

("Bank Club, Inc.".)

	25.00	Black	Sm-key	None	HS	R-8	30	60	90
	n/d	Lt Green	Sm-key	None	HS	R-8	20	40	60
	n/d	Turq.	Sm-key	None	HS	R-8	20	40	60

(Above two chips are marked BC in small letters only. The $25 is large letters.)

	RLT	Lt Green	Sm-key	None	HS	R-6	20	40	60
	RLT	Brown	Sm-key	None	HS	R-7	25	50	75
	RLT	Yellow	Sm-key	None	HS	R-8	30	60	90
	RLT	Red	Sm-key	None	HS	R-8	30	60	90

(Above roulettes have a clover pictured with "Bank Club".)

2nd	5.00	Orange	Arodie	None	HS	R-6	50	100	150
	RLT	4 diff.	Arodie	None	HS	R-8	50	100	150

(Colors: Black, Blue, Red, and White.)

3rd	.50	Beige	Horshu	None	HS	R-7	20	40	60

Issue	Den.	Color	Mold	Inserts	Inlay	Rarity	GD30	VF65	CS95
	1.00	Black	Horshu	None	HS	R-6	15	30	45
	5.00	Dk Pink	Horshu	3blk	HS	R-9	35	70	105
	25.00	Blue	Horshu	None	HS	R-6	20	40	60

(Above .50, $1, & $25 are only marked "BC".)

	RLT	Beige	.	Horshu	None	HS	R-5	20	40	60

(Same chip but with $1.00 overstamped on one side. The club probably needed extra dollars.)

	RLT	Maroon	Horshu	None	HS	R-7	25	50	75
	RLT	Blue	Horshu	None	HS	R-7	25	50	75

(Above roulette chips have a slot machine pictured with money spilling out.)

Issue	Den.	Color	Mold	Inserts	Inlay	Rarity	GD30	VF65	CS95
4th	1.00	Dk Pink	C&J	None	HS	R-4	10	20	30
5th	1.00	Dk Pink	Diecar	None	HS	R-3	10	20	30
	5.00	Beige	Diecar	3mar	HS	R-3	8	16	24
	25.00	Lt Green	Diecar	3org	HS	R-3	9	18	27
	25.00	Dk Green	Diecar	None	HS	R-3	8	16	24
	100.00	Black	Diecar	3mst	HS	R-4	15	30	45

Bank Club RLT (3rd)

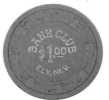

Bank Club $1 (4th)

CAPITOL CLUB　　ELY　　1931-55

Issue	Den.	Color	Mold	Inserts	Inlay	Rarity	GD30	VF65	CS95
1st	5.00	Brown	Hub	2org	HS	R-6	75	150	225
	n/d	White	Hub	None	HS	R-10	100	200	300

(Marked "CA" in a horseshoe. In 1939, 1,360 of these chips were ordered for the Capitol Buffet.)

2nd	5.00	Black	Diasqr	None	HS	Unique	200	400	600

(This club burned down one night in June, 1955.)

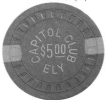

Capitol Club $5 (1st)

CHIEF, THE　　ELY　　1940's

Issue	Den.	Color	Mold	Inserts	Inlay	Rarity	GD30	VF65	CS95
1st	n/d	Lt Pink	Sm-key	None	HS	R-10	50	150	300
	n/d	Yellow	Sm-key	None	HS	R-10	75	225	450
	n/d	Blue	Sm-key	None	HS	R-10	75	225	450

(Chip has great picture of an Indian in full headdress, but no club name or city location. Only a couple of each were found. Located on the corner next to Hotel Nevada.)

The Chief n/d (1st)

CHRIS'S LOUNGE　　ELY　　1962-67

Issue	Den.	Color	Mold	Inserts	Inlay	Rarity	GD30	VF65	CS95
1st	5.00	Maroon	Sm-key	None	HS	R-9	40	80	120

(Chip is only initialed "C B" for Chris Barnamus who owned Chris's Lounge, situated next to the Northern.)

COLLINS COURT CASINO　　ELY　　1992-92

Issue	Den.	Color	Mold	Inserts	Inlay	Rarity	GD30	VF65	CS95
1st	5.00	Red	BJ	4wht	HS	R-7	50	100	150
	25.00	Green	BJ	8wht	HS	R-10	150	300	450

(This short-lived casino has rare chips because only a few walked out. The casino was forced to close due to a skimming operation. The local sheriff confiscated the chips and turned them over to Gaming to be destroyed and they were. James Campiglia purchased a stack of 20 $5 chips and may have been the only collector to do so. The $25 may be an R-9, but there are only three chips absolutely confirmed to exist.)

Collins Court Casino $5 (1st)

COMMERCIAL CLUB (CC)　　ELY　　1940's

Issue	Den.	Color	Mold	Inserts	Inlay	Rarity	GD30	VF65	CS95
1st	n/d	Lt Lav	Zigzag	None	HS	R-10	30	60	90

(Chips marked "CC" and were found in obscure Ruth, Nevada.)

COPPER CLUB (CC)　　ELY　　1931-56

Issue	Den.	Color	Mold	Inserts	Inlay	Rarity	GD30	VF65	CS95
1st	n/d	Red	Hub	None	HS	R-6	15	30	45
	n/d	White	Hub	None	HS	R-6	15	30	45
	n/d	Blue	Hub	None	HS	R-6	15	30	45
	n/d	Green	Hub	None	HS	R-6	15	30	45
	n/d	Yellow	Hub	None	HS	R-6	15	30	45

(Chips only marked "CC" interlocked. Owned by Harvey Lambert, the Copper Club was one of Ely's first legal casinos in 1931. As happened to many casinos in Ely, the building died via fire late on the night of May 5, 1956. According to the Mason Archives, the above set of chips was ordered in 1951 in quantities of 400. Today, about half a box of each remain.)

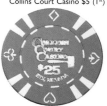

Collins Court Casino $25 (1st)

245

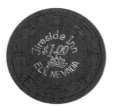

Fireside Inn $1 (1st)

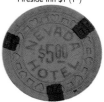

Hotel Nevada $5 (1st)

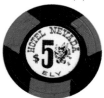

Hotel Nevada $5 (5th)

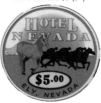

Hotel Nevada $5 (9th)

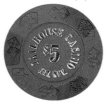

Jailhouse Casino $5 (1st)

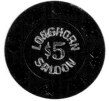

Longhorn Saloon $5 (1st)

Issue	Den.	Color	Mold	Inserts	Inlay	Rarity	GD30	VF65	CS95
FIRESIDE INN			ELY		**1970-74**				
					1982-94				
1st	1.00	Purple	C&J	None	HS	R-6	20	40	60
	5.00	Green	C&J	3mst	HS	R-6	30	60	90
2nd	1.00	Dk Purple	H&C	None	HS	R-5	15	30	45
	5.00	Green	H&C	3yel	HS	R-6	25	50	75
HOTEL NEVADA,			ELY		**1932-**				
NEVADA HOTEL									
1st	5.00	Yellow	Rcthrt	3nvy	HS	R-4	25	75	150
2nd	5.00	Dk Pink	C&J	None	HS	R-6	30	60	90
(Above two marked with early logo "Eastern Nevada's Finest" on reverse.)									
3rd	.10	Orange	C&J	None	HS	R-5	20	40	60
	.50	Green	C&J	None	HS	R-7	25	50	75
	RLT	5 diff.	C&J	None	HS	R-5	8	16	24
(Colors: Navy, Orange, Purple, Red, and Yellow. First through third issues say "Nevada Hotel.")									
4th	.25	Beige	C&J	None	HS	R-6	20	40	60
	5.00	Brown	C&J	3mst	HS	R-4	18	36	54
5th	.25	Pink	H&C	None	HS	R-5	12	24	36
(Larger printing than the 7th issue.)									
	1.00	Orange	C&J	3grn	R-white	R-3	10	20	30
	5.00	Black	C&J	3red	R-white	R-4	20	40	60
6th	5.00	Brown	Nevada	3mst	HS	R-4	15	30	45
7th	.25	Pink	H&C	None	HS	R-5	9	18	27
	.50	Yellow	H&C	None	HS	R-5	7	14	21
	1.00	Blue	H&C	None	R-white	R-3	6	12	18
	5.00	Brown	H&C	3yel	R-white	R-3	6	12	18
8th	.50	Yellow	BJ	None	HS	R-3	3	6	9
	1.00	Blue	H&C	None	R-white	R-3	5	10	15
	5.00	Red	H&C	4grn4blu	HUB-white	R-1	*	5	10
	25.00	Green	H&C	4pur4yel	SCA-white	R-1	*	25	50
	100.00	Black	H&C	6tan3pur	COG-white	R-3	20	40	60
(The above $5 & $25 issues are still in use.)									
9th	2.50	Blue	Chipco	None	FG	R-2	*	3	6
	5.00	Red	Chipco	None	FG	R-2	*	5	10
(Above are commemorative issues dated September 96 for the Pony Express ride, but are used on the tables.)									
JAILHOUSE CASINO			ELY		**1981-85**				
1st	.50	Orange	BJ	None	HS	R-3	3	6	9
	5.00	Maroon	Diecar	3blu	HS	R-3	5	10	15
	25.00	Green	Diecar	3pnk	HS	R-6	12	24	36
	25.00	Dk Green	Diecar	3pnk	HS	R-5	10	20	30
(Still open as a slot-only casino and decorated with great old pictures of Ely-area mining towns.)									
LONGHORN SALOON			ELY		**1970's-77**				
1st	5.00	Black	Diecar	None	HS	R-8	60	120	180
(Club burned down in June 1977.)									
MINERS CLUB			ELY		**1931-40's**				
1st	n/d	Black	Sm-key	None	HS	R-7	75	150	225
	n/d	Pink	Sm-key	None	HS	R-10	100	200	300
(Once attributed to Miners Club at Mountain City, these chips are now positively known to be from Ely.)									

Issue	Den.	Color	Mold	Inserts	Inlay	Rarity	GD30	VF65	CS95
MUSTANG CLUB		**ELY**			**1967-74**				
1st	pan .10	Lt Green	C&J	None	HS	R-10	175	350	525
	.25	Brown	C&J	None	HS	R-9	100	200	300
	1.00	Yel/Red	C&J	Dovetail-red	HS	R-7	60	120	180
	1.00	Yel/Red	C&J	Dovetail-yellow	HS	R-6	50	100	150
	pan 2.00	Orange	C&J	None	HS	R-10	150	300	450
	5.00	Yellow	C&J	3nvy	HS	R-10	300	600	900
2nd	5.00	Grey	Lg-key	3brn	R-white	R-8	250	500	750
3rd	1.00	Purple	Nevada	3crm	HS	R-6	40	80	120
	RLT	Beige	Horshu	None	HS	R-7	15	30	45
	RLT	Black	Horshu	None	HS	R-7	15	30	45

(According to Phil Jensen, the pan chips were very hard to acquire when in use. This is another Ely club which burned down. Mustang Club became the Saddle Club, then Winners Circle.)

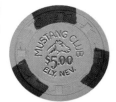

Mustang Club $5 (1st)

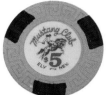

Mustang Club $5 (2nd)

Issue	Den.	Color	Mold	Inserts	Inlay	Rarity	GD30	VF65	CS95
NORTHERN LOUNGE		**ELY**			**Early 1900's to 50's**				
1st	5.00	Blue	Sm-key	None	HS	R-8	35	70	105
	5.00	Blue	Sm-key	None	HS	R-8	35	70	105

(Marked "NL", there are variants with small and large "5". The larger is believed rarer.)

2nd	Red	Rectl	None	HS		R-8	35	70	105

(Above marked NCL in block style letters for Northern Casino Lounge.)

3rd	n/d	Grey	Rectl	None	HS	R-8	25	50	75
	n/d	Lt Green	Rectl	None	HS	R-8	25	50	75

(Above marked only NL in block style letters. This original Hotel burned to the ground in 1964.)

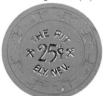

The Pit 25c (1st)

Issue	Den.	Color	Mold	Inserts	Inlay	Rarity	GD30	VF65	CS95
PIT, THE		**ELY**			**1960's-69**				
1st	.10	Yellow	C&J	None	HS	R-8	100	200	300
	.25	Lt Green	C&J	None	HS	R-8	70	140	210
	5.00	Black	C&J	3org	HS	R-8	75	150	225

(This 1st issue pictures a pick and a shovel.)

2nd	.10	Yellow	C&J	None	HS	R-8	75	150	225
	.25	Lt Green	C&J	None	HS	R-7	50	100	150
	1.00	Red	C&J	None	HS	R-8	75	150	225
	5.00	Black	C&J	None	HS	R-7	60	120	180

(This club had a fire and burned in 1969. This old brick building is reopened again as a bar.)

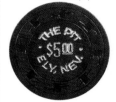

The Pit $5 (2nd)

Issue	Den.	Color	Mold	Inserts	Inlay	Rarity	GD30	VF65	CS95
SADDLE CLUB		**ELY**			**1975-79**				
1st	.25	Yellow	Scrown	None	HS	R-6	25	50	75
	1.00	Blue	Scrown	4yel	R-white	R-5	20	40	60
	5.00	Black	Scrown	None	HS-gold	R-6	30	60	90
	5.00	Black	Scrown	None	HS-silver	R-8	50	100	150

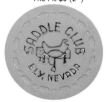

Saddle Club 25c (1st)

Issue	Den.	Color	Mold	Inserts	Inlay	Rarity	GD30	VF65	CS95
TOWN CLUB		**ELY**			**1958-59**				
1st	5.00	Blue	Arodie	3wht	HS	R-6	125	250	375

(This is a desirable Arodie as it lists the town & location, unlike many others.)

2nd	1.00	Red	Sm-key	3pur	HS	R-9	25	50	75
	5.00	Blue	Sm-key	3org	HS	R-9	25	50	75

("TC" only in odd slanted letters. Attributed to here.)

Issue	Den.	Color	Mold	Inserts	Inlay	Rarity	GD30	VF65	CS95
WINNERS CIRCLE		**ELY**			**1983-91**				
1st	5.00	Red	Diecar	3grn	HS	R-3	10	20	30
	25.00	Green	Diecar	3bei	HS	R-4	15	30	45

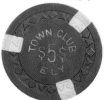

Town Club $5 (1st)

247

Louie's n/d (1st)

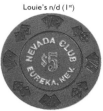

Nevada Club $5 (1st)

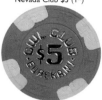

Owl Club $5 (4th)

Barney's Bank Club $5 (2nd)

Barrel House n/d (1st)

Bird Farm 10c (1st)

Issue	Den.	Color	Mold	Inserts	Inlay	Rarity	GD30	VF65	CS95
LINCOLN HOTEL			EUREKA			**1952-68**			
1st	1.00	Purple	Sm-key	None	HS	R-6	15	30	45
	5.00	Red	Sm-key	3grn	HS	Unique	50	100	150

(Above marked only "LH" in block letters.)

LOUIE'S			EUREKA			**1947-66**			
1st	n/d	Black	2Hubdi	None	HS	R-9	150	300	450

NEVADA CLUB			EUREKA			**1948- early 90's**			
1st	1.00	Beige	Diecar	None	HS	R-3	10	20	30
	5.00	Maroon	Diecar	None	HS	R-3	10	20	30
	25.00	Green	Diecar	3pnk	HS	R-4	20	40	60
2nd	1.00	White	BJ	None	HS	R-4	10	20	30

(All of the above chips exist in quantity. Some were released, but most are being held by the past owner. Values are for those currently available, but it's possible that more boxes exist as they played poker here.)

OWL CLUB			EUREKA			**1953- early 90's**			
1st	.50	Green	Rascir	None	HS	R-8	50	100	150
	1.00	Maroon	Rascir	None	HS	R-9	75	150	225
2nd	.50	Green	Sm-key	None	HS	R-9	75	150	225
	10.00	Orange	Sm-key	None	HS	R-9	75	150	225
3rd	5.00	Black	Hub	None	HS	R-9	50	100	150
	25.00	Orange	Hub	None	HS	R-9	50	100	150

(Above issues are marked VB for original owner Vic Berencia.)

	n/d	Maroon	Hub	None	HS	R-6	20	40	60

(Above chip acquired from Owl Club & is marked "Owl.")

4th	5.00	Red	H&C	4org4yel	HS	R-3	10	20	30

BARNEY'S BANK CLUB			FALLON			**1965-66**			
1st	.10	Red	Sm-key	None	HS	R-8	100	200	300
	.50	Blu-Gry	Sm-key	None	HS	R-10	125	250	375
2nd	1.00	Grey	Lg-key	3pur	HS	R-6	30	60	90
	5.00	Brown	Lg-key	3grn	HS	R-6	40	80	120

BARREL HOUSE			FALLON			**1935-52**			
1st	n/d	Orange	Lcrown	None	HS	R-7	25	50	75
	n/d	Red	Lcrown	None	HS	R-5	15	30	45
	n/d	White	Lcrown	None	HS	R-6	20	40	60
	n/d	Blue	Lcrown	None	HS	R-5	15	30	45

(Above might have been roulettes, but no other colors have been found. Originally, this was an old saloon opened in the early 1900s.)

BIRD FARM			FALLON			**1986-**			
1st	.10	Lt Blue	H&C	None	HS	R-4	*	6	12
	.25	Yellow	H&C	None	HS	R-3	*	2	4
	.50	White	H&C	None	HS	R-4	*	2	4
	1.00	Orange	H&C	None	HS	R-2	*	2	4
	5.00	Red	H&C	3blu3wht	R-white	R-2	*	5	10

(A very small club with one craps, blackjack and poker table where the dimes are used when the Military personnel come to play.)

BONANZA INN			FALLON			**1976-**			
1st	.10	Grey	Lg-key	None	HS	R-7	30	60	90
	.25	Pink	H&C	None	HS	R-5	5	10	15

Issue	Den.	Color	Mold	Inserts	Inlay	Rarity	GD30	VF65	CS95
	5.00	Brown	Nevada	None	HS	R-4	10	20	30
	25.00	Green	H&C	3grn	HS	R-5	25	50	75
2nd	.10	Brown	H&C	None	R-multi	R-3	*	4	8
	.25	Peach	H&C	None	R-multi	R-3	*	2	4
	1.00	White	H&C	None	R-multi	R-2	*	1	3
	2.50	Pink	H&C	1lav1pur	R-multi	R-3	*	4	8
	5.00	Red	H&C	3blu3grn	R-multi	R-2	*	5	10
	25.00	Dk Green	H&C	4nvy4ltblu	R-multi	R-3	*	25	35
	100.00	Black	H&C	3brn3yel3gry	R-multi	R-4	*	100	120

Bonanza Inn $5 (1st)

CLOVER CLUB FALLON 1940's

1st	5.00	Green	Sm-key	None	HS	Unique	100	200	300

(Chip has a picture of a 3-leaf clover.)

CLUB HORSESHOE FALLON 1953-76

1st	5.00	Rust	Arodie	None	HS	R-6	40	120	240

(This chip only has a picture of a horseshoe - no club name or city location.)

2nd	.25	Red	Scrown	4grn	HS	R-5	20	40	60
	.50	Orange	Scrown	4pur	HS	R-5	25	50	75
	1.00	Brown	Scrown	4yel	HS	R-4	10	20	40
3rd	.10	Black	Horshu	None	HS-white	R-10	200	400	600
	25.00	Green	Horshu	3pnk	HS-silver	R-5	50	100	150

Club Horseshoe $5 (1st)

CORNER BAR FALLON 1940's-54

1st	.10	Cream	Zigzag	None	HS	R-4	15	30	45
	.25	Rose	Zigzag	None	HS	R-4	12	24	36
	5.00	Blue	Zigzag	None	HS	R-5	20	40	60

(Above only marked "CB" in block letters - the ".10" is in larger lettering.)

Club Horseshoe $1 (2nd)

DEPOT FALLON 1987-

1st	5.00	Red	H&C	3pch3pur	R-white	R-2	*	5	10
	25.00	Green	H&C	3yel3org	SCA-white	R-2	*	25	35

EDDIE'S CLUB FALLON 1952-57

1st	n/d	Black	Arodie	None	HS	R-6	35	70	105
	n/d	Purple	Arodie	None	HS	R-8	40	80	120
	n/d	Red	Arodie	None	HS	R-8	50	100	150
2nd	.10	Purple	Sm-key	None	HS	R-10	125	250	375

(All above only marked "EHG.")

Depot $25 (1st)

ESQUIRE CLUB FALLON 1941-57

1st	.25	Red	Rcthrt	None	HS	R-7	60	120	180
	5.00	Grey	Rcthrt	3blk	HS	R-7	90	180	270
2nd	.05	Red	Scrown	None	HS	R-5	20	40	60

(Some controversy exists over this chip as one is known to have been made for a club in California. Owner Willie Cappucci states in a letter that this chip was used on his crap table. As discussed several times in this book, it was a common practice for casino owners to take their chips with them as they operated different clubs in different locales. This chip was probably used in California and Nevada. Therefore, this chip would be of value to both Nevada and California collectors, each judging the value differently.)

Eddie's Club n/d (1st)

FALLON NUGGET FALLON 1963-

1st	5.00	Red	T's	None	HS	R-6	50	100	150
	25.00	Blue	T's	None	HS	R-8	100	200	300
	100.00	Rust	T's	None	HS-blue	R-8	100	200	300

Fallon Nugget $25 (1st)

Fallon Nugget 10c (2nd)

Fallon Nugget $5 (5th)

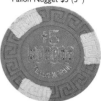

Fallon Nugget $5 (6th)

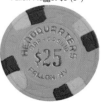

Headquarters $25 (1st)

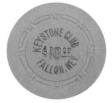

Keystone Club $10 (3rd)

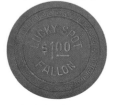

Lucky Spot $1 (1st)

Issue	Den.	Color	Mold	Inserts	Inlay	Rarity	GD30	VF65	CS95
2nd	.10	Purple	Sm-key	None	HS	R-9	125	250	375
	.25	Rust	Sm-key	None	HS	R-8	60	120	180
	5.00	Black	Sm-key	None	HS	R-7	55	110	165
3rd	.25	Orange	Scrown	3wht	HS	R-8	50	100	150
	1.00	Grey	Scrown	None	HS	R-5	10	20	30
	25.00	Black	Scrown	2gry	HS	R-9	150	300	450
	25.00	Blk/Blu	Scrown	½pie	HS	R-8	100	200	300
4th	1.00	Brown	Horshu	3gry	HS	R-6	25	50	75
5th	5.00	Red	Nevada	None	HS	R-7	40	80	120
6th	5.00	Purple	Lg-key	3bei	HS	R-7	60	120	180
7th	.25	Orange	H&C	None	HS	R-5	5	10	15
	5.00	Red	H&C	4gld4pch	HS	R-4	7	14	21
	25.00	Green	H&C	4blu4wht	HS	R-6	30	60	90
	NCV 1	Pink	H&C	None	HS	R-6	10	20	30
8th	.50	Yellow	H&C	2red2grn	OR-multi	R-3	*	2	4
	1.00	White	H&C	2pur2aqa	OR-multi	R-2	*	1	3
	2.50	Pink	H&C	4blu	OR-multi	R-3	*	4	8
	5.00	Red	H&C	4tan4org	OR-multi	R-2	*	5	10
	25.00	Grey	H&C	4blu4wht	OR-multi	R-2	*	25	35
	50.00	Purple	H&C	4pur4pnk	OR-multi	R-4	*	50	60
	100.00	Black	H&C	4grn4brn	OR-multi	R-4	*	100	130

FRANKIE'S CLUB FALLON 1957-77

1st	5.00	Navy	Sm-key	None	HS	R-5	25	50	75
	5.00	Dk Blue	Sm-key	None	HS	R-5	25	50	75

HEADQUARTERS CASINO FALLON 1987-

1st	5.00	Red	H&C	4blu4pch	HS	R-1	*	5	10
	25.00	Green	H&C	4org4nvy	HS	R-2	*	25	35
2nd	1.00	White	H&C	None	HS	R-2	*	1	3
	2.50	Pink	H&C	1blk1tan	HS	R-2	*	3	5

JERRY'S PASTIME CLUB FALLON 1965-66

1st	.10	Lt Green	Scrown	None	HS	R-10	175	350	525
	.25	Blue	Scrown	None	HS	R-5	20	40	60
	1.00	Lavender	Scrown	None	HS	R-5	25	50	75

KEYSTONE CLUB FALLON 1947-61

1st	5.00	Red	Sm-key	None	HS	R-4	20	40	60
2nd	5.00	Black	Arodie	None	HS	R-6	50	100	150
3rd	10.00	Beige	HCE	None	HS	R-4	25	50	75

LUCKY SPOT FALLON 1961-76

1st	1.00	Red	Sm-key	None	HS	R-5	20	40	60
	1.00	Yellow	Sm-key	None	HS	R-5	15	30	45

MOM'S PLACE FALLON 1961-77

1st	.10	Cream	Scrown	None	HS	R-9	100	200	300
	1.00	Red	Scrown	None	HS	R-6	30	60	90
2nd	10	Cream	Lg-key	None	HS	R-9	100	200	300

(Above chip does not have a decimal point and therefore could have been used for either a 10cent or $10 value. Mom (Emily Mitchell, the owner) was rumored to be dealing blackjack at around 100 years of age.)

Issue	Den.	Color	Mold	Inserts	Inlay	Rarity	GD30	VF65	CS95
NEVADA CLUB			**FALLON**		**1964-66**				
1st	1.00	Grey	Scrown	None	HS	R-3	10	20	30
	5.00	Red	Scrown	4gry	HS	R-4	15	30	45

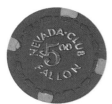

Nevada Club $5 (1st)

Issue	Den.	Color	Mold	Inserts	Inlay	Rarity	GD30	VF65	CS95
OWL CLUB			**FALLON**		**1931-51**				
1st	n/d	Brown	Hub	None	HS	R-9	20	40	60

(Only marked "OC" in outline print and block letters. These were ordered in 1947. Earlier issues are unknown.)

| 2nd | 5.00 | Black | Lcrown | None | HS | R-4 | 15 | 30 | 45 |

(Marked "LGL" in script, 200 of these chips were ordered in 1951 by owner Louie Latasa.)

Issue	Den.	Color	Mold	Inserts	Inlay	Rarity	GD30	VF65	CS95
PALACE CLUB			**FALLON**		**1939-67**				
1st	1.00	Purple	Sm-key	3org	HS	R-5	20	40	60
	5.00	Grey	Sm-key	3blk	HS	R-6	40	80	120
	20.00	Mustard	Sm-key	3pur	HS	R-7	50	100	225
	n/d	Mustard	Sm-key	None	HS	R-6	20	40	60
2nd	5.00	Maroon	Arodie	3wht	HS	R-7	100	200	400
	20.00	Mustard	Arodie	3wht	HS	R-5	50	100	150
	n/d	Navy	Arodie	None	HS	R-4	15	30	45
3rd	.10	Yellow	Scrown	None	HS	R-4	15	30	45
	.50	Green	Scrown	None	HS	R-7	35	70	105
	1.00	Navy	Scrown	3org	HS	R-4	12	24	36
4th	.25	Red	Horshu	None	HS	R-6	15	30	45
	n/d	Lavender	Horshu	None	HS	R-6	7	14	21

("PC"only.)

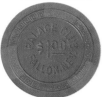

Palace Club $1 (1st)

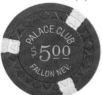

Palace Club $5 (2nd)

Issue	Den.	Color	Mold	Inserts	Inlay	Rarity	GD30	VF65	CS95
ROADSIDE INN			**FALLON**		**1946-80**				
1st	.25	Grey	Horshu	None	HS	R-10	50	100	150
	1.00	Mustard	Horshu	None	HS	R-3	6	12	18
	5.00	Brown	Horshu	3org	HS	R-3	6	12	18
	25.00	Green	Horshu	3blk	HS	R-4	12	24	36

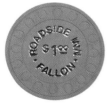

Roadside Inn $1 (1st)

Issue	Den.	Color	Mold	Inserts	Inlay	Rarity	GD30	VF65	CS95
SAGEBRUSH CLUB			**FALLON**		**1931-79**				
1st	5.00	Yellow	Lcrown	None	HS	R-7	60	120	180
2nd	n/d	Red	Arodie	None	HS	R-5	30	60	90
3rd	1.00	Purple	C&J	3yel	HS	R-5	15	30	45
	RLT	3 diff.	C&J	None	HS	R-7	10	20	30

(Colors: Beige, Red, and Green.)

4th	n/d	Green	Scrown	None	HS	R-6	10	20	30
	1.00	Pink	Scrown	3ltbrn	HS	R-3	10	20	30
	5.00	Turq.	Scrown	3ltbrn	HS	R-4	15	30	45
	25.00	Grey	Scrown	3yel	HS	R-5	20	40	50

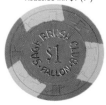

Sagebrush Club $1 (3rd)

Issue	Den.	Color	Mold	Inserts	Inlay	Rarity	GD30	VF65	CS95
STAR CLUB			**FALLON**		**1935-62**				
1st	n/d	4 diff.	Plain	None	HS	R-7	50	100	150

(Colors: Red, White, Blue, and Yellow.)

Issue	Den.	Color	Mold	Inserts	Inlay	Rarity	GD30	VF65	CS95
STOCKMAN'S			**FALLON**		**1960-**				
1st	5.00	Beige	Horshu	None	HS	R-8	100	200	300

(This chip is misspelled "Stockmen's".)

2nd	25.00	Green	Lg-key	4bei	HS	R-10	200	400	600
3rd	.25	Pink	HHR	None	HS	R-3	*	2	4
	5.00	Red	H&C	3lav3pur	R-white	R-2	*	5	10
	25.00	Green	H&C	4ltblu4wht	SCA-white	R-2	*	25	35

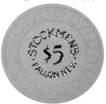

Stockman's $5 (1st)

Issue	Den.	Color	Mold	Inserts	Inlay	Rarity	GD30	VF65	CS95
FERNLEY NUGGET			**FERNLEY**		**1982-83**				
1st	5.00	Red	Horshu	3brn	R-white	R-7	75	150	225
	25.00	Brown	Horshu	3blk	R-white	R-8	100	200	300
SILVERADO CASINO			**FERNLEY**		**1994-**				
1st	5.00	Red	BJ-2	4wht	R-white	R-1	*	5	10
	25.00	Green	BJ-2	8yel	R-white	R-1	*	25	35
STURGEONS			**FERNLEY**		**1989-94**				
1st	5.00	Red	BJ-2	8gry	COIN	R-5	10	20	30
	25.00	Green	BJ-2	12gry	COIN	R-8	50	100	150
TRUCK INN			**FERNLEY**		**1984-98**				
1st	5.00	Red	Chipco	None	FG	R-4	5	10	15
	25.00	Green	Chipco	None	FG	R-5	15	30	45

(Opened as a slot house, live gaming started about 1990. Removed in 98. This place is actually a truck stop.)

Issue	Den.	Color	Mold	Inserts	Inlay	Rarity	GD30	VF65	CS95
KEYSTONE CLUB			**GABBS**		**1947-72**				
1st	1.00	Grey	Lg-key	None	HS	R-3	15	30	45
	5.00	Black	Lg-key	None	HS	R-4	20	40	60
TOIYABE CLUB			**GABBS**		**1943-61**				
1st	1.00	Mustard	Lg-key	None	HS	R-4	15	30	45
	5.00	Navy	Lg-key	None	HS	R-5	20	40	60
	25.00	Red	Lg-key	None	HS	R-5	20	40	60

(Since this club was open way back in 1943, there must be an unknown set of earlier chips.)

Issue	Den.	Color	Mold	Inserts	Inlay	Rarity	GD30	VF65	CS95
GOLDEN BUBBLE			**GARDNERVILLE**		**1945-70**				
1st	.25	Grey	Sm-key	None	HS	R-9	100	200	300
	.50	Lt Green	Sm-key	None	HS	R-9	100	200	300
	1.00	Maroon	Sm-key	None	HS	R-5	40	80	120
	5.00	Navy	Sm-key	3mst	HS	R-9	100	200	300
2nd	n/d	4 diff.	Arodie	None	HS	R-10	100	200	300

(Colors: Cream, Navy, Pink, and Yellow. These chips initialed "AJ" for owner Al Johnson.)

Issue	Den.	Color	Mold	Inserts	Inlay	Rarity	GD30	VF65	CS95
JOYLAND BAR			**GARDNERVILLE**		**1947-74**				
1st	.25	White	Plain	None	Embossed	R-10	200	400	600
2nd	5.00	Yellow	Sm-key	None	HS	R-10	50	100	150
	5.00	Blue	Sm-key	None	HS	R-10	50	100	150

(1st issue is marked "Joyland". Second issue is marked "JB".)

Issue	Den.	Color	Mold	Inserts	Inlay	Rarity	GD30	VF65	CS95
SHARKEY' S			**GARDNERVILLE**		**1971-**				
1st	.25	Green	Scrown	None	HS	R-6	30	60	90
	.50	Red	Scrown	None	HS	R-5	25	50	75
	1.00	Blue	Scrown	None	HS	R-6	30	60	90
	5.00	Brn/Org	Scrown	1/2pie	HS	R-6	40	80	120
	RLT	6 diff.	Plain	None	R-white	R-8	20	40	60
(Colors: Green, Grey, Lavender, Navy, Orange, and Tan.)									
2nd	1.00	Beige	Scrown	None	OR-white	R-6	15	30	45
	5.00	Yellow	Scrown	3pur	OR-white	R-8	30	60	90
	25.00	Turq.	Scrown	3tan	OR-white	R-8	30	60	90

(This second set of chips originally came from the Kings Crown in Las Vegas that never opened. Owner Sharkey bought a quantity and dug out the inlaid centers and added these stickers to make his chips. Not many are around but more are probably still in existence. This makes for an interesting chip and therefore hard to value as some say they are remakes.)

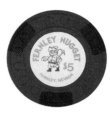

Fernley Nugget $5 (1st)

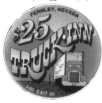

Truck Inn $25 (1st)

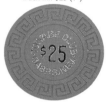

Toiyabe Club $25 (1st)

Golden Bubble $5 (1st)

Joyland Bar $5 (2nd)

Sharkey's 50c (1st)

Issue	Den.	Color	Mold	Inserts	Inlay	Rarity	GD30	VF65	CS95
3rd	1.00	Green	Lg-key	None	R-white	R-4	4	8	12
	3.00	Mustard	Lg-key	3brn3pnk	R-white	R-6	50	100	150
	5.00	Dk Green	Lg-key	4bei4pnk	R-white	R-5	8	16	24

(Above are now obsolete. Other chips were put in use although these are still negotiable.)

	25.00	Dk Red	Lg-key	4blk4crm	R-white	R-3	*	25	40
	100.00	Yellow	BJ-2	4blk	COIN-brass	R-3	*	100	125
4th	1.00	Green	Plain	None	R-white	R-4	3	6	9
5th	1.00	Green	H&C	None	OR-white	R-2	*	2	4
	5.00	Red	H&C	8wht4pur	FG-multi	R-2	*	5	10

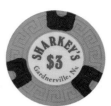

Sharkey's $3 (3rd)

BANK SALOON GERLACH 1930'S-40'S

Issue	Den.	Color	Mold	Inserts	Inlay	Rarity	GD30	VF65	CS95
1st	5.00	Orange	Zigzag	None	HS	R-8	50	100	150
	25.00	Black	Zigzag	None	HS	R-7	40	80	120

(Marked only "BS" in block style lettering)

CAPOOCH CLUB GERLACH 1932-57

Issue	Den.	Color	Mold	Inserts	Inlay	Rarity	GD30	VF65	CS95
1st	.05	Beige	Diamnd	None	HS	R-6	40	80	160
	.25	Red	Diamnd	None	HS	R-8	50	100	150
	1.00	Blue	Diamnd	None	HS	R-7	40	80	160
	5.00	Orange	Diamnd	None	HS	R-5	30	60	90

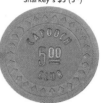

Capooch Club $5 (1st)

(Of the quantity recently found, most were cigarette burned or chipped. The quantities rumored to be found were: (35) 5cent, (5) 25cent (30) $1 and (100) $5.)

COUNTRY CLUB, BRUNO'S GERLACH 1953

Issue	Den.	Color	Mold	Inserts	Inlay	Rarity	GD30	VF65	CS95
1st	.50	Mustard	Sm-key	None	HS	R-8	100	200	300
	1.00	Red	Sm-key	None	HS	R-8	100	200	300
	5.00	Black	Sm-key	None	HS	R-7	100	200	300
	RLT	6 diff.	Arodie	None	HS	R-10	300	600	900

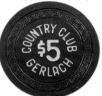

Country Club $5 (1st)

(Colors: Blue, Orange, Pink, Red, White, and Yellow. This is one of the most unique pictures on a chip, especially for a hot stamped Arodie. BS stands for owner Bruno Selmi. These chips are assumed incinerated in the fire that destroyed this club years ago. There is a rumor that a quantity of Sm-key chips was sold years ago.)

DESERT CLUB GERLACH 1959-71

Issue	Den.	Color	Mold	Inserts	Inlay	Rarity	GD30	VF65	CS95
1st	.50	Red	Lg-key	None	HS	R-7	35	70	105
	1.00	Tan	Lg-key	None	HS	R-7	50	100	150
	5.00	Navy	Lg-key	None	HS	R-7	50	100	150

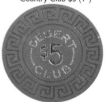

Desert Club $5 (1st)

JOE'S GERLACH CLUB GERLACH 1965-73

Issue	Den.	Color	Mold	Inserts	Inlay	Rarity	GD30	VF65	CS95
1st	.50	Lavender	Sqincr	4ltgrn	HS	R-5	15	30	45
	1.00	Orange	Sqincr	4ltgrn	HS	R-5	15	30	45
	5.00	Black	Sqincr	4ltgrn	HS	R-5	15	30	45

(These chips are marked "JOE'S." Once, these chips were nearly impossible to obtain. However, the group uncovered in 1999 solved that problem, as plenty are available if you know who has them. Unfortunately, some dealers have charged outrageous prices, despite knowing the owner has more chips.)

Joe's 50c (1st)

MINERS CLUB GERLACH 1941-56

Issue	Den.	Color	Mold	Inserts	Inlay	Rarity	GD30	VF65	CS95
1st	1.00	Pink	Lgsqur	None	HS	R-9	60	120	180
	10.00	Green	Zigzag	None	HS	R-7	25	50	75

(Above are marked "RVW". Phil Jensen says that V is for Vera, W is for Walt, but R is unknown.)

| 2nd | 1.00 | Orange | Diasqr | None | HS | R-10 | 200 | 400 | 600 |
| | 5.00 | Yellow | Arodie | 3tan | HS | R-10 | 350 | 700 | 1050 |

FAYNT HOTEL GOLCONDA 1938-40'S

Issue	Den.	Color	Mold	Inserts	Inlay	Rarity	GD30	VF65	CS95
1st	n/d	4 diff.	Sm-key	None	HS	R-9	50	100	150

Miners Club $5 (2nd)

Issue	Den.	Color	Mold	Inserts	Inlay	Rarity	GD30	VF65	CS95

(Colors: Brown, Lavender, Navy, and Red. Chips marked "RBF", for Robert B. Faynt. So far this is the only chip from this club, and for that matter, the city of Golconda.)

Santa Fe Saloon $5 (1st)

SANTA FE SALOON — GOLDFIELD — 1981-82

1st	5.00	Red	Ewing	None	HS	R-4	25	50	75

(This famous Goldfield bar was opened with gaming 1948-53. Where are these earlier chips?)

El Capitan Club 50c (1st)

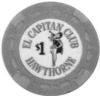

El Capitan Club $1 (1st)

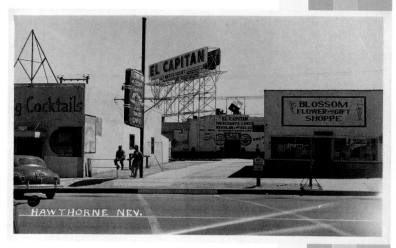

Postcard picture of El Capitan as it looked in 1954. Since then, it has expanded and survived as Hawthorne's only real casino.

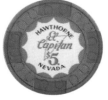

El Capitan Club $5 (2nd)

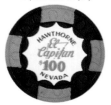

El Capitan Club $100 (2nd)

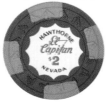

El Capitan $2 (3rd)

EL CAPITAN CLUB — HAWTHORNE — 1944-

1st	.50	Fuchsia	Scrown	None	R-white	R-10	400	800	1200
	1.00	Pink	Scrown	4yel	R-white	R-9	250	500	1000

(Above two chips picture a girl blowing a bugle. The model was Lynn Moser.)

	5.00	Blue	Scrown	4red	LSCA-white	R-10	300	600	900
	25.00	White	Scrown	4blu	LHUB-white	Unique	400	800	1200
	100.00	Black	HCE	None	HS	Unique*	400	800	1200

(The only known example is holed and damaged. The chip is marked "El Capitan Club.")

	FP 1.00	Black	Scrown	None	HS	R-9	100	200	300

(This chip is the only one marked "Casino". Also marked Free Play On Craps Or "21")

	RLT	Purple	Scrown	None	HS	R-8	50	100	150
2nd	5.00	Blu-Gry	Horshu	4ltorg	SCA-white	R-5	10	20	30
	25.00	Beige	Horshu	4nvy	SCA-white	R-6	25	50	75
	100.00	Black	Horshu	4grn	SCA-white	R-7	*	100	150
3rd	2.00	Green	HHR	4yel	SCA-white	R-6	40	80	120
	5.00	Gry-Blu	HHR	4red	SCA-white	R-2	*	5	15
	25.00	Beige	HHR	4nvy	SCA-white	R-2	*	25	45

(Above two are current, but have been in use nearly 20 years. The key is finding a nice one.)

	RLT	6 diff.	H&C	None	HS	R-5	5	10	15

(Colors: Lt Blue, Brown, Green, Orange, Purple, and Yellow.)

4th	.25	Green	Clover	None	HS	R-2	2	4	8
	1.00	Brown	H&C	3org3blk	HS	R-1	*	2	5

(Barney O'Mallia, who later owned Barney's Lake Tahoe, was the first owner of the El Capitan from 1941-1967. There has to be an older issue that is unknown, because the Scrown set dates from at least 1961 when the Smith Brothers owned the casino.)

Issue	Den.	Color	Mold	Inserts	Inlay	Rarity	GD30	VF65	CS95
HARRY'S CLUB			**HAWTHORNE**		**1941-46**				
1st	n/d	Blue	Zigzag	None	HS	R-10	200	400	600
	n/d	Red	Zigzag	None	HS	R-10	200	400	600
HAWTHORNE CLUB			**HAWTHORNE**		**1947-73**				
1st	5.00	Yellow	Lcrown	None	HS	R-5	50	100	150
	25.00	Blue	Sm-key	None	HS	R-5	60	120	180
2nd	.10	Green	Rcthrt	None	HS	R-5	25	50	75
	.10	White	Rcthrt	None	HS	R-6	35	70	105

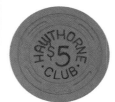

Hawthorne Club $5 (1st)

(Above two chips are marked "HC" in fancy letters.)

	5.00	Mustard	Rcthrt	3red	HS	R-6	75	150	300
3rd	.25	Brown	C&J	None	HS	R-9	125	250	375
	1.00	Grey	C&J	3grn	HS	R-9	125	250	375
HAWTHORNE'S MONTE CARLO			**HAWTHORNE**		**1956-58**				
1st	.25	Fuchsia	Sm-key	None	HS	R-7	75	150	225
	5.00	Lt Green	Sm-key	3nvy	HS	R-9	200	400	600
	25.00	Lavender	Sm-key	3blk	HS	R-10	400	800	1200
	RLT	5 diff.	Sm-key	None	HS	R-7	30	60	90

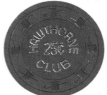

Hawthorne Club 25c (3rd)

(Colors: Brown, Orange, Mustard, Red, and White.)

	RLT	2 diff.	Sm-key	None	HS	R-6	25	50	75

(Colors: Grey and Blue.)
(These are among the most attractive hot stamped roulettes ever made for a small town.)

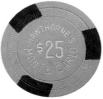

Monte Carlo $25 (1st)

JOE'S TAVERN			**HAWTHORNE**		**1943-45/1945-95**				
1st	.10	White	Hub	None	HS	R-5	20	40	60
	5.00	Yellow	Hub	None	HS	R-6	25	50	75
2nd	.25	Red	TK	None	HS	R-6	20	40	60
	1.00	Navy	TK	None	HS	R-6	25	50	75
	5.00	Lavender	TK	None	HS	R-7	40	80	120
	20.00	Black	TK	None	HS	R-6	30	60	90
3rd	.25	Red	Scrown	None	HS	R-4	5	10	15
	.50	Green	Scrown	None	HS	R-8	50	100	150
	1.00	Grey	Scrown	4org	HS	R-4	5	10	15
	5.00	Yellow	Scrown	3blu	HS	R-4	8	16	24
	25.00	Green	Scrown	4red	HS	R-5	30	60	90

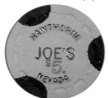

Joe's Tavern $5 (3rd)

LOG CABIN CLUB			**HAWTHORNE**		**1953-57**				
1st	n/d	Lavender	Arodie	None	HS	R-6	40	80	120
NEVADA CLUB			**HAWTHORNE**		**1931-56**				
1st	5.00	Yellow	Scrown	4ltblu	HS	R-5	40	80	120
TRENKLE BAR			**HAWTHORNE**		**1952-64**				
1st	1.00	Green	Scrown	None	HS	R-10	200	400	600

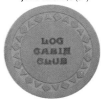

Log Cabin Club n/d (1st)

ALYSTRA CASINO			**HENDERSON**		**1997-98**				
1st	5.00	Red	H&C	3grn3gry	OR-multi	R-2	5	10	15
	25.00	Green	H&C	3grn3pur	OR-multi	R-5	20	40	60
	100.00	Black	H&C	4grn4yel4gld	OR-multi	R-9	75	150	225
	RLT	7 diff.	H&C	None	HS	R-7	5	10	15

(Colors: Lt Blue, Brown, Green, Orange, Purple, Red, and Yellow.)

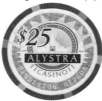

Alystra $25 (1st)

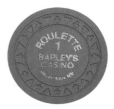

Barley's RLT 1 (1st)

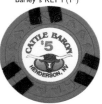

Cattle Baron $5 (1st)

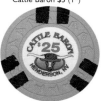

Cattle Baron $25 (1st)

Cowboy Gene's $25 (1st)

Eldorado Club 50c (2nd)

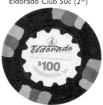

Eldorado Club $100 (5th)

Issue	Den.	Color	Mold	Inserts	Inlay	Rarity	GD30	VF65	CS95
BARLEY'S CASINO			**HENDERSON**		**1996-**				
1st	5.00	Red	H&C	3ltblu3ltorg	OR-white	R-1	*	5	10
	25.00	Dk Green	H&C	3gld3grn	OR-white	R-1	*	25	35
	100.00	Black	H&C	3red3pur3pnk	OR-white	R-3	*	100	110
	RLT 1	7 diff.	Triclb	None	HS	R-4	3	6	9

(Colors: Aqua, Green, Navy, Orange, Pink, Purple, and Tan.)

Issue	Den.	Color	Mold	Inserts	Inlay	Rarity	GD30	VF65	CS95
BINGO BARN			**HENDERSON**		**1978-79**				
1st	1.00	Blue	H&C	None	HS	R-8	50	100	150
	5.00	Red	H&C	None	HS	R-10	75	150	225
	25.00	Green	H&C	3yel	HS	R-10	75	150	225

(Above only marked "BB," supposedly owned by Benny Binion. Located on Boulder Highway.)

Issue	Den.	Color	Mold	Inserts	Inlay	Rarity	GD30	VF65	CS95
CATTLE BARON			**HENDERSON**		**1991-92**				
1st	.25	Mustard	HHR	None	HS	R-4	7	14	21
	1.00	Tan	HHR	None	HS	R-4	10	20	30
	5.00	Rust	HHR	6blk	R-white	R-5	50	100	150
	25.00	Green	HHR	6blk	R-white	R-10	200	400	600
	100.00	Black	HHR	?	R-white	Unknown	500	1000	1500

(This chip was definitely on the tables opening night and may exist somewhere in somebody's collection, but this is pure speculation. Ironically, co-author James Campiglia and his friend Bo Maciech played craps at the Cattle Baron on opening night. They got hot, winning stacks of $100 chips, until the casino closed the table down - an unusual event! Unfortunately, these same stacks were lost at the blackjack tables. Incredibly, even though this is a modern chip with a very attractive design, it appears that no chip collector in the country saved a single specimen! It is believed all the Cattle Baron chips were subsequently destroyed. This is the king of all modern 1990's chips. Previously was Swanky casino.)

Issue	Den.	Color	Mold	Inserts	Inlay	Rarity	GD30	VF65	CS95
COWBOY GENE'S			**HENDERSON**		**1979-80**				
1st	5.00	Orange	H&C	3wht3blk	HS	R-5	25	50	75
	5.00	Orange	H&C	3blk3wht	HS	R-10	30	60	90

(This variant has reversed edge inserts.)

	25.00	Green	H&C	3brn3pnk	HS	R-6	40	80	120

Issue	Den.	Color	Mold	Inserts	Inlay	Rarity	GD30	VF65	CS95
ELDORADO CLUB			HENDERSON		1962-				
1st	.25	Grey	Scrown	None	HS	R-9	50	100	150
	1.00	Grey	Scrown	None	HS	R-5	30	60	90
	n/d	Red/Grn	Scrown	1/2pie	HS	R-6	25	50	75
2nd	.50	Mustard	C&J	None	HS	R-8	60	120	180

(This is an early variant with no Nev. under Henderson)

3rd	.25	Rust	Diecar	None	HS	R-5	10	20	30
	.25	Salmon	C&J	None	HS	R-7	30	60	90
	1.00	Grey	C&J	None	HS	R-7	30	60	90
	1.00	Beige	C&J	None	HS	R-6	20	40	60
	5.00	Fuchsia	C&J	4nvy	HS	R-6	40	80	120
	25.00	Green	C&J	4blk	HS	R-10	150	300	450
4th	1.00	Beige	H&C	None	HS	R-5	10	20	30
5th	.25	Orange	H&C	None	HS	R-1	*	2	4
	1.00	Blue	H&C	4ltorg	HS	R-1	*	2	4
	5.00	Red	H&C	3org3lav	HUB-white	R-1	*	5	10
	25.00	Green	H&C	3wht3fch3gry	SCA-white	R-2	*	25	35
	100.00	Black	H&C	4gry4mar4pnk	COG-white	R-3	*	100	125
	RLT A	Navy	H&C	None	HS	R-3	2	4	6

Issue	Den.	Color	Mold	Inserts	Inlay	Rarity	GD30	VF65	CS95
JOKERS WILD			HENDERSON		1993-				
1st	.25	Orange	H&C	None	HS	R-1	*	1	3
	1.00	Blue	H&C	2org	R-white	R-1	*	1	3
	1.00	Blue	H&C	2org	R-white	R-1	*	1	3
(This variant has a larger inlay and bolder lettering.)									
	5.00	Red	H&C	3nvy3pch	HUB-white	R-1	*	5	10
	25.00	Green	H&C	3yel3red	SCA-white	R-1	*	25	35
	100.00	Black	H&C	4dkblu4ltorg4ltgrn	COG-white	R-2	*	100	120
KLONDIKE			HENDERSON		1999-				
1st	5.00	Red	H&C	2ltblu2pnk2ltgrn	OR-red	R-1	*	5	8
	25.00	Green	H&C	3brn3ltbrn	OR-green	R-1	*	25	30
	RLT K	7 diff.	H&C	None	HS	R-4	2	4	6
(Colors: Blue, Brown, Green, Lt Brown, Orange, Pink, and Yellow. This is the first set of roulettes seen marked "No Cash Value".)									
LIGOURI'S			HENDERSON		1961-98				
1st	1.00	Blue	H&C	None	HS	R-2	3	6	9
	5.00	Red	H&C	3brn3yel	HS	R-2	5	10	15
	25.00	Green	H&C	3brn3ltgrn	HS	R-4	25	50	75
	NCV 1	Grey	H&C	None	HS	R-5	4	8	12
	NCV 5	Pink	H&C	None	HS	R-5	4	8	12
	NCV 25	Green	H&C	None	HS	R-5	4	8	12
	NCV 100	Black	H&C	None	HS	R-5	5	10	15
2nd	1.00	Blue	H&C	None	OR-blue	R-2	4	8	12
	5.00	Red	H&C	3brn3yel	OR-red	R-2	6	12	18
	25.00	Green	H&C	3lim3pur	OR-green	R-4	20	40	60
(Second set marked "Jewel of the Desert." Chips designed by Dale Johnson of Henderson.)									
3rd	1.00	Blue	H&C	None	OR-multi	R-2	3	6	9
	1.00	Blue	H&C	None	OR-multi	R-4	5	10	15
(Above chips are identical, except that the latter is serial numbered from 1-300.)									
	5.00	Red	H&C	3brn3yel	OR-multi	R-2	6	12	18
	5.00	Red	H&C	3brn3yel	OR-multi	R-4	10	20	30
(Above chips are identical, except that the latter is serial numbered from 1-300. These chips were used in a 7 card stud hi-low split poker game.)									
	25.00	Green	H&C	3lim3pur	OR-multi	R-4	20	40	60
4th	10.00	White	H&C	2brn2lim	OR-multi	R-2	7	14	21
(This is also a "Jewel of the Desert" chip. It came out a year after the others and is marked "Poker.")									
LUCKY CLUB			HENDERSON		1962-73				
1st	5.00	Fuchsia	Rectl	3blk	HS	R-5	30	60	90
2nd	.10	Purple	C&J	None	HS	R-6	20	40	60
	.25	Yellow	C&J	None	HS	R-9	30	60	90
POT O' GOLD			HENDERSON		1996-				
1st	5.00	Red	H&C	1yel1blu1lav	OR-multi	R-1	*	5	10
	25.00	Green	H&C	4pur4wht	OR-multi	R-1	*	25	35
	100.00	Black	H&C	4pur4yel	OR-multi	R-2	*	100	115
RAILROAD PASS			HENDERSON		1931-				
1st	.25	Red	Lgsqur	None	HS	R-9	75	150	225
	5.00	Dk Blue	Lgsqur	None	HS	R-10	150	300	450

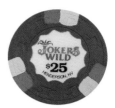

Jokers Wild $25 (1st)

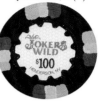

Jokers Wild $100 (1st)

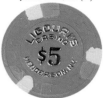

Ligouri's $5 (1st)

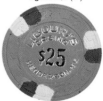

Ligouri's $25 (1st)

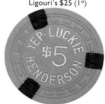

Lucky Club $5 (1st)

Pot O' Gold $5 (1st)

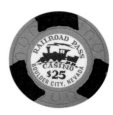

Railroad Pass $25 (2nd)

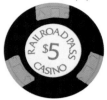

Railroad Pass $5 (3rd)

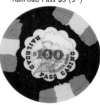

Railroad Pass $100 (4th)

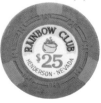

Rainbow Club $25 (2nd)

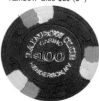

Rainbow Club $100 (4th)

Royal $5 (1st)

Issue	Den.	Color	Mold	Inserts	Inlay	Rarity	GD30	VF65	CS95
	25.00	Lt Green	Lgsqur	None	HS	R-10	150	300	450
	n/d	Grey	Lgsqur	None	HS	R-5	20	40	60
2nd	.25	Rust	HHR	None	HS	R-6	20	40	60
	5.00	Brown	Horshu	3tan	R-white	R-4	25	50	75
	25.00	Green	Horshu	3blk	R-white	R-10	350	700	1050
	100.00	Cream	Horshu	3red	R-white	R-10	400	800	1200

(This second issue lists the casino location as "Boulder City.")

Issue	Den.	Color	Mold	Inserts	Inlay	Rarity	GD30	VF65	CS95
3rd	.10	Navy	Ewing	None	HS	R-4	10	20	30
	1.00	Mustard	Ewing	None	HS	R-5	15	30	45
	5.00	Black	Ewing	3yel	R-white	R-6	60	120	180
	5.00	Black	Ewing	None	HS	R-5	40	80	120
	5.00	Red	Ewing	None	HS	R-10	100	200	300
	25.00	Green	Ewing	3blk	R-white	R-10	300	600	900
4th	.25	Pink	H&C	None	HS	R-1	*	1	3
	1.00	White	H&C	None	HS	R-1	*	2	4
	1.00	White	H&C	None	HS	R-1	*	2	4

(Variant with $1.00 & not just $1.)

Issue	Den.	Color	Mold	Inserts	Inlay	Rarity	GD30	VF65	CS95
	5.00	Red	H&C	4brn4pch	R-white	R-1	*	5	10
	25.00	Green	H&C	4pnk4grn	COG-white	R-2	*	25	35
	100.00	Black	H&C	3lav3yel3grn	SCA-white	R-3	*	100	125
	NCV 5	Orange	H&C	None	HS	R-8	10	20	30
	NCV 25	Green	H&C	None	HS	R-8	10	20	30

RAINBOW CLUB — HENDERSON — 1967-

Issue	Den.	Color	Mold	Inserts	Inlay	Rarity	GD30	VF65	CS95
1st	.10	Purple	C&J	None	HS	R-4	12	24	36
	.10	Purple	C&J	None	HS	R-4	12	24	36

(Slight purple color variant.)

Issue	Den.	Color	Mold	Inserts	Inlay	Rarity	GD30	VF65	CS95
2nd	.25	Black	HCE	None	HS	R-5	12	24	36
	.25	Black	HCE	None	HS-silver	R-6	15	30	45
	1.00	Grey	HCE	None	R-white	R-3	8	16	24
	5.00	Orange	HCE	3mst	R-white	R-5	25	50	75
	25.00	Green	HCE	3pnk	R-white	R-9	200	400	600
3rd	.10	Purple	H&C	None	HS	R-4	10	20	30
	.25	Black	H&C	None	HS	R-5	12	24	36
	1.00	Grey	H&C	None	R-white	R-3	6	12	18
	n/d	Purple	Nevada	None	HS	R-7	5	10	15

(Marked "RC" only.)

Issue	Den.	Color	Mold	Inserts	Inlay	Rarity	GD30	VF65	CS95
4th	.25	Brown	BJ	None	HS	R-4	4	8	12
	100.00	Black	H&C	3blu3pnk	HS	R-10	200	400	600

RESERVE — HENDERSON — 1997-

Issue	Den.	Color	Mold	Inserts	Inlay	Rarity	GD30	VF65	CS95
1st	1.00	White	Chipco	None	FG	R-1	*	1	3
	5.00	Red	Chipco	None	FG	R-1	*	5	10
	25.00	Green	Chipco	None	FG	R-1	*	25	35
	100.00	Black	Chipco	None	FG	R-1	*	100	120
2nd	.25	Orange	Unicrn	None	HS-green	R-1	*	1	2

ROYAL — HENDERSON — 1960-64

Issue	Den.	Color	Mold	Inserts	Inlay	Rarity	GD30	VF65	CS95
1st	.10	Tan	Zigzag	None	HS	R-6	25	50	75
	.25	Brown	Zigzag	None	HS	R-9	50	100	150
	.50	Lt Green	Zigzag	None	HS	R-6	20	40	60
	1.00	Navy	Zigzag	None	HS	R-6	25	50	75
	5.00	Mustard	Zigzag	None	HS	R-7	30	60	90
	10.00	Red	Zigzag	None	HS	R-6	25	50	75

Issue	Den.	Color	Mold	Inserts	Inlay	Rarity	GD30	VF65	CS95
2nd	1.00	Red	Rectl	None	HS	R-8	15	30	45
	5.00	Mustard	Rectl	None	HS	R-7	10	20	30
	25.00	Lt Green	Rectl	None	HS	R-10	25	50	75

(Second issue marked only "RC" with the denomination on back. James Campiglia found these and was told that after being used at the Royal, they were used to train dealers at the Rainbow.)

3rd	.25	Brown	C&J	None	HS	R-8	50	100	150
	1.00	Black	C&J	None	HS	R-4	15	30	45
	5.00	Navy	C&J	3mst	HS	R-7	75	150	225
	25.00	Red	C&J	3grn	HS	R-8	150	300	450

(In 1996, exactly nine chips were found at a junk shop in Las Vegas.)

Royal $25 (3rd)

SILVER SPUR — HENDERSON — 1984-88

	Den.	Color	Mold	Inserts	Inlay	Rarity	GD30	VF65	CS95
1st	1.00	Blue	H&C	None	HS	R-6	25	50	75
	5.00	Red	H&C	3brn3wht	HUB-white	R-9	100	200	300
	25.00	Green	H&C	3red3yel	SCA-white	Unique*	200	400	600

(The table was rarely open, making chips hard to get. The cage manager was once known to have a box, but these have never come out. We do not know if these were destroyed or saved.)

Silver Spur $25 (1st)

SKYLINE — HENDERSON — 1956-1965 / 1974-

	Den.	Color	Mold	Inserts	Inlay	Rarity	GD30	VF65	CS95
1st	1.00	Aqua	Diamnd	None	HS	R-8	100	200	300
	25.00	Black	Diamnd	None	HS	R-9	175	350	525
2nd	1.00	Navy	C&J	None	R-white	R-5	30	60	90
	5.00	Orange	C&J	3nvy	R-white	R-6	40	80	120
	25.00	Green	C&J	3nvy	R-white	R-10	300	600	900
3rd	1.00	Blue	H&C	None	HS	R-3	3	6	9
	5.00	Red	H&C	3gry	HS	R-4	10	20	30
	25.00	Green	H&C	3red	HS	R-9	75	150	225
4th	5.00	Red	H&C	3gry	HUB-white	R-1	*	5	10
	25.00	Green	H&C	3red	SCA-white	R-2	*	25	35
	100.00	Black	H&C	3yel3pnk3tan	COG-white	R-4	*	100	125

(These are hard to get, because the casino doesn't want you leaving with them! When this small casino opened, after the 7th One closed and became the Jackpot Club, the town was known as Pittman. Therefore, the 1st issue chips are from Pittman.)

Skyline $25 (2nd)

Skyline $5 (4th)

SUNSET STATION — HENDERSON — 1997-

	Den.	Color	Mold	Inserts	Inlay	Rarity	GD30	VF65	CS95
1st	1.00	White	H&C	1grn1pch	OR-white	R-1	*	1	3
	5.00	Red	H&C	3blu3org	OR-multi	R-1	*	5	10
	25.00	Green	H&C	4lim4gry	OR-multi	R-1	*	25	35
	100.00	Black	H&C	3blu3gld3red	OR-multi	R-1	*	100	115
	100.00	Green	H&C	6blu6brn	OR-multi	R-10	100	200	300

(This back-up chip was only in use a very short time. Only a few pieces are known.)

	NCV 1	Lt Orange	Unicorn	None	HS	R-5	3	6	9

("Win Cards" issue.)

	NCV 5	Pink	H&C	2grn2pur	R-white	R-4	5	10	15

Swanky Casino $1 (1st)

SWANKY CASINO — HENDERSON — 1947-57 / 1958-84

	Den.	Color	Mold	Inserts	Inlay	Rarity	GD30	VF65	CS95
1st	1.00	Lt Blue	H&C	None	HS	R-3	5	10	15
	5.00	Red	H&C	4ltblu4tan	HS	R-3	7	14	21
	25.00	Lt Green	H&C	4blk4pnk	HS	R-4	10	20	30

(When this club originally opened, this area was called Pittman. However, none of these early chips are known to exist - probably because the casino burnt to the ground in 1957.)

TOM'S SUNSET CASINO — HENDERSON — 1989-98

	Den.	Color	Mold	Inserts	Inlay	Rarity	GD30	VF65	CS95
1st	1.00	Beige	Plain	3blk	HS	R-5	5	10	15
	5.00	Maroon	HHR	2mst	R-white	R-4	8	16	24

Tom's Sunset $1 (1st)

259

Tom's Sunset $25 (1st)

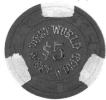

West World $5 (1st)

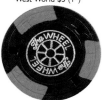

The Wheel $25 (1st)

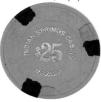

Indian Springs $25 (1st)

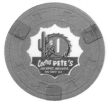

Cactus Pete's $1 (2nd)

Cactus Pete's $5 (2nd)

Issue	Den.	Color	Mold	Inserts	Inlay	Rarity	GD30	VF65	CS95
	25.00	Green	HHR	3sam	R-white	R-6	25	50	75
2nd	1.00	Tan	HHR	3blk	R-white	R-5	4	8	12

(This HHR $1 was put out before they closed and used at the poker table.)

TRIPLE J CASINO			HENDERSON		1993-98				
1st	5.00	Red	Chipco	2wht	FG	R-3	6	12	18
	25.00	Green	Chipco	2yel	FG	R-6	20	40	60
	100.00	Black	Chipco	None	FG	R-8	100	150	200

WEST WORLD			HENDERSON		1979-86				
1st	.50	Yellow	H&C	None	HS	R-6	40	80	120
	1.00	Blue	H&C	None	HS	R-7	50	100	150
	5.00	Red	H&C	3wht	HS	R-8	100	200	300

THE WHEEL			HENDERSON		1961-62				
1st	.25	Fuchsia	C&J	None	HS	R-10	125	250	375
	5.00	Mustard	C&J	3red	HS	R-7	80	160	240
	25.00	Black	C&J	3red	HS	R-6	70	140	210

WINNERS CIRCLE			HENDERSON		1979-79 / 1981-83				
1st	.25	White	H&C	None	HS	R-4	5	10	15
	1.00	Blue	H&C	None	HS	R-4	5	10	15
	5.00	Red	H&C	3yel	HS	R-4	5	10	15
	25.00	Green	H&C	3nvy	HS	R-5	12	24	36

BROOKS OASIS			INDIAN SPRINGS		1970's				
1st	1.00	Blue	H&C	None	HS	Unique	100	200	300

(Only one chip has been discovered. Unfortunately, very little information on this club is available.)

INDIAN SPRINGS CASINO			INDIAN SPRINGS		1985-				
1st	5.00	Red	H&C	4gry4pur	HS	R-3	5	10	15
	25.00	Green	H&C	3blk3org	HS	R-5	20	40	60
2nd	5.00	Red	H&C	4gry4pur	HS	R-5	6	12	18
	25.00	Green	H&C	3blk3org	HS	R-6	25	50	75

(This set was only in use a very short time.)

3rd	5.00	Red	H&C	1yel1blu1pnk	OR-multi	R-5	5	10	15
	25.00	Green	H&C	4wht4org	OR-multi	R-6	20	40	60

(Live gaming ended in 1999)

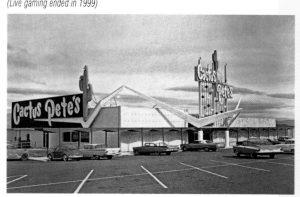

A great postcard view of roadside Americana, showing Cactus Pete's in the mid-1960s.
©Standard Printing Co., Twin Falls, Idaho.

Issue	Den.	Color	Mold	Inserts	Inlay	Rarity	GD30	VF65	CS95
CACTUS PETE'S			JACKPOT		1956-				
1st	5.00	Navy	Sm-key	3bei	HS	R-10	200	400	600
	RLT	Red	Sm-key	None	HS	R-8	35	70	105
	RLT	Lavender	Sm-key	None	HS	R-9	35	70	105
	RLT	Cream	Sm-key	None	HS	R-10	40	80	120
	RLT	Brown	Sm-key	None	HS	R-10	40	80	120
2nd	1.00	Salmon	C&J	3yel	R-white	R-7	75	150	225

(Reverse in red hot stamp; "Dick Sweeney".)

	1.00	Salmon	C&J	3yel	R-white	R-7	100	200	300

(Reverse in red hot stamp; "Pete Piersanti".)

	1.00	Salmon	C&J	3yel	R-white	R-7	125	250	375

(Reverse in red hot stamp; "Cork McKean".)

	1.00	Red	C&J	3grn	SCA-white	R-9	350	700	1050

(This chip is usually found drilled - only 3 nice examples are known.)

	5.00	Navy	C&J	3bei	SCA-white	R-8	250	500	750
	25.00	Green	C&J	3org	SCA-white	R-9	600	1200	1800
	RLT	Lt Green	Plain	None	SCA-white	R-8	150	300	450
	RLT	4 diff.	Plain	None	SCA-white	R-9	175	350	525

(Colors: Black, Red, White, and Yellow.)

	RLT	2 diff.	Plain	None	SCA-white	R-10	200	400	600

(Colors: Dk Green and Grey.)

3rd	1.00	Green	C&J	None	HS	R-9	125	250	375
4th	.25	Brown	H&C	None	HS	R-8	50	100	150
	5.00	Maroon	Diecar	3grn	HS	R-10	250	500	750
5th	5.00	Red	BJ-1	6blu	COIN	R-3	*	5	10
	25.00	Green	BJ-1	6org	COIN	R-4	*	25	35
6th	1.00	White	BJ-2	6org	COIN	R-1	*	1	3
	2.50	Yellow	BJ-2	6blu	COIN	R-2	*	3	6
	5.00	Red	BJ-2	6blu	COIN	R-1	*	5	10
	25.00	Green	BJ-2	6org	COIN	R-1	*	25	35
	100.00	Black	BJ-2	6org	COIN	R-1	*	100	125
	NN 1.00	Lt Blue	BJ	None	HS	R-9	10	20	30

("Tournament".)

7th	5.00	Purple	Chipco	None	FG	R-1	*	5	10

(40 year commemorative, 1956-96, used on tables.)
Original club opened approximately 12 miles down the road near Contact. Later moved to the town which became Jackpot.)

CLUB 93/CASINO 93			JACKPOT		1957-				
1st	1.00	Grey	T's	None	R-white	R-10	250	500	750
2nd	.50	Green	C&J	None	HS	R-9	150	300	450
	1.00	Black	C&J	None	HS	R-9	200	400	600
	5.00	Mustard	C&J	None	HS	R-10	225	450	675

(This early issue is marked "Club 93" and pictures the roadsign.)

3rd	1.00	Red	C&J	3bei	R-white	R-8	175	350	525
	5.00	Brown	C&J	3yel	R-white	R-8	175	350	525
	25.00	Navy	C&J	3red	R-white	R-10	400	800	1200
4th	5.00	Brown	Nevada	3yel	R-white	R-8	150	300	450
5th	5.00	White	BJ-1	3dkgrn	COIN	R-4	3	6	9

(Chip marked "Nevada.")

	5.00	Red	BJ-1	3brn	COIN	R-6	20	40	60
6th	1.00	White	BJ-1	3grn	COIN	R-3	*	2	4

(Chip marked "Nev.")

7th	1.00	White	BJ-2	3grn	COIN	R-2	*	2	4

(This issue has bold print.)

Cactus Pete's $25 (2nd)

Cactus Pete's RLT (2nd)

Cactus Pete's $5 (4th)

Cactus Pete's $5 (5th)

Club 93 $1 (2nd)

Casino 93 $25 (3rd)

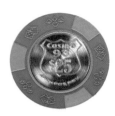

Casino 93 $25 (8th)

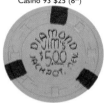

Diamond Jim's $5 (1st)

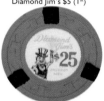

Diamond Jim's $25 (2nd)

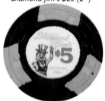

Diamond Jim's $5 (3rd)

Horseshu Club $1 (2nd)

Horseshu Club 10c (3rd)

Issue	Den.	Color	Mold	Inserts	Inlay	Rarity	GD30	VF65	CS95
8th	1.00	White	BJ-2	3grn	COIN	R-1	*	1	3
(This issue has fine print.)									
	5.00	Red	BJ-2	3brn	COIN	R-1	*	5	10
	25.00	Green	BJ-2	3pnk	COIN	R-1	*	25	35
	100.00	Black	BJ-2	4blu	COIN	R-2	*	100	120
	RLT	7 diff.	H&C	None	HS	R-3	3	6	9
(Colors: Green, Lt Orange, Dk Orange, White, Pink, Lt Blue, and Dk Blue. It is interesting to note that these are later H&C chips, but marked with "Club" & the old road sign.)									
9th	.25	Yellow	BJ	None	HS	R-2	2	4	6
	1.00	White	BJ-2	3grn	COIN	R-1	*	1	3
(Variant with smooth center.)									
10th	1.00	White	BJ-2	3grn	COIN	R-1	*	1	3
(Newest variant with slightly darker green printing & shinier smooth center.)									

DIAMOND JIM'S — JACKPOT — 1960-65

	Den.	Color	Mold	Inserts	Inlay	Rarity	GD30	VF65	CS95
1st	1.00	Grey	C&J	3grn	HS	R-4	25	50	75
	5.00	Mustard	C&J	3nvy	HS	R-5	40	80	120
	5.00	Black	C&J	None	HS	R-10	250	500	750
(In November, 1999, two chips were found in an Idaho antique shop.)									
	25.00	Green	C&J	3blk	HS	R-5	35	70	105
2nd	5.00	Mustard	C&J	3nvy	R-white	R-5	75	150	225
	25.00	Green	C&J	3blk	R-white	R-8	400	800	1200
(This $25 chip remains extremely rare with only 10-12 known. However, both Mustard $5 chips, the $1 chip, and the hot stamped $25 have been released in quantity.)									
	25.00	Grey	C&J	3red	R-white	Unique	600	1200	1800
(Possible prototype although not notched. Might be a unique backup chip.)									
3rd	5.00	Black	C&J	3mst	R-white	R-6	175	350	525
(This chip was not among the quantity released by the former owner's family. Might be an R-7.)									
4th	25.00	Red	HHR	3grn	R-white	R-10	500	1000	1500
(A full set to this $25 may exist, but that rumor is not verified.)									

HORSESHU CLUB/HOTEL — JACKPOT — 1956-

	Den.	Color	Mold	Inserts	Inlay	Rarity	GD30	VF65	CS95
1st	5.00	Purple	Sm-key	3red	HS	R-10	250	500	750
	25.00	Rose	Sm-key	3mst	HS	R-10	350	700	1050
	100.00	Beige	Sm-key	3blk	HS	Unique	500	1000	1500
2nd	1.00	Beige	Sqincr	3blk	HS	R-8	200	400	600
(Nearly all found are drilled, just like other Jackpot chips.)									
3rd	.10	Maroon	Lg-key	None	HS	R-8	175	350	525
	.25	Mustard	Lg-key	None	HS	R-9	150	300	450
4th	.25	Lt Mustard	H&C	None	HS	R-2	*	2	4
	1.00	White	H&C	6blu	R-white	R-1	*	1	3
	5.00	Red	H&C	3yel3grn	HUB-white	R-1	*	5	10
	25.00	Green	H&C	8yel	SCA-white	R-1	*	25	35
	100.00	Black	H&C	8ltblu8yel	COG-white	R-3	*	100	125
(This current set is marked with Hotel & Casino.)									

STARDUST, RAY & RUTH'S — JACKPOT — 1961-63

	Den.	Color	Mold	Inserts	Inlay	Rarity	GD30	VF65	CS95
1st	25.00	Red	C&J	2yel2grn	HS	Unique	350	700	1050
	n/d	Purple	C&J	None	HS	R-10	100	200	300
(This original Jackpot club opened as Pair of Dice - possibly only a slot joint. These remain the rarest of the Jackpot town chips so far.)									

BUFFALO BILL'S — JEAN/PRIMM — 1994-

	Den.	Color	Mold	Inserts	Inlay	Rarity	GD30	VF65	CS95
1st	1.00	Lt Blue	H&C	1yel1grn1fch	OR-white	R-1	2	4	6

Issue	Den.	Color	Mold	Inserts	Inlay	Rarity	GD30	VF65	CS95
	5.00	Red	H&C	4yel4grn	OR-white	R-2	5	10	15

(The above have variants with spots on the Buffalo in different locations & colorings.)

Issue	Den.	Color	Mold	Inserts	Inlay	Rarity	GD30	VF65	CS95
	25.00	Green	H&C	4pur4brn	OR-white	R-4	15	30	45
	100.00	Black	H&C	3gld3pnk	OR-white	R-1	*	100	120

(This is still in use with the Jean location, but for how long?)

Issue	Den.	Color	Mold	Inserts	Inlay	Rarity	GD30	VF65	CS95
2nd	1.00	Lt Blue	H&C	1yel1grn1fch	OR-blue	R-1	*	1	3
	5.00	Red	H&C	4yel4grn	OR-red	R-1	*	5	10
	25.00	Green	H&C	4lav4blk	OR-green	R-1	*	25	35
	RLT A	Grey	Roulet	None	OR-multi	R-2	3	6	9
	RLT B	Brown	Roulet	None	OR-multi	R-2	3	6	9

Buffalo Bill's $100 (1st)

GOLD STRIKE HOTEL — JEAN — 1987-

Issue	Den.	Color	Mold	Inserts	Inlay	Rarity	GD30	VF65	CS95
1st	.50	Purple	H&C	None	HS	R-3	2	4	6
	1.00	White	H&C	None	HS	R-2	1	3	5
	5.00	Red	H&C	4org	HUB-white	R-3	5	10	15
	25.00	Green	H&C	4wht4pnk	SCA-white	R-6	25	50	75
	100.00	Black	H&C	8grn4pur	COG-white	R-9	100	150	200
	NCV 5	Yellow	H&C	None	HS	R-7	5	10	15
	NCV 25	Lavender	H&C	None	HS	R-7	6	12	18
	NCV 100	Yellow	H&C	None	HS	R-7	7	14	21
	NCV 500	Peach	H&C	None	HS	R-8	10	20	30
2nd	1.00	White	H&C	None	HS	R-3	2	4	6

Buffalo Bill's $25 (2nd)

(Variant with "$1.00" instead of "$1".)

Issue	Den.	Color	Mold	Inserts	Inlay	Rarity	GD30	VF65	CS95
	RLT 1	7 diff.	HHR	None	R-white	R-4	5	10	15

(Colors: Brown, Green, Maroon, Navy, Orange, Purple, and Yellow.)

Issue	Den.	Color	Mold	Inserts	Inlay	Rarity	GD30	VF65	CS95
	RLT 2	7 diff.	HHR	None	R-white	R-4	5	10	15

(Colors: Brown, Green, Maroon, Navy, Orange, Purple, and Yellow.)

Issue	Den.	Color	Mold	Inserts	Inlay	Rarity	GD30	VF65	CS95
3rd	1.00	White	Chipco	None	FG	R-1	*	1	3
	5.00	Red	Chipco	None	FG	R-1	*	5	8
	25.00	Green	Chipco	None	FG	R-1	*	25	30
	100.00	Black	Chipco	None	FG	R-1	*	100	110

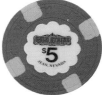

Gold Strike Hotel $5 (1st)

KACTUS KATE'S — CLARK COUNTY — 1984-91

Issue	Den.	Color	Mold	Inserts	Inlay	Rarity	GD30	VF65	CS95
1st	5.00	Red	H&C	3grn3yel	HUB-white	R-6	50	100	150
	25.00	Green	H&C	3yel3ltbrn	SCA-white	Unique*	350	700	1050

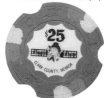

Kactus Kate's $25 (1st)

NEVADA LANDING — JEAN — 1989-

Issue	Den.	Color	Mold	Inserts	Inlay	Rarity	GD30	VF65	CS95
1st	.50	Purple	H&C	None	HS	R-3	2	4	6
	1.00	White	H&C	None	HS	R-2	1	3	5

(There are 2 variants: one with "$1.00" & one with "$1".)

Issue	Den.	Color	Mold	Inserts	Inlay	Rarity	GD30	VF65	CS95
	5.00	Red	H&C	4ltblu	HUB-white	R-3	5	10	15
	25.00	Green	H&C	4ltgrn4ltblu	SCA-white	R-6	25	50	75
	100.00	Black	H&C	3brn3wht3grn	COG-white	R-9	100	150	200
2nd	1.00	White	Chipco	None	FG	R-1	*	1	3
	5.00	Red	Chipco	None	FG	R-1	*	5	8
	25.00	Green	Chipco	None	FG	R-1	*	25	30
	100.00	Black	Chipco	None	FG	R-1	*	100	110

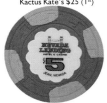

Nevada Landing $5 (1st)

POP'S OASIS — JEAN — 1964-late 80's

Issue	Den.	Color	Mold	Inserts	Inlay	Rarity	GD30	VF65	CS95
1st	.25	Maroon	Ewing	None	HS	R-8	50	100	150
	n/d	Maroon	Ewing	None	HS	R-5	10	20	30

(This variant had the .25 scratched off to be used as another denomination.)

Issue	Den.	Color	Mold	Inserts	Inlay	Rarity	GD30	VF65	CS95
	5.00	Maroon	Ewing	None	HS	R-9	75	150	225
2nd	1.00	Blue	BJ-1	3brn	COIN	R-4	10	20	30

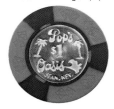

Pop's Oasis $1 (2nd)

Primadonna $1 (1st)

Issue	Den.	Color	Mold	Inserts	Inlay	Rarity	GD30	VF65	CS95
	5.00	Red	BJ-1	3yel	COIN	R-4	15	30	45
	25.00	Green	BJ-1	3pnk	COIN	R-4	25	50	75
	n/d	Maroon	Diecar	None	HS	R-4	8	16	24

(Originally opening in the late 1940's, this place was an old stopover on Highway 91. They had a gas station and motel all made of local sandstone. Slots were there all along, but Pop's didn't start live gaming until 1964 when the building expanded. At that time, the small casino featured one poker and two blackjack tables.)

PRIMADONNA			JEAN		1990-97				
1st	1.00	Lt Blue	H&C	4pnk	R-white	R-2	2	4	6
	5.00	Red	H&C	2yel2blu	HUB-white	R-3	6	12	18
	25.00	Green	H&C	4pnk4blu	SCA-white	R-5	20	40	60
	100.00	Black	H&C	4blu4yel4pnk	COG-white	R-7	100	150	200
	RLT	Grey	BJ	None	HS	R-6	5	10	15
	RLT 1	Purple	H&C	None	HS	R-6	4	8	12

(Changed name to Primm Valley Resort in 1997.)

Primadonna $100 (1st)

PRIMM VALLEY RESORT			PRIMM		1997-				
1st	1.00	Lt Blue	H&C	4pnk	OR-white	R-1	*	1	3
	5.00	Red	H&C	2yel2blu	OR-white	R-1	*	5	10
	25.00	Green	H&C	4pnk4blu	OR-white	R-1	*	25	35
	100.00	Black	H&C	4pnk4yel4ltblu	OR-white	R-1	*	100	120
	RLT A	White	H&C	None	OR-white	R-2	3	6	9

Sy Redd's Tower Club $5 (1st)

SY REDD'S TOWER CLUB			STATELINE I-15		1968-71/1980-82				
1st	5.00	Red	H&C	4wht	HS	R-9	250	500	750

WHISKEY PETE'S CASINO			CLARK COUNTY JEAN, PRIMM		1978-				
1st	1.00	Blue	H&C	None	R-white	R-8	125	250	375
	5.00	Red	H&C	3pnk	R-white	R-9	350	700	1050

(Of the four known examples, two are notched.)

Whiskey Pete's $5 (1st)

	25.00	Green	H&C	3yel	R-white	R-10*	500	1000	1500
2nd	1.00	Blue	H&C	None	R-white	R-5	10	20	30
	5.00	Red	H&C	3pch	R-white	R-6	30	60	90
	25.00	Green	H&C	3brn	R-white	R-8	75	150	225

(Second issue has bolder print on Clark County and other lettering.)

3rd	1.00	Blue	H&C	None	R-white	R-4	8	16	24
	5.00	Red	H&C	3ltorg	R-white	R-5	20	40	60
	25.00	Green	H&C	3brn	R-white	R-7	50	100	150

(Third issue has Clark County Nevada in thin print.)

4th	1.00	Blue	H&C	None	R-white	R-2	5	10	15
	5.00	Red	H&C	3ltorg	R-white	R-3	10	20	30
	25.00	Green	H&C	3brn	R-white	R-5	25	50	75
	100.00	Black	H&C	3dkorg	R-white	R-6	100	150	200

(Above set marked "Jean, Nevada.")

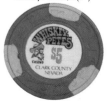

Whiskey Pete's $5 (2nd)

	n/d	Navy	H&C	None	R-white	R-8*	25	50	75

(1986 advertising chip for the "World Champion Professional Desert Motorcycle Race, Whiskey Pete's Hare & Hound III." Presently, all known examples of this chip are holed for use as a keychain.)

	RLT 1	Orange	H&C	None	HS	R-5	4	8	12
5th	1.00	Blue	H&C	None	OR-blue	R-1	*	1	2
	5.00	Red	H&C	3ltorg	OR-red	R-1	*	5	7
	25.00	Green	H&C	3brn	OR-green	R-1	*	25	30
	RLT A	Orange	Roulet	None	OR-multi	R-2	3	6	9
	RLT B	7 diff.	Roulet	None	OR-white	R-2	3	6	9

Whiskey Pete's $5 (3rd)

Issue	Den.	Color	Mold	Inserts	Inlay	Rarity	GD30	VF65	CS95

(Colors: Blue, Cream, Grey, Orange, Pink, Purple, & Yellow.)
(This fifth issue debuted in 1998 and is marked "Primm, Nevada".)

COLORADO BELLE — LAUGHLIN — 1980–

Issue	Den.	Color	Mold	Inserts	Inlay	Rarity	GD30	VF65	CS95
1st	.25	Yellow	H&C	None	HS	R-5	8	16	24
	1.00	Blue	H&C	3wht3gry	R-white	R-3	7	14	21
	5.00	Red	H&C	4grn4pur	HUB-white	R-4	15	30	45
	25.00	Green	H&C	4org4pnk	SCA-white	R-6	40	80	120
2nd	.50	Purple	H&C	None	HS	R-3	2	4	6
	.50	Purple	BJ	None	HS	R-2	*	2	4
	1.00	White	BJ-H	12blu8red	COIN	R-1	*	1	3
	2.50	Yellow	BJ-H	12blu	COIN	R-1	*	3	5
	5.00	Red	BJ-H	12yel	COIN	R-1	*	5	10
	25.00	Green	BJ-H	12grn	COIN	R-1	*	25	30
	100.00	Black	BJ-H	12pnk	COIN	R-1	*	100	120
	RLT	Blue	BJ	None	R-white	R-4	3	6	9

Colorado Belle $25 (1st)

Colorado Belle $2.50 (2nd)

COLORADO RIVER — SOUTHPOINT — 1979–80

Issue	Den.	Color	Mold	Inserts	Inlay	Rarity	GD30	VF65	CS95
1st	1.00	White	BJ-1	3org	COIN	R-6	60	120	180
	5.00	Red	BJ-1	3pnk	COIN	R-8	150	300	450
	25.00	Green	BJ-1	6blk	COIN	R-8	200	400	600
	100.00	Black	BJ-1	6blu	COIN	R-10	300	600	900

(These chips all have the location "Southpoint, Nev." In 1999, about 7 sets of the $1, $5, and $25 were found.)

Colorado River $25 (1st)

CRYSTAL PALACE — LAUGHLIN — 1978–85

Issue	Den.	Color	Mold	Inserts	Inlay	Rarity	GD30	VF65	CS95
1st	.25	Blue	H&C	None	HS	R-3	10	20	40
	1.00	Tan	H&C	None	HS	R-2	10	20	40
	5.00	Red	H&C	3wht	HS	R-3	25	50	125
	25.00	Green	H&C	3blk3org	HS	R-3	30	75	200

(These chips, especially the $5 and $25, are generally found in very worn condition.)

Crystal Palace 25c (1st)

DEL WEBB'S NEVADA CLUB — LAUGHLIN — 1978–88

Issue	Den.	Color	Mold	Inserts	Inlay	Rarity	GD30	VF65	CS95
1st	.25	Navy	Diecar	None	HS	R-6	12	24	36
	.50	Lavender	BJ-2	None	COIN	R-4	10	20	30
	1.00	White	BJ-2	None	COIN	R-3	5	10	15

(Spun metal coin center variant - as opposed to smooth metal.)

	1.00	White	BJ-2	None	COIN	R-6	10	20	30
	5.00	Red	BJ-2	12blu	COIN	R-6	20	40	60

(Spun metal coin center variant - as opposed to smooth metal.)

	5.00	Red	BJ-2	12blu	COIN	R-6	15	30	45
	25.00	Green	BJ-2	12wht	COIN	R-9	175	350	525
	100.00	Black	BJ-2	12org	COIN	R-10	250	500	750
	500.00	Yellow	BJ-2	6blk	COIN	Unique	300	600	900
	NCV 1	Orange	H&C	None	HS	R-5	4	8	12
	NCV 5	Blue	H&C	None	HS	R-4	4	8	12
	NCV 25	Green	H&C	None	HS	R-5	5	10	15
	RLT	Blue	BJ	None	HS	R-7	10	20	30
	RLT	Yellow	BJ	None	HS	R-7	10	20	30

Del Webb's $25 (1st)

EDGEWATER — LAUGHLIN — 1981–

Issue	Den.	Color	Mold	Inserts	Inlay	Rarity	GD30	VF65	CS95
1st	.25	Ochre	H&C	None	HS	R-6	10	20	30
	1.00	Beige	H&C	None	R-white	R-3	2	4	6
	1.00	Beige	H&C	None	R-white	R-4	3	6	9
	5.00	Red	H&C	4org4lim	HUB-white	R-4	6	12	18

Edgewater $5 (1st)

Issue	Den.	Color	Mold	Inserts	Inlay	Rarity	GD30	VF65	CS95
	25.00	Green	H&C	4blu4brn	SCA-white	R-5	20	40	75
	100.00	Black	H&C	4yel4blu	COG-white	R-8	75	150	225
2nd	.50	Purple	Unicrn	None	HS	R-2	*	2	4
	.50	Dk Purple	Unicrn	None	HS	R-2	*	2	4
	1.00	White	Chipco	None	FG	R-1	*	1	3
	rs 2.00	Blue	Chipco	None	FG	R-3	5	10	15

(Race & Sports Book. A rather unique low denomination for sports & great graphics.)

	2.50	Yellow	Chipco	None	FG	R-1	*	3	5
	5.00	Red	Chipco	None	FG	R-1	*	5	10
	25.00	Green	Chipco	None	FG	R-1	*	25	35
	100.00	Black	Chipco	None	FG	R-1	*	100	120
	NCV	Red	Chipco	None	FG	R-8	75	150	225

(New Years 1992, this chip is rarely found undrilled & was given away at a party.)

	NCV 1	Blue	H&C	None	HS	R-9	20	40	60

(This is a tournament chip. "No Cash Value" is on the back only.)

	RLT A	Green	Plain	None	R-white	R-5	3	6	9
	RLT A	Orange	Plain	None	R-white	R-5	3	6	9
	RLT C	Blue	Plain	None	R-white	R-5	3	6	9
	RLT C	Lavender	Plain	None	R-white	R-5	3	6	9
	RLT D	Blue	Plain	None	R-white	R-5	3	6	9

EP			LAUGHLIN		1970's				
1st	1.00	Dk Pink	Nevada	None	HS-black	R-6	10	20	30
	5.00	Red	Nevada	None	HS-black	R-5	5	10	15
	25.00	Blue	Nevada	None	HS-gold	R-7	10	20	30

(Ernie Primm had interests in some of the early Laughlin clubs, and it is very possible that these chips are affiliated with him, but this fact is not verified. These chips are marked "EP" in script.)

FLAMINGO HILTON			LAUGHLIN		1990-				
1st	1.00	Lt Blue	House	4grn	R-white	R-1	*	1	3
	5.00	Red	House	3org3blu	HUB-white	R-1	*	5	10
	25.00	Green	H&C	3yel3fch	SCA-white	R-1	*	25	35
	100.00	Black	H&C	4pur4ltblu4grn	COG-white	R-1	*	100	120
	RLT	6 diff.	Roulet	None	R-white	R-4	3	6	9

(Colors: Blue, Green, Orange, Pink, Purple, and Yellow. Picture of flamingo giving "OK" sign.)

	RLT	6 diff.	Roulet	None	R-white	R-4	3	6	9

(Colors: Blue, Green, Orange, Pink, Purple, and Yellow. Picture of flamingo waving.)

	RLT	6 diff.	Roulet	None	R-white	R-4	3	6	9

(Colors: Blue, Green, Orange, Pink, Purple, and Yellow. Picture of flamingo's face only.)

	RLT	6 diff.	Roulet	None	R-white	R-4	3	6	9

(Colors: Blue, Green, Orange, Pink, Purple, and Yellow. Picture of flamingo with sunglasses.)

	RLT	6 diff.	Roulet	None	R-white	R-4	3	6	9

(Colors: Blue, Green, Orange, Pink, Purple, and Yellow. Picture of flamingo reclining.)

2nd	5.00	Red	H&C	3org3blu	OR-black	R-2	15	30	45

(Dated Jan. 15, 1997, this chip commemorates the opening of the Nevada Gold Museum- the precursor to Steve Cutler's chip/memorabilia collection at the Tropicana. 750 were made, most of which were given out at the opening night party. The rest were put on the tables and hard to acquire.)

3rd	5.00	Red	H&C	3pnk3grn	OR-blue	R-2	10	20	30

(Dated Sept. 5,6,7, 1997, this chip advertises the Labor Day Casino Collectibles Expo I put on by noted collectors Charlie Rodgers and Steve Cutler. Exactly 750 were made.)

4th	n/d	Lt Green	H&C	None	OR-white	R-5	5	10	15

("Sic Bo".)

	NCV 5	Orange	H&C	None	HS	R-6	5	10	15
	NCV 25	Lt Green	H&C	None	HS	R-6	6	12	18

Edgewater $25 (1st)

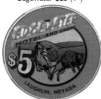

Edgewater $5 (2nd)

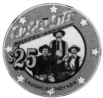

Edgewater $25 (2nd)

Flamingo Hilton $1 (1st)

Flamingo Hilton $5 (1st)

Flamingo Hilton RLT (1st)

Issue	Den.	Color	Mold	Inserts	Inlay	Rarity	GD30	VF65	CS95
NCV 100	Navy	H&C	None	HS	R-7	10	20	30	

("Tournament Chip".)

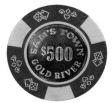
Gold River $500 (1ˢᵗ)

GOLD RIVER, SAM'S TOWN LAUGHLIN 1984-91
GOLD RIVER 1991-98

Issue	Den.	Color	Mold	Inserts	Inlay	Rarity	GD30	VF65	CS95
1ˢᵗ	.25	Purple	BJ	None	HS-silver	R-5	4	8	12
	.25	Lt Purple	BJ	None	HS-silver	R-5	4	8	12
	.25	Purple	BJ	None	HS-gold	R-6	6	12	18

(Card suits are filled in blue instead of white like the other two.)

Issue	Den.	Color	Mold	Inserts	Inlay	Rarity	GD30	VF65	CS95
	1.00	White	BJ	None	HS	R-3	4	8	12
	5.00	Red	BJ-2	3yel	COIN	R-4	12	24	36
	25.00	Green	BJ-2	3yel	COIN	R-10	200	400	600
	100.00	Black	BJ-2	3pnk	COIN	R-10	250	500	750
	500.00	Brown	BJ-2	3yel	COIN	R-10	250	500	750
	NCV 5	Brown	H&C	None	HS	R-9	25	50	75

(This first issue says "Sam's Town Gold River.")

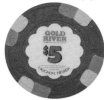
Gold River $5 (3ʳᵈ)

Issue	Den.	Color	Mold	Inserts	Inlay	Rarity	GD30	VF65	CS95
2ⁿᵈ	.25	Yellow	H&C	None	HS	R-3	2	4	6
	.50	Dk Purple	H&C	None	HS	R-2	*	2	4

(There is a variant with a Purple/Rose color.)

Issue	Den.	Color	Mold	Inserts	Inlay	Rarity	GD30	VF65	CS95
3ʳᵈ	1.00	Blue	H&C	2org2pch	R-white	R-2	1	2	3
	5.00	Red	H&C	4lim4tan	HUB-white	R-3	5	10	15
	25.00	Green	H&C	4org4pnk	SCA-white	R-5	20	40	60
	100.00	Black	H&C	4grn4pch	COG-multi	R-8	100	200	300
	NCV	4 diff.	H&C	None	HS	R-5	3	6	9

(These are tournament chips with 4 different colors: Black, Green, Pink, and Red.)

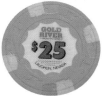
Gold River $25 (3ʳᵈ)

Issue	Den.	Color	Mold	Inserts	Inlay	Rarity	GD30	VF65	CS95
	NCV 5	Purple	BJ	None	HS	R-7	7	14	21

(In October 1998, Gold River became River Palms.)

GOLDEN NUGGET LAUGHLIN 1988-

Issue	Den.	Color	Mold	Inserts	Inlay	Rarity	GD30	VF65	CS95
1ˢᵗ	.25	Lt Brown	H&C	None	HS	R-6	10	20	30
	1.00	Blue	House	None	R-white	R-1	*	1	3
	5.00	Red	House	3org3pnk	HUB-white	R-1	*	5	10
	25.00	Green	House	4org4yel	SCA-white	R-1	*	25	35
	100.00	Black	House	8grn4ltblu	COG-white	R-1	*	100	120
	RLT A	4 diff.	BJ	None	HS	R-5	3	6	9

(Colors: Blue, Green, Lavender, and Yellow.)

Golden Nugget $25 (1ˢᵗ)

HARRAH'S DEL RIO LAUGHLIN 1988-92
HARRAH'S 1992-

Issue	Den.	Color	Mold	Inserts	Inlay	Rarity	GD30	VF65	CS95
1ˢᵗ	.25	Lt Blue	BJ	None	HS	R-4	3	6	9
	1.00	White	BJ-P	16blu	R-white	R-1	*	1	3
	1.00	White	BJ-P	16blu	R-white	R-1	*	1	3

(This variant has larger edge inserts.)

Harrah's Del Rio $1 (1ˢᵗ)

Issue	Den.	Color	Mold	Inserts	Inlay	Rarity	GD30	VF65	CS95
	5.00	Red	BJ-P	4gry	R-white	R-1	*	5	10
	25.00	Green	BJ-P	8ltgrn	R-white	R-1	*	25	35
	100.00	Black	BJ-P	4pnk	R-white	R-1	*	100	120

(First issue is marked "Harrah's Del Rio." These chips are still used along with the second issue.)

Issue	Den.	Color	Mold	Inserts	Inlay	Rarity	GD30	VF65	CS95
	NCV 1	White	BJ	None	HS-red	R-6	10	20	30
	NCV 1	White	BJ	None	HS	R-5	5	10	15
	NCV 5	Red	BJ	None	HS	R-5	5	10	15
	NCV 25	Green	BJ	None	HS	R-5	6	12	18
	NCV 100	Black	BJ	None	HS	R-5	6	12	18
	RLT 1	4 diff.	BJ-P	None	R-white	R-6	4	8	12

(Colors: Blue, Lt Brown, Lavender, and Turquoise.)

Harrah's Del Rio $5 (1ˢᵗ)

Monte Carlo 50c (1st)

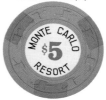

Monte Carlo $5 (1st)

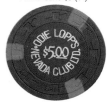

Nevada Club $5 (1st)

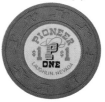

Pioneer Club $1 (1st)

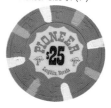

Pioneer Club $25 (3rd)

Ramada Express $5 (1st)

Issue	Den.	Color	Mold	Inserts	Inlay	Rarity	GD30	VF65	CS95
2nd	1.00	White	BJ-P	16blu	R-white	R-1	*	1	3
	5.00	Red	BJ-P	4gry	R-white	R-1	*	5	10
	25.00	Green	BJ-P	8ltgrn	R-white	R-1	*	25	35
	RLT 1	Purple	H&C	None	HS	R-5	3	6	9

MONTE CARLO — LAUGHLIN — 1968-77

Issue	Den.	Color	Mold	Inserts	Inlay	Rarity	GD30	VF65	CS95
1st	.25	Green	C&J	None	HS	R-9	150	300	450
	.50	Grn/Pur	C&J	1/2pie	HS	R-9	250	500	750

(Above two chips only marked "Monte Carlo" with no location. These come with both a green or purple tail.)

| | 1.00 | Grey | C&J | None | HS | R-8 | 100 | 200 | 300 |
| | 5.00 | Mustard | C&J | 3pnk | R-white | R-10 | 400 | 800 | 1200 |

*(Both $1 and $5 chips are marked Monte Carlo Resort. **Press Time hoard will slash values!**)*

NEVADA CLUB, ODIE LOPP'S — LAUGHLIN — 1970-75

Issue	Den.	Color	Mold	Inserts	Inlay	Rarity	GD30	VF65	CS95
1st	.25	Grey	C&J	None	HS	R-9	125	250	375
	.50	Brown	C&J	None	HS	R-9	125	250	375
	.50	Red	C&J	None	HS	R-9	125	250	375
	1.00	Pink	C&J	None	HS	R-6	70	140	210
	5.00	Navy	C&J	3red	HS	R-8	175	350	525

PIONEER CLUB — LAUGHLIN — 1980-

Issue	Den.	Color	Mold	Inserts	Inlay	Rarity	GD30	VF65	CS95
1st	.25	Lt Brown	H&C	None	HS	R-6	15	30	45
	1.00	Blue	H&C	None	R-yellow	R-5	20	40	60
	5.00	Red	H&C	4pnk	HUB-yellow	R-5	30	60	120
	25.00	Green	H&C	4ltorg	SCA-yellow	Unique	400	800	1200
2nd	.25	Orange	H&C	None	HS	R-4	4	8	12
	1.00	Blue	H&C	None	R-white	R-4	7	14	21
	5.00	Red	H&C	4pnk	HUB-white	R-4	20	40	80
	25.00	Green	H&C	4ltorg	SCA-white	R-9	200	400	600
	RLT	3 diff.	BJ	None	HS	R-6	4	8	12

(Colors: Brown, Navy, and Pink. These chips show only a large "P" with a hat.)

3rd	1.00	Blue	H&C	None	R-white	R-1	*	1	3
	5.00	Red	H&C	4yel4pur	HUB-white	R-1	*	5	10
	25.00	Green	H&C	4wht4pnk	SCA-white	R-1	*	25	35
	100.00	Black	H&C	6org6pur	COG-white	R-2	*	100	120
	RLT	Lavender	H&C	None	HS	R-4	3	6	9
	RLT	White	H&C	None	HS	R-4	3	6	9

RAMADA EXPRESS — LAUGHLIN — 1988-

Issue	Den.	Color	Mold	Inserts	Inlay	Rarity	GD30	VF65	CS95
1st	1.00	White	BJ-2	None	COIN	R-1	*	1	3
	2.50	Yellow	BJ-2	None	COIN	R-1	*	3	5
	5.00	Red	BJ-2	None	COIN	R-1	*	5	10
	25.00	Green	BJ-2	8org	COIN	R-1	*	25	35
	100.00	Black	BJ-2	4red	COIN	R-1	*	100	120
	500.00	White	BJ-2	4mar	COIN	R-2	*	500	500
	NCV	Navy	BJ	None	HS	R-5	5	10	15
	RLT A	4 diff.	H&C	None	HS	R-5	3	6	9

(Colors: Lt Blue, Maroon, Navy, and White.)

| | RLT C | 3 diff. | H&C | None | HS | R-5 | 3 | 6 | 9 |

(Colors: Lt Blue, Navy, and White.)

| | RLT | 4 diff. | BJ | None | R-yellow | R-4 | 3 | 6 | 9 |

(Colors: Blue, Green, Grey, and Yellow.)

| | RLT | 4 diff. | BJ | None | R-pink | R-4 | 3 | 6 | 9 |

(Colors: Blue, Grey, Navy, and Orange.)

Issue	Den.	Color	Mold	Inserts	Inlay	Rarity	GD30	VF65	CS95

REGENCY CASINO LAUGHLIN 1979-

Regency Casino $2 (1st)

Issue	Den.	Color	Mold	Inserts	Inlay	Rarity	GD30	VF65	CS95
1st	.50	Purple	H&C	None	HS	R-4	2	4	6
	.50	Dk Purple	H&C	None	HS	R-4	2	4	6

(These two chips are marked "RC" only.)

| | .50 | Purple | H&C | None | HS | R-4 | 2 | 4 | 6 |

(Chip is marked "Regency Casino.")

	1.00	White	H&C	None	R-blk/wht	R-3	3	6	9
	2.00	Yellow	H&C	3grn	R-yel/wht	R-3	5	10	15
	5.00	Red	H&C	4org	R-red/wht	R-1	*	5	10
	25.00	Green	H&C	4ltblu4gry	R-grn/wht	R-2	*	25	35
	n/d	Gold	C&J	None	HS	R-7	5	10	15

(Chip marked only "RC" in script on both sides. This chip is not positively identified as being used in the Regency.)

RIVER PALMS LAUGHLIN 1998-

River Palms $25 (1st)

Issue	Den.	Color	Mold	Inserts	Inlay	Rarity	GD30	VF65	CS95
1st	1.00	White	H&C	1pnk1blk	R-black	R-1	*	1	3
	5.00	Red	H&C	1lav1pur	R-black	R-1	*	5	10
	25.00	Green	H&C	2pch2yel	R-black	R-1	*	25	35
	100.00	Black	H&C	4pnk4wht	R-black	R-1	*	100	120

RIVERSIDE CASINO DAVIS DAM 1966-
LAUGHLIN

Riverside Casino $5 (1st)

Issue	Den.	Color	Mold	Inserts	Inlay	Rarity	GD30	VF65	CS95
1st	5.00	Red	C&J	None	HS	R-9	700	1400	2100

(This is the only chip marked Davis Dam and is one of the key pieces needed when trying to complete a Nevada City Type Set. Only four examples are known and one of those is notched.)

2nd	.25	Black	H&C	None	HS	R-10	100	200	300
	.50	Pink	H&C	3blk	HS	R-6	25	50	75
	.50	Pink	H&C	None	HS	R-5	15	30	45

(These chips are marked "Riverside Resort.")

Riverside Resort 50c (2nd)

	1.00	Blue	H&C	None	HS	R-3	8	16	24
3rd	.25	Orange	H&C	None	HS	R-3	2	4	6
	1.00	White	H&C	None	HS	R-2	2	4	6
	1.00	Lt Blue	H&C	None	HS	R-2	2	4	6
	1.00	Blue	H&C	None	HS	R-2	2	4	6
	5.00	Red	H&C	3pnk	R-white	R-2	5	10	15
	25.00	Green	H&C	3wht3org	SCA-white	R-6	25	50	75
	100.00	Black	H&C	6wht3yel	COG-white	R-7	75	150	225
	NCV	Green	H&C	None	HS	R-9	10	20	30
4th	2.50	Grey	BJ	None	HS	R-1	*	3	6
	5.00	Red	Wico	3wht	OR-multi	R-1	*	5	10
	25.00	Green	Wico	4org	OR-multi	R-1	*	25	35
	100.00	Black	Wico	4org	OR-multi	R-1	*	100	120
	NCV	Green	Dragon	None	HS	R-4	2	4	6
	NCV	Red	Dragon	None	HS	R-4	2	4	6
	RLT B	3 diff.	BJ	None	R-white	R-4	3	6	9

Riverside Hotel $5 (4th)

(Colors: Green, Pink, and White.)

SOUTHPOINT NEVADA CLUB SOUTHPOINT 1975-78

Issue	Den.	Color	Mold	Inserts	Inlay	Rarity	GD30	VF65	CS95
1st	.25	Gry-Grn	H&C	None	HS	Unique	400	800	1200
	5.00	Blue	H&C	3red	HS	R-8	150	300	600

(This is one of only two casinos marked Southpoint.)

Southpoint NC $5 (1st)

Big Meadow Club $25 (1st)

Davin's $2 (1st)

Felix's Bank Club $1 (1st)

Felix's Bank Club $5 (1st)

Felix's Bank Club $25 (1st)

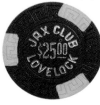

Jax Club $25 (1st)

Issue	Den.	Color	Mold	Inserts	Inlay	Rarity	GD30	VF65	CS95
BIG MEADOW CLUB			LOVELOCK		c.1946-60				
BIG MEADOW HOTEL			LOVELOCK		1962-70				
1st	5.00	Red	Hub	3yel	HS	R-6	60	120	180
	10.00	Navy	Hub	3yel	HS	R-6	60	120	180
	25.00	Maroon	Hub	3yel	HS	R-7	75	150	225
	RLT	5 diff.	Wave	None	HS	R-6	20	40	60
(Colors: Green, Navy, Red, White, and Yellow.)									
2nd	1.00	Mustard	Horshu	3nvy	R-white	R-3	15	30	45
	5.00	Tan	Horshu	3brn	R-white	R-4	20	40	60
	25.00	Black	Horshu	3gry	R-white	R-4	35	70	105
(This building burned down years ago and is now a vacant lot.)									
DAVIN'S			LOVELOCK		1974-77				
1st	2.00	Mustard	Horshu	None	HS	R-3	12	24	36
	5.00	Red	Horshu	None	HS	R-3	12	24	35
	25.00	Black	Horshu	None	HS	R-4	15	30	45

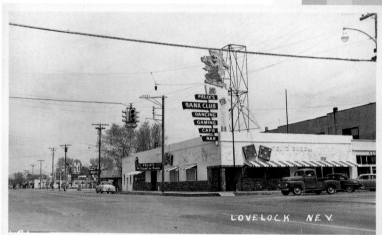

Postcard from Felix's Bank Club in the 1950s.

Issue	Den.	Color	Mold	Inserts	Inlay	Rarity	GD30	VF65	CS95
FELIX'S BANK CLUB			LOVELOCK		1953-77				
1st	1.00	Navy	Horshu	3mst	R-white	R-9	250	500	750
	5.00	Red	Horshu	3gry	R-white	R-5	40	80	120
	25.00	Green	Horshu	3blk	R-white	R-6	60	120	180

(A small hoard was found of the $5 & $25 when a table was purchased with some chips in 1998. The $1 remains exceedingly rare. For years collectors have tried to get chips from owner Felix Turillas, but to no avail. He says he just doesn't have anything. Felix is one of the gaming pioneers of Nevada.)

Issue	Den.	Color	Mold	Inserts	Inlay	Rarity	GD30	VF65	CS95
JAX CLUB			LOVELOCK		1974-78				
JAX 78 CLUB			LOVELOCK		1978-79				
JAX CASINO			LOVELOCK		1980-96				
1st	2.00	Yellow	Lg-key	None	HS	R-3	8	16	24
	5.00	Red	Lg-key	None	HS	R-3	8	16	24
	25.00	Black	Lg-key	3pnk	HS	R-4	15	30	45
2nd	2.00	Yellow	Horshu	None	HS	R-4	15	30	45

Issue	Den.	Color	Mold	Inserts	Inlay	Rarity	GD30	VF65	CS95
	5.00	Black	Horshu	None	HS	R-4	15	30	45
	25.00	Red	Horshu	None	HS	R-4	15	30	45
3rd	1.00	Blue	BJ	None	HS	R-2	3	6	9
	5.00	Red	BJ	None	HS	R-3	6	12	18
	25.00	Green	Diecar	4tan	HS	R-5	25	50	75

(First issue is "Jax Club;" second issue is "Jax 78 Club;" and the third issue is "Jax Casino.")

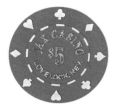

Jax Casino $5 (3rd)

PERSHING HOTEL　　LOVELOCK　　1948-67

1st	1.00	Pink	Smcirc	None	HS	R-7	10	20	30
	5.00	Black	Smcirc	None	HS	R-7	10	20	30
	25.00	Yellow	Smcirc	None	HS	R-7	10	20	30

(Above chips marked only with a denomination. These were found years ago in the Hotel by Phil Jensen. This is a very old hotel & possibly had gaming before the dates listed.)

2nd	5.00	Red	Sm-Key	3gry	HS	R-8	40	80	120

(Above only marked "M.")

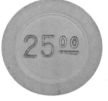

Pershing Hotel $25 (1st)

STURGEON'S　　LOVELOCK　　1982-

1st	2.00	Mustard	Lg-key	None	HS	R-6	35	70	105
	5.00	Red	Lg-key	None	HS	R-9	60	120	180
2nd	5.00	Red	BJ-2	8org	COIN	R-2	*	5	10
	25.00	Green	BJ-2	12org	COIN	R-4	*	25	35

(Originally called Log Cabin Auto Court. In the 1960's, the club became Sturgeons Log Cabin Motel, with only slots. Table games were installed later.)

Sturgeon's $5 (1st)

50 CLUB　　MCGILL　　1947-58

1st	5.00	Black	Zigzag	None	HS	R-7	175	350	525

(Located on Hwy. 50, the building is still there. Originally a motel and gas station, slots and blackjack were added by the late 40's or early 50's. This club featured dancing and live music, making it a popular attraction on the highway between Ely & McGill.)

50 Club $5 (1st)

STRAY ANTLERS　　MCGILL　　1927-32

1st	n/d	Cream	C&S	None	R-white	R-5	50	100	150
	n/d	Yellow	C&S	None	R-white	R-5	50	100	150
	n/d	Maroon	C&S	None	R-white	R-5	50	100	150
	n/d	Navy	C&S	None	R-white	R-6	75	150	225

(Historically speaking, these are very important chips. They are the first Nevada chips with the town name printed on them. Building was an Elks Lodge that got its own gaming operation going before it was legalized in 1931. These chips were used for poker games and poker was a gambling activity generally ignored by the authorities. Located on Highway 50, the building was torn down long ago.)

Stray Antlers n/d obv (1st)

VICTORY HALL CLUB　　MCGILL　　1930's-50's

1st	n/d	Cream	C&S	None	R-white	R-10	50	100	150

(This old chip was found in McGill & is marked V on one side & H on the back.)

SAY WHEN　　MC DERMITT　　1977-

1st	5.00	Brown	Lg-key	3yel	R-white	R-4	10	20	30
	25.00	Red	Lg-key	3nvy	R-white	R-6	30	60	90

(This first issue has lighter writing than the second issue.)

2nd	5.00	Brown	Lg-key	3yel	R-white	R-4	10	20	30
	25.00	Red	Lg-key	3nvy	R-white	R-6	30	60	90
3rd	5.00	Pink	H&C	3ltpnk3pur	R-multi	R-2	*	5	10
	25.00	Green	H&C	4lim4grn	R-multi	R-3	*	25	35
	100.00	Black	H&C	8wht4ltblu	R-multi	R-4	*	100	125

Say When $25(1st)

Issue	Den.	Color	Mold	Inserts	Inlay	Rarity	GD30	VF65	CS95

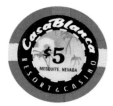

Casablanca $5 (1st)

CASABLANCA MESQUITE 1997-

Issue	Den.	Color	Mold	Inserts	Inlay	Rarity	GD30	VF65	CS95
1st	.50	Pink	H&C	None	HS	R-2	*	1	2
	1.00	White	H&C	2tan2nvy	R-white	R-1	*	1	2
	5.00	Red	H&C	2yel2grn	OR-white	R-1	*	5	7
	25.00	Green	H&C	3grn3pnk	OR-white	R-1	*	25	35
	100.00	Black	H&C	4pur4pch	OR-white	R-1	*	100	120
	RLT A	7 diff.	H&C	None	HS	R-3	3	6	9
	RLT B	7 diff.	H&C	None	HS	R-3	3	6	9

(Colors: Brown, Blue, Cream, Green, Lavender, Purple, & Orange.)

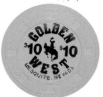

Golden West $10 (1st)

GOLDEN WEST MESQUITE 1996-97

Issue	Den.	Color	Mold	Inserts	Inlay	Rarity	GD30	VF65	CS95
1st	5.00	Red	H&C	None	HS	R-5	10	20	30
	10.00	Yellow	H&C	None	HS	R-5	15	30	45

(This club opened and closed quickly so it's doubtful many chips got out, making this a minor modern small town rarity.)

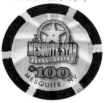

Mesquite Star $100 (1st)

MESQUITE STAR MESQUITE 1998-

Issue	Den.	Color	Mold	Inserts	Inlay	Rarity	GD30	VF65	CS95
1st	1.00	Blue	H&C	2wht2pnk	OR-multi	R-1	*	1	2
	5.00	Red	H&C	2pnk2lim	OR-multi	R-1	*	5	7

(There are actually five different $5 chips in use with these same insert colors.)

| | 25.00 | Green | H&C | 3ltblu6org | OR-multi | R-1 | * | 25 | 30 |
| | 100.00 | Black | H&C | 3yel3ltblu | OR-multi | R-2 | * | 100 | 120 |

OASIS RESORT MESQUITE 1995-

Issue	Den.	Color	Mold	Inserts	Inlay	Rarity	GD30	VF65	CS95
1st	1.00	Blue	H&C	None	OR-multi	R-1	*	1	3
	5.00	Red	H&C	2yel2tan	OR-multi	R-1	*	5	10
	25.00	Green	H&C	2wht2dkgrn2mst	OR-multi	R-1	*	25	35
	100.00	Black	H&C	3lav3org	OR-multi	R-1	*	100	120

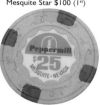

Peppermill $25 (1st)

PEPPERMILL MESQUITE 1981-95

Issue	Den.	Color	Mold	Inserts	Inlay	Rarity	GD30	VF65	CS95
1st	.50	Orange	H&C	None	HS	R-4	4	8	12
	1.00	Grey	H&C	None	R-white	R-2	4	8	12
	5.00	Red	H&C	2pnk2grn	HUB-white	R-4	10	20	30
	25.00	Green	H&C	2org2blu	SCA-white	R-6	30	60	90
	NCV 2.50	Yellow	H&C	None	HS	R-5	10	20	30

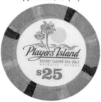

Player's Island $25 (2nd)

PLAYER'S ISLAND MESQUITE 1995-97

Issue	Den.	Color	Mold	Inserts	Inlay	Rarity	GD30	VF65	CS95
1st	1.00	Lt Blue	H&C	2yel2pnk	OR-white	R-3	3	6	9
	5.00	Red	H&C	2ltblu2blu	OR-white	R-4	6	12	18
	25.00	Green	H&C	4fch4pur	OR-white	R-6	25	50	75
	100.00	Black	H&C	4pur4pch	OR-white	R-9	100	200	300
2nd	25.00	Green	H&C	4pnk4nvy	R-white	R-6	25	50	75
	RLT 1	7 diff.	Roulet	None	OR-white	R-5	5	10	15

(Colors: Blue, Lt Blue, Fuchsia, Lt Green, Gold, Orange, & Yellow.)

| | RLT 2 | 7 diff. | Roulet | None | OR-white | R-5 | 5 | 10 | 15 |

(Colors: Brown, Dk Brown., Dk Blue, Lavender, Peach, Pink, & Turquoise.)

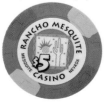

Rancho Mesquite $5 (1st)

RANCHO MESQUITE MESQUITE 1997-

Issue	Den.	Color	Mold	Inserts	Inlay	Rarity	GD30	VF65	CS95
1st	1.00	White	H&C	None	OR-blue	R-1	*	2	3
	5.00	Red	H&C	2org2pur	OR-white	R-1	*	5	10
	25.00	Green	H&C	4pnk4lim	OR-white	R-1	*	25	35
	100.00	Black	H&C	3pur3gld	OR-white	R-2	*	100	120
	NCV	3 diff.	BJ	None	HS	R-5	5	10	15

(Colors: Black, Green, and Red.)

| | RLT 1 | 7 diff. | H&C | None | HS | R-3 | 3 | 6 | 9 |

(Colors: Dk Blue, Lt Blue, Fuchsia, Green, Maroon, Orange, and Red.)

Issue	Den.	Color	Mold	Inserts	Inlay	Rarity	GD30	VF65	CS95

STATELINE CASINO (HOP'S) MESQUITE 1984-

1st	1.00	Tan	H&C	None	HS	R-6	12	24	36

(Initials "H.F" appear on this first issue.)

2nd	.50	Orange	H&C	None	HS	R-5	3	6	9
	1.00	Gray	H&C	None	HS	R-3	*	2	5
	5.00	Red	H&C	2yel2grn	HS	R-3	*	6	12

(This very small one table club is rarely open. Therefore, chips are difficult to obtain.)

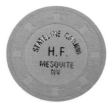

Stateline Casino $1 (1st)

VALLEY INN, (GEORGE HARMON'S) MESQUITE 1961-80's

1st	1.00	Navy	Diamnd	None	HS	R-4	20	40	60
	5.00	Rust	Diamnd	None	HS	R-4	20	40	60
2nd	1.00	Navy	Diamnd	None	R-white	R-4	15	30	45
	5.00	Brt Org	Diamnd	None	R-white	R-4	15	30	45

(This second set of chips has a sticker "Valley Inn Casino" over the original hot stamp with George Harmon's name. This club kept its license for years and the table remained covered. The chips were virtually impossible to obtain until another chip dealer was able to get some out when the owners realized they weren't going to reopen. This building became the Golden West.)

Valley Inn $5 (1st)

VIRGIN RIVER MESQUITE 1990-

1st	.25	Beige	H&C	None	HS	R-2	*	2	4
	.50	Pink	H&C	None	HS	R-2	*	2	4
	1.00	Blue	H&C	None	HS	R-1	*	2	4

(Variant with 1.00 instead of just $1, both are in use.)

2nd	1.00	Blue	H&C	None	HS	R-1	*	2	4
	5.00	Red	H&C	4grn4crm	HUB-white	R-1	*	5	10
	error 5.00	Red	H&C	4grn4crm	HUB/SCA-	Unique	100	200	300

(Rare error variant with $25 inlay on reverse.)

	25.00	Green	H&C	4org4ltorg	SCA-white	R-1	*	25	35
	100.00	Black	H&C	3org3grn3pch	COG-white	R-2	*	100	120

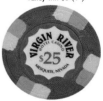

Virgin River $25 (2nd)

WESTERN VILLAGE MESQUITE 1959-84

1st	.10	Navy	H&C	None	HS	R-10	150	300	450
	.25	Pink	H&C	None	HS	R-7	25	50	75
	.50	Orange	H&C	None	HS	R-7	30	60	90
	1.00	Lt Orange	H&C	None	HS	R-6	25	50	75
	5.00	Red	H&C	4blu4pur	HS	R-7	60	120	180
2nd	5.00	Red	H&C	4crm4lav	HUB-multi	R-6	60	120	180
	25.00	Green	H&C	4trq	SCA-multi	R-10	250	500	750

(This casino opened in 1959 but no chips have been seen from that era. The only chips we know of are those listed here which were released in about 1976 on.)

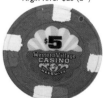

Western Village $5 (2nd)

MINA BAR MINA 1940s

1st	1.00	Red	Sqsqrt	None	HS	R-6	20	40	60
	5.00	Green	Sqsqrt	None	HS	R-9	40	80	120

(Chip only marked "MB". Found in Hawthorne. The owner of the chips said they came from here.)

Mina Bar $1 (1st)

CARSON VALLEY INN MINDEN 1984-

1st	.25	Yellow	H&C	None	HS	R-3	*	2	4
	1.00	Lt Blue	H&C	None	HS	R-1	*	1	3
	5.00	Lt Red	H&C	6pch3org	HUB-white	R-1	*	5	10
	25.00	Green	H&C	6ltgrn3grn	SCA-white	R-1	*	25	35
	100.00	Black	H&C	3dkbrn3yel3brn	COG-white	R-2	*	100	120
	RLT A	4 diff.	H&C	None	HS	R-5	4	8	12

(Colors: Grey, Green, Orange, and Pink.)

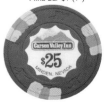

Carson Valley Inn $25 (1st)

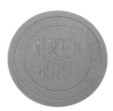

Minden Hotel $5 (1st)

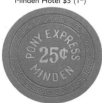

Pony Express 25c (1st)

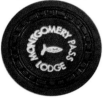

Mont. Pass Lodge RLT (1st)

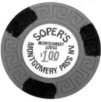

Mont. Pass Lodge $1 (3rd)

Rick's $1 (1st)

Miner's Club $5 (1st)

Issue	Den.	Color	Mold	Inserts	Inlay	Rarity	GD30	VF65	CS95
2nd	2.50	Yellow	Chipco	None	FG	R-1	*	3	5
	RLT A	Brown	HHR	None	HS	R-3	3	6	9
3rd	RLT A	Grey	HHR	None	R-white	R-2	3	6	9

MINDEN HOTEL			MINDEN		1959				
1st	5.00	Green	Sm-key	None	HS	R-5	40	80	120
	25.00	Black	Sm-key	None	HS	R-10	300	600	900

MINDEN INN			MINDEN		1943-73				
1st	5.00	Navy	Hub	None	HS	R-8	50	100	150

(Chip only initialed "VJR" for the owners: one of which was Joe Righi.)

PONY EXPRESS			MINDEN		1947-65				
1st	.05	Grey	Sm-key	None	HS	R-5	35	70	105
	.25	Red	Sm-key	None	HS	R-5	30	60	90
	1.00	Navy	Sm-key	None	HS	R-3	25	50	75
	5.00	Mustard	Sm-key	None	HS	R-4	25	50	75

MONTGOMERY PASS LODGE			MONTGOMERY PASS		1953-64				
SOPER'S LODGE					1965				
1st	1.00	Mustard	Sqsqrt	None	HS	R-4	12	24	36
	5.00	Beige	Sqsqrt	None	HS	R-5	18	36	54
	25.00	Brown	Sqsqrt	None	HS	R-6	35	70	105
	RLT	5 diff.	Sqsqrt	None	HS	R-5	9	18	27

(Colors: Pink, Navy, Peach, Green, Black)

2nd	1.00	Mustard	HHR	None	HS	R-4	15	30	45
	5.00	Beige	HHR	None	HS	R-4	15	30	45
	n/d	Blue	Plain	None	HS	R-10	25	50	75

(This chip is marked "Jackpot".)

3rd	1.00	Purple	Lg-key	3dkblu	R-white	R-3	*	2	5
	2.00	Beige	Lg-key	3dknvy	R-white	R-3	*	5	10
	5.00	Lime	Lg-key	3org	R-white	R-3	*	7	14

(Above three chips have fine, smaller print.)

	2.00	Tan	Lg-key	3dkgrn	R-white	R-3	*	5	10
	5.00	Green	Lg-key	3dkorg	R-white	R-2	*	6	12
	25.00	Brown	Lg-key	3yel	R-white	R-3	*	25	40

RICK'S			MOUNDHOUSE		1984				
1st	1.00	Gray	H&C	None	HS	R-5	10	20	30
	n/d	Red	H&C	None	HS	R-5	5	10	15
	n/d	Blue	H&C	None	HS	R-5	5	10	15
	n/d	Black	H&C	None	HS	R-5	5	10	15
	n/d	Lt Green	H&C	None	HS	R-5	5	10	15

("Rick's" on obverse with a nice picture of a horse head in a horseshoe on the reverse. There is no proof that live gaming actually existed here.)

MINER'S CLUB			MOUNTAIN CITY		1931-				
1st	1.00	Brown	Sm-key	None	HS	R-9	250	500	750

(These chips were verified burned by the owner. He pulled some games out & started using Ike dollars & burned these. We believe only 4 or 5 exist.)

	5.00	Red	Sm-key	3grn	HS	R-4	30	60	150

(Luckily for collectors some $5's were found, some very used, in late 1999. Mountain City is one of the "stoppers" for city type set collectors. These chips are positively attributed to Mountain City, but unfortunately, the chips do not show a location. This small town on the way to Idaho going out of Elko had 7 gambling joints over the years, but there is no live gaming anymore. Four of the clubs burned down. The Miner's Club is still standing today, as a bar only.)

Issue	Den.	Color	Mold	Inserts	Inlay	Rarity	GD30	VF65	CS95

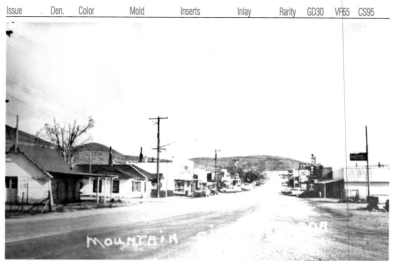

If you look closely at this postcard on the right side of the street, you can see a bit of the O'Meara's sign peeking out.©NYCE Manufacturing Co., Vernfield, PA.

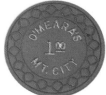

O'Meara's $1 (1st)

Mt. Charleston Lodge $1 (1st)

Mt. Charleston Lodge $5 (1st)

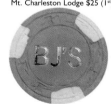

Mt. Charleston Lodge $25 (1st)

O'MEARA'S			**MOUNTAIN CITY**		**1965-74**				
1st	1.00	Red	Sqincr	None	HS	R-9	400	800	1200
	5.00	Blue	Sqincr	None	HS	Unknown	500	1000	1500
	25.00	White	Sqincr	None	HS	Unknown	500	1000	1500

(Exactly four $1 chips are known to exist. Two chips were found by Fred Holabird during the Spring of 1999 and one other was obtained by James Campiglia from the former owner several months later. The original order shows that 300 $1's, and 100 each of the $5's & $25's were made. We do not believe that a quantity of these exists, due to the extreme fire that burned this whole side of the highway for 3 hours! Along with O'Meara's, the White Front and Sportmen's burned as well as other businesses on the highway. In addition to the extreme rarity of these pieces, what makes them really special is that they are the only chips to actually show the name of this tiny, forgotten town.)

MOUNT CHARLESTON LODGE			**MOUNT CHARLESTON**		**1946-62**				
1st	1.00	Yellow	Zigzag	None	HS	R-10	500	1000	1500

(Possibly unique, this chip came from the Jerry Wall collection. Luckily, more $5's & $25's were saved. Owners of the Last Frontier ran this place in the mountains.)

	5.00	Red	Zigzag	None	HS	R-7	125	250	375
	25.00	Lavender	Zigzag	None	HS	R-6	100	200	300

BJ'S			**PAHRUMP**		**1978-79**				
1st	5.00	Red	H&C	2wht2grn	HS	R-5	12	24	36
	25.00	Green	H&C	3ltorg	HS	R-5	15	30	45

BJ's $25 (1st)

COTTON PICKIN' SALOON			**PAHRUMP**		**1980-81**				
1st	5.00	Red	H&C	3wht3nvy	HS	R-9	125	250	375

FRED'S BAR (B J)			**PAHRUMP**		**1948-70**				
1st	.10	Cream	Zigzag	None	HS	R-5	15	30	45
	.25	Green	Zigzag	None	HS	R-5	10	20	30
	.50	Purple	Zigzag	None	HS	R-5	10	20	30
	1.00	Red	Zigzag	None	HS	R-5	10	20	30
	5.00	Orange	Zigzag	None	HS	R-5	10	20	30

(Chips marked B with backwards J for Bar J. These early Pahrump chips were found by Steve McClendon.)

Cotton Pickin' Saloon $5 (1st)

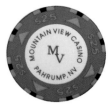

Mountain View Casino $25 (1st)

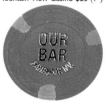

Our Bar $5 (1st)

Saddle West $1 (2nd)

Terrible's Lakeside $25 (1st)

Alamo Club $5 (1st)

Overland $5 (1st)

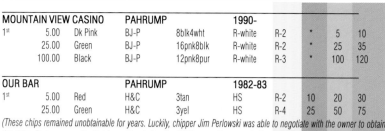

Issue	Den.	Color	Mold	Inserts	Inlay	Rarity	GD30	VF65	CS95
MOUNTAIN VIEW CASINO			**PAHRUMP**		**1990-**				
1st	5.00	Dk Pink	BJ-P	8blk4wht	R-white	R-2	*	5	10
	25.00	Green	BJ-P	16pnk8blk	R-white	R-2	*	25	35
	100.00	Black	BJ-P	12pnk8pur	R-white	R-3	*	100	120
OUR BAR			**PAHRUMP**		**1982-83**				
1st	5.00	Red	H&C	3tan	HS	R-2	10	20	30
	25.00	Green	H&C	3yel	HS	R-4	25	50	75

(These chips remained unobtainable for years. Luckily, chipper Jim Perlowski was able to negotiate with the owner to obtain the chips. These were sold off at face value during the 1997 convention as part of a membership promotion, and are now pretty common.)

Issue	Den.	Color	Mold	Inserts	Inlay	Rarity	GD30	VF65	CS95
SADDLE WEST			**PAHRUMP**		**1975-**				
1st	.25	Yellow	H&C	None	HS	R-6	25	50	75
	1.00	Blue	H&C	None	HS	R-5	20	40	60
	5.00	Red	H&C	3pur	HS	R-6	30	60	90
	5.00	Orange	H&C	None	HS	R-7	35	70	105
2nd	.25	Dk Grey	H&C	None	R-white	R-2	*	2	4
	1.00	White	H&C	4pur4mar	R-white	R-1	*	1	3
	5.00	Red	H&C	3org3grn3pnk	HUB-white	R-1	*	5	10
	25.00	Green	H&C	3nvy3lim3lav	SCA-white	R-2	*	25	35
	100.00	Black	H&C	3brn3wht	COG-white	R-2	*	100	125
	NCV 5.00	Orange	H&C	None	HS	R-7	5	10	15
	NCV 25.00	Pink	H&C	None	HS	R-7	5	10	15

(Marked "Poker".)

Issue	Den.	Color	Mold	Inserts	Inlay	Rarity	GD30	VF65	CS95
TERRIBLE'S LAKESIDE			**PAHRUMP**		**1999-**				
1st	1.00	Blue	H&C	4lav	OR-white	R-1	*	1	3
	5.00	Pink	H&C	4lav	OR-white	R-1	*	5	8
	25.00	Green	H&C	8ltpur	OR-white	R-1	*	25	30
	100.00	Black	H&C	4pur	OR-white	R-1	*	100	110
TERRIBLE'S TOWN			**PAHRUMP**		**1996-**				
1st	1.00	Blue	H&C	2wht2nvy	R-blue	R-1	*	1	3
	5.00	Red	H&C	2wht2blk	OR-white	R-1	*	5	10
	25.00	Green	H&C	4wht4nvy	OR-white	R-1	*	25	35
	100.00	Black	H&C	4grn4yel4gry	OR-white	R-2	*	100	120
ALAMO CLUB			**PIOCHE**		**1948-70s**				
1st	5.00	Blue	Lcrown	None	HS	R-6	50	100	150
	5.00	Red	Lcrown	None	HS	R-8	100	200	300
2nd	.25	Yellow	C&J	None	HS	R-5	15	30	45
	.50	Green	C&J	None	HS	R-5	12	24	36
	1.00	Beige	C&J	None	HS	R-5	12	24	36

(This old Pioche club is known to have one of Nevada's oldest liquor licenses. They very possibly had gaming years before the records show.)

Issue	Den.	Color	Mold	Inserts	Inlay	Rarity	GD30	VF65	CS95
OVERLAND HOTEL			**PIOCHE**		**1930's-47/48-74**				
1st	.25	Lavender	C&J	None	HS	R-7	35	70	105
	.50	Green	C&J	None	HS	R-4	10	20	30
	1.00	Orange	C&J	None	HS	R-4	12	24	36
	5.00	Black	C&J	None	HS	R-6	30	60	90
	n/d	Blue	Plain	None	HS	R-6	5	10	15

Issue	Den.	Color	Mold	Inserts	Inlay	Rarity	GD30	VF65	CS95
	n/d	Red	Plain	None	HS	R-6	5	10	15

(Above two are only marked "WHB" for William H. Brown - one of the past owners from the 1960's to 1990. This old hotel burned in May 1947, along with the Pioche Club next door. No chips are known from either of these clubs before the fire.)

VALENTE CLUB, JOE'S PIOCHE 1946-50's

1st	n/d	Yellow	C&S	None	R-white	R-9	25	50	75

Valente Club n/d (1st)

(This chip is marked "J " on one side, "V" on the other. This chip was found with the Caliente Club chips. The Costanzos bought this club and the Silver Club. These chips were also used in the Silver Club as well as "CW" chips from Freeman's Bar in Evanston, Wyoming and "RIO" chips from Yellowstone Hotel, Pocatello, ID. This shows how chips travelled and ended up being used in other clubs by owners who kept their chips. These other two initialed chips are not Nevada chips per se but ended up that way, from Wyoming to Pioche to Caliente.)

7TH ONE PITTMAN 1953-56

1st	1.00	Orange	Rectl	None	HS	R-7	250	500	750

(This is the only chip that is actually marked "Pittman." Pittman was located between Sunset Rd. and Water St. on Boulder Highway. An area once littered with many bars & clubs, this is now all part of Henderson. 7 th ONE was located where the Skyline is today.)

7th One $1 (1st)

ALIBI CLUB PITTMAN 1950-56/1959-62

1st	1.00	Green	C&J	None	HS	R-5	30	60	90
	5.00	Fuchsia	C&J	None	HS	R-5	40	80	120
	5.00	Navy	C&J	None	HS	R-9	100	200	300

DON'S SALOON PITTMAN 1953-54

1st	.25	Orange	Zigzag	None	HS	R-10	100	200	300
	5.00	Lavender	Zigzag	None	HS	R-9	75	150	225
	n/d	Beige	Diasqr	None	HS	R-9	50	100	150
	n/d	Red	Diamnd	None	HS	R-9	50	100	150

(All chips only have the name "Don" in block letters.)

Alibi Club $1 (1st)

MIDWAY PITTMAN 1944-46

1st	n/d	White	Plain	None	HS	R-7	75	150	225
	n/d	Red	Plain	None	HS	R-7	75	150	225
	n/d	Navy	Plain	None	HS	R-8	100	200	300

(Located midway between Vegas & Boulder. This town called Midway in the 30's, became Pittman. Old dice marked MIDWAY were found with these chips in 1999, from a past dealer from the club.)

Midway n/d (1st)

SILVER SLIPPER PITTMAN 1944-51

1st	5.00	Red	Zigzag	None	HS	R-8*	200	400	600
	25.00	Yellow	Zigzag	None	HS	Unique*	400	800	1200

(The name was bought by the Silver Slipper on the Strip. This club then became Satin Shoe.)

VIC'S JOLLY JUG PITTMAN 1965-66

1st	.10	Mustard	C&J	None	HS	R-5	25	50	75
	.25	Red	C&J	None	HS	R-5	20	40	60
	1.00	Orange	C&J	None	HS	R-5	20	40	60
	5.00	Black	C&J	None	HS	R-5	25	50	75

Vic's Jolly Jug 10c (1st)

(This old club originally opened in the 40's as the Jolly Jug. A new owner, Vic, put his name on the chips when he took over in 1965.)

VICTORY CLUB PITTMAN 1940s

1st	10.00	Orange	Sm-key	None	HS	Unique	100	200	300

(This chip is attributed to here. There was also a Victory Tavern Downtown, lower Fremont St.)

Vic's Jolly Jug $5 (1st)

277

Jubilee $5 (1st)

Harold's Gun Club $100 (1st)

Bank Club n/d (1st)

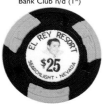

El Rey $25 (3rd)

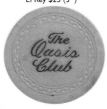

Oasis Club n/d(1st)

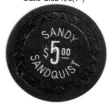

Sandy Sandquist $5 (1st)

Issue	Den.	Color	Mold	Inserts	Inlay	Rarity	GD30	VF65	CS95
JUBILEE INN			**PLEASANT VLY**		**1953-59**				
1st	1.00	Black	Sm-key	None	HS	R-6	75	150	225
	5.00	Yellow	Sm-key	3blk	R-white	R-6	150	300	450
	25.00	Green	Sm-key	3nvy	R-white	R-8	350	700	1050
HAROLD'S GUN CLUB			**PYRAMID LAKE**		**1962-79**				
1st	5.00	Maroon	HCE	None	HS	R-8	200	400	600
	20.00	Navy	HCE	3red3yel	HS	R-10	450	900	1350
	25.00	Tan	HCE	6blk	HS	R-8	300	600	900
	100.00	Mustard	HCE	3nvy3red	HS-blue	R-8	300	600	900
	RLT	7 diff.	HCE	None	HS	R-8	20	40	60

(Colors: Beige, Blue, Light Blue, Grey, Mustard, Orange, and Red.)

Issue	Den.	Color	Mold	Inserts	Inlay	Rarity	GD30	VF65	CS95
BANK CLUB			**SEARCHLIGHT**		**1946-51**				
1st	5.00	Mustard	Lcrown	None	HS	R-6	25	50	75
	25.00	Brown	Lcrown	None	HS	R-6	30	60	90
	pan n/d	Green	Lcrown	None	HS	R-6	20	40	60
CHEVRON BAR			**SEARCHLIGHT**		**1957-69**				
1st	1.00	Black	Rectl	None	HS	R-4	15	30	45
	5.00	Green	Rectl	None	HS	R-5	20	40	60
	10.00	Lavender	Rectl	None	HS	R-5	25	50	75

(The entire inventory was purchased by James Campiglia from a past owner in 1990 - 200 $1 and 100 each of the others. This place is now a storage building near a gas station that once had one blackjack table and a few slots.)

Issue	Den.	Color	Mold	Inserts	Inlay	Rarity	GD30	VF65	CS95
EL REY			**SEARCHLIGHT**		**1946-73**				
1st	5.00	Beige	Arodie	3blk	HS	R-10	150	300	450

(Currently very rare but some are sitting in non collectors hands which may never get to collections.)

2nd	5.00	Navy	Lcrown	None	HS	R-8	100	200	300
	NN 1.00	Orange	Scrown	None	HS	R-9	75	150	225
3rd	1.00	Navy	C&J	3red	R-white	R-7	125	250	375
	5.00	Grey	C&J	3org	R-white	R-8	250	500	750
	25.00	Black	C&J	3yel	R-white	R-6	125	250	375
4th	1.00	Orange	C&J	None	HS	R-5	20	40	60
	5.00	Lt Green	C&J	None	HS	R-8	100	200	400
	1000.00	Black	Plain	None	FG-printed	R-9	50	100	150

(A very collectible plastic advertising chip with Willie Martello's name - the famous owner. This club burned in 1947 and again in 1962.)

Issue	Den.	Color	Mold	Inserts	Inlay	Rarity	GD30	VF65	CS95
OASIS CLUB, THE			**SEARCHLIGHT**		**1947-1954**				
1st	n/d	Maroon	Zigzag	None	HS	R-7	30	60	90
	n/d	Yellow	Zigzag	None	HS	R-7	30	60	90
	n/d	Navy	Zigzag	None	HS	R-7	30	60	90
SANDY SANDQUIST			**SEARCHLIGHT**		**1954-67**				
1st	5.00	Black	Arodie	None	HS	R-7	40	100	400
	25.00	Red	Arodie	None	HS	R-6	100	200	400

(Virtually all $5 chips are very worn. Sandy Sandquist ran the games in many of the clubs in Searchlight, these chips probably having been used in most. Sandy ran the Golden Eagle 1946 to 47, Union Bar from 1947 to 48, Oasis 1952 to 55, Searchlight Casino 1954 to 56, and Sandy's Club from 1957 to 1967. This town once boasted over a dozen clubs, hotels, etc. operating at the same time in the 1930's & 40's. From their heyday to present, twenty clubs in all held live games.)

Issue	Den.	Color	Mold	Inserts	Inlay	Rarity	GD30	VF65	CS95
SEARCHLIGHT NUGGET			**SEARCHLIGHT**		**1967-**				
1st	5.00	Red	BJ-2	6yel	COIN	R-2	*	5	10
	25.00	Green	BJ-2	12yel	COIN	R-2	*	25	35
2nd	5.00	Red	BJ-2	6yel	COIN	R-2	*	5	10

(All above are currently in use. The casino reordered the $5 and the edge design is different.)

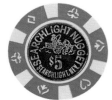
Searchlight Nugget $5 (2nd)

Issue	Den.	Color	Mold	Inserts	Inlay	Rarity	GD30	VF65	CS95
TEXAS CLUB			**SEARCHLIGHT**		**1931-34**				
1st	n/d	Red	Sm-key	None	HS	R-6	10	20	30
	n/d	Yellow	Sm-key	None	HS	R-6	10	20	30
	n/d	Black	Sm-key	None	HS	R-6	10	20	30

(These old chips are possibly from Searchlight, but research is inconclusive. Therefore value is low at this time.)

Issue	Den.	Color	Mold	Inserts	Inlay	Rarity	GD30	VF65	CS95
RED COACH			**SILVER SPRINGS**		**1967-68/76-87**				
1st	1.00	Yellow	Horshu	None	HS	R-3	7	14	21
	5.00	Red	Horshu	None	HS	R-3	7	14	21
	10.00	Black	Horshu	None	HS	R-4	8	16	24

Red Coach $10 (1st)

Issue	Den.	Color	Mold	Inserts	Inlay	Rarity	GD30	VF65	CS95
CARVER'S COUNTRY			**SMOKY VALLEY**		**1983-94**				
1st	5.00	Red	H&C	3nvy	HS	R-5	15	30	45
	25.00	Green	H&C	3org3lim	HS	R-6	40	80	160

Carvers Country $25 (1st)

Issue	Den.	Color	Mold	Inserts	Inlay	Rarity	GD30	VF65	CS95
ALAMO TRAVEL CENTER			**SPARKS**		**1997-**				
1st	5.00	Red	H&C	3pur3pnk	OR-multi	R-1	*	5	10
	25.00	Green	H&C	4blu4tan	OR-green	R-2	*	25	35
	100.00	Black	H&C	4gry4ltblu4lav	OR-white	R-2	*	100	120

Issue	Den.	Color	Mold	Inserts	Inlay	Rarity	GD30	VF65	CS95
BALDINI'S			**SPARKS**		**1988-**				
1st	.25	Purple	H&C	None	HS	R-5	2	4	6
	.50	Yellow	H&C	None	HS	R-3	*	1	2
	1.00	Blue	H&C	None	HS	R-1	*	1	3
	5.00	Red	H&C	4blu	R-white	R-1	*	5	7
	25.00	Green	H&C	3wht3yel	HUB-white	R-2	*	25	30
	100.00	Black	H&C	4ltblu4wht	COG-white	R-2	*	100	110

Baldini's $5 (1st)

Issue	Den.	Color	Mold	Inserts	Inlay	Rarity	GD30	VF65	CS95
BAR WEST			**SPARKS**		**1977-79**				
1st	5.00	Red	H&C	3blk	HS	R-4	20	40	60

Issue	Den.	Color	Mold	Inserts	Inlay	Rarity	GD30	VF65	CS95
CLAIM STAKE			**SPARKS**		**1979-79**				
1st	1.00	Blue	H&C	3gry	HS	R-2	3	6	9
	5.00	Red	H&C	3org3gry	R-white	R-2	5	10	15
	25.00	Green	H&C	3wht3pnk	SCA-white	R-3	8	16	24

(Claim Stake became the Treasury Club.)

Claim Stake $25 (1st)

Issue	Den.	Color	Mold	Inserts	Inlay	Rarity	GD30	VF65	CS95
CRYSTAL CARD CLUB			**SPARKS**		**1951-68**				
1st	1.00	Blue	Sm-key	None	HS	R-10	150	300	450
	5.00	Mustard	Sm-key	None	HS	Unique	200	400	600
	10.00	Lt Purple	Sm-key	None	HS	Unique	200	400	600
	20.00	Lt Green	Sm-key	None	HS	Unique	200	400	600

(This club used to be a two-story building with an upstairs brothel. Now it's a parking lot.)

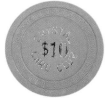
Crystal Card Club $10 (1st)

Issue	Den.	Color	Mold	Inserts	Inlay	Rarity	GD30	VF65	CS95
D & N BAR			**SPARKS**		**1944-62**				
1st	.05	Brown	Lcrown	None	HS	R-6	60	120	180
	.10	White	Lcrown	None	HS	R-6	60	120	180
	.25	Red	Lcrown	None	HS	R-10	125	250	375

279

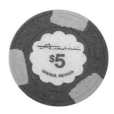

Giudici's $5 (1st)

Gold Club $1 obv (1st)

McCarlie's Gold Club $5 (4th)

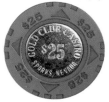

Gold Club $25 (5th)

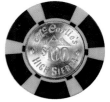

High Sierra $100 (1st)

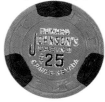

Howard Johnson's $25 (1st)

Issue	Den.	Color	Mold	Inserts	Inlay	Rarity	GD30	VF65	CS95
	.50	Navy	Lcrown	None	HS	R-8	100	200	300

(These exact same chips were also used in the Reno Casino, located in Downtown Reno. The same person was running the games in both casinos. These chips marked "RC" were ordered in 1944 from T.R. King in Los Angeles, according to their records. This can be considered a dual usage chip as like chips were used at both places, although they were used in Reno first. See Reno Casino listing.)

2nd	5.00	Orange	Scrown	2nvy	HS	R-10	150	300	450
3rd	25.00	Purple	Flower	None	HS	R-9	125	250	375

(Above is marked D & N and is attributed to this bar.)

GIUDICI'S — SPARKS — 1989-94

1st	5.00	Red	H&C	3pch	HUB-white	R-4	5	10	15
	25.00	Green	H&C	6pch	SCA-white	R-7	20	40	60
	100.00	Black	H&C	3crm	COG-white	R-7	100	125	175

(Formerly the King of Clubs.)

GOLD CLUB — SPARKS — 1966-74
GOLD CLUB, OVERLAND — SPARKS — 1974-78
GOLD CLUB, McCARLIE'S — SPARKS — 1978-79
GOLD CLUB CASINO — SPARKS — 1987-91

1st	1.00	Green	Sm-key	None	HS	R-5	12	24	36
2nd	.25	Red	Lg-key	None	HS	R-5	15	30	45
	1.00	Mustard	Lg-key	3blk	HS	R-6	20	40	60
	5.00	Black	Lg-key	3mst	HS	R-6	25	50	75
3rd	5.00	Pink	Scrown	4blu4blk	OR-white	R-1	5	10	15

(This chip was used simultaneously at Overland in Reno and Topaz Lodge Casino in Topaz Lodge.)

	5.00	Red	Ewing	3yel	R-white	R-10*	250	500	750

("Overland Gold Club" during Pick Hobson's ownership 1974-78. This incredibly rare chip may not have hit the tables. The only known specimens are manufacturer's samples.)

4th	5.00	Red	BJ-1	6blu	COIN	R-3	7	14	21
	25.00	Green	BJ-1	6wht	COIN	R-3	10	20	30

(Fourth issue is "McCarlie's Gold Club" from 1978-79.)

5th	.25	Purple	BJ	None	HS	R-3	2	4	6
	1.00	Blue	BJ	None	HS	R-2	3	6	9
	5.00	Red	BJ-2	4wht	COIN-brass	R-2	4	8	12
	25.00	Green	BJ-2	12red	COIN-brass	R-2	8	16	24
	100.00	Black	BJ-2	16wht	COIN-brass	R-4	15	30	45
	RLT	7 diff.	BJ	None	HS	R-5	5	10	15

(Colors: Blue, Lt Brown, Dk Brown, Cream, Fuchsia, Orange, and Yellow. This last issue is marked "Gold Club Casino.")

HIGH SIERRA, McCARLIE'S — SPARKS — 1977-80

1st	5.00	Red	BJ-1	6blu	COIN	R-2	4	8	12
	25.00	Green	BJ-1	6wht	COIN	R-2	6	12	18
	100.00	Black	BJ-1	6yel	COIN	R-4	20	40	60
	NN 1.00	Grey	Diecar	3crm	HS	R-5	6	12	18
	NN 1.00	Navy	Diecar	None	HS	R-3	3	6	9
	NN 5.00	Maroon	Diecar	3pur	HS	R-3	5	10	15
	NN 25.00	Green	Diecar	3yel	HS	R-4	8	16	24

(These non-negotiable chips are marked "High Sierra.")

HOWARD JOHNSON'S — SPARKS — 1975-77

1st	1.00	Tan	H&C	None	HS	R-6	20	40	60
	5.00	Orange	H&C	3nvy	HS	R-2	5	10	15
	25.00	Green	H&C	3blk	HS	R-4	15	30	45
	100.00	Black	H&C	3wht3yel	HS	R-4	25	50	75

Issue	Den.	Color	Mold	Inserts	Inlay	Rarity	GD30	VF65	CS95

KARL'S HOTEL CASINO **SPARKS** **1968-89**
KARL'S SILVER CLUB

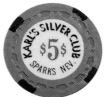

Karl's $5 (1st)

Issue	Den.	Color	Mold	Inserts	Inlay	Rarity	GD30	VF65	CS95
1st	.10	Lt Pink	Scrown	None	HS	R-6	15	30	45
	.10	Dk Pink	Scrown	None	HS	R-6	20	40	60
	.50	Blue	Scrown	None	HS	R-5	10	20	30
	1.00	Green	Scrown	None	HS	R-5	10	20	30
	2.50	Brown	Scrown	3yel3tan	HS	R-6	30	60	90
	2.50	Brown	Scrown	3yel3tan	R-white	R-6	40	80	120
	5.00	Brown	Scrown	4dkbrn	OR-white	R-4	15	30	45
	5.00	Brown	Scrown	4dkbrn	R-white	R-6	25	50	75
	25.00	Blue	Scrown	3yel3brn	R-white	R-5	30	60	90
	100.00	Yellow	Scrown	4grn4brn	OR-white	R-6	50	100	150

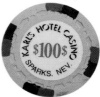

Karl's $100 (1st)

(Above set marked Hotel Casino)

Issue	Den.	Color	Mold	Inserts	Inlay	Rarity	GD30	VF65	CS95
2nd	.25	Yellow	Diasqr	None	HS	R-7	35	70	105
	.50	Navy	Diasqr	None	HS	R-7	35	70	105
3rd	.25	Cream	Lg-key	None	HS	R-5	10	20	30
4th	.25	White	H&C	None	HS	R-6	10	20	30

(Variant marked Hotel/Casino & Karl's)

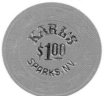

Karl's $1 (4th)

Issue	Den.	Color	Mold	Inserts	Inlay	Rarity	GD30	VF65	CS95
	.25	White	H&C	None	HS	R-6	10	20	30
	1.00	Green	H&C	None	HS	R-4	8	16	24
	NCV 5	Blue	H&C	3org	HS	R-4	4	8	12
	NCV 25	Ochre	H&C	3red	HS	R-4	6	12	18
	NCV 100	Gray	H&C	3ltgrn	HS	R-4	8	16	24
	NCV	Black	H&C	3org	HS	R-6	10	20	30
	NCV	Fuchsia	H&C	3org	HS	R-5	5	10	15
	NCV	Green	H&C	3blu	HS	R-5	5	10	15

KING OF CLUBS **SPARKS** **1975-81**

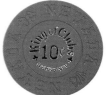

King of Clubs 10c (1st)

Issue	Den.	Color	Mold	Inserts	Inlay	Rarity	GD30	VF65	CS95
1st	.10	Rust	Nevada	None	HS	R-7	50	100	150
	.25	Navy	Nevada	None	HS	R-5	15	30	45
	5.00	Red	BJ-1	3pnk	COIN	R-4	12	24	36
	25.00	Green	BJ-1	3wht	COIN	R-4	20	40	60
	100.00	Black	BJ-1	6yel	COIN	R-5	30	60	90
	100.00	Black	BJ-1	3wht	COIN	R-10	75	150	225

(Above is a notched manufacturer's sample. May have been a backup)

MINT, THE **SPARKS** **1985-**

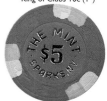

The Mint $5 (1st)

Issue	Den.	Color	Mold	Inserts	Inlay	Rarity	GD30	VF65	CS95
1st	5.00	Red	H&C	3ltorg3ltblu	HS	R-3	6	12	18

(Club is still open, but table games were removed in 1996.)

NUGGET, THE **SPARKS** **1955-58**

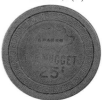

The Nugget 25c (1st)

Issue	Den.	Color	Mold	Inserts	Inlay	Rarity	GD30	VF65	CS95
1st	.25	Navy	Arodie	None	HS	R-9	150	300	450
2nd	.25	Orange	Sm-key	None	HS	R-6	35	70	105
	.25	Black	Sm-key	3red	HS	R-9	60	120	180
	.25	Tan	Sm-key	None	HS	R-9	50	100	150
	1.00	Maroon	Sm-key	None	HS	R-7	50	100	150
	5.00	Navy	Sm-key	None	HS	R-9	125	250	375
	25.00	Green	Sm-key	None	HS	R-10	200	400	600

(These chips were probably used originally in Reno from 1947-53. They were restamped Sparks in the nugget picture. Originally opened by Dick Graves' at 12 th & B St. which is across the street from the present location.)

281

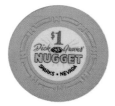

Dick Graves' Nugget $1 (1st)

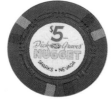

Dick Graves' Nugget $5 (1st)

D Graves' Nugget RLT obv (1st)

D Graves' Nugget RLT rev (1st)

Nugget Casino $5 (1st)

Nugget Casino $100 (2nd)

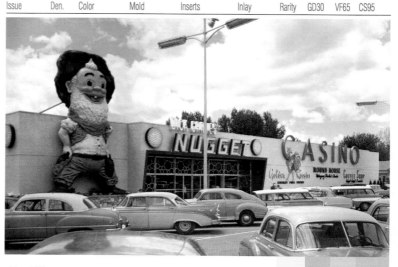

A late 1950s postcard shot of Dick Graves Nugget in Sparks, a club which has left a legacy of rare and valuable chips.©Colourpicture Publishers, Inc., Boston, MA.

NUGGET, DICK GRAVES SPARKS 1955-60

Issue	Den.	Color	Mold	Inserts	Inlay	Rarity	GD30	VF65	CS95
1st	1.00	Grey	HCE	None	R-white	R-7	125	250	375
	5.00	Maroon	HCE	3nvy3yel	R-white	R-10	500	1000	1500
	25.00	Dk Green	HCE	3pur3pnk	R-white	R-10*	600	1200	1800
	100.00	Black	HCE	3yel3wht	R-white	R-10*	700	1400	2100

(This set was used when Dick Graves relocated across the street. Possibly the others were brought over and also used there.)

	n/d	White	Sm-key	None	HS	R-9	100	200	300
	n/d	Yellow	Sm-key	None	HS	R-10	150	300	450
	n/d	Lavender	Sm-key	None	HS	R-10	150	300	450

(Owner Dick Graves had a 15 pound, 18 karat gold rooster insured for $40,000 on display in his casino. The federal government, which is always looking to loot and rob private citizens, decided it wanted to steal Dick Graves' golden rooster. At that time, in the 1950's, owning gold bullion was illegal. Anyway, Graves' lawyers had the golden rooster legally declared a work of art - an exception that kept it safe from government thieves. Dick Graves commemorated this glorious victory by picturing his rooster on these chips.)

NUGGET, JOHN ASCUAGA'S SPARKS 1960-

	Den.	Color	Mold	Inserts	Inlay	Rarity	GD30	VF65	CS95
1st	1.00	Tan	Zigzag	None	HS	R-4	8	16	24
	1.00	Mustard	Zigzag	3blk	HS	R-9	75	150	225

("John Ascuaga's Nugget")

	5.00	Orange	Zigzag	3grn	R-white	R-6	35	70	105

("Nugget Casino")

2nd	5.00	Orange	Horshu	3grn	R-white	R-5	25	50	75
	25.00	Mustard	Horshu	3blu	R-white	R-7	75	150	225
	100.00	Black	Horshu	3red	R-white	R-10	300	600	900

("Nugget Casino")

	RLT	3 diff.	Plain	None	OR-white	R-6	12	24	36

(Colors: Fuchsia 1, Green 1, Red 2)

3rd	5.00	Red	PMSC	4 brass	BRASS	R-2	5	10	20
	25.00	Green	PMSC	4 brass	BRASS	R-4	25	50	75
	100.00	Black	PMSC	4 brass	BRASS	R-7	100	125	175
	500.00	Orange	PMSC	4 brass	BRASS	R-10	500	600	700
	RLT	6 diff.	Diasqr	3ltgry	HS	R-6	10	20	30

Issue	Den.	Color	Mold	Inserts	Inlay	Rarity	GD30	VF65	CS95
(Colors: Brown, Fuchsia, Green, Lavender, Navy, Red)									
	RLT	6 diff.	Diasqr	3org	HS	R-6	10	20	30
(Colors: Brown, Fuchsia, Green, Lavender, Navy, Red)									
	RLT	6 diff.	Diasqr	3mst	HS	R-6	10	20	30
(Colors: Brown, Fuchsia, Green, Lavender, Navy, Red)									
	RLT	9 diff.	Horshu	3blk	HS	R-5	8	16	24
(Colors: Beige, Dk Brown, Lt Brown, Green, Lavender, Navy, Orange, Red, Salmon.)									
	RLT	8 diff.	Horshu	3org	HS	R-5	8	16	24
(Colors: Beige, Dk Brown, Lt Brown, Lavender, Navy, Orange, Red, Salmon.)									
4th	1.00	Blue	H&C	6pur3pnk	OR-white	R-1	*	2	3
(There are three variations to this chip; two have different colored lettering on the $1 & "one dollar" which is spelled out. The other is the older style H&C that doesn't go out to the edges.)									
	RLT 2	Purple	H&C	None	HS	R-5	3	6	9
5th	5.00	Purple	H&C	6grn	OR-multi	R-1	*	5	10
(This is a commemorative advertising the existence of "Nugget 1955-95," and was used on the tables.)									
	RLT C	7 diff.	Roulet	None	R-white	R-2	3	6	9
(Colors: Lt Blue, Brown, Green, Grey, Orange, Pink, and Yellow.)									
	RLT E	6 diff.	Roulet	None	R-white	R-2	3	6	9
(Colors: Brown, Green, Orange, Pink, Purple, and Yellow.)									
6th	5.00	Red	H&C	2yel2blu	OR-multi	R-1	*	5	7
	25.00	Green	H&C	3wht3org	OR-multi	R-1	*	25	30
	100.00	Black	H&C	3org3gld3brn	OR-multi	R-1	*	100	110
	500.00	Purple	H&C	4trq4pch	OR-multi	R-2	*	500	525

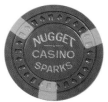

Nugget Casino RLT (3rd)

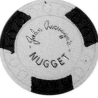

J Ascuaga's Nugget RLT (3rd)

J Ascuaga's Nugget RLT 2 (4th)

PLANTATION			SPARKS		1977-93				
1st	5.00	Red	Scrown	4yel	LSC-white	R-5	20	40	60
	25.00	Dk Purple	Scrown	4yel4org	LSC-white	R-6	35	70	105
	100.00	Dk Yellow	Scrown	4yel4grn	LSC-white	R-6	40	80	120
	RLT	Yellow	Scrown	None	HS	R-5	5	10	15
(Overstamped "Big 6 Only". Was a roulette initially, but then used for the Big 6 wheel.)									
	RLT	3 diff.	Scrown	None	HS	R-5	5	10	15
(Colors: Aqua, Fuchsia, and Ochre.)									
	NN 1.00	7 diff.	Lg-key	None	HS	R-5	10	20	30
(Colors: Brown, Cream, Green, Grey, Maroon, Mustard, and Purple.)									
(These issues are marked "Pit-Keno-Bar," with "Non Negotiable" on back.)									
2nd	.25	Blue	BJ	None	HS	R-5	4	8	12
	1.00	Brown	BJ-2	3wht	COIN	R-3	2	4	6
	5.00	Red	BJ-2	12wht	COIN	R-4	8	16	24
	25.00	Green	BJ-2	4wht	COIN	R-6	25	50	75
3rd	.25	White	BJ	None	HS	R-4	3	6	9

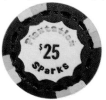

Plantation $25 (1st)

RAIL CITY			SPARKS		1997-				
1st	.25	Orange	H&C	None	HS	R-2	*	1	3
	5.00	Red	H&C	3grn3org	FG-multi	R-1	*	5	10
	25.00	Green	H&C	3wht3org3nvy	FG-multi	R-1	*	25	35
	NCV 1	Pink	BJ	6wht	HS	R-4	3	6	9
	NCV	5 diff.	BJ	None	HS	R-3	3	6	9
(Colors: Black, Green, Orange, Purple, and Red.)									

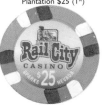

Rail City $25 (1st)

SHY CLOWN, ROD'S			SPARKS		1974-76				
SHY CLOWN					1976-81				
1st	5.00	Orange	Scrown	3blk	R-white	R-2	5	10	15
	25.00	Fuchsia	Scrown	3gry	R-white	R-2	7	14	21
(First issue, 1974-76, is "Rod's Shy Clown." Second issue, 1976-81, is just "Shy Clown.")									

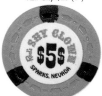

Rod's Shy Clown $5 (1st)

283

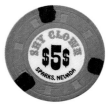

Shy Clown $5 (2nd)

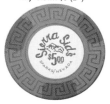

Sierra Sid's $5 (2nd)

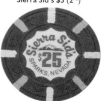

Sierra Sid's $25 (4th)

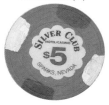

Silver Club $5 (1st)

Silver Club NCV 3 (2nd)

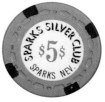

Sparks Silver Club $5 (2nd)

Issue	Den.	Color	Mold	Inserts	Inlay	Rarity	GD30	VF65	CS95
2nd	.25	Yellow	H&C	None	HS	R-4	4	8	12
	5.00	Orange	H&C	3blk	R-white	R-2	4	8	12
	25.00	Green	H&C	3yel	R-white	R-3	8	16	24
	100.00	Black	H&C	3yel3lav	HS	R-4	12	24	36
	NCV 1.00	Purple	H&C	None	HS	R-5	4	8	12
	NCV 5.00	Orange	H&C	None	HS	R-5	4	8	12
	RLT A	5 diff.	H&C	None	HS	R-5	2	4	6

(Colors: Brown, Grey, Pink, Purple, and White.)

| | RLT B | 6 diff. | H&C | None | HS | R-5 | 2 | 4 | 6 |

(Colors: Brown, Grey, Orange, Pink, Purple, and White.)

SIERRA SID'S — SPARKS — 1978-97

Issue	Den.	Color	Mold	Inserts	Inlay	Rarity	GD30	VF65	CS95
1st	5.00	Red	Diasqr	None	HS	R-8	60	120	180
2nd	5.00	Green	Lg-key	3blu	R-white	R-8	75	150	225
	25.00	Brown	Lg-key	3org	R-white	R-9	125	250	375
3rd	.10	Brown	H&C	None	HS	R-4	10	20	30
	.25	Orange	H&C	None	HS	R-5	10	20	30
	5.00	Red	H&C	8pnk	HUB-white	R-6	40	80	120
4th	5.00	Red	H&C	2yel2pnk	HUB-white	R-4	10	20	30
	25.00	Green	H&C	4wht4lim	SCA-white	R-6	30	60	90
	FP 2.00	Brown	H&C	None	HS	R-7	15	30	45
	FP 5.00	Fuchsia	H&C	None	HS	R-7	15	30	45

(Owner Sid Doan closed the tables around 1997, supposedly due to heavy losses from the players!)

SILVER CLUB — SPARKS — 1989-

Issue	Den.	Color	Mold	Inserts	Inlay	Rarity	GD30	VF65	CS95
1st	.25	Gold	H&C	None	HS-blue	R-4	2	4	6
	.25	Blue	H&C	None	HS	R-2	*	2	3
	1.00	Blue	H&C	2nvy	R-white	R-1	*	1	3
	5.00	Pink	H&C	2wht2lav	HUB-white	R-1	*	5	10
	25.00	Green	H&C	4pnk4org	SCA-white	R-1	*	25	30
	100.00	Black	H&C	6pnk6org	COG-white	R-2	*	100	120
2nd	5.00	Red	Chipco	None	FG	R-1	5	10	15

(Chip is marked "1992, 3rd Anniversary," with a picture of the casino and used on the tables.)

	NCV 2	Pink	Chipco	None	FG	R-5	6	12	18
	NCV 3	Pink	HHR	None	HS	R-5	4	8	12
	NCV 5	Maroon	HHR	None	HS	R-6	10	20	30
	RLT	2 diff.	Roulet	None	R-white	R-2	3	6	9

(Colors: Grey and Orange.)

SPARKS SILVER CLUB — SPARKS — 1963-67

Issue	Den.	Color	Mold	Inserts	Inlay	Rarity	GD30	VF65	CS95
1st	.25	Orange	C&J	None	HS	R-7	30	60	90
	1.00	Tan	C&J	None	HS	R-5	20	40	60
	5.00	Red	C&J	None	HS	R-6	30	60	90
	25.00	Black	C&J	None	HS	R-7	50	100	150
2nd	.50	Blue	Scrown	None	HS	R-6	15	30	45
	1.00	Lt Blue	Scrown	None	HS	R-6	15	30	45
	1.00	White	Scrown	None	HS	R-9	30	60	90

(Above two are marked "Payable For Fun" on back.)

	5.00	Brown	Scrown	4dkbrn	OR-white	R-5	20	40	60
	25.00	Fuchsia	Scrown	4yel4red	R-white	R-5	35	70	105
	100.00	Yellow	Scrown	4grn4brn	OR-white	R-7	60	120	180
	1.00	Green	Scrown	None	HS	R-5	10	20	30

Issue	Den.	Color	Mold	Inserts	Inlay	Rarity	GD30	VF65	CS95
	5.00	Brown	Scrown	4grn	HS	R-5	10	20	30
	20.00	Orange	Scrown	3gry	HS	R-5	15	30	45

(Above three are marked "Good at Poker Table Only" on back.)

Issue	Den.	Color	Mold	Inserts	Inlay	Rarity	GD30	VF65	CS95
	RLT	Orange	Plain	None	R-white	R-6	10	20	30
3rd	.50	Blue	Nevada	None	HS-silver	R-6	15	30	45

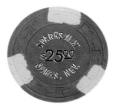

Sparks Mint $25 (1st)

SPARKS MINT — SPARKS — 1972-81

Issue	Den.	Color	Mold	Inserts	Inlay	Rarity	GD30	VF65	CS95
1st	.25	Orange	H&C	None	HS	R-5	10	20	30
	.50	Purple	H&C	None	HS	R-5	8	16	24
	1.00	White	H&C	None	HS	R-5	7	14	21
	5.00	Red	H&C	3wht	HS	R-5	12	24	36
	25.00	Green	H&C	3yel	HS	R-5	25	50	75
	100.00	Black	H&C	3lav3grn3crm	HS	R-10	75	150	225

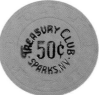

Treasury Club 50c (1st)

TRADER DICK'S — SPARKS — 1958-60

Issue	Den.	Color	Mold	Inserts	Inlay	Rarity	GD30	VF65	CS95
1st	RLT	5 diff.	Horshu	None	HS	R-6	20	40	60

(Colors: Beige, Black, Green, Red, and Yellow. This casino was originally The Nugget. It's unusual they didn't have any denominated chips. Possibly they used the old The Nugget chips. Trader Dick's later became the name of the bar in John Ascuaga's Nugget.)

TREASURY CLUB — SPARKS — 1989-98

Issue	Den.	Color	Mold	Inserts	Inlay	Rarity	GD30	VF65	CS95
1st	.50	Yellow	H&C	None	HS	R-2	4	8	12
	5.00	Red	H&C	2yel2org	HS	R-4	5	10	15
	25.00	Green	H&C	4ltorg4ltgrn	HS	R-4	20	40	60

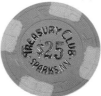

Treasury Club $25 (1st)

WESTERN VILLAGE — SPARKS — 1987-

Issue	Den.	Color	Mold	Inserts	Inlay	Rarity	GD30	VF65	CS95
1st	.25	Orange	H&C	None	HS	R-5	7	14	21
	1.00	Blue	H&C	None	HS	R-1	*	1	5

(Very hard to find in top condition)

Issue	Den.	Color	Mold	Inserts	Inlay	Rarity	GD30	VF65	CS95
	5.00	Red	H&C	3yel3gry	HUB-white	R-1	*	5	10
	25.00	Green	H&C	3pch3pur	SCA-white	R-1	*	25	35
	100.00	Black	H&C	3ltblu3pur3org	COG-white	R-3	*	100	125
	NCV	Lt Orange	H&C	3nvy	HS	R-6	5	10	15
	NCV	Grey	H&C	3nvy	HS	R-6	5	10	15

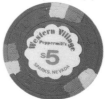

Western Village $5 (1st)

SCOREBOARD SPORTS BAR — SPRING CREEK — 1997-

Issue	Den.	Color	Mold	Inserts	Inlay	Rarity	GD30	VF65	CS95
1st	1.00	Lt Blue	H&C	None	OR-multi	R-2	*	2	4
	5.00	Red	H&C	4lav4nvy	OR-multi	R-2	*	5	10
	25.00	Green	H&C	4ltgrn4dkgrn	OR-multi	R-3	*	25	30

Scoreboard $25 (1st)

HOBEY' S — SUN VALLEY — 1988-90

Issue	Den.	Color	Mold	Inserts	Inlay	Rarity	GD30	VF65	CS95
1st	5.00	Red	H&C	3yel3ltblu	HS	R-10	150	300	450

SH CORRAL — SUN VALLEY — 1976-79

Issue	Den.	Color	Mold	Inserts	Inlay	Rarity	GD30	VF65	CS95
1st	5.00	Orange	Horshu	3brn	R-white	R-3	12	24	36
	25.00	Red	Horshu	3tan	R-white	R-4	18	36	54
	100.00	Green	Horshu	3yel	R-white	R-5	22	44	66

Sun Valley Casino $5 (1st)

SUN VALLEY CASINO — SUN VALLEY — 1974-75

Issue	Den.	Color	Mold	Inserts	Inlay	Rarity	GD30	VF65	CS95
1st	5.00	Brown	Lg-key	3yel	R-white	R-8	250	500	1000

(This chip is susceptible to lifting inlays, due to its original adhesive. May not exist in top condition.)

Ace Club $5 (1ˢᵗ)

Ace Club $5 (2ⁿᵈ)

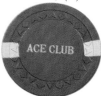

Ace Club $5 (3ʳᵈ)

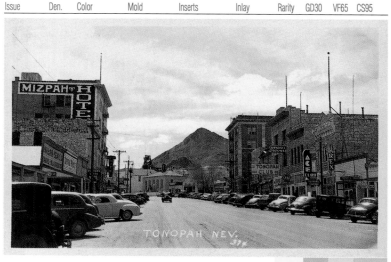

A rare postcard depicting the heyday of 1940s Tonopah gambling clubs.

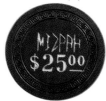

Mizpah Hotel $25 (3ʳᵈ)

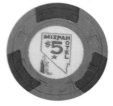

Mizpah Hotel $5 (5ᵗʰ)

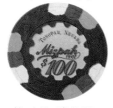

Mizpah Hotel $100 (8ᵗʰ)

Issue	Den.	Color	Mold	Inserts	Inlay	Rarity	GD30	VF65	CS95
ACE CLUB			**TONOPAH**		**1944-65**				
1ˢᵗ	5.00	Salmon	Lcrown	None	HS	R-6	50	100	150
2ⁿᵈ	5.00	Black	Sm-key	None	HS	R-7	75	150	225
3ʳᵈ	5.00	Navy	Arodie	2bei	HS	R-8	150	300	450
MIZPAH HOTEL			**TONOPAH**		**1948-53/ 53-84**				
1ˢᵗ	n/d	Beige	Lcrown	None	HS	R-6	30	60	90
2ⁿᵈ	5.00	Navy	Sm-key	None	HS	R-7	75	150	225
	25.00	Mustard	Sm-key	None	HS	R-8	100	200	300
(Above marked "Club" and are the first issues.)									
3ʳᵈ	5.00	Purple	Sm-key	None	HS	R-3	10	20	30
	25.00	Black	Sm-key	None	HS	R-3	15	30	45
(Above two chips only marked "Mizpah.")									
4ᵗʰ	.10	Rust	Sm-key	None	HS	R-6	40	80	120
	.25	Red	Sm-key	None	HS	R-8	40	80	120
	5.00	Mustard	Sm-key	3trq	R-white	R-3	15	30	45
	RLT	3 diff.	Sm-key	None	HS	R-7	25	50	75
(Colors: Green, Red, and Yellow.)									
5ᵗʰ	1.00	Lavender	C&J	None	HS	R-3	12	24	36
	5.00	Mustard	C&J	3red	R-white	R-3	15	30	45
	25.00	Black	C&J	3grn	R-white	R-4	30	60	90
6ᵗʰ	.25	Red	Lg-key	None	HS	R-6	12	24	36
7ᵗʰ	.25	Black	H&C	None	HS	R-6	10	20	30
	5.00	Red	H&C	3yel	R-white	R-3	10	20	30
	25.00	Green	H&C	3wht	HUB-white	R-3	15	30	45
	NCV 1	Orange	H&C	None	HS	R-3	2	4	6
8ᵗʰ	5.00	Red	H&C	3yel	R-gold	R-3	8	16	24
	25.00	Green	H&C	3wht	HUB-gold	R-3	15	30	45
	100.00	Black	H&C	3org3brn3pnk	COG-gold	R-4	25	50	75
PASTIME CLUB			**TONOPAH**		**1947-1967**				
1ˢᵗ	1.00	Green	Sm-key	None	HS	R-5	20	40	60

Issue	Den.	Color	Mold	Inserts	Inlay	Rarity	GD30	VF65	CS95
	5.00	Red	Sm-key	None	HS	R-5	25	50	75
	5.00	Yellow	Sm-key	None	HS	R-5	25	50	75
	n/d	Grey	Sm-key	None	HS	R-5	15	30	45
2nd	1.00	Rust	Lg-key	None	HS	R-10	100	200	300

(Second issue was found in Tonopah & is from this club although not marked with the town name.)

REX $1 (1st)

REX			TONOPAH		1953-78				
1st	1.00	Brown	C&J	None	HS	R-5	15	30	45
	20.00	Purple	Lcrown	None	HS	R-7	30	60	90

(Above marked only "RC" and were found here years ago by Phil Jensen. Originally ordered for Reno Casino, as per T.R. King's records.)

Silver Strike $5 (1st)

SILVER STRIKE			TONOPAH		1981-92				
1st	.25	Yellow	H&C	None	HS	R-4	4	8	12
	.50	Peach	H&C	None	HS	R-4	4	8	12
	.50	Lt Turq	H&C	None	HS	R-4	4	8	12
	1.00	Blue	H&C	4grn	R-multi	R-3	5	10	15
	2.00	White	H&C	None	R-multi	R-3	6	12	18
	5.00	Pink	H&C	4pur	HS	R-5	15	30	45
	5.00	Red	H&C	4org	HUB-multi	R-3	12	24	36
	25.00	Green	H&C	4gry4fch	SCA-multi	R-4	20	40	60

Station House $25 (1st)

STATION HOUSE			TONOPAH		1982-				
1st	.25	Pink	H&C	None	HS	R-4	2	4	6
	5.00	Red	H&C	3org3nvy	HS	R-1	*	5	10
	25.00	Green	H&C	3org3brn	HS	R-2	*	25	35
	n/d	Pink	HHR	None	HS	R-5	4	8	12
2nd	.25	Pink	Plain	None	HS	R-5	3	6	9
	1.00	Grey	HHR	None	HS	R-2	*	2	4
	1.00	Beige	HHR	None	HS	R-2	*	2	4
3rd	1.00	Beige	Triclb	None	R-white	R-2	*	1	3

Tonopah Belle $5 (1st)

TONOPAH BELLE			TONOPAH		1969-74				
1st	1.00	Orange	HHR	None	HS	R-6	15	30	45
	5.00	Black	HHR	None	HS	R-6	15	30	45

(Above only marked "RWP" for owner Robert W. Perchetti and were used here and in other clubs.)

Tonopah Club 10c (1st)

TONOPAH CLUB			TONOPAH		1913-74				
1st	.10	Red	Zigzag	None	HS	R-7	30	60	90
	5.00	Yellow	Zigzag	None	HS	R-5	20	40	60

(These chips are just initialed "TC.")

2nd	.25	Dk Grey	Sm-key	None	HS	R-7	40	80	120
	5.00	Red	Sm-key	None	HS	R-9	60	120	180

(The $5 chip is initialed "TC," but the 25 cent chip says "Tonopah Club.")

3rd	5.00	Black	Hub	None	HS	R-7	60	120	180
4th	5.00	Yellow	HCE	3red	HS	R-6	10	20	30

("TC" stamped in block letters.)

Tonopah Club $5 (3rd)

	n/d	Black	Lcrown	None	HS	R-6	10	20	30

(This chip has "TC" written in script with "#213" on the reverse.)

5th	1.00	Tan	Diamnd	None	HS	R-4	25	50	75
	5.00	Navy	Diamnd	None	HS	R-10	20	40	60

(This chip was given to Phil Jensen by Jim Dotson of Jim & Lorraine's Bar in Eureka. Jim told him the chip was from Tonopah, but there is no way to prove the attribution.)

6th	.25	Green	C&J	None	HS	R-5	20	40	60

Issue	Den.	Color	Mold	Inserts	Inlay	Rarity	GD30	VF65	CS95
	25.00	Black	C&J	None	HS	R-5	35	70	105
7th	1.00	Maroon	HHR	None	HS	R-7	40	80	120
	1.00	Beige	HHR	None	HS	R-5	20	40	60
	20.00	Dk Red	HHR	None	HS	R-5	30	60	90

Town Hall Club $5 (1st)

TOWN HALL CLUB — TONOPAH — 1948-49

Issue	Den.	Color	Mold	Inserts	Inlay	Rarity	GD30	VF65	CS95
1st	.25	Red	Sm-key	None	HS	R-7	40	80	120
	5.00	Navy	Sm-key	3yel	HS	R-8	100	200	300

CASEY' S — TOPAZ LAKE — 1968-69

Issue	Den.	Color	Mold	Inserts	Inlay	Rarity	GD30	VF65	CS95
1st	.25	Yellow	Lg-key	None	HS	R-9	50	100	150
	1.00	Dk Grey	Lg-key	None	HS	R-9	60	120	180
	5.00	Brown	Lg-key	None	HS	R-8	60	120	180

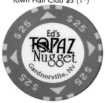

Ed's Topaz Nugget $25 (1st)

ED'S TOPAZ NUGGET — TOPAZ LAKE — 1999-

Issue	Den.	Color	Mold	Inserts	Inlay	Rarity	GD30	VF65	CS95
1st	5.00	Red	BJ	8pnk	R-white	R-1	*	5	10
	25.00	Green	BJ	12yel	R-white	R-1	*	25	35

(These chips are actually marked "Gardnerville", but this casino is in Topaz.)

GREG-MAR LODGE — TOPAZ LAKE — 1963-68/ 71-73

Issue	Den.	Color	Mold	Inserts	Inlay	Rarity	GD30	VF65	CS95
1st	1.00	Lavender	C&J	None	HS	R-4	20	40	60
	5.00	Beige	C&J	3grn	HS	R-4	20	40	60
	25.00	Maroon	C&J	None	HS	Unique	200	400	600

Greg-Mar Lodge $1 (1st)

HORIZONS — TOPAZ LAKE — 1973-79

Issue	Den.	Color	Mold	Inserts	Inlay	Rarity	GD30	VF65	CS95
1st	1.00	Brown	Lg-key	3org	HS	R-3	10	20	30
	1.00	Brown	Lg-key	3yel	HS	R-3	10	20	30
	5.00	Yellow	Lg-key	3grn	HS	R-3	15	30	45

LIBRANDI'S — TOPAZ LAKE — 1980-86

Issue	Den.	Color	Mold	Inserts	Inlay	Rarity	GD30	VF65	CS95
1st	5.00	Brown	Horshu	3org	HS	R-9	150	300	450

(This chip was pulled quickly after the owners realized the name was misspelled. The Chip reads "Li Brandi's" instead of "Librandi's". Most of the few known examples are drilled.)

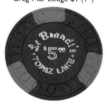

Librandi's $5 (1st)

Issue	Den.	Color	Mold	Inserts	Inlay	Rarity	GD30	VF65	CS95
2nd	5.00	Red	Lg-key	3wht	HS	R-5	25	50	75
	25.00	Green	Lg-key	3mst	HS	R-5	25	50	75

OVERLAND/TOPAZ LODGE PICK HOBSON'S — TOPAZ LAKE — 1974-78

Issue	Den.	Color	Mold	Inserts	Inlay	Rarity	GD30	VF65	CS95
1st	5.00	Pink	Scrown	4blu4blk	OR-white	R-1	5	10	15
	RLT	7 diff.	Plain	None	OR-white	R-5	5	10	15

(Colors: Brown, Green, Navy, Pink, Red, White, and Yellow. These chips were also used in Reno at the Overland.)

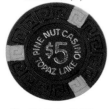

Pine Nut Casino $5 (1st)

PINE NUT CASINO — TOPAZ LAKE — 1960-63/ 68-80

Issue	Den.	Color	Mold	Inserts	Inlay	Rarity	GD30	VF65	CS95
1st	1.00	Grey	Lg-key	None	HS	R-3	15	30	45
	5.00	Black	Lg-key	3gry	HS	R-5	25	50	75

TOPAZ LODGE/CASINO — TOPAZ LAKE — 1953-66/ 67-

Issue	Den.	Color	Mold	Inserts	Inlay	Rarity	GD30	VF65	CS95
1st	5.00	Purple	Lcrown	3yel	HS	R-10	300	600	900
2nd	5.00	Navy	Arodie	2org	R-white	R-7	150	300	450
3rd	n/d	Red	Diasqr	None	HS	R-4	10	20	30
	1.00	Rust	C&J	None	HS	R-5	12	24	36
	5.00	Black	C&J	3yel	R-white	R-5	200	400	600

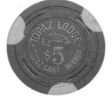

Topaz Lodge $5 (1st)

(Nearly all known examples are overstamped with a black "T". These examples are only worth 15% of the listed price. The uncancelled version exists in only a few collections and is considered an R-9 or R-10. Beware of chips with a removed cancellation.)

Issue	Den.	Color	Mold	Inserts	Inlay	Rarity	GD30	VF65	CS95
4th	5.00	Navy	Lg-key	3grn	HS	R-4	15	30	45
	25.00	Green	Lg-key	3pnk	HS	R-4	20	40	60
5th	.50	Salmon	H&C	None	HS	R-2	*	2	4
	5.00	Red	H&C	3blu3gry	OR-white	R-1	*	5	10
	25.00	Green	H&C	3org3yel	OR-white	R-2	*	25	35
	100.00	Black	H&C	2org2gry	OR-white	R-4	*	100	125
6th	5.00	Red	Chipco	None	FG	R-2	5	10	15

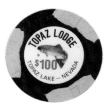

Topaz Lodge $100 (5th)

TOPAZ LODGE HAROLD'S TOPAZ LAKE 1965-66

Issue	Den.	Color	Mold	Inserts	Inlay	Rarity	GD30	VF65	CS95
1st	.25	Green	Lg-key	None	HS	R-5	20	40	60
	.50	Beige	Lg-key	None	HS	R-5	20	40	60

LAS VEGAS GUN CLUB TULE SPRINGS 1954-57

| 1st | 5.00 | Red | Scrown | 4brn | LSCA-wht | R-8 | 300 | 600 | 900 |
| | 25.00 | Green | Scrown | 4brn | LHUB-wht | R-9 | 350 | 700 | 1050 |

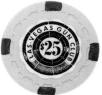

Las Vegas Gun Club $25 (1st)

BOOMTOWN VERDI 1967-

1st	1.00	Mustard	Horshu	3org	R-multi	R-10	300	600	900
	5.00	Brown	Horshu	3org	R-multi	R-7	125	250	375
	25.00	Black	Horshu	3org	R-multi	R-10	500	1000	1500
2nd	1.00	Blue	House	3wht3nvy	R-multi	R-1	*	1	3
	5.00	Red	House	3wht3pnk	R-multi	R-5	10	20	30

(Chip does not say "Verdi." This chip is seldom found in use.)

	25.00	Green	House	3yel3blu	SCA-multi	R-1	*	25	35
	100.00	Black	House	3org3wht	COG-multi	R-2	*	100	120
3rd	5.00	Red	House	3wht3pnk	R-multi	R-1	*	5	10

(This chip marked "Verdi, NV.".)

| 4th | 1.00 | Blue | H&C | 3wht3nvy | R-multi | R-1 | * | 1 | 2 |
| | 5.00 | Red | H&C | 3wht3pnk | R-multi | R-1 | * | 5 | 7 |

(This set marked "Verdi, NV.")

| | NCV 1 | Purple | BJ | None | HS | R-6 | 3 | 6 | 9 |

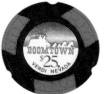

Boomtown $25 (1st)

GOLD RANCH VERDI 1987-

| 1st | 5.00 | Purple | BJ-2 | 6pnk | COIN | R-1 | * | 5 | 10 |
| | 25.00 | Green | BJ-2 | 4ltgrn | COIN | R-2 | * | 25 | 35 |

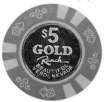

Gold Ranch $5 (1st)

NUGGET CASINO VERDI 1985-87

| 1st | 5.00 | Red | BJ-2 | 6wht | COIN | R-8 | 50 | 100 | 150 |
| | 25.00 | Green | BJ-2 | 6yel | COIN | R-9 | 100 | 200 | 300 |

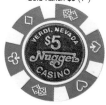

Nugget Casino $5 (1st)

PROSPECTOR TRUCK PLAZA VERDI 1978-82
PROSPECTOR CASINO 1982-85

1st	5.00	Red	Lg-key	None	HS	R-5	15	30	45
	25.00	Green	Lg-key	None	HS	R-5	15	30	45
2nd	5.00	Purple	BJ-2	3pnk	COIN	R-6	30	60	90
	25.00	Green	BJ-2	8ltgrn	COIN	R-9	100	200	300

(The 1st issue is "Truck Plaza." The 2nd issue is just "Casino.")

VERDI INN VERDI c.1970's

1st	1.00	Cream	Lg-key	3grn	R-white	Unique*	250	500	750
	5.00	Red	Lg-key	?	R-white	Unique*	250	500	750
	25.00	Green	Lg-key	3pnk	R-white	Unique*	250	500	750
	100.00	Black	Lg-key	3org	R-white	Unique*	250	500	750

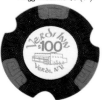

Verdi Inn $100 (1st)

Issue	Den.	Color	Mold	Inserts	Inlay	Rarity	GD30	VF65	CS95
BONANZA CLUB			**VIRGINIA CITY**		**1963-70's**				
1st	.25	Brown	H&C	None	HS	R-7	30	60	90
	1.00	Blue	H&C	None	HS	R-4	12	24	36
	5.00	Red	H&C	3pnk	HS	R-6	25	50	75
BUCKET OF BLOOD			**VIRGINIA CITY**		**1946-**				
1st	1.00	Red	C&J	None	HS	R-3	10	20	30
	5.00	Navy	C&J	3red	R-white	R-3	15	30	45

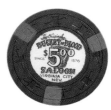

Bucket of Blood $5 (1st)

(Live gaming ceased in the 1970's, but this casino is still open as a slot house. These chips are from the last issue of the club. Unfortunately, no earlier chips have been positively attributed.)

Issue	Den.	Color	Mold	Inserts	Inlay	Rarity	GD30	VF65	CS95
CAPITOL SALOON			**VIRGINIA CITY**		**1938-52**				
1st	5.00	Yellow	Sm-key	None	Diecut-Metal	R-7	150	300	450
	25.00	Black	Sm-key	None	Diecut-Metal	R-10	400	800	1200

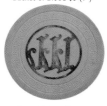

Capitol Saloon $5 (1st)

(Chips have "JJJ" only.)

Issue	Den.	Color	Mold	Inserts	Inlay	Rarity	GD30	VF65	CS95
CRYSTAL SALOON			**VIRGINIA CITY**		**1870's-1945**				
	10.00	Black	Sm-key	2wht	HS	R-6	100	200	300

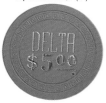

Delta Club $5 (2nd)

Issue	Den.	Color	Mold	Inserts	Inlay	Rarity	GD30	VF65	CS95
DELTA CLUB			**VIRGINIA CITY**		**1948-60's**				
1st	n/d	Yellow	Plain	None	R-white	R-6	20	40	60
2nd	.50	Yellow	Sm-key	None	HS	R-7	60	120	180
	.50	Lavender	Sm-key	None	HS	R-7	60	120	180
	1.00	Grey	Sm-key	3blk	HS	R-6	35	70	105
	5.00	Red	Sm-key	None	HS	R-7	50	100	150
3rd	.50	Yellow	Horshu	None	HS	R-8	20	40	60

(For some inexplicable reason, this chip was only marked ".50", but was definitely used here.)

Issue	Den.	Color	Mold	Inserts	Inlay	Rarity	GD30	VF65	CS95
PAT HART'S BRASS RAIL			**VIRGINIA CITY**		**1947-77**				
1st	1.00	Grey	Sm-key	None	HS	R-7	40	80	120
	5.00	Maroon	Sm-key	None	HS	R-7	50	100	150

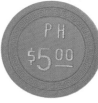

Pat Hart's Brass Rail $5 (1st)

(Both chips marked "PH".)

Issue	Den.	Color	Mold	Inserts	Inlay	Rarity	GD30	VF65	CS95
RED GARTER			**VIRGINIA CITY**		**1961-78**				
1st	5.00	Red	Sm-key	3wht	HS	R-7	50	100	150
2nd	1.00	Mustard	Horshu	None	HS	R-3	10	20	30
	5.00	Navy	Horshu	None	HS	R-5	20	40	60
	25.00	Black	Horshu	None	HS	R-5	20	40	60

(Note: A former owner of Red Garter told Bud Meyer that the 25 cent Arodie chip "RGS" listed last year was not from Red Garter, because they did not use quarter chips.)

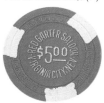

Red Garter $5 (1st)

Issue	Den.	Color	Mold	Inserts	Inlay	Rarity	GD30	VF65	CS95
SILVER QUEEN			**VIRGINIA CITY**		**1964-**				
1st	1.00	Blue	H&C	None	HS	R-5	10	20	30
	5.00	Red	H&C	4org	HS	R-7	30	60	90
	25.00	Green	H&C	4pnk	HS	R-8	50	100	150

(Live gaming was eliminated in the 1980's, but the club still operates as a slot house today.)

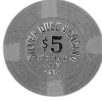

Silver Queen $5 (1st)

Issue	Den.	Color	Mold	Inserts	Inlay	Rarity	GD30	VF65	CS95
WASHOE CLUB (WC)			**VIRGINIA CITY**		**1935-45**				
1st	n/d	Mustard	Hub	None	HS	R-8	20	40	60

(These chips, initialed WC, were discovered in Virginia City. However, they were originally manufactured for another club – then brought and used here.)

Issue	Den.	Color	Mold	Inserts	Inlay	Rarity	GD30	VF65	CS95
4 WAY CASINO			**WELLS**		**1953-**				
1st	1.00	Purple	C&J	None	HS	R-9	80	160	240

("4 Way Casino," no location & large print.)

Issue	Den.	Color	Mold	Inserts	Inlay	Rarity	GD30	VF65	CS95
	1.00	Purple	C&J	None	HS	R-7	50	100	150

("4 Way Casino, Wells, Nev." In smaller print.)

Issue	Den.	Color	Mold	Inserts	Inlay	Rarity	GD30	VF65	CS95
	5.00	Mustard	C&J	None	HS	R-7	60	120	180
2nd	5.00	Mustard	HHR	None	HS	R-4	20	40	60
3rd	1.00	Purple	Lg-key	None	HS	R-4	20	40	60
	5.00	Mustard	Lg-key	None	HS	R-7	60	120	180
4th	5.00	Red	BJ-2	3pur	COIN	R-1	*	5	10
	25.00	Green	BJ-2	6wht	COIN	R-2	*	25	35
5th	5.00	Red	BJ-2	3pur	COIN	R-1	*	5	10

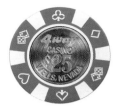

4 Way Casino $25 (4th)

(The difference between the 4th and 5th issue is that the mold design was altered.)

BULL'S HEAD BAR WELLS 1930's-55

Issue	Den.	Color	Mold	Inserts	Inlay	Rarity	GD30	VF65	CS95
1st	5.00	Blue	Sqsqrt	None	HS	R-9	350	700	1050

(This club was located in the Wells' Hotel and was closed for cheating! Only four chips are known to exist at present time.)

Bull's Head Bar $5 (1st)

CHINATOWN CASINO WELLS 1984-88

Issue	Den.	Color	Mold	Inserts	Inlay	Rarity	GD30	VF65	CS95
1st	5.00	Dk Org	H&C	3org	HS	R-5	40	80	120
	25.00	Dk Green	H&C	3blu	HS	R-5	50	100	150

(According to chip dealer Mel Jung, the owner showed him a box of each denomination, and he was able to buy ten $5 and four $25 chips.)

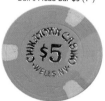

Chinatown Casino $5 (1st)

EL RANCHO HOTEL WELLS 1952-58 / 1962-80

Issue	Den.	Color	Mold	Inserts	Inlay	Rarity	GD30	VF65	CS95
1st	5.00	Red	Diasqr	None	HS	R-6	75	150	225
	25.00	Black	Diasqr	None	HS	R-7	90	180	270
2nd	1.00	Navy	Lg-key	None	HS	R-7	80	160	240
	5.00	Red	Lg-key	None	HS	R-10	150	300	450
3rd	5.00	Red	H&C	4org	HS	R-5	35	70	105
	25.00	Green	H&C	4org	HS	R-5	40	80	120

(Oddly enough, the same dealer as above, Mel Jung, tells the exact same story about these chips as the ones above. The same owner owned both casinos. Therefore, there are ten $5 chips and four $25 chips available from the original box.)

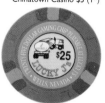

Lucky J's $25 (1st)

LUCKY J's WELLS 1994-

Issue	Den.	Color	Mold	Inserts	Inlay	Rarity	GD30	VF65	CS95
1st	5.00	Red	H&C	6blu3dkorg	OR-multi	R-1	*	5	10
	25.00	Green	H&C	6brn3org	OR-multi	R-2	*	25	35

OLD WEST INN WELLS 1978-82

Issue	Den.	Color	Mold	Inserts	Inlay	Rarity	GD30	VF65	CS95
1st	1.00	Tan	Diecar	3red	HS	R-5	10	20	30
	1.00	Cream	Diecar	None	HS	R-5	10	20	30
	5.00	Red	Diecar	3grn	HS	R-8	40	80	120
	25.00	Green	Diecar	3crm	HS	R-9	50	100	150

(Casino owner, a Mr. Cooper, still holds his gaming license and chips. He will not sell any chips unless he starts the tables up again. These values and rarities are for the chips that are out now. Formerly, this was the Pequop Hotel.)

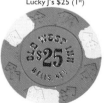

Old West Inn $25 (1st)

PEQUOP HOTEL WELLS 1948-71

Issue	Den.	Color	Mold	Inserts	Inlay	Rarity	GD30	VF65	CS95
1st	5.00	Black	Sm-key	None	HS	R-9	175	350	525
	20.00	Red	Sm-key	None	HS	R-9	225	450	675
2nd	.05	Cream	Arodie	None	HS	Unique	750	1500	2250
	.25	Maroon	Arodie	None	HS	Unique	600	1200	1800
	.25	Yellow	Arodie	None	HS	R-10	500	1000	1500
	25.00	Lt Green	Arodie	None	HS	R-8	300	600	900
3rd	1.00	Fuchsia	C&J	None	HS	R-7	75	150	225

RANCH HOUSE WELLS 1955-92

Issue	Den.	Color	Mold	Inserts	Inlay	Rarity	GD30	VF65	CS95
1st	5.00	Black	Arodie	2mst	HS	R-10	150	300	450

(Chip is initialed "RH.")

Pequop Casino 5c (2nd)

Ranch House $5 (2nd)

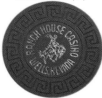

Ranch House $25 (2nd)

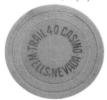

Trail 40 n/d (1st)

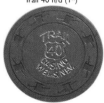

Trail 40 $1 (2nd)

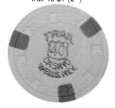

Trail 40 $5 (2nd)

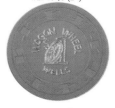

Wagon Wheel $1 (2nd)

Issue	Den.	Color	Mold	Inserts	Inlay	Rarity	GD30	VF65	CS95
2nd	1.00	Beige	Lg-key	None	HS	R-8	125	250	375
	5.00	Maroon	Lg-key	None	HS	R-9	150	300	450
	25.00	Green	Lg-key	None	HS	R-9	200	400	600
3rd	.50	Dk Green	PMSC	8brass	Brass	R-5	40	80	120
	.50	Lt Green	PMSC	8brass	Brass	R-5	50	100	150
	1.00	Turq.	PMSC	8brass	Brass	R-4	25	50	75
	1.00	Blue	PMSC	8brass	Brass	R-4	25	50	75
error	1.00	Black	PMSC	8brass	Brass	R-10	300	600	900
	5.00	Red	PMSC	8brass	Brass	R-4	20	40	60
	25.00	Black	PMSC	8brass	Brass	R-5	50	100	150
error	25.00	Red	PMSC	8brass	Brass	Unique	300	600	900

(This chip was supposed to have a $5 inlay.)

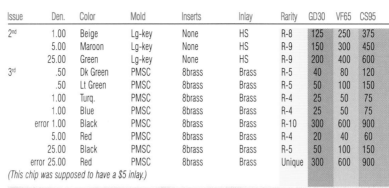

Postcard of Wells' Trail 40 Cafe. This seems a strange place to have gambling, but that's part of Nevada's inherent charm.

TRAIL 40 CASINO — WELLS — 1957-70

Issue	Den.	Color	Mold	Inserts	Inlay	Rarity	GD30	VF65	CS95
1st	n/d	Beige	Sm-key	None	HS	Unique	200	400	600
	n/d	Red	Sm-key	None	HS	Unique	200	400	600
2nd	.50	Red	C&J	None	HS	Unique	300	600	900
	1.00	Navy	C&J	None	HS	R-9	200	400	600
	5.00	Grey	C&J	3grn	HS	R-10	225	450	675
3rd	5.00	Green	Scrown	None	HS	R-10	175	350	525
	10.00	Black	Scrown	None	HS	R-10	200	400	600

(Third issue is marked "Cards Trail 40.")

WAGON WHEEL — WELLS — 1948-74
WAGON WHEEL, GRIFF'S

Issue	Den.	Color	Mold	Inserts	Inlay	Rarity	GD30	VF65	CS95
1st	5.00	Red	Hub	None	HS	R-9	150	300	450
	10.00	Green	Hub	None	HS	R-10	250	500	750
	25.00	Black	Hub	None	HS	R-10	250	500	750
	25.00	Lt Green	Hub	None	HS	R-10	250	500	750
2nd	1.00	Orange	C&J	None	HS	R-9	150	300	450
3rd	.50	Green	Lg-key	3crm	R-white	R-9	175	350	525
	1.00	Tan	Lg-key	3nvy	R-white	R-9	200	400	600

Issue	Den.	Color	Mold	Inserts	Inlay	Rarity	GD30	VF65	CS95
	5.00	Maroon	Lg-key	3crm	R-white	R-10	300	600	900

(Third issue is "Griff's Wagon Wheel.")

A-1 CLUB/ CASINO WENDOVER 1947-70

Issue	Den.	Color	Mold	Inserts	Inlay	Rarity	GD30	VF65	CS95
1st	5.00	Maroon	Diamnd	None	HS	R-5	60	120	180
2nd	1.00	Mustard	C&J	3nvy	HS	R-7	100	200	400
	5.00	Navy	C&J	3red	HS	R-8	150	300	450

(This was the smallest of the Wendover clubs with just one "21" table. 17 $1 chips are known.)

A-1 Casino $5 (2nd)

GOLD RUSH WENDOVER 1981-84

Issue	Den.	Color	Mold	Inserts	Inlay	Rarity	GD30	VF65	CS95
1st	1.00	Tan	Lg-key	None	HS	R-7	75	150	225
	5.00	Red	Lg-key	2blk	R-white	R-8	200	400	600
	25.00	Green	Lg-key	2yel	R-white	R-9	400	800	1200

(Research indicates that there are about 4 $25 chips and about 8-10 $5 chips. A former owner claims all remaining chips were sent to Reno to be destroyed after closing.)

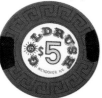

Gold Rush $5 (1st)

HIDE-AWAY WENDOVER 1976-

Issue	Den.	Color	Mold	Inserts	Inlay	Rarity	GD30	VF65	CS95
1st	.50	Purple	Ewing	None	HS	R-6	20	40	60
	1.00	Red	Ewing	3gry	HS	R-5	10	20	30
	5.00	Green	Ewing	None	HS	R-5	15	30	45
	5.00	Green	Ewing	None	HS	R-5	15	30	45

(Above have variants as to the lettering size.)

	25.00	Rust	Ewing	None	HS	R-6	30	60	90
2nd	1.00	Beige	H&C	None	HS	R-6	20	40	60
	5.00	Red	H&C	None	HS	R-6	20	40	60

(This small casino once had two "21" tables & is still open, but live gaming was eliminated in 1995.)

Hide-Away $5 (1st)

JIM'S CASINO & SALOON W. WENDOVER c.1971-84

Issue	Den.	Color	Mold	Inserts	Inlay	Rarity	GD30	VF65	CS95
1st	1.00	Navy	C&J	3yel	R-white	R-7	70	140	210
	5.00	Red	C&J	3grn	R-white	R-9	150	300	450
	25.00	Green	C&J	3pur	SCA-white	R-10	500	1000	1500
	25.00	Lavender	C&J	3pur	SCA-white	R-10*	500	1000	1500
2nd	.50	Tan	Diecar	None	HS	R-7	30	60	90

(Marked Casino- Motel, with no location.)

	1.00	Navy	Diecar	3mst	R-white	R-8	100	200	300
3rd	.50	Tan	Nevada	None	HS	R-6	30	60	90

(Marked Casino- Motel, also no location.)

	.50	Beige	Nevada	None	HS	R-7	35	70	105

(Marked Casino & Saloon, West Wendover, Nevada.)

4th	.50	Orange	Ewing	None	HS	R-9	75	150	225

(Marked Casino & Saloon, as above. All of the above chips give Jim's location as "West Wendover" unless noted- the only chips thus marked. Beware of a yellowish colored .50 that is fake.)

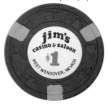

Jim's Casino $1 (1st)

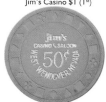

Jim's Casino 50c (4th)

NEVADA CROSSING WENDOVER 1968-94

Issue	Den.	Color	Mold	Inserts	Inlay	Rarity	GD30	VF65	CS95
1st	.50	Blue	BJ	None	HS	R-4	3	6	9
	.50	Blue	BJ	None	HS	R-4	3	6	9

(Location given as Wendover, U.S.A; no Nev.)

	1.00	White	BJ-2	None	COIN	R-3	2	4	6
	5.00	Red	BJ-2	6wht	COIN	R-4	5	10	15
	25.00	Green	BJ-2	8wht	COIN	R-9	60	120	180
	100.00	Black	BJ-2	12wht	COIN	R-9	100	200	300
	NCV	Lime	BJ	None	HS	R-5	4	8	12

Nevada Crossing $5 (1st)

Peppermill $25 (1st)

Rainbow Casino $1 (1st)

Red Garter $1 (1st)

Red Garter $25 (2nd)

Silver Smith 50c (1st)

Silver Smith $25 (1st)

Issue	Den.	Color	Mold	Inserts	Inlay	Rarity	GD30	VF65	CS95
PEPPERMILL			WENDOVER		1985-				
1st	.25	Brown	H&C	None	HS	R-5	5	10	15
	1.00	Blue	H&C	None	HS	R-1	*	1	3
	5.00	Red	H&C	3org3gry	HUB-white	R-1	*	5	10
	25.00	Green	H&C	3org3brn	SCA-white	R-1	*	25	35
	100.00	Black	H&C	6org3wht	HUB-white	R-1	*	100	125
	RLT A	Pink	BJ	None	HS	R-5	3	6	9
	RLT C	Navy	HHR	None	HS	R-5	3	6	9
(Formerly the Gold Rush Casino.)									
RAINBOW CASINO			WENDOVER		1995-				
1st	1.00	Blue	H&C	1lim1pnk1org	OR-white	R-1	*	2	4
	5.00	Pink	H&C	2yel2pch	OR-white	R-1	*	5	10
	25.00	Green	H&C	4yel4org	OR-white	R-1	*	25	35
	100.00	Black	H&C	4pnk4yel4org	OR-white	R-1	*	100	125
	RLT	4 diff.	H&C	None	HS	R-4	3	6	9
(Colors: Lavender, Orange, Pink, and Yellow. Rainbow replaced Nevada Crossing.)									
RED GARTER			WENDOVER		1981-				
1st	.50	Purple	Horshu	None	HS	R-5	8	16	24
	1.00	Tan	Horshu	3nvy	R-white	R-3	2	4	6
	5.00	Red	Horshu	3blk	R-white	R-4	8	16	24
	25.00	Green	Horshu	3mst	R-white	R-6	25	50	75
(Above are marked "Saloon.")									
2nd	.25	Brown	Lg-key	None	HS	R-6	15	30	45
	1.00	Beige	Lg-key	3nvy	R-white	R-3	2	4	6
	5.00	Red	Lg-key	3blk	R-white	R-4	7	14	21
	25.00	Green	Lg-key	3mst	R-white	R-6	25	50	75
	100.00	Black	Lg-key	3pnk	R-white	R-7	100	200	300
(Above marked "Casino.")									
3rd	.25	Mustard	H&C	None	HS	R-4	5	10	15
	.50	Purple	H&C	None	HS	R-4	5	10	15
	NCV 1.00	White	H&C	None	HS	R-4	3	6	9
4th	1.00	Cream	H&C	6brn	OR-white	R-1	*	1	3
	5.00	Red	H&C	2gry2gld	OR-white	R-1	*	5	10
	25.00	Green	H&C	2mar2org	OR-white	R-1	*	25	32
SILVER SMITH			WENDOVER		1971-				
1st	.25	Orange	H&C	None	HS	R-4	4	8	12
	.50	White	H&C	None	R-white	R-2	*	2	4
(There are up to 5 variants of the above issue - mostly in the style of the .50)									
	1.00	Blue	PMSC	4brass	BRASS	R-1	*	2	4
	1.00	Blue	PMSC	4brass	BRASS	R-1	*	2	4
(Above issue appears newer and is a darker blue color.)									
	5.00	Red	PMSC	4brass	BRASS	R-1	*	5	10
	25.00	Green	PMSC	4brass	BRASS	R-1	*	25	35
	25.00	Green	PMSC	4brass	BRASS	R-1	*	25	35
(Above issue appears newer and is a darker green color.)									
	100.00	Yellow	PMSC	4brass	BRASS	R-2	*	100	120
	RLT 1	3 diff.	H&C	None	R-white	R-5	3	6	9
(Colors: Black, Brown, and Purple)									
	RLT 2	Black	H&C	None	R-white	R-5	3	6	9
2nd	RLT S	Yellow	HHR	None	R-white	R-2	3	6	9

Issue	Den.	Color	Mold	Inserts	Inlay	Rarity	GD30	VF65	CS95

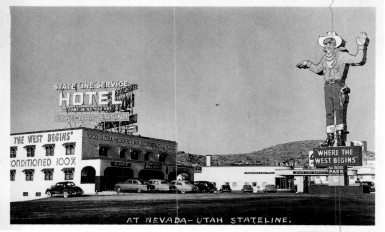

Stateline Hotel $5 obv (2nd)

Stateline Hotel $5 rev (2nd)

This postcard picture was taken shortly after the big Wendover Will statue was erected in 1953. At this time, the property was called the Stateline Service Hotel. Within a year, the garage was demolished, the facade remodeled, and the casino gambling was emphasized over the hotel.

State Line Casino 50c (3rd)

STATE LINE CASINO WENDOVER 1948-

1st	5.00	Maroon	Horshu	3bei	HS	R-10	300	600	900

(Picture of Wendover Will. For some reason, no location is listed)

2nd	.50	Mustard	C&J	None	HS	R-10*	350	700	1050
	1.00	Blue	C&J	3red	HS	R-10	350	700	1050
	5.00	Red	C&J	3crm	HS	R-10	350	700	1050

(These recently discovered chips are marked "Stateline Hotel". On the reverse is a nice picture of Wendover Will.)

3rd	.50	Green	Diswrl	4nvy	SCA-white	R-9	200	400	600
	1.00	Black	Diswrl	None	SCA-white	R-9	250	500	750

(Chips say "Stateline Casino." This swirling dice mold is very popular as this one & Binions Horseshoe were the only casinos to use it. Rumor is that a $5 and $25 have been located, but owner still has them and these aren't in a chip collection yet.)

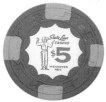

State Line Casino $5 (4th)

4th	.50	Green	C&J	4nvy	SCA-white	R-8	125	250	375
	1.00	Black	C&J	4org	SCA-white	R-8	175	350	525
	5.00	Red	C&J	4yel	SCA-white	R-9	400	800	1200
	25.00	Lavender	C&J	3blk	SCA-white	R-10	700	1400	2100
5th	.50	Green	Diecar	None	R-white	R-9	100	200	300
	.50	Green	Nevada	None	R-white	R-6	30	60	90
	1.00	Dk Grey	BJ-1	3org	COIN	R-5	15	30	45
	1.00	Lt Grey	BJ-1	3org	COIN	R-5	15	30	45
	5.00	Red	BJ-1	3wht	COIN	R-8	75	150	225
	25.00	Green	BJ-1	3wht	COIN	R-9	125	250	375
	RLT	5 diff.	Diecar	None	HS	R-9	20	40	60
6th	.50	Blue	BJ	None	HS	R-1	*	1	3
	1.00	Grey	BJ-2	3org	COIN	R-1	*	1	3
	5.00	Red	BJ-2	6wht3blk	COIN	R-1	*	5	10
	25.00	Green	BJ-2	6wht3org	COIN	R-1	*	25	35
	100.00	Yellow	BJ-2	6blk3red	COIN	R-2	*	100	120
	500.00	Purple	BJ-2	6blk3lav	COIN	R-3	*	500	525

(This place started as a service station with a few slots in 1926. The large statue, Wendover Will, was erected in 1953.)

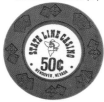

State Line Casino 50c (5th)

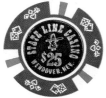

State Line Casino $25 (6th)

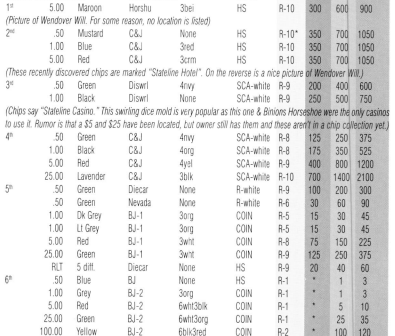

Issue	Den.	Color	Mold	Inserts	Inlay	Rarity	GD30	VF65	CS95

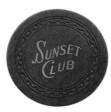

Sunset Club $1 (1st)

RENDEZVOUS CLUB — WHITNEY — 1940s

1st	5.00	Green	Rectl	None	HS	R-10	400	800	1200

(Was called Lou's Rendezvous club in the late 1940s.)

SUNSET CLUB — WHITNEY — 1932-34

	1.00	Maroon	Zigzag	None	HS	Unique	300	600	900
	25.00	Black	Zigzag	None	HS	R-6	50	100	150

(Sunset Club was quoted as being 8 miles out from Las Vegas. Las Vegas started at Charleston and Fremont, at Boulder Highway. Four-mile area was four miles out and had a dozen clubs.)

Atomic Club $5 (1st)

ATOMIC CLUB — WINNEMUCCA — 1951-64

1st	1.00	Black	Arodie	2tan	HS	R-5	30	60	90
	5.00	Yellow	Arodie	None	HS	R-5	35	70	105
	n/d	Red	Arodie	None	HS	R-9	80	160	240

BOON DOCK'S — WINNEMUCCA — 1981-85

1st	.10	Navy	Horshu	None	HS	R-8	35	70	105
	.25	Beige	Horshu	None	HS	R-8	30	60	90
	1.00	Purple	Horshu	None	HS	R-8	30	60	90
	5.00	Yellow	Horshu	None	HS	R-8	30	60	90
	25.00	Maroon	Horshu	None	HS	R-8	30	60	90
	25.00	Black	Horshu	None	HS	R-9	100	200	300

Cattlemens $5 (1st)

CATTLEMEN'S — WINNEMUCCA — 1985-90

1st	.25	Pink	H&C	None	HS	R-9	75	150	225
	5.00	Red	H&C	4grn4ltgrn	HUB-white	R-8	100	200	300
	25.00	Green	H&C	4wht4pnk	SCA-white	R-10	250	500	750
	100.00	Black	H&C	6ltblu3red	COG-white	R-10	300	600	900

Felix's Hotel $25 (1st)

FELIX'S HOTEL & CASINO — LOVELOCK/ WINN. — 1956-58

1st	5.00	Mustard	Arodie	3blk	HS	R-10	750	1500	3000

(Exactly three pieces have been discovered; two by James Campiglia and one by Phil Jensen. Unfortunately, all of these survivors are in horrible condition.)

	25.00	Brown	Arodie	3blk	HS	R-10	1000	2000	3000

Feriss Hotel 25c (1st)

FERRIS HOTEL/CLUB — WINNEMUCCA — 1948-73

1st	.25	Tan	Sm-key	None	HS	R-9	150	300	450
	1.00	Maroon	Sm-key	3pnk	HS	R-7	75	150	225
	5.00	Lavender	Sm-key	None	HS	R-8	100	200	300
	25.00	Salmon	Sm-key	None	HS	R-8	125	250	375

(This issue is spelled "Feriss Hotel".)

2nd	1.00	Brown	Sm-key	3pur	HS	R-7	60	120	180
	5.00	Navy	Sm-key	3bei	HS-yellow	R-6	60	120	180

(Marked $5.00.)

	5.00	Navy	Sm-key	3gry	HS-gold	R-7	70	140	210

(This is a variant stamped with just $5.)

Ferris Hotel $5 (2nd)

	25.00	Green	Sm-key	3mst	HS	R-8	100	200	300

(This second issue is spelled "Ferris." This club had various owners and therefore many chip changes and different spellings. This larger club featured many games of the day such as faro, pan, poker, craps, blackjack, and slots.)

3rd	5.00	Green	Sqincr	None	HS	Unknown	175	350	525
	25.00	Yellow	Sqincr	None	HS	R-8	60	120	180

(This issue is spelled "Farris Club" and is not misspelled. Opened by Jack Farris. Records show that 300 of the $5's were ordered & none are yet found. Only 150 of the $25's were ordered. All were destroyed by the owner but for some reason some $25's got out.)

Issue	Den.	Color	Mold	Inserts	Inlay	Rarity	GD30	VF65	CS95

FORTY NINER TRUCK PLAZA WINNEMUCCA 1979-92

Issue	Den.	Color	Mold	Inserts	Inlay	Rarity	GD30	VF65	CS95
1st	1.00	Cream	Lg-key	None	HS	R-6	40	80	120
	5.00	Maroon	Lg-key	None	HS	R-6	40	80	120
2nd	5.00	Red	H&C	3org3lim	R-white	R-9	150	300	450

(This originally opened as Winnemucca Auto Truck Plaza and is listed as having blackjack also, although no chips have been found.)

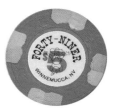

Forty Niner Truck Plaza $5 (2nd)

GEM BAR WINNEMUCCA 1931-64

Issue	Den.	Color	Mold	Inserts	Inlay	Rarity	GD30	VF65	CS95
1st	1.00	Yellow	Cord	None	HS	R-8	150	300	450

(Located among the other small clubs on Bridge St., this historic club is known to be one of the first gaming operations in the Northern Nevada area and the first to have a sports book. Listed as "Club" by 1948. They featured poker & craps as well as slots.)

HUMBOLDT CASINO WINNEMUCCA 1931-75

Issue	Den.	Color	Mold	Inserts	Inlay	Rarity	GD30	VF65	CS95
1st	5.00	Navy	Hub	2yel	HS	R-6	35	70	105
2nd	1.00	Cream	C&J	None	HS	R-4	10	20	30
	5.00	Red	C&J	3yel	SCA-white	R-3	12	24	36
	25.00	Green	C&J	3dkorg	SCA-white	R-4	20	40	60
3rd	.25	Navy	Lg-key	None	HS	R-5	15	30	45
	1.00	Tan	Lg-key	None	HS	R-4	8	16	24

Humboldt Casino $25 (2nd)

(This old hotel opened as the Eldorado last century and became the Humboldt around the late 1920's. Gambling is first listed officially in 1952, but these old hotels were usually on the bandwagon to get their live gaming going when it became legal again in 1931. Casino burned down in 1975.)

Humboldt Casino 25¢ (3rd)

IRONHORSE CASINO WINNEMUCCA 1981-82

Issue	Den.	Color	Mold	Inserts	Inlay	Rarity	GD30	VF65	CS95
1st	.25	Brown	Lg-key	None	HS	R-8	30	60	90
	5.00	Red	Lg-key	None	HS	R-4	10	20	30
	25.00	Green	Lg-key	None	HS	R-4	10	20	30

(This casino featured craps, blackjack, and slots. The Ironhorse became Cattlemens in 1985.)

LEGENDS CASINO WINNEMUCCA 1996-

Issue	Den.	Color	Mold	Inserts	Inlay	Rarity	GD30	VF65	CS95
1st	5.00	Red	HHR	3yel	R-multi	R-1	*	5	10
	25.00	Green	HHR	3wht	R-multi	R-1	*	25	35

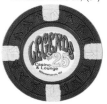

Legends Casino $25 (1st)

MINT CLUB WINNEMUCCA 1948-56

Issue	Den.	Color	Mold	Inserts	Inlay	Rarity	GD30	VF65	CS95
1st	.25	Red	Sm-key	None	HS	R-6	35	70	105

(This chip is only marked "MINT" with the denomination on the back.)

MODEL T TRUCK STOP, KEITH'S WINNEMUCCA 1969-70/70-

Issue	Den.	Color	Mold	Inserts	Inlay	Rarity	GD30	VF65	CS95
1st	.25	Purple	Nevada	None	HS	R-7	75	150	225
	1.00	Rust	Nevada	None	HS	R-7	75	150	225
	5.00	Green	Nevada	3red	HS	R-9	175	350	525
	25.00	Black	Nevada	3brn	HS	Unique	300	600	900

Model T Truck Stop $5 (1st)

(This is a great set of hot stamped picture chips with the old Model T. Beware of imitations with a Diecar mold, including a black $100 with no edge inserts.)

Issue	Den.	Color	Mold	Inserts	Inlay	Rarity	GD30	VF65	CS95
2nd	5.00	Red	H&C	3pch3blu	R-white	R-1	*	5	10
	25.00	Green	H&C	3org3gry	SCA-white	R-2	*	25	35

(Keith's Model T Truck Stop became Parker's Model T in 1970 and they are still in business.)

PEPPERS WINNEMUCCA 1975-75

Issue	Den.	Color	Mold	Inserts	Inlay	Rarity	GD30	VF65	CS95
1st	5.00	Mustard	Horshu	None	HS	R-10	250	500	750

(An early ad shows they were open in 1953. However, those particular chips are unknown.)

Model T $25 (2nd)

Red Lion Inn $5 (1st)

Scotty's Club $25 (1st)

Sonoma Inn $5 (4th)

Sierra Sid's $5 (1st)

Star Broiler $25 (2nd)

Star $25 (3rd)

Issue	Den.	Color	Mold	Inserts	Inlay	Rarity	GD30	VF65	CS95
RED LION INN CASINO			**WINNEMUCCA**		**1978-**				
1st	5.00	Red	H&C	3grn3lim	HUB-white	R-1	*	5	10
	25.00	Green	H&C	3yel3pnk3org	SCA-white	R-1	*	25	35
	100.00	Black	H&C	3lav3pch3brn	COG-white	R-3	*	100	125
	RLT	2 diff.	H&C	None	HS	R-2	3	6	9
(Colors: Brown and Orange. There is a picture of a lion head.)									
SCOTTY'S CLUB			**WINNEMUCCA**		**1954-67**				
1st	1.00	Fuchsia	Sm-key	None	HS	R-10	250	500	750
	5.00	Green	Sm-key	None	HS	R-10	250	500	750
	25.00	Yellow	Sm-key	None	HS	R-6	60	120	180
SONOMA INN			**WINNEMUCCA**		**1947-68**				
1st	5.00	Black	Sm-key	3yel	HS	R-10*	250	500	750
	n/d	Navy	Sm-key	None	HS	R-6	15	30	45
	n/d	White	Sm-key	None	HS	R-8	20	40	60
(These were either roulettes or were used for whatever denomination was needed.)									
2nd	1.00	Yellow	Arodie	None	HS	R-5*	100	200	300
	5.00	Green	Arodie	None	HS	R-5*	125	250	375
(The above price is mostly theoretical, because all known examples are overstamped with a vertical "Christie" over "Sonoma". Remember the rule that overstamped/cancelled chips are worth, at most, about 30% of the listed price.)									
	10.00	Pink	Arodie	None	HS	R-8	100	200	300
	20.00	Orange	Arodie	None	HS	R-8	125	250	375
3rd	1.00	Brown	C&J	3nvy	SCA-white	R-4	20	40	60
	5.00	Red/Blk	C&J	1/2pie	SCA-white-	R-4	30	60	90
	25.00	Yel/Grn	C&J	1/2pie	SCA-white	R-5	40	80	120
3rd	5.00	Brown	C&J	4mst	SCA-white	R-4	20	40	60
4th	5.00	Fuchsia	C&J	3bei	SCA-white	R-4	25	50	75
SIERRA SID'S			**WINNEMUCCA**		**1970s-80s**				
1st	5.00	Green	Lg-key	None	R-white	R-8	75	150	225
(Issue marked Sparks/Winnemucca.)									
	5.00	Green	Lg-key	None	R-white	R-9	80	160	240
STAR BROILER			**WINNEMUCCA**		**1958-78**				
STAR			**WINNEMUCCA**		**1982-85**				
1st	1.00	Tan	Horshu	3brn	HS	R-7	50	100	150
	5.00	Red	Horshu	3yel	HS	R-8	75	150	225
(Above picture a "Star" with the denomination in the center.)									
2nd	1.00	Tan	Horshu	3brn	R-white	R-10	300	600	900
	5.00	Red	Horshu	3mst	R-white	R-9	300	600	900
	25.00	Black	Horshu	3fch	R-white	R-10	500	1000	1500
3rd	5.00	Red	H&C	3gry3org	HUB-white	R-7	50	100	150
	25.00	Green	H&C	3wht3brn	SCA-white	R-10	200	400	600

(Third issue is just "Star." This building was originally the Star Hotel dating back to the early 1900's. Gaming started in 1958 as the New Star. In 1964, Joe Mackie purchased the operation and called it Star Broiler. In 1969, Mackie bought Winner's, formerly Sonoma Inn, located across the street, and used the same chips at both locations. After Star Broiler was fire damaged in June, 1976, six years elapsed until 1982 when the place was re-opened. In 1985, the building closed and is now a convention center.)

Issue	Den.	Color	Mold	Inserts	Inlay	Rarity	GD30	VF65	CS95
SUNDANCE			**WINNEMUCCA**		**1978-**				
1st	.25	Yellow	Ewing	None	HS	R-6	15	30	45
	1.00	Orange	Ewing	None	HS	R-5	12	24	36
	5.00	Green	Ewing	None	HS	R-5	15	30	45
2nd	2.50	Blue	BJ-2	None	COIN	R-8	125	250	375
3rd	5.00	Red	H&C	3bei	HS	R-4	10	20	30

(Live gaming was taken out about 1995.)

Sundance $5 (3rd)

Issue	Den.	Color	Mold	Inserts	Inlay	Rarity	GD30	VF65	CS95
T.J.'S DIRTY BIRD			**WINNEMUCCA**		**1974-77**				
1st	1.00	Blue	H&C	None	HS	R-6	20	40	60
	5.00	Fuchsia	Lg-key	None	HS	R-6	25	50	75
	25.00	Yellow	Lg-key	3brn3nvy	HS	R-6	30	60	90

(Was located next to Sundance. Became part of the Sundance when owners were caught cheating.)

T.J.'s Dirty Bird $25 (1st)

Issue	Den.	Color	Mold	Inserts	Inlay	Rarity	GD30	VF65	CS95
VIC'S CLUB			**WINNEMUCCA**		**1948-50's**				
1st	n/d	Lavender	Arodie	None	HS	R-9	100	200	300
	n/d	Dk Grey	Arodie	None	HS	R-9	100	200	300
	n/d	Red	Arodie	None	HS	R-9	100	200	300
	n/d	Navy	Arodie	None	HS	R-9	100	200	300

Winners $1 (1st)

Issue	Den.	Color	Mold	Inserts	Inlay	Rarity	GD30	VF65	CS95
WINNER'S INN			**WINNEMUCCA**		**1969-79**				
WINNER'S HOTEL & CASINO					**1989-**				
1st	.25	Red	Horshu	3gry	HS	R-9	100	200	300
	.50	Navy	Horshu	3mst	HS	R-9	100	200	300
	1.00	Grey	Horshu	3blk	HS	R-7	50	100	150

(Above marked "Star" on one side, "Winners" on other.)

Issue	Den.	Color	Mold	Inserts	Inlay	Rarity	GD30	VF65	CS95
2nd	5.00	Mustard	Horshu	3brn	R-white	R-9	125	250	375
	25.00	Black	Horshu	3red	R-white	R-10	250	500	750
	100.00	Lime	Horshu	3crm	R-white	R-10	350	700	1050

(Above marked "Winners Inn.")

Issue	Den.	Color	Mold	Inserts	Inlay	Rarity	GD30	VF65	CS95
	RLT	Brown	Horshu	None	HS	R-10	50	100	150
	RLT	Mustard	Horshu	None	HS	R-10	50	100	150
	RLT	Mustard	Horshu	3org	HS	R-10	50	100	150

(Above marked "Winners Inn" believed to be roulette but could be just non-denominational.)

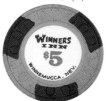

Winners Inn $5 (2nd)

Issue	Den.	Color	Mold	Inserts	Inlay	Rarity	GD30	VF65	CS95
3rd	.25	Grey	H&C	None	HS	R-1	*	2	4
	5.00	Red	H&C	3yel	R-white	R-1	*	5	10
	25.00	Green	H&C	3org	SCA-white	R-1	*	25	35
	100.00	Black	H&C	3wht	R-white	R-4	*	100	150
	RLT R	Black	Roulet	None	HS	R-3	3	6	9

Issue	Den.	Color	Mold	Inserts	Inlay	Rarity	GD30	VF65	CS95
CASINO WEST			**YERINGTON**		**1974-**				
1st	5.00	Brown	Lg-key	3org	HS	R-1	*	5	15
	25.00	Black	Lg-key	3tan	HS	R-2	*	25	40
	100.00	Pink	Lg-key	3grn	HS	R-5	*	100	125
	RLT	4 diff.	Lg-key	None	HS	R-10	25	50	75

(Colors: Grey, Lavender, Red, and Yellow.)

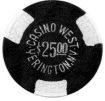

Casino West $25 (1st)

Issue	Den.	Color	Mold	Inserts	Inlay	Rarity	GD30	VF65	CS95
EAGLE CLUB			**YERINGTON**		**1938-64**				
1st	.25	Red	Hub	2yel	HS	R-6	75	150	225

(These chips were purchased by Steve Cutler from the owner's son, and are the only verifiable chips from this club. The Lcrown chips some claim were from here, definitely originated in California. The manufacturer's records prove this. Was The Nugget 1953 to 55, no chips known.)

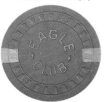

Eagle Club 25c (1st)

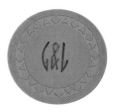

L&L Bar $5 (1st)

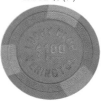

Lucky Club $1 (1st)

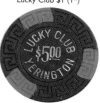

Lucky Club $5 (2nd)

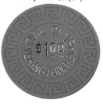

Owl Club $1 (2nd)

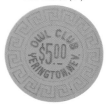

Owl Club $5 (2nd)

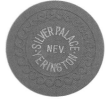

Silver Palace RLT (1st)

Issue	Den.	Color	Mold	Inserts	Inlay	Rarity	GD30	VF65	CS95
KOPPER KORNER GAMES			**YERINGTON**		**1961-67**				
1st	5.00	Orange	Sm-key	None	HS	R-7	20	40	60
(Above only marked "KKG" and are currently in use at the Casino West as markers on the blackjack table. However, they are nearly impossible to obtain.)									
L & L BAR			**YERINGTON**		**1931-39 / 1956-60**				
1st	.25	Grey	Sm-key	None	HS	R-9	100	200	300
	5.00	Yellow	Arodie	None	HS	R-4	15	30	45
LUCKY CLUB			**YERINGTON**		**1933-**				
1st	1.00	Purple	Sm-key	3aqa	HS	R-5	25	50	75
2nd	5.00	Dk Green	Lg-key	3red	HS	R-3	6	12	18
	25.00	Mustard	Lg-key	3blu	HS	R-4	20	40	60
(Table games were removed in 1994.)									
LYON HOTEL			**YERINGTON**		**1946-52**				
1st	.25	Black	Sm-key	None	HS	R-10	50	100	150
	5.00	Beige	Sm-key	None	HS	R-10	50	100	150
	5.00	Yellow	Sm-key	None	HS	R-10	50	100	150
(Chips only marked "DSN" for Don S. Neighbors, the owner.)									
OWL BAR/CLUB			**YERINGTON**		**1948-77**				
1st	5.00	Black	HCE	3lav	HS	R-4	20	40	60
2nd	1.00	Red	Lg-key	None	HS	R-4	15	30	45
	5.00	Yellow	Lg-key	None	HS	R-6	25	50	75
SILVER PALACE			**YERINGTON**		**1931-71**				
1st	5.00	Red	Flower	None	HS	R-5	15	30	45
(Only marked "S-P.")									
	RLT	10 diff.	Wave	None	HS	R-5	7	14	21
(Colors: Aqua, Beige, Black, Brown, Dk Brown, Grey/Green, Grey/Blue, Navy, Red, and Yellow.)									

Issue	Den.	Color	Mold	Inserts	Inlay	Rarity	GD30	VF65	CS95

Black Hawk

BLACK HAWK STATION — BLACK HAWK — 1991-

Issue	Den.	Color	Mold	Inserts	Inlay	Rarity	GD30	VF65	CS95
1st	5.00	Red	Chipco	None	FG	R-4	7	14	21

(This variety has closed train windows.)

2nd	5.00	Red	Chipco	None	FG	R-2	*	5	7

(This variety has open train windows.)

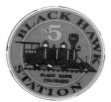

Black Hawk Station $5 (2nd)

BLAZING SADDLES — BLACK HAWK — 1993-96

Issue	Den.	Color	Mold	Inserts	Inlay	Rarity	GD30	VF65	CS95
1st	1.00	White	Chipco	None	FG	R-1	*	2	5
	5.00	Red	Chipco	None	FG	R-2	5	10	15

BRONCO BILLY'S — BLACK HAWK — 1992-98

Issue	Den.	Color	Mold	Inserts	Inlay	Rarity	GD30	VF65	CS95
1st	5.00	Red	BJ	12yel	HS	R-2	5	10	15

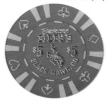

Bronco Billy's $5 (1st)

BULL DURHAM — BLACK HAWK — 1993-

Issue	Den.	Color	Mold	Inserts	Inlay	Rarity	GD30	VF65	CS95
1st	5.00	Red	H&C	4blu4grn	R-white	R-2	5	10	15
2nd	25.00	Green	Chipco	None	FG	R-4	*	25	30

BULLWHACKERS — BLACK HAWK — 1992-

Issue	Den.	Color	Mold	Inserts	Inlay	Rarity	GD30	VF65	CS95
1st	1.00	White	Chipco	None	FG	R-1	*	1	2
	5.00	Dk Red	Chipco	None	FG	R-1	*	5	7
	5.00	Maroon	Chipco	None	FG	R-1	*	5	7
	25.00	Green	Chipco	None	FG	R-4	*	25	30

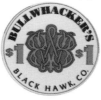

Bullwhackers $1 (1st)

CLAIM JUMPERS — BLACK HAWK — 1992

Issue	Den.	Color	Mold	Inserts	Inlay	Rarity	GD30	VF65	CS95
1st	5.00	Red	H&C	4grn4gld	R-white	R-4	15	30	45

COLORADO CENTRAL — BLACK HAWK — 1993-

Issue	Den.	Color	Mold	Inserts	Inlay	Rarity	GD30	VF65	CS95
1st	1.00	White	Chipco	None	FG	R-3	4	8	12
	5.00	Red	Chipco	None	FG	R-3	5	10	15
2nd	1.00	White	Chipco	None	FG	R-1	*	1	2
	2.50	Pink	Chipco	None	FG	R-1	*	3	4
	5.00	Red	Chipco	None	FG	R-1	*	5	7
	25.00	Green	Chipco	None	FG	R-3	*	25	30

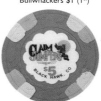

Claim Jumpers $5 (1st)

CRACKER FACTORY — BLACK HAWK — 1992-93

Issue	Den.	Color	Mold	Inserts	Inlay	Rarity	GD30	VF65	CS95
1st	1.00	White	Chipco	None	FG	R-3	9	18	27
	5.00	Red	Chipco	None	FG	R-4	20	40	60
	25.00	Green	Chipco	None	FG	R-8	400	800	1200

EL DORADO — BLACK HAWK — 1991-94

Issue	Den.	Color	Mold	Inserts	Inlay	Rarity	GD30	VF65	CS95
1st	1.00	White	Chipco	None	FG	R-3	9	18	27
	5.00	Red	Chipco	None	FG	R-4	15	30	45

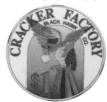

Cracker Factory $1 (1st)

EUREKA — BLACK HAWK — 1991-

Issue	Den.	Color	Mold	Inserts	Inlay	Rarity	GD30	VF65	CS95
1st	5.00	Red	Chipco	None	FG	R-2	*	5	7

FITZGERALDS — BLACK HAWK — 1995-

Issue	Den.	Color	Mold	Inserts	Inlay	Rarity	GD30	VF65	CS95
1st	1.00	White	Chipco	None	FG	R-1	*	1	2
	5.00	Red	Chipco	None	FG	R-2	*	5	7
	25.00	Green	Chipco	None	FG	R-4	*	25	30
	100.00	Black	Chipco	None	FG	R-4	*	100	110

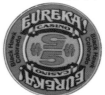

Eureka $5 (1st)

Issue	Den.	Color	Mold	Inserts	Inlay	Rarity	GD30	VF65	CS95
GILPIN HOTEL			**BLACK HAWK**		1991-				
1st	1.00	White	Chipco	None	FG	R-1	*	1	2
	5.00	Red	Chipco	None	FG	R-2	*	5	7
	25.00	Green	Chipco	None	FG	R-3	*	25	30
	100.00	Black	Chipco	None	FG	R-4	*	100	110
GOLD MINE			**BLACK HAWK**		1991-				
1st	1.00	White	Chipco	None	FG	R-2	*	1	2
	2.50	Pink	Chipco	None	FG	R-3	*	3	4
	5.00	Red	Chipco	None	FG	R-2	*	5	7
GOLDEN GATES			**BLACK HAWK**		1992-				
1st	1.00	White	Chipco	None	FG	R-2	*	1	2
	5.00	Red	Chipco	None	FG	R-2	*	5	7
GREGORY STREET			**BLACK HAWK**		1991-96				
1st	1.00	White	Chipco	None	FG	R-5	250	500	750
	5.00	Red	Chipco	None	FG	R-3	*	5	7
HARRAH'S			**BLACK HAWK**		1993-97				
1st	1.00	White	Chipco	None	FG	R-1	1	2	3
	5.00	Red	Chipco	None	FG	R-2	10	20	30
	25.00	Green	Chipco	None	FG	R-4	20	40	60
JAZZ ALLEY			**BLACK HAWK**		1991-				
1st	1.00	White	Chipco	None	FG	R-3	5	10	15
	2.50	Pink	Chipco	None	FG	R-2	*	3	4
	5.00	Red	Chipco	None	FG	R-2	*	5	7
LILLY BELLE'S			**BLACK HAWK**		1991-94				
1st	1.00	White	Chipco	None	FG	R-4	12	24	36
	5.00	Red	Chipco	None	FG	R-4	25	50	75
	25.00	Green	Chipco	None	FG	R-8	300	600	900

(Note: There are about 10 known examples right now, but it is believed that two boxes (200 chips) still exist in the safe and could come on the market eventually.)

Issue	Den.	Color	Mold	Inserts	Inlay	Rarity	GD30	VF65	CS95
LODGE CASINO			**BLACK HAWK**		1998-				
1st	1.00	White	Chipco	None	FG	R-1	*	1	2
	5.00	Red	Chipco	None	FG	R-1	*	5	7
	25.00	Green	Chipco	None	FG	R-1	*	25	30
LUCKY STAR			**BLACK HAWK**		1991-				
1st	5.00	Red	BJ	6blk	HS	R-3	10	20	30
MAIN STREET 101			**BLACK HAWK**		1992-93				
1st	5.00	Red	Chipco	None	FG	R-4	50	100	150
	25.00	Green	Chipco	None	FG	R-8	1200	2400	3600
OTTO'S			**BLACK HAWK**		1991-				
1st	5.00	Red	BJ	12wht	R-white	R-2	5	10	15
PICK A DILLY			**BLACK HAWK**		1993-94				
1st	5.00	Red	Chipco	None	FG	R-3	7	14	21

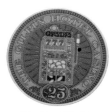

Gilpin Hotel $25 (1st)

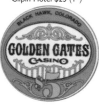

Golden Gates $5 (1st)

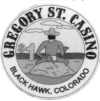

Gregory St. $1 rev (1st)

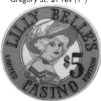

Lilly Belle's $5 (1st)

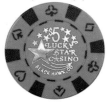

Lucky Star $5 (1st)

Mainstreet 101 $25 (1st)

Issue	Den.	Color	Mold	Inserts	Inlay	Rarity	GD30	VF65	CS95
PROSPECTOR			**BLACK HAWK**		**1991-92**				
1st	1.00	White	Chipco	None	FG	R-2	5	10	15
	5.00	Red	Chipco	None	FG	R-3	10	20	30
	25.00	Green	Chipco	None	FG	R-4	25	50	75
RED DOLLY			**BLACK HAWK**		**1991-**				
1st	5.00	Pink	H&C	4brn4crm	HUB-white	R-2	5	10	15
RICHMAN			**BLACK HAWK**		**1991-**				
1st	1.00	White	Chipco	None	FG	R-5	100	200	300
	5.00	Red	Chipco	None	FG	R-2	*	5	7
	25.00	Green	Chipco	None	FG	R-4	*	25	30
ROHLING INN			**BLACK HAWK**		**1992-93**				
1st	5.00	Pink	H&C	3ltblu3dkblu	HUB-white	R-3	10	20	30
2nd	1.00	White	H&C	4blu4crm4blu	R-white	R-3	10	20	30
	5.00	Pink	H&C	4ltblu4dkblu	HUB-white	R-2	5	10	15
	25.00	Green	H&C	4yel4blk	R-white	R-4	25	50	75
ROYAL FLUSH			**BLACK HAWK**		**1991-92**				
1st	1.00	White	Chipco	None	FG	R-3	10	20	30
	5.00	Red	Chipco	None	FG	R-2	5	10	15
SILVERHAWK			**BLACK HAWK**		**1992-**				
1st	1.00	White	Chipco	None	FG	R-3	10	20	30
	5.00	Red	Chipco	None	FG	R-2	*	5	7

(Note: $1 is no longer used and is obsolete.)

Central City

Issue	Den.	Color	Mold	Inserts	Inlay	Rarity	GD30	VF65	CS95
ANNIE OAKLEY' S			**CENTRAL CITY**		**1991-93**				
1st	5.00	Red	Chipco	None	FG	R-2	5	10	15
BABY DOE'S			**CENTRAL CITY**		**1991-94**				
1st	5.00	Red	HHR	3wht4gry	R-black	R-3	15	30	45
BONANZA			**CENTRAL CITY**		**1992-**				
1st	5.00	Red	H&C	3pch3pur3tan	HUB-white	R-2	*	5	10
2nd	1.00	White	Chipco	None	FG	R-2	*	1	2
	5.00	Red	Chipco	None	FG	R-4	35	70	105
	25.00	Green	Chipco	None	FG	R-4	*	25	30
BULLWHACKERS			**CENTRAL CITY**		**1992-**				
1st	1.00	White	H&C	3grn3pur	R-white	R-2	*	1	2
	5.00	Red	H&C	4gld4blu	HUB-white	R-2	*	5	7
	25.00	Green	H&C	4org4blu	COG-white	R-4	*	25	30
CENTRAL PALACE			**CENTRAL CITY**		**1992-**				
1st	1.00	White	BJ	4ltblu	HS	R-3	5	10	15
	5.00	Red	BJ	6yel	HS	R-3	*	5	7

Prospector $5 (1st)

Richman $5 (1st)

Royal Flush $1 (1st)

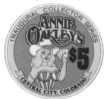

Annie Oakley's $5 (1st)

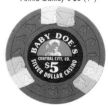

Baby Doe's $5 (1st)

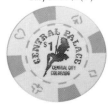

Central Palace $1 (1st)

303

Issue	Den.	Color	Mold	Inserts	Inlay	Rarity	GD30	VF65	CS95
COYOTE CREEK			**CENTRAL CITY**		**1994-**				
1st	5.00	Red	Chipco	None	FG	R-2	*	5	7
2nd	5.00	Red	Chipco	None	FG	R-2	5	10	15

(This is the same chip, but commemorates the national chip collecting club, CC>CC.)

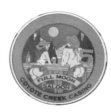

Coyote Creek $5 (1st)

DILLON'S DOUBLE EAGLE			**CENTRAL CITY**		**1992-93**				
1st	1.00	White	BJ	8red	HS	R-3	7	14	21
	5.00	Red	BJ	6wht	HS	R-3	15	30	45
GLORY HOLE			**CENTRAL CITY**		**1992-93**				
1st	1.00	White	Chipco	None	FG	R-2	5	10	15
	5.00	Red	Chipco	None	FG	R-3	10	20	30
	25.00	Green	Chipco	None	FG	R-4	15	30	45

Glory Hole $1 (1st)

GOLD STAR			**CENTRAL CITY**		**1992**				
1st	5.00	Red	Chipco	None	FG	R-3	5	10	15
GOLDEN ROSE			**CENTRAL CITY**		**1992-**				
1st	1.00	White	H&C	6org2grn	R-white	R-2	*	1	2
	5.00	Red	H&C	4tan4wht	HUB-white	R-2	*	5	7
	25.00	Green	H&C	3tan3gry	COG-white	R-4	*	25	30

Grubstake $5 (1st)

GRUBSTAKE			**CENTRAL CITY**		**1991-92**				
1st	5.00	Red	BJ	3wht	HS	R-6	200	400	600
HARRAH'S			**CENTRAL CITY**		**1993-97**				
1st	1.00	White	Chipco	None	FG	R-2	1	2	3
	5.00	Red	Chipco	None	FG	R-2	5	10	15
HARVEYS			**CENTRAL CITY**		**1994-**				
1st	1.00	Tan	H&C	2grn2pur	R-white	R-7	125	250	375

(This price is only for the 20 to 24 known examples in unnotched condition. Colorado law mandates that all dollar chips be white. These tan chips were considered too dark to be lawful and Harvey's was forced to make a second issue. Thousands of these chips were notched and given away by the casino for souvenirs. These notched chips are only worth about $10-$15 each.)

Harvey's $5 (2nd)

2nd	1.00	White	H&C	2grn2pur	R-white	R-1	*	1	2
	5.00	Red	H&C	8pnk4red	R-white	R-1	*	5	7
	25.00	Green	H&C	4ltgrn4dkgrn	R-white	R-3	*	25	30
LADY LUCK			**CENTRAL CITY**		**1993-97**				
1st	1.00	White	BJ	8red	HS	R-2	4	8	12
	5.00	Red	BJ	8wht	HS	R-2	5	10	15

Lady Luck $1 (1st)

LONG BRANCH			**CENTRAL CITY**		**1991-94**				
1st	1.00	White	H&C	2blk2red	R-white	R-2	5	10	15
	5.00	Red	H&C	4blk4grn	HUB-white	R-3	10	20	30
MAYOR WILLIE'S			**CENTRAL CITY**		**1992-92**				
1st	5.00	Red	Chipco	None	FG	R-6	200	400	600
MINERS PICK			**CENTRAL CITY**		**1992-92**				
1st	1.00	White	Chipco	None	FG	R-3	20	40	60
	5.00	Red	Chipco	None	FG	R-4	40	80	120

Mayor Willie's $5 (1st)

Issue	Den.	Color	Mold	Inserts	Inlay	Rarity	GD30	VF65	CS95
MOLLY' S			CENTRAL CITY		1991-92				
1st	5.00	Red	BJ	3white	HS	R-3	15	30	45
NEVADA HOUSE			CENTRAL CITY		1992-93				
1st	1.00	White	Chipco	None	FG	R-3	10	20	30
	5.00	Red	Chipco	None	FG	R-3	15	30	45
	25.00	Green	Chipco	None	FG	R-9	1250	2500	3750
NITRO CLUB			CENTRAL CITY		1991-93				
1st	1.00	White	H&C	6pur3wht	R-white	R-3	12	24	36
	5.00	Pink	H&C	4pur4yel	HUB-white	R-4	20	40	60
PAPONE'S PALACE			CENTRAL CITY		1992-96				
1st	5.00	Red	BJ	4blk	HS	R-2	5	10	15
PETE'S PLACE			CENTRAL CITY		1993-94				
1st	1.00	White	Chipco	None	FG	R-2	3	6	9
	5.00	Red	Chipco	None	FG	R-3	5	10	15
SILVER SLIPPER			CENTRAL CITY		1991-93				
1st	1.00	White	Chipco	None	FG	R-4	25	50	75
	5.00	Red	Chipco	None	FG	R-3	15	30	45
TELLER HOUSE			CENTRAL CITY		1991-				
1st	.50	Blue	Chipco	None	FG	R-2	*	1	2
	1.00	White	Chipco	None	FG	R-1	1	2	3
	5.00	Red	Chipco	None	FG	R-2	3	6	9
	25.00	Green	Chipco	None	FG	R-4	*	30	45

(Note: Casino is still open, but the blackjack game was removed in 1997.)

Issue	Den.	Color	Mold	Inserts	Inlay	Rarity	GD30	VF65	CS95
TERPS			CENTRAL CITY		1992-92				
1st	1.00	White	Chipco	None	FG	R-2	10	20	30
	5.00	Red	Chipco	None	FG	R-3	20	40	60
	25.00	Green	Chipco	None	FG	R-6	100	200	300
TOLL GATE			CENTRAL CITY		1992-95				
1st	5.00	Maroon	HHR	3blu	R-white	R-3	15	30	45
2nd	1.00	White	Summit	6dkblu3ltblu	R-white	R-2	5	10	15
	5.00	Red	Summit	6wht3blk	R-white	R-2	10	20	30

Cripple Creek

Issue	Den.	Color	Mold	Inserts	Inlay	Rarity	GD30	VF65	CS95
ASPEN MINE			CRIPPLE CREEK		1993-96				
1st	1.00	White	Chipco	None	FG	R-5	150	300	450
	5.00	Red	Chipco	None	FG	R-2	7	14	21
	25.00	Green	Chipco	None	FG	R-4	20	40	60
BLACK DIAMOND			CRIPPLE CREEK		1991-				
1st	5.00	Red	Chipco	None	FG	R-6	250	500	750

(Blackjack hand on face. Order recalled and only 59 survived.)

Issue	Den.	Color	Mold	Inserts	Inlay	Rarity	GD30	VF65	CS95
2nd	5.00	Red	Chipco	None	FG	R-2	*	5	7

Nevada House $5 (1st)

Nitro Club $5 (1st)

Silver Slipper $1 (1st)

Terps $5 (1st)

Aspen Mine $1 (1st)

Black Diamond $5 (1st)

Issue	Den.	Color	Mold	Inserts	Inlay	Rarity	GD30	VF65	CS95
BOWL OF GOLD			**CRIPPLE CREEK**		**1992-92**				
1st	1.00	White	Chipco	None	FG	R-3	10	20	30
	error 1.00	White	Chipco	None	FG	R-9	300	600	900
(Walking Liberty design on both sides.)									
	error 1.00	White	Chipco	None	FG	R-9	300	600	900
(Bowl of Gold design on both sides.)									
	5.00	Red	Chipco	None	FG	R-3	20	40	60
	25.00	Green	Chipco	None	FG	R-5	100	200	300
BRASS ASS			**CRIPPLE CREEK**		**1991-**				
1st	5.00	Red	H&C	None	HS	R-2	7	14	21
BRONCO BILLY' S			**CRIPPLE CREEK**		**1991-**				
1st	5.00	Red	BJ	12yel	HS	R-2	*	5	7
COLORADO GRANDE			**CRIPPLE CREEK**		**1991-**				
1st	5.00	Red	BJ	6wht	HS	R-2	*	5	7
CRAPPER JACK'S			**CRIPPLE CREEK**		**1995-**				
1st	5.00	Red	Summit	8wht	OR-Red	R-2	*	5	7
	25.00	Green	Summit	6org	OR-Green	R-4	*	25	30
CREEKERS			**CRIPPLE CREEK**		**1991-**				
1st	5.00	Red	Chipco	None	FG	R-2	*	5	7
	25.00	Green	Chipco	None	FG	R-3	*	25	30
CRIPPLE CREEK'S ORE HOUSE			**CRIPPLE CREEK**		**1991-92**				
1st	1.00	White	Chipco	None	FG	R-3	15	30	45
	5.00	Red	Chipco	None	FG	R-4	30	60	90
	25.00	Green	Chipco	None	FG	R-8	400	800	1200
DIAMOND LIL' S			**CRIPPLE CREEK**		**1992-93**				
1st	5.00	Red	BJ	12blk	R-white	R-3	15	30	45
DILLON'S DOUBLE EAGLE			**CRIPPLE CREEK**		**1992-93**				
1st	1.00	White	BJ	8red	HS	R-2	7	14	21
	5.00	Red	BJ	6wht	HS	R-3	15	30	45
DOUBLE EAGLE			**CRIPPLE CREEK**		**1996-**				
1st	5.00	Red	Chipco	None	FG	R-1	*	5	7
	25.00	Green	Chipco	None	FG	R-3	*	25	30
ELK CREEK			**CRIPPLE CREEK**		**1993-95**				
1st	5.00	Red	BJ	12blu	R-white	R-2	7	14	21
GLITTER GULCH			**CRIPPLE CREEK**		**1996-**				
1st	5.00	Red	H&C	3pch3pur	FG	R-2	*	5	7
	25.00	Green	H&C	4yel4blu	FG	R-4	*	25	30
GOLD DIGGER'S			**CRIPPLE CREEK**		**1992-**				
1st	5.00	Red	Chipco	None	FG	R-2	*	5	7
	25.00	Green	Chipco	None	FG	R-3	*	25	30

Bowl of Gold $1 (1st)

Brass Ass $5 (1st)

Creekers $5 (1st)

CC's Ore House $1 (1st)

Diamond Lil's $5 (1st)

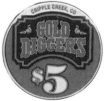

Gold Digger's $5 (1st)

Issue	Den.	Color	Mold	Inserts	Inlay	Rarity	GD30	VF65	CS95
GOLD RUSH			CRIPPLE CREEK		1992-				
1st	1.00	White	Chipco	None	FG	R-3	15	30	45
	5.00	Red	Chipco	None	FG	R-2	*	5	7
	25.00	Green	Chipco	None	FG	R-2	*	25	30
GOLDEN EAGLE			CRIPPLE CREEK		N/A				
1st	5.00	Red	H&C	3wht6blu	HUB-white	R-3	20	40	60
(This casino never opened.)									
GOLDEN HORSESHOE			CRIPPLE CREEK		1992-92				
1st	1.00	White	Chipco	None	FG	R-3	15	30	45
	5.00	Red	Chipco	None	FG	R-4	30	60	90
IMPERIAL			CRIPPLE CREEK		1992-				
1st	1.00	White	Chipco	None	FG	R-2	*	1	2
	5.00	Red	Chipco	None	FG	R-3	*	5	7
INDEPENDENCE HOTEL			CRIPPLE CREEK		1992-				
1st	5.00	Red	H&C	3pnk3red	HUB-white	R-2	4	8	12
J.P. McGILL'S			CRIPPLE CREEK		1997-				
1st	1.00	White	Chipco	None	FG	R-2	*	1	2
	5.00	Red	Chipco	None	FG	R-2	*	5	7
	25.00	Green	Chipco	None	FG	R-4	*	25	30
	100.00	Black	Chipco	None	FG	R-4	*	100	110
JOHNNY NOLON'S			CRIPPLE CREEK		1991-				
1st	1.00	White	H&C	None	R-white	R-2	2	4	6
	5.00	Red	H&C	6tan	HUB-white	R-2	5	10	15
	25.00	Green	H&C	4grn4org	SCA-white	R-4	30	60	90
2nd	1.00	White	Chipco	None	FG	R-1	*	1	2
	5.00	Red	Chipco	None	FG	R-2	*	5	7
	25.00	Green	Chipco	None	FG	R-4	*	25	30
JUBILEE CASINO			CRIPPLE CREEK		1992-				
1st	1.00	White	Chipco	None	FG	R-1	*	1	2
	5.00	Red	Chipco	None	FG	R-2	*	5	7
	25.00	Green	Chipco	None	FG	R-3	*	25	30
LONG BRANCH			CRIPPLE CREEK		1992-94				
1st	1.00	White	H&C	4tan4pur	R-white	R-2	2	4	6
	5.00	Red	H&C	3pnk3trq3grn	HUB-white	R-2	4	8	12
LOOSE CABOOSE			CRIPPLE CREEK		1991-				
1st	1.00	White	Chipco	None	FG	R-2	3	6	9
	5.00	Red	Chipco	None	FG	R-2	5	10	15
LUCKY LOLA'S			CRIPPLE CREEK		1992-				
1st	1.00	White	Chipco	None	FG	R-2	4	8	12
	5.00	Red	Chipco	None	FG	R-2	*	5	7
MADAM JUNE'S			CRIPPLE CREEK		1992-92				
1st	1.00	White	Chipco	None	FG	R-2	5	10	15

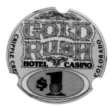

Gold Rush $1 (1st)

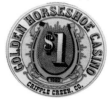

Golden Horseshoe $1 (1st)

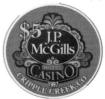

JP McGill's $5 (1st)

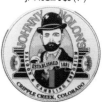

Johnny Nolon's $1 (2nd)

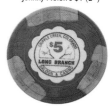

Long Branch $5 (1st)

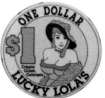

Lucky Lola's $1 (1st)

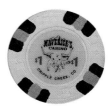

Maverick's $1 (1st)

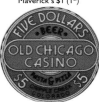

Old Chicago $5 (1st)

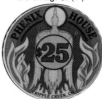

Phenix House $25 (2nd)

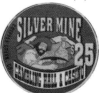

Silver Mine $25 (1st)

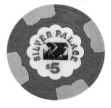

Silver Palace $5 (1st)

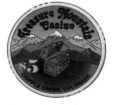

Treasure Mountain $5 (1st)

Issue	Den.	Color	Mold	Inserts	Inlay	Rarity	GD30	VF65	CS95
	5.00	Red	Chipco	None	FG	R-3	10	20	30
	25.00	Green	Chipco	None	FG	R-4	25	50	75
MAVERICK'S			**CRIPPLE CREEK**		**1992-**				
1st	1.00	White	H&C	4pnk8pur	R-white	R-3	6	12	18
	5.00	Red	H&C	2mst2pnk	HUB-white	R-2	*	5	10
MIDNIGHT ROSE			**CRIPPLE CREEK**		**1992-**				
1st	1.00	White	H&C	3pur3brn	R-white	R-1	*	1	2
	5.00	Red	H&C	4grn4blu	R-white	R-2	*	5	7
	25.00	Green	H&C	4yel4pnk	SCA-white	R-3	*	25	30
OLD CHICAGO			**CRIPPLE CREEK**		**1992-**				
1st	1.00	White	Chipco	None	FG	R-2	*	1	2
	5.00	Red	Chipco	None	FG	R-2	*	5	7
	25.00	Green	Chipco	None	FG	R-3	*	25	30
PALACE HOTEL			**CRIPPLE CREEK**		**1992-**				
1st	1.00	White	Chipco	None	FG	R-2	*	1	2
	5.00	Red	Chipco	None	FG	R-2	*	5	7
PHENIX HOUSE			**CRIPPLE CREEK**		**1991-96**				
1st	5.00	Red	BJ	4wht	HS	R-5	50	100	150
2nd	1.00	White	Chipco	None	FG	R-2	4	8	12
	5.00	Red	Chipco	None	FG	R-2	5	10	15
	25.00	Green	Chipco	None	FG	R-4	20	40	60
SILVER MINE			**CRIPPLE CREEK**		**1991-93**				
1st	1.00	White	Chipco	None	FG	R-4	?	?	?
(All 200 of these chips are owned privately, but not as yet available to collectors.)									
	5.00	Red	Chipco	None	FG	R-4	40	80	120
	25.00	Green	Chipco	None	FG	R-9	700	1400	2100
SILVER PALACE			**CRIPPLE CREEK**		**1992-94**				
1st	5.00	Red	H&C	4grn4blu	HUB-white	R-3	20	40	60
SILVER SPUR			**CRIPPLE CREEK**		**1997-**				
1st	1.00	White	Chipco	None	FG	R-2	*	1	2
	5.00	Red	Chipco	None	FG	R-2	*	5	7
	25.00	Green	Chipco	None	FG	R-4	*	25	30
(Chips formerly sold at Black Diamond cage, but are no longer available.)									
STAR			**CRIPPLE CREEK**		**1992-96**				
1st	1.00	White	Chipco	None	FG	R-2	9	18	27
	5.00	Red	Chipco	None	FG	R-2	4	8	12
	25.00	Green	Chipco	None	FG	R-4	25	50	75
(Above set has no border around the word "STAR", giving a blurry appearance.)									
2nd	1.00	White	Chipco	None	FG	R-4	15	30	45
	5.00	Red	Chipco	None	FG	R-2	4	8	12
	25.00	Green	Chipco	None	FG	R-4	25	50	75
(Above set has a border around the word "STAR" which appears clear vs. the first issue.)									
TREASURE MOUNTAIN			**CRIPPLE CREEK**		**1996-**				
1st	5.00	Red	Chipco	None	FG	R-2	*	5	7

Issue	Den.	Color	Mold	Inserts	Inlay	Rarity	GD30	VF65	CS95
TURF CLUB			**CRIPPLE CREEK**		**1991-93**				
1st	1.00	White	Chipco	None	FG	R-2	7	14	21
(There are two versions of the horse: light brown and dark brown.)									
	5.00	Red	Chipco	None	FG	R-2	10	20	30
	25.00	Green	Chipco	None	FG	R-3	25	50	75
WILD BILL' S			**CRIPPLE CREEK**		**1991-94**				
1st	1.00	White	H&C	4yel4org	HS	R-2	5	10	15
	5.00	Red	H&C	4lav	HS	R-3	15	30	45
WILD HORSE SALOON			**CRIPPLE CREEK**		**1992-92**				
1st	5.00	Red	H&C	3pnk3blk3blu	HUB-white	R-5	50	100	150
	25.00	Green	H&C	6grn6pur	HUB-white	R-6	125	250	375
WOMACK'S			**CRIPPLE CREEK**		**1992-**				
1st	1.00	White	Chipco	None	FG	R-2	*	1	2
	5.00	Red	Chipco	None	FG	R-2	*	5	7
	25.00	Green	Chipco	None	FG	R-3	*	25	30
2nd	2.50	Pink	Chipco	None	FG	R-2	*	3	4
	5.00	Red	Chipco	None	FG	R-2	*	5	7
	25.00	Green	Chipco	None	FG	R-3	*	25	30

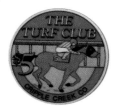

Turf Club $5 (1st)

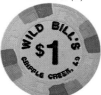

Wild Bill's $1 (1st)

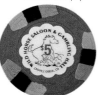

Wild Horse Saloon $5 (1st)

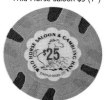

Wild Horse Saloon $25 (1st)

Womack's $1 (1st)

Womack's $5 (1st)

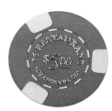

76 Restaurant $5 (1st)

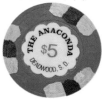

Anaconda $5 (1st)

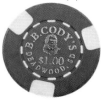

B.B. Cody's $1 (1st)

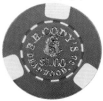

B.B. Cody's $1 (2nd)

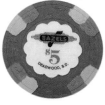

Bazels $5 (1st)

Bella Union $25 (2nd)

Issue	Den.	Color	Mold	Inserts	Inlay	Rarity	GD30	VF65	CS95

Deadwood

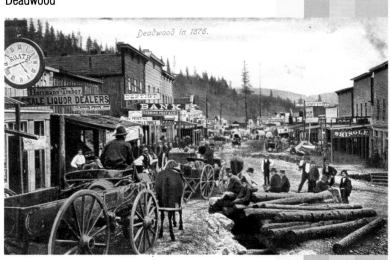

Postcard picturing a street scene in Deadwood, 1876. ©Bloom Bros.

Issue	Den.	Color	Mold	Inserts	Inlay	Rarity	GD30	VF65	CS95
76 RESTAURANT			**DEADWOOD**		**1989-91**				
1st	1.00	White	Plain	3blk	HS	R-4	10	20	30
	5.00	Red	Plain	3wht	HS	R-6	50	100	150
ANACONDA			**DEADWOOD**		**1990-94**				
1st	1.00	White	H&C	3blu3grn	R-white	R-4	5	10	15
	5.00	Red	H&C	3org3brn3gry	R-white	R-5	15	30	45
B.B. CODY' S			**DEADWOOD**		**1989-97**				
1st	1.00	Blue	Plain	3wht	HS	R-2	2	4	6
	5.00	Red	Plain	3wht	HS	R-4	5	10	15
(First issue has thin lettering. Second issue has thicker, wider lettering.)									
2nd	1.00	Blue	Plain	3wht	HS	R-2	2	4	6
	5.00	Red	Plain	3wht	HS	R-5	10	20	30
3rd	1.00	White	Plain	3blk	HS	R-3	3	6	9
4th	1.00	White	Chipco	None	FG	R-4	7	14	21
	5.00	Red	Chipco	None	FG	R-3	*	5	7
	25.00	Green	Chipco	None	FG	R-4	*	25	30
BAZELS			**DEADWOOD**		**1990-94**				
1st	5.00	Red	H&C	3trq3gry	HUB-white	R-5	25	50	75
BELLA UNION			**DEADWOOD**		**1989-94**				
1st	1.00	White	Plain	3blk	HS	R-2	2	4	6
	error 1.00	White	Plain	3blk	HS	R-9	100	200	300
(There is no printing on one side.)									
	5.00	Red	Plain	3wht	HS	R-3	3	6	9
2nd	1.00	White	H&C	3blu3grn3pnk	R-white	R-2	2	4	6
	5.00	Red	H&C	3grn	HUB-white	R-4	7	14	21
	25.00	Green	H&C	2wht2pnk	SCA-white	R-6	40	80	120

Issue	Den.	Color	Mold	Inserts	Inlay	Rarity	GD30	VF65	CS95

BLACKJACK — DEADWOOD — 1990-

Issue	Den.	Color	Mold	Inserts	Inlay	Rarity	GD30	VF65	CS95
1st	5.00	Red	H&C	3blk3tan3pur	HUB-white	R-2	*	5	7

(This chip is actually used in the First Gold Hotel.)

Blackjack $5 (1st)

BODEGA — DEADWOOD — 1990-

Issue	Den.	Color	Mold	Inserts	Inlay	Rarity	GD30	VF65	CS95
1st	1.00	White	BJ-2	4blu	COIN	R-2	*	1	2
	5.00	Red	BJ-2	4wht	COIN	R-3	*	5	7

BUFFALO SALOON — DEADWOOD — 1990-94

Issue	Den.	Color	Mold	Inserts	Inlay	Rarity	GD30	VF65	CS95
1st	1.00	White	Plain	3blk	HS	R-2	2	4	6
	5.00	Red	Plain	3wht	HS	R-4	9	18	27

Bullock Hotel $1 (2nd)

BULLOCK HOTEL — DEADWOOD — 1989-

Issue	Den.	Color	Mold	Inserts	Inlay	Rarity	GD30	VF65	CS95
1st	1.00	White	Plain	6blk	Paper Center	R-4	6	12	18
	5.00	Red	Plain	6wht	Paper Center	R-4	9	18	27
2nd	1.00	White	H&C	4pnk4pur	R-white	R-2	2	4	6
	5.00	Red	H&C	3grn3yel3org	HUB-white	R-3	3	6	9
3rd	1.00	White	Chipco	None	FG	R-2	*	1	2
	5.00	Red	Chipco	None	FG	R-3	*	5	7

BUTCH CASSIDY — DEADWOOD — 1990-94

Issue	Den.	Color	Mold	Inserts	Inlay	Rarity	GD30	VF65	CS95
1st	1.00	Cream	H&C	4grn4pur	R-white	R-3	4	8	12
	5.00	Red	H&C	3grn3wht3blu	HUB-white	R-4	10	20	30

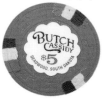

Butch Cassidy $5 (1st)

CALAMITY JANES — DEADWOOD — 1989-91

Issue	Den.	Color	Mold	Inserts	Inlay	Rarity	GD30	VF65	CS95
1st	1.00	White	Plain	6blk	Paper Center	R-4	7	14	21
	5.00	Red	Plain	6gry	Paper Center	R-4	9	18	27
2nd	1.00	White	H&C	3pur3olv	R-white	R-4	7	14	21
	5.00	Red	H&C	4grn4gry4org	HUB-white	R-5	15	30	45

CAPONES — DEADWOOD — 1990-91

Issue	Den.	Color	Mold	Inserts	Inlay	Rarity	GD30	VF65	CS95
1st	5.00	Red	H&C	6grn3gry	R-white	R-7	200	400	600

(This is unquestionably the rarest regular issue Deadwood chip and the key to the series.)

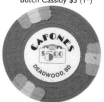

Capones $5 (1st)

CARRIE NATION'S TEMPERANCE SALOON, DEADWOOD — 1990-94

Issue	Den.	Color	Mold	Inserts	Inlay	Rarity	GD30	VF65	CS95
1st	1.00	White	H&C	4pnk4gry	R-white	R-2	2	4	6
	5.00	Red	H&C	3pnk3olv3blu	HUB-white	R-4	9	18	27
	25.00	Green	H&C	3grn3org3blu	SCA-white	R-4	*	25	30

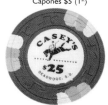

Casey's $25 (1st)

CASEY' S — DEADWOOD — 1990-94

Issue	Den.	Color	Mold	Inserts	Inlay	Rarity	GD30	VF65	CS95
1st	1.00	White	H&C	3pnk3olv	R-white	R-2	3	6	9
	5.00	Red	H&C	3yel3blk3grn	R-white	R-3	8	16	24
	25.00	Green	H&C	3pch3blu3gry	R-white	R-4	30	60	90

(Chipper Ford Jensen was allowed to view the chip inventory and confirmed that 200 $25 chips were ordered, and 192 remained in the safe of the Mineral Palace. Therefore, only 8 chips are in collector's hands and the casino absolutely will not sell any of the remaining 192 chips.)

COUSIN JACKS — DEADWOOD — 1990-94

Issue	Den.	Color	Mold	Inserts	Inlay	Rarity	GD30	VF65	CS95
1st	1.00	White	H&C	4org4blu	R-white	R-3	3	6	9
	5.00	Red	H&C	3org3blk3grn	HUB-white	R-4	10	20	30
	25.00	Green	H&C	3pch3blu3pur	SCA-white	R-4	30	60	90

(There are 2 boxes of chips retained by the casino owners who adamantly refuse to part with any. The actual number in collections would make the chip an R-10.)

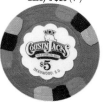

Cousin Jacks $5 (1st)

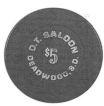

D.T. Saloon $5 (1st)

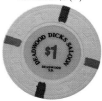

Deadwood Dick's $1 (2nd)

Deadwood Junction $5 (1st)

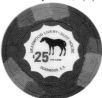

Deadwood Livery $25 (1st)

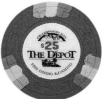

Depot error $25/$5 (1st)

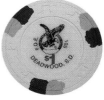

F.O.E. 105 (Eagles) $1 (1st)

Issue	Den.	Color	Mold	Inserts	Inlay	Rarity	GD30	VF65	CS95
D.T. SALOON/DAKOTA TERRITORY, DEADWOOD					**1989-**				
1st	1.00	White	BJ	None	HS	R-4	7	14	21
	5.00	Red	BJ	None	HS	R-5	15	30	45
2nd	1.00	White	H&C	3blu3pch	R-white	R-2	*	1	2
	5.00	Red	H&C	3lav3yel3grn	HUB-white	R-3	*	5	7

(The first issue is "D.T. Saloon," and the second issue is "Dakota Territory.")

DEADWOOD DICK'S			**DEADWOOD**		**1989-**				
1st	1.00	White	Mr. L	None	Paper Center	R-4	6	12	18
	5.00	Red	Mr. L	None	Paper Center	R-4	8	16	24
2nd	1.00	White	H&C	2grn2gry	R-white	R-2	1	2	3
	5.00	Red	H&C	3blu3org	HUB-white	R-3	4	8	12

DEADWOOD GULCH SALOON			**DEADWOOD**		**1990-94**				
1st	1.00	White	BJ-2	4gry	COIN	R-2	1	2	3
	5.00	Red	BJ-2	4gry	COIN	R-3	3	6	9

DEADWOOD GULCH RESORT			**DEADWOOD**		**1994-97**				
1st	1.00	White	H&C	4dkbrn4brn	R-white	R-2	1	2	3
	5.00	Red	H&C	4gry4ltblu4dkblu	R-white	R-3	3	6	9

DEADWOOD JUNCTION			**DEADWOOD**		**N/A**				
1st	1.00	White	H&C	4org4nvy	R-white	R-3	3	6	9
	5.00	Red	H&C	6org3nvy	HUB-white	R-4	5	10	15
	25.00	Green	H&C	3yel3nvy	SCA-white	R-5	15	30	45

(This casino never opened.)

DEADWOOD LIVERY			**DEADWOOD**		**1989-**				
1st	1.00	White	H&C	4grn4pnk	R-white	R-3	5	10	15
	5.00	Red	H&C	6wht3dkgrn	R-white	R-4	10	20	30
	25.00	Green	H&C	3pur3tan3pnk	R-white	R-5	25	50	75

(This casino has been open from the beginning as a slot house, but has never actually put in table games. The owner had chips made at one point, but has kept them and they are not available. These prices are what we think the chips would be worth if they come on the market.)

DEPOT			**DEADWOOD**		**1990-**				
1st	1.00	Cream	H&C	8pur4pnk	R-white	R-2	1	2	3
	5.00	Red	H&C	3olv3pnk3ltblu	R-white	R-3	*	5	7
	25.00	Green	H&C	3dkpnk3pur3pch	R-white	R-5	*	25	30
error	$25/$5	Red	H&C	3olv3pnk3ltblu	R-white	R-10	250	500	750

(This is probably the rarest of all Deadwood chips. Only two examples are known at present time, although it is possible that more exist. One side mistakenly has a $25 inlay. Deadwood gaming law mandates that all $5 chips be red, and any chips not of this color must be destroyed.)

F.O.E. 105 (EAGLES)			**DEADWOOD**		**1991-94**				
1st	1.00	Yellow	H&C	3pch3brn	R-white	R-3	3	6	9
	5.00	Red	H&C	3org3pur3yel	R-white	R-4	10	20	30

FOUR ACES			**DEADWOOD**		**1993-**				
1st	1.00	White	BJ-2	4blu	R-silver	R-2	1	2	3
	5.00	Red	BJ-2	12blk	R-silver	R-3	*	5	7
	25.00	Green	BJ-2		R-silver	R-4	*	25	30

(This chip's unusual in that it is current, but the management won't sell or use the chip on the tables!)

Issue	Den.	Color	Mold	Inserts	Inlay	Rarity	GD30	VF65	CS95
FRANKLIN HOTEL			**DEADWOOD**		**1989-**				
1st	1.00	White	H&C	None	R-white	R-2	1	2	3
	5.00	Red	H&C	2dkgrn2ltgrn	R-white	R-3	3	6	9
2nd	1.00	White	H&C	None	R-white	R-2	*	1	2

(The first issue has smaller letters and the stem points right; the second issue points left.)

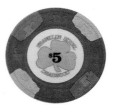
Franklin Hotel $5 (1st)

Issue	Den.	Color	Mold	Inserts	Inlay	Rarity	GD30	VF65	CS95
GOLD DUST			**DEADWOOD**		**1990-**				
1st	1.00	White	Chipco	None	FG	R-2	1	2	3
	5.00	Red	BJ-2	6yel	COIN	R-3	*	5	7

(This Bud Jones chip is only used for blackjack. All of the Chipcos are used for poker.)

	5.00	Red	Chipco	None	FG	R-3	*	5	7
	10.00	Blue	Chipco	None	FG	R-4	*	10	15
	25.00	Green	Chipco	None	FG	R-4	*	25	30
	100.00	Black	Chipco	None	FG	R-5	*	100	110
2nd	5.00	Maroon	Chipco	None	FG	R-2	*	5	7

("Black Hills Motor Classic, 58th Annual 1998".)

3rd	5.00	Maroon	Chipco	None	FG	R-2	*	5	7

("Black Hills Motor Classic, 59th Annual 1999".)

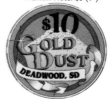
Gold Dust $10 (1st)

Issue	Den.	Color	Mold	Inserts	Inlay	Rarity	GD30	VF65	CS95
GOLD STREET			**DEADWOOD**		**1989-97**				
1st	1.00	White	Mr. L	None	Paper Center	R-4	7	15	30

(Hard to find with good printing.)

	5.00	Red	Mr. L	None	Paper Center	R-4	8	16	24
2nd	1.00	White	H&C	3blu3org	R-white	R-4	6	12	18
	5.00	Red	H&C	4pch4grn4pur	HUB-white	R-4	10	20	30
	25.00	Green	H&C	3yel3ltblu	SCA-white	R-5	20	40	60

Gold Street $25 (2nd)

Issue	Den.	Color	Mold	Inserts	Inlay	Rarity	GD30	VF65	CS95
GOLDBERG GAMING			**DEADWOOD**		**1990-98**				
1st	1.00	White	Chipco	None	FG	R-1	1	2	3

(Regular issue chip has "Big Jakes" on one side, "Soda Fountain" on the other.)

	error $1	("Big Jakes" on both sides.)			FG	R-7	75	150	225
	error $1	("Soda Fountain" on both sides.)			FG	R-7	75	150	225

(Between them both, there are exactly fifty total error chips - about 25 of each. The entire inventory was searched, so this count will not change.)

	5.00	Red	BJ-2	4wht	COIN	R-3	3	6	9
	10.00	Blue	Chipco	None	FG	R-4	6	13	20

Goldberg Gaming $1 (1st)

Issue	Den.	Color	Mold	Inserts	Inlay	Rarity	GD30	VF65	CS95
GOLDIGGERS			**DEADWOOD**		**1990-97**				
1st	1.00	White	Chipco	None	FG	R-1	1	2	3
	5.00	Red	Chipco	None	FG	R-1	3	6	9
	25.00	Green	Chipco	None	FG	R-1	10	20	30
	100.00	Black	Chipco	None	FG	R-4	35	70	105

(The entire inventory is for sale. Exactly 200 $100 chips were made.)

Goldiggers $1 (1st)

Issue	Den.	Color	Mold	Inserts	Inlay	Rarity	GD30	VF65	CS95
HICKOK HOUSE			**DEADWOOD**		**1990-94**				
1st	5.00	Red	H&C	3org3blk3grn	R-white	R-4	10	20	30
HICKOK'S			**DEADWOOD**		**1990-**				
1st	5.00	Red	Plain	3gry	HS	R-4	7	14	21
2nd	1.00	White	Chipco	None	FG	R-4	7	14	21
	5.00	Red	Chipco	None	FG	R-3	*	5	7
	25.00	Green	Chipco	None	FG	R-4	*	25	30

Hickok House $5 (1st)

313

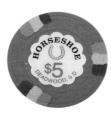

Horseshoe $5 (1st)

Last Chance Saloon $5 (1st)

Midnight Star $100 (2nd)

Nugget $5 (1st)

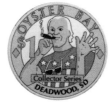

Oyster Bay $1 (1st)

Phatty Thompson's $5 (1st)

Issue	Den.	Color	Mold	Inserts	Inlay	Rarity	GD30	VF65	CS95
HORSESHOE			**DEADWOOD**		**1990-94**				
1st	1.00	White	H&C	4olv4pnk	R-white	R-4	10	20	30
	5.00	Red	H&C	3olv3pch3dkblu	HUB-white	R-4	15	30	45
JACKPOT CHARLEY' S			**DEADWOOD**		**1989-93**				
1st	1.00	White	BJ	None	HS	R-3	5	10	15
	error 1.00	White	BJ	None	HS	R-9	125	250	375
(As is the case with the Bella Union error, there is no printing on one side.)									
	5.00	Red	BJ	None	HS	R-5	20	40	60
LAST CHANCE SALOON			**DEADWOOD**		**1990-93**				
1st	5.00	Red	H&C	3pch3yel3ltgrn	HUB-white	R-4	10	20	30
LUCKY WRANGLER			**DEADWOOD**		**1989-97**				
1st	1.00	White	Plain	3blk	HS	R-2	2	4	6
	5.00	Red	Plain	3gry	HS	R-4	6	12	18
MIDNIGHT STAR			**DEADWOOD**		**1991-**				
1st	5.00	Brown	H&C	3wht	R-white	R-3	*	5	7
2nd	25.00	Green	H&C	4dkgrn4bei	R-white	R-4	*	25	30
	100.00	Black	H&C	4ltblu4gld	R-white	R-5	*	100	110
MISS KITTY' S			**DEADWOOD**		**1990-**				
1st	5.00	Red	H&C	3pch3org3tan	HUB-white	R-2	*	5	10
MOTHER LODE			**DEADWOOD**		**1990-95**				
1st	5.00	Red	H&C	4brn4blk4grn	R-white	R-3	*	5	7
	25.00	Green	H&C	3tur3yel3pur	R-white	R-4	*	25	30
NUGGET			**DEADWOOD**		**1990-91**				
1st	1.00	White	H&C	8red4pur	R-white	R-4	7	14	21
	5.00	Red	H&C	4pch4ltblu4grn	HUB-white	R-6	40	80	120
	25.00	Green	H&C	8lav4wht	SCA-white	R-10	150	300	450

(No quantity of these chips is known at present. No one knows whether these chips were destroyed by the former owners or retained. Only a couple pieces are in collections. In time, this may turn out to be the king of Deadwood chips. However, if a box appears, the value will become much more modest.)

Issue	Den.	Color	Mold	Inserts	Inlay	Rarity	GD30	VF65	CS95
OYSTER BAY			**DEADWOOD**		**1993-95**				
1st	1.00	White	Chipco	None	FG	R-2	*	2	4
	5.00	Red	Chipco	None	FG	R-3	*	7	10

(Until recently, these chips were available at The Fairmont Hotel. They are now all sold out.)

Issue	Den.	Color	Mold	Inserts	Inlay	Rarity	GD30	VF65	CS95
PEACOCK CLUB			**DEADWOOD**		**1989-96**				
1st	1.00	White	H&C	4brn4grn	R-white	R-3	*	1	2
	5.00	Red	H&C	3grn3yel3blu	HUB-white	R-4	*	5	7
PHATTY THOMPSON'S			**DEADWOOD**		**1990-91**				
1st	5.00	Red	H&C	4yel4olv4ltblu	HS	R-6	75	150	225
PINK PALACE			**DEADWOOD**		**1989-96**				
1st	1.00	White	H&C	4olv	HS	R-2	2	4	6
	5.00	Red	H&C	3pnk3grn3pur	HS	R-3	4	8	12

Issue	Den.	Color	Mold	Inserts	Inlay	Rarity	GD30	VF65	CS95
POKER ALICE			DEADWOOD		1989-91				
1st	1.00	White	Plain	3blk	HS	R-4	10	20	30
	5.00	Red	Plain	3gry	HS	R-6	75	150	225

Poker Alice $5 (1st)

Issue	Den.	Color	Mold	Inserts	Inlay	Rarity	GD30	VF65	CS95
PRAIRIE EDGE GAMING			DEADWOOD		1990-93				
1st	1.00	Grey	Diecar	None	R-white	R-3	3	6	9
	5.00	Red	BJ-2	6yel	COIN	R-5	15	30	45

Issue	Den.	Color	Mold	Inserts	Inlay	Rarity	GD30	VF65	CS95
SALOON NO. 10			DEADWOOD		1989-				
1st	1.00	White	H&C	3org3blu	R-white	R-1	*	1	2
	error 1.00	White	H&C	3org3blu	R-white	R-9	150	300	450

(One side of the inlay says "five" instead of one. A bored pit boss was looking through some chips and purely by accident, discovered the error. He then went through the entire casino inventory and found exactly 6 pieces. He kept one and the other five are now dispersed in collections.)

	5.00	Red	H&C	4lav4pnk	HUB-white	R-3	*	5	7

Saloon No. 10 error $1 (1st)

Issue	Den.	Color	Mold	Inserts	Inlay	Rarity	GD30	VF65	CS95
SILVERADO			DEADWOOD		1990-				
1st	5.00	Red	BJ-2	12ltgrn	COIN	R-2	*	5	7
2nd	25.00	Green	BJ-2	12wht	COIN	R-4	*	25	30

Issue	Den.	Color	Mold	Inserts	Inlay	Rarity	GD30	VF65	CS95
WILD BILL BAR			DEADWOOD		1989-				
1st	1.00	White	H&C	4yel	R-white	R-3	*	1	3
	5.00	Red	H&C	3ltblu3grn	HUB-white	R-3	*	5	10
	25.00	Green	H&C	4pnk4pch4lav	SCA-white	R-5	25	50	75

(A box exists, but the casino will not release any chips.)

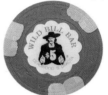

Wild Bill Bar $5 (1st)

Issue	Den.	Color	Mold	Inserts	Inlay	Rarity	GD30	VF65	CS95
WILD WEST			DEADWOOD		1996-				
WINNERS CLUB									
1st	1.00	White	Chipco	None	FG	R-1	*	1	2
	5.00	Red	Chipco	None	FG	R-2	*	5	7

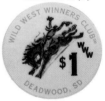

Wild West Winners $1 (1st)

Issue	Den.	Color	Mold	Inserts	Inlay	Rarity	GD30	VF65	CS95
WILDERNESS EDGE			DEADWOOD		1989-96				
1st	1.00	Grey	H&C	None	HS	R-2	1	2	3
	5.00	Red	H&C	4blu4grn	HS	R-3	3	6	9

(The above chips have no $ sign.)

2nd	1.00	Grey	H&C	None	HS	R-2	1	2	3

(These chips are in use at Miss Kitty's.)

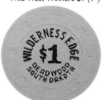

Wilderness Edge $1 (2nd)

Issue	Den.	Color	Mold	Inserts	Inlay	Rarity	GD30	VF65	CS95
WINDFLOWER			DEADWOOD		1989-90				
1st	5.00	Red	H&C	3nvy3tan3blu	HUB-white	R-6	50	100	150

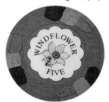

Windflower $5 rev (1st)

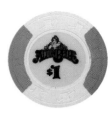

Alton Belle $1 (1st)

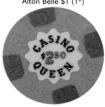

Casino Queen $2.50 (1st)

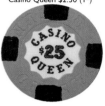

Casino Queen $25 (3rd)

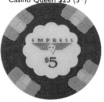

Empress $5 (1st)

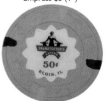

Grand Victoria 50c (1st)

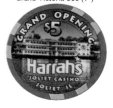

Harrah's Joliet $5 (2nd)

Illinois

Issue	Den.	Color	Mold	Inserts	Inlay	Rarity	GD30	VF65	CS95
ALTON BELLE			**ALTON**		**1991-**				
1st	1.00	White	H&C	2ltgrn	R-white	R-1	*	1	3
(Hair bun)									
	5.00	Red	H&C	4yel4brn	HUB-white	R-1	*	5	8
	25.00	Green	H&C	8lav	SCA-white	R-2	*	25	30
	100.00	Black	H&C	4org4yel	COG-white	R-2	*	100	110
2nd	1.00	White	H&C	2ltgrn	R-white	R-1	*	1	3
(No Hair bun)									
CASINO QUEEN			**EAST ST. LOUIS**		**1993-**				
1st	.50	Lt Yellow	House	4grn	NOT-white	R-4	5	10	20
	1.00	White	House	4ltblu	R-white	R-3	1	3	5
	2.50	Pink	House	4blu	SCA-white	R-4	10	20	40
	5.00	Red	House	4crm	HUB-white	R-3	5	10	15
	25.00	Green	House	4org	SCA-white	R-3	12	25	50
	100.00	Black	House	4pnk	COG-white	R-3	50	100	150
2nd	.50	Lt Yellow	House	4blk	NOT-white	R-3	1	3	6
3rd	.50	Yellow	House	4blu	NOT-white	R-2	*	1	2
	1.00	White	House	4gry	R-white	R-1	*	1	3
	5.00	Red	House	4crm	HUB-white	R-1	*	5	8
	25.00	Green	House	4nvy	SCA-white	R-1	*	25	30
	100.00	Black	House	4yel	COG-white	R-2	*	100	120
EMPRESS			**JOLIET**		**1992-**				
1st	1.00	White	H&C	3blu3gry3mar	R-white	R-1	*	1	3
	2.50	Pink	H&C	2lim	STAR-white	R-1	*	3	5
	5.00	Red	H&C	8lim4yel	HUB-white	R-1	*	5	8
	25.00	Green	H&C	4org	SCA-white	R-1	*	25	30
	100.00	Black	H&C	4brn4blu	COG-white	R-1	*	100	110

(All of the above chips come in long and short cane versions, with no effect on rarity or price. The short canes may have been the first to actually hit the tables.)

Issue	Den.	Color	Mold	Inserts	Inlay	Rarity	GD30	VF65	CS95
GRAND VICTORIA			**ELGIN**		**1994-**				
1st	.50	Tan	H&C	2org2dkgrn	STAR-white	R-4	2	4	8
	1.00	White	H&C	2ltblu2fch	HUB-white	R-1	*	1	3
	5.00	Red	H&C	4ltpur	OR-white	R-1	*	5	8
	25.00	Green	H&C	8lav	SCA-white	R-1	*	25	30
	100.00	Black	H&C	4grn4yel4org	COG-white	R-1	*	100	110
HARRAH'S			**JOLIET**		**1993-**				
1st	1.00	White	H&C	3ltpur3trq	R-white	R-1	*	1	3
	2.50	Pink	H&C	3dkgrn	STAR-white	R-1	*	3	5
	5.00	Red	H&C	6blu	HUB-white	R-1	*	5	8
	25.00	Green	H&C	3pnk3dkgrn	SCA-white	R-1	*	25	30
	100.00	Black	H&C	8pur4pch	COG-white	R-1	*	100	110
2nd	5.00	Red	H&C	6blu	OR-multi	R-3	*	5	10
("Grand Opening Southern Star II".)									
3rd	5.00	Red	H&C	6blu	OR-white	R-3	*	5	10
("Harrah's 60th Anniversary 1997".)									
4th	5.00	Red	H&C	6blu	OR-multi	R-3	*	5	10
("5th Anniversary 1993-1998".)									

Issue	Den.	Color	Mold	Inserts	Inlay	Rarity	GD30	VF65	CS95

HOLLYWOOD CASINO AURORA 1993-

Issue	Den.	Color	Mold	Inserts	Inlay	Rarity	GD30	VF65	CS95
1st	1.00	White	BJ-2	8lav	BJPI-white	R-1	*	1	3
	2.50	Dk Pink	BJ-2	4trq	BJPI-white	R-1	*	3	5
	5.00	Red	BJ-2	8blu	BJPI-white	R-1	*	5	8

(Pinkish tint. "Casino" in thicker writing.)

| | 5.00 | Red | BJ-2 | 8blu | BJPI-white | R-1 | * | 5 | 8 |

(More red in color. "Casino" in thinner writing.)

	25.00	Green	BJ-2	4blu	BJPI-white	R-1	*	25	30
	100.00	Black	BJ-2	8pnk	BJPI-white	R-1	*	100	110
2nd	1.00	White	BJ-2	8trq	BJPI-white	R-5	25	50	100
3rd	5.00	Red	BJ-2	8blu	BJPI-white	R-3	*	5	10

(5th Anniversary 1998.)

Hollywood Casino $2.50 (1st)

Hollywood Casino $5 (1st)

PAR - A - DICE PEORIA 1991-

Issue	Den.	Color	Mold	Inserts	Inlay	Rarity	GD30	VF65	CS95
1st	1.00	White	H&C	3red3pch	R-white	R-3	1	3	5
	2.50	Pink	H&C	3brn3wht	STAR-white	R-3	2	4	6

(Short canes only)

	5.00	Red	H&C	4ltpnk	HUB-white	R-3	3	6	12
	25.00	Green	H&C	4pch4org	SCA-white	R-3	12	25	50
	100.00	Black	H&C	8gld	COG-white	R-4	100	130	160

(All of the above come in long and short cane versions, except the $2.50.)

2nd	1.00	White	H&C	3pch3lav	OR-multi	R-1	*	1	3
	2.50	Pink	H&C	3brn3wht	STAR-multi	R-1	*	3	5
	5.00	Maroon	H&C	4ltpnk	HUB-multi	R-1	*	5	8
	25.00	Green	H&C	4pch4org	SCA-multi	R-1	*	25	30
	100.00	Black	H&C	8gld	COG-multi	R-1	*	100	110

Par-A-Dice $1 (1st)

PLAYERS RIVERBOAT METROPOLIS 1993-

Issue	Den.	Color	Mold	Inserts	Inlay	Rarity	GD30	VF65	CS95
1st	.50	Yellow	BJ-2	4grn	BJPI-white	R-5	20	40	80
	1.00	White	BJ-2	8blu	BJPI-white	R-4	5	10	20
	5.00	Red	BJ-2	3blu	BJPI-white	R-2	*	5	8
	25.00	Green	BJ-2	6yel	BJPI-white	R-2	*	25	30
	100.00	Black	BJ-2	4gry	BJPI-white	R-2	*	100	120
2nd	1.00	Tan	BJ-2	8brn	BJPI-white	R-2	*	1	3

Players Riverboat 50c (1st)

Players Riverboat $5 (1st)

Rock Island $1 (1st)

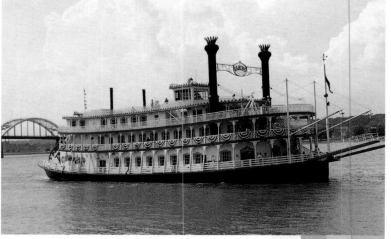

The Rock Island riverboat, cruising in the summer of 1994.

Rock Island $5 (1st)

Silver Eagle 50c (1st)

Argosy $5 (1st)

Aztar $5 (1st)

Aztar $25 (1st)

Caesars $1 (1st)

Issue	Den.	Color	Mold	Inserts	Inlay	Rarity	GD30	VF65	CS95
ROCK ISLAND			**ROCK ISLAND**		**1993-**				
1st	.50	Mustard	H&C	3nvy	NOT-white	R-2	*	1	2
	1.00	White	H&C	2red	R-white	R-1	*	1	3
	5.00	Red	H&C	4grn	HUB-white	R-1	*	5	8
	25.00	Green	H&C	8yel	SCA-white	R-2	*	25	30
	100.00	Black	H&C	4yel4pur	COG-white	R-2	*	100	120

(All of the above chips come in long and short cane versions, no effect on rarity or price.)

Issue	Den.	Color	Mold	Inserts	Inlay	Rarity	GD30	VF65	CS95
SILVER EAGLE			**E. DUBUQUE**		**1992-95/96-97**				
1st	.50	Mustard	BJ-2	4blu	BJPI-white	R-4	2	4	8
	1.00	Beige	BJ-2	3org	BJPI-white	R-4	2	4	8
	5.00	Red	BJ-2	6bei	BJPI-white	R-4	5	10	20
	25.00	Green	BJ-2	4lav	BJPI-white	R-4	25	50	100
	100.00	Black	BJ-2	6mar	BJPI-white	R-4	50	100	200

Indiana

Issue	Den.	Color	Mold	Inserts	Inlay	Rarity	GD30	VF65	CS95
ARGOSY			**LAWRENCEBURG**		**1996-**				
1st	.50	Yellow	H&C	1grn1pur	STAR-multi	R-1	*	1	2
	1.00	White	H&C	1grn1pur1bei	HUB-multi	R-1	*	1	3
	2.50	Pink	H&C	1grn1gld	NOT-multi	R-1	*	3	5
	5.00	Red	H&C	3pnk3grn	OR-multi	R-1	*	5	8
	25.00	Green	H&C	4pnk4lim4brn	SCA-multi	R-1	*	25	30
	100.00	Black	H&C	4lav4gry4pnk	COG-multi	R-1	*	100	110

(These chips are marked "Indiana Gaming Company, L.P." There exists another set, not covered in this text, with all chips heavily cancelled, marked "Argosy Casino." However, these chips were not approved and never actually used because the insurance giant Conseco owns a large percentage of the operation under the Indiana Gaming Co. L.P. banner.)

Issue	Den.	Color	Mold	Inserts	Inlay	Rarity	GD30	VF65	CS95
AZTAR			**EVANSVILLE**		**1995-**				
1st	1.00	White	H&C	4pur	NOT-white	R-1	*	1	3
	2.50	Pink	H&C	2ltorg2dkgrn	TRI-white	R-1	*	3	5
	5.00	Red	H&C	2blu2grn	OR-white	R-1	*	5	8
	5.00	Red	H&C	2blu2grn	OR-multi	R-2	*	5	10
("Grand Opening December 1995".)									
	25.00	Green	H&C	4blu4pur	HEX-white	R-1	*	25	30
	100.00	Black	H&C	6gry6ltblu	COG-white	R-1	*	100	110

Issue	Den.	Color	Mold	Inserts	Inlay	Rarity	GD30	VF65	CS95
BLUE CHIP			**MICHIGAN CITY**		**1997-**				
1st	1.00	White	H&C	1pur 1dkgrn	HEX-multi	R-1	*	1	3
	2.50	Pink	H&C	1red1grn	STAR-multi	R-1	*	3	5
	5.00	Red	H&C	4org4nvy	OR-multi	R-1	*	5	8
	5.00	Red	H&C	4org4nvy	OR-multi	R-1	*	5	10
("Grand Opening, Fall 1997".)									
	25.00	Green	H&C	4red4ltpur	NOT-multi	R-1	*	25	30
	100.00	Black	H&C	3red3org3pnk	4SAW-multi	R-1	*	100	110

Issue	Den.	Color	Mold	Inserts	Inlay	Rarity	GD30	VF65	CS95
CAESAR'S			**HARRISON COUNTY**		**1998-**				
1st	1.00	White	Chipco	None	FG	R-1	*	1	3
	2.50	Pink	Chipco	None	FG	R-1	*	3	5
	5.00	Red	Chipco	None	FG	R-1	*	5	7
	5.00	Red	Chipco	None	FG	R-1	*	5	7

("1998 Grand Opening".)

Issue	Den.	Color	Mold	Inserts	Inlay	Rarity	GD30	VF65	CS95
	20.00	Yellow	Chipco	None	FG	R-1	*	20	25
	25.00	Green	Chipco	None	FG	R-1	*	25	30
	100.00	Black	Chipco	None	FG	R-1	*	100	110

Caesars $20 rev (1st)

EMPRESS — HAMMOND — 1996-

Issue	Den.	Color	Mold	Inserts	Inlay	Rarity	GD30	VF65	CS95
1st	1.00	White	H&C	2red2blu	HUB-white	R-1	*	1	3
	5.00	Red	H&C	3blu3pnk	OR-white	R-1	*	5	8
	25.00	Green	H&C	4grn4red	SCA-white	R-1	*	25	30
	100.00	Black	H&C	6grn6lav	COG-white	R-1	*	100	110
2nd	2.50	Pink	H&C	1grn1gld	TRI-multi	R-1	*	3	5
	5.00	Red	H&C	3blu3pnk	OR-multi	R-2	*	5	10

("Happy New Year 1997".)

| 3rd | 5.00 | Red | H&C | 3blu3pnk | OR-multi | R-2 | * | 5 | 10 |

("1st Anniversary June 26, 1997".)

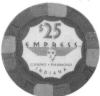

Empress $25 (1st)

GRAND VICTORIA — RISING SUN — 1996-

Issue	Den.	Color	Mold	Inserts	Inlay	Rarity	GD30	VF65	CS95
1st	1.00	White	H&C	1grn1tan	HUB-multi	R-1	*	1	3
	2.50	Pink	H&C	1tan1lim	TRI-multi	R-1	*	3	5
	5.00	Red	H&C	2lim2lav	OR-multi	R-1	*	5	8
	25.00	Green	H&C	8yel4gld	SCA-multi	R-1	*	25	30
	100.00	Black	H&C	4blu4pnk4lim	COG-multi	R-1	*	100	110
2nd	5.00	Red	H&C	2grn2ltpnk	OR-multi	R-6	25	50	100

(Used for about a week in May 1998.)

Grand Victoria $1 (1st)

HARRAH'S — E. CHICAGO — 1999-

Issue	Den.	Color	Mold	Inserts	Inlay	Rarity	GD30	VF65	CS95
1st	1.00	White	H&C	2pnk2trq	TRI-multi	R-1	*	1	3
	2.50	Pink	H&C	2blk2tan	STAR-multi	R-1	*	3	5
	5.00	Red	H&C	2nvy2ltgrn	OR-multi	R-1	*	5	8
	5.00	Red	H&C	2nvy2ltgrn	OR-multi	R-2	*	5	10

("Grand Opening March 1999.")

| | 25.00 | Green | H&C | 4org4lav | OCT-multi | R-1 | * | 25 | 30 |
| | 100.00 | Black | H&C | 3lav3wht3gry | LHUB-multi | R-1 | * | 100 | 110 |

Majestic Star $5 (1st)

MAJESTIC STAR — GARY — 1996-

Issue	Den.	Color	Mold	Inserts	Inlay	Rarity	GD30	VF65	CS95
1st	1.00	White	H&C	2org2nvy	NOT-white	R-1	*	1	3
	2.50	Pink	H&C	1pur1brn	TRI-white	R-1	*	3	5
	5.00	Red	H&C	3blu3ltyel	OR-white	R-1	*	5	8
	5.00	Red	H&C	3blu3ltyel	OR-white	R-2	*	5	10

("Grand Opening".)

| | 25.00 | Green | H&C | 4mar4gry4pnk | HEX-white | R-1 | * | 25 | 30 |
| | 100.00 | Black | H&C | 4pnk4gld4lim | WHL-white | R-1 | * | 100 | 110 |

Majestic Star $25 (1st)

SHOWBOAT — E. CHICAGO — 1997-99

Issue	Den.	Color	Mold	Inserts	Inlay	Rarity	GD30	VF65	CS95
1st	1.00	White	H&C	2pnk2ltgrn	HUB-multi	R-3	2	4	8
	5.00	Red	H&C	2nvy2grn	OR-multi	R-3	3	6	12
	5.00	Red	H&C	2nvy2grn	OR-multi	R-3	5	10	20

("Grand Opening Spring '97".)

| | 25.00 | Green | H&C | 4pnk4lav | SCA-multi | R-3 | 12 | 25 | 50 |
| | 100.00 | Black | H&C | 3gry3wht3mar | COG-multi | R-3 | 50 | 100 | 150 |

(Became Harrah's in 1999.)

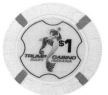

Majestic Star $1 (1st)

TRUMP — GARY — 1996-

Issue	Den.	Color	Mold	Inserts	Inlay	Rarity	GD30	VF65	CS95
1st	1.00	White	H&C	2org2gld	NOT-white	R-1	*	1	3
	2.50	Pink	H&C	1grn1nvy	TRI-white	R-1	*	3	5

Trump $1 (1st)

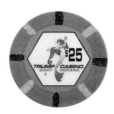

Trump $25 (1st)

Ameristar $2.50 (1st)

Ameristar $5 (1st)

Belle of Sioux City $1 (1st)

Catfish Bend $2.50 (1st)

Issue	Den.	Color	Mold	Inserts	Inlay	Rarity	GD30	VF65	CS95
	5.00	Red	H&C	2ltblu2dkblu	OR-white	R-1	*	5	8
	25.00	Green	H&C	4brn4ltblu	HEX-white	R-1	*	25	30
	100.00	Black	H&C	6org6lav	WHL-white	R-1	*	100	110

Iowa

AMERISTAR			COUNCIL BLUFFS		1996-				
1st	1.00	White	BJ-2	4pur	R-white	R-1	*	1	3
	2.50	Pink	BJ-2	4trq	R-white	R-1	*	3	5
	5.00	Red	BJ-2	4yel	R-white	R-1	*	5	8
	5.00	Red	H&C	4yel	OR-multi	R-2	*	5	10
("Grand Opening 1996.")									
	5.00	Red	H&C	4yel	OR-multi	R-3	5	10	15
("Iowa 150th Anniversary.")									
	25.00	Green	BJ-2	8bei	R-white	R-1	*	25	30
	100.00	Black	BJ-2	16red8wht	R-white	R-1	*	100	110
2nd	5.00	Red	H&C	4yel	OR-multi	R-2	*	5	10
("1st Anniversary.")									
3rd	5.00	Red	H&C	4yel	OR-multi	R-2	*	5	10
("2nd Anniversary Jan. 19, 1998".)									
4th	5.00	Red	H&C	8nvy	OR-multi	R-2	*	5	8
("3rd Anniversary Series. 4 different chips: Ruth Anne Dodge; Dodge House; Lincoln Monument, and Lewis & Clark.)									

BELLE OF SIOUX CITY			SIOUX CITY		1994-				
1st	1.00	White	H&C	1lav1yel 1blu	R-black	R-1	*	1	3
	2.50	Pink	H&C	1yel 1ltgrn	R-black	R-1	*	3	5
	5.00	Red	H&C	4pch4ltblu	R-black	R-1	*	5	8
	25.00	Green	H&C	8ltgrn	R-black	R-1	*	25	30
	100.00	Black	H&C	6pnk6ltblu	R-black	R-2	*	100	120
2nd	5.00	Red	Chipco	None	FG	R-2	*	5	10
("Rivercade 1998".)									

CATFISH BEND			FORT MADISON		1994-				
1st	.50	Yellow	H&C	None	HS	R-1	*	1	2
	1.00	White	H&C	2yel2pur	OR-green	R-1	*	1	3
	2.50	Pink	H&C	1ltblu1trq	OR-multi	R-2	2	4	8
(No longer in use, but still available at the cage.)									
	5.00	Red	H&C	2bei2lav	OR-multi	R-1	*	5	8
	5.00	Red	H&C	2bei2lav	OR-multi	R-2	*	5	10
("Grand Opening 1994.")									
	25.00	Green	H&C	8bei4nvy	OR-multi	R-1	*	25	30
	100.00	Black	H&C	4grn4pch	OR-multi	R-2	*	100	120
(This riverboat docks in Fort. Madison from Nov. to April and in Burlington from May to Oct.)									

DIAMOND JO CASINO			DUBUQUE		1992-				
1st	.50	Yellow	H&C	None	HS	R-1	*	1	2
	1.00	Beige	H&C	2grn2trq2pur	OR-white	R-1	*	1	3
	5.00	Red	H&C	3pur3grn	OR-white	R-3	5	10	15
	25.00	Green	H&C	8wht4trq	OR-white	R-1	*	25	30
	100.00	Black	H&C	3org3pnk3gry	OR-white	R-2	*	100	120
2nd	.25	Navy	H&C	None	HS	R-4	3	6	12
	5.00	Red	H&C	3pur3grn	OR-white	R-1	*	5	8

Diamond Jo Casino 50c (1st)

Issue	Den.	Color	Mold	Inserts	Inlay	Rarity	GD30	VF65	CS95
DIAMOND LADY			**BETTENDORF**		**1991-93**				
1st	1.00	White	H&C	2org2gry	R-white	R-4	5	10	20
	2.50	Pink	H&C	2ltblu	R-white	R-5	12	25	50
	2.50	Pink	H&C	2bei	R-white	R-9	50	100	200

(4 known. These were backup chips used in training school. It is possible that more exist, but no new specimens have appeared recently.)

Issue	Den.	Color	Mold	Inserts	Inlay	Rarity	GD30	VF65	CS95
	5.00	Red	H&C	4org4tan	HUB-white	R-4	12	25	50
	25.00	Green	H&C	3lim3ltgrn	SCA-white	R-7	50	100	200

(This set is marked "Steamboat, Casino River Cruises," with no location given. Long and short cane versions exist for this set.)

Diamond Lady $2.50 (1st)

Issue	Den.	Color	Mold	Inserts	Inlay	Rarity	GD30	VF65	CS95
DUBUQUE CASINO BELLE			**DUBUQUE**		**1991-93**				
1st	.50	Yellow	H&C	None	HS	R-4	5	10	20
	1.00	White	H&C	2pnk2nvy	R-white	R-4	5	10	20
	5.00	Red	H&C	3blu3wht	HUB-white	R-4	10	20	40
	25.00	Green	H&C	8lav	SCA-white	R-4	20	40	80
	100.00	Black	H&C	4grn4pnk	COG-white	R-4	25	50	100

(The above set exists in both long and short cane versions- except for the $100 which has short canes only.)

Dubuque Casino Belle $100 (1st)

Issue	Den.	Color	Mold	Inserts	Inlay	Rarity	GD30	VF65	CS95
2nd	5.00	Red	Chipco	None	FG-multi	R-4	10	20	40

("New Year 1992".)

Issue	Den.	Color	Mold	Inserts	Inlay	Rarity	GD30	VF65	CS95
3rd	1.00	White	H&C	None	HS	R-4	5	10	20

("$1.00" Short canes.)

Issue	Den.	Color	Mold	Inserts	Inlay	Rarity	GD30	VF65	CS95
4th	1.00	White	H&C	None	HS	R-4	5	10	20

("$1" Long and short canes exist.)

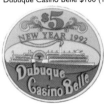

Dubuque Casino Belle $5 (2nd)

Issue	Den.	Color	Mold	Inserts	Inlay	Rarity	GD30	VF65	CS95
EMERALD LADY			**BURLINGTON**		**1994-95**				
1st	1.00	White	H&C	2org2gld	R-white	R-4	5	10	20
	2.50	Pink	H&C	2trq	R-white	R-5	12	25	50
	5.00	Red	H&C	4org4ltgrn	HUB-white	R-5	15	30	60
	25.00	Green	H&C	3fch3ltblu	SCA-white	R-7	75	150	250

(This set is also marked "Steamboat, Casino River Cruises," with no location given.)

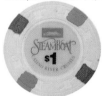

Emerald lady $1 (1st)

Issue	Den.	Color	Mold	Inserts	Inlay	Rarity	GD30	VF65	CS95
HARVEY'S			**COUNCIL BLUFFS**		**1996-**				
1st	1.00	White	H&C	2pnk2brn	OR-multi	R-1	*	1	3
	2.50	Pink	H&C	1tan1brn	OR-multi	R-1	*	3	5
	5.00	Red	H&C	3pch3grn	OR-multi	R-1	*	5	8
	25.00	Green	H&C	4red4gry	OR-multi	R-1	*	25	30
	100.00	Black	H&C	3grn3lim3gry	OR-multi	R-1	*	100	110
2nd	5.00	Red	Chipco	None	FG	R-2	*	5	10

("First Anniversary".)

Issue	Den.	Color	Mold	Inserts	Inlay	Rarity	GD30	VF65	CS95
3rd	5.00	Red	Chipco	None	FG	R-2	*	5	10

(Bill Cosby.)

Issue	Den.	Color	Mold	Inserts	Inlay	Rarity	GD30	VF65	CS95
4th	5.00	Red	Chipco	None	FG	R-2	*	5	10

("2nd Anniversary 1998".)

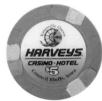

Harvey's $5 (1st)

Issue	Den.	Color	Mold	Inserts	Inlay	Rarity	GD30	VF65	CS95
LADY LUCK			**BETTENDORF**		**1995-**				
1st	1.00	White	Chipco	None	FG	R-3	2	4	8

(Linen finish.)

Issue	Den.	Color	Mold	Inserts	Inlay	Rarity	GD30	VF65	CS95
	1.00	White	Chipco	None	FG	R-3	2	4	8

(Satin finish. Checkerboard field is different.)

Issue	Den.	Color	Mold	Inserts	Inlay	Rarity	GD30	VF65	CS95
	1.00	White	Chipco	None	FG	R-1	*	1	3

("Roger Craig's Sports Bar".)

Issue	Den.	Color	Mold	Inserts	Inlay	Rarity	GD30	VF65	CS95
	5.00	Red	Chipco	None	FG	R-1	*	5	8

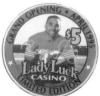

Lady Luck $5 (1st)

321

Lady Luck $25 (1st)

Issue	Den.	Color	Mold	Inserts	Inlay	Rarity	GD30	VF65	CS95
("Grand Opening 1995.")									
	25.00	Green	Chipco	None	FG	R-1	*	25	30
	100.00	Black	Chipco	None	FG	R-1	*	100	110
2nd	5.00	Red	BJ-2	16wht8gry	OR-multi	R-2	*	5	10
("Roger Craig's Sports Bar. 2nd Anniversary November 23, 1997".)									
3rd	5.00	Red	BJ-2	16wht8org	OR-multi	R-2	*	5	10
("Hotel Grand Opening September 1998".)									
4th	5.00	Red	BJ-2	12blk8wht	OR-multi	R-2	*	5	10
("Roger Craig's Sports Bar. 3rd Anniversary November 23, 1998".)									

Miss Marquette $1 (1st)

MISS MARQUETTE			MARQUETTE		1994-				
1st	1.00	Beige	H&C	2yel2lav	R-white	R-1	*	1	3
	5.00	Red	H&C	3blu3grn	R-white	R-1	*	5	8
	25.00	Green	H&C	8pnk4dkgry	R-white	R-1	*	25	30
	100.00	Black	H&C	4grn4lav	R-white	R-2	*	100	120
2nd	.25	Navy	H&C	None	HS	R-3	2	4	8
	2.50	Pink	H&C	1gld1grn	R-white	R-1	*	3	5

Mississippi Belle II $1 (1st)

MISSISSIPPI BELLE II			CLINTON		1993-				
1st	.25	Brown	H&C	None	HS	R-3	2	4	8
("MBII" on one side, "25c" on the other.)									
	.50	Blue	BJ-H	None	HS-gold	R-1	*	1	2
	.50	Blue	BJ-H	None	HS-silver	R-1	*	1	2
	1.00	White	H&C	None	HS	R-1	*	1	3
(Space between "MB" and "II". Short canes only.)									
	1.00	White	H&C	None	HS	R-1	*	1	3
(No space between "MB" and "II". Long and short canes.)									
	2.50	Pink	BJ-2	16dkpnk	COIN	R-1	*	3	5
	5.00	Red	BJ-2	8yel	COIN	R-1	*	5	8
	25.00	Green	BJ-2	4wht	COIN	R-1	*	25	30
	100.00	Black	BJ-2	8lav	COIN	R-2	*	100	120

Mississippi Belle II $5 (1st)

PRESIDENT			DAVENPORT		1991-				
1st	.25	Navy	H&C	None	HS	R-3	2	5	10
(Thin letters.)									
	1.00	White	H&C	2tan2dkbrn	R-white	R-2	1	3	5
	5.00	Red	H&C	3wht3nvy	HUB-white	R-2	*	5	8
	5.00	Red	Chipco	None	FG-multi	R-4	6	12	25
("Grand Opening 1991".)									
	25.00	Green	H&C	4org4ltyel	SCA-white	R-1	*	25	35
	100.00	Black	H&C	4pch4ltblu	COG-white	R-2	*	100	120
2nd	.25	Navy	H&C	None	HS	R-2	1	3	5
(Thick letters.)									
	1.00	White	H&C	2tan2dkbrn	OR-white	R-1	*	1	3
("President" has blue box background, marked 'Davenport, Iowa'.)									
3rd	1.00	White	H&C	2tan2dkbrn	OR-white	R-1	*	1	3
("Davenport, IA".)									
	5.00	Red	H&C	3wht3blu	HUB-white	R-1	*	5	8

President $5 (1st)

Sioux City Sue $5 (1st)

SIOUX CITY SUE			SIOUX CITY		1993-94				
1st	.50	Dk Yellow	BJ-2	4blu	R-white	R-6	5	10	20
	1.00	Beige	BJ-2	3grn	R-white	R-4	3	6	12
	5.00	Red	BJ-2	6yel	R-white	R-4	5	10	20
	5.00	Red	Chipco	None	FG-multi	R-5	10	20	40

Issue	Den.	Color	Mold	Inserts	Inlay	Rarity	GD30	VF65	CS95
	25.00	Green	BJ-2	4org	R-white	R-6	50	100	150

(Originally, Iowa had a $5 limit on all bets. The Sioux City Sue closed before the limits were raised, explaining the lack of a $100 chip.)

Louisiana

Bally's $1 (1st)

ARGOSY			**BATON ROUGE**		**1999-**				
1st	1.00	White	Chipco	None	FG	R-1	*	1	3
	5.00	Red	Chipco	4yel	FG	R-1	*	5	8
	25.00	Green	Chipco	5red	FG	R-1	*	25	30
	100.00	Black	Chipco	4yel4red	FG	R-1	*	100	110

(Formerly the Belle of Baton Rouge.)

Bally's $2.50 (1st)

BALLY' S			**NEW ORLEANS**		**1995-**				
1st	1.00	White	H&C	2blu2gld	OR-multi	R-1	*	1	3
	2.50	Pink	H&C	1ltyel1pur	OR-multi	R-1	*	3	5
	5.00	Red	H&C	4lav4crm4trq	OR-multi	R-1	*	5	8
	25.00	Green	H&C	4org4blu	OR-multi	R-1	*	25	30
	100.00	Black	H&C	?	OR-multi	R-1	*	100	110

BELLE OF BATON ROUGE			**BATON ROUGE**		**1994-99**				
1st	1.00	White	H&C	2grn2ltyel	OR-white	R-2	1	3	5
	5.00	Red	H&C	4gry4yel	OR-white	R-2	3	6	10
	25.00	Green	H&C	4ltpur4pnk	OR-white	R-3	10	25	40
	100.00	Black	H&C	3org3tan	OR-white	R-3	50	100	150
2nd	5.00	Red	H&C	4gry4yel	OR-multi	R-2	5	10	15

("4th Anniversary".)

3rd	25.00	Green	H&C	4ltpur4pnk	OR-multi	R-2	10	20	35

("New Year's '99".)

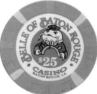

Belle of Baton Rouge $25 (1st)

BOOMTOWN BELLE			**HARVEY**		**1994-**				
1st	1.00	White	H&C	2lav2blu	OR-multi	R-2	*	1	3
	2.50	Lt Blue	H&C	1blu1pur1bei	OR-multi	R-2	*	3	5
	5.00	Red	H&C	4nvy4yel4ltblu	OR-multi	R-2	*	5	8
	25.00	Green	H&C	4brn4yel	OR-multi	R-2	*	25	30
	100.00	Black	H&C	4yel4wht	OR-multi	R-3	100	125	150

(1st issue pictures a stagecoach.)

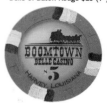

Boomtown Belle $5 (1st)

2nd	5.00	Red	Chipco	None	FG	R-3	5	10	20

("First Anniversary, August 1995".)

3rd	1.00	White	H&C	2lav2blu	OR-multi	R-1	*	1	3
	2.50	Lt Blue	H&C	1blu1pur1bei	OR-multi	R-1	*	3	5
	5.00	Red	H&C	4nvy4yel4ltblu	OR-multi	R-1	*	5	8
	25.00	Green	H&C	4brn4yel	OR-multi	R-1	*	25	30
	100.00	Black	H&C	4yel4wht	OR-multi	R-1	*	100	110

(3rd issue pictures a riverboat.)

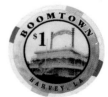

Boomtown Belle $1 (3rd)

CASINO MAGIC			**BOSSIER CITY**		**1996-**				
1st	1.00	White	BJ-2	3blu	OR-white	R-1	*	1	3
	2.50	Pink	BJ-2	4red	OR-white	R-1	*	3	5
	5.00	Red	BJ-2	6yel	OR-white	R-1	*	5	8
	5.00	Red	BJ-2	6yel	OR-white	R-1	*	5	8

(Same as above, but has grooves around the edges.)

	25.00	Green	BJ-2	8wht	OR-white	R-1	*	25	30

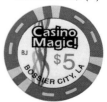

Casino Magic $5 (1st)

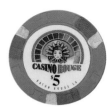

Casino Rouge $5 (1st)

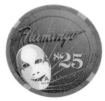

Flamingo $25 (1st)

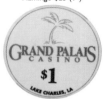

Grand Palais $1 (1st)

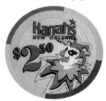

Harrah's NO $2.50 (1st)

Harrah's NO $5 (1st)

Harrah's NO $25 (1st)

Issue	Den.	Color	Mold	Inserts	Inlay	Rarity	GD30	VF65	CS95
	100.00	Black	BJ-2	?	OR-white	R-1	*	100	110
2nd	5.00	Red	BJ-2	8yel	OR-multi	R-2	*	5	10
("Millenium Series. 10 chips, one for each decade in the 1900's.)									

CASINO ROUGE — BATON ROUGE 1994-

	Den.	Color	Mold	Inserts	Inlay	Rarity	GD30	VF65	CS95
1st	1.00	White	H&C	2mar2blu	OR-white	R-1	*	1	3
	2.50	Pink	H&C	1gry1yel	OR-white	R-1	*	3	5
	5.00	Red	H&C	3blu3mar3yel	OR-white	R-1	*	5	8
	25.00	Green	H&C	2pch2gry	OR-white	R-1	*	25	30
	100.00	Black	H&C	4org4bei	OR-white	R-1	*	100	120

FLAMINGO — NEW ORLEANS 1994-97

	Den.	Color	Mold	Inserts	Inlay	Rarity	GD30	VF65	CS95
1st	1.00	White	H&C	1dkpnk1blu	OR-multi	R-2	1	3	5
	5.00	Red	H&C	1grn1lav1org	OR-multi	R-2	5	8	10
	25.00	Green	H&C	4pnk	OR-multi	R-2	25	35	50
	100.00	Black	H&C	2grn2pur	OR-multi	R-3	50	100	150

GRAND PALAIS — LAKE CHARLES 1996-

	Den.	Color	Mold	Inserts	Inlay	Rarity	GD30	VF65	CS95
1st	1.00	White	Chipco	2blu	FG	R-1	*	1	3
	2.50	Pink	Chipco	4wht	FG	R-1	*	3	5
	5.00	Red	Chipco	12yel	FG	R-1	*	5	8
	5.00	Red	Chipco	12yel	FG	R-2	*	5	10
("Grand Opening 1996".)									
	25.00	Green	Chipco	10wht5yel	FG	R-1	*	25	30
	100.00	Black	Chipco	?	FG	R-1	*	100	110

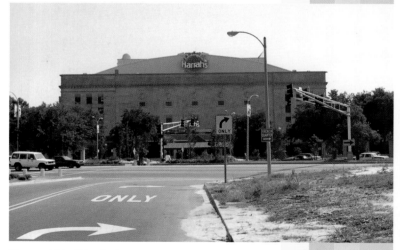

The original ill-fated Harrah's, shortly after opening.

HARRAH'S — NEW ORLEANS 1995-95/1999-

	Den.	Color	Mold	Inserts	Inlay	Rarity	GD30	VF65	CS95
1st	1.00	White	H&C	2org2tan	OR-multi	R-1	*	1	3
	2.50	Pink	H&C	1mar1dkgry	OR-multi	R-1	*	3	5
	5.00	Red	H&C	4grn4blu4yel	OR-multi	R-1	*	5	8
	5.00	Red	H&C	4grn4blu4yel	OR-multi	R-3	10	20	40
("Grand Opening 1995".)									
	25.00	Green	H&C	4nvy4pnk	OR-multi	R-1	*	25	30

Issue	Den.	Color	Mold	Inserts	Inlay	Rarity	GD30	VF65	CS95
	100.00	Black	H&C	8grn4lav	OR-multi	R-1	*	100	110

(Harrah's is actually a land-based casino - the only one permitted by law in Louisiana, except for Indian casinos. Harrah's finally reopened this long-closed, ill-fated casino in October 1999, after a four year delay. They are using the same rack of chips previously issued in 1995, except for the 1995 Grand Opening chip.)

Harrah's SHR $5 (1st)

HARRAH'S			**SHREVEPORT**		**1994-**				
1st	1.00	White	H&C	1pur1grn1pch	OR-multi	R-2	1	3	5
	2.50	Pink	H&C	4yel4brn	OR-multi	R-2	2	4	8

(Light inlay.)

	2.50	Pink	H&C	4yel4brn	OR-multi	R-2	2	4	8

(Dark inlay.)

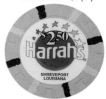

Harrah's SHR $2.50 (2nd)

	5.00	Red	H&C	8wht4pnk	OR-multi	R-2	5	8	10
	5.00	Red	H&C	8wht4pnk	OR-multi	R-2	5	8	10

(Bigger inlay and dated 1994.)

	25.00	Green	H&C	4ltorg4dkpnk	OR-multi	R-1	*	25	35
	100.00	Black	H&C	4org4pnk	OR-multi	R-2	*	100	120

(1st set pictures a rose.)

2nd	1.00	White	H&C	1pur1grn1pch	OR-white	R-1	*	1	3
	2.50	Pink	H&C	4yel4brn	OR-white	R-1	*	3	5
	5.00	Red	H&C	8wht4pnk	OR-white	R-1	*	5	8

("60th Anniversary 1997".)

	100.00	Black	H&C	4org4pnk	OR-white	R-1	*	100	110

(2nd set pictures the Harrah's logo.)

3rd	5.00	Red	H&C	8wht4pnk	OR-white	R-2	*	5	10

("Harrah's 5th Anniversary." Picture of A.J. Foyt.)

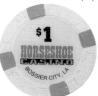

Horseshoe $1 (1st)

	100.00	Black	H&C	8wht4pnk	OR-white	R-5	*	*	150

(All of these chips were put in paperweights and given away to premium players. According to a cage employee, 100 were made, but verification has not been positive.)

HORSESHOE			**BOSSIER CITY**		**1995-**				
1st	1.00	White	H&C	2gry2ltgrn	OR-white	R-1	*	1	3

(Smooth inlay.)

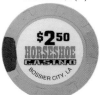

Horseshoe $2.50 (1st)

	1.00	White	H&C	2gry2ltgrn	OR-white	R-1	*	1	3

(Textured inlay.)

	2.50	Pink	H&C	1pur1lim	OR-white	R-1	*	3	5
	5.00	Red	H&C	8blu4yel	OR-white	R-1	*	5	8
	25.00	Green	H&C	4red4org	OR-white	R-1	*	25	30
	100.00	Black	H&C	3pnk3org	OR-white	R-1	*	100	110

ISLE OF CAPRI			**BOSSIER CITY**		**1994-**				
1st	1.00	White	H&C	1pch1mar1blu	OR-white	R-1	*	1	3

(Small red feathers.)

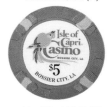

Isle of Capri BC $5 (1st)

	1.00	White	H&C	1pch1mar1blu	OR-white	R-1	*	1	3

(Large red feathers.)

	2.50	Pink	H&C	4grn4lav	OR-white	R-1	*	3	5

(Small red feathers.)

	2.50	Pink	H&C	4grn4lav	OR-white	R-1	*	3	5

(Large red feathers.)

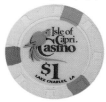

Isle of Capri LC $1 (1st)

	5.00	Red	H&C	8blu4ltblu	OR-white	R-1	*	5	8
	25.00	Green	H&C	4ltblu4org	OR-white	R-1	*	25	35
	100.00	Black	H&C	?	OR-white	R-1	*	100	120
2nd	5.00	Red	H&C	8blu4ltblu	OR-white	R-2	5	10	15

("Stephens vs. Hughes, Oct 26, 1994".)

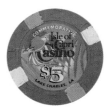

Isle of Capri LC $5 (1st)

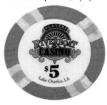

Players $5 (1st)

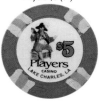

Players $5 (4th)

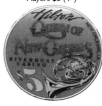

Queen of New Orleans $5 (1st)

River City GP $5 (1st)

River City CCQ $5 (2nd)

Issue	Den.	Color	Mold	Inserts	Inlay	Rarity	GD30	VF65	CS95
ISLE OF CAPRI			**LAKE CHARLES**		**1995-**				
1st	1.00	White	H&C	1grn1blu1pnk	OR-white	R-1	*	1	3
	2.50	Pink	H&C	1grn1brn	OR-white	R-1	*	3	5
	5.00	Red	H&C	2pch2grn	OR-white	R-1	*	5	8
	5.00	Red	H&C	2pch2grn	OR-multi	R-1	*	5	10
("Commemorative" - used as a Grand Opening.)									
	25.00	Green	H&C	4pnk4org	OR-multi	R-1	*	25	30
	100.00	Black	H&C	4blu4yel4lav	OR-multi	R-1	*	100	110
PLAYERS RIVERBOAT			**LAKE CHARLES**		**1993-97**				
PLAYERS CASINO					**1997-**				
1st	1.00	White	H&C	2pnk2blu	OR-white	R-2	1	2	3
	5.00	Red	H&C	8yel4lav	OR-white	R-2	*	5	8
	5.00	Red	Chipco	None	FG	R-4	5	10	20
("Grand Opening, Dec 1993".)									
	25.00	Green	H&C	3dkgrn	OR-white	R-1	*	25	35
	100.00	Black	H&C	4lav4wht	OR-white	R-1	*	100	120
(This issue is marked "Riverboat Casino".)									
2nd	5.00	Red	Chipco	None	FG	R-2	5	10	15
("Mardi Gras 1994".)									
	5.00	Red	Chipco	None	FG	R-2	5	10	15
("Contraband Days '94".)									
3rd	5.00	Red	H&C	8yel4lav	OR-multi	R-2	*	5	10
("Commemorative". Picture of Merv Griffin.)									
4th	1.00	White	H&C	2pnk2blu	OR-multi	R-1	*	1	3
("Players Casino" and large pirate and bird.)									
	5.00	Red	H&C	8yel4lav	R-white	R-1	*	5	8
(Obverse has palm trees and reverse has picture of a pirate.)									
QUEEN OF NEW ORLEANS			**NEW ORLEANS**		**1994-94**				
1st	1.00	White	Chipco	None	FG	R-3	2	5	10
	5.00	Red	Chipco	None	FG	R-4	6	12	25
	25.00	Green	Chipco	None	FG	R-6	25	50	100
	100.00	Black	Chipco	None	FG	R-8	100	175	250
(Became the Flamingo.)									
RIVER CITY			**NEW ORLEANS**		**1995-95**				
1st	1.00	White	H&C	2grn2brn	OR-black	R-3	2	5	10
	2.50	Pink	H&C	1grn1blu	OR-black	R-3	5	10	20
	5.00	Red	H&C	4yel4gld	OR-black	R-3	6	12	25
("Grand Opening 1995".)									
	25.00	Green	H&C	4gry4pnk	OR-black	R-5	50	100	200
	100.00	Black	H&C	4org4lim	OR-black	R-5	100	175	250
(River City had two boats. The above set of chips is from the Grand Palais.)									
2nd	1.00	Lt Blue	H&C	1org1dkgry1bei	OR-multi	R-3	2	5	10
	2.50	Pink	H&C	2grn	OR-multi	R-3	5	10	20
	5.00	Red	H&C	2ltgrn2bei	OR-multi	R-3	6	12	25
("Grand Opening 1995".)									
	25.00	Green	H&C	4bei4red4brn	OR-multi	R-5	50	100	200
	100.00	Black	H&C	4blu4pnk	OR-multi	R-5	100	175	250
(River City had two boats. The above set of chips is from the Crescent City Queen.)									

(All River City chips were returned to Paulson, overstamped with cancellation, then made available to the public. These prices are for chips that walked off the boat, not chips with removed cancellations. Cancelled chips are worth very little.)

Issue	Den.	Color	Mold	Inserts	Inlay	Rarity	GD30	VF65	CS95

STAR CASINO — NEW ORLEANS 1993-95 — LAKE CHARLES 1995-

Issue	Den.	Color	Mold	Inserts	Inlay	Rarity	GD30	VF65	CS95
STAR CASINO			NEW ORLEANS	1993-95					
			LAKE CHARLES	1995-					
1st	1.00	White	H&C	2red2trq	R-white	R-4	5	10	20
(Long and short canes.)									
	5.00	Red	H&C	2brn2blu	R-white	R-4	7	15	30
	25.00	Green	H&C	4yel4lav	R-white	R-5	50	100	150
	100.00	Black	H&C	12yel6blu	R-white	R-6	75	150	250
(This first issue is from New Orleans.)									
2nd	1.00	White	Chipco	2blu	FG	R-1	*	1	3
	5.00	Red	Chipco	3wht	FG	R-1	*	5	8
	25.00	Green	Chipco	6wht3dkgry	FG	R-1	*	25	30
	100.00	Black	Chipco	12yel	FG	R-1	*	100	110
3rd	5.00	Red	H&C	3tan3nvy	OR-white	R-2	*	5	10
(One side is marked "Players Island Star Casino". The other side has a picture of a toucan.)									
(2nd and 3rd issues are from Lake Charles.)									

Star $5 (1st)

Issue	Den.	Color	Mold	Inserts	Inlay	Rarity	GD30	VF65	CS95
TREASURE CHEST			KENNER	1994-					
1st	.50	Peach	H&C	4blu	HS	R-2	*	1	2
	1.00	White	H&C	3org3grn3blu	OR-multi	R-2	1	3	5
	5.00	Red	H&C	2grn2blu	OR-multi	R-5	25	50	75
(The multi-colored inserts resembled the $25 chip too closely and was removed from play after 5 weeks.)									
	25.00	Green	H&C	4pur4pnk	OR-multi	R-2	25	35	50
	100.00	Black	H&C	3pnk3lav	OR-multi	R-3	100	125	150
(1st issue pictures a treasure chest, except for the $100 that shows two mermaids.)									
2nd	5.00	Dk Pink	H&C	4red	OR-multi	R-2	5	8	10
3rd	1.00	White	H&C	3brn3grn3lav	OR-multi	R-1	*	1	3
	5.00	Red	H&C	2nvy2lav	OR-multi	R-1	*	5	8
	25.00	Green	H&C	4org4pnk	OR-multi	R-1	*	25	30
	100.00	Black	H&C	3org3pur	OR-multi	R-1	*	100	110
(3rd issue pictures a mermaid.)									

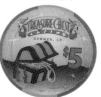

Star $5 (2nd)

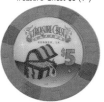

Treasure Chest $5 (1st)

Mississippi

Issue	Den.	Color	Mold	Inserts	Inlay	Rarity	GD30	VF65	CS95
AMERISTAR			VICKSBURG	1994-					
1st	1.00	White	BJ-2	4lav	R-multi	R-1	*	1	3
	2.50	Pink	BJ-2	4wht	R-multi	R-1	*	3	5
	5.00	Red	BJ-2	4blu	R-multi	R-1	*	5	8
	25.00	Green	BJ-2	16org	R-multi	R-1	*	25	30
	100.00	Black	BJ-2	4yel	R-multi	R-1	*	100	110
2nd	5.00	Red	H&C	2bei2yel	FG	R-2	*	5	10
("5th Anniversary February 1999".)									

Treasure Chest $5 (2nd)

Ameristar $2.50 (1st)

Issue	Den.	Color	Mold	Inserts	Inlay	Rarity	GD30	VF65	CS95
BALLY' S			TUNICA	1993-95/95-					
1st	1.00	White	House	2gry2org	R-white	R-1	*	1	3
	2.50	Pink	House	1grn1lav	R-white	R-1	*	3	5
	5.00	Red	House	2blu2gry	FG	R-4	10	20	40
(Red desert, no date.)									
	5.00	Red	House	2blu2gry	FG	R-4	10	20	40
(Light-colored desert, dated 1993.)									
	25.00	Green	House	4yel4blu	R-white	R-1	*	25	30
	100.00	Black	House	4pnk4gry4wht	R-white	R-1	*	100	120
2nd	5.00	Red	House	2blu2gry	OR-multi	R-1	*	5	8

Bally's $5 (1st)

Bayou Caddy's Jubilee $5 (1ˢᵗ)

Bayou Caddy's $5 GO (1ˢᵗ)

Beau Rivage $1 (1ˢᵗ)

Biloxi Belle $25 (1ˢᵗ)

Boomtown $1 (1ˢᵗ)

Boomtown $5 (2ⁿᵈ)

Issue	Den.	Color	Mold	Inserts	Inlay	Rarity	GD30	VF65	CS95
("I Struck it Rich".)									
error	5.00	Red	House	2blu2gry	OR-multi	R-7	50	100	150
(Under close examination, you can see "$25" stamped in the mold.)									
BAYOU CADDY'S JUBILEE			**LAKESHORE**		**1994-95**				
			GREENVILLE		**1995-**				
1ˢᵗ	.25	Yellow	H&C	None	HS	R-3	5	10	15
(Marked "Bayou Caddy".)									
	1.00	White	HHR	None	R-white	R-1	*	1	3
error	1.00	White	HHR	None	R-white	Unique?	200	400	600
(Has a $500 inlay instead of $1.)									
	5.00	Maroon	HHR	4yel	R-white	R-1	*	5	8
	5.00	Red	Chipco	None	FG	R-3	5	10	20
("Grand Opening 1993".)									
	25.00	Green	HHR	6pnk	R-white	R-1	*	25	35
	100.00	Black	HHR	3yel3bei	R-white	R-2	*	100	120
BEAU RIVAGE			**BILOXI**		**1999-**				
1ˢᵗ	1.00	White	House	1bei1brn	OR-white	R-1	*	1	2
	5.00	Red	House	2pch2grn	OR-white	R-1	*	5	7
	25.00	Green	House	4ltbrn4pnk	OR-white	R-1	*	25	30
	100.00	Black	House	3sam3gld	OR-white	R-1	*	100	110
BILOXI BELLE			**BILOXI**		**1992-95**				
1ˢᵗ	1.00	White	H&C	8blu4pch	R-white	R-3	3	6	12
	2.50	Pink	H&C	3org	STAR-white	R-4	6	12	25
	5.00	Red	H&C	4grn4pch	HUB-white	R-4	7	15	30
	25.00	Green	H&C	2nvy2ltblu	SCA-white	R-5	20	40	80
(Short canes only.)									
	100.00	Black	H&C	4yel4wht	COG-white	R-5	50	100	150
(Long canes only.)									
2ⁿᵈ	5.00	Red	Chipco	None	FG	R-3	10	20	40
("1ˢᵗ Birthday 1993".)									
BOOMTOWN			**BILOXI**		**1994-**				
1ˢᵗ	1.00	White	H&C	4blu	OR-multi	R-1	*	1	3
	5.00	Red	H&C	8pnk4red	OR-multi	R-1	*	5	8
	5.00	Red	Chipco	None	FG	R-2	5	10	15
("Grand Opening 1994".)									
	25.00	Green	H&C	4lim4grn	OR-multi	R-1	*	25	30
	100.00	Black	H&C	6gld3gry	OR-multi	R-1	*	100	120
2ⁿᵈ	5.00	Red	Chipco	None	FG	R-5	10	20	40
("Happy New Year 1995".)									
3ʳᵈ	5.00	Red	Chipco	None	FG	R-2	5	10	15
("1ˢᵗ Anniversary July 18, 1995".)									
4ᵗʰ	5.00	Red	Chipco	None	FG	R-2	5	8	10
("2ⁿᵈ Annual All-American Birthday Bonanza July 22, 1996".)									
5ᵗʰ	5.00	Red	Chipco	None	FG	R-2	5	8	10
("Cruisin' the Coast October 10-13, 1996".)									
6ᵗʰ	5.00	Red	Chipco	None	FG	R-2	5	8	10
("3ʳᵈ Birthday Bonanza July 22, 1997".)									
CASINO MAGIC			**BAY ST. LOUIS**		**1992-**				
1ˢᵗ	1.00	White	BJ-2	8blu	R-white	R-2	1	2	3

Issue	Den.	Color	Mold	Inserts	Inlay	Rarity	GD30	VF65	CS95
	5.00	Red	BJ-2	3wht	R-white	R-2	5	8	10
	25.00	Green	BJ-2	4yel	R-white	R-2	25	30	40
	100.00	Black	BJ-2	6wht3mar	R-white	R-2	100	125	150
2nd	5.00	Red	Chipco	None	FG	R-3	5	10	20

("Fats Domino July 14, 1994".)

3rd	5.00	Red	Chipco	None	FG	R-3	5	10	20
	25.00	Green	Chipco	None	FG	R-3	12	25	50

("2nd Anniversary Sept. 1994".)

4th	5.00	Red	Chipco	None	FG	R-2	5	8	10

("Cruisin' the Coast Oct 10-13, 1996".)

5th	5.00	Red	Chipco	None	FG	R-3	5	10	20
	25.00	Green	Chipco	None	FG	R-3	25	35	50
	100.00	Black	Chipco	None	FG	R-3	100	125	150

("Celebrating 5 years of Magic 1997".)

6th	1.00	White	H&C	1brn1pur	OR-white	R-1	*	1	3
	2.50	Pink	H&C	1ltpur1pch	OR-white	R-1	*	3	5
	5.00	Red	H&C	2grn2gld	HUB-white	R-1	*	5	8
	25.00	Green	H&C	4blu4gry	SCA-white	R-1	*	25	30
	100.00	Black	H&C	4grn4pnk	WHL-white	R-1	*	100	110

Casino Magic BSL $1 (1st)

Casino Magic BSL $25 (5th)

CASINO MAGIC BILOXI 1993-

Issue	Den.	Color	Mold	Inserts	Inlay	Rarity	GD30	VF65	CS95
1st	1.00	White	H&C	2grn2ltblu	R-white	R-1	*	1	3
	5.00	Red	H&C	8wht4nvy	HUB-white	R-1	*	5	8
	25.00	Green	H&C	4brn4crm	SCA-white	R-1	*	25	30
	100.00	Black	H&C	3bei3pnk3gld	COG-white	R-1	*	100	110
2nd	5.00	Red	Chipco	None	FG	R-2	5	8	10
	25.00	Green	Chipco	None	FG	R-3	25	35	50

("1st Anniversary 1994".)

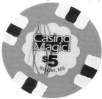

Casino Magic BLX $5 (1st)

3rd	5.00	Red	Chipco	None	FG	R-2	5	8	10

("Cruisin' the Coast October 10-13, 1996".)

CIRCUS CIRCUS ROBINSONVILLE 1994-97

Issue	Den.	Color	Mold	Inserts	Inlay	Rarity	GD30	VF65	CS95
1st	.50	Purple	Unicrn	None	HS	R-2	1	3	5
	1.00	Beige	BJ-2	16pnk	R-white	R-2	2	4	8
	5.00	Red	BJ-2	4blu	R-white	R-2	5	8	12
	5.00	Lavender	BJ-2	8ltblu	R-white	R-2	5	10	15

("Grand Opening".)

	25.00	Green	BJ-2	12wht	R-white	R-3	25	40	60
	100.00	Black	BJ-2	4pur	R-white	R-3	100	125	150

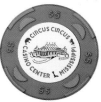

Circus Circus $5 (1st)

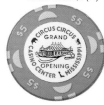

Circus Circus $5 GO (1st)

COPA CASINO GULFPORT 1993-

Issue	Den.	Color	Mold	Inserts	Inlay	Rarity	GD30	VF65	CS95
1st	1.00	White	H&C	2gld2pur	OR-white	R-1	*	1	3
	5.00	Red	H&C	4wht4blu	HUB-white	R-1	*	5	8
	25.00	Green	H&C	3pnk3pur	SCA-white	R-1	*	25	30
	100.00	Black	H&C	4wht4lav	COG-white	R-1	*	100	110
2nd	5.00	Red	H&C	4blk4org	FG	R-2	5	10	15

("Memorial Day Blowout 16th Annual".)

3rd	5.00	Red	H&C	4blk4org	FG	R-2	5	8	10

("Memorial Day Blowout 17th Annual".)

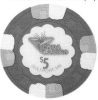

Copa Casino $5 (1st)

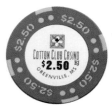

Cotton Club $2.50 (1st)

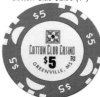

Cotton Club $5 (1st)

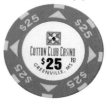

Cotton Club $25 (1st)

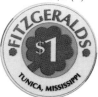

Fitzgeralds $1 (1st)

Gold Shore $5 (1st)

Gold Strike $25 (1st)

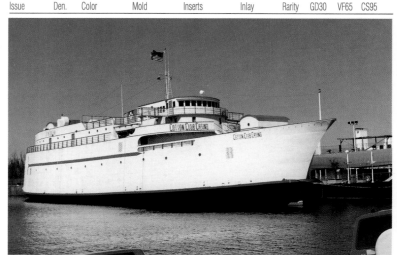

The Cotton Club, one of the few Mississippi casinos that was actually a riverboat—most others are just barges that appear to be land-based.

Issue	Den.	Color	Mold	Inserts	Inlay	Rarity	GD30	VF65	CS95
COTTON CLUB			**GREENVILLE**		**1993-95**				
			LAKESHORE		**1995-96**				
1st	1.00	Beige	BJ-2	8ltblu	R-white	R-2	2	4	8
	2.50	Purple	BJ-2	4pnk	R-white	R-2	3	6	10
	5.00	Red	BJ-2	12wht	R-white	R-2	5	10	15
	25.00	Green	BJ-2	8yel	R-white	R-3	25	50	75
	100.00	Black	BJ-2	?	R-white	R-4	50	100	150
FITZGERALD'S			**TUNICA**		**1994-**				
1st	1.00	White	Chipco	None	FG	R-1	*	1	3
	5.00	Red	Chipco	None	FG	R-1	*	5	8
	25.00	Green	Chipco	None	FG	R-1	*	25	30
	100.00	Black	Chipco	None	FG	R-1	*	100	110
GOLD SHORE			**BILOXI**		**1994-95**				
1st	1.00	White	H&C	3blk3gry	OR-white	R-3	3	6	12
	2.50	Pink	H&C	1tan1brn	OR-white	R-3	6	12	25
	5.00	Red	H&C	4org4grn	OR-white	R-3	7	15	30
	25.00	Green	H&C	4yel4wht	OR-white	R-5	50	100	150
	100.00	Black	H&C	?	OR-white	R-6	75	150	200
GOLD STRIKE			**ROBINSONVILLE**		**1997-**				
1st	.50	Purple	Unicrn	None	HS	R-1	*	1	2
	1.00	White	Chipco	None	FG	R-1	*	1	3
	5.00	Red	Chipco	None	FG	R-1	*	5	8
	25.00	Green	Chipco	None	FG	R-1	*	25	30
	100.00	Black	Chipco	None	FG	R-1	*	100	110
GRAND CASINO			**BILOXI**		**1994-**				
1st	1.00	White	Chipco	None	FG	R-1	*	1	3
(Linen finish.)									
	1.00	White	Chipco	None	FG	R-1	*	1	3

Issue	Den.	Color	Mold	Inserts	Inlay	Rarity	GD30	VF65	CS95
(Satin finish.)									
	2.50	Dk Pink	Chipco	None	FG	R-5	40	80	120
(Taken out of play because the color was too similar to the $5 chip.)									
	5.00	Red	Chipco	None	FG	R-1	*	5	8
	5.00	Red	Chipco	None	FG	R-2	5	8	10
("Grand Opening 1993".)									
	25.00	Green	Chipco	None	FG	R-1	*	25	30
	100.00	Black	Chipco	None	FG	R-1	*	100	110
2nd	2.50	Pink	Chipco	None	FG	R-1	*	3	5
(Linen finish.)									
	2.50	Pink	Chipco	None	FG	R-1	*	3	5
(Satin finish.)									
3rd	5.00	Red	Chipco	None	FG	R-2	5	8	10
("Cruisin' the Coast October 10-13, 1996".)									
4th	.25	Lt Orange	H&C	None	HS	R-2	*	1	2
("No picture. Large 25c. Used only for a very brief period of time.)									
5th	.25	Lt Orange	H&C	None	HS	R-2	*	1	2
(Picture of a pot of gold. Small 25c".)									

Grand Casino BLX $5 (1st)

Grand Casino BLX 25c (5th)

Issue	Den.	Color	Mold	Inserts	Inlay	Rarity	GD30	VF65	CS95
GRAND CASINO			**GULFPORT**		**1993–**				
1st	1.00	White	H&C	4pur4yel4org	R-white	R-1	*	1	3
	2.50	Pink	H&C	4org4pur	STAR-white	R-1	*	3	5
	5.00	Red	H&C	8nvy4wht	HUB-white	R-1	*	5	8
	5.00	Red	Chipco	None	FG	R-2	5	10	15
("Grand Opening May 1993".)									
	25.00	Green	H&C	4red4ltgrn	SCA-white	R-1	*	25	30
	100.00	Black	H&C	4grn4pnk4yel	COG-white	R-1	*	100	110
2nd	5.00	Red	Chipco	None	FG	R-2	*	5	10
("Cruisin' the Coast October 10-13, 1996".)									
3rd	5.00	Red	Chipco	None	FG	R-2	*	5	10
("3rd Annual Cruisin' the Coast October 8-11, 1998".)									

Grand Casino GP $1 (1st)

Issue	Den.	Color	Mold	Inserts	Inlay	Rarity	GD30	VF65	CS95
GRAND CASINO			**TUNICA**		**1996–**				
1st	1.00	Lt Blue	H&C	3lav	OR-multi	R-1	*	1	3
	2.50	Pink	H&C	1tan1gry	OR-multi	R-1	*	3	5
	5.00	Red	H&C	3lav3grn	OR-multi	R-1	*	5	8
	5.00	Red	H&C	3lav3grn	OR-multi	R-2	5	8	10
("Grand Opening June 1996".)									
	25.00	Green	H&C	4pnk4pur	OR-multi	R-1	*	25	30
	100.00	Black	H&C	3org3pch3brn	OR-multi	R-1	*	100	110

Grand Casino TUN $25 (1st)

Issue	Den.	Color	Mold	Inserts	Inlay	Rarity	GD30	VF65	CS95
HARRAH'S			**TUNICA**		**1993-97**				
1st	1.00	White	H&C	1blu1pch1grn	R-white	R-2	2	4	8
	5.00	Red	H&C	8ltblu4wht	HUB-white	R-3	5	10	15
	5.00	Red	Chipco	None	FG	R-4	7	15	30
("Grand Opening".)									
	25.00	Green	H&C	4pnk4lav	SCA-white	R-4	25	50	75
	100.00	Black	H&C	?	?	R-4	50	100	150
2nd	5.00	Red	Chipco	None	FG	R-4	10	20	30
("1st Anniversary Nov 29, 1994".)									
3rd	2.50	Pink	Chipco	None	FG	R-3	5	10	20

Harrah's TUN $5 (1st)

Issue	Den.	Color	Mold	Inserts	Inlay	Rarity	GD30	VF65	CS95
HARRAH'S MARDI GRAS			**TUNICA**		**1996–**				
1st	1.00	White	H&C	1pnk1red	FG	R-1	*	1	3

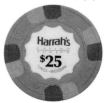
Harrah's TUN $25 (1st)

Issue	Den.	Color	Mold	Inserts	Inlay	Rarity	GD30	VF65	CS95
	2.50	Pink	H&C	1lav1dkgry	FG	R-1	*	3	5
	5.00	Red	H&C	2grn2pur	FG	R-1	*	5	8
	25.00	Green	H&C	3org3blu	FG	R-1	*	25	30
	100.00	Black	H&C	4org4wht4grn	FG	R-1	*	100	110
2nd	5.00	Red	H&C	8ltblu4wht	FG	R-2	5	8	10

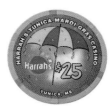

Harrah's TMG $25 (1st)

("60th Anniversary 1997".)

HARRAH'S — VICKSBURG — 1993–

Issue	Den.	Color	Mold	Inserts	Inlay	Rarity	GD30	VF65	CS95
1st	1.00	White	H&C	1pch1grn1pur	R-white	R-1	*	1	3
	2.50	Pink	H&C	3wht3grn3gld	STAR-white	R-1	*	3	5
	5.00	Red	H&C	8wht4pnk	HUB-white	R-1	*	5	8
	25.00	Green	H&C	4org4pnk	SCA-white	R-1	*	25	30
	100.00	Black	H&C	4ltblu4grn	COG-white	R-1	*	100	110
2nd	5.00	Red	Chipco	None	FG	R-4	10	20	30

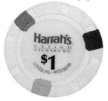

Harrah's VKS $1 (1st)

("Miss Mississippi Pageant July 1995".)

HOLLYWOOD CASINO — TUNICA — 1994–

Issue	Den.	Color	Mold	Inserts	Inlay	Rarity	GD30	VF65	CS95
1st	1.00	White	H&C	1red1pur1dkgrn	OR-black	R-1	*	1	3
	2.50	Pink	H&C	2ltgrn2pur	OR-black	R-1	*	3	5
	5.00	Red	H&C	3ltgrn3org3grn	OR-black	R-1	*	5	8
	25.00	Green	H&C	4pnk4gry-blu	OR-black	R-1	*	25	30
	100.00	Black	H&C	4pnk4blu4pch	OR-black	R-1	*	100	110
2nd	5.00	Red	Chipco	None	FG	R-2	5	8	10

Hollywood $25 (1st)

("Adventure".)

HORSESHOE — TUNICA — 1995–

Issue	Den.	Color	Mold	Inserts	Inlay	Rarity	GD30	VF65	CS95
1st	1.00	Beige	H&C	2pnk2grn	R-multi	R-1	*	1	3
	2.50	Pink	H&C	2yel	R-multi	R-1	*	3	5
	5.00	Red	H&C	8ltblu4org	R-multi	R-1	*	5	8
error	5.00	Red	H&C	8ltblu4org	R-multi	Unique	100	200	300

(One side mistakenly has a $2.50 inlay.)

| | 5.00 | Red | Chipco | None | FG | R-2 | 5 | 8 | 10 |

("Collector's Series" was released on opening.)

| | 25.00 | Green | H&C | 4lav4blu | R-multi | R-1 | * | 25 | 30 |
| | 100.00 | Black | H&C | 4ltgrn4ltpur | R-multi | R-1 | * | 100 | 110 |

Horseshoe $2.50 (1st)

IMPERIAL PALACE — BILOXI — 1997–

Issue	Den.	Color	Mold	Inserts	Inlay	Rarity	GD30	VF65	CS95
1st	1.00	Grey	H&C	None	OR-white	R-1	*	1	3
	5.00	Red	H&C	3gld	OR-white	R-1	*	5	8
	25.00	Green	H&C	4ltgrn	OR-white	R-1	*	25	30
	100.00	Black	H&C	3grn3org	OR-white	R-1	*	100	110

Imperial Palace $5 (1st)

ISLE OF CAPRI — BILOXI — 1992–

Issue	Den.	Color	Mold	Inserts	Inlay	Rarity	GD30	VF65	CS95
1st	1.00	White	H&C	4blu4grn4org	R-white	R-1	*	1	3
	2.50	Pink	H&C	3yel3ltgrn	STAR-white	R-2	3	6	12
	5.00	Red	H&C	6yel3pur	HUB-white	R-1	*	5	8
	25.00	Green	H&C	8brn	SCA-white	R-1	*	25	30

(Above four chips exist in both long and short cane versions.)

| | 100.00 | Black | H&C | 6lav6gld | COG-white | R-3 | 100 | 125 | 150 |

(Long canes only.)

| 2nd | 2.50 | Pink | H&C | 3yel3ltgrn | STAR-white | R-2 | 3 | 6 | 10 |

("Crown Plaza Resort"

| | 5.00 | Red | H&C | 6yel3pur | OR-multi | R-2 | 5 | 8 | 10 |

Isle of Capri BLX $25 (1st)

("Grand Re-Opening".)

Issue	Den.	Color	Mold	Inserts	Inlay	Rarity	GD30	VF65	CS95
	5.00	Red	H&C	6yel3pur	OR-multi	R-2	5	8	10
("Mississippi's First Casino".)									
	5.00	Red	H&C	2pur2gld2mar	OR-multi	R-2	5	8	10
("Happy Mardi Gras 1997".)									
	5.00	Red	H&C	6yel3red	OR-multi	R-2	5	8	10
("Celebrating Five Years, August 1, 1997".)									
3rd	100.00	Black	H&C	6pnk3grn	OR-multi	R-1	*	100	110

Isle of Capri VKS $2.50 (1st)

ISLE OF CAPRI VICKSBURG 1993-

Issue	Den.	Color	Mold	Inserts	Inlay	Rarity	GD30	VF65	CS95
1st	1.00	White	H&C	4grn4org4blu	R-white	R-1	*	1	3
	2.50	Pink	H&C	4yel4wht	STAR-white	R-1	*	3	5
	5.00	Red	H&C	3trq3pnk3dkgrn	HUB-white	R-1	*	5	8
	5.00	Red	Chipco	None	FG	R-2	5	8	10
("Grand Opening".)									
	25.00	Green	H&C	3pnk3org	SCA-white	R-1	*	25	30
	100.00	Black	H&C	4yel4ltblu4org	COG-white	R-1	*	100	110
2nd	1.00	White	Chipco	None	FG	R-2	1	3	5
("First Anniversary 1994".)									
	2.50	Pink	Chipco	None	FG	R-1	*	3	5

Isle of Capri VKS $1 (2nd)

ISLE OF CAPRI TUNICA 1999-

Issue	Den.	Color	Mold	Inserts	Inlay	Rarity	GD30	VF65	CS95
1st	1.00	White	H&C	1tan1pch	OR-white	R-1	*	1	3
	2.50	Pink	H&C	2nvy2grn	OR-white	R-1	*	3	5
	5.00	Red	H&C	2pch2org	OR-white	R-1	*	5	8
	5.00	Red	H&C	2pch2org	OR-multi	R-3	5	10	15
("Grand Opening".)									
	25.00	Green	H&C	3mar3nvy	OR-white	R-1	*	25	30
	100.00	Black	H&C	4pnk4bei	OR-white	R-1	*	100	110

Lady Luck BLX $25 (1st)

LADY LUCK BILOXI 1993-98

Issue	Den.	Color	Mold	Inserts	Inlay	Rarity	GD30	VF65	CS95
1st	1.00	White	Chipco	None	FG	R-2	2	4	8
	error 1.00	White	Chipco	None	FG	Unique	75	150	225
(Lady Luck's picture on both sides.)									
	2.50	Pink	Chipco	None	FG	R-3	7	15	30
	5.00	Red	Chipco	None	FG	R-2	5	10	15
	25.00	Green	Chipco	None	FG	R-3	25	40	50
	100.00	Black	Chipco	None	FG	R-3	100	125	150

Lady Luck CO $1 (1st)

LADY LUCK COAHOMA LULA 1997-

Issue	Den.	Color	Mold	Inserts	Inlay	Rarity	GD30	VF65	CS95
1st	1.00	White	Chipco	None	FG	R-2	1	3	5
	5.00	Red	Chipco	None	FG	R-2	5	8	10
	25.00	Green	Chipco	None	FG	R-2	25	40	50
	100.00	Black	Chipco	None	FG	R-3	100	125	150
(Formerly Lady Luck Tunica.)									
2nd	1.00	White	H&C	1pch1dkgrn	OR-multi	R-1	*	1	3
	5.00	Red	H&C	1pnk1olv	OR-multi	R-1	*	5	8
	25.00	Green	H&C	3org3mar	OR-multi	R-1	*	25	30
	100.00	Black	H&C	4tan4pnk	OR-multi	R-1	*	100	110
3rd	5.00	Red	H&C	2pnk2tan	FG	R-2	5	8	10
("Country Hotel Grand Opening".)									

Lady Luck CO $25 (1st)

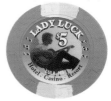
Lady Luck Lula $5 (2nd)

LADY LUCK NATCHEZ 1993-

Issue	Den.	Color	Mold	Inserts	Inlay	Rarity	GD30	VF65	CS95
1st	1.00	White	H&C	2brn2gry	R-white	R-1	*	1	3

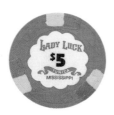

Lady Luck TUN $5 (1st)

Las Vegas Casino $1 (1st)

Las Vegas Casino $2.50 (1st)

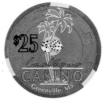

Las Vegas Casino $25 (1st)

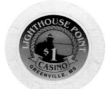

Lighthouse Point $1 (1st)

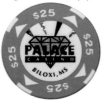

Palace Casino $25 (1st)

Issue	Den.	Color	Mold	Inserts	Inlay	Rarity	GD30	VF65	CS95
	5.00	Red	H&C	3yel3blu	HUB-white	R-1	*	5	10
	25.00	Green	H&C	8tan4trq	SCA-white	R-1	*	25	35
	100.00	Black	H&C	3org3grn	COG-white	R-2	*	100	120
LADY LUCK			**TUNICA**		**1993-94**				
1st	1.00	White	H&C	2brn2gry	R-white	R-5	5	10	20
	5.00	Red	H&C	3yel3blu	HUB-white	R-5	10	20	40
	25.00	Green	H&C	8brn4grn	SCA-white	R-6	50	100	150
	100.00	Black	H&C	3org3gld	COG-white	R-6	75	150	225

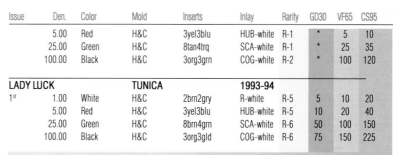

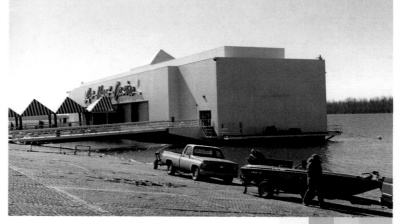

Closed in 1998, this was arguably Mississippi's least attractive casino, with the wildly ironic name of Las Vegas Casino.

Issue	Den.	Color	Mold	Inserts	Inlay	Rarity	GD30	VF65	CS95
LAS VEGAS CASINO			**GREENVILLE**		**1994-98**				
1st	1.00	Blue	H&C	None	FG	R-3	3	6	10
	2.50	Pink	H&C	1grn1ltgrn	FG	R-3	5	10	20
	5.00	Red	H&C	2blu2bei	FG	R-3	5	10	20
	25.00	Green	H&C	3yel3lav	FG	R-3	25	40	50
	100.00	Black	H&C	6org6lav	FG	R-4	100	125	150
LIGHTHOUSE POINT			**GREENVILLE**		**1996-**				
1st	1.00	White	H&C	None	OR-multi	R-1	*	1	3
	2.50	Pink	H&C	1blk1ltpur	OR-multi	R-1	*	3	5
	5.00	Red	H&C	2org2dkgrn	OR-multi	R-1	*	5	8
	25.00	Green	H&C	3pch3wht	OR-multi	R-1	*	25	30
	100.00	Black	H&C	2blu2wht	OR-multi	R-2	*	100	120
2nd	5.00	Red	Chipco	None	FG	R-2	*	5	10
("First Anniversary Jan. 1998".)									
PALACE CASINO			**BILOXI**		**1994-**				
1st	1.00	White	BJ-2	8blu	R-multi	R-1	*	1	3
	5.00	Red	BJ-2	4wht	R-multi	R-1	*	5	8
	25.00	Green	BJ-2	4wht	R-multi	R-1	*	25	30
	100.00	Black	BJ-2	8wht	R-multi	R-1	*	100	110
2nd	.25	Yellow	H&C	None	HS	R-2	2	4	8
3rd	5.00	Red	H&C	2trq2pur	FG	R-2	*	5	10

Issue	Den.	Color	Mold	Inserts	Inlay	Rarity	GD30	VF65	CS95
("Tricentennial".)									
4th	.25	Yellow	H&C	None	HS	R-8	25	50	75
("The New Palace". These were pulled quickly and only 8 walked out!)									

President Biloxi $2.50 (1st)

PRESIDENT — BILOXI — 1992-

Issue	Den.	Color	Mold	Inserts	Inlay	Rarity	GD30	VF65	CS95
1st	1.00	White	H&C	3brn3pnk	R-white	R-1	*	1	3
(Long and Short canes.)									
	2.50	Pink	H&C	6yel	STAR-white	R-1	*	3	5
(Short canes only.)									
	5.00	Red	H&C	4grn4wht	HUB-white	R-1	*	5	8
(Long and Short canes.)									
	25.00	Green	H&C	2pch2grn	SCA-white	R-1	*	25	35
(Long and Short canes.)									
	100.00	Black	H&C	6bei3trq	COG-white	R-1	*	100	120
(Short canes only.)									
2nd	5.00	Red	Chipco	None	FG	R-2	*	5	10
("Commemorative Series".)									

President Biloxi $5 (1st)

PRESIDENT — TUNICA — 1993-94

Issue	Den.	Color	Mold	Inserts	Inlay	Rarity	GD30	VF65	CS95
1st	1.00	White	H&C	8org4brn	OR-white	R-5	5	10	20
	2.50	Pink	H&C	8gld4olv	OR-white	R-5	7	15	30
	5.00	Red	H&C	4wht4ltgrn	OR-white	R-5	10	20	40
	25.00	Green	H&C	3ltblu3bei	OR-white	R-6	50	100	150
	100.00	Black	H&C	4org4gry	OR-white	R-6	75	150	225

President Tunica $5 (1st)

RAINBOW CASINO — VICKSBURG — 1994-

Issue	Den.	Color	Mold	Inserts	Inlay	Rarity	GD30	VF65	CS95
1st	1.00	White	H&C	1pur1org1grn1yel	OR-white	R-1	*	1	3
	5.00	Red	H&C	3nvy3ltorg3grn	OR-white	R-1	*	5	8
	25.00	Green	H&C	4dkgrn	OR-white	R-1	*	25	35
	100.00	Black	H&C	8org4yel	OR-white	R-2	*	100	120
2nd	2.50	Pink	Chipco	None	FG	R-2	3	5	8
3rd	5.00	Red	Chipco	None	FG	R-2	*	5	10
("Pointer Sisters, July 23, 1998".)									

Rainbow Casino $2.50 (2nd)

SAM'S TOWN — TUNICA — 1994-

Issue	Den.	Color	Mold	Inserts	Inlay	Rarity	GD30	VF65	CS95
1st	1.00	White	H&C	2blu	OR-white	R-1	*	1	3
	5.00	Red	H&C	2tan2nvy	OR-white	R-1	*	5	8
	25.00	Green	H&C	4pur4org	OR-white	R-1	*	25	35
	100.00	Black	H&C	8wht4gry	OR-white	R-1	*	100	120
2nd	5.00	Red	H&C	2tan2nvy	OR-white	R-1	*	5	8
	25.00	Green	H&C	4pur4org	OR-white	R-2	*	25	30
	100.00	Black	H&C	8wht4gry	OR-white	R-3	*	100	120
("5th Anniversary set. All chips are individually serial-numbered.)									

Sam's Town $1 (1st)

SHERATON — TUNICA — 1994-

Issue	Den.	Color	Mold	Inserts	Inlay	Rarity	GD30	VF65	CS95
1st	1.00	White	H&C	2yel2lav	OR-white	R-1	*	1	3
	2.50	Pink	H&C	1crm1ltblu1dkgry	OR-white	R-1	*	3	5
	5.00	Red	H&C	8blu4org	OR-white	R-1	*	5	8
	25.00	Green	H&C	4pch4pur	OR-white	R-1	*	25	30
	100.00	Black	H&C	8yel	OR-white	R-1	*	100	110

SOUTHERN BELLE — TUNICA — 1994-94

Issue	Den.	Color	Mold	Inserts	Inlay	Rarity	GD30	VF65	CS95
1st	1.00	White	H&C	2blu2lav	OR-white	R-3	5	10	20
	2.50	Pink	H&C	2gry2ltgrn	OR-white	R-4	7	15	30

Sheraton $5 (1st)

Southern Belle $5 (1ˢᵗ)

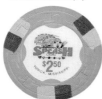

Splash $2.50 (1ˢᵗ)

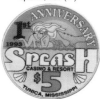

Splash $5 (3ʳᵈ)

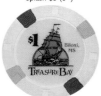

Treasure Bay BLX $1 (1ˢᵗ)

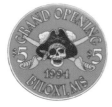

Treasure Bay BLX $5 (1ˢᵗ)

Treasure Bay BLX $5 (2ⁿᵈ)

Issue	Den.	Color	Mold	Inserts	Inlay	Rarity	GD30	VF65	CS95
	5.00	Red	H&C	4yel4gry	OR-white	R-4	10	20	40
	25.00	Green	H&C	4org4ltgrn	OR-white	R-5	25	50	100
	100.00	Black	H&C	3bei3pnk3yel	OR-white	R-4	50	100	150

(About 200 of these were overstamped with "No Cash Value" and used at Harrah's school. Some chip doctors have removed the overstamp and buffed out the traces of the cancellation. Beware if you are offered one as "mint", because very few of these actually walked off the boat. Check any such chip carefully with a magnifying glass under a strong light. Legitimate specimens are quite rare, at least R-7 or better.)

SPLASH		**TUNICA**			**1992-95**				
1ˢᵗ	1.00	White	H&C	2ltblu	R-white	R-3	5	10	20

(Long and Short canes.)

	2.50	Pink	H&C	3pch3dklav	NOT-white	R-7	100	200	300

(Used for only a very short time, because the B&W surveillance cameras couldn't tell this chip from the $5. They re-ordered the $2.50 immediately, creating this modern rarity.)

	5.00	Red	H&C	4org4ltgrn	HUB-white	R-3	7	15	30

(Long and Short canes.)

	5.00	Red	Chipco	None	FG	R-4	12	25	50
	25.00	Green	H&C	8pch	SCA-white	R-5	25	50	100
	100.00	Black	H&C	6ltblu3bei	COG-white	R-5	50	100	150
2ⁿᵈ	2.50	Pink	H&C	3brn	NOT-white	R-3	10	20	40
3ʳᵈ	5.00	Red	Chipco	None	FG	R-3	12	25	50

("1ˢᵗ Anniversary 1993".)

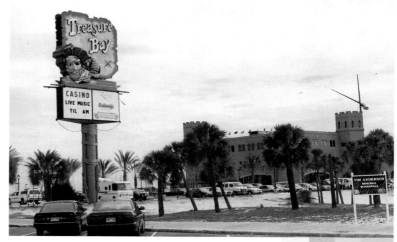

Treasure Bay, Biloxi—A modern Las Vegas-style casino within a very picturesque building.

TREASURE BAY		**BILOXI**			**1994-**				
1ˢᵗ	1.00	White	H&C	2lav2ltpur	OR-white	R-1	*	1	3
	5.00	Red	H&C	2wht2pnk2pch2org	OR-white	R-1	*	5	8
	5.00	Red	Chipco	None	FG	R-2	*	5	10

("Grand Opening 1994".)

	25.00	Green	H&C	3lav3blu3org	OR-white	R-1	*	25	30
	100.00	Black	H&C	3lav3dkgry3grn	OR-white	R-1	*	100	110
2ⁿᵈ	5.00	Red	Chipco	None	FG	R-2	*	5	10

Issue	Den.	Color	Mold	Inserts	Inlay	Rarity	GD30	VF65	CS95
("1st Anniversary April 29, 1995".)									
3rd	.25	Orange	Unicrn	None	HS	R-2	1	3	5
4th	5.00	Red	Chipco	None	FG	R-2	*	5	10
("2nd Anniversary 1996".)									
5th	5.00	Red	Chipco	None	FG	R-2	*	5	10
("Happy Birthday". Chip was given to slot card members during their birthday month as part of a promotion.)									
	5.00	Red	Chipco	None	FG	R-2	*	5	10
("Cruisin' the Coast October 10-13, 1996".)									
6th	5.00	Red	Chipco	None	FG	R-2	*	5	10
("Sea Wolves 1997-1998".)									

Treasure Bay BLX $5 (5th)

TREASURE BAY			**TUNICA**		**1994-95**				
1st	.25	Yellow	BJ	None	HS	Unique	300	600	900
(This chip was put on a 25c dice table only two days before the casino unexpectedly closed. This chip was mixed in with the inlaid 25c chips that were becoming in short supply.)									
	.25	Yellow	H&C	None	OR-white	R-5	12	25	50
	1.00	White	H&C	2lav2ltpur	OR-white	R-3	5	10	20
	5.00	Red	H&C	2wht2pnk2pch2org	OR-white	R-4	10	20	35
	25.00	Green	H&C	3lav3blu3org	OR-white	R-8	75	150	225
	100.00	Black	H&C	?	OR-white	R-8	100	200	300
(The $25 and $100 exist in only a few collections. It is not known whether the owners of Treasure Bay destroyed the inventory or kept them. These chips could be anything from R-9 to R-4.)									

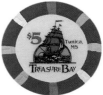

Treasure Bay TUN $1 (1st)

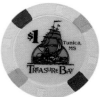

Treasure Bay TUN $5 (1st)

Missouri

ARGOSY CASINO			**RIVERSIDE**		**1994-**				
1st	.50	Pink	H&C	1pch1dkgrn	SCA-multi	R-1	*	1	2
	1.00	White	H&C	3grn3nvy	HUB-multi	R-1	*	1	3
	5.00	Red	H&C	4ltblu4pnk	OR-multi	R-1	*	5	8
	25.00	Green	H&C	3blu3brn	HEX-multi	R-1	*	25	30
	100.00	Black	H&C	3pnk3tan	COG-multi	R-1	*	100	110
(1st set chips are all marked "Riverside Casino".)									
2nd	5.00	Red	H&C	4pnk4ltblu	OR-white	R-1	*	5	8
(2nd issue marked "Argosy Casino".)									

Argosy $1 (1st)

CASINO AZTAR			**CARUTHERSVILLE**		**1995-**				
1st	.50	Pink	H&C	1blu1gry	SCA-white	R-2	2	5	10
	1.00	White	H&C	2pnk2gld	HUB-white	R-1	*	1	3
	5.00	Red	H&C	1yel1nvy1dkgry	OR-white	R-1	*	5	8
	25.00	Green	H&C	4yel4pur4gry	HEX-white	R-1	*	25	30
	100.00	Black	H&C						
2nd	5.00	Red	H&C	1yel1nvy1dkgry	OR-multi	R-2	*	5	10
("1st Anniversary Celebration".)									
3rd	.50	Pink	H&C	1pur1wht	SCA-white	R-1	*	1	2

Aztar $1 (1st)

CASINO ST. CHARLES			**ST. CHARLES**		**1994-**				
1st	.50	Pink	BJ	8yel	HS	R-1	*	1	2
	1.00	White	BJ-2	4lav	BJPI-multi	R-1	*	1	3
	5.00	Red	BJ-2	4trq	BJPI-multi	R-1	*	5	8
	25.00	Green	BJ-2	8wht4grn	BJPI-multi	R-1	*	25	30
	100.00	Black	BJ-2	16grn8lav	BJPI-multi	R-1	*	100	110

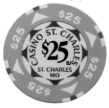

Casino St Charles $25 (1st)

Flamingo KC $1 (1st)

Flamingo KC $25 (1st)

Harrah's MH 50c (1st)

Harrah's KC $1 (1st)

Harrah's KC $5 (2nd)

Harrah's KC $5 1st Ann (2nd)
(1st Anniversary)

Issue	Den.	Color	Mold	Inserts	Inlay	Rarity	GD30	VF65	CS95
FLAMINGO			**KANSAS CITY**		**1996-**				
1st	.50	Pink	BJ	8gry	HS	R-1	*	1	2
	.50	Pink	BJ	8gry	HS	R-1	*	1	2
(Grooves on edge.)									
	1.00	White	BJ-2	12blu	BJPI-multi	R-1	*	1	3
	5.00	Red	BJ-2	4wht	BJPI-multi	R-1	*	5	8
	5.00	Red	BJ-2	4wht	OR-white	R-1	*	5	8
("Grand Opening 1996".)									
	25.00	Green	BJ-2	16ltgrn	BJPI-multi	R-1	*	25	30
	100.00	Black	BJ-2	8ltblu	BJPI-multi	R-1	*	100	110
HARRAH'S			**MARYLAND HEIGHTS**		**1997-**				
1st	.50	Pink	H&C	1tan1dkgrn	SCA-multi	R-1	*	1	2
	1.00	White	H&C	2org2olv	NOT-multi	R-1	*	1	3
	5.00	Red	H&C	2pnk2lav	OR-multi	R-1	*	5	8
	5.00	Red	H&C	2pnk2lav	OR-multi	R-2	*	5	10
("Grand Opening"									
	25.00	Green	H&C	4lav4ltpur	HEX-multi	R-1	*	25	30
	100.00	Black	H&C	6blu6ltblu	WHL-multi	R-1	*	100	110

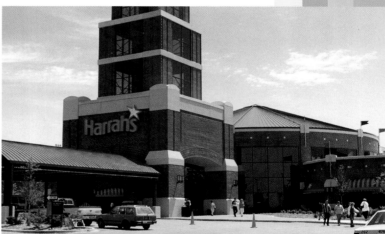

Harrah's North Kansas City is one of the country's most successful riverboat casinos.

Issue	Den.	Color	Mold	Inserts	Inlay	Rarity	GD30	VF65	CS95
HARRAH'S			**N. KANSAS CITY**		**1994-**				
1st	.50	Pink	H&C	2lav	TRI-white	R-1	*	1	2
	1.00	White	H&C	2gry2ltblu	NOT-white	R-1	*	1	3
	5.00	Red	H&C	3pnk3brn	OR-white	R-1	*	5	8
	5.00	Red	H&C	3pnk3brn	OR-multi	R-3	5	10	20
("Grand Opening".)									
	25.00	Green	H&C	4yel4ltgrn	HEX-white	R-1	*	25	30
	100.00	Black	H&C	4pnk4grn4lav	WHL-white	R-1	*	100	110
2nd	5.00	Red	H&C	3pnk3brn	OR-multi	R-2	5	10	15
("Clock Tower")									
	5.00	Red	H&C	3pnk3brn	OR-multi	R-2	*	5	10

Issue	Den.	Color	Mold	Inserts	Inlay	Rarity	GD30	VF65	CS95
	5.00	Red	BJ-2	16yel	OR-multi	R-2	*	5	10
(Pictures a Jester's face.)									
	5.00	Red	BJ-2	12yel	OR-multi	R-2	*	5	10
(2ⁿᵈ Anniversary)									
	5.00	Red	Chipco	None	FG	R-2	*	5	10
("60ᵗʰ Anniversary".)									
	5.00	Red	BJ-2	8yel	OR-multi	R-2	*	5	10
("5ᵗʰ Anniversary".)									

Players Island MH 50c (1ˢᵗ)

PLAYERS ISLAND MARYLAND HEIGHTS 1997-

Issue	Den.	Color	Mold	Inserts	Inlay	Rarity	GD30	VF65	CS95
1ˢᵗ	.50	Pink	H&C	1blu1brn	SCA-white	R-1	*	1	2
	1.00	White	H&C	1blu1dkgry	TRI-white	R-1	*	1	3
	5.00	Red	H&C	2blu2pur	OR-white	R-1	*	5	8
	5.00	Red	H&C	2blu2pur	OR-multi	R-2	*	5	10
("1997 Grand Opening")									
	25.00	Green	H&C	4lav4dkgrn	HEX-white	R-1	*	25	30
	100.00	Black	H&C	3pnk3dkpnk	WHL-white	R-1	*	100	110

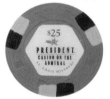
President STL $5 (1ˢᵗ)

PRESIDENT CASINO ST. LOUIS 1994-

Issue	Den.	Color	Mold	Inserts	Inlay	Rarity	GD30	VF65	CS95
1ˢᵗ	.50	Pink	H&C	1olv1pur	SCA-white	R-1	*	1	2
(Type I: "President" is bigger - 15mm.)									
	.50	Pink	H&C	1olv1pur	SCA-white	R-1	*	1	2
(Type II: "President" is smaller - 13mm.)									
	1.00	White	H&C	3org3trq	OR-white	R-1	*	1	3
	5.00	Red	H&C	4bei4ltblu	HUB-white	R-1	*	5	8
(Type I: "President" is bigger - 15mm.)									
	5.00	Red	H&C	4bei4ltblu	HUB-white	R-1	*	5	8
(Type II: "President" is smaller - 13mm.)									
	25.00	Green	H&C	3dkgrn3yel	HEX-white	R-1	*	25	30
	100.00	Black	H&C	3mar3pch	STAR-white	R-2	*	100	120
2ⁿᵈ	5.00	Red	Chipco	None	FG	R-2	*	5	10
("Christmas 1997".)									

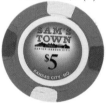
President STL $25 (1ˢᵗ)

SAM'S TOWN KANSAS CITY 1995-98

Issue	Den.	Color	Mold	Inserts	Inlay	Rarity	GD30	VF65	CS95
1ˢᵗ	.50	Pink	H&C	1grn1ltlav	HS	R-2	1	2	3
	1.00	White	H&C	1nvy1lav1crm	OR-multi	R-2	2	4	8
	5.00	Red	H&C	2brn2crm	OR-multi	R-2	5	10	15
	25.00	Green	H&C	8pch4blu	HEX-multi	R-2	25	35	50
	100.00	Black	H&C	4grn4wht4lav	WHL-white	R-3	50	100	150
2ⁿᵈ	5.00	Red	Chipco	None	FG	R-2	7	15	30
	25.00	Green	Chipco	None	FG	R-3	25	50	75
(Both of the above chips are marked "2ⁿᵈ Anniversary 1997", and have a picture of Sam Boyd.)									

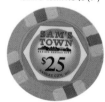
Sam's Town KC $5 (1ˢᵗ)

Sam's Town KC $25 (1ˢᵗ)

ST. JO FRONTIER ST. JOSEPH 1994-

Issue	Den.	Color	Mold	Inserts	Inlay	Rarity	GD30	VF65	CS95
1ˢᵗ	.50	Pink	H&C	2blu	HS	R-1	*	1	2
	1.00	White	H&C	2tan2nvy	R-multi	R-1	*	1	3
	5.00	Red	H&C	8blu4grn	OR-multi	R-1	*	5	8
	25.00	Green	H&C	4red4lav	HEX-multi	R-1	*	25	30
	100.00	Black	H&C	8org4lim	COG-multi	R-1	*	100	120
2ⁿᵈ	5.00	Red	H&C	4ltblu4grn	OR-multi	R-2	*	5	10
("First Anniversary June 24, 1995".)									

STATION CASINO KANSAS CITY 1997-

Issue	Den.	Color	Mold	Inserts	Inlay	Rarity	GD30	VF65	CS95
1ˢᵗ	.50	Pink	H&C	1pch1blu	SCA-multi	R-1	*	1	2

St Jo Frontier $1 (1ˢᵗ)

Station Casino $1 (1st)

Station Casino $25 (1st)

Atlantis $100 (1st)

Bally's Grand $25 (1st)

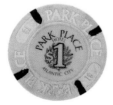

Bally's Park Place $1 (1st)

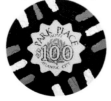

Bally's Park Place $100 (2nd)

Issue	Den.	Color	Mold	Inserts	Inlay	Rarity	GD30	VF65	CS95
	1.00	White	H&C	1org1nvy	TRI-multi	R-1	*	1	3
	1.00	White	H&C	1org1nvy	TRI-multi	R-1	*	1	3
("Grand Opening".)									
	5.00	Red	H&C	3grn3brn	OR-multi	R-1	*	5	8
	5.00	Red	H&C	3grn3brn	OR-multi	R-1	*	5	8
("Grand Opening".)									
	25.00	Green	H&C	4yel4red	HEX-multi	R-1	*	25	30
	100.00	Black	H&C	4wht4blu4mar	WHL-white	R-1	*	100	110
2nd	5.00	Red	H&C	3grn3brn	OR-multi	R-1	*	5	8
(1st Anniversary Jan 16, 1998".)									

Atlantic City, New Jersey

Issue	Den.	Color	Mold	Inserts	Inlay	Rarity	GD30	VF65	CS95
A.C. HILTON			**ATLANTIC CITY**		**1997-**				
1st	1.00	White	House	4org	FG	R-1	*	1	3
	2.50	Pink	House	3blu	FG	R-1	*	3	4
	5.00	Red	House	4wht	FG	R-1	*	5	7
	25.00	Green	House	4pnk4tan	FG	R-1	*	25	30
	100.00	Black	House	4pnk8gry	FG	R-1	*	100	110
ATLANTIS			**ATLANTIC CITY**		**1984-89**				
1st	1.00	White	House	4grn	R-white	R-3	10	20	30
	2.50	Pink	House	2grn	SCA-white	R-5	40	80	120
	5.00	Red	House	4grn	HUB-white	R-5	40	80	120
	25.00	Green	House	4wht4grn	HEX-white	R-7	200	400	600
	100.00	Black	House	6red6yel	STAR-white	R-8	400	800	1200
BALLY'S GRAND			**ATLANTIC CITY**		**1986-96**				
1st	1.00	White	House	4grn	R-white	R-2	2	4	6
	2.50	Pink	House	2red	SCA-white	R-3	3	6	9
	5.00	Red	House	4yel	HUB-white	R-3	5	10	15
	25.00	Green	House	8blu	HEX-white	R-4	20	40	60
	100.00	Black	House	6grn6org	STAR-white	R-5	75	150	225
BALLY'S PARK PLACE			**ATLANTIC CITY**		**1979-**				
1st	1.00	White	House	4dkbrn	R-white	R-3	5	10	15
	2.50	Pink	House	2grn	SCA-grey	R-3	5	10	15
	5.00	Red	House	4blu	HUB-red	R-5	50	100	150
	20.00	Yellow	House	8pur	SCA-yellow	R-8	400	800	1200
	25.00	Green	House	8red	HEX-green	R-4	25	50	75
	100.00	Black	House	12blu	STAR-white	R-6	250	500	750
2nd	1.00	White	House	4ltbrn	R-white	R-2	5	10	15
	5.00	Red	House	4dkbrn	HUB-red	R-2	5	10	15
(There's an identical variation of the above chip with a rose colored inlay; same rarity & price)									
	25.00	Green	House	8ltorg	HEX-green	R-9	500	1000	1500
	100.00	Black	House	6blu6wht	STAR-white	R-6	100	200	300
3rd	1.00	White	House	4ltbrn	R-white	R-2	2	4	6
(The previous two issues have a white $1, this third issue has a black $1.)									
4th	1.00	White	House	4ltbrn	FG	R-2	1	2	3
	2.50	Pink	House	2grn	FG	R-2	2	4	6
	5.00	Red	House	4dkbrn	FG	R-2	5	6	9
	25.00	Green	House	8red	FG	R-4	25	40	60
	100.00	Black	House	6blu6wht	FG	R-5	100	125	175

Issue	Den.	Color	Mold	Inserts	Inlay	Rarity	GD30	VF65	CS95
5th	1.00	White	House	4dkbrn	FG	R-1	*	1	2
	2.50	Pink	House	2gld	FG	R-1	*	3	4
	5.00	Red	House	2pnk2ltblu	FG	R-1	*	5	7
	10.00	Blue	H&C	3yel3pnk	FG	R-1	*	10	12
	25.00	Green	House	8org	FG	R-1	*	25	30
	100.00	Black	House	6yel6blk	FG	R-1	*	100	110

Brighton $1 (1st)

BRIGHTON			ATLANTIC CITY		1980-81				
1st	1.00	White	House	4pur	R-white	R-4	15	30	45
	2.50	Pink	House	2fch	SCA-white	R-6	175	350	525
	5.00	Red	House	4org	HUB-white	R-5	125	250	375
	25.00	Green	House	8wht	HEX-white	R-8	500	1000	1500
	100.00	Black	House	12gry	STAR-white	R-10	1500	3000	4500

Brighton $25 (1st)

BOARDWALK REGENCY			ATLANTIC CITY		1979-87				
1st	1.00	White	House	3grn	R-white	R-3	10	20	30
	2.50	Pink	House	3gry	R-white	R-5	100	200	300
	5.00	Red	House	3wht3yel	R-white	R-4	35	70	105
	20.00	Yellow	House	3blu3grn3pnk	SCA-white	R-9	700	1400	2100
	25.00	Green	House	3blu3org	SCA-white	R-6	200	400	600
	100.00	Black	House	3pnk3red3blu	HUB-white	R-8	400	800	1200
2nd	1.00	White	House	4pnk	R-white	R-2	5	10	15
	2.50	Pink	House	2brn	SCA-white	R-4	30	60	90
	5.00	Red	House	4blu	HUB-white	R-4	20	40	60
	20.00	Yellow	House	8gry	SCA-white	R-7	200	400	600
	25.00	Green	House	8blk	HEX-white	R-5	50	100	150
	100.00	Black	House	12pur	STAR-white	R-7	250	500	750

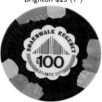

Boardwalk Regency $100 (1st)

(Caesars purchased Boardwalk Regency in 1981, but didn't discontinue the name "Boardwalk Regency" from their chips until 1987.)

CAESARS			ATLANTIC CITY		1987-				
1st	1.00	White	House	2red2blu	R-white	R-1	1	2	3
	2.50	Pink	House	2org2gry	SCA-white	R-1	2	4	6
	5.00	Red	House	2wht2grn	HUB-white	R-3	10	20	30
	20.00	Yellow	House	8blu	SCA-white	R-5	75	150	225
	25.00	Green	House	4red4wht	HEX-white	R-1	*	25	35
	100.00	Black	House	6red6blu	STAR-white	R-7	250	500	750
2nd	100.00	Black	House	6red6wht	STAR-white	R-6	200	400	600
3rd	100.00	Black	House	6blu6wht	STAR-blue	R-5	150	300	450

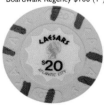

Caesars $20 (1st)

(The above chip has a hologram center.)

4th	5.00	Red	Chipco	None	FG	R-1	*	5	7

(There are two versions; one with light green leaves and the other with dark green leaves.)

	20.00	Yellow	Chipco	None	FG	R-1	*	20	25

(There are two versions; light and dark printing.)

	25.00	Green	Chipco	None	FG	R-5	100	200	300
	100.00	Black	Chipco	None	FG	R-1	*	100	110

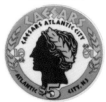

Caesars $5 (4th)

CLARIDGE			ATLANTIC CITY		1982-				
1st	1.00	White	BJ-H	None	COIN	R-2	3	6	9

(There are two versions; one with lt. green letters and one with dk. green letters.)

	2.50	Pink	BJ-H	None	COIN	R-2	5	10	15

(There are two versions; one is pink and one is a rose color.)

	5.00	Red	BJ-H	None	COIN	R-2	10	20	30

(There are two versions; one is bright red and one is red/purple.)

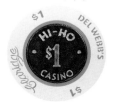

Claridge $1 (1st)

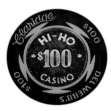

Claridge $100 (1st)

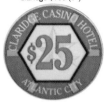

Claridge $25 (4th)

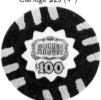

Golden Nugget $100 (2nd)

Harrah's $20 (1st)

Harrah's at Trump $20 (1st)

Harrah's at Trump $100 (1st)

Issue	Den.	Color	Mold	Inserts	Inlay	Rarity	GD30	VF65	CS95
	25.00	Green	BJ-H	None	COIN	R-4	40	80	120
	100.00	Black	BJ-H	None	COIN	R-5	75	150	225

(All of the first issues have "Hi-Ho Casino" on the coin inlay.)

2nd	2.50	Pink	BJ-H	None	COIN	R-8	600	1200	1800

(This extremely rare chip was used in a tournament and some of the players used them to tip the cocktail waitresses. These are the only survivors today! This chip is different from the second issue in that it has brown letters instead of turquoise.)

3rd	1.00	White	BJ-H	None	COIN	R-2	2	4	6
	2.50	Pink	BJ-H	None	COIN	R-3	4	8	12
4th	1.00	White	Chipco	None	FG	R-1	1	2	3
	2.50	Pink	Chipco	None	FG	R-1	*	3	4
	5.00	Red	Chipco	None	FG	R-1	*	5	7
	25.00	Green	Chipco	None	FG	R-1	*	25	30
	100.00	Black	Chipco	None	FG	R-1	*	100	110

GOLDEN NUGGET — ATLANTIC CITY — 1980-86

Issue	Den.	Color	Mold	Inserts	Inlay	Rarity	GD30	VF65	CS95
1st	1.00	White	House	4org	R-white	R-1	7	14	21
	2.50	Pink	House	2blu	SCA-white	R-4	25	50	75
	5.00	Red	House	4wht	HUB-white	R-4	40	80	120
	20.00	Yellow	House	8org	SCA-white	R-6	250	500	750
	25.00	Green	House	8yel	HEX-white	R-5	100	200	300
	100.00	Black	House	12red	STAR-white	R-7	250	500	750
2nd	1.00	White	House	4org	R-white	R-1	5	10	15
	5.00	Red	House	4wht	HUB-white	R-4	25	50	75
	25.00	Green	House	8yel	HEX-white	R-6	175	350	525
	100.00	Black	House	6blu6gry	STAR-white	R-7	250	500	750

HARRAH'S — ATLANTIC CITY — 1980-

Issue	Den.	Color	Mold	Inserts	Inlay	Rarity	GD30	VF65	CS95
1st	1.00	White	BJ-H	None	COIN	R-2	5	10	15

(This chip has a black ring around the inlay.)

	2.50	Rose	BJ-H	None	COIN	R-2	2	4	6
	5.00	Red	BJ-H	None	COIN	R-1	*	5	7
	20.00	Yellow	BJ-H	None	COIN	R-3	15	30	45
	25.00	Green	BJ-H	None	COIN	R-1	*	25	35
	100.00	Black	BJ-H	None	COIN	R-1	*	100	110
2nd	1.00	White	BJ-H	None	COIN	R-1	*	1	3

(This chip has a grey ring around the inlay.)
(Casino originally opened as Harrah's Marina, but dropped the "Marina" in 1991.)

HARRAH'S AT TRUMP PLAZA — ATLANTIC CITY — 1984-85

Issue	Den.	Color	Mold	Inserts	Inlay	Rarity	GD30	VF65	CS95
1st	1.00	White	BJ-H	None	COIN	R-3	10	20	30
	2.50	Pink	BJ-H	None	COIN	R-4	50	100	150

(There is a variation which is rose/pink, but with the same value.)

	5.00	Red	BJ-H	None	COIN	R-4	50	100	150

(There is a variation which is dull red, but with the same value.)

	20.00	Yellow	BJ-H	None	COIN	R-8	350	700	1050
	25.00	Green	BJ-H	None	COIN	R-8	250	500	750

(There is a variation with a darker red ring around the inlay.)

	100.00	Black	BJ-H	None	COIN	R-8	400	800	1200

(There are four versions of this chip, each having slightly different colored letters around the coin inlay: Reddish-Brown, Maroon, Brown, Red)

HILTON — ATLANTIC CITY — Never Opened

(These Hilton chips were used by Trump Castle when it opened.)

Issue	Den.	Color	Mold	Inserts	Inlay	Rarity	GD30	VF65	CS95
1st	1.00	White	House	2blu2org	R-white	R-1	10	20	30

Issue	Den.	Color	Mold	Inserts	Inlay	Rarity	GD30	VF65	CS95
	2.50	Pink	House	1grn1yel	SCA-white	R-5	100	200	300
	5.00	Red	House	2pch2grn	HUB-white	R-5	100	200	300
	25.00	Green	House	4blu4org	HEX-white	R-7	250	500	750
	100.00	Black	House	6blu6org	STAR-white	R-8	600	1200	1800

(There are exactly 15 surviving chips.)

Hilton $25 (1st)

PLAYBOY ATLANTIC CITY 1981-84

Issue	Den.	Color	Mold	Inserts	Inlay	Rarity	GD30	VF65	CS95
1st	1.00	White	BJ-H	None	COIN	R-2	10	20	30

(There are two variations; one with a blue bunny and one with a dark blue bunny.)

Issue	Den.	Color	Mold	Inserts	Inlay	Rarity	GD30	VF65	CS95
	2.50	Pink	BJ-H	None	COIN	R-4	50	100	150
	5.00	Red	BJ-H	None	COIN	R-4	50	100	150
	25.00	Green	BJ-H	None	COIN	R-6	150	300	450
	100.00	Black	BJ-H	None	COIN	R-9	500	1000	1500
2nd	100.00	Black	BJ-H	None	COIN	R-7	300	600	900

Playboy $25 (1st)

RESORTS INTERNATIONAL ATLANTIC CITY 1978-

Issue	Den.	Color	Mold	Inserts	Inlay	Rarity	GD30	VF65	CS95
1st	1.00	White	H&C	3pnk	R-white	R-4	30	60	90
	2.50	Pink	H&C	3blu	R-white	R-5	150	300	450
	5.00	Red	H&C	6blu3yel	SCA-white	R-5	130	260	390
	bac 5	Red	H&C	3wht3pch3blu	R-white	R-9	1100	2200	3300
	bac 20	Yellow	H&C	3blu3org3grn	R-white	R-9	1200	2400	3600
	25.00	Green	H&C	3grn3brn3pnk	HUB-white	R-8	750	1500	2250
	100.00	Black	H&C	3red3wht3blu	COG-white	R-7	350	700	1050
	bac 100	Black	H&C	3red3gry3pnk	HUB-white	R-10	1750	3500	5250
2nd	1.00	White	House	3pnk	R-white	R-5	100	200	300
	25.00	Green	House	8yel	HEX-white	R-8	500	1000	1500
3rd	1.00	White	House	4blu	R-white	R-1	*	1	3
	2.50	Pink	House	2brn	SCA-white	R-1	*	3	5
	5.00	Red	House	4grn	HUB-white	R-1	*	5	7
	20.00	Yellow	House	8brn	SCA-white	R-5	150	300	450
	25.00	Green	House	8blu	HEX-white	R-6	200	400	600
	100.00	Black	House	12pnk	STAR-white	R-5	125	250	375
4th	25.00	Green	House	4org4yel	HEX-white	R-1	*	25	35
	100.00	Black	House	12org	STAR-white	R-1	*	100	110

Resorts $5 bac (1st)

Resorts $25 (2nd)

Resorts $2.50 (3rd)

SANDS ATLANTIC CITY 1981-

Issue	Den.	Color	Mold	Inserts	Inlay	Rarity	GD30	VF65	CS95
1st	1.00	White	House	4gry	R-multi	R-1	*	1	3

(There's a variation with sea green color in multi-circle.)

Issue	Den.	Color	Mold	Inserts	Inlay	Rarity	GD30	VF65	CS95
	2.50	Pink	House	2org	SCA-multi	R-1	*	3	5
	5.00	Red	House	4pur	HUB-multi	R-4	40	80	120
	20.00	Yellow	House	8red	SCA-multi	R-4	50	100	150
	25.00	Green	House	8pnk	HEX-multi	R-5	150	300	450
	100.00	Black	House	12yel	STAR-multi	R-6	250	500	750
2nd	5.00	Red	House	4org	HUB-multi	R-1	*	5	7
	25.00	Green	House	8wht	HEX-multi	R-1	*	25	35
	100.00	Black	House	12gry	STAR-multi	R-1	*	100	110

Sands $20 (1st)

SHOWBOAT ATLANTIC CITY 1987-

Issue	Den.	Color	Mold	Inserts	Inlay	Rarity	GD30	VF65	CS95
1st	1.00	White	House	2org2pch	R-white	R-2	2	4	6
	2.50	Pink	House	2brn2red	SCA-white	R-3	4	8	12
	5.00	Red	House	4brn4wht	HUB-white	R-3	5	10	15
	25.00	Green	House	4blu4ltbrn	HEX-white	R-4	25	50	75
	100.00	Black	House	6yel6pnk	STAR-white	R-6	100	200	300
2nd	100.00	Black	House	6pnk6ltblu	STAR-white	R-5	100	175	250

Showboat $5 (1st)

Showboat $100 (4th)

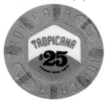

Tropicana $25 (1st)

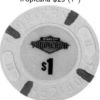

Tropicana $1 (2nd)

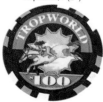

Tropworld $100 (4th)

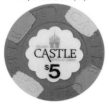

Trump Castle $5 (2nd)

Trump Plaza $1 (1st)

Issue	Den.	Color	Mold	Inserts	Inlay	Rarity	GD30	VF65	CS95
3rd	100.00	Black	H&C	6yel6grn	STAR-white	R-5	100	150	200
(The above chip has a hologram center.)									
4th	1.00	White	House	2pch2org	FG	R-1	*	1	3
	2.50	Pink	House	2brn2red	FG	R-1	*	3	5
	5.00	Red	House	4brn4wht	FG	R-1	*	5	7
	25.00	Green	House	4brn4gry	FG	R-1	*	25	30
	100.00	Black	House	6yel6grn	FG	R-1	*	100	110

TROPICANA/TROPWORLD — ATLANTIC CITY — 1981-

Issue	Den.	Color	Mold	Inserts	Inlay	Rarity	GD30	VF65	CS95
1st	1.00	White	House	4pur	R-white	R-3	5	10	15
	2.50	Pink	House	2pur	SCA-white	R-3	10	20	30
	5.00	Red	House	4blu	HUB-white	R-3	25	50	75
	25.00	Green	House	8pur	HEX-white	R-5	100	200	300
	100.00	Black	House	12wht	STAR-white	R-6	175	350	525
2nd	1.00	White	House	4pur	R-white	R-2	4	8	12
	5.00	Red	House	4org	HUB-white	R-2	6	12	18
	25.00	Green	House	8pur	HEX-white	R-3	25	50	75
	100.00	Black	House	12grn	STAR-white	R-5	150	300	450
3rd	1.00	White	House	4org	R-white	R-3	5	10	15
	100.00	Black	House	6wht6grn	STAR-white	R-4	100	200	300
4th	1.00	White	H&C	4pur	FG	R-2	2	4	6
	2.50	Pink	H&C	2org	FG	R-3	3	6	9
	5.00	Red	H&C	4org	FG	R-3	5	10	15
	25.00	Green	H&C	8pur	FG	R-4	25	50	75
	100.00	Black	H&C	6wht6grn	FG	R-5	*	125	175
(The 4th issue is Tropworld. The rest are Tropicana.)									
5th	1.00	White	House	4pur	FG	R-1	*	1	3
	2.50	Pink	House	2pch	FG	R-1	*	3	5
	5.00	Red	House	4org	FG	R-1	*	5	7
	25.00	Green	House	8pur	FG	R-1	*	25	30
	100.00	Black	House	6pur6pch	FG	R-1	*	100	110

TRUMP CASTLE — ATLANTIC CITY — 1985-97

Issue	Den.	Color	Mold	Inserts	Inlay	Rarity	GD30	VF65	CS95
1st	1.00	White	House	2red2gry	R-white	R-1	1	2	3
	2.50	Pink	House	2blu	SCA-white	R-2	2	4	6
	5.00	Red	House	2pch2blk	HUB-white	R-2	5	10	15
	25.00	Green	House	4blk4org	HEX-white	R-4	25	50	75
	100.00	Black	House	6red6org	STAR-white	R-5	100	175	250
2nd	2.50	Pink	House	1yel1grn	SCA-white	R-2	3	6	9
	5.00	Red	House	2pch2grn	HUB-white	R-2	5	8	10
	25.00	Green	House	4blu4org	HEX-white	R-3	25	35	50

TRUMP MARINA — ATLANTIC CITY — 1997-

Issue	Den.	Color	Mold	Inserts	Inlay	Rarity	GD30	VF65	CS95
1st	1.00	White	House	2org2blu	OR-multi	R-1	*	1	2
	2.50	Pink	House	1grn1yel	OR-multi	R-1	*	3	5
	5.00	Red	House	2pch2gry	OR-multi	R-1	*	5	7
	25.00	Green	House	4blk4brn	OR-multi	R-1	*	25	30
	100.00	Black	House	6org6blu	OR-multi	R-1	*	100	110
(From 1997 to 1999 Trump Marina was using Trump Castle chips.)									

TRUMP PLAZA — ATLANTIC CITY — 1984-

Issue	Den.	Color	Mold	Inserts	Inlay	Rarity	GD30	VF65	CS95
1st	1.00	White	House	4red	R-white	R-2	2	4	6
	2.50	Pink	House	2blk	SCA-white	R-3	5	10	15

Issue	Den.	Color	Mold	Inserts	Inlay	Rarity	GD30	VF65	CS95
	5.00	Red	House	4pur4wht	HUB-white	R-3	10	20	30
	25.00	Green	House	4wht4red	HEX-white	R-5	150	300	450
	100.00	Black	House	6wht6pur	STAR-white	R-6	200	400	600
2nd	25.00	Green	House	4wht4grn	HEX-white	R-1	*	25	30
	100.00	Black	House	12grn	STAR-white	R-5	125	250	375
3rd	100.00	Black	House	6pnk6blu	STAR-white	R-1	*	100	110
4th	1.00	White	Chipco	none	FG	R-1	*	1	3
	2.50	Pink	Chipco	none	FG	R-1	*	3	5
	5.00	Red	Chipco	none	FG	R-1	*	5	7
	20.00	Yellow	Chipco	none	FG	R-1	*	20	25

Trump Plaza $100 (2nd)

Trump Plaza $1 (4th)

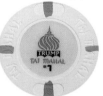

Trump Taj Mahal $1 (1st)

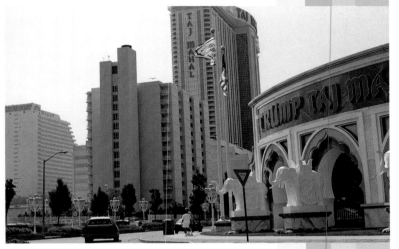

Reportedly, Trump's Taj Mahal must make about $1 million a day in order to be profitable.

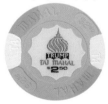

Trump Taj Mahal $2.50 (1st)

TRUMP TAJ MAHAL ATLANTIC CITY 1990-

Issue	Den.	Color	Mold	Inserts	Inlay	Rarity	GD30	VF65	CS95
1st	1.00	White	House	2pnk2org	R-white	R-1	*	1	3
	2.50	Pink	House	2pnk2wht	SCA-white	R-1	*	3	5
	5.00	Red	House	4pch4gry	HUB-white	R-1	*	5	7
	25.00	Green	House	4wht4red	HEX-white	R-1	*	25	30
	100.00	Black	House	12grn	STAR-white	R-1	*	100	110

(The above chip has a hologram center.)

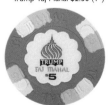

Trump Taj Mahal $5 (1st)

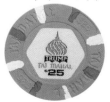

Trump Taj Mahal $25 (1st)

Collecting Commemorative Casino Chips From Nevada

Collecting modern (1990 and later) limited edition com-
memorative issue chips has grown greatly in popularity in the
last few years. More casinos are seeing the demand for an
advertising chip which can be used and also collected. New
collectors are noticing that this is a big chip hobby when they
see casinos issuing these colorful chips for various events.
Many new collectors are born this way, figuring if the big casino
is making 1,000 to 5,000 or so chips for collectors to walk off
with for a certain event or occassion, then there must be other
collectors out there just like them who are saving chips. These
collectors then find the obsolete chips from closed casinos to
be appealling historically, and in many cases sentimentally, as a
reminder of past visits to Vegas or other gambling destinations
across the country.

Not all chips are created equally, or are used for the same
kind of promotion. Some are released in limited numbers per
person, and only on the day of the event, like a big boxing
match. Others are given out at special invitation-only parties,
like many of the Tropicana chips. Numbers issued range from
as low as 100; such a very low number is usually bought up by
collectors quickly, as it creates a truly scarce chip. The range
can also venture up to as many as 50,000 chips per run, like the
Bugsy Siegal chip at the Flamingo, which has become a regular
rack chip. Many are numbered one of a certain number or just
engraved with the actual total number that was minted. Mint-
ages listed in this book are from the Gaming Control records.
Special sets are made commemorating events such as the
Millennium, for which many casinos issued twelve-piece sets,
with a new chip coming out monthly for the entire year.

The Millennium chips are by far the hottest casino chips yet

minted in the 20th century. For this huge event, nearly all casinos made some type of Millennium chip, with many great colorful full-graphic chips produced in low numbers. Sports, entertainment, and automobile chips remain on the top of most collectors' lists, as this is a cross-over collectible field with much demand from many areas. Grand opening chips are hot as collectors of regular issue chips enjoy adding these chips to their collection. Many are dated and will always hold an historical value. This type issued on opening night usually sells out quickly with average mintages at only 2,000 chips.

Values are given as average show or internet selling and trading prices, based on mint condition. Some dealers sell for more or less depending on many factors—one being the demand for a particular chip the another being how hard it was to acquire when issued.

The casino name, as well as the mold type and description of the inlay, are arranged alphabetically, hopefully making it easier to find your chip.

Las Vegas, Henderson, and Boulder City are listed together, as many are collecting this area together. Other collectors are branching out and collecting the rest of Southern Nevada, as well as Northern Nevada, which includes Reno, Lake Tahoe, Carson City, and some smaller towns.

Collecting these commemorative chips are, as Steven Cutler, curator of *The Casino Legends Hall of Fame* exhibit at the Tropicana says, "a no-brainer, as they are the only true collectible which can be cashed back in for full value if this ever needed to be done." With more collectors climbing aboard the chip-collecting craze daily, most would be able to profit on their collection by selling older limited edition chips to beginning collectors. Just ask at your favorite casino's cage and you should find a collector who can tell you what chips they have issued and what they have in stock.

Special gratitude goes to Dave and Debbie Harber of Cheques in the Mail for checking all the mintages and overall accuracy of this entire section . For more information on collecting commemoratives, reach them at www.lasvegas-chips.com.

Las Vegas Casino Limited Edition Chips

Casino	Denom	Mold	Inlay	Mintage	Value
Aladdin	$5	BJ	Kenny G New Year	4000	$15
Aladdin	$5	Chipco	2nd Chip Convention '94	2000	$20
Aladdin	$5	Chipco	3rd Chip Convention '95	2000	$20
Aladdin	$5	Chipco	CC & GTCC 1993	2000	$20
Aladdin	$5	Chipco	Feel the Magic	2000	$15
Aladdin	$5	Chipco	Poker Tournament 1993	1000	$15
Aladdin	$5	H&C	3rd Chip Convention '95	2000	$20
Aladdin	$5	H&C	4th Chip Convention 1996	2000	$15
Aladdin	$5	H&C	5th Chip Convention 1997	2000	$15
Aladdin	$5	H&C	Kenny Rogers New Year '97	2000	$20
Aladdin	$5	H&C	Miss Universe 1996	2000	$15
Auto Truck Plaza	$5	H&C	25th Anniversary	2000	$10
AZ. Charlie's	$10	H&C	10th Anniversary Ernie Becker	1000	$15
AZ. Charlie's	$5	H&C	50th Anniversary Air Force	5000	$10
AZ. Charlie's	$5	H&C	8th Anniv. Palace Grand 1899	1000	$10
AZ. Charlie's	$5	H&C	8th Anniv.Arizona Charlie	1000	$10
AZ. Charlie's	$5	H&C	8th Anniv.Charles Meadows	1000	$10
AZ. Charlie's	$5	H&C	8th Anniv.Charlie Meadows 96	1000	$10
AZ. Charlie's	$5	H&C	8th Anniversary Age 24	1000	$10
AZ. Charlie's	$5	H&C	8th Anniversary Age 32	1000	$10
AZ. Charlie's	$5	H&C	96 Football #30 Blocking	1000	$10
AZ. Charlie's	$5	H&C	96 Football Kicker	1000	$10
AZ. Charlie's	$5	H&C	96 Football Passer Red	1000	$10
AZ. Charlie's	$5	H&C	96 Football Passer#30	1000	$10
AZ. Charlie's	$5	H&C	96 Football Pic.Helmet	1000	$10
AZ. Charlie's	$5	H&C	96 Football Picture	1000	$10
AZ. Charlie's	$5	H&C	96 Football Rusher #30	1000	$10
AZ. Charlie's	$5	H&C	96 Football Rusher Green	1000	$10
AZ. Charlie's	$5	H&C	96 Football Rusher White	1000	$10
AZ. Charlie's	$5	H&C	97 Superbowl	1000	$10
AZ. Charlie's	$5	H&C	9th Anniversary Charlie	750	$10
AZ. Charlie's	$5	H&C	9th Anniversary Portrait	750	$10
AZ. Charlie's	$5	H&C	Akeman Rodgers Show 96	1000	$10
AZ. Charlie's	$5	H&C	Asleep at the Wheel	1000	$10
AZ. Charlie's	$5	H&C	Bob Feller	500	$15
AZ. Charlie's	$5	H&C	Dante Lavelli	500	$15
AZ. Charlie's	$5	H&C	Football Don Maynard #13	1000	$10
AZ. Charlie's	$5	H&C	Football Don Maynard Bust	1000	$10
AZ. Charlie's	$5	H&C	Football Paul Rochester 72	1000	$10
AZ. Charlie's	$5	H&C	Football Paul Rochester At The Line	1000	$10
AZ. Charlie's	$5	H&C	Halloween 97	750	$15
AZ. Charlie's	$5	H&C	Lou Groza	500	$15
AZ. Charlie's	$5	H&C	New Year's 1998	750	$10
AZ. Charlie's	$5	H&C	Otto Graham	500	$15
AZ. Charlie's	$5	H&C	Terri Clark Black Hat	2000	$15
AZ. Charlie's	$5	H&C	Terri Clark White Hat	2000	$15
Bally's	$5	BJ	Andrew Dice Clay 1997	2500	$10
Bally's	$5	BJ	Anne Murray 1997	2500	$10
Bally's	$5	BJ	Barbara Mandrell 1997	2500	$10
Bally's	$5	BJ	Englebert Humperdinck 1997	2500	$10
Bally's	$5	BJ	George Carlin 1997	2500	$10
Bally's	$5	BJ	Jeff Foxworthy 1998	2500	$10

Casino	Denom	Mold	Inlay	Mintage	Value
Bally's	$5	BJ	Liza Minnelli 1997	2500	$10
Bally's	$5	BJ	Louie Anderson 1997	2500	$10
Bally's	$5	BJ	Paul Anka 1997	2500	$10
Bally's	$5	BJ	Penn & Teller 1997	2500	$10
Bally's	$5	Chipco	Barbara Mandrell	1000	$20
Bally's	$5	Chipco	Bernadette Peters	1000	$15
Bally's	$5	Chipco	Billy Ray Cyrus 1992	1000	$40
Bally's	$5	Chipco	Englebert 1993	2000	$15
Bally's	$5	Chipco	Englebert 1995	1000	$20
Bally's	$5	Chipco	George Carlin	1000	$15
Bally's	$5	Chipco	Harry Blackstone	1000	$10
Bally's	$5	Chipco	Jubilee	2000	$10
Bally's	$5	Chipco	Louie Anderson	1000	$10
Bally's	$5	Chipco	Monorail	2000	$10
Bally's	$5	Chipco	Paul Anka	1000	$15
Bally's	$5	Chipco	Penn & Teller	2000	$10
Bally's	$5	Chipco	The Oak Ridge Boys	1000	$15
Bally's	$5	H&C	Back to the Past 2 Party		$150
Bally's	$5	House	Millennium	2500	$10
Bally's	$5	House	USAF Apache Helicopter	1000	$10
Bally's	$5	House	USAF B-52 Bomber	1000	$10
Bally's	$5	House	USAF A-20 Havoc	1000	$10
Bally's	$5	House	USAF F-16 Fighter	1000	$10
Bally's	$5	House	USAF B-2 Stealth Bomber	1000	$10
Bally's	$10	BJ	Tejano Super Weekend	1000	$20
Bally's	$25	H&C	25th Anniversary 1998	10000	$40
Bally's	$25	House	Evander Holyfield	2500	$75
Bally's	$25	House	Lennox Lewis	2500	$75
Bally's	$25	House	Millennium	1500	$40
Bally's	$100	House	Don King	500	$175
Barcelona	$5	BJ	USAF 50th Anniversary	1000	$10
Barbary Coast	$5	House	Millennium	4000	$15
Barley's	$5	H&C	1st Anniv. Glass of beer	1000	$10
Barley's	$5	H&C	1st Anniv. Sign	1000	$10
Barley's	$5	H&C	1st Anniv. Silo	1000	$10
Barley's	$5	H&C	Black Mountain 1996	500	$25
Barley's	$5	H&C	Blue Diamond 1996	500	$25
Barley's	$5	H&C	Grand Opening 1996	500	$25
Barley's	$5	H&C	Red Rock 1996	500	$25
Big Horn	$5	Chipco	Bigshot 99	1000	$10
Boardwalk	$5	H&C	Y2K	2000	$10
Boomtown	$5	BJ	1994-1997 Goodbye	1500	$15
Boomtown	$5	BJ	Big Game Feast 1996	1000	$15
Boomtown	$5	BJ	Football 1997	500	$25
Boomtown	$5	BJ	Halloween 1996	1000	$15
Boomtown	$5	BJ	July 4th 1997	1000	$15
Boomtown	$5	BJ	Labor Day 1996	1000	$15
Boomtown	$5	BJ	Memorial Day 1997	1000	$15
Boomtown	$5	BJ	New Year 1997	1000	$15
Boomtown	$5	BJ	Run For It 1997	500	$25
Boomtown	$5	BJ	Valentine's Day 1997	1000	$10
Boomtown	$5	BJ	Wake the Dragon 1996	1500	$10
Boomtown	$5	H&C	John Wain	10000	$10
Boomtown	$10	BJ	Merle Haggard	1000	$20
Boulder Station	$5	BJ	1st Anniversary 1995	1000	$10

Casino	Denom	Mold	Inlay	Mintage	Value
Boulder Station	$5	BJ	5th Anniversary		$10
Boulder Station	$5	BJ	Grand Opening 1994	5000	$20
Boulder Station	$5	BJ	Millennium	10000	$10
Boulder Station	$5	Chipco	Grand Opening August 23, 1994. 2 of 4	2000	$10
Caesars Palace	$5	H&C	Magical Empire 1996	10000	$15
Caesars Palace	$5	House	Atlantis and Palace Tower	10000	$10
Caesars Palace	$5	House	Davis Cup 9/22/95	5000	$15
Caesars Palace	$5	House	George Burns 100th B-day	10000	$25
Caesars Palace	$5	House	Planet Hollywood 1994	5000	$20
Caesars Palace	$25	Chipco	25th Anniversary	1000	$50
Caesars Palace	$25	H&C	Atlantis and Palace Tower	1000	$40
Caesars Palace	$25	H&C	Celine Dion 1998	1000	$50
Caesars Palace	$25	H&C	Magical Empire 1996	1000	$40
Caesars Palace	$25	House	Millennium	2000	$35
Caesars Palace	$25	House	Planet Hollywood 1994	1000	$40
Caesars Palace	$25	House	Davis Cup 9/22/95	1000	$40
Caesars Palace	$100	House	Millennium	500	$125
Caesars Palace	$100	H&C	Celine Dion	500	$150
Caesars Palace	$100	H&C	George Burns 100th B-Day	500	$175
California Hotel	$5	BJ	Mahalo Nui Loa 96-98	2000	$10
California Hotel	$5	H&C	Fremont Street Experience	2500	$15
California Hotel	$5	H&C	Millennium	2500	$20
California Hotel	$5	H&C	Rainbow Football 1995	2000	$10
California Hotel	$5	H&C	Rainbow Football 1997	2500	$10
California Hotel	$5	H&C	Richard Petty 1998	2500	$15
California Hotel	$5	H&C	Richard Petty 1999	3000	$10
California Hotel	$25	Chipco	Hi Cal Golf	1000	$50
California Hotel	$25	H&C	Millennium	500	$75
CBS Sports World	$1	BJ	Established 1997	1000	$5
CBS Sports World	$5	BJ	Established 1997	1000	$15
Circus Circus	NCV	Chipco	2nd Birthday Theme Park		$50
Circus Circus	$5	Chipco	30th Anniv. Bell Boy	2500	$10
Circus Circus	$5	Chipco	30th Anniv. Bldg.	2500	$10
Circus Circus	$5	Chipco	30th Anniv. Dog	2500	$10
Circus Circus	$5	Chipco	30th Anniv. Female Clown	2500	$10
Circus Circus	$5	Chipco	30th Anniv. Jester	2500	$10
Circus Circus	$5	Chipco	30th Anniv. Spitting Flame	2500	$10
Circus Circus	$5	Chipco	New Year's 2000	2000	$10
Circus Circus	$5	Chipco	Super Sunday 1999	2000	$10
Circus Circus	$5	Chipco	Super Sunday 2000	750	$15
Circus Circus	$5	Chipco	Y2C	2000	$40
Circus Circus	$25	Chipco	New Year's 1999	200	$50
Circus Circus	$100	Chipco	Jester	200	$125
Continental	$5	Chipco	15 Yr. Anniv. 1981-1996	1000	$15
Continental	$5	Chipco	15th Anniversary	1000	$15
Continental	$5	Chipco	Big Daddy's Diner	1500	$15
Continental	$5	Chipco	Cook E. Jarr Orange	1000	$20
Continental	$5	Chipco	Cook E. Jarr Purple	2000	$10
Continental	$5	Chipco	Steve Rossi, Backbeat	1000	$15
Continental	$500	Chipco	Cook E. Jarr	200	$500
Desert Inn	$5	H&C	Dennis Miller 1999	1000	$10
Desert Inn	$5	H&C	Temptations	1000	$20
Desert Inn	$25	H&C	Don Rickles New Year's 2000	1000	$75
Desert Inn	$25	H&C	Tony Bennett New Year's 2000	1000	$75
El Cortez	$1	H&C	Benny Binion, w/#	200	$10

Casino	Denom	Mold	Inlay	Mintage	Value
El Cortez	$1	H&C	Jackie Gaughan, w/#	200	$10
El Cortez	$5	H&C	Benny Binion	1800	$10
El Cortez	$5	H&C	Benny Binion, w/#	200	$20
El Cortez	$5	H&C	Fremont Street Experience	2000	$15
El Cortez	$5	H&C	Jackie Gaughan	2000	$10
El Cortez	$5	H&C	Jackie Gaughan, w/#	200	$20
El Cortez	$5	H&C	Legendary Gaughan	2000	$10
El Cortez	$25	H&C	Benny Binion w/#	200	$50
El Cortez	$25	H&C	Jackie Gaughan w/#	200	$50
El Cortez	$100	H&C	Benny Binion w/#	200	$150
El Cortez	$100	H&C	Jackie Gaughan w/#	200	$150
Eldorado	$5	H&C	1962-1997 35 Years	1500	$20
Excalibur	$5	Chipco	8th Anniversary	10000	$10
Excalibur	$5	Chipco	Austria	1500	$10
Excalibur	$5	Chipco	Dragon	1500	$10
Excalibur	$5	Chipco	France	1500	$10
Excalibur	$5	Chipco	Hungary	1500	$10
Excalibur	$5	Chipco	Ireland	1500	$10
Excalibur	$5	Chipco	Norway	1500	$10
Excalibur	$5	Chipco	Russia	1500	$10
Excalibur	$5	Chipco	Spain	1500	$10
Excalibur	$5	H&C	4th Birthday	2000	$10
Excalibur	$5	H&C	5th Anniversary	10000	$10
Fiesta	$1	Chipco	Millennium First	1000	$4
Fiesta	$1	Chipco	Millennium Last	1000	$4
Fiesta	$2.50	Chipco	Millennium First	1000	$6
Fiesta	$2.50	Chipco	Millennium Last	1000	$6
Fiesta	$5	BJ	2nd Anniversary '96	1000	$10
Fiesta	$5	BJ	3rd Anniversary/New Year	1000	$10
Fiesta	$5	BJ	4th Anniversary	1000	$10
Fiesta	$5	BJ	Carmen Basilio	1000	$10
Fiesta	$5	BJ	Christmas '96	1000	$10
Fiesta	$5	BJ	Cinco de Mayo '98	500	$10
Fiesta	$5	BJ	Duke Snyder	1000	$10
Fiesta	$5	BJ	John Buck Neil	750	$10
Fiesta	$5	BJ	Leon Spinks	750	$15
Fiesta	$5	BJ	Mahlon Duckett	1000	$10
Fiesta	$5	BJ	Mickey McDermott	750	$10
Fiesta	$5	BJ	Napolean Culley	1000	$10
Fiesta	$5	BJ	Ray Boone	750	$10
Fiesta	$5	BJ	Sam Jethroe	1000	$10
Fiesta	$5	BJ	Slam Dunk 1998 BJ Tourny	750	$10
Fiesta	$5	BJ	Ted Radcliff	1000	$10
Fiesta	$5	BJ	Tommy Henrich	1000	$10
Fiesta	$5	BJ	Verdell Mathis '97	750	$10
Fiesta	$5	BJ	Walt Dropo '97	750	$10
Fiesta	$5	Chipco	April Fools Day 1999	750	$10
Fiesta	$5	Chipco	Best of LV Gardunos	1000	$10
Fiesta	$5	Chipco	Best of LV Buffet	1000	$10
Fiesta	$5	Chipco	Best of LV Paycheck	1000	$10
Fiesta	$5	Chipco	Best of LV Video Poker	1000	$10
Fiesta	$5	Chipco	Christmas 1998	750	$10
Fiesta	$5	Chipco	Halloween 1997	1000	$10
Fiesta	$5	Chipco	Halloween 1998	1000	$10
Fiesta	$5	Chipco	Kentucky Derby 1999	750	$15

Casino	Denom	Mold	Inlay	Mintage	Value
Fiesta	$5	Chipco	Millennium First	1000	$10
Fiesta	$5	Chipco	Millennium Last	1000	$10
Fiesta	$5	Chipco	Roxy's/ Garduno's	1000	$10
Fiesta	$5	Chipco	4th of July 1999	750	$10
Fiesta	$5	H&C	10 of Clubs	750	$10
Fiesta	$5	H&C	10 of Diamonds	750	$10
Fiesta	$5	H&C	10 of Hearts	750	$10
Fiesta	$5	H&C	10 of Spades	750	$10
Fiesta	$5	H&C	1st Anniv. New Year	2500	$10
Fiesta	$5	H&C	50,000th Royal Flush	750	$10
Fiesta	$5	H&C	50th Anniv. Air Force	5000	$10
Fiesta	$5	H&C	Ace of Clubs	750	$10
Fiesta	$5	H&C	Ace of Diamonds	750	$10
Fiesta	$5	H&C	Ace of Hearts	750	$10
Fiesta	$5	H&C	Ace of Spades	750	$10
Fiesta	$5	H&C	Al Gionfriddo	650	$10
Fiesta	$5	H&C	Amos Otis	750	$10
Fiesta	$5	H&C	April Fools '97	1200	$10
Fiesta	$5	H&C	Carl Erskine	750	$10
Fiesta	$5	H&C	Carlos Palomino	750	$10
Fiesta	$5	H&C	Charles Drew	750	$10
Fiesta	$5	H&C	Charter Membership employees	200	$75
Fiesta	$5	H&C	Cinco de Mayo '96	2000	$10
Fiesta	$5	H&C	Club Royal Flush	750	$10
Fiesta	$5	H&C	Danny Lopez	750	$10
Fiesta	$5	H&C	Diamond Royal Flush	750	$10
Fiesta	$5	H&C	Dick Williams	1000	$10
Fiesta	$5	H&C	Ed Kranepool	750	$10
Fiesta	$5	H&C	Frederick Douglas	750	$10
Fiesta	$5	H&C	George Maloof	2000	$10
Fiesta	$5	H&C	Grand Opening '95	1000	$15
Fiesta	$5	H&C	Ground Hog Day '98	1000	$10
Fiesta	$5	H&C	Harriet Tubman	750	$10
Fiesta	$5	H&C	Heart Royal Flush	750	$10
Fiesta	$5	H&C	Jack of Clubs	750	$10
Fiesta	$5	H&C	Jack of Diamonds	750	$10
Fiesta	$5	H&C	Jack of Hearts	750	$10
Fiesta	$5	H&C	Jack of Spades	750	$10
Fiesta	$5	H&C	Jim Gentile	750	$10
Fiesta	$5	H&C	John Blankcaro	750	$10
Fiesta	$5	H&C	Johnny Podres	1000	$10
Fiesta	$5	H&C	King of Clubs	750	$10
Fiesta	$5	H&C	King of Diamonds	750	$10
Fiesta	$5	H&C	King of Hearts	750	$10
Fiesta	$5	H&C	King of Spades	750	$10
Fiesta	$5	H&C	Larry Sherry	650	$10
Fiesta	$5	H&C	Madame C.J. Walker	750	$10
Fiesta	$5	H&C	Mars Landing 7/4/97	1000	$10
Fiesta	$5	H&C	Norm Sherry	650	$10
Fiesta	$5	H&C	Pete Coscarart	650	$10
Fiesta	$5	H&C	Queen of Clubs	750	$10
Fiesta	$5	H&C	Queen of Diamonds	750	$10
Fiesta	$5	H&C	Queen of Hearts	750	$10
Fiesta	$5	H&C	Queen of Spades	750	$10
Fiesta	$5	H&C	Ron Swoboda	750	$10

Casino	Denom	Mold	Inlay	Mintage	Value
Fiesta	$5	H&C	Ryne Duren	750	$10
Fiesta	$5	H&C	Spade Royal Flush	750	$10
Fiesta	$5	H&C	Spider Jorgensen	750	$10
Fiesta	$5	H&C	Wrong Way Corrigan	1200	$10
Fiesta	$25	Chipco	Millennium First	200	$40
Fiesta	$25	Chipco	Millennium Last	200	$40
Fiesta	$25	Chipco	Millennium First, Last	1000	$40
Fiesta	$100	Chipco	Millennium First	100	$175
Fiesta	$100	Chipco	Millennium Last	100	$175
Fitzgerald's	$2.50	H&C	Mr. O'Lucky	1000	$5
Fitzgerald's	$5	Chipco	10th Anniversary	2500	$15
Fitzgerald's	$5	Chipco	St. Patrick's Day 1992	2000	$10
Fitzgerald's	$5	Chipco	St. Patrick's Day 1996	2500	$10
Fitzgerald's	$5	Chipco	St. Patrick's Day 1998	2000	$10
Fitzgerald's	$5	H&C	Fremont Street Experience	2500	$15
Fitzgerald's	$5	H&C	New Millennium	2000	$10
Fitzgerald's	$10	H&C	New Millennium	750	$20
Fitzgerald's	$25	H&C	New Millennium	400	$50
Fitzgerald's	$100	H&C	New Millennium	100	$175
Flamingo Hilton	$5	Chipco	New Year's Eve 1991	10000	$40
Flamingo Hilton	$5	H&C	1955 Bel Aire (misspelled)	1500	$15
Flamingo Hilton	$5	H&C	1957 Corvette	1500	$15
Flamingo Hilton	$5	H&C	1962 Starfire	1500	$15
Flamingo Hilton	$5	H&C	1964 Corvette	1500	$15
Flamingo Hilton	$5	H&C	1965 Shelby	1500	$15
Flamingo Hilton	$5	H&C	1966 Thunderbird	1500	$15
Flamingo Hilton	$5	H&C	1967 Barracuda	1500	$15
Flamingo Hilton	$5	H&C	1970 Buick GS 455	1500	$15
Flamingo Hilton	$5	H&C	1970 Corvette	1500	$15
Flamingo Hilton	$5	H&C	1970 Dodge Charger	1500	$15
Flamingo Hilton	$5	H&C	1970 Shelby	1500	$15
Flamingo Hilton	$5	H&C	1971 Cutlass	1500	$15
Flamingo Hilton	$5	H&C	Millennium	4500	$10
Flamingo Hilton	$5	H&C	Radio City Rockettes	50000	$35
Flamingo Hilton	$5	H&C	Rockettes Dancers	1500	$15
Flamingo Hilton	$5	H&C	Rockettes Dancers Kick	1500	$15
Flamingo Hilton	$5	H&C	Rockettes Dance Line	1500	$15
Flamingo Hilton	$5	House	Bugsy Siegel	50000	$10
Flamingo Hilton	$5	House	Bugsy Siegel Serial #	5000	$20
Flamingo Hilton	$25	H&C	Millennium	500	$40
Four Queens	NCV	BJ	UNLV	5000	$10
Four Queens	.25	BJ	Battle at Gonzales	500	$15
Four Queens	$1	BJ	Independence March 1836	500	$15
Four Queens	$1	H&C	Millennium	8000	$3
Four Queens	$1	H&C	Millennium Ltd. #2000	2000	$5
Four Queens	$2.50	H&C	Millennium	750	$6
Four Queens	$5	BJ	30th Anniversary	2000	$15
Four Queens	$5	BJ	Anabelle Harmon	2500	$10
Four Queens	$5	BJ	Andy Carey	1000	$10
Four Queens	$5	BJ	Ann Tran 1994	1200	$10
Four Queens	$5	BJ	Archie Moore-action	500	$15
Four Queens	$5	BJ	Archie Moore-face	500	$15
Four Queens	$5	BJ	Barbara Enright	2000	$10
Four Queens	$5	BJ	Blackjack Tournament	2500	$10
Four Queens	$5	BJ	Blue Moon Odom-face	700	$15

Casino	Denom	Mold	Inlay	Mintage	Value
Four Queens	$5	BJ	Blue Moon Odom-action	700	$15
Four Queens	$5	BJ	Brent Carter 1995	1200	$10
Four Queens	$5	BJ	Catherine Brown	1200	$10
Four Queens	$5	BJ	Dave Crunkleton 1994	1200	$10
Four Queens	$5	BJ	Dewey Weum 1994	1200	$10
Four Queens	$5	BJ	Dick Williams-action	700	$15
Four Queens	$5	BJ	Dick Williams-face	700	$15
Four Queens	$5	BJ	Don Larsen	1000	$10
Four Queens	$5	BJ	Don Larsen 5 Faces	1000	$10
Four Queens	$5	BJ	Doyle Brunson 1994	1200	$10
Four Queens	$5	BJ	Dracula 1996	1200	$10
Four Queens	$5	BJ	Enos Slaughter	1000	$10
Four Queens	$5	BJ	Faye Dancer	2500	$10
Four Queens	$5	BJ	Frankenstein 1996	1200	$10
Four Queens	$5	BJ	Gene Grumble	1200	$5
Four Queens	$5	BJ	Gill Mc Dougal	1000	$10
Four Queens	$5	BJ	Halloween Ghost 1995	1500	$10
Four Queens	$5	BJ	Halloween Pumpkin 1995	1500	$10
Four Queens	$5	BJ	Halloween R.I.P 1995	1500	$10
Four Queens	$5	BJ	Halloween Witch 1995	1500	$10
Four Queens	$5	BJ	Hank Bauer	1000	$10
Four Queens	$5	BJ	Hank Bauer- action	1000	$10
Four Queens	$5	BJ	Hank Bauer- bust	1000	$10
Four Queens	$5	BJ	Helen Campbell	2500	$10
Four Queens	$5	BJ	Herb Bronstein 1995	1200	$10
Four Queens	$5	BJ	Irv Noren- action	1000	$10
Four Queens	$5	BJ	Irv Noren- bust	1000	$10
Four Queens	$5	BJ	Israel Aug. 1995	2500	$10
Four Queens	$5	BJ	Jerry Kyle 1995	1200	$10
Four Queens	$5	BJ	Jim Boyd 1994	1200	$10
Four Queens	$5	BJ	Joey Giambra- action	500	$15
Four Queens	$5	BJ	Joey Giambra-face	500	$15
Four Queens	$5	BJ	John Bonetti 1993	1200	$10
Four Queens	$5	BJ	July 4, 1995	3000	$10
Four Queens	$5	BJ	July 4th 1996	1500	$10
Four Queens	$5	BJ	Kentucky Derby 1995	1600	$20
Four Queens	$5	BJ	Kentucky Derby 1996	1500	$15
Four Queens	$5	BJ	Labor Day 1996	1200	$10
Four Queens	$5	BJ	Memorial Day 1996	1500	$10
Four Queens	$5	BJ	Mike Sexton 1993	1200	$10
Four Queens	$5	BJ	Moose Skowron- action	1000	$10
Four Queens	$5	BJ	Moose Skowron- bust	1000	$10
Four Queens	$5	BJ	Mt. Rushmore Jefferson	500	$20
Four Queens	$5	BJ	Mt. Rushmore Lincoln	500	$20
Four Queens	$5	BJ	Mt. Rushmore Roosevelt	500	$20
Four Queens	$5	BJ	Mt. Rushmore Washington	500	$20
Four Queens	$5	BJ	New Year's 1995	1000	$10
Four Queens	$5	BJ	New Year's 2000	1000	$10
Four Queens	$5	BJ	Nilly Premrajh	1200	$10
Four Queens	$5	BJ	Pat Flemming 1995	1200	$10
Four Queens	$5	BJ	Pauline Crowley	2500	$10
Four Queens	$5	BJ	Poker Classic 1995	1000	$10
Four Queens	$5	BJ	Poker SS Jenny Kaye	500	$15
Four Queens	$5	BJ	Poker SS Peter Vilandos	500	$15
Four Queens	$5	BJ	Pok SS Hans "Tuna" Lund	500	$15

Casino	Denom	Mold	Inlay	Mintage	Value
Four Queens	$5	BJ	Ray Rumler 1991	1200	$10
Four Queens	$5	BJ	Remember the Alamo	4500	$10
Four Queens	$5	BJ	Rodeo 1997	1500	$10
Four Queens	$5	BJ	Snooker Doyle	2500	$10
Four Queens	$5	BJ	St. Patrick's Day 1995	1500	$10
Four Queens	$5	BJ	St. Patrick's Day 1996	1500	$10
Four Queens	$5	BJ	Steve Morrow, Dir.	1200	$10
Four Queens	$5	BJ	Stu Unger 1991	1200	$10
Four Queens	$5	BJ	Super Sunday 1996	4000	$15
Four Queens	$5	BJ	Superbowl 1995	1000	$15
Four Queens	$5	BJ	T.J.Cloutier 1995	1200	$10
Four Queens	$5	BJ	The Mummy 1996	1200	$10
Four Queens	$5	BJ	Thomas Chung 1992	1200	$10
Four Queens	$5	BJ	Tommy Davis- action	500	$15
Four Queens	$5	BJ	Tommy Davis- face	500	$15
Four Queens	$5	BJ	Vida Blue- action	700	$15
Four Queens	$5	BJ	Vida Blue- face	700	$15
Four Queens	$5	BJ	Vince Burgio 1992	1200	$10
Four Queens	$5	BJ	Werewolf 1996	1200	$10
Four Queens	$5	Chipco	13 Colonies (set of 13)	500	$10ea.
Four Queens	$5	Chipco	4th of July Drummer	500	$20
Four Queens	$5	Chipco	4th of July Flag	500	$20
Four Queens	$5	Chipco	4th of July Liberty Bell	500	$20
Four Queens	$5	Chipco	4th of July Signing	500	$20
Four Queens	$5	Chipco	Air Force	750	$15
Four Queens	$5	Chipco	April Fools Day 1999	750	$10
Four Queens	$5	Chipco	Army	750	$15
Four Queens	$5	Chipco	Boogie Fever		$10
Four Queens	$5	Chipco	Butch Gilliland	750	$15
Four Queens	$5	Chipco	Christmas 1998	1000	$10
Four Queens	$5	Chipco	Christmas 1999	750	$10
Four Queens	$5	Chipco	Eagle has Landed		$10
Four Queens	$5	Chipco	Father's Day 1998	1000	$10
Four Queens	$5	Chipco	Football 1999-Field	500	$20
Four Queens	$5	Chipco	Football 1999-Football	500	$20
Four Queens	$5	Chipco	Halloween 1998-Black Cat	750	$15
Four Queens	$5	Chipco	Halloween 1998-Frankenstein	750	$15
Four Queens	$5	Chipco	Halloween 1998-Pumpkin	750	$15
Four Queens	$5	Chipco	Halloween 1998-Witch	750	$15
Four Queens	$5	Chipco	Jimmy Spencer	750	$15
Four Queens	$5	Chipco	Labor Day 1998	1000	$10
Four Queens	$5	Chipco	Lance Norick	750	$15
Four Queens	$5	Chipco	Man On The Moon		$10
Four Queens	$5	Chipco	Marines	750	$15
Four Queens	$5	Chipco	Memorial Day/Indy 500	1000	$15
Four Queens	$5	Chipco	Mike Kenke	750	$15
Four Queens	$5	Chipco	Millennium Jan.	500	$15
Four Queens	$5	Chipco	Millennium Feb.	500	$15
Four Queens	$5	Chipco	Millennium March	500	$15
Four Queens	$5	Chipco	Millennium April	500	$15
Four Queens	$5	Chipco	Millennium May	500	$15
Four Queens	$5	Chipco	Millennium June	500	$15
Four Queens	$5	Chipco	Millennium July	500	$15
Four Queens	$5	Chipco	Millennium Aug.	500	$15
Four Queens	$5	Chipco	Millennium Sept.	500	$15

Casino	Denom	Mold	Inlay	Mintage	Value
Four Queens	$5	Chipco	Millennium Oct.	500	$15
Four Queens	$5	Chipco	Millennium Nov.	500	$15
Four Queens	$5	Chipco	Millennium Dec.	500	$15
Four Queens	$5	Chipco	Millennium Jan. 2000	500	$15
Four Queens	$5	Chipco	Mother's Day 1998	1000	$10
Four Queens	$5	Chipco	Navy	750	$15
Four Queens	$5	Chipco	New Years 1999	1500	$10
Four Queens	$5	Chipco	Opening of Nickel Palace	1000	$10
Four Queens	$5	Chipco	Rodeo-1998	1000	$10
Four Queens	$5	Chipco	Speedway set of 4	750	$10ea.
Four Queens	$5	Chipco	St. Patrick's Day 1998	1000	$10
Four Queens	$5	Chipco	St. Patrick's Day 1999	1000	$10
Four Queens	$5	Chipco	The Boys of Summer	1000	$15
Four Queens	$5	Chipco	Top Dog #1 Collie	500	$15
Four Queens	$5	Chipco	Top Dog #2 German Shep.	500	$15
Four Queens	$5	Chipco	Top Dog #3 Poodle	500	$15
Four Queens	$5	Chipco	Top Dog #4 Shih-Tzu	500	$15
Four Queens	$5	Chipco	Top Dog #5 Doberman	500	$15
Four Queens	$5	Chipco	Top Dog #6 Rotweiller	500	$15
Four Queens	$5	Chipco	Top Dog #7 Gold Retriever	500	$15
Four Queens	$5	Chipco	Year of the Rabbit	1999	$10
Four Queens	$5	Chipco	Year of the Tiger	1000	$15
Four Queens	$5	H&C	57 Chevy	750	$15
Four Queens	$5	H&C	Bud Bowl 2000	1000	$15
Four Queens	$5	H&C	Christmas 1997	1500	$10
Four Queens	$5	H&C	Fremont Street Exp.	2500	$15
Four Queens	$5	H&C	Halloween 1999	999	$15
Four Queens	$5	H&C	Labor Day 1999	750	$10
Four Queens	$5	H&C	Millennium	1000	$10
Four Queens	$5	H&C	New Year's 1996	2500	$15
Four Queens	$5	H&C	New Year's 1998	2500	$10
Four Queens	$5	H&C	NFR Rodeo 1999	750	$10
Four Queens	$5	H&C	Oscar Goodman	250	$35
Four Queens	$5	H&C	Super Bowl 1998	2500	$10
Four Queens	$5	H&C	Thanksgiving 1997	1500	$10
Four Queens	$5	H&C	Thanksgiving 1999	100	$50
Four Queens	$5	H&C	Valentine's Day 1998	1500	$10
Four Queens	$10	BJ	Defeat of Santa Ana	500	$30
Four Queens	$10	BJ	Four Queens Clubs 1995	2500	$15
Four Queens	$10	BJ	Four Queens Diamonds 1995	2500	$15
Four Queens	$10	BJ	Four Queens Hearts 1995	2500	$15
Four Queens	$10	BJ	Four Queens Spades 1995	2500	$15
Four Queens	$20	Chipco	Best Of The Bunch	777	$25
Four Queens	$25	BJ	Admission to Union	500	$40
Four Queens	$25	H&C	New Year's 2000	250	$50
Four Queens	$25	Chipco	April Fools Day 1999	500	$40
Four Queens	$25	Chipco	St. Patrick's Day 1998	500	$40
Four Queens	$25	H&C	57 Chevy	150	$60
Four Queens	$25	H&C	Bud Bowl 2000	300	$50
Four Queens	$25	H&C	Christmas 1999	100	$60
Four Queens	$25	H&C	Halloween 1999	444	$50
Four Queens	$25	H&C	Millennium	250	$50
Four Queens	$25	H&C	NFR Rodeo 1999	150	$50
Four Queens	$25	H&C	Oscar Goodman	250	$40
Four Queens	$25	H&C	Thanksgiving 1999	100	$50

357

Casino	Denom	Mold	Inlay	Mintage	Value
Four Queens	$100	BJ	First Texas Oil Well	500	$150
Four Queens	$100	BJ	Hugo's Cellar 1995	2500	$100
Four Queens	$100	H&C	Bud Bowl 2000	100	$175
Four Queens	$100	H&C	Millennium	100	$175
Four Queens	$100	H&C	New Year's 2000	100	$175
Four Queens	$100	H&C	Oscar Goodman	100	$200
Fremont	$5	BJ	Mahalo Nui Loa 1996- 97	2000	$15
Fremont	$5	Chipco	40th Anniversary	3000	$10
Frontier	$5	H&C	Arie Luyendyk	1500	$15
Fremont	$5	H&C	Fremont St. Experience	3000	$15
Fremont	$5	H&C	Millennium	5000	$10
Fremont	$5	H&C	Richard Petty 1998	2500	$15
Fremont	$5	H&C	Richard Petty 1999	3000	$10
Fremont	$25	H&C	Millennium	1000	$50
Frontier	$5	H&C	Scott Goodyear	1500	$50
Frontier	$25	H&C	Arie Luyendyk	1000	$50
Frontier	$25	H&C	Scott Goodyear	1000	$50
Gold Coast	$5	H&C	Jakes Barnes	5200	$10
Gold Coast	$5	H&C	Joe Baumgardner	5200	$10
Gold Coast	$5	H&C	Joe Beaver	5200	$10
Gold Coast	$5	H&C	Ote Berry	5200	$10
Gold Coast	$5	H&C	Rockabilly Weekend	2000	$15
Gold Coast	$5	House	Bodacious	5250	$10
Gold Coast	$5	House	Bruce Ford	1000	$10
Gold Coast	$5	House	Charles Sampson 1997	5350	$10
Gold Coast	$5	House	Clint Johnson	1000	$10
Gold Coast	$5	House	Dan Mortensen	1000	$10
Gold Coast	$5	House	Don Gay 1997	5350	$10
Gold Coast	$5	House	Jim Sharp 1997	5350	$10
Gold Coast	$5	House	Lane Frost	5250	$10
Gold Coast	$5	House	Lewis Field	1000	$10
Gold Coast	$5	House	Millennium	2500	$10
Gold Coast	$5	House	Redrock	5250	$10
Gold Coast	$5	House	Tuff Hedeman	5250	$10
Gold Coast	$5	House	Wolfman 1997	5350	$10
Gold Coast	$25	House	Bodacious 1994, 1995 Bull of the Year	1100	$40
Gold Coast	$25	House	Bruce Ford	500	$40
Gold Coast	$25	House	Charles Sampson 1997	900	$40
Gold Coast	$25	House	Clint Johnson	500	$40
Gold Coast	$25	House	Don Gay 1997	900	$40
Gold Coast	$25	House	Jim Sharp 1997	900	$40
Gold Coast	$25	House	Lane Frost 1987 Champ.	1100	$40
Gold Coast	$25	House	Lewis Field	500	$40
Gold Coast	$25	House	Red Rock 1987 Bull of the Year	1100	$40
Gold Coast	$25	House	Tuff Hedeman 1986, 1989, 1991 Champ.	1100	$40
Gold Coast	$25	House	Wolfman 1997	900	$40
Golden Gate	$5	H&C	90th Anniversary	2500	$10
Golden Gate	$5	H&C	Fremont St. Experience	2500	$10
Golden Gate	$5	H&C	Millennium	500	$15
Golden Gate	$5	H&C	Shrimp Cocktail	3000	$10
Golden Gate	$25	H&C	Christmas/Piano	250	$50
Golden Gate	$25	H&C	Millennium	250	$50
Golden Gate	$100	H&C	Millennium	100	$175
Golden Nugget	$5	H&C	Fremont St. Experience	2500	$15
Golden Nugget	$5	House	1946-1996 50th Anniversary	50000	$10

Casino	Denom	Mold	Inlay	Mintage	Value
Golden Nugget	$5	House	Millennium	20000	$10
Golden Nugget	$25	House	1946-1996 50th Anniversary	15000	$35
Golden Nugget	$25	House	Millennium	7500	$35
Golden Nugget	$100	House	1946-1996 50thAnniversary	2500	$120
Golden Nugget	$100	House	Millennium	500	$150
Gold Strike	$5	BJ	4th of July 1995	1500	$20
Gold Strike	$5	BJ	4th Of July 1996	1500	$20
Gold Strike	$5	BJ	4th of July 1997	1500	$20
Gold Strike	$5	BJ	Big Horn Ram 1996	1500	$20
Gold Strike	$5	BJ	Christmas '96/New Year's '97	1500	$20
Gold Strike	$5	BJ	Doby Doc 1996	1500	$20
Gold Strike	$5	BJ	Gold Strike Inn 1996	1500	$20
Gold Strike	$5	BJ	Halloween 1995	1500	$20
Gold Strike	$5	BJ	Hoover Dam 1996	1500	$20
Gold Strike	$5	BJ	Labor Day 1996	1500	$20
Gold Strike	$5	BJ	Labor Day 9/4/95	1500	$20
Gold Strike	$5	BJ	Lake Mead 1996	1500	$20
Gold Strike	$5	BJ	Olympics 5/1/96	1500	$20
Gold Strike	$5	BJ	R.I.P. 1996	1000	$20
Gold Strike	$5	BJ	River Rafting 1996	1500	$20
Hacienda-BC	$5	BJ	Grand Opening	1500	$10
Hacienda-BC	$25	BJ	Grand Opening	500	$40
Hacienda	$5	H&C	Corrida De Toros 6/8/96	1000	$20
Hacienda	$10	H&C	BJ Tournament Aug. 1996	1000	$30
Hacienda	$100	H&C	Final Sunset/Final Flight	500	$275
Hard Rock	$5	H&C	4th of July – ERROR	2	$250
Hard Rock	$5	H&C	4th of July 1997	5000	$20
Hard Rock	$5	H&C	4th of July 1998	5000	$15
Hard Rock	$5	H&C	Barris Ala Kart	1375	$50
Hard Rock	$5	H&C	Barris Hirobata Merc	1375	$50
Hard Rock	$5	H&C	Barris Kopper Kart	1375	$50
Hard Rock	$5	H&C	Barris The Emperor	1375	$50
Hard Rock	$5	H&C	Christmas 1995	5000	$30
Hard Rock	$5	H&C	Christmas 1996	7500	$20
Hard Rock	$5	H&C	Christmas 1998	5000	$15
Hard Rock	$5	H&C	Christmas 1999	5000	$10
Hard Rock	$5	H&C	Christmas w/angel 1997	3750	$15
Hard Rock	$5	H&C	Christmas w/building 1997	3750	$15
Hard Rock	$5	H&C	CON AIR 1997	5000	$30
Hard Rock	$5	H&C	Fairway to Heaven 1997	2500	$40
Hard Rock	$5	H&C	Fairway to Heaven 1999		$40
Hard Rock	$5	H&C	Fairway to Heaven 1999	2000	$25
Hard Rock	$5	H&C	First Anniversary	20000	$10
Hard Rock	$5	H&C	Halloween 1996	2500	$25
Hard Rock	$5	H&C	Halloween 1997	7500	$20
Hard Rock	$5	H&C	Halloween 1998	5000	$15
Hard Rock	$5	H&C	Halloween 1999	5000	$20
Hard Rock	$5	H&G	Hoops in Las Vegas	5000	$15
Hard Rock	$5	H&C	Hootie/New Year's 1997	10000	$25
Hard Rock	$5	H&C	King of the Beach 1997	5000	$20
Hard Rock	$5	H&C	King of the Beach 1998	5000	$15
Hard Rock	$5	H&C	Marilyn Manson	5000	$20
Hard Rock	$5	H&C	Mellencamp 1/23/98	5000	$20
Hard Rock	$5	H&C	Millennium	10000	$15
Hard Rock	$5	H&C	Neville Brothers 1997	5000	$20

Casino	Denom	Mold	Inlay	Mintage	Value
Hard Rock	$5	H&C	Roth Cars Beatnick Bandit	625	$100
Hard Rock	$5	H&C	Roth Cars Mysterion	625	$100
Hard Rock	$5	H&C	Roth Cars Outlaw	625	$100
Hard Rock	$5	H&C	Roth Cars Road Agent	625	$100
Hard Rock	$5	H&C	Sheryl Crow	5000	$30
Hard Rock	$5	H&C	Valentine's Day 1997	5000	$20
Hard Rock	$5	H&C	Valentine's Day 1998	5000	$15
Hard Rock	$5	H&C	ZZ Top	5000	$30
Hard Rock	$25	H&C	Billy Joel 1999	5000	$40
Hard Rock	$25	H&C	Rolling Stones	10000	$40
Hard Rock	$100	H&C	Tom Petty	5000	$125
Hard Rock	$100	H&C	Tom Petty – ERROR	2	$250
Harrah's	$5	H&C	60th Anniversary	1000	$10
Harrah's	$5	H&C	Carnivale of Poker	1000	$10
Harrah's	$5	H&C	Carnivale of Poker	1000	$10
Harrah's	$5	H&C	Football 1995	2000	$15
Harrah's	$5	H&C	I Kicked the Dealer's Butt	5000	$10
Harrah's	$5	H&C	Party Animal 1995	5000	$10
Harrah's	$5	House	Millennium	2000	$10
Harrah's	$25	House	Millennium	500	$35
Hilton	$5	Chipco	Starlight Express Electra		$15
Hilton	$5	Chipco	Starlight Express GVS Ball		$15
Hilton	$5	Chipco	Starlight Express Pearl		$15
Hilton	$5	Chipco	Starlight Express Poppa		$15
Hilton	$5	Chipco	Starlight Express Rusty		$15
Hilton	$5	House	Barron Hilton	2000	$15
Hilton	$5	House	Clubs	1000	$10
Hilton	$5	House	Diamonds	1000	$10
Hilton	$5	House	Hearts	1000	$10
Hilton	$5	House	Spades	1000	$10
Hilton	$5	House	50th Anniv. Air Force	5000	$15
Hilton	$25	House	Clubs	1000	$40
Hilton	$25	House	Diamonds	1000	$40
Hilton	$25	House	Hearts	1000	$40
Hilton	$25	House	Spades	1000	$40
Hilton	$25	House	Evander Holyfield	2500	$60
Hilton	$25	House	Lennox Lewis	2500	$60
Hilton	$100	House	Don King/Holyfield-Lewis	1000	$150
Holiday Inn	$5	H&C	Grand Opening	2000	$15
Holiday Inn	$5	H&C	Grand Opening 1995	4000	$15
Holiday Inn	$5	H&C	Ring in the New Year	1500	$15
Horseshoe, Binion's	$2.50	H&C	Amarillo Slim Preston	1000	$15
Horseshoe, Binion's	$2.50	H&C	Benny Binion	1000	$15
Horseshoe, Binion's	$2.50	H&C	Berry Johnston	1000	$15
Horseshoe, Binion's	$2.50	H&C	Bill Smith	1000	$15
Horseshoe, Binion's	$2.50	H&C	Bobby Baldwin	1000	$15
Horseshoe, Binion's	$2.50	H&C	Brad Daugherty	1000	$15
Horseshoe, Binion's	$2.50	H&C	Dan Harrington	1000	$15
Horseshoe, Binion's	$2.50	H&C	Dan Harrington 1995	2000	$20
Horseshoe, Binion's	$2.50	H&C	Doyle Brunson	1000	$15
Horseshoe, Binion's	$2.50	H&C	Hal Fowler	1000	$15
Horseshoe, Binion's	$2.50	H&C	Hamid Dastmalchi	1000	$15
Horseshoe, Binion's	$2.50	H&C	Huck Seed	2500	$10
Horseshoe, Binion's	$2.50	H&C	Jack Keller	1000	$15
Horseshoe, Binion's	$2.50	H&C	Jack Strauss	1000	$15

Casino	Denom	Mold	Inlay	Mintage	Value
Horseshoe, Binion's	$2.50	H&C	Jim Bechtel	1000	$15
Horseshoe, Binion's	$2.50	H&C	Johnny Chan	1000	$15
Horseshoe, Binion's	$2.50	H&C	Johnny Moss	1000	$15
Horseshoe, Binion's	$2.50	H&C	Mansour Matloubi	1000	$15
Horseshoe, Binion's	$2.50	H&C	Phil Hellmuth	1000	$15
Horseshoe, Binion's	$2.50	H&C	Puggy Pearson	1000	$15
Horseshoe, Binion's	$2.50	H&C	Russ Hamilton	1500	$15
Horseshoe, Binion's	$2.50	H&C	Sailor Roberts	1000	$15
Horseshoe, Binion's	$2.50	H&C	Stu Unger	5000	$15
Horseshoe, Binion's	$2.50	H&C	Stu Unger 1997	1000	$15
Horseshoe, Binion's	$2.50	H&C	Thuan Nguyen	1000	$10
Horseshoe, Binion's	$2.50	H&C	Tom McEvoy	1000	$15
Horseshoe, Binion's	$5	Chipco	WSOP Stu Unger 1999		$15
Horseshoe, Binion's	$5	H&C	Amarillo Slim Preston	2000	$20
Horseshoe, Binion's	$5	H&C	Barbara Enwright	1000	$20
Horseshoe, Binion's	$5	H&C	Barbara Freer	1000	$20
Horseshoe, Binion's	$5	H&C	Barbara Samuelson	1000	$20
Horseshoe, Binion's	$5	H&C	Benny Binion	2000	$20
Horseshoe, Binion's	$5	H&C	Bill Boyd	2000	$20
Horseshoe, Binion's	$5	H&C	Binion's-Millennium '75	1000	$20
Horseshoe, Binion's	$5	H&C	Bloundie Forbes	2000	$20
Horseshoe, Binion's	$5	H&C	Corky McCorqudale	2000	$20
Horseshoe, Binion's	$5	H&C	David Reese	2000	$20
Horseshoe, Binion's	$5	H&C	Doyle Brunson	2000	$20
Horseshoe, Binion's	$5	H&C	Edmund Hoyle	2000	$20
Horseshoe, Binion's	$5	H&C	Fremont Street Experience	5000	$15
Horseshoe, Binion's	$5	H&C	Henry Green	2000	$20
Horseshoe, Binion's	$5	H&C	Hotel Apache-Millenium	1000	$20
Horseshoe, Binion's	$5	H&C	Jack Keller	2000	$20
Horseshoe, Binion's	$5	H&C	Millennium 2000	1000	$20
Horseshoe, Binion's	$5	H&C	Joe Bernstein	2000	$20
Horseshoe, Binion's	$5	H&C	Johnny Moss	2000	$20
Horseshoe, Binion's	$5	H&C	Little Man Popwell	2000	$15
Horseshoe, Binion's	$5	H&C	Marsha Waggoner	1000	$20
Horseshoe, Binion's	$5	H&C	Murph Harold	2000	$20
Horseshoe, Binion's	$5	H&C	Nick the Greek	2000	$20
Horseshoe, Binion's	$5	H&C	Puggy Pearson	2000	$20
Horseshoe, Binion's	$5	H&C	Red Hodges	2000	$20
Horseshoe, Binion's	$5	H&C	Red Wynn	2000	$20
Horseshoe, Binion's	$5	H&C	Rodeo 1995	5000	$15
Horseshoe, Binion's	$5	H&C	Roger Moore	2000	$20
Horseshoe, Binion's	$5	H&C	Sarge Ferris	2000	$20
Horseshoe, Binion's	$5	H&C	Sid Wyman	2000	$20
Horseshoe, Binion's	$5	H&C	Tom Abdo	2000	$20
Horseshoe, Binion's	$5	H&C	Treetop Strauss	2000	$20
Horseshoe, Binion's	$5	H&C	Wendeen Eolis	1000	$20
Horseshoe, Binion's	$5	H&C	Wild Bill Hickok	2000	$20
Horseshoe, Binion's	$10	H&C	Johnny Moss 1907-1995	1000	$25
Horseshoe, Binion's	$10	H&C	Johnny Moss 1970	1000	$25
Horseshoe, Binion's	$10	H&C	Johnny Moss 1974	1000	$25
Horseshoe, Binion's	$10	H&C	Johny Moss 1971	1000	$25
Horseshoe, Binion's	$10	H&C	Poker 1995	5000	$15
Horseshoe, Binion's	$25	Chipco	WSOP Johnny Moss 1999	500	$40
Horseshoe, Binion's	$100	Chipco	WSOP Benny Binion 1999	500	$125
Imperial Palace	$5	H&C	15th Anniversary Auto Collection	5000	$15

Casino	Denom	Mold	Inlay	Mintage	Value
Imperial Palace	$5	H&C	20th Anniv. 1976-1996	5000	$15
Imperial Palace	$5	H&C	50th Anniversary Air Force	5000	$20
Imperial Palace	$5	H&C	Football 1996	5000	$15
Imperial Palace	$5	H&C	Football 1997	5000	$15
Imperial Palace	$5	H&C	Millennium	7500	$20
Imperial Palace	$5	H&C	Ralph Englestad Owner	1500	$10
Imperial Palace	$25	H&C	Millennium	5000	$75
Jerry's Nugget	$5	BJ	1964 Corvette	1000	$20
Jerry's Nugget	$5	BJ	1964 GTO	1000	$15
Jerry's Nugget	$5	BJ	1964 Mustang	1000	$15
Jerry's Nugget	$5	BJ	35th Anniversary 64-99	535	$20
Jerry's Nugget	$5	BJ	Chief Joseph	500	$15
Jerry's Nugget	$5	BJ	Cinco de Mayo 1997	1000	$15
Jerry's Nugget	$5	BJ	Cinco de Mayo 1998	500	$15
Jerry's Nugget	$5	BJ	Cinco de Mayo 1999	500	$15
Jerry's Nugget	$5	BJ	Fam. Lawman Bill Hickok	500	$15
Jerry's Nugget	$5	BJ	Fam. Lawman Pat Garrett	500	$15
Jerry's Nugget	$5	BJ	Famous Lawman Wyatt Earp	500	$15
Jerry's Nugget	$5	BJ	Geronimo	500	$15
Jerry's Nugget	$5	BJ	Halloween 1997	1000	$15
Jerry's Nugget	$5	BJ	Millennium	2000	$10
Jerry's Nugget	$5	BJ	Sitting Bull	500	$15
Key Largo	$5	BJ	Grand Opening 1997	2500	$15
Lady Luck	$5	BJ	St. Patrick's Day 1997	1001	$15
Lady Luck	$5	Chipco	Fishing Derby 1997/Fathers Day	1111	$10
Lady Luck	$5	Chipco	Memorial Day 1997	1100	$10
Lady Luck	$5	Chipco	Millennium	2000	$15
Lady Luck	$5	H&C	Happy Birthday to You	1000	$10
Lady Luck	$5	H&C	New Year 1996	3000	$10
Lady Luck	$5	H&C	Oktoberfest 1995	2500	$10
Lady Luck	$5	H&C	Puttin on the Ritz 1995	3000	$10
Lady Luck	$5	H&C	Rodeo 1995	1500	$10
Lady Luck	$5	H&C	Super Bowl XXX	1500	$15
Lady Luck	$7.50	BJ	April Fool's Day 1997	1001	$15
Lady Luck	$10	Chipco	Kentucky Derby 1997	1111	$25
Lady Luck	$10	Chipco	Puttin on the Ritz 1997	1111	$20
Lady Luck	$25	Chipco	Millennium	150	$50
Lady Luck	$25	Chipco	Puttin on the Ritz 1998	500	$50
Lady Luck	$25	H&C	Gary Garrison Roast	500	$50
Lady Luck	$100	Chipco	Millennium	100	$175
Lady Luck	$100	Chipco	Puttin on the Ritz 1998	250	$125
Las Vegas Club	$5	BJ	4th of July 1995	1500	$15
Las Vegas Club	$5	H&C	Christmas/New Year's 1995	1500	$15
Las Vegas Club	$5	H&C	Fremont Street Experience	2500	$15
Las Vegas Club	$10	BJ	Bob Feller	1500	$25
Las Vegas Club	$10	BJ	Dizzy Dean 1995	1500	$25
Las Vegas Club	$10	BJ	Home Run Chip 1927 Babe Ruth/Lou Gehrig	1500	$30
Las Vegas Club	$10	BJ	Jesse Owens 1936-1996	1500	$25
Las Vegas Club	$10	BJ	Shoeless Joe Jackson 1995	1500	$25
Las Vegas Club	$25	BJ	Ty Cobb	1500	$50
Las Vegas Club	$100	BJ	Babe Ruth 1995	1500	$150
Ligouri's	$1	H&C	Jewel of the Desert	1000	$10
Ligouri's	$1	H&C	7 Stud Hi/Lo Serial #	300	$10
Ligouri's	$1	H&C	7 Stud Hi/Lo	2000	$10
Ligouri's	$5	H&C	Jewel of the Desert	1000	$15

Casino	Denom	Mold	Inlay	Mintage	Value
Ligouri's	$5	H&C	7 Stud Hi/Lo	1000	$15
Ligouri's	$5	H&C	7 Stud Hi/Lo Serial #	300	$20
Ligouri's	$10	H&C	Jewel of the Desert	1500	$25
Ligouri's	$25	H&C	Jewel of the Desert	100	$60
Ligouri's	$25	H&C	7 Stud Hi/Lo Serial #	300	$50
Longhorn	.50	H&C	Longhorn Days	1000	$10
Longhorn	$5	H&C	8th Anniversary	888	$15
Longhorn	$5	H&C	9th Anniversary 1998	999	$10
Longhorn	$5	H&C	Longhorn Days	1000	$10
Longhorn	$5	H&C	Rodeo 1995	3000	$10
Longhorn, Joe's	$5	H&C	Rodeo 1995	2000	$15
Longhorn	$25	H&C	Longhorn Days	1000	$40
Longhorn	$100	H&C	7th Anniversary	500	$120
Luxor	$5	BJ	3rd Anniversary	2000	$15
Luxor	$5	BJ	Millennium	2500	$10
Luxor	$5	BJ	New Year's 1997	2500	$10
Luxor	$5	BJ	Rodeo 1996	2500	$10
Luxor	$5	Chipco	5th Anniversary	2500	$10
Luxor	$5	Chipco	World Cup Soccer 1994	5000	$20
Luxor	$5	H&C	1st Anniversary	3000	$15
Luxor	$5	H&C	Happy New Year 1996	2000	$10
Luxor	$5	H&C	New Year's 1996	2000	$10
Luxor	$5	H&C	Rodeo 1994	5000	$10
Luxor	$5	H&C	Rodeo 1995	2500	$10
Luxor	$5	H&C	Super Bowl 1996	3000	$10
Luxor	$5	H&C	Valentine's Day 1996	2000	$10
Luxor	$8	H&C	Year of the Rat 1996	3888	$15
Luxor	$10	Chipco	2nd Anniversary	5000	$20
Luxor	$25	BJ	Millennium	1000	$50
Luxor	$100	BJ	Millennium	500	$175
Luxor	$2000	BJ	Millennium	3 sold	$2000
Main St. Station	$5	BJ	Mahalo 1996-1997	3000	$10
Main St. Station	$5	H&C	Millennium	2500	$15
Main St. Station	$5	H&C	Mucha Artist Lady #1	1000	$50
Main St. Station	$5	H&C	Mucha Artist Lady #2	1000	$25
Main St. Station	$5	H&C	Mucha Artist Lady #3	1000	$25
Main St. Station	$5	H&C	Mucha Artist Lady #4	1000	$25
Main St. Station	$5	H&C	Mucha Artist Lady #5	1000	$25
Main St. Station	$5	H&C	Mucha Artist Lady #6	1000	$25
Main St. Station	$5	H&C	Mucha Artist Lady #7	1000	$25
Main St. Station	$5	H&C	Richard Petty 1998	2500	$10
Main St. Station	$5	H&C	Richard Petty 1999	1000	$10
Main St. Station	$25	H&C	Millennium	500	$50
Mandalay Bay	$5	H&C	Oscar de la Hoya	2000	$15
Mandalay Bay	$5	H&C	Radio Music Awards	500	$15
Mandalay Bay	$5	House	Don King	500	$10
Mandalay Bay	$5	House	Grand Opening	2000	$15
Mandalay Bay	$5	House	Holyfield/Lewis	1000	$25
Mandalay Bay	$5	House	House of Blues	2000	$15
Mandalay Bay	$5	House	Luciano Pavarotti	2000	$15
Mandalay Bay	$5	House	Radio Music Awards	500	$20
Mandalay Bay	$25	H&C	Oscar de la Hoya	500	$50
Mandalay Bay	$25	H&C	Radio Music Awards	100	$75
Mandalay Bay	$25	House	Don King	100	$35
Mandalay Bay	$25	House	Grand Opening	500	$50

Casino	Denom	Mold	Inlay	Mintage	Value
Mandalay Bay	$25	House	Holyfield//Lewis	400	$45
Mandalay Bay	$25	House	House of Blues	500	$50
Mandalay Bay	$25	House	Luciano Pavarotti	500	$50
Mandalay Bay	$25	House	Oscar de La Hoya/Trinidad	400	$100
Mandalay Bay	$25	House	Radio Music Awards	100	$60
Mandalay Bay	$25	House	Millennium	1200	$75
Mandalay Bay	$100	House	Millennium	200	$150
Mandalay Bay	$100	House	Oscar de La Hoya/Trinidad	100	$300
MGM Grand	NCV	H&C	Derby Day 1997		$100
MGM Grand	$5	BJ	Betty Boop	10000	$40
MGM Grand	$5	BJ	Grand Opening 1993	2000	$35
MGM Grand	$5	BJ	Julio Caesar Chavez	1000	$30
MGM Grand	$5	H&C	EFX Michael Crawford	20000	$10
MGM Grand	$5	H&C	Kirk Kerkorian		$25
MGM Grand	$5	H&C	Mortal Enemies 1995	7500	$15
MGM Grand	$5	House	Millennium	5000	$10
MGM Grand	$10	H&C	Tyson/Holyfield II 1997	2000	$25
MGM Grand	$10	H&C	Tyson/Botha 98	1000	$20
MGM Grand	$25	H&C	Bruno/Tyson	2500	$50
MGM Grand	$25	H&C	George Foreman 1995	2500	$50
MGM Grand	$25	H&C	Tyson/Botha	500	$60
MGM Grand	$25	H&C	Tyson/Bruno 1996	2000	$40
MGM Grand	$25	H&C	Tyson/Holyfield II	2500	$50
MGM Grand	$25	H&C	Tyson-He's Back	2000	$50
MGM Grand	$25	H&C	Seldon/Tyson 7/13/96	2000	$50
MGM Grand	$25	H&C	Seldon/Tyson 9/7/96	2000	$50
MGM Grand	$25	H&C	Tyson/Holyfield 11/9/96	2000	$50
MGM Grand	$25	H&C	Tyson/Mathis	2000	$50
MGM Grand	$25	House	5th Anniversary	1000	$50
MGM Grand	$25	House	Millennium	2500	$40
MGM Grand	$100	H&C	Bruno/Tyson	2000	$175
MGM Grand	$100	H&C	Tyson/Botha	100	$135
MGM Grand	$100	H&C	Tyson/Holyfield II	1000	$175
MGM Grand	$100	H&C	Tyson/McNeely	2000	$175
MGM Grand	$100	H&C	Tyson/Holyfield #1	1500	$175
MGM Grand	$100	H&C	Tyson/Mathis 11/4/95	2000	$175
MGM Grand	$100	H&C	Seldon/Tyson 7/13/96	2000	$175
MGM Grand	$100	H&C	Seldon/Tyson 9/7/96	2000	$175
MGM Grand	$100	House	Millennium	2500	$175
MGM Grand	$500	House	Millennium	500	$500
MGM Grand	$500	H&C	Tyson/Holyfield II	100	$600
Mirage	$5	House	Siegfried & Roy	20000	$10
Monte Carlo	$5	Chipco	Racing	2000	$15
Monte Carlo	$5	H&C	1st Anniversary 1997	1200	$15
Monte Carlo	$5	H&C	2nd Anniversary 1998	1200	$15
Monte Carlo	$5	H&C	Brewmaster's Special	1200	$15
Monte Carlo	$5	H&C	Grand Opening	10000	$10
Monte Carlo	$5	H&C	High Roller Red	1200	$15
Monte Carlo	$5	H&C	Jackpot Pale	1200	$15
Monte Carlo	$5	H&C	Lance Burton	10000	$10
Monte Carlo	$5	H&C	Las Vegas Lights/Maroon	600	$15
Monte Carlo	$5	H&C	Las Vegas Lights/Purple	600	$15
Monte Carlo	$5	H&C	Millennium	1200	$15
Monte Carlo	$5	H&C	Silver State Stout	1200	$15
Monte Carlo	$5	H&C	Winner's Wheat	1200	$15

Casino	Denom	Mold	Inlay	Mintage	Value
Monte Carlo	$25	H&C	Millennium	500	$40
Monte Carlo	$100	H&C	Millennium	200	$175
Nevada Palace	$1	BJ	20th Anniversary	1000	$4
Nevada Palace	$1	BJ	Gaming Times Show 1998	2000	$3
Nevada Palace	$2.50	BJ	20th Anniversary	500	$10
Nevada Palace	$2.50	BJ	Gaming Times Show 1998	1000	$5
Nevada Palace	$5	BJ	20th Anniversary	1000	$10
Nevada Palace	$5	BJ	Christmas 1996	1000	$10
Nevada Palace	$5	BJ	Gaming Times 1998/Dancer	750	$10
Nevada Palace	$5	BJ	Gaming Times 1998/Sunset	750	$10
Nevada Palace	$5	BJ	Halloween 1995	1000	$10
Nevada Palace	$5	BJ	New Year's 1996	2500	$10
Nevada Palace	$5	BJ	New Year's 1997	1000	$10
Nevada Palace	$5	BJ	Oktoberfest 1995	1000	$10
Nevada Palace	$5	BJ	Oktoberfest 1996	1000	$10
Nevada Palace	$5	BJ	Oktoberfest 1997	2000	$10
Nevada Palace	$5	BJ	St. Patrick's Day 1997	1000	$10
Nevada Palace	$25	BJ	20th Anniversary	100	$100
Nevada Palace	$5	H&C	Oktoberfest 1998	1000	$10
New Frontier	$5	BJ	Millennium	3000	$15
New Frontier	$5	H&C	Millennium	5000	$10
New Frontier	$5	H&C	Gilley's Grand Opening	2000	$10
New Frontier	$25	BJ	Millennium	500	$60
New Frontier	$25	H&C	Gilley's Grand Opening	300	$50
New York NY	NCV	H&C	Derby Day 97		$100
New York NY	$5	H&C	Millennium	5000	$10
New York NY	$10	H&C	Grand Opening	10000	$15
New York NY	$10	H&C	1st Anniversary	2500	$25
New York NY	$100	H&C	Millennium	150	$125
New York NY	$25	H&C	1st Anniversary	1000	$40
New York NY	$500	H&C	Millennium	75	$500
New York NY	$1000	H&C	Millennium	25	$1000
Opera House	$5	BJ	St. Patrick's Day 1996	2000	$10
Opera House	$5	Chipco	All Star Baseball 1997	888	$20
Opera House	$5	Chipco	April Fool's Day 1997	1000	$15
Opera House	$5	Chipco	Armchair Quarterback 1997	1000	$15
Opera House	$5	Chipco	Armchair Quarterback 1998 (never released)		
Opera House	$5	Chipco	Baseball Best 1998	888	$15
Opera House	$5	Chipco	Christmas 1998	888	$15
Opera House	$5	Chipco	Halloween 1997	1000	$15
Opera House	$5	Chipco	Halloween 1998	888	$15
Opera House	$5	Chipco	Halloween 1999	777	$40
Opera House	$5	Chipco	Happy Holidays 1996	1500	$10
Opera House	$5	Chipco	Memorial Day 1998	888	$15
Opera House	$5	Chipco	Memorial Day 1997	1200	$15
Opera House	$5	Chipco	Mother's Day 1997	1200	$15
Opera House	$5	Chipco	New Year's 1997	1500	$10
Opera House	$5	Chipco	St. Patrick's Day 1997	1000	$15
Opera House	$5	Chipco	St. Patrick's Day 1998	888	$15
Opera House	$5	Chipco	St. Patrick's Day 1998	888	$15
Opera House	$5	Chipco	Thanksgiving 1996	1500	$10
Opera House	$5	Chipco	Thanksgiving 1997	888	$15
Opera House	$5	Chipco	Thanksgiving 1998	888	$15
Opera House	$5	Chipco	Valentine's Day 1997	1000	$15
Opera House	$5	Chipco	Valentine's Day 1998	888	$15

Casino	Denom	Mold	Inlay	Mintage	Value
Opera House	$5	Chipco	Y2 Win	888	$10
Opera House	$5	Chipco	4th of July 1996	1000	$15
Opera House	$5	H&C	Easter 1996	1000	$20
Opera House	$5	H&C	Phantom of the Opera	1200	$10
Opera House	$5	H&C	4th of July 1997	1000	$15
Opera House	$7.50	BJ	I Blackjacked the Dealer	750	$20
Opera House	$25	H&C	Fat Lady	800	$35
Opera House	$100	H&C	Skinny Lady	300	$125
Orleans	$5	H&C	6th Annual Convention	1000	$15
Orleans	$5	H&C	7th Annual Convention	2000	$10
Orleans	$5	H&C	Poker Tournament 1997	3000	$15
Orleans	$5	H&C	Poker Tournament 1998	1500	$10
Orleans	$5	H&C	Poker Tournament 1999	1500	$10
Orleans	$5	House	Grand Opening	3000	$15
Orleans	$5	House	Millennium	4000	$10
Palace Station	$5	BJ	20th Anniversary 1996	1500	$20
Palace Station	$5	BJ	Cards set of 4	2000	$10
Palace Station	$5	Chipco	Opening Date July 76 1 of 4	2000	$10
Palace Station	$5	H&C	Frank Fertitta	2000	$10
Palace Station	$25	BJ	20th Anniversary 1996	500	$75
Palace Station	$100	BJ	20th Anniversary 1996	100	$300
Paris	$5	H&C	Millennium	1500	$20
Paris	$25	H&C	Evander Holyfield	1500	$75
Paris	$25	H&C	Lennox Lewis	1500	$75
Paris	$25	H&C	Millennium	500	$75
Paris	$100	House	Don King/Holyfield- Lewis	500	$125
Pioneer Club	.25	H&C	50th Anniversary	200	$25
Pioneer Club	.50	H&C	50th Anniversary	200	$25
Pioneer Club	$1	H&C	50th Anniversary	200	$25
Pioneer Club	$5	H&C	Atomic Test 1951	2000	$15
Pioneer Club	$5	H&C	Comstock Lode	2000	$15
Pioneer Club	$5	H&C	Convention Center	2000	$15
Pioneer Club	$5	H&C	First Railroad 1905	2000	$15
Pioneer Club	$5	H&C	Fremont Street 1920's	2000	$15
Pioneer Club	$5	H&C	Gambling Legalized	2000	$15
Pioneer Club	$5	H&C	Helldorado Parade	2000	$15
Pioneer Club	$5	H&C	Hoover Dam	2000	$15
Pioneer Club	$5	H&C	Nevada State Flag	2000	$15
Pioneer Club	$5	H&C	River Run 1996	1500	$15
Pioneer Club	$5	H&C	State of Nevada 1864	2000	$15
Pioneer Club	$5	H&C	Vegas Vic-1951	2000	$15
Pioneer Club	$25	H&C	50th Anniversary	200	$75
Pioneer Club	$100	H&C	50th Anniversary	200	$150
Poker Palace	$5	Chipco	25th Anniversary 1974- 99	1000	$15
Poker Palace	$5	Chipco	Christmas 1999	1000	$10
Poker Palace	$5	Chipco	Christmas/New Year's 1998	1000	$10
Poker Palace	$5	Chipco	Valentine's Day 1999	800	$10
Poker Palace	$7.50	Chipco	Millennium	750	$20
Railroad Pass	$5	BJ	66 Years	1000	$15
Railroad Pass	$5	BJ	Oktoberfest 1997	1000	$10
Railroad Pass	$5	H&C	Millennium	2000	$20
Reserve	$5	Chipco	Grand Opening Chip	5000	$15
Reserve	$5	Chipco	Safari 2000	2000	$10
Resort at Summerlin	$25	BJ	Picture of Building		$35
Rio	NCV	H&C	Race & Sports		$50

Casino	Denom	Mold	Inlay	Mintage	Value
Rio	$5	H&C	Carnival of Poker II	1000	$10
Rio	$5	H&C	Danny Gans	25000	$10
Rio	$5	H&C	Football 1995	5000	$10
Rio	$5	H&C	Mardi Gras Mask	1500	$10
Rio	$5	H&C	Millennium	25000	$10
Rio	$5	H&C	New Year's 1995	5000	$10
Rio	$5	H&C	Poker Playing Clowns	1500	$10
Rio	$5	H&C	Rodeo 1996	1000	$10
Rio	$5	H&C	Rodeo 1997	1000	$10
Rio	$5	H&C	Tony Marnell	1000	$10
Rio	$25	H&C	Millennium/Rod Stewart 99	10000	$35
Riviera	$5	BJ	40th Anniversary	5000	$10
Riviera	$5	Chipco	4th of July 1999	1000	$10
Riviera	$5	Chipco	Beach Bash Blackjack Tourn.	500	$15
Riviera	$5	Chipco	Bobby Vee	1000	$10
Riviera	$5	Chipco	Bobby Vinton 1999	1000	$10
Riviera	$5	Chipco	Christmas 1999	500	$10
Riviera	$5	Chipco	Dart Tournament 1999	1000	$10
Riviera	$5	Chipco	David Brenner	1000	$10
Riviera	$5	Chipco	DL Hughley	1000	$10
Riviera	$5	Chipco	DL Hughley (error)		$100
Riviera	$5	Chipco	Football #15 1999	500	$10
Riviera	$5	Chipco	Football #21 1999	500	$10
Riviera	$5	Chipco	Football #50 1999	500	$10
Riviera	$5	Chipco	Football #8 1999	500	$10
Riviera	$5	Chipco	Football Kickoff 1999	1000	$10
Rivera	$5	Chipco	Football XXXIV 2000 (stackable set of 4)	1000	$10ea.
Riviera	$5	Chipco	Halloween 1999	500	$15
Riviera	$5	Chipco	Jackie the Jokeman	1000	$10
Riviera	$5	Chipco	Jimmy Walker	1000	$10
Riviera	$5	Chipco	Kentucky Derby 1999	1000	$10
Riviera	$5	Chipco	Louie Anderson	1000	$10
Riviera	$5	Chipco	Millennium 2000	1000	$10
Riviera	$5	Chipco	Millennium Englebert Humperdink 1970's	1000	$15
Riviera	$5	Chipco	Millennium Mission	4500	$10
Riviera	$5	Chipco	Millennium Opening 1955	1000	$15
Riviera	$5	Chipco	Millennium Shangri la's	1000	$10
Riviera	$5	Chipco	Millennium Shecky Green 1960's	1000	$15
Riviera	$5	Chipco	Millennium Splash 1980's	1000	$15
Riviera	$5	Chipco	Millennium www.TheRiviera.com	1000	$15
Riviera	$5	Chipco	New Year's 1999	1000	$10
Riviera	$5	Chipco	Porn Star Heather Hunter	1500	$75
Riviera	$5	Chipco	Porn Star Jenna Jameson	1500	$75
Riviera	$5	Chipco	Porn Star Nikki Tyler	1500	$75
			(Set was pulled & approx. 600 total chips are out).		
Riviera	$5	Chipco	Rich Little	1000	$10
Riviera	$5	Chipco	Riviera Racing 1999	1000	$10
Riviera	$5	Chipco	Show Set Comedy Club	5000	$10
Riviera	$5	Chipco	Show Set Crazy Girls	5000	$10
Riviera	$5	Chipco	Show Set La Cage	5000	$10
Riviera	$5	Chipco	Show Set Splash	5000	$10
Riviera	$5	Chipco	St. Patrick's Day 1999	1000	$10
Riviera	$5	Chipco	Thanksgiving 1999	500	$10
Riviera	$5	Chipco	Tommy Davidson	1000	$10
Riviera	$5	H&C	NFR Rodeo 1998	1000	$10

Casino	Denom	Mold	Inlay	Mintage	Value
Riviera	$5	House	NFR Rodeo 1999	1000	$10
Riviera	$10	Chipco	Millennium The Tokens	1000	$30
Riviera	$25	Chipco	Millennium Frankie Avalon	1000	$35
Riviera	$25	House	NFR Rodeo 1999	200	$50
Riviera	$100	Chipco	Millennium	350	$150
Sahara	$5	BJ	Speedworld 1997	2000	$15
Sahara	$5	H&C	Bill Bennett	2000	$10
Sahara	$5	H&C	1952-1996	5000	$15
Sahara	$5	H&C	50th Anniversary Air Force	5000	$15
Sam's Town	$1	H&C	Fred Whitfield	2000	$3
Sam's Town	$5	BJ	Wolf 1994-1995	5500	$10
Sam's Town	$5	Chipco	Poker Classic 1999	1500	$10
Sam's Town	$5	H&C	20th Anniversary/Boyd Pic.	2000	$10
Sam's Town	$5	H&C	20thAnniversary/Building	2000	$10
Sam's Town	$5	H&C	Millennium	5000	$10
Sam's Town	$5	H&C	Richard Petty 1998	5000	$10
Sam's Town	$5	H&C	Richard Petty 1999	3000	$10
Sam's Town	$5	H&C	Rodeo Cody Ohl	1000	$10
Sam's Town	$5	H&C	Rusty Wallace 1999	3000	$10
Sam's Town	$25	H&C	Rodeo Joe Beaver	300	$40
Sam's Town	$25	H&C	Millennium (never released)		
San Remo	$25	H&C	Millennium	2000	$35
Santa Fe	$5	BJ	6th Anniversary 1997	2000	$10
Santa Fe	$5	BJ	7th Anniversary 1998	2000	$10
Santa Fe	$5	BJ	Roll Back the Time 1998-50's	1000	$10
Santa Fe	$5	BJ	Valentine's Day 1996	2000	$10
Santa Fe	$5	Chipco	8th Anniversary	1000	$10
Santa Fe	$5	Chipco	Christmas 1998	1000	$10
Santa Fe	$5	Chipco	New Year's 1999	2000	$10
Santa Fe	$5	Chipco	Veteran's Day 1998	1000	$10
Santa Fe	$5	H&C	New Years 2000	500	$10
Santa Fe	$5	H&C	Paul Lowden	1000	$10
Showboat	$5	BJ	45th Anniversary 54-99	750	$10
Showboat	$5	BJ	45th Anniversary 99	750	$10
Showboat	$5	BJ	4th of July 1995	1500	$10
Showboat	$5	BJ	Dick Webber	2000	$10
Showboat	$5	BJ	Earl Anthony	2000	$10
Showboat	$5	BJ	Happy New Year's 1996	2000	$10
Showboat	$5	BJ	Mark Roth	2000	$10
Showboat	$5	BJ	Mike Aulby	2000	$10
Showboat	$5	BJ	Millenium	1000	$10
Showboat	$5	BJ	Nevada Day Oct. 31, 1864	2000	$10
Showboat	$5	BJ	PBA Tour	750	$10
Showboat	$5	H&C	40th "Anniversary	1000	$10
Showboat	$25	BJ	Happy New Years 1996	500	$40
Silver City	$5	BJ	New Year's 1999	2500	$10
Silver Dollar Saloon	$5	H&C	30th Anniversary 1996	1000	$40
Silver Saddle Saloon	$5	H&C	Grand Opening	1000	$25
Silver Nugget	$2.50	BJ	Blackjack Bonus	2500	$10
Silver Nugget	$5	BJ	35th Anniversary	535	$15
Silver Nugget	$5	BJ	4th of July 1996, Mahoney's	1000	$15
Silver Nugget	$5	BJ	4th of July 1997	1000	$15
Silver Nugget	$5	BJ	7 Come 11	1000	$15
Silver Nugget	$5	BJ	April Fool's 1998	888	$15
Silver Nugget	$5	BJ	Boxcars	1000	$15

Casino	Denom	Mold	Inlay	Mintage	Value
Silver Nugget	$5	BJ	Christmas 96/NY's 97	1000	$15
Silver Nugget	$5	BJ	Christmas 97/NY's 98	1000	$15
Silver Nugget	$5	BJ	Halloween 1995	1500	$15
Silver Nugget	$5	BJ	Halloween 1996	1000	$15
Silver Nugget	$5	BJ	Halloween 1997	1000	$15
Silver Nugget	$5	BJ	Halloween 1999	777	$10
Silver Nugget	$5	BJ	Hard 8 1997	1000	$15
Silver Nugget	$5	BJ	Mother's Day 1997	1000	$15
Silver Nugget	$5	BJ	Snake Eyes 1997	1000	$15
Silver Nugget	$5	BJ	St. Patrick's Day 1996	1500	$15
Silver Nugget	$5	BJ	Valentine's Day 1996	1500	$15
Silver Nugget	$5	BJ	Valentine's Day 1997	1250	$15
Silver Nugget	$5	Chipco	Christmas 1995	1000	$15
Silver Nugget	$5	Chipco	Christmas 1998/NY's 98	888	$15
Silver Nugget	$5	Chipco	Millennium	888	$10
Silver Nugget	$5	Chipco	Mother's Day 1997	1000	$15
Silver Nugget	$5	Chipco	Mother's Day 1998	888	$15
Silver Nugget	$5	Chipco	New Year's 1996	1000	$15
Silver Nugget	$5	Chipco	Outhouse	888	$10
Silver Nugget	$5	Chipco	St. Patrick's Day 1998	888	$15
Silver Nugget	$5	Chipco	Valentine's Day 1998	888	$20
Silverton	$5	BJ	President's Day 1998	1000	$15
Silverton	$5	BJ	Super Bowl 1998	1500	$10
Silverton	$5	Chipco	Grand Opening	1000	$15
Skyline	$5	BJ	Halloween 1995	1500	$10
Skyline	$5	BJ	Labor Day 9/4/95	1500	$10
Skyline	$5	BJ	Valentine's Day 1996	1000	$10
Slots-a-Fun	$5	BJ	Millennium	2000	$10
Slots-a-Fun	$5	BJ	New Year's 1999	2500	$10
Sport of Kings	$5	Chipco	Grand Opening	2000	$60
Stardust	$5	BJ	Millennium	2000	$10
Stardust	$5	H&C	2nd Grand Old Times Dinner	1000	$20
Stardust	$5	H&C	Bill Boyd	2000	$10
Stardust	$5	H&C	Millennium	2000	$10
Stardust	$5	H&C	Richard Petty 1998	5000	$10
Stardust	$5	H&C	Richard Petty 1999	2000	$10
Stardust	$25	BJ	Millennium	500	$50
Stardust	$100	BJ	Millennium	200	$150
Stratosphere	$5	H&C	Grand Opening April 1996	10000	$15
Sunset Station	$5	Chipco	"21" of Clubs Opening 6/10/97 4 of 4	2000	$10
Sunset Station	$5	Chipco	Football 2000	1000	$10
Sunset Station	$5	Chipco	Millennium Ace's	1000	$15
Sunset Station	$5	Chipco	Millennium: 2's	1000	$15
Sunset Station	$5	Chipco	Millennium: 3's	1000	$15
Sunset Station	$5	Chipco	Millennium: 4's	1000	$15
Sunset Station	$5	Chipco	Millennium: 5's	1000	$15
Sunset Station	$5	Chipco	Millennium: 6's	1000	$15
Sunset Station	$5	Chipco	Millennium: 7's	1000	$15
Sunset Station	$5	Chipco	Millennium: 8's	1000	$15
Sunset Station	$5	Chipco	Millennium: 9's	1000	$15
Sunset Station	$5	Chipco	Millennium: 10's	1000	$15
Sunset Station	$5	Chipco	Millennium: Jack's	1000	$15
Sunset Station	$5	Chipco	Millennium: Queen's	1000	$15
Sunset Station	$5	Chipco	Millennium: King's	1000	$15
Sunset Station	$5	Chipco	New Year's 1999	2000	$10

Casino	Denom	Mold	Inlay	Mintage	Value
Sunset Station	$5	Chipco	New Year's 2000	2000	$10
Sunset Station	$5	H&C	Grand Opening 6/10/97	5000	$20
Sunset Station	$5	H&C	1st Birthday 1998	1500	$15
Texas Station	$5	BJ	2000 AD	1000	$15
Texas Station	$5	BJ	2nd Anniversary	5000	$10
Texas Station	$5	BJ	Brent Thurman 1994	5000	$10
Texas Station	$5	BJ	Grand Opening 1995	5000	$15
Texas Station	$5	Chipco	Opening Date 7/12/95	2000	$10
Texas Station	$25	Chipco	2000 AD	500	$40
Texas Station	$25	BJ	Martini Ranch	2000	$35
Treasure Island	$5	House	Millennium	15000	$10
Treasure Island	$5	House	Mystere	80000	$10
Treasure Island	$25	House	Millennium	2500	$35
Treasure Island	$100	House	Millennium	1000	$125
Tropicana	NCV	H&C	A Time to Remember	750	$100
Tropicana	$5	BJ	Football Cheerleader 98	1000	$10
Tropicana	$5	BJ	Football Sunday 98	1000	$10
Tropicana	$5	H&C	1900's	750	$15
Tropicana	$5	H&C	1910's	750	$15
Tropicana	$5	H&C	1920's	750	$15
Tropicana	$5	H&C	1930's	750	$15
Tropicana	$5	H&C	1940's	750	$15
Tropicana	$5	H&C	1950's	750	$15
Tropicana	$5	H&C	1960's	750	$15
Tropicana	$5	H&C	1970's	750	$15
Tropicana	$5	H&C	1980's	750	$15
Tropicana	$5	H&C	1990's	750	$15
Tropicana	$5	H&C	35th Anniversary 1st Issue	2000	$15
Tropicana	$5	H&C	35th Anniversary 2nd Issue	5000	$10
Tropicana	$5	H&C	4th of July	750	$10
Tropicana	$5	H&C	4th of July 1999	1000	$10
Tropicana	$5	H&C	BBQ Cook Off 1996	1000	$10
Tropicana	$5	H&C	Big Game Day 1999	750	$10
Tropicana	$5	H&C	Christmas 1998	750	$15
Tropicana	$5	H&C	Christmas 1999	1000	$15
Tropicana	$5	H&C	Felicidades 96	1000	$10
Tropicana	$5	H&C	Fires and Implosions	750	$15
Tropicana	$5	H&C	Follies Bergere 1997	1000	$10
Tropicana	$5	H&C	Football 1995	2000	$10
Tropicana	$5	H&C	Hall of Fame Grand Opening	750	$25
Tropicana	$5	H&C	Hall of Headliners	750	$15
Tropicana	$5	H&C	Halloween 1998	750	$15
Tropicana	$5	H&C	Halloween Creature From Lagoon 99	750	$20
Tropicana	$5	H&C	Halloween Frankenstein 99	750	$20
Tropicana	$5	H&C	Halloween Mummy 99	750	$20
Tropicana	$5	H&C	Hawaiian Tropic 1999/ Yellow	750	$15
Tropicana	$5	H&C	Hawaiian Tropic 1999/Gold	750	$15
Tropicana	$5	H&C	Inductee Juliet Prowse	750	$15
Tropicana	$5	H&C	Jade Palace	1000	$10
Tropicana	$5	H&C	Jeremy Mayfield	1000	$10
Tropicana	$5	H&C	Keely Smith	750	$15
Tropicana	$5	H&C	Kentucky Derby 1996	500	$60
Tropicana	$5	H&C	Kentucky Derby 1999	750	$15
Tropicana	$5	H&C	Las Vegas 400 1998	500	$20
Tropicana	$5	H&C	Leroy Neiman	1000	$10

Casino	Denom	Mold	Inlay	Mintage	Value
Tropicana	$5	H&C	Let's Make a Deal	750	$15
Tropicana	$5	H&C	Maguire Sisters	750	$15
Tropicana	$5	H&C	Mary Kaye Trio	750	$15
Tropicana	$5	H&C	Millennium	750	$15
Tropicana	$5	H&C	Miss Hawaiian Tropic	1000	$10
Tropicana	$5	H&C	Miss Hawaiian Tropic 1997	500	$25
Tropicana	$5	H&C	Miss Hawaiian Tropic 1999 2 chicks	750	$15
Tropicana	$5	H&C	Montage of Movies	750	$15
Tropicana	$5	H&C	New Year's 1996	1000	$10
Tropicana	$5	H&C	New Year's 1999	750	$15
Tropicana	$5	H&C	NFR Barrel Race 1995	1250	$10
Tropicana	$5	H&C	NFR Bronco 1995	1250	$10
Tropicana	$5	H&C	NFR Bucking Bronco 1995	1250	$10
Tropicana	$5	H&C	NFR Buckle 1988	1500	$10
Tropicana	$5	H&C	NFR Buckle 1989	1500	$10
Tropicana	$5	H&C	NFR Buckle 1990	1500	$10
Tropicana	$5	H&C	NFR Buckle 1991	1500	$10
Tropicana	$5	H&C	NFR Buckle 1992	1500	$10
Tropicana	$5	H&C	NFR Buckle 1993	1500	$10
Tropicana	$5	H&C	NFR Buckle 1994	1500	$10
Tropicana	$5	H&C	NFR Buckle 1995	1500	$10
Tropicana	$5	H&C	NFR Buckle 1996	1500	$10
Tropicana	$5	H&C	NFR Bull Rider 1995	1250	$10
Tropicana	$5	H&C	NFR Clown /Bull 1995	1250	$10
Tropicana	$5	H&C	NFR Roping 1995	1250	$10
Tropicana	$5	H&C	NFR Steer Roper 1995	1250	$10
Tropicana	$5	H&C	NFR Steer Wrestler 1995	1250	$10
Tropicana	$5	H&C	Olympics-Hockey 1998	500	$20
Tropicana	$5	H&C	Olympics-Skating 1998	500	$20
Tropicana	$5	H&C	Olympics-Ski Jump	500	$20
Tropicana	$5	H&C	Olympics-Skiing 1998	500	$20
Tropicana	$5	H&C	Pro Football Arm Wrestling	750	$15
Tropicana	$5	H&C	Pro Football Championship 2000	750	$15
Tropicana	$5	H&C	Pug Pearson	750	$15
Tropicana	$5	H&C	Rich Little	750	$15
Tropicana	$5	H&C	Rick Thomas Magician	1000	$15
Tropicana	$5	H&C	Rodeo 1997	2000	$10
Tropicana	$5	H&C	Rodeo 1999	750	$10
Tropicana	$5	H&C	Showgirl Janell'	750	$15
Tropicana	$5	H&C	Smithsonian Showgirls	750	$15
Tropicana	$5	H&C	Sports Bill Walton	1000	$10
Tropicana	$5	H&C	Sports Bob Lilly	1000	$10
Tropicana	$5	H&C	Sports Bobby Hull	1000	$10
Tropicana	$5	H&C	Sports Brooks Robinson	1000	$10
Tropicana	$5	H&C	Sports Deacon Jones	1000	$10
Tropicana	$5	H&C	Sports Dick Butkus	1000	$10
Tropicana	$5	H&C	Sports Earl Monroe	1000	$10
Tropicana	$5	H&C	Sports Ernie Banks	1000	$10
Tropicana	$5	H&C	Sports Mike Bossy	1000	$10
Tropicana	$5	H&C	Sports Rick Barry	1000	$10
Tropicana	$5	H&C	Sports Stan Mikita	1000	$10
Tropicana	$5	H&C	Sports Willie Stargell	1000	$15
Tropicana	$5	H&C	St. Patrick's Day	750	$15
Tropicana	$5	H&C	Super Bash 1997	1000	$15
Tropicana	$5	H&C	Super Bowl XXVII	1000	$15

Casino	Denom	Mold	Inlay	Mintage	Value
Tropicana	$5	H&C	Super Bowl XXX	2000	$10
Tropicana	$5	H&C	Tessra Ultra Showgirl	750	$15
Tropicana	$5	H&C	Vegas Visionaries	750	$15
Tropicana	$5	H&C	Yasou	1000	$10
Tropicana	$5	H&C	Zodiac-Aquarius 1998	1000	$10
Tropicana	$5	H&C	Zodiac-Aries 1998	1000	$10
Tropicana	$5	H&C	Zodiac-Cancer 1998	1000	$10
Tropicana	$5	H&C	Zodiac-Capricorn 1998	1000	$10
Tropicana	$5	H&C	Zodiac-Gemini 1998	1000	$10
Tropicana	$5	H&C	Zodiac-Leo 1998	1000	$10
Tropicana	$5	H&C	Zodiac-Libra 1998	1000	$10
Tropicana	$5	H&C	Zodiac-Pisces 1998	1000	$10
Tropicana	$5	H&C	Zodiac-Sagittarius 1998	1000	$10
Tropicana	$5	H&C	Zodiac-Scorpio 1998	1000	$10
Tropicana	$5	H&C	Zodiac-Taurus 1998	1000	$10
Tropicana	$5	H&C	Zodiac-Virgo 1998	1000	$10
Tropicana	$25	H&C	1900's	750	$50
Tropicana	$25	H&C	1910's	750	$50
Tropicana	$25	H&C	1920's	750	$50
Tropicana	$25	H&C	1930's	750	$50
Tropicana	$25	H&C	1940's	750	$50
Tropicana	$25	H&C	1950's	750	$50
Tropicana	$25	H&C	1960's	750	$50
Tropicana	$25	H&C	1970's	750	$50
Tropicana	$25	H&C	1980's	750	$50
Tropicana	$25	H&C	1990's	750	$50
Tropicana	$25	H&C	4th of July, 1999	200	$75
Tropicana	$25	H&C	Big Game Day 1999	100	$100
Tropicana	$25	H&C	Christmas 1998	100	$100
Tropicana	$25	H&C	Christmas 1999	100	$100
Tropicana	$25	H&C	Fires and Implosions	100	$100
Tropicana	$25	H&C	Hall of Fame Grand Opening	100	$100
Tropicana	$25	H&C	Hall of Headliners	100	$100
Tropicana	$25	H&C	Halloween Creature From Lagoon 1999	100	$100
Tropicana	$25	H&C	Halloween Frankenstein 99	100	$100
Tropicana	$25	H&C	Halloween Mummy 99	100	$100
Tropicana	$25	H&C	Jeremy Mayfield	200	$75
Tropicana	$25	H&C	Keely Smith	100	$100
Tropicana	$25	H&C	Kentucky Derby 1999	100	$100
Tropicana	$25	H&C	Leroy Neiman	200	$75
Tropicana	$25	H&C	Let's Make a Deal	100	$100
Tropicana	$25	H&C	Maguire Sisters	100	$100
Tropicana	$25	H&C	Mary Kaye Trio	100	$100
Tropicana	$25	H&C	Millennium	100	$100
Tropicana	$25	H&C	Millennium ERROR (backwards printing)	41	$200
Tropicana	$25	H&C	Miss Hawaiian Tropic 1999/Gold	100	$100
Tropicana	$25	H&C	Miss Hawaiian Tropic 1999/Yellow	100	$100
Tropicana	$25	H&C	Miss Hawaiian Tropic 2 chicks	100	$100
Tropicana	$25	H&C	Montage of Movies	100	$100
Tropicana	$25	H&C	New Year's 1999	200	$75
Tropicana	$25	H&C	NFR 1995	1000	$50
Tropicana	$25	H&C	NFR Buckle 1996	500	$50
Tropicana	$25	H&C	Pro Football Arm Wrestling	100	$100
Tropicana	$25	H&C	Pug Pearson	100	$75

Casino	Denom	Mold	Inlay	Mintage	Value
Tropicana	$25	H&C	Rich Little	100	$100
Tropicana	$25	H&C	Rodeo 1999	100	$60
Tropicana	$25	H&C	Showgirl Janell'	100	$75
Tropicana	$25	H&C	Showgirl Tessra	100	$75
Tropicana	$25	H&C	Smithsonian of Showgirls	100	$75
Tropicana	$25	H&C	St. Patrick's Day	100	$75
Tropicana	$25	H&C	Vegas Visionaries	100	$100
Tropicana	$100	H&C	Ferrari Weekend 1996	550	$150
Tropicana	$100	H&C	New Year's 1997	500	$150
Tropicana	$100	H&C	New Year's 1998	2000	$150
Tropicana	$100	H&C	Presidential Gala	500	$150
Tropicana	$500	H&C	Platinum Club	50	$750
Union Plaza	$5	H&C	Fremont Street Experience	2000	$15
Vacation Village	$5	Chipco	2000 Final	500	$15
Vacation Village	$5	Chipco	Fall 1999	500	$15
Vacation Village	$5	Chipco	Spring 1999	500	$15
Vacation Village	$5	Chipco	Summer 1999	500	$15
Vacation Village	$5	Chipco	Winter 1999	500	$15
			Above is a stackable Millennium set.		
Venetian	$5	H&C	Grand Opening	2000	$15
Venetian	$5	House	Grand Canal Shops	1000	$10
Venetian	$5	House	Madame Tussaud's	2500	$10
Venetian	$5	House	Millennium	6000	$10
Venetian	$25	House	Grand Canal Shops	1000	$35
Venetian	$25	House	Millennium	3000	$40
Venetian	$100	House	Millennium	1000	$150
Westward Ho	NCV	H&C	2nd Anniversary 1984	200	$80
Westward Ho	$5	H&C	Grubstake Jamboree/Mill	2000	$10
Westward Ho	$5	H&C	Ho Waiian Luau/Mill	2000	$10
Westward Ho	$5	H&C	Puttin on the Ritz/Mill	2000	$10
Westward Ho	$25	H&C	Grubstake Jamboree/Mill	700	$40
Westward Ho	$25	H&C	Ho Waiian Luau/Mill	700	$40
Westward Ho	$25	H&C	Puttin on the Ritz/Mill	700	$40
Westward Ho	$100	H&C	Grubstake Jamboree/Mill	80	$150
Westward Ho	$100	H&C	Ho Waiian Luau/Mill	80	$150
Westward Ho	$100	H&C	Puttin on the Ritz/Mill	80	$150
Wild Wild West	$5	H&C	Grand Opening	1500	$15

Non-Las Vegas Casino Limited Edition Chips

Casino	City	Denom.	Mold	Inlay	Mintage	Value
Atlantis	Reno	$5	BJ	Grand Opening 1996	2500	$15
Atlantis	Reno	$5	BJ	Have a Ball In Reno	2000	$10
Atlantis	Reno	$5	BJ	Hot August Nights 1997	1000	$15
Atlantis	Reno	$5	BJ	Hot August Nights 1998	6000	$10
Atlantis	Reno	$5	BJ	Hot August Nights 1999	3000	$10
Atlantis	Reno	$5	BJ	Millennium	2000	$10
Atlantis	Reno	$5	BJ	New Year's 1998	2000	$10
Atlantis	Reno	$5	BJ	New Year 2000	3000	$10
Atlantis	Reno	$25	BJ	Millennium	2000	$35
Bally's	Reno	$5	Chipco	Hot August Nights 1991	2000	$30
Bally's	Reno	$5	Chipco	New Year's Havana 1991	1500	$30
Bally's	Reno	$5	Chipco	New Year's 1992	2000	$20
Bally's	Reno	$5	Chipco	Reno Air Races 1990	1000	$30
Bally's	Reno	$5	Chipco	Reno Air Races 1991	1000	$25
Bally's	Reno	$5	Chipco	Rodeo 1991	1000	$20
Bally's	Reno	$5	Chipco	Rodeo 1992	2000	$20
Boomtown	Verdi	$5	BJ	Boomtown Goes Hollywood	1000	$10
Boomtown	Verdi	$5	BJ	Buck-a-Roo 1997	1000	$10
Boomtown	Verdi	$5	BJ	Hot August Nights 1997	2000	$10
Boomtown	Verdi	$5	BJ	Mother's Day 1997	1000	$10
Boomtown	Verdi	$5	BJ	Reno Air Races 1997	1000	$10
Boomtown	Verdi	$5	BJ	Rodeo 1997	1000	$10
Boomtown	Verdi	$5	Chipco	Boomdowns 1992	2000	$15
Boomtown	Verdi	$5	Chipco	Family Entertainment Ctr. 1993	2000	$10
Boomtown	Verdi	$5	Chipco	Jamboree 1992	1000	$10
Boomtown	Verdi	$5	Chipco	Millennium	1000	$15
Boomtown	Verdi	$25	Chipco	25th Anniversary	500	$40
Buffalo Bill's	Primm	$5	H&C	Millennium	2000	$10
Buffalo Bill's	Primm	$25	H&C	Millennium	2000	$35
Cactus Jack's	Carson City	$5	Chipco	Abe Curry	2000	$10
Cactus Jack's	Carson City	$5	Chipco	Bugsy Seigel 1997	2000	$10
Cactus Jack's	Carson City	$5	Chipco	Flight of the Century	2000	$10
Cactus Jack's	Carson City	$5	Chipco	Gateway to Comstock	2000	$10
Cactus Jack's	Carson City	$5	Chipco	Harvey Gross 2000	2000	$10
Cactus Jack's	Carson City	$5	Chipco	Nevada Capitols	2000	$10
Cactus Jack's	Carson City	$5	Chipco	Pappy Smith 1999	2000	$10
Cactus Jack's	Carson City	$5	Chipco	Peter Piersanti 2001	2000	$10
Cactus Jack's	Carson City	$5	Chipco	Railroad 1994	2000	$10
Cactus Jack's	Carson City	$5	Chipco	William Harrah 1998	2000	$10
Cactus Pete's	Jackpot	$5	Chipco	40th Anniversary 1956-1996	5000	$10
Caesars	Lake Tahoe	$5	Chipco	Golf Tournament 1994	5000	$10
Caesars	Lake Tahoe	$5	Chipco	Golf Tournament 1995	5000	$10
Caesars	Lake Tahoe	$5	H&C	New Year's 1997	5000	$15
Caesars	Lake Tahoe	$25	Chipco	Golf Tournament 1991	500	$50
Caesars	Lake Tahoe	$25	Chipco	Golf Tournament 1992	500	$50
Cal Nev Ari	Cal Nev Ari	$5	BJ	30th Anniversary	1500	$10
Cal Neva	Lake Tahoe	$5	Chipco	70th Anniversary Biker	1000	$10
Cal Neva	Lake Tahoe	$5	Chipco	70th Anniversary Golfer	1000	$10
Cal Neva	Lake Tahoe	$5	Chipco	70th Anniversary Sailboat	1000	$10
Cal Neva	Lake Tahoe	$5	Chipco	70th Anniversary Skier	1000	$10
Cal Neva	Lake Tahoe	$5	Chipco	Since 1926	1000	$20
Carson Nugget	Carson City	$5	Chipco	5 piece Stackable Set	500ea.	$10ea.

Casino	City	Denom	Mold	Inlay	Mintage	Value
Carson Valley Inn	Minden	$5	Chipco	10th Anniversary	2000	$10
Carson Valley Inn	Minden	$5	Chipco	15th Anniversary	2000	$10
Carson Valley Inn	Minden	$5	Chipco	Animals	2000	$10
Carson Valley Inn	Minden	$5	Chipco	Duck on Lake	2000	$10
Carson Valley Inn	Minden	$5	Chipco	Hot Air Ballon	2000	$15
Carson Valley Inn	Minden	$5	Chipco	Rainbow 1993	2000	$15
Circus Circus	Reno	$2.50	Chipco	Hot August Nights 1999	2000	$5
Circus Circus	Reno	$5	Chipco	E. Kelly Jr./Giraffe	2000	$15
Circus Circus	Reno	$5	Chipco	E. Kelly Jr./Sitting	2000	$15
Circus Circus	Reno	$5	Chipco	E. Kelly Jr./Sweeping	2000	$15
Circus Circus	Reno	$5	Chipco	E. Kelly Jr./Tiger	2000	$15
Circus Circus	Reno	$5	Chipco	E.Kelly Jr./Elephant	2000	$15
Circus Circus	Reno	$5	Chipco	E.Kelly Jr./Trapeze	2000	$15
Circus Circus	Reno	$5	Chipco	Hot August Nights 1999	2000	$10
Circus Circus	Reno	$5	Chipco	New Year's 1993 Clown	2000	$20
Circus Circus	Reno	$5	Chipco	Street Vibrations 1999	2000	$10
Circus Circus	Reno	$5	Chipco	Summer Nights 1992 (Clown in '57 Chevy)	2000	$25
Clarion	Reno	$5	Chipco	30 Ft. Waterfall	2000	$10
Clarion	Reno	$5	Chipco	1991	2000	$10
Club Cal Neva	Reno	$5	Chipco	Bowling 100th Anniversary	2000	$10
Club Cal Neva	Reno	$5	Chipco	Bowling 1998	2000	$10
Club Cal Neva	Reno	$5	Chipco	Mapes Implosion	500	$20
Club Cal Neva- Virginian	Reno	$5	Chipco	New Years 1999- 2000		$10
Colorado Belle	Laughlin	$5	BJ	10th Birthday 1997	2000	$10
Colorado Belle	Laughlin	$5	BJ	4th of July 1998	2000	$10
Colorado Belle	Laughlin	$5	BJ	Boiler Room	3300	$10
Colorado Belle	Laughlin	$5	BJ	Gator Days August 1998	1500	$10
Colorado Belle	Laughlin	$5	BJ	Gator Days July 1998	1500	$10
Colorado Belle	Laughlin	$5	BJ	Gator Days June 1998	1500	$10
Colorado Belle	Laughlin	$5	BJ	Millennium	2000	$10
Colorado Belle	Laughlin	$5	BJ	New Year's 1999	1999	$10
Colorado Belle	Laughlin	$5	BJ	River Run 1997	3000	$10
Colorado Belle	Laughlin	$5	BJ	River Run 1998	5750	$10
Colorado Belle	Laughlin	$5	BJ	River Run 1999	1999	$10
Colorado Belle	Laughlin	$5	BJ	Spring Run 1999	1000	$10
Colorado Belle	Laughlin	$5	Chipco	Football 1999	1999	$10
Colorado Belle	Laughlin	$5	H&C	Gator Days 1999	1999	$10
Colorado Belle	Laughlin	$5	H&C	River Run 1996	4000	$10
Colorado Belle	Laughlin	$25	BJ	Millennium	1000	$75
Comstock	Reno	$5	Chipco	Birthday 1993	2000	$15
Diamonds	Reno	$5	Chipco	New Year's 1996 Blue	2000	$10
Diamonds	Reno	$5	Chipco	New Year's 1996 Green	2000	$10
Diamonds	Reno	$5	Chipco	New Year's 1996 Red	2000	$10
Diamonds	Reno	$5	Chipco	New Year's 1996 Yellow	2000	$10
Diamonds	Reno	$5	Chipco	Pony Express	5000	$10
Diamonds	Reno	$25	Chipco	Diamond Lil	3000	$30
Eddie's Fab. 50's	Reno	NCV	H&C	Grand Opening – Red 1987	1000	$20
Eddie's Fab. 50's	Reno	NCV	H&C	Grand Opening – Navy 1987	1000	$20
Edgewater	Laughlin	$5	BJ	Millennium	2000	$10
Edgewater	Laughlin	$5	BJ	River Run 1999	1500	$10
Edgewater	Laughlin	$5	BJ	River Stampede 1995	1000	$10
Edgewater	Laughlin	$5	BJ	River Stampede 1996	1000	$10
Edgewater	Laughlin	$5	BJ	River Stampede 1997	1000	$10
Edgewater	Laughlin	$5	BJ	River Stampede 1998	1000	$10

Casino	City	Denom	Mold	Inlay	Mintage	Value
Edgewater	Laughlin	$5	BJ	River Stampede 1999	1000	$10
Edgewater	Laughlin	$5	BJ	Rodeo 1995	1000	$10
Edgewater	Laughlin	$5	BJ	Rodeo 1996	1000	$10
Edgewater	Laughlin	$5	BJ	Rodeo 1997	1000	$10
Edgewater	Laughlin	$5	BJ	Rodeo 1998	1000	$10
Edgewater	Laughlin	$5	Chipco	4th of July 1996	2000	$10
Edgewater	Laughlin	$5	Chipco	4th of July 1997	1000	$10
Edgewater	Laughlin	$5	Chipco	4th of July 1998	1000	$10
Edgewater	Laughlin	$5	Chipco	Christmas 1996	2000	$10
Edgewater	Laughlin	$5	Chipco	Football 1999	1000	$10
Edgewater	Laughlin	$5	Chipco	New Year's 1996	2500	$10
Edgewater	Laughlin	$5	Chipco	New Year's 1997	2000	$10
Edgewater	Laughlin	$5	Chipco	New Year's 1998	1000	$10
Edgewater	Laughlin	$5	Chipco	New Year's 1999	1500	$10
Edgewater	Laughlin	$5	Chipco	New Years 1998	1500	$10
Edgewater	Laughlin	$5	Chipco	Super Bowl 1996	2000	$15
Edgewater	Laughlin	$5	Chipco	Super Bowl 1998	1500	$10
Edgewater	Laughlin	$5	Chipco	Super Bowl 2000	1000	$10
Edgewater	Laughlin	$5	Chipco	Super Sunday 1997	1000	$10
Edgewater	Laughlin	$5	H&C	River Run 1996	4000	$10
Edgewater	Laughlin	$10	BJ	River Run 1998	2000	$20
Edgewater	Laughlin	$10	H&C	River Run 1997	1000	$20
Edgewater	Laughlin	$25	BJ	Millennium	2000	$50
Edgewater	Laughlin	$100	BJ	Millennium	2000	$125
Eldorado	Reno	$5	Chipco	Great Italian Festival 1991	3000	$20
Eldorado	Reno	$5	Chipco	New Year's 1991	2000	$25
Eldorado	Reno	$25	BJ	Pavarotti 4/26/97	5000	$50
Exchange Club	Beatty	$5	BJ	Historic 1906	1000	$10
Exchange Club	Beatty	$25	BJ	Historic 1906	300	$35
				Above two chips are also used as regular issues		
Fitzgerald's	Reno	$5	Chipco	Bowling 100th Anniv. ABC	2000	$15
Fitzgerald's	Reno	$5	Chipco	St.Patrick's Day 1992	2000	$20
Fitzgerald's	Reno	$5	H&C	Millennium	1500	$15
Fitzgerald's	Reno	$25	H&C	Millennium	400	$50
Fitzgerald's	Reno	$100	H&C	Millennium	100	$125
Flamingo Hilton	Laughlin	$5	H&C	1934 Timmis Ford	1500	$15
Flamingo Hilton	Laughlin	$5	H&C	1947 Ford	1500	$15
Flamingo Hilton	Laughlin	$5	H&C	1947 Ford Woody	1500	$15
Flamingo Hilton	Laughlin	$5	H&C	1949 Chrysler	1500	$15
Flamingo Hilton	Laughlin	$5	H&C	1957 Bel Air	1500	$15
Flamingo Hilton	Laughlin	$5	H&C	1957 Thunderbird	1500	$15
Flamingo Hilton	Laughlin	$5	H&C	1959 Cadillac	1500	$15
Flamingo Hilton	Laughlin	$5	H&C	1961 Corvette	1500	$15
Flamingo Hilton	Laughlin	$5	H&C	1964 Chevelle	1500	$15
Flamingo Hilton	Laughlin	$5	H&C	1965 Pontiac GTO	1500	$15
Flamingo Hilton	Laughlin	$5	H&C	1966 Buick	1500	$15
Flamingo Hilton	Laughlin	$5	H&C	1967 Galaxy	1500	$15
Flamingo Hilton	Laughlin	$5	H&C	1967 Shelby GT	1500	$15
Flamingo Hilton	Laughlin	$5	H&C	Abraham Lincoln	1500	$15
Flamingo Hilton	Laughlin	$5	H&C	Annie Oakley	1500	$15
Flamingo Hilton	Laughlin	$5	H&C	Bat Masterson	1500	$15
Flamingo Hilton	Laughlin	$5	H&C	Belle Star	1500	$15
Flamingo Hilton	Laughlin	$5	H&C	Billy the Kid	1500	$15
Flamingo Hilton	Laughlin	$5	H&C	Buffalo Bill Cody	1500	$15

Casino	City	Denom	Mold	Inlay	Mintage	Value
Flamingo Hilton	Laughlin	$5	H&C	Butch Cassidy	1500	$15
Flamingo Hilton	Laughlin	$5	H&C	Confederate Prisoners	1500	$15
Flamingo Hilton	Laughlin	$5	H&C	Cool Bird-Bellman	1500	$15
Flamingo Hilton	Laughlin	$5	H&C	Cool Bird-Biker	1500	$15
Flamingo Hilton	Laughlin	$5	H&C	Cool Bird-Comedy	1500	$15
Flamingo Hilton	Laughlin	$5	H&C	Cool Bird-Country	1500	$15
Flamingo Hilton	Laughlin	$5	H&C	Cool Bird-Elf	1500	$15
Flamingo Hilton	Laughlin	$5	H&C	Cool Bird-Gambler	1500	$15
Flamingo Hilton	Laughlin	$5	H&C	Cool Bird-Golfer	1500	$15
Flamingo Hilton	Laughlin	$5	H&C	Cool Bird-James Dean	1500	$15
Flamingo Hilton	Laughlin	$5	H&C	Cool Bird-Jet Ski	1500	$15
Flamingo Hilton	Laughlin	$5	H&C	Cool Bird-Leprechaun	1500	$15
Flamingo Hilton	Laughlin	$5	H&C	Cool Bird-Luau	1500	$15
Flamingo Hilton	Laughlin	$5	H&C	Cool Bird-Magician	1500	$15
Flamingo Hilton	Laughlin	$5	H&C	Doc Holiday	1500	$15
Flamingo Hilton	Laughlin	$5	H&C	Jeb Stewart	1500	$15
Flamingo Hilton	Laughlin	$5	H&C	Jefferson Davis	1500	$15
Flamingo Hilton	Laughlin	$5	H&C	Jesse James	1500	$15
Flamingo Hilton	Laughlin	$5	H&C	John Brown	1500	$15
Flamingo Hilton	Laughlin	$5	H&C	Labor Day Casino Expo 1997	750	$60
Flamingo Hilton	Laughlin	$5	H&C	Pat Garrett	1500	$15
Flamingo Hilton	Laughlin	$5	H&C	Robert E. Lee	1500	$15
Flamingo Hilton	Laughlin	$5	H&C	Sassacus & Albemarle	1500	$15
Flamingo Hilton	Laughlin	$5	H&C	Steven Cutler-Curator	750	$50
Flamingo Hilton	Laughlin	$5	H&C	Stonewall Jackson	1500	$15
Flamingo Hilton	Laughlin	$5	H&C	Sundance Kid	1500	$15
Flamingo Hilton	Laughlin	$5	H&C	The St. Louis	1500	$15
Flamingo Hilton	Laughlin	$5	H&C	Ulysses S. Grant	1500	$15
Flamingo Hilton	Laughlin	$5	H&C	Union Army Private	1500	$15
Flamingo Hilton	Laughlin	$5	H&C	Wild Bill Hickock	1500	$15
Flamingo Hilton	Laughlin	$5	H&C	William Sherman	1500	$15
Flamingo Hilton	Laughlin	$5	H&C	Wyatt Earp	1500	$15
Flamingo Hilton	Reno	$5	BJ	Gulf Cobra	1500	$15
Flamingo Hilton	Reno	$5	BJ	Gulf Falcon	1500	$15
Flamingo Hilton	Reno	$5	BJ	Gulf Sheath	1500	$15
Flamingo Hilton	Reno	$5	BJ	Korea Corsair	1500	$15
Flamingo Hilton	Reno	$5	BJ	Korea Sabre	1500	$15
Flamingo Hilton	Reno	$5	BJ	Vietnam Huey	1500	$15
Flamingo Hilton	Reno	$5	BJ	Vietnam Super Sabre	1500	$15
Flamingo Hilton	Reno	$5	BJ	WWI DH4	1500	$15
Flamingo Hilton	Reno	$5	BJ	WWI Squad 13	1500	$15
Flamingo Hilton	Reno	$5	BJ	WWII Hellcat	1500	$15
Flamingo Hilton	Reno	$5	BJ	WWII Mustang	1500	$15
Flamingo Hilton	Reno	$5	BJ	Gulf Eagle	1500	$15
Flamingo Hilton	Reno	$5	Chipco	Bowling 1995	4000	$10
Flamingo Hilton	Reno	$5	Chipco	Chinese New Year 1995	1000	$15
Flamingo Hilton	Reno	$5	Chipco	Elvis Caricature	2000	$35
Flamingo Hilton	Reno	$5	Chipco	Marquee 1993	1000	$20
Flamingo Hilton	Reno	$5	Chipco	Marilyn Monroe Caricature	2000	$25
Flamingo Hilton	Reno	$5	Chipco	Reno Air/Balloon Race 1995	2500	$20
Flamingo Hilton	Reno	$5	Chipco	Sammy Davis Jr. Caricature	2000	$20
Flamingo Hilton	Reno	$5	Chipco	Year of the Tiger 1998	5000	$10
Flamingo Hilton	Reno	$5	H&C	1930 Cadillac V-16	1500	$15
Flamingo Hilton	Reno	$5	H&C	1934 Cord 812	1500	$15

Casino	City	Denom	Mold	Inlay	Mintage	Value
Flamingo Hilton	Reno	$5	H&C	1950 Mercury Winfield	1500	$15
Flamingo Hilton	Reno	$5	H&C	1951 Ford Victoria	1500	$15
Flamingo Hilton	Reno	$5	H&C	1954 Buick Skylark	1500	$15
Flamingo Hilton	Reno	$5	H&C	1954 Corvette	1500	$15
Flamingo Hilton	Reno	$5	H&C	1954 Ford Crestline	1500	$15
Flamingo Hilton	Reno	$5	H&C	1955 Cadillac Eldorado	1500	$15
Flamingo Hilton	Reno	$5	H&C	1956 Chevy Bel-Air	1500	$15
Flamingo Hilton	Reno	$5	H&C	1957 Chevy Nomad	1500	$15
Flamingo Hilton	Reno	$5	H&C	1958 Ford Fairlane	1500	$15
Flamingo Hilton	Reno	$5	H&C	1962 T-Bird Roadster	1500	$15
Flamingo Hilton	Reno	$5	H&C	Endangered Species-Butterfly	1500	$15
Flamingo Hilton	Reno	$5	H&C	Endangered Species-Cheetah	1500	$15
Flamingo Hilton	Reno	$5	H&C	Endangered Species-Condor	1500	$15
Flamingo Hilton	Reno	$5	H&C	Endangered Species-Gorilla	1500	$15
Flamingo Hilton	Reno	$5	H&C	Endangered Species-Koala Bear	1500	$15
Flamingo Hilton	Reno	$5	H&C	Endangered Species-Orangutan	1500	$15
Flamingo Hilton	Reno	$5	H&C	Endangered Species-Panda Bear	1500	$15
Flamingo Hilton	Reno	$5	H&C	Endangered Species-Rhino	1500	$15
Flamingo Hilton	Reno	$5	H&C	Endangered Species-Spoonbill	1500	$15
Flamingo Hilton	Reno	$5	H&C	Endangered Species-Tamarin	1500	$15
Flamingo Hilton	Reno	$5	H&C	Endangered Species-Turtle	1500	$15
Flamingo Hilton	Reno	$5	H&C	Endangered Species-Whale	1500	$15
Flamingo Hilton	Reno	$5	H&C	ZodiacAquarius	1500	$15
Flamingo Hilton	Reno	$5	H&C	Zodiac-Aries	1500	$15
Flamingo Hilton	Reno	$5	H&C	Zodiac-Cancer	1500	$15
Flamingo Hilton	Reno	$5	H&C	Zodiac-Capricorn	1500	$15
Flamingo Hilton	Reno	$5	H&C	Zodiac-Gemini	1500	$15
Flamingo Hilton	Reno	$5	H&C	Zodiac-Leo	1500	$15
Flamingo Hilton	Reno	$5	H&C	Zodiac-Libra	1500	$15
Flamingo Hilton	Reno	$5	H&C	Zodiac-Pisces	1500	$15
Flamingo Hilton	Reno	$5	H&C	Zodiac-Sagittarius	1500	$15
Flamingo Hilton	Reno	$5	H&C	Zodiac-Scorpio	1500	$15
Flamingo Hilton	Reno	$5	H&C	Zodiac-Taurus	1500	$15
Flamingo Hilton	Reno	$5	H&C	Zodiac-Virgo	1500	$15
Gold River	Laughlin	$5	Chipco	River Run 1993	5000	$15
Gold Strike	Jean	$5	Chipco	Admission is Free	1000	$10
Gold Strike	Jean	$5	Chipco	All You Can Eat Buffet	1000	$10
Gold Strike	Jean	$5	Chipco	Jackpots Paid in Person	1000	$10
Gold Strike	Jean	$5	Chipco	Millennium Magic	1500	$10
Gold Strike	Jean	$5	Chipco	No Charges Free Items	1000	$10
Gold Strike	Jean	$5	Chipco	Open 24 Hours	1000	$10
Gold Strike	Jean	$5	Chipco	Our Comps Are Free	1000	$10
Gold Strike	Jean	$5	Chipco	Our Gas is Unleaded	1000	$10
Gold Strike	Jean	$5	Chipco	Our Restaurants	1000	$10
Gold Strike	Jean	$5	Chipco	Our Rooms Have Beds	1000	$10
Gold Strike	Jean	$5	Chipco	You're in Jean Now	1000	$10
Gold Strike	Jean	$25	Chipco	Our Comps Are Free	300	$30
Gold Strike	Jean	$25	Chipco	Our Rooms Have Beds	300	$30
Gold Strike	Jean	$25	Chipco	You're in Jean Now	300	$30
Golden Nugget	Laughlin	$5	BJ	New Year's 1996	2500	$10
Golden Nugget	Laughlin	$5	H&C	Millennium	1000	$10
Golden Nugget	Laughlin	$5	H&C	River Run 1999	1000	$10
Golden Nugget	Laughlin	$5	House	4th of July 1999	1000	$10
Golden Nugget	Laughlin	$5	House	Cool River Nites 99	1000	$10

Casino	City	Denom	Mold	Inlay	Mintage	Value
Golden Nugget	Laughlin	$5	House	New Year's 1999	1500	$10
Harrah's	Lake Tahoe	$5	Chipco	Sailboat 1990	2000	$40
Harrah's	Lake Tahoe	$5	Chipco	4th of July 1995	2000	$15
Harrah's	Lake Tahoe	$5	Chipco	New Year's 1995	2000	$15
Harrah's	Lake Tahoe	$5	H&C	Bud Ice- Good as Gold	500	$20
Harrah's	Lake Tahoe	$5	H&C	Bud Ice- Shuffle in & Win	500	$20
Harrah's	Lake Tahoe	$5	H&C	Bud Ice- There's a Party	500	$20
Harrah's	Laughlin	$2.50	H&C	10th Anniversary	3000	$5
Harrah's	Laughlin	$2.50	H&C	But it's a Dry Heat	3000	$5
Harrah's	Laughlin	$2.50	H&C	Dry Heat #2	3500	$5
Harrah's	Laughlin	$2.50	H&C	New Year's 2000	3000	$5
Harrah's	Laughlin	$5	Chipco	New Year's 1994	3000	$10
Harrah's	Laughlin	$5	H&C	60 Years 1997	4000	$10
Harrah's	Laughlin	$5	H&C	Cisco's Party 1995	4000	$10
Harrah's	Laughlin	$5	H&C	Millennium	3000	$10
Harrah's	Reno	$5	BJ	60 Years 1937-1997	5000	$10
Harrah's	Reno	$5	BJ	Reno Rodeo 1997	1000	$15
Harrah's	Reno	$5	BJ	Reno Air Races 1997	1000	$15
Harrah's	Reno	$5	BJ	Air Races 1998	2000	$10
Harrah's	Reno	$5	BJ	Air Races 1999	2000	$10
Harrah's	Reno	$5	BJ	Hot August Nights 1999	2500	$10
Harrah's	Reno	$5	BJ	Millennium	5000	$10
Harrah's	Reno	$5	Chipco	ABC Tournament 1995	2000	$15
Harrah's	Reno	$5	Chipco	Air Races 1993	2000	$25
Harrah's	Reno	$5	Chipco	Air Races 1994	2000	$20
Harrah's	Reno	$5	Chipco	Air Races 1995	2000	$20
Harrah's	Reno	$5	Chipco	Air Races 1996	2000	$15
Harrah's	Reno	$5	Chipco	Balloon Races 1996	2000	$15
Harrah's	Reno	$5	Chipco	Balloon Races 1997	1000	$15
Harrah's	Reno	$5	Chipco	Dawn Patrol Reno 1996	1500	$15
Harrah's	Reno	$5	Chipco	Gaming Through the Ages (13-pc. set)	500 sets	$15
Harrah's	Reno	$5	Chipco	Happy Birthday	2000	$10
Harrah's	Reno	$5	Chipco	Hot Air Baloons 9/8/95	2000	$20
Harrah's	Reno	$5	Chipco	Hot Air Baloons Sept. 8-10	2000	$15
Harrah's	Reno	$5	Chipco	Hot August Nights 1993 T-Bird	2000	$25
Harrah's	Reno	$5	Chipco	Hot August Nights 1994 Vette	2000	$25
Harrah's	Reno	$5	Chipco	Hot August Nights 1995 Caddy	2000	$25
Harrah's	Reno	$5	Chipco	Hot August Nights 1996 55 Chevy	2000	$15
Harrah's	Reno	$5	Chipco	Hot August Nights 1997 57 Nomad	2500	$15
Harrah's	Reno	$5	Chipco	Hot August Nights 1998 Truck	2000	$15
Harrah's	Reno	$5	Chipco	Planet Hollywood 1994	3000	$15
Harrah's	Reno	$5	Chipco	Rodeo 1994	3000	$15
Harrah's	Reno	$5	Chipco	Year of the OX	1500	$10
Harrah's	Reno	$5	Chipco	Year of the Rabbit 1999	2000	$10
Harrah's	Reno	$5	Chipco	Year of the Rat	1000	$15
Harrah's	Reno	$5	Chipco	Year of the Tiger 1998	1500	$15
Harrah's	Reno	$25	Chipco	Planet Hollywood 1994	1000	$50
Harvey's	Lake Tahoe	$5	Chipco	50th Anniversary	1500	$15
Harvey's	Lake Tahoe	$5	Chipco	1964-1974/Building	1500	$15
Harvey's	Lake Tahoe	$5	Chipco	Cabin 1991	1500	$15
Harvey's	Lake Tahoe	$5	Chipco	Gambling Hall 1992	1500	$15
Harvey's	Lake Tahoe	$5	Chipco	Party at Harvey's 1994	1500	$15
Harvey's	Lake Tahoe	$5	Chipco	Year 2000	4000	$10
Harvey's	Lake Tahoe	$10	H&C	Bill Cosby-No Date	3000	$20

Casino	City	Denom	Mold	Inlay	Mintage	Value
Harvey's	Lake Tahoe	$10	H&C	Bill Cosby-8/2/97	3000	$20
Harvey's	Lake Tahoe	$10	H&C	Bill Cosby-11/1/97	3000	$20
Harvey's	Lake Tahoe	$25	Chipco	Year 2000	1000	$35
Hilton	Reno	$5	Chipco	ABC Bowling 1995	2000	$10
Hilton	Reno	$5	Chipco	Air Races 1996	1400	$15
Hilton	Reno	$5	Chipco	Air Races 1997	2000	$15
Hilton	Reno	$5	Chipco	Air Races 1998	800	$15
Hilton	Reno	$5	Chipco	Air Races/Balloons 1999	3000	$10
Hilton	Reno	$5	Chipco	Aireus 1 of 6 1997	500	$15
Hilton	Reno	$5	Chipco	Aireus 2 of 6 1997	500	$15
Hilton	Reno	$5	Chipco	Aireus 3 of 6 1997	500	$15
Hilton	Reno	$5	Chipco	Aireus 4 of 6 1997	500	$15
Hilton	Reno	$5	Chipco	Aireus 5 of 6 1997	500	$15
Hilton	Reno	$5	Chipco	Aireus 6 of 6 1997	500	$15
Hilton	Reno	$5	Chipco	Bob Hoover 1995 Air Races	2500	$20
Hilton	Reno	$5	Chipco	Bowling WIBC-1997	2500	$20
Hilton	Reno	$5	Chipco	Chili Cook Off 1996	1400	$25
Hilton	Reno	$5	Chipco	Chili Cook Off 1997	2000	$20
Hilton	Reno	$5	Chipco	Earthwinds 1993	1500	$20
Hilton	Reno	$5	Chipco	Grand Prix 1996	500	$20
Hilton	Reno	$5	Chipco	Grand Prix II 1997	1400	$20
Hilton	Reno	$5	Chipco	Hot August Nights 1998	800	$20
Hilton	Reno	$5	Chipco	Hot August Nights 1999	1750	$10
Hilton	Reno	$5	Chipco	Hot N' Fiery 1998	800	$15
Hilton	Reno	$5	Chipco	Indy Grand Prix 1993	1500	$25
Hilton	Reno	$5	Chipco	Millennium (stackable set of 12)	750	$10ea.
Hilton	Reno	$5	Chipco	New Year's 1996	1500	$20
Hilton	Reno	$5	Chipco	Pot of Gold 1998	2000	$15
Hilton	Reno	$5	Chipco	Rolling Thunder 1993	1500	$30
Hilton	Reno	$5	Chipco	Splash 1994	2000	$15
Hilton	Reno	$5	Chipco	Street Vibrations	800	$15
Hilton	Reno	$25	Chipco	Air Races 1996	100	$75
Hilton	Reno	$25	Chipco	Air Races 1998	200	$60
Hilton	Reno	$25	Chipco	Chili Cook Off 1996	100	$75
Hilton	Reno	$25	Chipco	Grand Prix 1997	100	$75
Hilton	Reno	$25	Chipco	Hot August Nights 1998	200	$60
Hilton	Reno	$25	Chipco	Hot August Nights 1999	200	$60
Hilton	Reno	$25	Chipco	Hot N' Fiery 1998	200	$60
Hilton	Reno	$25	Chipco	Millennium (stackable set of 12)	100	$50ea.
Hilton	Reno	$25	Chipco	Street Vibrations	200	$60
Horseshoe Club	Reno	$5	Chipco	New Year's 1992	2000	$25
Hotel Nevada	Ely	$2.50	Chipco	Horses	2000	$5
Hotel Nevada	Ely	$5	Chipco	Horses	1000	$10
Hyatt Regency	Lake Tahoe	$1	Chipco	20th Anniversary 1995	2000	$5
Hyatt Regency	Lake Tahoe	$5	Chipco	20th Anniversary 1995	1000	$15
Hyatt Regency	Lake Tahoe	$25	Chipco	20th Anniversary 1995	500	$50
Hyatt Regency	Lake Tahoe	$5	Chipco	Lake Scenes (Stackable Set of 5)	500	$10ea.
Indian Springs	Indian Springs	$5	H&C	Millennium	500	$15
Monte Carlo	Reno	$5	Chipco	Racing	2000	$15
Nevada Landing	Jean	$5	Chipco	Admission is Free	1000	$10
Nevada Landing	Jean	$5	Chipco	All You Can Eat Buffet	1000	$10

Casino	City	Denom	Mold	Inlay	Mintage	Value
Nevada Landing	Jean	$5	Chipco	Jackpot Paid in Person	1000	$10
Nevada Landing	Jean	$5	Chipco	Millennium	1500	$10
Nevada Landing	Jean	$5	Chipco	No Charges on Free Items	1000	$10
Nevada Landing	Jean	$5	Chipco	Open 24 Hours a Day	1000	$10
Nevada Landing	Jean	$5	Chipco	Our Comps Are Free	1000	$10
Nevada Landing	Jean	$5	Chipco	Our Gas is Unleaded	1000	$10
Nevada Landing	Jean	$5	Chipco	Our Restaurants	1000	$10
Nevada Landing	Jean	$5	Chipco	Our Rooms Have Beds	1000	$10
Nevada Landing	Jean	$5	Chipco	You're in Jean Now	1000	$10
Nevada Landing	Jean	$10	Chipco	10th Birthday	2000	$20
Nevada Landing	Jean	$25	Chipco	Our Comps Are Free	300	$30
Nevada Landing	Jean	$25	Chipco	Our Rooms Have Beds	300	$30
Nevada Landing	Jean	$25	Chipco	You're in Jean Now	300	$30
Nugget	Fallon	$5	H&C	Merry Christmas 1996	400	$20
Nugget	Fallon	$5	H&C	Home of Top Gun	1500	$15
Nugget	Sparks	$5	Chipco	Rib Cook Off 1991	2500	$20
Nugget	Sparks	$5	Chipco	Rib Cook Off 1992	2500	$20
Nugget	Sparks	$5	Chipco	Rib Cook Off 1993	2500	$20
Nugget	Sparks	$5	H&C	Celebrating 40 Yrs.	10000	$10
Oasis	Mesquite	$5	BJ	86th Birthday	2000	$10
Oasis	Mesquite	$5	H&C	Si Redd	2000	$10
Ormsby House	Carson City	$5	Chipco	1991 Building	2000	$15
Peppermill	Reno	NCV	H&C	ABC Bowling	1000	$20
Peppermill	Reno	$5	Chipco	Slot August Nights	1000	$15
Peppermill	Reno	$5	H&C	Hot August Nights 1999	1000	$15
Peppermill	Reno	$5	H&C	Millennium	1000	$15
Peppermill	Reno	$5	H&C	Rodeo 1998	500	$20
Peppermill	Reno	$5	H&C	Rodeo 1999	500	$20
Pioneer	Laughlin	$5	H&C	Millennium	100	$40
Pioneer	Laughlin	$5	H&C	River Run 1996	2000	$10
Pioneer	Laughlin	$5	H&C	River Run 1997	500	$15
Pioneer	Laughlin	$5	H&C	River Run 1998	600	$20
Pioneer	Laughlin	$5	H&C	River Run 1999	1000	$10
Primm Valley	Primm	$5	H&C	Millennium	2000	$10
Primm Valley	Primm	$25	H&C	Millennium	2000	$35
Ramada Express	Laughlin	$5	BJ	10th Anniversary	1000	$15
Ramada Express	Laughlin	$5	BJ	4th of July 1998	1000	$10
Ramada Express	Laughlin	$5	BJ	4th of July 1999	1000	$10
Ramada Express	Laughlin	$5	BJ	Air Corp.-U.S. Army	1000	$10
Ramada Express	Laughlin	$5	BJ	Balloon Race 1997	1000	$10
Ramada Express	Laughlin	$5	BJ	Christmas 1998	1000	$10
Ramada Express	Laughlin	$5	BJ	Christmas 1999	1000	$10
Ramada Express	Laughlin	$5	BJ	International Rally Car	1000	$10
Ramada Express	Laughlin	$5	BJ	Kill Him	1000	$10
Ramada Express	Laughlin	$5	BJ	Loose Talk	1000	$10
Ramada Express	Laughlin	$5	BJ	Merchant's Navy	1000	$10
Ramada Express	Laughlin	$5	BJ	Millennium	2000	$10
Ramada Express	Laughlin	$5	BJ	Navy Dark	500	$20
Ramada Express	Laughlin	$5	BJ	Navy Lite	500	$20
Ramada Express	Laughlin	$5	BJ	New Year's 1999	1000	$10
Ramada Express	Laughlin	$5	BJ	River Run 1998	2000	$10
Ramada Express	Laughlin	$5	BJ	River Run 1999	1000	$10
Ramada Express	Laughlin	$5	BJ	River Stampede 1999	1000	$10
Ramada Express	Laughlin	$5	BJ	St. Patrick's Day 1998	2300	$10

Casino	City	Denom	Mold	Inlay	Mintage	Value
Ramada Express	Laughlin	$5	BJ	St. Patrick's Day 1999	2500	$10
Ramada Express	Laughlin	$5	BJ	The U.S. Army	1000	$10
Ramada Express	Laughlin	$5	BJ	U.S. Marines	1000	$10
Ramada Express	Laughlin	$5	BJ	Uncle Sam	1000	$10
Ramada Express	Laughlin	$5	BJ	United Nation	1000	$30
Ramada Express	Laughlin	$5	BJ	Veteran's Day 1998	1000	$20
Ramada Express	Laughlin	$5	BJ	WAAC	1000	$30
Ramada Express	Laughlin	$5	BJ	War Bonds	1000	$30
Ramada Express	Laughlin	$5	BJ	We Can Do It	1000	$30
Ramada Express	Laughlin	$5	Chipco	Grand Opening 1993	1000	$15
Ramada Express	Laughlin	$5	Chipco	River Run 1996	5000	$10
Red Lion	Elko	$5	H&C	Cowboy Poetry 1997	3000	$10
Red Lion	Elko	$5	H&C	Cowboy Poetry 1998	3000	$10
Red Lion	Elko	$5	H&C	Cowboy Poetry 1999	1000	$10
Red Lion	Elko	$5	H&C	Millennium/Cowboy Poetry	3000	$10
River Palms	Laughlin	$5	H&C	Grand Opening	2000	$15
Riverboat	Reno	$5	Chipco	5 Year Anniversary 1993	2000	$15
Riverside	Laughlin	$5	Wico	Football 1996	5000	$10
Riverside	Laughlin	$5	Wico	River Run 1996	5000	$10
Sands Regency	Reno	$5		Millennium	800	$15
Silver Club	Sparks	$5	Chipco	3rd Anniversary 1992	2000	$15
Silver Club	Sparks	$5	Chipco	Millennium/Building	3000	$10
Silver Club	Sparks	$5	Chipco	Y2K Bug	3000	$10
Silver Legacy	Reno	$5	H&C	1st Anniversary 1996	2000	$15
Silver Legacy	Reno	$5	H&C	Hot August Nights	3000	$10
Silver Legacy	Reno	$5	H&C	Kenny Rogers 1996	6000	$10
Silver Legacy	Reno	$5	H&C	Rodeo Bucking Bronco 1999	1000	$10
Silver Legacy	Reno	$5	H&C	Rodeo Horse & Bulls 1999	1000	$10
Silver Legacy	Reno	$5	H&C	Rodeo Steer Hearding 1999	1000	$10
Silver Smith	Wendover	NCV	H&C	Chinese New Year 1998	500	$35
Silver Smith	Wendover	$5	BJ	Kung Hei Fat Choi		$10
Silver Smith	Wendover	$25	H&C	Millennium	500	$50
Silver Smith	Wendover	$5	H&C	New Years 2000	250	$25
Silver Smith	Wendover	$5	BJ	Thanksgiving 99	200	$40
State Line	Wendover	$5	BJ	Kung Hei Fat Choi		$10
State Line	Wendover	$5	BJ	New Years 2000	750	$15
State Line	Wendover	$5	BJ	Thanksgiving 99	250	$40
State Line	Wendover	$25	BJ	Millennium	1000	$35
Stateline Saloon	Amargosa Valley	.10	H&C	Old Building 1960	450	$10
Stateline Saloon	Amargosa Valley	$1	H&C	Outline of Nevada	450	$15
Stateline Saloon	Amargosa Valley	$2.50	H&C	Pupfish	450	$15
Stateline Saloon	Amargosa Valley	$3	H&C	Lightning	450	$15
Stateline Saloon	Amargosa Valley	$5	H&C	4th of July 1996	300	$15
Stateline Saloon	Amargosa Valley	$5	H&C	Christmas 1996	300	$40
Stateline Saloon	Amargosa Valley	$5	H&C	Christmas-1 Partridge	1000	$15
Stateline Saloon	Amargosa Valley	$5	H&C	Christmas-2 Turtle Doves	1000	$10
Stateline Saloon	Amargosa Valley	$5	H&C	Christmas-3 French Hens	1000	$10
Stateline Saloon	Amargosa Valley	$5	H&C	Christmas-4 Calling Birds	1000	$10
Stateline Saloon	Amargosa Valley	$5	H&C	Christmas-5 Golden Rings	1000	$10
Stateline Saloon	Amargosa Valley	$5	H&C	Christmas-6 Geese	1000	$10
Stateline Saloon	Amargosa Valley	$5	H&C	Christmas-7 Swans	1000	$10
Stateline Saloon	Amargosa Valley	$5	H&C	Christmas-8 Maids	1000	$10
Stateline Saloon	Amargosa Valley	$5	H&C	Christmas-9 Drummers	1000	$10
Stateline Saloon	Amargosa Valley	$5	H&C	Christmas-10 Pipers	1000	$10

Casino	City	Denom	Mold	Inlay	Mintage	Value
Stateline Saloon	Amargosa Valley	$5	H&C	Christmas-11 Ladies	1000	$10
Stateline Saloon	Amargosa Valley	$5	H&C	Christmas-12 Lords	1000	$10
Stateline Saloon	Amargosa Valley	$5	H&C	Desert Splendor	450	$20
Stateline Saloon	Amargosa Valley	$5	H&C	Easter Large Bird 1997	300	$40
Stateline Saloon	Amargosa Valley	$5	H&C	Easter Large Bunny 1997	300	$40
Stateline Saloon	Amargosa Valley	$5	H&C	Halloween 1996	300	$40
Stateline Saloon	Amargosa Valley	$5	H&C	New Year's 1997	300	$40
Stateline Saloon	Amargosa Valley	$5	H&C	Pioneer Territory	450	$40
Stateline Saloon	Amargosa Valley	$5	H&C	Thanksgiving 1996	300	$40
Stateline Saloon	Amargosa Valley	$5	H&C	Valentine's Day 1997	300	$40
Stateline Saloon	Amargosa Valley	$25	H&C	Desert		$40
Stateline Saloon	Amargosa Valley	$25	H&C	1st Lady of Gaming	450	$50
Stockman's	Elko	$25	H&C	Millennium	1000	$35
Sundowner	Reno	$5	H&C	Fuzzy Shimada	3000	$10
Sundowner	Reno	$5	H&C	Millennium	1500	$10
Tahoe Biltmore	Lake Tahoe	$5	H&C	50th Anniversary	3000	$15
Tahoe Biltmore	Lake Tahoe	$5	H&C	Millennium		$15
Tahoe Biltmore	Lake Tahoe	$25	H&C	Millennium		$40
Terrible's Lakeside	Pahrump	$5	Chipco	Millennium (4 different)	250	$15
Terrible's Lakeside	Pahrump	$5	H&C	Herbst Racing Team 99	750	$15
Terrible's Town	Pahrump	$1	Chipco	Millennium	250	$20
Terrible's Town	Pahrump	$5	Chipco	Millennium	250	$25
Terrible's Town	Pahrump	$5	H&C	Herbst Racing Team 99	750	$10
Terrible's Town	Pahrump	$25	Chipco	Millennium	250	$50
Terrible's Town	Pahrump	$100	Chipco	Millennium	250	$125
Topaz Lodge	Lake Topaz	$5	Chipco	Fishing Derby 1992	2000	$10
Whiskey Pete's	Primm	$5	H&C	Millennium	2000	$15
Whiskey Pete's	Primm	$25	H&C	Millennium	2000	$40

Index of Casinos and Chips

Abbreviations: Atlantic City (AC); Battle Mountain (BM); Carson City (CC); Colorado (CO); Deadwood (DW); Illinois (IL); Indiana (IN); Iowa (IA); Las Vegas (LV); North Las Vegas (NLV); West Las Vegas (WLV); Lake Tahoe (LT); Laughlin (LGH); Louisiana (LA); Mississippi (MS); Missouri (MO); Virginia City (VC)

Membership Application

Casino Chips and Gaming Tokens Collectors Club

NAME _____

ADDRESS _____

CITY_____ STATE _____ ZIP _____

PHONE

- My Collections Interests are:
 - ☐ Chips ☐ Tokens
 - ☐ U.S. ☐ Foreign ☐ Other _____
- Please publish my:
 - ☐ Name and Address ☐ Phone
 - in the club directory
- Publish my name, e-mail address and collecting interests on the club web page:
 - ☐ Yes ☐ No
- ☐ Do Not Publish my information in either.

- I have enclosed my Annual Dues for:
 - ☐ Life Membership ($300) 3rd Class Delivery
 - ☐ One Year ($20) 3rd Class Delivery
 - ☐ Associate ($5) member in same household as regular member
 - ☐ Foreign ($35) Postal money order or U.S. funds
 - ☐ **For First Class magazine delivery add ($12) U.S. only**
 - Foreign mailings are First Class, regular mailings are Third Class unless First Class is added.

Mail your completed application with check made out to CC>CC to:
 CC>CC Membership Officer
 James Steffner
 PO Box 368
 Wellington, OH 44090

1-877-4CCGTCC

Sponsored by: **American Chip Enterprises, Inc.**
Members #207 & #2246

DON'T FORGET:

CC>CC Club Membership entitles you to Free admission and auction privileges at the year's biggest and best Chip Show, The CC>CC National Convention held July 19-21, 2000 at the Orleans Casino & Hotel in Las Vegas, Nevada.